EARLY AMERICAN
CARTOGRAPHIES

Published for the
Omohundro Institute of Early American
History and Culture,
Williamsburg, Virginia,
by the University of North Carolina Press,
Chapel Hill

EARLY AMERICAN

CARTOGRAPHIES

Edited by Martin Brückner

Early American Cartographies *has received a
subvention from the general publications fund of
the Newberry Library, Chicago, in recognition of
its contributions to Renaissance studies and the
history of cartography.*

*Publication of this book has been assisted by the
College of Arts and Sciences and the Department
of English at the University of Delaware.*

The Omohundro Institute of Early American
History and Culture is sponsored jointly
by the College of William and Mary and
the Colonial Williamsburg Foundation. On
November 15, 1996, the Institute adopted
the present name in honor of a bequest from
Malvern H. Omohundro, Jr.

Library of Congress
Cataloging-in-Publication Data
Early American cartographies /
edited by Martin Brückner. — Ed. 1.
p. cm.
"Published for the Omohundro Institute
of Early American History and Culture,
Williamsburg, Virginia."
Includes bibliographical references
and index.
ISBN 978-0-8078-3469-5 (cloth : alk. paper)
1. America—Historical geography—Maps.
2. Cartography—America—History.
I. Brückner, Martin, 1963– II. Omohundro
Institute of Early American History &
Culture.
G1101.S1E2 2012
912.73—dc23
2011024077

The paper in this book meets the guidelines
for permanence and durability of the
Committee on Production Guidelines for
Book Longevity of the Council on Library
Resources.

The University of North Carolina Press has
been a member of the Green Press Initiative
since 2003.

This volume received indirect support from
an unrestricted book publication grant
awarded to the Institute by the L. J. Skaggs
and Mary C. Skaggs Foundation of Oakland,
California.

15 14 13 12 11 5 4 3 2 1

J. A. LEO LEMAY

In Memoriam

ACKNOWLEDGMENTS

In its completed state, this book explores more than the enduring significance of maps from the perspective of an American cartographic culture. It is an example of the collaboration and interdisciplinary thinking that have become the foundation of Americanist scholarship at home and abroad, not only in universities but also in public libraries, special collections, and museums. The book represents the conclusion of a lengthy process that began in 2006 at a thematic conference bearing the title "Early American Cartographies," hosted by the Newberry Library in Chicago and sponsored by the Center for Renaissance Studies, the Hermon Dunlap Smith Center for the History of Cartography, the D'Arcy McNickle Center for American Indian History, the Dr. William M. Scholl Center for Family and Community History, the Institute for Scholarship in the Liberal Arts, College of Arts and Letters, University of Notre Dame, and the Society of Early Americanists. At the time, the stated goal of the conference—namely, to investigate the cartographic representation of space and place from an early American perspective—was greeted with great enthusiasm by a large audience consisting of scholars and the general public. Now that the book has moved from conception through publication, the book has received valuable support and help from many colleagues and institutions. I am most grateful to the editorial team at the Omohundro Institute of Early American History and Culture. In particular, I would like to thank Fredrika Teute, without whose enthusiasm and continual guidance this book would not have happened, and Virginia Montijo for her attentive copyediting and careful close readings. For funding and institutional support, I am deeply grateful to the Newberry Library. It provided not only a generous award at a crucial juncture of this project, but many contributions collected in this volume are indebted to the Newberry's archivists, librarians, and curators, who generously shared their knowledge of all things related to American maps. Furthermore, I am thankful for additional support from the College of Arts and Sciences and the Department of English at the University of Delaware. In the project's early stages, I received advice from Jim Akerman, Gordon Sayre, and Carla Zecher. Toward the end, the book benefited immensely as a whole and in its parts from comments offered by David Buisseret, Tom Conley, and Max Edelson. A special thanks for consultations and advice (and patience) goes to all the contributors. As always, I am grateful to my family, Kristen Poole and Corinna and Juliana Brückner.

CONTENTS

Acknowledgments / vii
List of Illustrations / xi
Introduction: The Plurality of Early American Cartography / 1
 Martin Brückner

PART I.
CARTOGRAPHIC HORIZONS AND IMPERIAL POLITICS

1. DEEP ARCHIVES; OR, THE EMPIRE HAS TOO MANY MAPS

From Abstraction to Allegory:
 The Imperial Cartography of Vicente de Memije / 35
 Ricardo Padrón
Centers and Peripheries in English Maps of America, 1590–1685 / 67
 Ken MacMillan

2. THE (UN)MAKING OF COLONIES

A Compass to Steer by:
 John Locke, Carolina, and the Politics of Restoration Geography / 93
 Jess Edwards
Rebellious Maps:
 José Joaquim da Rocha and the Proto-Independence Movement
 in Colonial Brazil / 116
 Junía Ferreira Furtado

PART II.
CARTOGRAPHIC ENCOUNTERS AND LOCAL KNOWLEDGE

3. NATIVE MAPS / MAPPING NATIVES

The Wrong Side of the Map?
 The Cartographic Encounters of John Lederer / 145
 Gavin Hollis
An Image to Carry the World within It:
 Performance Cartography and the Skidi Star Chart / 169
 William Gustav Gartner
Closing the Circle: Mapping a Native Account of Colonial Land Fraud / 248
 Andrew Newman

4. COSMOPOLITAN MAPS

Competition over Land, Competition over Empire:
 Public Discourse and Printed Maps of the Kennebec River,
 1753–1755 / 276
 Matthew H. Edney
Building Urban Spaces for the Interior:
 Thomas Penn and the Colonization of Eighteenth-Century
 Pennsylvania / 306
 Judith Ridner
Mapping Havana in the *Gentleman's Magazine*, 1740–1762 / 339
 Scott Lehman

PART III.
META-CARTOGRAPHIES: ICONS, OBJECTS, AND METAPHORS

National Cartography and Indigenous Space in Mexico / 363
 Barbara E. Mundy
The Spectacle of Maps in British America, 1750–1800 / 389
 Martin Brückner
Hurricanes and Revolutions / 442
 Michael J. Drexler

Notes on Contributors / 467
Index / 469

ILLUSTRATIONS

Abraham Ortelius, *Americae Sive Novi Orbis, Nova Descriptio* / 2
Henry S. Tanner, *America* / 3
A Map of Lewis and Clark's Track / 22
John Melish, *Map of the United States* / 23
Vicente de Memije, *Aspecto geográphico del mundo Hispánico* / 36
Vicente de Memije, *Aspecto symbólico del mundo Hispánico* / 37
Johannes Bucius, *Europa Regina* / 39
Descripción de las Indias Ocidentalis / 42
Descripción de las Indias del Poniente / 43
Frontispiece from Abraham Ortelius, *Theatrum Orbis Terrarum* / 46
Francisco Diaz Romero and Antonio Ghandia, *Carta chorographica del Archipielago de las Islas Philippinas* / 51
Pedro Murillo Velarde, *Carta hydrographica y chorographica de las Yslas Filipinas* / 56
Juan de la Cruz Cano y Olmedilla, *Mapa geográfico de América Meridional* / 65
Edward Wright, *Map of the World* / 72
Theodore de Bry, *Americae Pars, Nunc Virginia Dicta* / 74
John Smith, *Virginia* / 75
John Smith, *New England* / 76
John Mason, *Newfound Land* / 77
Title page of John Smith, *The Generall Historie of Virginia* / 85
John Ogilby, *A New Discription of Carolina* / 96
Locke's Carolina Memoranda / 102
"Locke 1671" / 103
John Locke, "Writers of Carolina" / 104
Joel Gascoyne, *A New Map of the Country of Carolina* / 107
Willem Janszoom Blaeu, *Brasilia* / 118
Mapa das Cortes / 124
José Joaquim da Rocha, *Mapa da capitania de Minas Geraes* / 136
José Joaquim da Rocha, *Mappa da Comarca do Sabara* / 140
John Smith, *Virginia* / 148
John Lederer, *A Map of the Whole Territory* / 155
The Skidi Pawnee Heartland in Eastern Nebraska, circa AD 1500–1876 / 173
The Skidi Star Chart / 174

Identified Stars, Planets, Asterisms, Constellations, and Other Celestial
 Objects Depicted on the Skidi Star Chart / 180
Selected Pawnee Representations of Stars / 181
Pawnee Settlements / 184
Details of the Skidi Star Chart / 189
The Skidi Star Chart as a Map of Ceremonials and the Night Sky / 196
Chief's Circle / 212
The Stretchers / 213
The Deer Stars / 214
A Skidi Earth Lodge / 217
Earth Lodge Topology in the Oral Traditions, Rituals, and Songs Performed
 during the Thunder Ceremony / 223
A Small Painted Symbol Representing the Vault of the Heavens and the
 Breath of Heaven / 228
The Integration of the Map and the Paramap through Performance
 Geography / 234
"Deceptive Land Purchase: 'Ox Hide Measure'" / 252
Tobias Stimmer, "Dido Cutting the Ox-Hide" / 267
Matthäus Merian, Queen Dido Founding Carthage / 268
Rembrandt Studio, "Dido Cutting the Ox-Hide" / 269
At a Meeting of the Proprietors of the Township of Brunswick / 282
Detail of the cartouche from Thomas Johnston, *A True Coppy from an*
 Ancient Plan / 286
Thomas Johnston, *This Plan of Kennebeck and Sagadahock Rivers* / 288
Detail of inset map from Thomas Johnston, *This Plan of Kennebeck and*
 Sagadahock Rivers / 293
[John Green], *A Plan of Kennebek and Sagadahok Rivers* / 296
Plan of the Town of Carlisle / 323
Thomas Holme, *A Portraiture of the City Philadelphia* / 325
The Plat of the Cittie of Londonderrie / 328
Center Square of Carlisle / 331
John Creigh, The Plan of the Town of Carlisle / 336
Plan of the City of Havanah / 345
Plan of the City and Harbour of Havanna / 351
A Plan of the Siege of the Havana / 356
"Explanation of the References to the Plan of the Siege of the
 Havannah" / 357
Antonio García Cubas, *Carta etnográfica* / 368
Relación geográfica map of Misquiahuala / 372
Carta de los ferrocarriles de los Estados Unidos Mexicanos / 375

Map of Tenochtitlan and the Gulf Coast / 378

Lienzo de San Pedro Ixcatlan / 381

John Henry, A New and Accurate Map of Virginia / 390

John Bowles, frontispiece to A Catalogue of Maps, Prints, Copy-Books / 400

Henry Popple, A Map of the British Empire in America / 407

John Mitchell, A Map of the British and French Dominions in North
 America / 410

Edward Savage, after Robert Edge Pine, Congress Voting Independence / 411

Detail of Corps de Garde van Hollandsche Officers / 415

An Extraordinary Gazette; or, The Disappointed Politicians / 418

The Council of the Rulers / 419

Isaac Ware, A Complete Body of Architecture / 426

Dining Room, Governor's Palace, Williamsburg, Virginia / 428

Cartouche in Robert de Vaugondy, Partie de l'Amérique septentrionale / 429

Thomas Chippendale, "Pier Glass Frames" / 430

A Map of the Present Seat of War in North America / 434

Ralph Earl, Thomas Earle / 438

Verifiable Hurricane Strikes and Trajectories, June–November 1772 / 443

The Itineraries of the San Dominick in Herman Melville's Benito Cereno / 448

Benjamin Franklin, A Chart of the Gulph Stream / 460

Benjamin Franklin, Franklin-Folger Chart of the Gulf Stream / 461

Winslow Homer, The Gulf Stream / 463

EARLY AMERICAN

CARTOGRAPHIES

INTRODUCTION

THE PLURALITY OF
EARLY AMERICAN
CARTOGRAPHY

Martin Brückner

Two atlas maps showing the Western Hemisphere—*Americae Sive Novi Orbis, Nova Descriptio* (1587) by Abraham Ortelius and the map *America* (1823) by Henry S. Tanner—illustrate the story that is most frequently told about three centuries of early American cartography (Figures 1 and 2). The Ortelius map, designed at the peak of sixteenth-century reconnaissance expeditions and travel reports and after the introduction of the Mercator projection, permanently changed formerly speculative depictions of the New World. Published in an atlas entitled *Theatrum Orbis Terrarum,* the map was indicative of the general adoption of cartography as the graphic container of geographical information. Placed inside a world atlas, it documented the rise of "America" from an initially mapless to a map-dominated representation. Indeed, beginning with maps such as *Americae Sive Novi Orbis* discussions about America—be they political, economic, or academic—became subsequently carto-coded; from public documents to personal writings, references to specific map titles, coordinates, and the uniquely sculpted visual form of the American continent would from here forward reflect and shape the idea of America as a place, space, or environment.

If we fast-forward to the Tanner map, the story of early American cartography changes less in form but more in matters of function. Published in a Philadelphia edition of a popular atlas, the continental map of the Americas now reflected two and a half centuries of knowledge production and transfer. On the one hand, the once malleable image of America had become stabilized as more accurate geodetic data had replaced formerly fuzzy information while filling in the details of previously unmapped blank spaces. On the other hand, being the latest product of a burgeoning print market, geographic mobility, and popular education, Tanner's large-scale map hailed the presence of an array of similar maps, including hundreds of much smaller-scaled views charting American localities. Serving as the implied gateway to a vast cartographic

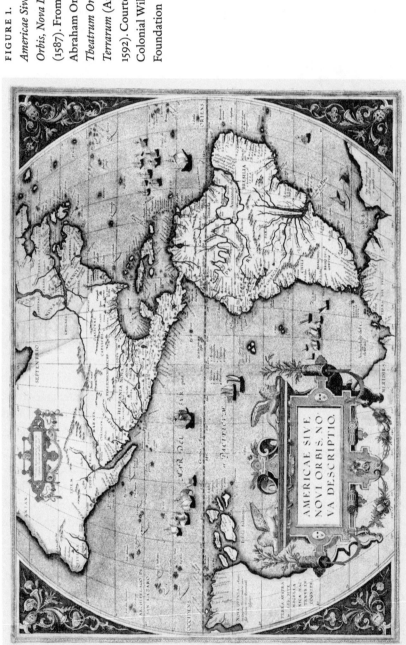

FIGURE 1.
Americae Sive Novi Orbis, Nova Descriptio (1587). From Abraham Ortelius, *Theatrum Orbis Terrarum* (Antwerp, 1592). Courtesy, The Colonial Williamsburg Foundation

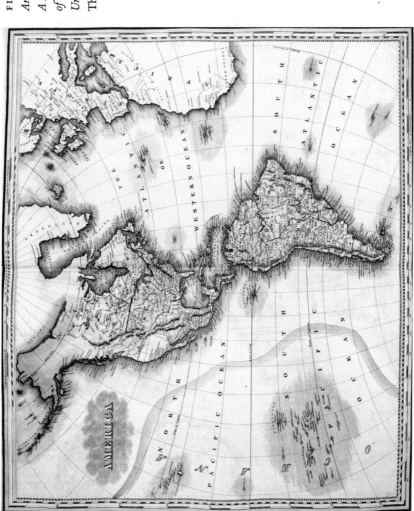

FIGURE 2.

America (1823). From Henry S. Tanner,
*A New American Atlas Containing Maps
of the Several States of the North American
Union . . .* (Philadelphia, 1823). Courtesy,
The Library Company of Philadelphia

archive, this map demonstrated early American cartography's development into a highly diversified commodity that was intended to reach a broad carto-literate readership on both sides of the Atlantic.[1]

When read together, maps like those by Ortelius and Tanner provide the bookends for stories that celebrate progress and knowledge, technology and transparency. Rich and comprehensive as these stories are, they are based on narrow definitions describing the cartographic culture in the early Americas. Academic and popular writings consistently understood the term "cartography" as a marvel of European science whose protocols and products not only dominate the representation of space but seem to do so with a singular technological and discursive edge. Traditional cartographic histories emphasize with great regularity that, just as cartography emerged from a combination of craft and print culture, the printed map's graphic properties—the grid lines and topographic symbols—also rendered maps made in the European vein not only useful but irresistible to all people living in the Americas.[2]

Using dates that frequently bracket several centuries or shorthand terms such as "early," these writings locate the story of early American maps and the cartographic culture surrounding them inside a rigorously periodized framework that, structured by a progressive idea of history, invariably tied descriptions of map design (maps showing America) and production (maps made in America) to a Eurocentric conception of cartographic beginnings. According to most studies, these beginnings were multiple; they happened in fits and starts, ranging from sixteenth-century map inscriptions to eighteenth-

1. Academic histories in this vein include Lloyd A. Brown, *The Story of Maps* (New York, 1949), 275–278; Fredi Chiappelli, Michael J. B. Allen, and Robert L. Benson, *First Images of America: The Impact of the New World on the Old*, 2 vols. (Berkeley, Calif., 1976); Leo Bagrow, *History of Cartography*, 2d ed., rev. and enl. R. A. Skelton (1964; rpt. Chicago, 1985), 105–194; Norman J. W. Thrower, *Maps and Civilization: Cartography in Culture and Society* (1972; rpt. Chicago, 1996), 58–124; and J. H. Andrews, *Maps in Those Days: Cartographic Methods before 1850* (Dublin, 2009), 1–34. Popular histories include Pierluigi Portinaro and Franco Knirsch, *The Cartography of North America, 1500–1800* (New York, 1987); John Goss, *The Mapping of North America: Three Centuries of Map-Making, 1500–1800* (Secaucus, N.J., 1990); and Nathaniel Harris, *Mapping the World: Maps and Their History* (San Diego, Calif., 2002).

2. On the form and function of "cartography," see, especially, J. B. Harley, *The New Nature of Maps: Essays in the History of Cartography*, ed. Paul Laxton (Baltimore, 2001); Matthew H. Edney, *The Origins and Development of J. B. Harley's Cartographic Theories*, Monograph 54, *Cartographica*, XL, nos. 1–2 (Spring–Summer 2005), 1–143; and Edney, "Putting 'Cartography' into the History of Cartography: Arthur H. Robinson, David Woodward, and the Creation of a Discipline," *Cartographic Perspectives*, LI (Spring 2005), 14–29.

century mapping initiatives; and, above all, they invoked value judgments that persistently decried the poor quality of American-made maps while celebrating those of European origins. Last but not least, stories about early modern cartography, while endlessly fascinated with "American" maps, tend to gloss over or abbreviate the highly varied history of maps and mapping practices as they played out in specifically American settings. For the most part, the term "American" is used adjectivally, serving as a geographic referent to better differentiate a map's content, but not to address a map in its local context and explain its relevance from an American perspective. If addressed at all, cartographic culture in the early Americas was either a footnote to European histories of mapmaking or a brief excerpt foreshadowing the rise of Anglo-American and Ibero-American nation-states.[3] The terms "cartography," "early," and "American" signal a rather prescriptive understanding of cartographic history, the very concept of maps, and the study of cartographic representation and practice in the Americas.

Yet, hiding behind these stories is a varied and complicated history of cartographic theories and practices that was concentrated in Europe but also that spanned the Atlantic and informed a more broadly defined cartographic culture in the Americas. Traditional stories about early American cartography consistently overlook that the very term "cartography" was a neologism coined by a member of the incipient British Geographical Society in 1859 and thus gained currency long after the period marked as "early" and after the term "America" had acquired certain modern meanings unavailable in previous centuries. In its singular definition, the term "cartography" signaled the advent of the standardization of maps and the professionalization of the mapping industry (which was further reified by the appearance of the

3. The cartographic historian Lloyd Brown expressed this evaluative attitude best when he writes: "Thousands of maps embracing what is now the United States of America were made between 1500 and 1800. They ranged from crude, conjectural sketches to accurately made surveys of limited areas. Nearly every country in Europe had a part in the mapping of the New World, but no such thing as a scientific national survey existed in the United States before 1800" (Brown, *The Story of Maps*, 275). See also John Noble Wilford, *The Mapmakers* (New York, 1981), 174–215. On discussions of map quality or "good" and "bad" maps, see Mary Sponberg Pedley, *The Commerce of Cartography: Making and Marketing Maps in Eighteenth-Century France and England* (Chicago, 2005), 10; and Catherine Delano-Smith, "The Map as Commodity," in David Woodward, Delano-Smith, and Cordell D. K. Yee, *Plantejaments i objectius d'una història universal de la cartografia / Approaches and Challenges in a Worldwide History of Cartography* (Barcelona, 2001), 91–109. For examples of the inadvertent conflation of narratives about early American cartography with national history, see footnote 14, below.

term "cartographer" in 1863). But, by adopting this neologism, mapmakers and map users glossed over the enduring presence of alternative notions of cartography. On the one hand, the term "cartography" suddenly contained and streamlined the presence of more than fifty "map" definitions that circulated in England before 1850, including denotations ranging from "picture" and "portraiture" to "landscape" and "view" (and that also served to bury the semantic ambiguity surrounding the label of mapmakers who used sobriquets such as "geographer," "plat-maker," "draughtsman," or "map-publisher"). On the other hand, the advent of the term "cartography" propagated a Eurocentric idea of maps and mapping practices and thus failed to take into account the vast array of European and non-European maps and mapping practices used in the Americas (and around the globe), many of which operated outside official cartographic conventions, using neither latitude and longitude nor symbols or letter codes.[4]

This omission begs questions about how a monothetic definition of "cartography" came to dominate the description and interpretation of cartographic archives that existed in America before 1859. But, more significantly, and for the purposes of this book, it raises questions that address the plurality rather than the singularity underpinning cartographic definitions, artifacts, and practices. For example, what are the historical differences, formal similarities, and informal uses that were shaping maps informed by European and indigenous modes of cartographic representation? How did three centuries of contact, conquest, and collaboration in the Americas affect maps and map uses in local society? How did American maps that simultaneously hinged on local technologies and were globally intertwined shape attitudes toward spatial conceptions of the communal and the personal? Indeed, once we allow ourselves to imagine a cartographic history that is anchored in the Americas rather than in Europe, what did an America-centric, or intra-American, cartographic culture look like and how did it operate in a time and space yet unaffected by the fixation of cartography in name and protocol to the demands of European and emerging American institutions?

This collection of essays responds to these questions by adopting a more pluralistic and inclusive perspective in order to recover the polythetic nature of cartographic culture in the Americas as it existed before the nineteenth century. Such a perspective provides a historically more representative frame-

4. The *Oxford English Dictionary* traces the term "cartography" to an essay on central Africa: R[ichard F.] Burton, "The Lake Regions of Central Equatorial Africa . . . ," *Journal of the Royal Geographical Society*, XXIX (1859), 28.

work for the description and interpretation of maps that not only originated at the same time on both sides of the Atlantic but also that traveled simultaneously in vastly different cultural circles from the Americas to the European and the Pacific worlds. Inspired by the multiple connotations that revolved around maps and mapmaking, *Early American Cartographies* thus addresses maps from a broad range of disciplines (history, cartography, geography, art history, material culture, literature). As the various essays treat maps as a graphic, verbal, and performative form of communication, they collectively explore and document the conceptual, cultural, and material pluralism that informed maps and mapping practices in early America itself. By emphasizing cultural production rather than historical genealogy, the essays on the whole approach maps as polyvalent genetic texts that contain at once transcultural and local stories. By conceiving maps in terms of stories rather than as articles of fact, the essays retrace some of the familiar ways in which European, Euro-American, and Amerindian perspectives affected the production of maps and map knowledge. At the same time, the essays trace new paths of inquiry to better show, for example, the recently diversified early American canon of maps or the uneven patterns with which early American cartographies traveled in and out of American communication networks and knowledge systems, simultaneously fettered and unfettered by colonial, imperial, and national mapping projects. Pursuing, then, a hemispheric, multicultural, and international study of the early American cartographic archive, the essays illustrate that the florescence of cartographic knowledge *about* America was inextricably linked to a richly varied cartographic culture *in* the Americas.

CARTOGRAPHY AND HISTORIOGRAPHY: THE ONE MAP MODEL

With the goal to broaden the scope of critical inquiry and methodology, the essays in *Early American Cartographies* are informed by two powerful and persuasive strands of historiography that are the central building blocks responsible for the predominantly monothetic interpretation of American cartographic culture. In the first tradition, historical accounts valued maps showing the early Americas as a graphic supplement that provided authentic period views of geographical settings hosting historical events such as decisive battles, momentous journeys, or negotiated boundaries. By contrast, in the second tradition, early American maps advanced from being passive textual supplements to becoming central texts whose geometrized graphic designs actively shaped at once historical events in the past as well as critical attitudes toward the Americas as a historical place and environment in the present. Both historiographies offer useful methodologies and frameworks

for interpreting the history and influence of maps in early America. But, as the following overview will show—and so will the various essays in this collection—indispensable and useful as both frameworks have been to inquiries into historical cartography they are based on nineteenth-century definitions of cartography that effectively prevented us from realizing the polythetic nature of early American cartographies.

The first historiographic tradition begins in the late eighteenth and early nineteenth century, when an increasingly standardized cartography was primarily considered as the "handmaiden" to either the academic history of geography or the more exciting (because deemed heroic) history of discovery and exploration.[5] This tradition has its roots in academic and popular writings, which, after declaring geography to be "the eye and key of history," went on to define maps as "a geographical picture on which lands and seas are delineated according to the longitude and latitude."[6] Following these definitions, historians treated old maps showing the Americas as decorative textual supplements, depicting certain American spaces, on the one hand, and historical events, on the other, in a graphic form that also reviewed the status of geographic knowledge during a certain historical period. In the eighteenth- and nineteenth-century world of publishing—and the following examples from the United States have their match in Mexico as well as in Brazil—popular storytellers and nonacademic map users, such as journalists and novelists, commonly called upon historical maps with their conventional show of water, land, and settlements because they were best equipped for illustrating (or imagining) historical events as they had once unfolded in time and space. With the advent of historical studies in secondary schools and universities, this approach became more formalized; historical maps appeared as facsimiles in historical atlases, encouraging readers not only to read about but to actively

5. J. B. Harley laments this attitude in "The Map and the Development of the History of Cartography," in Harley and David Woodward, eds., *Cartography in Prehistoric, Ancient, and Medieval Europe and the Mediterranean,* vol. I of *The History of Cartography* (Chicago, 1987), 12.

6. The ocular analogy of geography is widespread during the eighteenth century before losing its explanatory appeal by the mid-nineteenth century, when it nevertheless showed up in John Walker, *A Critical Pronouncing Dictionary and Expositor of the English Language* ... (London, 1838), 319, and in primers such as *First Lessons in English and Tamul: Designed to Assist Tamul Youth in the Study of the English Language* (Manepy, 1836), 86. The ocular connotation of maps dates back to Johan Blaeu's preface dedicated to Louis XIV in *Le grand atlas* ..., 3d ed. (Amsterdam, 1663). On map definitions in general, see J. H. Andrews, "What Was a Map? The Lexicographers Reply," *Cartographica,* XXXIII, no. 4 (Winter 1996), 1–11.

chart the journeys of Christopher Columbus and Captain James Cook or the battles of Generals James Wolfe and George Washington.[7]

After geographers and mapmakers embraced the monothetical definition of "cartography," the emerging disciplines of the natural sciences and the humanities at once preserved and popularized the supplemental function of early American maps when both the antiquarian and academic interest shifted toward comparative and thematic studies. Focusing on empiricism and scientific data mining about climate zones, population density, or the American frontier, progress-driven historical accounts used early maps as the narrative backdrop for establishing evolutionary tales (the before-and-after effect) in highly sensitive areas of politics, economics, disease control, and social planning.[8] Roughly at the same time that "cartography" emerged in the academic dictionaries, natural historians (Louis Agassiz), historians (Francis Parkman), cultural critics (Alexis de Tocqueville), novelists (James Fenimore Cooper), and artists (John James Audubon) commonly applied map inserts or cartographic data when seeking to outline a people's knowledge of place, their sense of historical consciousness, and even their most heartfelt desires.[9] Indeed, similar to the way in which E. M. W. Tillyard could present the medieval notion of an orderly "chain of being" when illustrating the worldview of Renaissance England, nineteenth- and early-twentieth-century studies across a broad range of disciplines treated early American maps as anatomies of an American worldview.[10]

By comparison, in the second historiography postmodern critiques of cartography revised this older, auxiliary understanding that cartography mir-

7. See Jeremy Black, *Maps and History: Constructing Images of the Past* (New Haven, Conn., 1997), esp. 6–76; and Susan Schulten, "Mapping American History," in James R. Akerman and Robert W. Karrow, Jr., eds., *Maps: Finding Our Place in the World* (Chicago, 2007), 159–205.

8. See Arthur H. Robinson, *Early Thematic Mapping in the History of Cartography* (Chicago, 1982). For retrospectives of specific maps and mapping events, see Dava Sobel, *Longitude: The True Story of a Lone Genius Who Solved the Greatest Scientific Problem of His Time* (New York, 1995); Simon Winchester, *The Map That Changed the World: William Smith and the Birth of Modern Geology* (New York, 2001); or Andro Linklater, *Measuring America: How an Untamed Wilderness Shaped the United States and Fulfilled the Promise of Democracy* (New York, 2002).

9. Here I take a page from U.S. cultural history; the same could be done from the perspective of nineteenth-century Mexican or South American history. See Raymond B. Craib, *Cartographic Mexico: A History of State Fixations and Fugitive Landscapes* (Durham, N.C., 2004); and Neil Safier, *Measuring the New World: Enlightenment Science and South America* (Chicago, 2008).

10. E. M. W. Tillyard, *The Elizabethan World Picture* (New York, 1959).

rored social life and societal structures, declaring it to be less a supplemental by-product and more a foundational ideology of Western civilization. During the final decades of the twentieth century, many critical assumptions about modernity took a "spatial turn" that emphasized the systemic impact of geometrical representation and territoriality, influencing everything from social constructions to the phenomenological experience of lifeworlds. According to scholars across the disciplinary spectrum—including Henri Lefebvre (sociology), Michel DeCerteau (philosophy), Immanuel Wallerstein (history), Benedict Anderson and Anthony Giddens (political science), Edward Soja, David Harvey, and Denis Cosgrove (geography), among others—maps ceased to be viewed as spatial depictions of historical events or mentalities. Instead, as the map's unique geometric organization (the geodetic grid or "graticule") increasingly determined human interactions with space, the pervasive application of geometry was now considered responsible for the gradual alignment of maps with all modes of social production.[11]

In this second historiography, to follow Lefebvre's influential work, *The Production of Space* (1991), geometrically configured maps emerged in Europe as a common spatial code for organizing everything from high culture to everyday life between the sixteenth and the nineteenth century. At the same time, conquest and colonization turned this European mapping practice into a global phenomenon for imagining geographical and cultural spaces. The producers of these spaces were itinerant land surveyors, sedentary map engravers, and a host of spatial architects, including landscape designers and urban planners. Their cartographic products were easy to recognize both locally and globally because the geometrical organization of cartography created a fundamentally isotropic, one-size-fits-all graphic model that subsumed and transformed all other conceptions of space. Indeed, with the widespread adoption of a geometric mode of cartographic representation—involving coordinates, grid lines, and a global calculus for reckoning locations and finding places—early modern maps, including early American maps, were recognized not only as abstract but also as easy-to-manipulate paper constructs. As long as it was framed by geometry, to paraphrase Bruno Latour, early American cartography was "no bigger than an *atlas* the plates of which may be flattened, combined, reshuffled, superimposed, redrawn at will." American maps stand

11. The term "graticule," although frequently applied to denote cartographic grid lines, is another anachronism; its meaning was not established until the late nineteenth century. See "graticule" in Helen M. Wallis and Arthur H. Robinson, eds., *Cartographical Innovations: An International Handbook of Mapping Terms to 1900* (London, 1987), 172–174.

and fall not only according to a hegemonic mode of geometric representation but at the bidding of a political will motivated by interest and desire. By the same token that "the cartographer *dominates* the world" in this second historiography, maps emerged as agents of domination and have thus been singled out in more recent histories and theories involving early American maps as the effective accomplice in the creation and maintenance of state power and social control.[12]

As this overview shows, each historiography provides constructive platforms for examining maps in early modern culture. The first and residual one, emerging from the progressive rhetoric of European national histories, rediscovers and popularizes conventional maps as a viable graphic context for illustrating narratives and social analysis. More than a century later, the second and emergent historiography, informed by the proposition that conventional maps are actually extraordinary texts, calls attention to the pervasiveness with which Western maps, in particular, and their geometrical design informed many aspects of cultural life. Together, both historiographies provide a tectonic view of cartography according to which early American maps function as record, as actual event, or as perceived consciousness, and thus are integral to the structure of historical discourse. But, in their instrumentalist view of maps and all things related to maps, both historiographies end up reifying the monothetic definition of cartography. Both cleave to Eurocentric conceptions of space and spatial representation (the older one on purpose, the more recent one on principle). And both thus pursue questions about cartographic representation and its attending culture from a particular ideological vantage point (be it scientific progress or political power) that, although essential to the study of maps, effectively blocks other non-European ideologies from registering alternative avenues for examining early American cartographies.

12. See Henri Lefebvre, *The Production of Space*, trans. Donald Nicholson-Smith (Cambridge, 1991), 229–291; Bruno Latour, *Science in Action: How to Follow Scientists and Engineers through Society* (Cambridge, Mass., 1987), 224. Lefebvre's cartographic take on the spatial organization of European and European-influenced cultures is manifest in studies beginning in the 1990s and across academic disciplines; aside from Harley's *New Nature of Maps*, see James C. Scott, *Seeing Like a State: How Certain Schemes to Improve the Human Condition Have Failed* (New Haven, Conn., 1998); D. Graham Burnett, *Masters of All They Surveyed: Exploration, Geography, and a British El Dorado* (Chicago, 2000); and Christian Jacob, *The Sovereign Map: Theoretical Approaches in Cartography throughout History*, ed. Edward H. Dahl, trans. Tom Conley (Chicago, 2006).

What prevented both historiographies from conceiving American carto-graphic representations in more polythetic terms is the widespread adoption of an inescapably Eurocentric political ideology according to which maps express the authenticity and legitimacy of a particular American spatial his-tory. This map-induced spatial history included everything from large-scale continental maps, such as Alberto Cantino's world map of 1502 that divided South America into Spanish and Portuguese imperial territories, to small-scale property maps—the surveyor's plats—which beginning with the 1670s transformed North America's northeastern and mid-Atlantic countryside into private commodified legal tender. But, in stories commonly told about maps circulating in the early Americas, perhaps the most pertinent spatial history revolved around statecraft and the process by which cartographic names and graphic forms invented American polities as a pre-determined and permanent reality. One prominent case of such storytelling occurred in the aftermath of the ceremonial unveiling of the first map to show the name "America"—Martin Waldseemüller's *Universalis Cosmographia* (1507)—at the Library of Congress in 2003, when maps dating to the Columbian decades were compared to national "birth certificates."[13]

That the very map that according to Edmundo O'Gorman is responsible for "the invention of America" should foreshadow the existence of American nation-states—here the United States—is a stretch of the historical imagina-tion. But it is not a historical gaffe; it deeply resonates with both traditional and more recent accounts of early American cartography. Surveys of carto-graphic history, from Seymour I. Schwartz and Ralph E. Ehrenberg's *Mapping of America* (1980) to John Rennie Short's *Representing the Republic: Mapping the United States, 1600–1900* (2001), viewed early American maps through a retrospective lens that inadvertently correlated their stories to a national car-tography.[14] The assumption that all maps lead to the nation-state is compel-

13. See Seymour I. Schwartz, *Putting "America" on the Map: The Story of the Most Important Graphic Document in the History of the United States* (Amherst, N.Y., 2007); and John R. Hébert, "The Map That Named America: Library Acquires 1507 Waldsee-müller Map of the World," *Library of Congress Information Bulletin*, LXII, no. 9 (Sep-tember 2003), *http://www.loc.gov/loc/lcib/0309/maps.html* (accessed July 2010).

14. Edmundo O'Gorman, *The Invention of America: An Inquiry into the Historical Nature of the New World and the Meaning of Its History* (Bloomington, Ind., 1961); Sey-mour I. Schwartz and Ralph E. Ehrenberg, *The Mapping of America* (New York, 1980); John Rennie Short, *Representing the Republic: Mapping the United States, 1600–1900* (London, 2001). See also David N. Livingstone, *The Geographical Tradition: Episodes in the History of a Contested Enterprise* (Oxford, 1992), 142–149; and Charles W. J. Withers,

ling, but only if the historical focus rests squarely on the period of American nation building between the 1780s and 1850s—and here we can invoke parallels that stretch from the United States to Brazil and from Mexico to Chile. Recent work on postcolonial states has documented the reciprocal relationship between cartography and the cultural practices involved in establishing national political cultures and sovereign states in the Americas. Newly founded governments quickly called on cartography to represent, differentiate, and manage the new polity; nationalistic education reforms lobbied for textbook maps bearing the logo-like outline image of the nation's territory; teachers and parents instructed students and children to draw and memorize this logo map; poets and painters embellished it; and printers and entrepreneurs packaged and repackaged the nation's map images to profit from the emergent passion for a national cartography.[15]

But these studies were also quick to point out that prominent postcolonial maps, such as John Melish's *Map of the United States with the Contiguous British and Spanish Possessions* (1816; Figure 4) or Garcia Cubas's *Carta General de la República Mexicana* (1858), were expected to work as national birth certificates only because they belonged—and were recognized as belonging—to an international mode of certification steeped in previously colonial American cartographic projects. Important to discussing any early American cartographic culture is the recognition that the national impulse that dominated nineteenth-century maps was by and large the historical continuation of a preexisting imperial cartography imported to the Americas since the late fifteenth century. Two statements from England are representative of national *and* imperial imperatives that informed map production and consumption in the early Americas. When in 1670 the English statesman Fulke Greville postulated that "Powre must use lawes, as her best instrument; Lawes bring Mappes," he addressed English lawmakers arguing over the feasibility of the English nation-state. However, this instrumental understanding of cartography also extended to imperial mapping projects. In the same year, the English crown demanded that its colonial agents "procure exact Mapps, Platts or Charts of all and Every [of] our said Plantations abroad, togeather with the Mapps and Descriptions of their respective Ports, Harbours, Forts, Bayes,

Placing the Enlightenment: Thinking Geographically about the Age of Reason (Chicago, 2007), 228.

15. See Martin Brückner, *The Geographic Revolution in Early America: Maps, Literacy, and National Identity* (Chapel Hill, N.C., 2006); and Craib, *Cartographic Mexico*. These studies are influenced by Benedict Anderson, *Imagined Communities: Reflections on the Origin and Spread of Nationalism* (London, 1991).

Rivers with the Depth of their respective Channells," which "[they] are carefully to Register and Keepe." These instructions not only borrowed a formula that aligned maps with governance and sovereignty but exported cartography as the mechanism for managing landed possessions and political abstraction to territorial outliers such as plantations and colonies.[16]

As numerous studies examining imperial or colonial cultures in the Americas have shown, cartographic projects launched during the age of imperialism—be they European or Anglo-, Ibero-, Franco-, or Dutch-American—followed this power/law/map nexus to the letter. The geometric figures of cartography were present in royal edicts and macropolitics (for example, the Treaties of Tordesillas [1494] or Paris [1763], which parceled out large chunks of America among European powers) as much as they were present in local customs and microgovernments (cartography informed communal affairs from New England Puritans to Caribbean planters, from village life in New Spain to tax codes in South American cities). Encoded with European symbols of political authority, early American maps revealed themselves to be not only a specialized writing technology highly amenable for representing the dictates of European notions of territoriality and land management. In the course of three centuries' deployment in the service of the spatial discourse of empire, the cultural technology of cartography had become codependent, if not synonymous, with the constitution of American political culture.[17]

16. Fulke Greville, "Of Lawes," quoted in Matthew H. Edney, "The Irony of Imperial Mapping," in James R. Akerman, ed., *The Imperial Map: Cartography and the Mastery of Empire* (Chicago, 2009), 11. For instructions to the Board of Trade, see Charles M. Andrews, *British Committees, Commissions, and Councils of Trade and Plantations, 1622–1675* (Baltimore, 1908), 122. The literature on the export of state power via cartography is numerous: see, for example, Harley, *New Nature of Maps;* Denis Wood and John Fels, *The Power of Maps* (New York, 1992); Anne Godlewska and Neil Smith, eds., *Geography and Empire* (Oxford, 1994); James R. Akerman, *Cartography and Statecraft: Studies in Governmental Mapmaking in Modern Europe and Its Colonies,* Monograph 52, *Cartographica,* XXXV, nos. 3–4 (Autumn–Winter 1998); Mark Neocleous, "Off the Map: On Violence and Cartography," *European Journal of Social Theory,* VI (2003), 409–425; and John Pickles, *A History of Spaces: Cartographic Reason, Mapping, and the Geo-Coded World* (London, 2004).

17. On imperial mapping ventures in America, see Mary Louise Pratt, *Imperial Eyes: Travel Writing and Transculturation* (London, 1992); Walter D. Mignolo, *The Darker Side of the Renaissance: Literacy, Territoriality, and Colonization* (Ann Arbor, Mich., 1995); Barbara E. Mundy, *The Mapping of New Spain: Indigenous Cartography and the Maps of the Relaciones Geográficas* (Chicago, 1996); Burnett, *Masters of All They Surveyed;* Safier, *Measuring the New World;* Ricardo Padrón, *The Spacious Word: Cartography, Literature, and Empire in Early Modern Spain* (Chicago, 2004); Heidi V. Scott, *Contested Territory:*

Ironically, the very ideological inflection of critical inquiries, which in more recent accounts has threatened to limit the understanding of cartography as a discursive juggernaut privileging nothing but power relations, was also responsible for a widespread critical effort that challenged the monothetic conceptions of early American cartography (and thus effectively moved beyond the two historiographic traditions). When cartographic studies, following the lead of J. B. Harley, took a "literary turn" during the late 1980s and early 1990s, questions of power and politics became possible precisely because maps were treated for the first time as "thick texts" operating by "signs, symbols, and rhetoric." From the moment that the textuality rather than the accuracy of maps came under scrutiny, early modern maps showing America became a fertile ground for the study of imperial ideology and its colonial and postcolonial adaptations. Cartographic lines, symbols, and names were compared to genealogies of socially constructed knowledge. What were previously considered conventional inscriptions or ornamental drawings now signified not just graphic variations of geographic knowledge but also complex relationships involving power structures, concepts of ethnicity, and habits of sociability.[18]

Similar to the recovery projects spurred by the canon wars in early American literary studies that during the 1980s brought back into focus the overlooked writings by women, African, and native American authors, cartographic histories that had taken a literary turn spurred a similar revaluation of the early American map canon during the 1990s. On the one hand, if tracing semiotic changes in map content meant tracing power relations via map meaning, a new generation of studies influenced by the second school of his-

Mapping Peru in the Sixteenth and Seventeenth Centuries (Notre Dame, Ind., 2009). On the geographic uncertainty of Europeans powers concerning the interior of North America, see Paul W. Mapp, _The Elusive West and the Contest for Empire, 1713–1763_ (Chapel Hill, N.C., 2011).

On the relationship between maps, constitutions, and sovereignty, see Lauren Benton, _A Search for Sovereignty: Law and Geography in European Empires, 1400–1900_ (Cambridge, 2010); and Eric Slauter, "The Dividing Line of American Federalism: Partitioning Sovereignty in the Early Republic," in Martin Brückner and Hsuan L. Hsu, eds., _American Literary Geographies: Spatial Practice and Cultural Production, 1500–1900_ (Newark, Del., 2007), 61–88.

18. See the essays by Harley, "Text and Contexts in the Interpretation of Early Maps," "Maps, Knowledge, Power," and "Deconstructing the Map," in Harley, _New Nature of Maps_, 33–49, 51–81, 149–168. See also William Boelhower, "Inventing America: A Model of Cartographic Semiosis," _Word and Image_, IV, (1988), 475–497; and the at times heated debates over maps being texts that were published in the journals _Cartographica_ and _Imago Mundi_ during the 1990s.

toriography began comparing "classic" maps, that is, maps of high political importance, with an array of maps that historically had been of little political consequence but nevertheless had been popular, often homemade, and known for their great everyday appeal. As a consequence, traditional discussions of "great" maps, such as John Mitchell's *Map of the British and French Dominions in North America* (1755), expanded to include "little" and "middling" maps ranging from atlas maps, generic textbook maps, and cut-out magazine maps.[19] Or, to put it differently, the traditional archive of European and Euro-American maps delineating all or sections of America now included surveys that contained crude manuscript sketches next to sophisticated printed maps, politically delicate information next to rote school exercises, the randomness of land lotteries next to carefully strategized geopolitical maneuvers.[20]

Responding to the expansion of the cartographic canon, critical approaches expanded many of the established parameters when discussing early American maps. Whereas modern and postmodern criticism extolled the virtues or vices (depending on ideological outlook) of early modern cartography's spatial rationalization, studies that focus on the Americas increasingly have moved beyond lines of longitude and latitude, boundaries and claims of territorial sovereignty. The geometrization of the Western Hemisphere is no longer the exclusive focus; it is now supplemented (although not superseded) by a more tectonic outlook that explores the figuration of islands and regions or the role of oceans and continents in cartographic representations of the Americas. Correlating cartographic epistemology with historical map experiences, a new generation of critical studies takes into account that maps, like the physical geography they represent, reveal fragmentary glimpses rather

19. I borrow this terminology from Delano-Smith, "The Map as Commodity," in Woodward, Delano-Smith, and Yee, *Plantejaments i objectius*, 94–100. Examples for the expanded survey are Margaret Beck Pritchard and Henry G. Taliaferro, *Degrees of Latitude: Mapping Colonial America* (New York, 2002); Brückner, *Geographic Revolution*, 98–141; Schulten "Mapping American History," in Akerman and Karrow, eds., *Maps*, 159–205.

20. Books offering comprehensive surveys of maps circulating in the Americas before 1800 are numerous but mostly focused on North America. For examples, see William P. Cumming, *The Southeast in Early Maps*, 3d ed., rev. and enl. Louis De Vorsey, Jr. (Chapel Hill, N.C., 1998); Pritchard and Taliaferro, *Degrees of Latitude*; Richard W. Stephenson and Marianne M. Mckee, eds., *Virginia in Maps: Four Centuries of Settlement, Growth, and Development* (Richmond, Va., 2000); Barbara Backus McCorkle, *New England in Early Printed Maps, 1513 to 1800: An Illustrated Carto-Bibliography* (Providence, R.I., 2001); Dennis Reinhartz and Charles C. Colley, eds., *The Mapping of the American Southwest* (College Station, Tex., 1987).

than holistic and totalized overviews. Thematic maps, such as Benjamin Franklin's map of the Gulf Stream or Alexander von Humboldt's isomorphic maps of vegetation and climate are now at the center of discussions over the cartographic configuration of American spaces. A burgeoning interest in the extracartographic application of maps in areas of law, economics, and material culture, to name a few, have more or less complemented the revision of some of the oldest historiographic parameters. By the end of the 1990s, studies had changed the temporal framework, comparing and interpreting early American maps with those dating back to Ptolemy or the Middle Ages in Europe.[21] At the same time, the Eurocentric approach to cartographic culture in America had lost its canonical grip with the recognition of non-European cartography. Time and story lines established by cartographic history now had to be reconciled with indigenous cultures of mapping and mapmaking that involved nongeometric designs, nonsequential notions of history, and nontextual modes of storytelling.[22]

With the inclusion of non-European maps, textual approaches to American cartography increasingly incorporated nontextual modes of analysis. Allusions to the early modern definition that compared the map of the world to the "theatrum orbis terrarum," for example, expanded the mode of historicizing cartography by addressing maps in terms of theatricality and perfor-

21. Anthony Grafton with April Shelford and Nancy Siraisi, *New Worlds, Ancient Texts: The Power of Tradition and the Shock of Discovery* (Cambridge, Mass., 1992); Anthony Pagden, *Lords of All the World: Ideologies of Empire in Spain, Britain, and France, c.1500–c.1800* (New Haven, Conn., 1998); Martin W. Lewis and Kären E. Wigen, *The Myth of Continents: A Critique of Metageography* (Berkeley, Calif., 1997); and María M. Portuondo, *Secret Science: Spanish Cosmography and the New World* (Chicago, 2009).

22. See Emerson W. Baker et al., eds., *American Beginnings: Exploration, Culture, and Cartography in the Land of Norumbega* (Lincoln, Nebr., 1994); Mark Warhus, *Another America: Native American Maps and the History of Our Land* (New York, 1997); David Woodward and G. Malcolm Lewis, eds., *Cartography in the Traditional African, American, Arctic, Australian, and Pacific Societies,* vol. II, book 3 of *The History of Cartography* (Chicago, 1998); G. Malcolm Lewis, ed., *Cartographic Encounters: Perspectives on Native American Mapmaking and Map Use* (Chicago, 1998); and seminal essays such as Benjamin Orlove, "The Ethnography of Maps: The Cultural and Social Contexts of Cartographic Representations in Peru," in Robert A Rundstrom, ed., *Introducing Cultural and Social Cartography,* Monograph 44, *Cartographica,* XXX, no. 1 (Spring 1993), 29–46; Rundstrom, "Mapping, Postmodernism, Indigenous People, and the Changing Direction of North American Cartography," *Cartographica,* XXVIII, no. 2 (Summer 1991), 1–12; and Matthew Sparke, "Between Demythologizing and Deconstructing the Map: Shawnadithit's New-found-land and the Alienation of Canada," *Cartographica,* XXXII, no. 1 (Spring 1995), 1–21.

mance culture. Treating maps as snapshots documenting a specific cultural view of geographic knowledge, scholars now identify early modern maps as staging grounds that function similarly to theatrical sceneries; like the stage master's graphic "plot," they project real spatial actions while also projecting imagined reactions to a geometrically determined space. When applied to early American cartography, this performative understanding resituates maps as multidimensional spectacles. Not only disparate textual elements, such as image and word, were joined, but nontextual practices ranging from stage props and text-body interactions to indigenous friendship rituals and memory landscapes were often enmeshed beyond easy recognition—but not beyond recovery.[23]

Insofar as pre–nineteenth-century maps generated in both Europe and the Americas contain traces of discursive and nondiscursive practices, the history of these maps can be understood as a story about a specific place that is structured not only by the historical actions of a few select subjects but also by an array of interactions involving actors and agencies, objects and happenstance. Early American maps are best understood as flexible spaces containing a host of mobile elements and their interactions occurring within. As a form of composition, early American maps become spatial stories representing the various elements and their movements. On the side of map production, these spatial stories emerged from the map's conceptual and discursive flexibility to contain mappings from different cultural origins. On the side of map reception, the spatial story of individual maps reflects a cartographic history that is not determined by evolutionary or stadial accounts of particular maps and genres. Instead, it accounts for the map as a time- and space-sensitive palimpsest reflecting multiple patterns of short- and long-durational consequence. By the same token that a map is a totalizing tableau documenting the state of geographic knowledge, the essays in this collection examine the conditions that shape the state of cartographic knowledge, knowledge that in its diverse origins at once borrowed from its prehistory, laid claim to the present, and projected into the future. While investigating the stories of linear development,

23. On the theatrical dimension of cartography, see Jean-Christophe Agnew, *Worlds Apart: The Market and the Theater in Anglo-American Thought, 1550–1750* (Cambridge, 1986); John Gillies, *Shakespeare and the Geography of Difference* (Cambridge, 1994); Garrett A. Sullivan, Jr., *The Drama of Landscape: Land, Property, and Social Relations on the Early Modern Stage* (Stanford, Calif., 1998); Martin Brückner and Kristen Poole, "The Plot Thickens: Surveying Manuals, Drama, and the Materiality of Narrative Form in Early Modern England," *English Literary History*, LXIX (2002), 617–648; Henry S. Turner, *The English Renaissance Stage: Geometry, Poetics, and the Practical Spatial Arts, 1580–1630* (Oxford, 2006).

map-induced hegemony, and European domination, the essays fan out in new directions to study the American cartographic pluralism reflected by the diversity of cartographic cultures and practices.[24]

AN EXAMPLE OF CARTOGRAPHIC PLURALITY

A brief example, involving the mappings of the Nechecole people, the Lewis and Clark expedition, and an ideologically overdetermined national map, illustrates the cultural density and cartographic layers that make up early American maps. On a spring day in 1806, after having successfully reached the Pacific Ocean and looking to sketch out alternative routes for the return trip, William Clark asked members of the Nechecole tribe about the geography of the western Rocky Mountains. In response, one of the tribe's elders took his finger and drew a map into the dust; Clark took a pencil and copied the map into his notebook. After two years of travel, cartographic interviews like this had become a routine experience for members of the Lewis and Clark expedition. Tribal elders on both sides of the continental divide—be they Mandan and Hidatsa or Nez-Pierce and Shoshone—demonstrated the ability to think in cartographic terms. They not only used various modes of projection and scales of abstraction, but they also represented the land like a map.[25]

For the duration of the interviews, the map established a unique sense of sameness between local native people and the mixed company of passing strangers. After the interviews were over, however, the application of maps revealed a difference in cartographic sensibility separating Amerindian from Euro-American. As Lewis and Clark discovered, just as the Nechecole elder could produce maps at will, he had no interest in or need for preserving them. For Clark, the record keeper, the sketch map yielded vital information about "4 nations," "40 miles" of waterways, and "11 Towns." For the elder, who drew the map from memory, the map was part of a performance used during oral rituals intended to recount the Nechecole's sense of geography in relational rather than spatial terms. For the Nechecole elder—and even more so for the delegation of elders who, according to Clark's account, "had arrived at a great age, and appeared to be helthy tho' blind"—the memory and the story of their immediate geography was more important than the actual map and visual representation of the place. In most ritual encounters, map sketches ended

24. Michel de Certeau, "Spatial Stories," *The Practice of Everyday Life,* trans. Steven F. Rendall (Berkeley, Calif., 1984), 117, 121.
25. Gary Moulton, ed., *The Journals of the Lewis and Clark Expedition,* 13 vols. (Lincoln, Nebr., 1987), III, 269, 276, V, 88, 157, 296, VII, 54, 66, 68–69 (pencil map), 86, 92, 132, 149, 242, 244.

with their ceremonial erasure. By contrast, for the expedition leaders, who were quickly passing through the area, paper copies of indigenous maps were treasured objects; documenting the journey's progress in durable form, they were considered hard evidence and material knowledge integral not only for the immediate purpose of orientation but also for the expedition's overall success.[26]

By the spring of 1806, the preparation of a master map illustrating the journey's geographical findings had become the expedition's primary objective. The map was intended for shipment to the capital of the United States, where it would serve two important functions: it would answer a question from the past and raise another for the future. *A Map of Lewis and Clark's Track, across the Western Portion of North America from the Mississippi to the Pacific Ocean* (1814; Figure 3), originally drawn by William Clark and published as the expedition's official map, permanently put to rest the historical question about the existence of a transcontinental waterway. Where older maps had left blank most of the space west of the Rocky Mountains, Clark's map now erected multiple mountain ranges; it filled in valleys of imaginary waterways; and it populated with tribal names vast areas that were previously presumed to have been unpopulated.[27]

26. Moulton, ed., *Journals of the Lewis and Clark Expedition*, VII, 66. The passage does not suggest that the "old man" who drew the map himself was blind. But Clark's prose implies that, although the map sketch was a single person's effort, it was in all likelihood performed with the blind elders present. I emphasize this moment because it underscores two things. First, it reveals the performative and mnemonic nature of native American mappings. Second, although it was for European eyes a representation of actual physical geography, the sand map emphasized the elders' collective knowledge of tribal geography and history; it delineated their relationship to the physical and sacred world, possibly including distances between places known in the past and those of the present.

The Nechecole-Clark episode strongly resembles a French-Chinese cartographic encounter discussed by Bruno Latour, illustrating at once the global dispersal of European cartographic technology and the widespread presence of non-Western mapping techniques. See Latour's "Visualization and Cognition: Thinking with Eyes and Hands," in Henrika Kuklick and Elizabeth Long, eds., *Knowledge and Society: Studies in the Sociology of Culture Past and Present* (Greenwich, Conn., 1986), 5–6. In Latour's interpretation, the cartographic encounter sets into motion the imperial process of knowledge transfer in which all maplike data is treated as cartographic data before getting folded into Europe's master maps. What is easily overlooked, however, is the way in which non-European maps were habitually misunderstood, thus becoming sources of disinformation. See Brückner, *Geographic Revolution*, 204–237.

27. Clark's manuscript version was completed in 1810. It was then engraved and

A landmark of early American cartography, the map was quickly adopted by contemporary mapmakers for more than the obvious reason that it provided new information.[28] For many cartographers, it provided optical fodder fueling propagandistic questions about the new nation's territorial reach. National maps, such as the *Map of the United States* (1816; Figure 4) by John Melish, included Clark's representation of western topography in great detail. But they also omitted many local references to tribes in order to make a better argument for a U. S.-controlled American empire. Or, as Melish wrote: "To present a picture of [the western territory] was desirable in every point of view. The map so constructed, shows at a glance the whole extent of the United States territory from sea to sea; and, in tracing the probable expansion of the human race from east to west, the mind finds an agreeable resting place on its western limits. The view is complete, and leaves nothing to be wished for. It also adds to the beauty and symmetry of the map; which will, it is confidently believed, be found one of the most useful and ornamental works ever executed in this country."[29]

Maps like the ones by Clark and Melish strictly adhered to the principles of abstraction and geometric symmetry; they emphasized concepts of location over local experience, aesthetic objects over human subjects. Like their European counterparts, American mapmakers used their maps to signal the cultural status of cartographic representation as being definitive and, above

printed by the Philadelphia cartographer, Samuel Lewis, for inclusion in Nicholas Biddle's *History of the Expedition under the Command of Captains Lewis and Clark . . .*, 2 vols. (Philadelphia, 1814).

28. Although the Clark map was quickly incorporated into works of professional cartographers, the public reception of the map following its publication in Biddle's *History* was mixed. In the United States, the map failed to attract attention; reviews published for example in the *Analectic Magazine* commented on Biddle's prose style but not on the map. In Europe, some readers complained about the map's being "deficient in names of positions; and the routes through the mountains should by all means have been marked in colours, for the mere purpose of distinctness." See *Analectic Magazine*, V (1815), 233; and *Eclectic Review*, n.s., V (1816), 132. On the map's (lack of) reception by U.S. Americans, see the correspondence collected in Donald Jackson, ed., *Letters of the Lewis and Clark Expedition with Related Docments, 1783–1854*, 2d ed. (Urbana, Ill., 1978); and Paul Russell Cutright, *A History of the Lewis and Clark Journals* (Norman, Okla., 1976). For a European response, see William E. Foley, "Lewis and Clark's American Travels: The View from Britain," *Western Historical Quarterly*, 3d Ser., XXXIV (2003), 301–324.

29. John Melish, *A Geographical Description of the United States, with the Contiguous British and Spanish Possessions; Intended as an Accompaniment to Melish's Map of These Countries* (Philadelphia, 1816), 4.

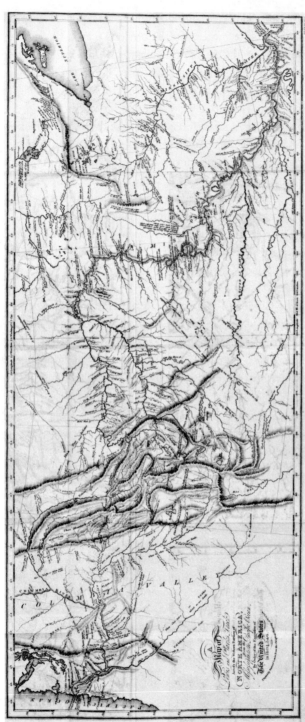

FIGURE 3: [William Clark and] Samuel Lewis, *A Map of Lewis and Clark's Track, across the Western Portion of North America from the Mississippi to the Pacific Ocean; by Order of the Executive of the United States in 1804, 5, and 6 . . .* (London, 1814). Courtesy, The Library Company of Philadelphia

FIGURE 4. John Melish, *Map of the United States with the Contiguous British and Spanish Possessions* (Philadelphia, 1816). Courtesy of the Library of Congress

all, scientific. They presented maps as empirical systems whose primary goal was to establish order "at a glance," while disowning the map's unempirical history of production, the prolonged human efforts, and the idiosyncrasies of local mapping encounters. In this understanding of early American cartography, maps conformed to the standards of geometric representation, and mathematical calculation had neither space nor signs available for showing a more experiential or local reckoning of cartography. Local maps—the foundation of early American cartography—not to mention the authors, events, and stories surrounding them—were for the most part lost inside the elegant but impersonal symmetry of the final map.

But beneath the symmetry of the printed maps and its representation of a modern homogenous spatiality were always hovering the manifold traces of locally specific cartographic activities. These activities took place simultaneously on two sides of the globe: they included the Nechecole mapping practice in which tribal history, ceremonial ritual, and spatial knowledge of the Pacific Northwest converged; and they included the expedition's base map, which had been composed using a mixed archive consisting of French, Spanish, German, and English maps.[30] Bearing the traces of the Nechecole sand map, the Clark and then the Melish map were, like so many of the maps showing the Americas in the metropolitan centers of America and Europe, the product of a continuum of cultural collaboration. This continuum of collaboration involved, on one side, multilingual translations, indigenous ceremonies, and ephemeral maps such as sand drawings. On the other side, it involved printed maps that, although claimed to be definitive representations of national or imperial domains, were themselves tentative, subject to collaborative practices spurred by the competitive network of map sponsors and publishers.[31] Mapmakers and map users on either side of this spectrum would have had great difficulty agreeing on the same definition of a map. Are maps two-dimensional paper constructs or three-dimensional objects representing just space or both space and time? Are they required to operate by graphic design and visual cognition, or can they be multisensory vehicles of communication, tapping, for example, tactile and auditory expressions of individual

30. During the journey, Lewis and Clark used an "empty" base map prepared by Nicholas King in 1803 on the instructions of Albert Gallatin, Jefferson's secretary of treasury. On the maps that shaped this base map, see John Logan Allen, *Passage through the Garden: Lewis and Clark and the Image of the American Northwest* (Urbana, Ill., 1975), 73–108.

31. On the intricate relationship of map production, collaboration, and piracy, see Mary Sponberg Pedley, *The Commerce of Cartography* (Chicago, 2005).

or collective memories? Although easily recognized as maps, are they comparable between cultures that share neither the same linguistic nor cosmological outlook of space and spatial representation? The cartographic nexus of the Clark-Melish maps, while also bearing the traces of the Nechecole dirt map, suggests all of the above has to be taken into account when describing and analyzing the culture of early American cartographies.[32]

THE "CARTOGRAPHIC TURN" IN EARLY
AMERICAN HISTORY AND CULTURE

This account of the Nechecole-Clark-Melish maps, involving trajectories that fan out from a single cartographic event into multiple cartographic histories, describes some of the material, discursive, and critical issues that are at the heart of this collection of essays. While continuing to engage with questions posed by the ideological and literary analysis of maps, *Early American Cartographies* on the whole argues for a "cartographic turn" in the study of early American history and culture, a turn that has given rise to a number of influential works that rethink the Eurocentric, putatively scientific, and all-too-often metaphorical conception of cartography. As noted above, such studies have produced invaluable insights from a variety of perspectives: aside from increasing our awareness of the richness of the American cartographic archive and chronicling national cartographies, studies now address early American mappings through the lens of cultural geography, ethnography, and early American literature; the mapping impulse that was traced into art history and the historiography of empire now underwrites critical work on carto-literacy, definitions of liberty, and constitutional law.

The methodological diversity of these studies reflects the interdisciplinary recognition of the ways in which cartographic representations not only impinged upon questions of space and place in the Atlantic world but also increasingly touched on cartographic encounters in the Western Hemisphere. But many of these studies are bounded by space and time, cleaving to disciplinary demands on periodization and area-specific methodologies. By tapping the methodological diversity of their various disciplines, this collection of essays loosens these boundaries. Exploring early American cartographies

32. Matthew Edney sums up the uncertainty surrounding what constitutes a map in academic and popular perception: by the same token that "maps are now understood to possess fluid, ambiguous, highly partial, and persistently ideological meanings . . . we can no longer insist even that maps must be graphic in form; we now accept that they can be verbal, tectonic, gestural, or performative." See Edney, "Irony of Imperial Mapping," in Akerman, ed., *The Imperial Map*, 12.

as a practice of cultural mediation, it both reconciles and expands dominant notions of pre–nineteenth-century spatiality in the Americas through investigating ideas of alternative spatial imaginings, patterns of local production and global reception, not to mention the fundamentally uneven processes responsible for the selection of cartographic knowledge.

The following essays put pressure on opinions like the ones expressed by John Melish quoted above; they examine maps as both scientific and aesthetic objects ("beauty and symmetry"), as cultural icons representing political ambition ("probable expansion"), and as proto-industrial products ("useful") performing individuated cultural work. In this historical materialist perspective, maps continue to emerge from a linear history in which maps beget maps. By the same token that this narrative is about a diachronic sense of cartography according to which new maps supersede the old, the collection offers a synchronic assessment of the way in which both monumental and ephemeral maps traveled beyond the circle of imperial ambition and nation building.

That said, by branching out from the confines of period definition and demarcated geographies, *Early American Cartographies* plumbs the ephemeral nature of cartographic exchange in the Americas. The essays explore dirty maps: the indigenous maps sketched into sand or painted on skins as well as the European sketch maps written with pen and pencil on paper scraps or into field books. They also examine the most ephemeral of cartographies, the residual maps that inhabit cultural memory, visual perception, and the literary imagination. In this ephemeral perspective, the collection engages with a deep historical archive that is shown to be situated at the intersection of multicultural memories and mnemonic practices, which involve local habits of learning and unlearning, including the process of internalizing cartographic knowledge over time before and after becoming externalized in particular map forms.

Throughout, *Early American Cartographies* traces the cartographic representation of American spaces in relation to the communication circuits and knowledge networks spanning not only the Atlantic but also the American world. By the same token that spatial information packaged in the format of the map moved unevenly between local tribes, colonial agents, and European courts, all the time crossing and recrossing cultural and political boundaries, the process of knowledge transfer in early American maps was as substantial as it was relational. The cartographic culture in early America was fundamentally dialogic in practice, ranging from face-to-face encounters to published correspondence to graphic transfers such as script-into-print adaptations. Situated inside a media landscape that predates most of the local powers of

yet-to-be-formed American nation-states, cartographic production and consumption resulted less from a vertical, top-down one-way traffic system as it has been imagined by Foucaultian or Latourian analyses of cartographic history; rather, the spatial stories of early American maps occurred horizontally, in a two-way traffic pattern, in which concrete local practice and abstract global theory were not only mutually constitutive but also the fulcrum for a wide variety of ideas, uses, and valuations of space on the ground.[33]

PART I. CARTOGRAPHIC HORIZONS AND IMPERIAL POLITICS
The essays in Part I provide a common ground for the overall project of *Early American Cartographies* by investigating current assumptions about early American cartography, territoriality, and imperial power. In their review of well-known European mapping ventures, using classic and lesser-known archives, these essays at once confirm and expand the strategic interpretation of cartography from both macro- and microhistorical perspectives. In section 1, "Deep Archives; or, The Empire Has Too Many Maps," Ricardo Padrón reviews the history of imperial cartography at the crossroads of 1750, when the Treaty of Madrid realigned Spanish and Portuguese possessions in South America. By foregrounding the cartographic work of Vincente de Memije, an army captain stationed in the Philippines, Padrón offers a decentralized perspective on the mapping of Spain's empire. Through the example of Memije's map, Padrón illustrates the global reach of cartography and the discourse of power. He both makes a case for the expansion of the cartographic canon and critically reassesses cartographic ideologies, which, contrary to current critical expectations of conformity, instead struggle to keep up with imperial aspirations. Ken MacMillan offers a parallel review of imperial cartography but from the British perspective. By discussing intranational applications of cartographic theory in maps circulating in early modern England, his essay examines cartographic authority in relation to international territorial demands that were made along the conceptual fault line of *imperium* (absolute

33. The essays indirectly or directly engage classic models of knowledge transmission in early America established in two very different fields of inquiry: Latour's concept of immutable mobiles described in *Science in Action* and Robert Darnton's concept of the communication circuit in "What Is the History of Books?" *Daedalus*, CXI, no. 3 (Summer 1982), 65–83. For general application in cartography, see Pedley, *Commerce of Cartography;* and Withers, *Placing the Enlightenment,* 167–233. Seminal studies that document the horizontal movement of information in noncartographic discourses include, for example, Joseph Roach, *Cities of the Dead: Circum-Atlantic Performance* (New York, 1996); Susan Scott Parrish, *American Curiosity: Cultures of Natural History in the Colonial British Atlantic World* (Chapel Hill, N.C., 2006).

sovereignty) and *dominium* (territorial possession). A comparison of maps produced in the center of imperial England with maps originally made in the colonial periphery, in particular the maps of Captain John Smith, reasserts the cartographic history of central authority and territorial hegemony.

Section 2, "The (Un)Making of Colonies," investigates maps made by colonial officials as representing America from the inside out in an Atlantic culture of cartographic exchange. Jess Edwards, using the *First Lords Proprietors' Map* of Carolina, examines the liberal nature of seventeenth-century geography in relation to seventeenth-century dictates of colonization and economic reform. Having adopted elements of John Locke's theories of property and individual rights, geography and by extension also early American cartography forged a rhetorical compromise between old and new, traditional and progressive social visions. Both geographers and cartographers articulated an accommodation between a liberal ethos of individual endeavor and a conservative one of stable, hierarchical community and aristocratic social stewardship. As Júnia Ferreira Furtado shows in her essay, late-eighteenth-century Luso-Brazilian mappings of the gold country in the Minas Gerais captaincy expressed similar concerns about individual freedom and communal order. Surveys and maps by the colonial mapmaker José Joaquim da Rocha, while adhering to the protocols of modern mapping technologies, contained at once the discursive mechanics of imperial control and the rhetoric of political independence. Territorial maps initially designed to ascertain colonial resources were quickly construed as graphic icons capable of negotiating political dissent within the colony and launching a nationalistic separatist agenda pitting the colony against the Portuguese empire.

PART II. CARTOGRAPHIC ENCOUNTERS AND LOCAL KNOWLEDGE
The essays collected in Part II examine the concept of "invention," which has been at once a crucial term in the representation of American spaces and a key concept in the historiography of early American maps. To follow Edmundo O'Gorman's influential study, "the invention of America" is a cartographic process that began with the first naming of "America" on a map and has continued ever since with the cartographic projection of America in map publications. For O'Gorman, the cartographic invention of America allowed him to question critical assumptions about how America registered in the European imagination. The following essays focus instead on the process of mapping and mapmaking in inventing America as a space or place from within American cultures. Looking at indigenous and European mapping projects, the essays are case studies that explore cartographic invention unfolding simultaneously and locally "on the ground" while also becoming folded into global

patterns of cartographic transmission. Throughout Part II, the essays begin to reinvent the study of cartographic production and consumption as a multi-tiered and interconnected field where maps are at once culturally distinct but inherently comparable, familiar and yet strange, mass-produced but also uniquely crafted, in short, a field in which map design, meaning, and function are driven by the plurality of maps.

Section 3, "Native Maps / Mapping Natives," examines three instances of indigenous encounters with maps, ranging from cartographic collaboration to tribal performance to the imbrication of local indigenous culture with global cartographic events. By investigating *The Discoveries of John Lederer* (1672), Gavin Hollis examines a particular cartographic encounter between Europeans and native Americans. Viewed through the lens of ethnocartographic history, this encounter is a locus classicus for documenting maps and mapping practices as a much overlooked medium for facilitating moments of cultural contact while also affecting subsequent historical narratives and interpretations. Looking to the semiotic and textual nature of indigenous maps, in particular a Skidi Star Chart whose origins date back to the sixteenth century, William Gustav Gartner recovers a rare moment of North American indigenous astronomical mapping in which a spatial inventory of the heavens also graphically facilitates a spatial understanding of Skidi worlds on the ground. Showing the Skidi Star Chart to employ ancient cartographic conventions, this essay explores the conceptual ambiguities and interpretive challenges that arise from the application of modern Western notions of spatial relationships and geographic understanding. That Western notions of cartography infiltrated indigenous cultures is central to the essay by Andrew Newman. His investigation of the manipulation of indigenous rituals of cartographic collaboration during the Walking Purchase of 1737 discovers a global pattern of land transaction and colonization. Land acquisitions based on the "hide trick" were steeped in a folkloric cartographic discourse dating back to classical mythology. But appropriating territory the size of an ox hide and then laying cut-up strips end to end to maximize the area proved to be a tactical strategy encircling the globe: beginning as a story of Euro-American contact, the story of the hide trick is attributed to the Spaniards in the Philippines, the Portuguese in Cambodia, Malaysia, and Burma, and the Dutch in Java, Cambodia, Taiwan, South Africa, and New York.

Section 4, "Cosmopolitan Maps," examines the relationship of cartographic representation and transatlantic urbanism. Beginning with an example from New England, Matthew H. Edney discusses the rhetorical finesse of public engagement underlying the simultaneous publication of land grant maps in both Boston and London during the mid-eighteenth century. Three maps

showing the Kennebec River in the Eastern District of the colony of Massachusetts Bay illustrate the complex relationship between maps and print culture in a public sphere defined by publicity, sociability, and literacy. In this culture, maps and mapping practices exemplified the notion of a printed discourse resting on a rhetoric of disinterest, truthfulness, and rationality. Yet the maps of the Kennebec show the cultural significance of printing to be more variable, as the maps and cartographic writing were deployed strategically as tokens of interest and passion in the eighteenth century's critical public discourse. The interest of mapmakers and their sponsors inform Judith Ridner's example of imperial cartography playing itself out in midcentury urban-planning activities. When the land speculator, Thomas Penn, founded Carlisle in Pennsylvania, cartographic conventions that had previously informed visionary settlements from Massachusetts to Florida provided a stagelike town plan in which mapping activities fuse the principles of sociability and civility to capitalist commerce. A different impulse of strategic thinking is the focus of Scott Lehman's discussion of harbor plans showing the city of Havana in the *Gentleman's Magazine* between the 1740s and 1760s. Investigating the symbiotic relationship between maps and news against the background of an emergent "journalistic cartography," this essay illustrates that even the most rudimentary maps were instruments of political propaganda in an Atlantic world defined by cartography and mass print culture.

PART III. META-CARTOGRAPHIES:
ICONS, OBJECTS, AND METAPHORS
The final part of the collection opens the circle of cartographic exchange the widest by exploring the relationship between cartographic artifact and cartographic thinking from a contextual perspective that includes the museum and interior architecture, material and visual culture, and map-based representations linking ecological disaster to slave resistance in literatures far removed from the cartographic experience. Examining international exhibitions, such as the Columbus centennial of 1892 in Madrid, Barbara E. Mundy finds the historical reach of multilayered maps that are at the heart of the spatial story of early American cartographies. Put on display halfway around the globe, the Mexican *Atlas geográfico* (1858) not only contained an assortment of geographical maps eagerly asserting the national independence of the state of Mexico but also included select indigenous maps to support the authority of the new national cartography. Although these indigenous maps were used to affirm the historical depth of the nation space, and by association the legitimacy of the nation itself, they were also highly ambivalent signifiers. Though appropriated for all the reasons that have exposed cartographic products to

be minions of ideology and power, the reproduction of indigenous maps destabilized the modern order of knowledge, in particular the logic of a national cartography.

Exploring a different range of maps and exhibits, Martin Brückner discusses public and private map displays in relation to British American material culture during the second half of the eighteenth century. By reviving the "ornamental" understanding of maps, the essay approaches cartographic maps, that is, conventional geometric maps, as consumer goods whose meaning is contingent on the materiality surrounding their presentation. With maps being embedded — real and symbolically — inside physical places (architecture), the decorative arts (pictures), and the material culture of everyday life (furniture), maps were at the core of a performative culture that cartocoded the map consumers' sensory and bodily experience of the mapped spaces they inhabited. Testing the systemic thinking that underlies the discussion of mappings and cartographies, Michael Drexler proposes a counterfactual experiment. Barely referencing the image, object, or history of early American cartographies, his essay posits the cartographically imagined space of the Caribbean as the site in which hurricanes and slave revolts track each other in quasi-cartographic patterns. By substituting the language of maps for that of storms and catastrophe, the analysis of texts ranging from Benjamin Franklin's map of the Gulf Stream (1769), Philip Freneau's poem "The Hurricane" (1785), Frederick Douglass's only work of fiction *The Heroic Slave* (1853), and Herman Melville's novella *Benito Cereno* (1856), the essay calls attention to the vocabulary responsible for the arbitrary construction of national and political borders. By the same token that the vocabulary of storms was able to assert, like maps, the geographical centrality of the Caribbean or the Atlantic world as a concrete space, this language could never be precise or efficient enough to be exhausted by one particular mode of signification. The implied language of maps, using word and image for tracking storms and revolts, in the end cannot maintain a spatial representation promising local solidarity and a sense of community in the Americas.

■ In what follows, then, *Early American Cartographies* investigates the enduring significance of the cartographic representation of space and place in scholarship specifically focused on the early Americas. In the course of its fourteen essays, the volume provides overviews and introductions to traditional subject areas involving early American cartography. On the whole, the essays show a breadth of coverage not only in terms of period materials (classic and lesser-known maps) and critical issues (empire building, colonization, nationalism) but also offer comparative approaches to American maps reflect-

ing Anglo- and Ibero-American mapping ventures. The majority of essays address cartographic projects and mapping habits as they took place on the ground. Demonstrating the local and global nature of cartographic exchange in the Americas, they present original work (and many unpublished primary materials) on local mapping ventures involving not only Euro-American but indigenous mapmakers whose works were shaped as much by colonial and imperial agendas as by extrapolitical attitudes toward maps and mappings.

As a result of the collection's emphasis on cartographic pluralism, the essays throughout redefine and categorize early American maps and mapping projects as a composite aspect of early American cultural production. By grafting the literary motif of composition to the methodologies of standard cartographic inquiry, the essays describe maps as a thickly textured medium representing Western and non-Western short-term fantasies about the Americas as well as those conceived over long periods of time; cartographic users and their relationship to imperial conflicts and colonialism in the Americas; the portrayal of rural and urban spaces in print and manuscript from North to South America; the conception of geographic space by grid and nongeodetic mappings; map trade and map consumption in the Americas; maps used in land speculation and promotional schemes; the rhetorical and psychological application of maps; and the use of maps in the arts and everyday life.

By emphasizing that pre–nineteenth-century cartography was a highly multiform and multicultural affair, the essays throughout *Early American Cartographies* pursue a comparative approach: they pair macro- with microhistories; they juxtapose cartographic materials of different ethnic origins; and they offer models of different modes of historical and cultural analysis. By design *Early American Cartographies* thus provides a general and comprehensive introduction to the history and function of maps and mappings in the early Americas. Blending standard historiographies, new historical information, and an array of critical approaches, it offers a new history of cartographic pluralism to invigorate the study and teaching of spatial relations among people in the early Americas.

PART ONE

CARTOGRAPHIC HORIZONS AND IMPERIAL POLITICS

FROM ABSTRACTION TO ALLEGORY

THE IMPERIAL CARTOGRAPHY
OF VICENTE DE MEMIJE

Ricardo Padrón

In 1761, Vicente de Memije, a creole living in Manila, published two maps of what he called "the Hispanic world." The first, *Aspecto geográfico del mundo Hispánico,* was a fairly conventional geographical map of just over half the world, from Italy westward to the Straits of Malacca, compiled from existing printed maps, mostly French and English (Figure 1); the second was an extraordinary allegorical adaptation of this same map (Figure 2). The allegorical map, *Aspecto symbólico del mundo Hispánico,* represents one of the most stunning cartographic images of the Hispanic monarchy ever produced. It depicts Spain and its overseas possessions as a female figure wearing a crown engraved with the names of the Spanish kingdoms on the Iberian Peninsula, draped in a mantle made of the map of the Americas, and standing upon a map of the Philippine Islands. Around her neck, a compass rose hangs from a chain of treasure galleons. The maritime routes from the Americas to the Philippines become the folds of her skirt. Her eyes gaze at cherubs who hand her the sword of the faith, while the Holy Spirit illuminates her from above. The royal arms flutter from a graduated staff she holds in her hand. Clearly, the *Aspecto symbólico* represents the apex of Spanish attempts to envision its territory, celebrate its power, and legitimate its hegemony over so much of the globe through the medium of imperial maps. It calls to mind Aristotle's characterization of political entities in organic terms, with a head and a body integrated in hierarchical fashion. It reminds us of Judith, the warrior woman of the Old Testament, and of the Immaculate Virgin Mary, the patron saint of the monarchy by recent royal decree. It speaks of the Hispanic monarchy as the nearly global incarnation of the Church Militant, a political body both blessed by Providence and called by it to champion the faith. But these readily evident meanings are only the beginning of what this map has to tell us. When we place it in the context of other contributions to the mapping of Spain's

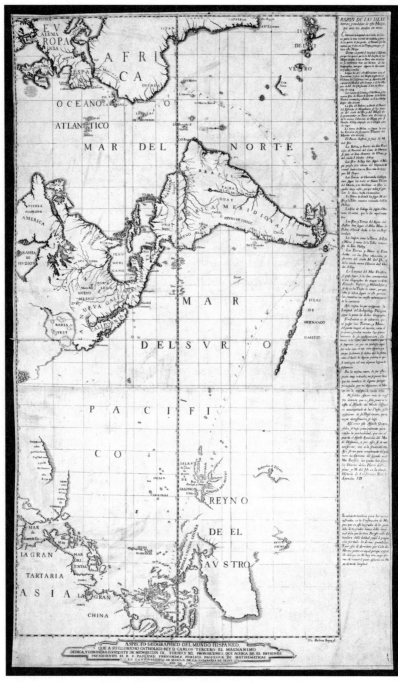

FIGURE 1. Vicente de Memije, *Aspecto geográfico del mundo Hispánico* (Manila, 1761). © The British Library Board

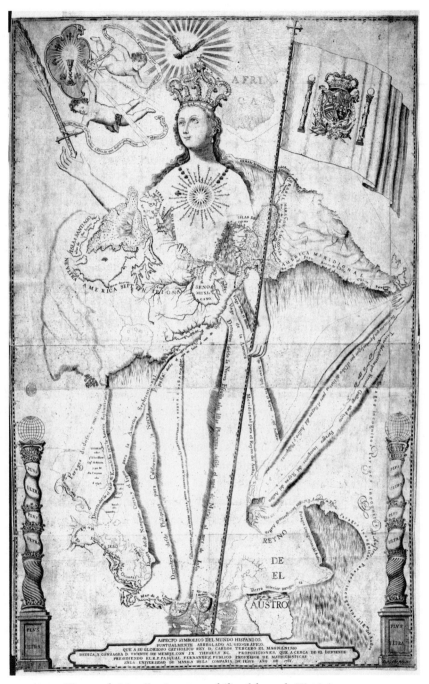

FIGURE 2. Vicente de Memije, *Aspecto symbólico del mundo Hispánico*
(Manila, 1761). © The British Library Board

empire, we discover that it represents a last-ditch effort to modernize a thoroughly bankrupt cartographic ideology during a century in which the crown sought to chart Spain's empire with improved accuracy while also bearing witness to Spain's newly circumscribed imperial aspirations.

Memije's *Aspecto symbólico* sometimes appears as a sidebar to the history of Spanish imperial and colonial cartography, an idiosyncratic curiosity with some obvious and even commonplace things to say about Spain and its empire. Although it is worthy of praise for the skill that went into its manufacture and the imagination evident in its conceptualization, we are told, it is hardly to be taken seriously as a contribution to Spain's continuing efforts to map its empire and its parts. For example, Carlos Quirino, the foundational figure in the history of the cartography of the Philippines, calls it "the most imaginative map of the Spanish empire we have seen" and praises the skill of its Filipino engraver, Laureano Atlas, but cannot ultimately integrate it into his history of Philippine cartography, which traces the replacement of early, fanciful portrayals of the islands by later, more accurate ones. Oskar Spate, the dean of Pacific geography, describes the *Aspecto symbólico* as "charming and instructive" but clearly has more respect for the *Aspecto geográfico*, a "more sober map of the geographical aspect of the Hispanic world." He admits that Memije has "done his homework" but also patronizes the mapmaker, remarking that he "hardly appears a modern man"; instead, Memije demonstrates a "backward-looking . . . temper" and seems "truly and delightfully quixotic." How could these scholars have thought otherwise? The *Aspecto symbólico* does indeed look like a throwback, resembling allegorical maps from the sixteenth century—such as Johannes Bucius's *Europa Regina* (1537), which personifies the continent of Europe in a similar manner—more than it does the carefully surveyed, meticulously engraved maps and charts of the Age of Enlightenment (Figure 3). The history of cartography during that period has commonly been understood as a continuation of the scientific revolution that began in the sixteenth century, a story of increasing technical sophistication and deeper professionalization in the production of maps, and therefore of quantum leaps in their accuracy and availability. How can this allegorical image be taken seriously as a part of such a story?[1]

Of course, the past two decades have witnessed a significant shift in the approaches used to study maps and their history. It has become clear that cul-

1. Carlos Quirino, *Philippine Cartography, 1320–1899*, 2d ed. (Amsterdam, 1963), 57; O. H. K. Spate, *Monopolists and Freebooters* (Minneapolis, Minn., 1983), 279–280, 399; Norman J. W. Thrower, *Maps and Civilization: Cartography in Culture and Society* (Chicago, 1996), 91–124.

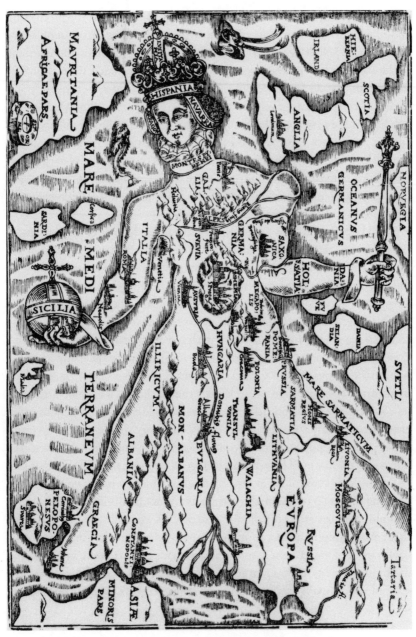

FIGURE 3. Johannes Bucius, *Europa Regina* (1537). From the Collections
of the Geography and Map Division, Library of Congress

ture and ideology, even imagination, play a significant role in the production and consumption of any map, even those that claim to be the most objective and accurate.[2] No longer need we emplot the history of maps and mapping as the story of ever-increasing scientific accuracy, nor need we marginalize those maps that do not represent significant advances in either the technical sophistication of cartography or the state of geographical knowledge. But, although these new approaches suggest that we should be careful about excluding "imaginative" maps like Memije's from the study of "serious" maps, we are still learning what it means to include them in the new history of cartography. I hope to make a small contribution to this reorientation of the history of cartography by finding a place for Memije's map in the history of more sober attempts to map Spain's overseas possessions.

I also hope to confront a problem of more immediate interest, perhaps, to the readers of this collection of essays: What does an allegorical map of the Spanish empire made by an army captain in the Philippines have to do with the colonial cartographies of the Americas? The image clearly does not belong among those fascinating examples of colonial cartography in which the spatial imaginations of Europe and native America come together in such complex ways, maps like those that appear in Felipe Guamán Poma de Ayala's *Primer nueva corónica y buen gobierno* (1615–1616) or among the many contributions to the corpus of the *Relaciones geográficas de Indias* of the 1570s. Although in material terms the *Aspecto symbólico* is the product of a Filipino artisan, in its conceptualization and design it shows no evidence of indigenous influence. Bereft of any apparent *mestizaje*, it could very well lend itself to interpretation as a product of *criollo* consciousness, but this is not the line that I pursue. To do so would have the advantage of incorporating the analysis into an established theme of Latin American cultural history, but it would also risk ignoring the larger problem: the marginality, if not invisibility, of the colonial Philippines in the study of colonial America. As we shall see, it is very much that relationship that is at issue in this map. Memije's map may indeed be backward-looking in some respects and perhaps even quixotic in others, but it is by no means as self-assured as it might seem, nor is it out of touch with the ways in which Spain was inventing and reinventing its overseas possessions,

2. Christian Jacob, *The Sovereign Map: Theoretical Approaches in Cartography throughout History*, ed. Edward H. Dahl, trans. Tom Conley (Chicago, 2006); Denis Wood and John Fels, *The Power of Maps* (London, 1992); J. B. Harley, *The New Nature of Maps: Essays in the History of Cartography*, ed. Paul Laxton (Baltimore, Md., 2001); John Pickles, *A History of Spaces: Cartographic Reason, Mapping, and the Geo-coded World* (London, 2004).

both in the Far East and in the Americas. In fact, it should be understood as a concerted response to the direction that process was taking.

The Spanish Bourbons inherited an official cartography of their overseas possessions that was obsolete even as it was going into print for the first time. One of its centerpieces was the series of maps made to accompany Antonio de Herrera's *Historia general de los hechos de los Castellanos en las Islas i Tierra Firme del Mar Océano* (1601), an official history that was published in various editions and translated into several European languages. The historian Andrés González de Barcia trotted out an edition of Herrera in 1730, complete with the maps. The printed maps were themselves derived from manuscript charts constructed in the 1570s by Spain's official cosmographer-chronicler of the Indies, Juan López de Velasco, as part of his attempt to synthesize what was then known about the geography of the monarchy and about the maritime routes that tied together its disparate parts. Although mapmakers working for the crown continued to equip it with maps of all sorts during the century between the first edition of Herrera and the ascent of the Bourbons, very few of these maps have come down to us, largely because none made it into print. So the Herrera maps, despite their poverty of detail and ornament, despite their questionable accuracy in many respects, continued by default to play their role as the officially sanctioned, public cartography of Spain's early modern overseas empire.[3]

Two of these maps are of interest here, the general map, entitled *Descripción de las Indias Ocidentalis* [sic], and the last of the regional maps, the *Descripción de las Indias del Poniente* (Figures 4 and 5). They immediately demonstrate that, for Spain's official cartography, the operative geographical concept in the mapping of empire was, not "America" or even the "New World," but "the Indies," conceived as the entire expanse between the original line of demarcation established by the 1493 papal encyclicals and the 1494 Treaty of Tordesillas and a counterpart established during the first third of the sixteenth century, when that original half meridian was extended into a full meridian encompassing the globe. The position of this so-called antimeridian was a matter of some dispute. As López de Velasco himself explains in his *Geografía y descripción universal de las Indias* (written in 1574, published in 1880), the Portuguese ran it through the Indonesian island of Gilolo (present-day Halmahera), Castilian geographers placed it almost forty degrees west, in Bengal, and, based on relatively recent observations of lunar eclipses, he him-

3. On Spanish cartography during the seventeenth century, see Pedro Texeira, *El atlas del rey planeta: La "Descripción de España y de las costas y puertos de sus reinos,"* ed. Felipe Pereda and Fernando Marías (Madrid, 2002).

FIGURE 4.
Descripción de las Indias Ocidentalis. From Antonio de Herrera [y Tordesillas], *Descripción de las Indias Ocidentales,* vol. I of *Historia general de los hechos de los Castellanos en las Islas i Tierra Firme del Mar Océano* (Madrid, 1601). Courtesy, The Albert and Shirley Small Special Collections Library, University of Virginia Library

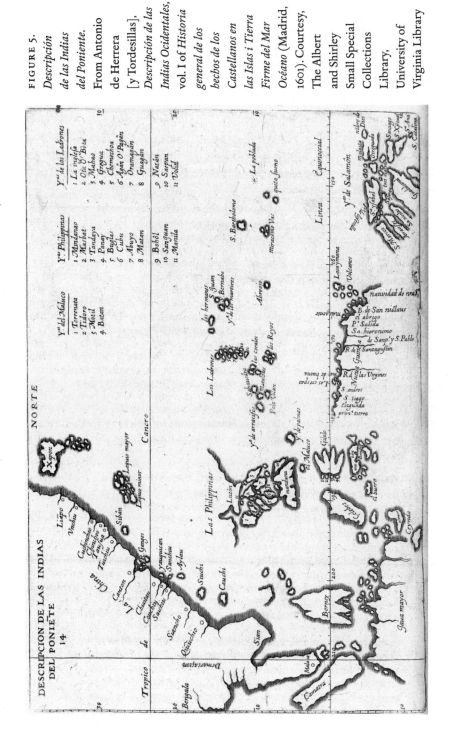

FIGURE 5. *Descripción de las Indias del Poniente.* From Antonio de Herrera [y Tordesillas], *Descripción de las Indias Ocidentales,* vol. I of *Historia general de los hechos de los Castellanos en las Islas i Tierra Firme del Mar Océano* (Madrid, 1601). Courtesy, The Albert and Shirley Small Special Collections Library, University of Virginia Library

self placed it between these two positions, at the longitude of Malacca. He thereby claimed for the Castilian hemisphere not only the bulk of the New World but also a significant slice of East and Southeast Asia, including such gems as the Spice Islands, China, and Japan. It was to Spain, not to Portugal, that these most lucrative places fell, as potential trading partners, potential allies, and even potential objects of conquest. For López de Velsaco, these were originally the "Islas del poniente," the "Islands of the West," but later they became the "Indias del poniente," the "Indies of the West." The map printed with Herrera's history followed the parameters established earlier by López de Velasco, who delineates the region as those "islands and mainlands that fall within the demarcation of the Kings of Castile, to the west of the Indies of New Spain and Peru, which are comprehended in ninety degrees of longitude, and from 13° or 14° latitude south to 35° or 40° latitude north." Crucially, they are conceived, not as "East Indies," but as "Indies of the West." The maps attempt to tie the so-called Indies of the West to the Americas, as the westernmost extension of the larger, Spanish "Indias Occidentales."[4]

Elsewhere I examine how this effort to imagine the East as the farthest West involved tackling several cartographic challenges. The endeavor was only possible because, during the sixteenth century, crucial variables involved in mapping the globe were still open to contestation, thanks in large measure to the profound difficulties involved in measuring longitude. It was not just a matter of being unable to place the lines of demarcation on a more or less known geography. The trouble extended to mapping that geography itself. It was possible, for example, to offer different values for the longitudinal extent of Eurasia and, later, of the Pacific Ocean, particularly if one turned to classical authorities like Ptolemy to settle questions that were so difficult to address empirically. With so much wiggle room available, it was possible for different mapmakers to map the demarcation in different ways and still lay claim to a considerable measure of intellectual respectability. Not only were there dis-

4. Juan López de Velasco, *Geografía y descripción universal de las Indias,* ed. Marcos Jiménez de la Espada (Madrid, 1971), 289. On the line of demarcation and the antimeridian, see Luis de Albuquerque, "O Tratado de Tordesilhas e as dificuldades técnicas da sua aplicaçao rigorosa," in *El Tratado de Tordesillas y su Proyección, actas do. 1 Colóquio Luso-Espanhol de História de Ultramar,* I (Valladolid, 1973), 119–136; Ramón Ezquerra Abadía, "La idea del antimeridiano," in A. Teixeira da Mota, ed., *A viagem de Fernao de Magalhaes e a questao das Molucas: Actas do II Colóquio Luso-Espanhol de História Ultramarina* (Lisboa, 1975); Juan Manzano Manzano, "El derecho de la Corona de Castilla al descubrimiento y conquista de las Indias de Poniente," *Revista de Indias,* III, no. 3 (1942), 397–427.

crepancies between mapmakers working for Castile and those working for Portugal, as we have seen, but also among Spaniards themselves. The Pacific is wider on Castilian-sponsored maps from the 1520s than it is on Herrera's *Descripción de las Indias Ocidentalis,* and throughout the sixteenth century many influential figures within the Spanish imperial bureaucracy expressed their doubts that the "Islands of the West" were indeed within the Spanish demarcation, even as the crown was licensing expeditions to sail to them. So, even though all cartography can be thought of as political, Herrera's maps must be thought of as such, and in rather egregious ways. The positions of the line of demarcation and of the antimeridian relative to the lands they claim on Spain's behalf are very much informed by political and economic interests.[5]

But, even if one ignores such interests, even if one accepts the claims these maps make on the purely intellectual grounds that López de Velasco provides for them, a crucial obstacle stands in the way of mapping Spain's overseas possessions as a trans-Pacific entity that yokes East and Southeast Asia to America. We can call this attempt to map empire using the abstract language of lines of longitude "demarcation cartography." This species of imperial mapping drew upon a particular vein of the Renaissance geographical tradition, the quantitative language of parallels and meridians most readily associated with Ptolemy. The trouble is that, within the demarcation cartography exemplified by the *Descripción de las Indias Ocidentalis,* as well as other maps made under Spanish auspices, the cartographic language sliced across the other vein of the geographical tradition, the qualitative and descriptive one. Renaissance geographical thought embraced the so-called myth of the continents as a central component of its image of the world.[6] Invariably, descriptions of the world turned to accounts of its four parts, Europe, Asia, Africa, and America, and Renaissance thought associated distinctive human qualities with the inhabitants of each of these parts. By the last quarter of the sixteenth century, the four parts of the world were often figured as four women bedecked in costume (or bereft of it) that encoded the cultural identities of their inhabitants, as Europeans saw them (Figure 6). That the four parts of the world could be allegorized as four women tells us that each part was conceived as an organic whole with its own character. It was an easy step from the wholeness and coherence of a continent to the wholeness and coherence

5. Ricardo Padrón, "A Sea of Denial: The Early Modern Spanish Invention of the Pacific Rim," *Hispanic Review,* LXXVII (2008), 1–27.

6. James R. Akerman, ed., *The Imperial Map: Cartography and the Mastery of Empire* (Chicago, 2009); Martin W. Lewis and Kären E. Wigen, *The Myth of the Continents: A Critique of Metageography* (Berkeley, Calif., 1997).

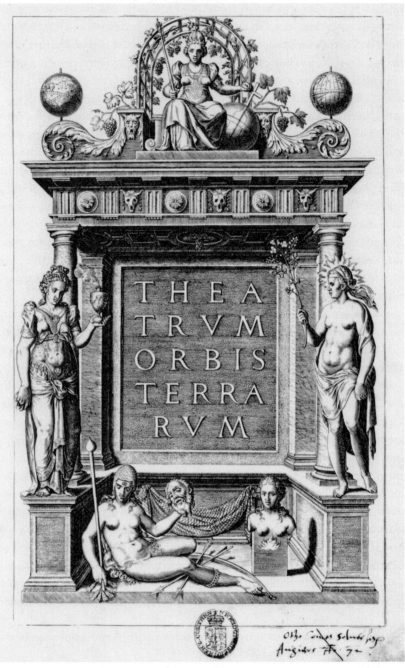

FIGURE 6. Frontispiece from Abraham Ortelius, *Theatrum Orbis Terrarum* (1570).
Courtesy, The Albert and Shirley Small Special Collections Library, University of
Virginia Library

of a human body. But Spain's territorial claims, as defined by the lines of demarcation, sliced through the satisfying, easily allegorized wholes of Asia and America and attempted to forge a new geography from the pieces. Although there might have been other metageographical ideas at work that made this new whole look less contrived than it does today, the strains upon it were not invisible during the early modern period, particularly when one admitted just how broad the Pacific Ocean actually was, and therefore how far apart from each other the pieces lay. The *Descripción de las Indias Ocidentalis* confronts these various challenges by isolating the Indies from Asia (this is a regional map, not a world map), underestimating the breadth of the Pacific, and arranging line and word in ways that visually tie the *Indias del Poniente* to the New World. From these various design choices emerges a more or less coherent image of the Indies as a region spanning the Americas and the Pacific, into East and Southeast Asia. The Indies are, as Herrera's title indicates, not the New World, not America, but the islands and mainlands of the "Ocean Sea," lying within the hemisphere accorded Castile by treaties and papal encyclicals.[7]

This concept of the Indies as a trans-Pacific entity was already running into problems even as it came into print with Herrera's *Historia general.* Herrera's text itself attests to this fact. The opening volume of his mammoth oeuvre is entitled *Descripción de las Indias Ocidentales* and contains an extensive account of the physical geography, economy, and political organization of the Spanish Indies. Drawn in large measure from López de Velasco's earlier work, it is where we find the maps. The section opens with a conventional description of the world as a whole, one that enumerates its four parts before specifying the position of the lines of demarcation. At that point, Herrera must explain that the section of Asia just east of the antimeridian, although it was really "part of Oriental India," was called the "Indias del poniente" because it lay to the west of Castile. Even in the context of a monumentalizing official history, the designation resisted naturalization, so contrary was it to conventional notions of physical geography in which places belonged primarily to continents rather than to abstract demarcations and in which some were naturally "eastern" while others were "western." By Memije's time, the cracks threatening to rip the Indies apart into its constituent elements had become even wider. Various political and intellectual developments had led to the abandonment of demarcation cartography. Meanwhile, other developments in the mapping of

7. Padrón, "A Sea of Denial," *Hispanic Review*, LXXVII (2008), 15–20. The metageography in question is the concept of the tropics. See Nicolás Wey Gómez, *The Tropics of Empire: Why Columbus Sailed South to the Indies* (Cambridge, Mass, 2008).

the Philippine Islands themselves demonstrated considerably less interest in conceiving of them as a western extension of the Americas.[8]

The abandonment of demarcation cartography was triggered by a crisis involving Portuguese encroachment well to the west of the line of demarcation in Brazil, a crisis that culminated in the 1750 Treaty of Madrid, which revoked all prior treaties establishing the line of demarcation and the antimeridian. This treaty determined that the sovereign rights of Spain and Portugal would be determined by the principle of *uti possidetis, ita possideatis,* or "squatter's rights." It was crucially important to Spain's interests in the Philippines, since advancements in cartography had eliminated the wiggle room that had made Herrera's map possible and had vindicated Portuguese arguments that the Philippines and other locations of interest were on the Lusitanian side of the antimeridian. In effect, the Treaty of Madrid allowed Portugal to hold on to parts of Brazil on the wrong side of the line of demarcation in exchange for Portuguese recognition of Spain's sovereignty over the Philippines. But the new arrangement did not hold. The 1761 Treaty of El Pardo revoked the 1750 agreement and reinstated the old treaties. A short interregnum ensued during which the line of demarcation and the antimeridian enjoyed a new lease on life, only to meet their definitive deaths with the 1777 Treaty of San Ildefonso, in which Spain and Portugal once again erased the lines from the map—this time for good. Until Mexico became independent from Spain, the Philippines continued to form part of the Viceroyalty of New Spain and could therefore be thought of as its westernmost extension. No longer was it necessary to designate the islands or surrounding lands as "western," however, as a way of insisting that they were Spanish rather than Portuguese.[9]

The Memije maps were produced just after the Treaty of Madrid was revoked, but it would be a mistake to believe that they are a throwback to the old demarcation cartography, inspired by the restoration of the old treaties. The Treaty of El Pardo was signed in January 1761, and the maps were probably ready by the spring of that same year. In a treatise that Memije wrote to accompany his maps, the *Theses mathemáticas de cosmographia, geographia, y hydrographia en que el globo terraqueo se contempla por respecto al Mundo Hispanico,* we learn that the author presented his arguments in a public disputation held at the Pontifical University of the Society of Jesus in Manila on

8. Antonio de Herrera [y Tordesillas], *Descripción de las Indias Ocidentales,* vol. I of *Historia general de los hechos de los Castellanos en las Islas i Tierra Firme del Mar Océano* (Madrid, 1601), 2.

9. See María Lourdes Diaz-Trechuelo, "Filipinas y el Tratado de Tordesillas," in *El Tratado de Tordesillas,* 239–240.

April 27, 1761. Surely the maps would have been available by then, ready to serve as visual aids in the presentation. If so, they would have been conceived and executed in complete ignorance of the Treaty of El Pardo, since news of its signing would not have reached Manila until well after the public event. Furthermore, neither the maps nor the treatise mention the lines of demarcation. The titles of the maps themselves refer to the "Hispanic World," something that cannot be confused with "the Indies" or the old demarcation. As we read in the *Theses mathematicas* and see on the *Aspecto symbólico*, the "Hispanic World" includes not just the Americas and the Philippines but also the Iberian kingdoms as well. The treatise explicitly defines it as everything lying within the 250 degrees of longitude that stretched westward from the easternmost tip of Catalonia to the westernmost tip of the island of Palawan in the Philippines, by way of the Atlantic, the Americas, and the Pacific. The longitudinal values in the treatise and on the maps are taken from up-to-date English, French, and Dutch maps, placing Manila roughly 193 degrees west of the mouth of the Amazon, unmistakably outside the old Spanish demarcation. Clearly, Memije was working within the intellectual and political universe created by the Treaty of Madrid and the cartographic advancements of his day, a world in which the lines of demarcation were no longer at issue. The royal standard on the *Aspecto symbólico* thus flies from a 250-degree section of the equator, rather than from a graduated meridian standing for the line of demarcation, as we might expect.[10]

In the universe that Memije inhabited, the centripetal pressures exerted by the lines of demarcation, pressures that had bound the Philippines to the Americas as bookends of the Spanish Indies, had melted away, creating an opportunity to develop a new cartography of empire. The Treaties of Madrid and San Ildefonso, however, were only the final phases in the process of disintegration. Already by the 1730s, the official cartography of the Philippine Islands themselves had begun to abandon the long-standing attempt to figure them as part of the "Indies of the West." The shift is visible on two maps published in quick succession, the *Carta chorographica del Archipielago de las Islas Philippinas,* by the Spanish admiral Francisco Díaz Romero and Sergeant Major Antonio de Ghandia (1727), and the *Carta hydrographica y choro-*

10. Vicente de Memije, *Theses mathemáticas de cosmographia, geographia, y hydrographia en que el globo terraqueo se contempla por respecto al Mundo Hispanico . . .* (Manila, 1761). Memije himself identifies the flagpole as "la graduada Linea Equinocial" in the preface to the *Theses mathemáticas.* On the *Aspecto symbólico,* we can see that the graduation of the line reaches 250 degrees, which would make no sense if this were the line of demarcation, a half meridian of 180 degrees.

graphica de las Yslas Filipinas, by Pedro Murillo Velarde (1734). Quirino is unambiguous about the importance of the Murillo Velarde map, calling it "the most accurate and largest [map] ever drawn of the archipelago" and describing its subsequent influence upon eighteenth-century mapmakers—Spanish, French, English, German, Italian—who copied it and adapted it. The map came out in response to a royal decree ordering the creation of a reliable nautical chart of the islands, but Murillo Velarde was most likely already working on it when the decree was made. As we shall see, the map he produced is more than just a guide for navigation. Its influence cannot be doubted. The map was incorporated into histories of the Philippines, including Murillo Velarde's own *Historia de la Provincia de Philipinas de la Compañía de Jesús* (1749) and the monumental *Historia general sacro-profana, política y natural de las Islas de Poniente llamadas Filipinas* by Juan Delgado (1892). In 1921, the Philippine Bureau of Printing reproduced it as part of a commemorative pamphlet containing speeches that had been given at a public celebration of the quadricentennial of the discovery of the islands by Magellan. The pamphlet, Quirino writes, called it the first cartographic representation of the Philippines. This statement indicates how thoroughly the earlier, much less influential map by Romero and Ghandia had been eclipsed. For our purposes, however, the nearly forgotten earlier map is absolutely indispensable.[11]

The Romero-Ghandia map was one of the many maps that issued from the presses of Spain's newly professionalized armed forces (Figure 7). Beautifully engraved, it measures sixty by thirty-eight inches. Surprisingly for a map that calls itself a "chorographic chart" of the Philippine Islands, it does not limit its scope to the islands themselves but places them in a regional context that includes the southern coast of China, Formosa, most of the coastline of modern Vietnam, parts of Borneo, and other islands of modern Indonesia. It also includes an ample expanse of ocean stretching eastward from the Philippines to include the islands of Palau and the Marianas. Its geographical scope is essential to its visual rhetoric, which works to tie the Philippines to the Americas as its westernmost extension. In this way, the *Carta chorographica del Archipielago de las Islas Philippinas* can be considered a successor to the *Descripción de las Indias del Poniente.* The geographical scope is narrower, and no antimeridian appears to lay claim to the region as a whole, but there is nonetheless an effort to figure the Philippines as "western islands." This effort involves just about every aspect of the map's design, from its scale, shape, and orientation to its internal spatial structure and its iconography.

The scale and dimensions have been chosen to depict the Philippines in

11. Quirino, *Philippine Cartography,* 46, 59–61.

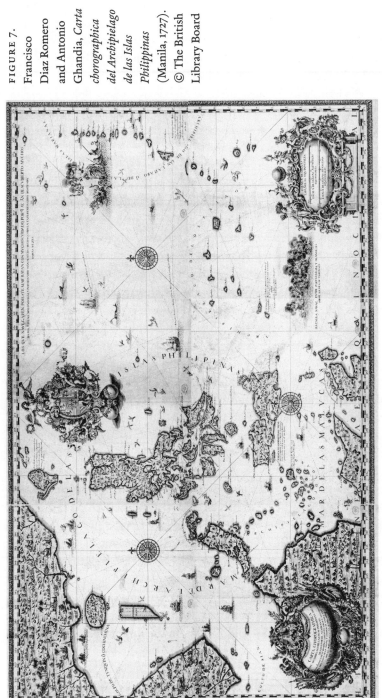

FIGURE 7. Francisco Diaz Romero and Antonio Ghandia, *Carta chorographica del Archipielago de las Islas Philippinas* (Manila, 1727). © The British Library Board

considerable detail, but without excluding the surrounding area. The map is rectangular and has been set lengthwise to include places east and west of the Philippines, at the expense of greater inclusiveness along the north-south axis. The choice makes considerable sense, given that the Philippines were tied politically and commercially to Mexico by the predominantly east-west travels of the Manila Galleon. The east-west axis dominates Spain's relationship with the islands, and so it determines the framing of the map. Other aspects of the map lead the eye to travel around the space it frames. The Philippines are set within a graceful arc of words—"Mar del Archipielago de las Islas Philipinas"—that convert the island into a bull's-eye. But this bull's-eye has been placed left of center, thus competing with other visual elements for the gaze of the onlooker. The primary focus is the Bourbon arms, which are depicted as if they were a three-dimensional mass sitting atop the map casting a shadow upon its surface. They rest upon two spheres that suggest the expansive, ballsy might of the Spanish Bourbons and support a riot of celebrating putti as well as an angelic herald. These arms, in turn, form the apex of a triangle whose base is anchored by the title cartouche in the lower left and the cartouche with the map's scale in the lower right. The subtle lines of the map's *marteloire,* its network of crisscrossing rhumb lines, describe this triangle, falling downward from a point just above the arms, passing through two prominent compass roses, and meeting the edges of the map just above the cartouches. The eye of the onlooker cannot help but travel from the circle containing the Philippines, to the arms, to the cartouches, and even to the center of this triangle, which itself becomes another focal point of the map. As a focal point, however, the center of the map is unsatisfying. Drawn there, the eye finds nothing on which to fasten and so keeps traveling to one of the other prominent stopping places. Even though the map exhibits considerable symmetry—mostly land on the left, mostly water on the right, a symmetrical triangle at its center—the off-centered portrayal of the Philippines imbues the image with internal tension and movement.

The tension and movement make this map lovely to look at, but they are also key to its ideological operation. Foundering in the seas at the center of the triangle, the eye easily follows the rhumb line that leads northeastward through one of the compass roses, or the arc of islands (Palau and the Marianas) below that line, or even the series of charming ships and sea creatures above it until it stumbles upon the allegory in the upper right corner. There it discovers Faith personified sailing westward from the Marianas, and by implication the Americas, in a sea chariot bedecked with a Castilian escutcheon that echoes the royal arms and escorted by sword-brandishing, natatorial Leonese lions with Castilian castles on their heads. The image reminds the

reader that Spanish might and the Catholic faith arrived in the Philippines together from across the Pacific. The movement of the eye thus begins to echo the historical journeys of Spanish power. The map comes to represent not just the geography of the Philippines but also a central aspect of their history, their discovery and conquest by Spain. If the eye then follows the line of islands down from this allegory to the cartouche expressing the map's scale, it finds another allegory that adds more layers of meaning onto the map's ideological message. Two anthropomorphic figures flank the cartouche, an American Indian and an Asiatic native, affirming the status of the Philippine Islands as the site of a trans-Pacific encounter between Asia and the New World.

The message of the map, however, goes even further. The Philippine Islands form part of the land-cluttered left side of the map, which is to say they form part of Asia. But the map's elements of design and decor serve to wrest the islands from their Asian location and associate them with the trans-Pacific world of Spanish sovereignty, represented synecdochically by the predominantly oceanic right side of the map. The toponymic circle isolates the islands from the rest of Asia. The royal arms hover above them, asserting Spain's right to rule. The triangle described by the arms and cartouches reasserts the importance of the map's geometric center, drawing the eye away from the Philippines toward the right, eastward into the Pacific. The rhumb lines, islands, and decorative images then conspire to bring us to the crucial allegory of Faith and Power afloat, which then remits us, not to the mere encounter between Asia and America figured in the cartouche, but to the conquest, evangelization, and continued governance of a part of Asia—the Philippines—by Spain, by way of Spanish America. The circle of sovereignty described by "Mar del archipielago de las Islas Philippinas" becomes the westernmost link in a chain of such circles extending eastward from the Philippines themselves to include the "Archipielago de los Palaos," the "Archipielago de San Lázaro o de las Islas Marianas," and, by implication, the New World. And to round off this eloquent assertion of Spain's trans-Pacific claims, the map provides a contrast between Spain's mission to civilize and Christianize as well as to govern with the supposedly less constructive efforts of its two greatest rivals in this part of the world, Portugal and Holland. As Faith sails westward to bring the true religion to the Philippines, the Dutch and the Portuguese are destroying each other in a naval battle depicted just to the left of the lower-right cartouche.

Why was the Romero-Ghandia map eclipsed by the Murillo Velarde map—and in rather short order? Despite its eloquence, the Romero-Ghandia map suffered crucial defects, particularly in its handling of the island of Mindanao. It has been noted that this southernmost of the major islands of the Philippines is depicted with an excessively rectangular shape, and one of its

outlying islands is missing altogether.[12] I would add that the island is also marginalized by the map's design. If we complete the imaginary circle described by the toponymic arc containing the Philippine Islands, we see that Mindanao clearly lies inside it, but the words themselves are not extended to make this inclusion concrete and therefore more assertive. Mindanao can all too easily be perceived as the frontier region that in fact it was and continues to be. Moreover, the channel separating it from the Leyte Islands to the north is depicted as a broad, empty passage, effectively setting off Mindanao from the rest of the Philippines. Compare this depiction with any modern map of the Philippines, on which Mindanao appears much closer to the Leyte Islands, very much integrated with the rest of the archipelago. Not only is Mindanao isolated from the rest of the islands, but it is then drawn toward the toponym that appears boldly across the sea to its south, "Mar de las Maluccas." Does Mindanao belong there, among the Spice Islands now in Dutch hands, as another monument to lost opportunities in the Southeast Asian archipelago? The Romero-Ghandia map, so boldly assertive of Spanish claims, seems in the end to have clay feet. It fails to make those claims stick where they are most in question, in the southern Philippines where the population persistently resisted Spanish rule and, particularly, Spanish religion.

The Murillo Velarde makes a number of improvements over Romero-Ghandia but also adopts a very different overall strategy for representing the Philippine Islands (Figure 8). The difference is immediately apparent: whereas the Romero-Ghandia map represents the Philippine Islands as part of larger geographies and hydrographies, the Murillo Velarde map isolates the Philippines from their surroundings and presents the islands as a world unto themselves. Regarding troublesome Mindanao, this choice offers an immediate advantage over Romero-Ghandia. On the banderole that stretches across the waterway between Mindanao and the Visayas, one has to look closely to read the map's sole acknowledgement of the existence of an internal frontier in this region. There we read, "Desde Samboangan hasta Caraga por el norte es de España," testifying that Spanish control did not extend to the Muslim sultanates in the south of the island. But the political and cultural realities witnessed by the banderole are overwhelmed by the map's more prominent insistence upon the pertinence of the island of Mindanao to the Philippine world. By excluding the world beyond the archipelago—with the exception of a piece of Borneo—the Murillo Velarde map cuts off Mindanao from the Moluccas to the south. The problematic island appears more triangular than rectangular, and its northeastern corner reaches up as if trying to touch the

12. Ibid., 45.

southern tip of Leyte. No longer is it separated from the Visayas by an inconveniently broad passage. Most important, perhaps, the southeastern corner of Mindanao squares in a satisfying fashion with the frame of the map, converting the whole island into a foundation of sorts upon which the rest of the archipelago sits. The simple act of isolating the Philippines from the surrounding area thus belies that Spanish authority and influence were very unevenly distributed throughout the islands, strongest in and around Manila, weaker in the farther reaches of the island of Luzón and in the Visayas to the south, and practically nonexistent in Mindanao and Jolo. The islands appear as an integrated archipelago entirely belonging to the Bourbon monarchy, whose arms appear in the title cartouche.

The work of the geographical frame finds support in the map's verbal and allegorical program. A miniaturized history of the islands appears in the cartouche on the lower left, anchoring the geography of the Philippines in the story of their discovery by Magellan and conquest by Legazpi as well as in brief lists of their current economic resources, their governmental, military, cultural, and ecclesiastical institutions, and their population, organized according to the religious orders that minister to it. Throughout, Mindanao is included without mention of its marginal status. Atop the cartouche, one of the royal lions that was swimming toward the Philippines on the Romero-Ghandia map sits high and dry, looking over Mindanao with sword and scepter in hand (or paw). Below its pendulous orbs, Magellan's *Victoria* sails between southwestern Mindanao and the island of Jolo, another problematic frontier island, commemorating the discovery of the islands by a Spanish expedition. Meanwhile, the title cartouche in the upper right proudly displays the royal arms above two seated female figures holding a cloth with the map's title.

These female figures provide a significant contrast to the allegorical program of the Romero-Ghandia map. Bedecked with charts, an armillary sphere, and other scientific instruments, the women in the title cartouche personify geographical knowledge rather than particular geographies. Instead of portraying the encounter of America with Asia, the Murillo Velarde map uses allegory to assert its own technical sophistication, or perhaps the sophistication of the geographical sciences in Bourbon Spain. Elsewhere, the map elides other opportunities to link the Philippines to the New World. The microhistory of the islands in the lower cartouche says nothing about where Magellan and Legazpi sailed from, nor does it make any reference to the authorities, in America or Spain, to whom the institutions listed in the cartouche must answer. The sole acknowledgement of American ties is the depiction of the sailing routes that connect Manila with New Spain. One might expect these

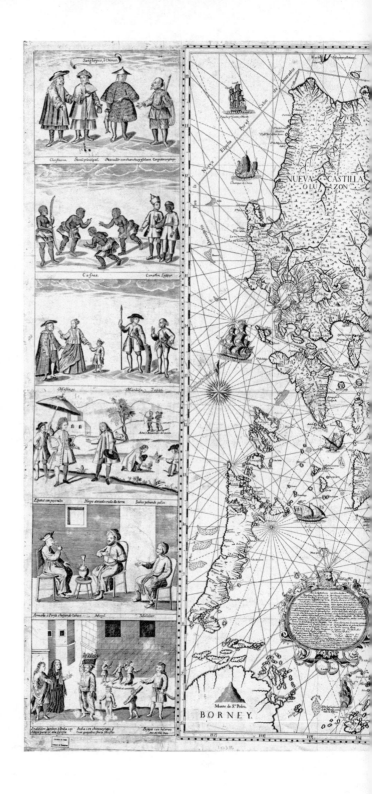

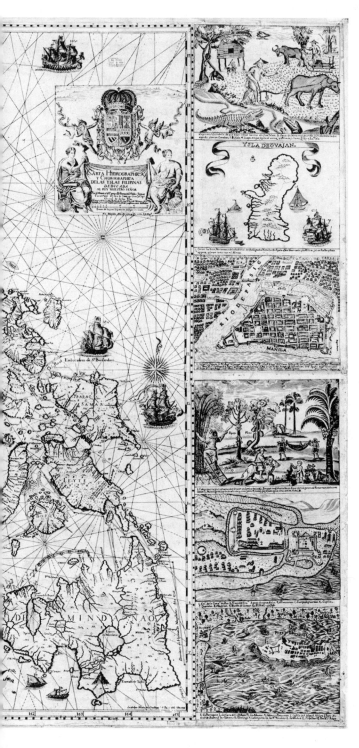

FIGURE 8.
Pedro Murillo
Velarde, *Carta
hydrographica
y chorographica
de las Yslas
Filipinas . . .*
(Manila, 1734).
From the
Collections of
the Geography
and Map
Division, Library
of Congress

routes to appear on any map that hoped to satisfy the king's demand for an accurate hydrographic chart that could facilitate maritime commerce with the Philippines, but their handling by Murillo Velarde emphasizes local issues rather than trans-Pacific connections. The map depicts two routes, one taken by ships leaving for Acapulco around the northern tip of the island of Luzón and the other taken by ships arriving from Acapulco through the Visayan archipelago. By contrast with the Romero-Ghandia map, the Murillo Velarde map deemphasizes the trans-Pacific connections created by the galleon trade and emphasizes instead the intricacies of the local leg of the journey. Nor is the trade with Acapulco the only connection represented by the map. Images of different sorts of sailing vessels dot the map, including a European-style ship marked "Patache para Canton y Macan" and a Chinese junk labeled "Champan de China." These reminders of Manila's commercial relationships with China and Portuguese Macao assert the importance of the Philippines as an entrepôt between Asia and the Americas while at the same time reminding us that the commercial value of the islands resides precisely in their not merely being an extension of New Spain. Overall, the status of the Philippines as a colony of a colony remains unacknowledged in favor of a deliberate assertion of the islands as a unique component of Spain's empire.

This assertion comes through loud and clear in the series of images designed to flank the original version of the map. These twelve images were done by a different engraver—also a native Filipino artisan, like the engraver of the map itself—and combined with the map on a single large sheet. Three of them depict scenes from Filipino life, one in the city and two in the country. They feature the flora, fauna, and forms of life that one could find in descriptions of the islands. Four offer cartographic images of important localities, Manila (the capital), Zamboangan (a fortified town on Mindanao), Cavite (the port serving Manila), and Guam (one of the Marianas Islands and a way station for the trans-Pacific trade). The remaining five are ethnographic images portraying members of some of the colony's major ethnic and racial groups. Among them we find Spaniards, mestizos, Africans, Chinese, Armenians, Persians, Japanese, and members of ethnic groups indigenous to the Philippines themselves. The Philippines on the Murillo Velarde map are depicted as an insular world, but they do not exhibit the homogeneity that one expects in isolated locations. They are at once insular and cosmopolitan, distinct yet diverse. That internal cultural diversity, however, emphasizes the archipelago's relationship with Asia, not America. Asian groups predominate, and there is not an Amerindian in sight.

Twin developments thus structured the cartographic efforts of Pedro Murillo Velarde's latter-day colleague in Philippine cartography, Vicente de

Memije. On the one hand, science and politics had conspired to erase the lines of demarcation that held the Americas and the Philippines together as parts of a single "western" demarcation mapped in opposition to an "eastern," Portuguese hemisphere. On the other, local cartography had registered, in the Murillo Velarde map, a powerful assertion of Filipino identity that rejected the lingering assimilation of the archipelago to the Americas that was inherent in the old demarcation cartography and still evident in the Romero-Ghandia map. As we saw, the Treaty of Madrid implicitly called for a new cartography of empire that could replace the old demarcation cartography and that would address the status of the Philippines. Memije attempted to answer this call in his maps and in his treatise.

Memije must have felt liberated by the consignment of the lines of demarcation to the historical trash bin. Reading the *Theses mathemáticas* in conjunction with the *Aspecto symbólico,* one is struck by the enthusiasm and creativity with which Memije attempts to seize the cartographical and rhetorical day, converting the erasure of the lines of demarcation into an opportunity to forge a new, more coherent, more expansive imperial cartography from the relics of the old one. As we saw, Herrera's cartography had to struggle against the myth of the continents, the idea that the world's major landmasses constituted coherent geographical unities that served as homes to particular manifestations of human character and civilization (or lack thereof). Memije seems to have decided that he could not beat this myth and so instead would join it, or, rather, he would harness its powerful allegorical strategies to his own ends. He personifies the disparate territories of the Hispanic world as a single female body, suggesting very powerfully that the monarchy exhibits the sort of unity ordinarily ascribed to the continents. The move would have been impossible in the old cartographic dispensation, which purchased its claim on the Castilian hemisphere by admitting that part of the Portuguese demarcation lay between Spanish America and Spain itself. It is hard to imagine how a cartographical imagination centered on the depiction of the original line of demarcation in the Atlantic could have ever personified the monarchy the way Memije does for the simple reason that the line would have cut the head off from the rest of the body.

Freed from this inconvenience, Memije can forge the seductive personification featured in the *Aspecto symbólico* and explicated in the *Theses mathemáticas.* The *Theses* acknowledges that the Hispanic world spans the world but tries to convert this reality into an advantage. "Europe," we read, "serves as the canopy" of the Hispanic world, "the New World as its clothing, Asia as its pedestal, and Africa as the shadow to its highlights." The personification of the Hispanic world thus involves the concomitant objectification of the four

continents, leaving the monarchy incarnate as a solo actor in the theater of the world. It suggests the organic unity of the monarchy as well as the physiological integration of its parts. Its ships, Memije writes, "like the blood, which, circulating through the veins, communicates to all the members of the body vital spirits . . . navigate throughout all the Seas" in order to take to the New World judges, men of letters, captains, bishops, archbishops, and missionaries who will assure that the monarchy is well shepherded both temporally and spiritually. They issue, it would seem, from the head of the figure, where we find the orb of monarchical authority as well as a crown engraved with the names of the various Iberian kingdoms. Among the places served are the Philippines, which Memije refers to as part of "the Archipelagos of Asia" but also as "this part of the New World." They have become the feet "with which the Catholic Religion of the Hispanic World trods, like the Woman pronounced by the Majesty of God, upon the head of the Dragon: *ipsa conteret caput tuum* [she shall crush your head (Gen 3:15)]."[13]

This emphasis on Catholicity is crucial. The *Aspecto symbólico* is reminiscent of the personification of the four parts of the world, which give visible form to something invisible on the maps of the period, the character of human beings in each of the four parts as Europeans understood them. But it is also quite unlike those personifications in some very significant respects. As we saw, the use of human bodies to figure the continents responds to (and reinforces) the idea that continents represent naturally given wholes, both in geographical and cultural terms. The monarchy represents no such thing. In fact, Memije's *Aspecto geográfico* allows us to see quite plainly that the Hispanic world is made up of disparate territories divided by two wide oceans. The *Aspecto symbólico* then allows us to perceive this geography differently, by filling in the blanks among the territories—the head, the crown, the nautical links (the necklace, the folds of the dress) that integrate them temporally and spiritually. Disparate places become a single body, integrated physically and animated spiritually. The "soul of the Hispanic World, the Catholic Religion," becomes the real signified of the image. That "most sublime ornament . . . that cannot be represented on any map" becomes precisely what this map allows us to see.[14]

That body, moreover, does not stand apart from the cartographic representation of territory, as do the four female figures representing the parts of the world, but is instead built from the map of the Hispanic world itself. This is the real genius of Memije's image: the territorial fragmentation so visible

13. Memije, *Theses mathemáticas*, 2, 6, 7, 10.
14. Ibid., 2, 4.

on the *Aspecto geográfico* is not erased; it is transcended. That fragmentation remains visible, allowing us to see how its integration can only be providential. Furthermore, that integrated image of Catholic empire acquires an air of authority that it might not otherwise have had. Certainly, Memije must have understood the rhetorical power of an accurate map. In the long note we find along the right edge of the *Aspecto geográfico,* the mapmaker assiduously documents his sources, so eager is he to convince his reader of the intellectual respectability and cartographic accuracy of his map. By building the *Aspecto symbólico* from the *Aspecto geográfico,* he transfers that authority from the purely empirical, scientific image onto the more imaginative, clearly ideological one. We should not oppose, as Spate does, the ideological fantasy of the *Aspecto symbólico* to the "sobriety" of the *Aspecto geográfico* if we are to understand what Memije was trying to do. It is the very sobriety of the *Aspecto geográfico* that grounds the ideological claims of the *Aspecto symbólico,* suggesting to the reader that its claims about the spiritual integrity of the Hispanic world are just as real, just as reliable, as the measures of longitude taken from Memije's cartographic sources. Memije is most certainly a modern man, one who knew what was going on in the cartography of his day and who could appreciate the power of a good map, but he was also a Spanish patriot and a Catholic, eager to graft a very Catholic and Hispanic political ideology onto the authoritative armature of a modern map.

But Memije was also a Filipino patriot. No spiritual ancestor of José Rizal, that great Filipino nationalist of the nineteenth century, he was like other criollos who were loyal to the crown while at the same time zealous for their colonial home. His concern for the welfare of the Philippines, moreover, was quite caught up in the status of the islands as either Asian or American. The Filipino mapmaker continued in the vein of others before him who figured the Philippines as the westernmost outpost of the Spanish Indies. In referring to the islands as a "part of the New World" and in representing them as the feet of a body that included the New World, Memije showed himself to be the heir of Romero and Ghandia, not to mention of Herrera and López de Velasco. His *Theses mathemáticas,* however, reveals a different intellectual and political affiliation. The purpose of the treatise, and therefore of the maps as well, was to persuade Carlos III that it would be advantageous to cultivate the use of a direct trade route between Spain and the Philippines by way of the Strait of Magellan, bypassing the Novohispanic middlemen so deeply involved in the fortunes of the islands. The argument implies something that does not enter into Memije's explication of the *Aspecto symbólico.* It seems that the Matron's arteries are clogged, somewhere in the Americas, and that the civilizing mission of Spain is having trouble making its way to her Filipino extremities.

Conveniently, Memije's cartographic work began by setting the geography of the monarchy on its side, so to speak, so that east is at the top of the map. The decision makes the *Aspecto geográfico* look odd, but it serves Memije's purposes quite well. If this map had been drawn in a more conventional manner, with north at the top, we would find the Philippines off to the left side, marginalized from the bulk of the monarchy in the Americas by the breadth of the Pacific Ocean. By rotating the map and personifying the territory as a whole, Memije redresses this position of marginality, laying the groundwork for the depiction of the Philippines as the feet of our upright Matron. In fact, the Philippines become the sandals of the biblical warrior Judith, which ravished the eyes of the Assyrian Holofernes (Jth. 16:11). Memije can tell us, "So that which most frightens Lucifer are these Islands" as well as "the feet, with which the Catholic Religion trods, like the Woman, pronounced by the Majesty of God, on the head of the Dragon: *ipsa conteret caput tuum* [She shall crush your head (Gen. 3:15)]." The Americas, meanwhile, are set on their side and thereby defamiliarized. We more readily accept their depiction as part of a whole, the mantle of the Matron, rather than insist upon seeing them as the main attraction.[15]

But the *Theses mathemáticas* also figures the Philippines as the feet of the statue in the dream of Nebuchadnezzar, a statue that crumbled when the feet made of iron and clay were struck with a stone. Memije calls upon the king not to neglect the Philippines, lest the entire monarchy fall when they should crumble. One might think, therefore, that his argument would involve a catalog of economic, social, or political woes stemming from the monarchy's supposed neglect of the islands, but Memije must have realized that complaint never makes for a very compelling rhetorical strategy. Instead, he painted a rosy picture of what would happen if the Philippines received proper support from the crown. Not only would they solidly ground the existing empire; they would become the springboard for the creation of an even grander one. Spain, Memije argues, would have the opportunity to extend the faith to the *Terra Australis Incognita,* or the "Reyno del Austro," as he calls it, "so that you [Charles III of Spain] can bring under your sovereign assistance all of its unhappy inhabitants and render them fortunate with your most just Laws, and even more so with the celestial light of the Gospel."[16]

The most extravagant of Memije's claims, however, involve his use of the quantitative language of modern cartography so central to demarcation mapping, although he uses it for an entirely different purpose. The *Theses mathe-*

15. Ibid., 6.
16. Ibid., 7.

máticas begins with what would seem to be a purely scientific assertion, that degrees of longitude should only be counted westward, going around the globe 360 degrees (Thesis I). It offers some reasons rooted in cosmography, such as that the sun moves across the sky from east to west (or, for the Copernicans, that the Earth revolves under the westward march of our feet), but they conjoin these reasons to more jingoistic ones. It is only natural, the text suggests, that degrees of longitude be counted in this direction because the conquests of Spain, the greatest empire the world has ever seen, have moved from east to west. In the absence of an antimeridian to mark the western terminus of that movement, moreover, there is no reason to imagine an end to that westward march. Having conquered a full 250 degrees of the globe's longitude, Memije asserts, Spanish sovereignty should push onward, bringing the remainder of the globe under its laws and faith: "Having rounded the entire Terraqueous Globe, the PLUS ULTRA [that is, Spanish expansion] may return to Spain full of innumerable trophies and then certainly we shall pronounce: NON PLUS ULTRA. But in a sense so very different from what Hercules put on his Columns."[17]

The quantitative language of cartography no longer provides boundaries within which to contain Spanish sovereignty—or to keep the Portuguese out of places in which Spain is interested. Instead, it provides Spanish expansionism with a curious numerology. The operation of that numerology, moreover, depends upon Memije's use of up-to-date measures of longitude. Unlike a hemisphere or a full sphere, a 250-degree section of the globe does not represent a satisfying whole. It lies suspended between those two more satisfying possibilities, calling out for either truncation or extension. Sacrificing territory is certainly not an option, so Memije converts the 250-degree section of the globe represented by the Hispanic world into a figure for an unrealized destiny. The fullness of the globe's 360 degrees of longitude becomes the whole toward which expansionism should aspire. Thus, whereas Herrera's map struggled with the problem of constructing the image of a coherent territory from the scraps of geographies dismembered by the quantitative language of the lines of demarcation, Memije constructs a powerfully compelling territorial body only to use quantitative language to suggest its eventual transcendence. The rhetorical hyperboles of the *Theses mathemáticas* point toward a future—a utopian one, certainly, in ever respect—in which the territory of the monarchy and the abstract globe will be one and the same.

Who in Madrid, however, would have been ready to give ear to such overweening aspirations, even if they were only rhetorical hyperboles? Roughly

17. Ibid., 10.

seventeen months after Memije made his presentation, an English fleet under British brigadier general William Draper fell upon Manila and quickly took control of the city and its port. Although both would revert to Spanish control in 1764, after the end of the Seven Years' War, the ease of the British takeover clearly demonstrated just how feeble Spanish power in the area actually was, just as the war as a whole represented an exercise in Spain's new status as a third-fiddle power on the world's stage. True, Spain was quickly modernizing its institutions and enjoying increasing prosperity under its new French dynasty, but it was doing so within definitely circumscribed boundaries. Memije's rhapsody about universal monarchy belonged much more to the ideological climate of the sixteenth century than to the political realities of the eighteenth.

The new dispensation acquired one of its most visible cartographic forms in the *Mapa geográfico de América Meridional,* produced by the Spanish crown in 1775 under the direction of Juan de la Cruz Cano y Olmedilla (Figure 9). This monumental map, measuring six feet by eight feet when mounted, arose from the disputes with Portugal over the boundary between Brazil and the Viceroyalty of Peru. It was meant for internal use by the Spanish state, although copies got into the hands of various outsiders, including Thomas Jefferson.[18] Its desirability had to do with its accuracy and level of detail, but what interests us here are the engravings that embellished the map in its original form. A garland of New World products drapes the top half of the map, while America herself is personified in the lower right corner, in the company of Europa and the Faith. The escutcheons of Spain's New World kingdoms dangle on a chain from the royal arms and wrap around a bust of Christopher Columbus inscribed with the phrase "A Castilla y a León, Nuevo Mundo dió Colón [To Castille and Leon, Columbus gave a New World]." The decorative scheme speaks of the significance of the discovery of the Americas for world history and celebrates Spain's accomplishment in discovering it, bringing to it the light of the faith, establishing there a variety of prosperous kingdoms, and making available for the world's consumption the natural riches of the New World. This may be a map of South America, but the decorative scheme converts the map into something much more, a symbol for Spain's historical identity, a testament to its crucial role in the history of the world.

There seems to have been no role for the Philippines or any of the other "Indies of the West" in that image. Despite the new lease on life given the lines of demarcation by the Treaty of El Pardo, the Cruz Cano map was not con-

18. Thomas R. Smith, "Cruz Cano's Map of South America, Madrid, 1775: Its Creation, Adversities, and Rehabilitation," *Imago Mundi,* XX (1966), 67–70.

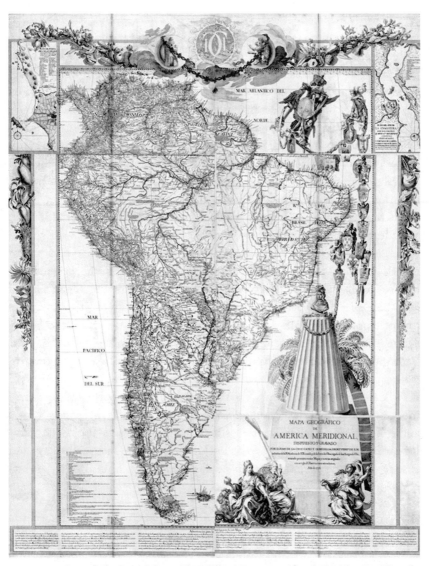

FIGURE 9. Juan de la Cruz Cano y Olmedilla, *Mapa geográfico de América Meridional* (Madrid, 1775). Courtesy, The Albert and Shirley Small Special Collections Library, University of Virginia Library

ceived, to my knowledge, as part of an effort to map the Indies as a whole or to map the Philippines as their western extension. In effect, the Cruz Cano map embraces the so-called invention of America, the cultural project of forging the lands we know of as the Americas into a continent (or continents) independent of the Old World. As we know, that process began early in the sixteenth century, but we have seen that the official cartography of the Hapsburg monarchy held it at bay. Eager as it was to support its claims upon trans-Pacific locales, it preferred "the Indies" to "America" in mapping the metageography of its sovereign aspirations. It attempted to use number, line, and abstraction to forge an image of empire that ran counter to the geographical tradition, both as it had existed for centuries and as it was being reinvented at the time. The replacement of the Romero-Ghandia map with the Murillo Velarde map charts the bankruptcy of that metageography, at least among some Filipinos living and working in Manila during the first half of the eighteenth century. There we see the Indies transformed from the westernmost outpost of the New World into an Asian colony of Spain. The Memije maps, and the *Theses mathemáticas,* by contrast, attempt to revive the old geography of empire by grafting allegory and rhetoric onto the new cartography of the Age of Enlightenment. Ironically, they do so in order to advocate for a marginalized colony that would soon fall prey to an increasingly powerful international rival. By the time of the Cruz Cano map, the old Indies seem to have been consigned to history, the Philippines cut loose of their trans-Pacific moorings (ideologically, although not politically, socially, or economically), and America was finally invented as such by its appearance on official Spanish cartography—just in time to be lost by Spain, not to mention Britain and France, and to be once again reimagined as yet something else.

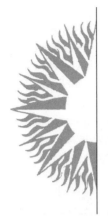

CENTERS AND PERIPHERIES
IN ENGLISH MAPS OF AMERICA,
1590–1685
Ken MacMillan

In the past few decades, historians have become interested in the relation-
ship between centers and peripheries in the construction of early modern
American empires. As described most notably by sociologist Edward Shils,
"As we move from the center ... in which authority is possessed ... to the ...
periphery, over which authority is exercised, attachment to the central value
system becomes attenuated." In addition, "the further one moves territorially
from the locus of authority, the less one appreciates authority." Among the
wide-ranging implications of these conclusions in a variety of academic disci-
plines, this theory has assisted historians in better understanding the often
tense relationship between England and its colonies in North America. As
explained by Jack P. Greene, because the imperial center lacked the fiscal, ad-
ministrative, and coercive resources necessary to impose its authority on dis-
tant American colonial peripheries, the latter enjoyed considerable autonomy
from the former, and any authority exercised by the center, far from being
hegemonic and absolute, was nominal and negotiated.[1]

 The author wishes to thank Martin Brückner for the invitation to contribute to this
volume and the John Carter Brown Library for a Helen Watson Buckner Memorial fel-
lowship, during which some of the ideas in this essay developed.
 1. Edward Shils, *Center and Periphery: Essays in Macrosociology* (Chicago, 1975), 3–16.
For an early use of this theory in colonial discourse (using the terms "core" and "periph-
ery"), see Immanuel Wallerstein, *The Modern World-System*, 3 vols. (New York, 1976–
1989). See also Jack P. Greene, *Peripheries and Center: Constitutional Development in the
Extended Polities of the British Empire and the United States, 1607–1788* (Athens, Ga.,
1986); Greene, "Negotiated Authorities: The Problem of Governance in the Extended
Polities of the Early Modern Atlantic World," in Greene, ed., *Negotiated Authorities:
Essays in Colonial Political and Constitutional History* (Charlottesville, Va., 1994), 1–24;
and Greene, "Transatlantic Colonization and the Redefinition of Empire in the Early
Modern Era: The British-American Experience," in Christine Daniels and Michael V.

This conception is generally consistent with the findings of more recent, revisionist historians. Arguing against earlier notions that the British empire was a powerful political and ideological entity from the late sixteenth century onward, modern historians characterize English activities in America before about 1675 as mundane, commercial ventures that were extremely fragile and always in jeopardy of failure. This fitfulness was, as Kenneth Andrews and others have argued, largely because of the lack of crown interest in enterprises that brought no wealth and power to the monarchy. Elizabeth I and the early Stuarts had few imperial aspirations, did little to help overseas adventurers and trading companies, and were hesitant to get involved even when such involvement appeared to be necessary and justified. Instead, the crown relegated the mercantile "empire" to private commercial interests. This transatlantic relationship was reinforced by the extensive legislative and sometimes viceregal powers awarded to the peripheral authorities in colonial charters. Under this revisionist interpretation, English efforts in America were, at least before the establishment by Charles II of the Lords of Trade in 1675, colonial and commercial but not imperial. Thus, rather than attempting but failing to extend central authority over the peripheries, in the first century of these affairs the English center deliberately relinquished its authority over its American colonies, expecting that the designated system of trading company and proprietorial government, together with peripheral legislative assemblies and governors with broad powers, would relieve the "weak state" of the burden of empire.[2]

Kennedy, eds., *Negotiated Empires: Centers and Peripheries in the Americas, 1500–1820* (New York, 2002), 267–282.

2. Kenneth R. Andrews, *Trade, Plunder, and Settlement: Maritime Enterprise and the Genesis of the British Empire, 1480–1630* (Cambridge, 1984); and, generally, Nicholas Canny, ed., *The Origins of Empire: British Overseas Enterprise to the Close of the Seventeenth Century*, vol. I of Wm. Roger Louis, gen. ed., *The Oxford History of the British Empire* (Oxford, 1998). On the extensive powers awarded to patentees in colonial charters, see Ken MacMillan, *Sovereignty and Possession in the English New World: The Legal Foundations of Empire, 1576–1640* (Cambridge, 2006), chap. 3; and Elizabeth Mancke, "Chartered Enterprises and the Evolution of the British Atlantic World," in Mancke and Carole Shammas, eds., *The Creation of the British Atlantic World* (Baltimore, 2005), 237–262. On the seventeenth-century model of governance, see Michael J. Braddick, *State Formation in Early Modern England, c. 1550–1700* (Cambridge, 2000); John Brewer, *The Sinews of Power: War, Money, and the English State, 1688–1783* (New York, 1989). With direct regard to the empire, see, for example, Ian K. Steele, "The Anointed, the Appointed, and the Elected: Governance of the British Empire, 1689–1784," in P. J. Marshall, ed., *The Eighteenth Century*, vol. II of Louis, gen. ed., *The Oxford History of*

Though different in their particulars, both Greene's and the revisionists' arguments attest to an attenuated Anglo-American center-periphery relationship, one in which the colonies demanded and retained significant degrees of independence from a generally weak and disinterested English crown. An examination of several important seventeenth-century English printed maps of the New World provides another way to evaluate these theses. It is now well known through the work of J. B. Harley, David Woodward, and others that early modern maps were not value free and innocent. Despite their claims to scientific accuracy through the development of new cartographical techniques and greater knowledge of the world, maps were laden with political and ideological messages. Through various rhetorical and semiotic devices and careful omissions (or "silences"), artists could convey the desired official view of the territories in question, which turned maps into political tools of the sovereign authority for whom the mapmaker worked. The relationship between central authority and the peripheries over which that authority was exercised was an important part of this message. In Christopher Saxton's famous English county atlas of 1579, for example, explicit messages of central authority were evident through the presence on the maps of royal coats of arms, distinct national symbols, and traditional English toponyms. This made clear, as Richard Helgerson has pointed out, the relationship of royal power to the land depicted on the maps: "Not only are these the queen's maps; this is the queen's land, her kingdom." Even in those peripheral regions of England where there was little central intrusion, on Saxton's maps the authority of local magnates was almost entirely elided in favor of expressions of central authority.[3]

the British Empire (Oxford, 1998); Jack M. Sosin, *English America and the Restoration Monarchy of Charles II: Transatlantic Politics, Commerce, and Kinship* (Lincoln, Nebr., 1980); and Stephen Saunders Webb, *1676: The End of American Independence* (New York, 1984).

3. J. B. Harley, "Meaning and Ambiguity in Tudor Cartography," in Sarah Tyacke, ed., *English Map-Making, 1500–1650: Historical Essays* (London, 1983), 22–45. Many of Harley's writings have been collected in Harley, *The New Nature of Maps: Essays in the History of Cartography*, ed. Paul Laxton (Baltimore, 2001). See also Harley and David Woodward, "Concluding Remarks," in Harley and Woodward, eds., *Cartography in Prehistoric, Ancient, and Medieval Europe and the Mediterranean*, vol. I of *The History of Cartography* (Chicago, 1987), 506. On English maps, see Peter Barber, "England II: Monarchs, Ministers, and Maps, 1550–1625," in David Buisseret, ed., *Monarchs, Ministers, and Maps: The Emergence of Cartography as a Tool of Government in Early Modern Europe* (Chicago, 1992), esp. 62–77; Andrew Gordon and Bernhard Klein, *Literature, Mapping, and the Politics of Space in Early Modern Britain* (Cambridge, 2001). On Saxton's atlas,

Whereas Saxton's atlas depicted lands that were local and familiar, those of America showed lands distant and foreign. Royal authority over territorial England was long uncontested, and symbols of such authority were largely conventional. Imposing that authority on maps of contested regions in North America, however, was a powerful political message. In comparison to English county maps, the potency of the center-periphery relationship in maps depicting America, far from being attenuated by distance and the inability or unwillingness to exert authority, was instead accentuated. Regardless of the lack of on-the-ground imperial oversight, it was essential that published maps showing the territories settled by the English in America demonstrated both the *imperium* (absolute sovereignty) and the *dominium* (territorial possession) of the English crown. Historically and legally, the crown was the central body that exercised authority over all aspects of the British composite monarchy. These messages had to be communicated both to foreign and domestic audiences so that other competing colonizers would recognize the legal claim of England to overseas territories. As a consequence of the need to demonstrate mastery over settled regions of, and the continued authority of the imperial center over, America, there are few indications on the maps of peripheral independence from the center. At least from the perspective of certain metropolitan artists, what emerges is a picture of central authority and territorial hegemony over Anglo-American peripheries. Regardless of how laissez-faire and negotiated this relationship was in reality, little of this attenuation was to be found on early English maps of America.

KNOWLEDGE AND MASTERY

Perhaps the best-known example of a center-periphery message imposing itself on maps is found in the transition from the medieval *T-O mappa mundi* to the early modern Mercator projection. The former depicted the known world within an *O* and placed Jerusalem and Italy at its center, with Africa, Asia, and Europe—the three Old World continents—along the *T*. Befitting its role as the heart of Christendom, the region of the Holy Land and Holy See was the physical center of the world, which was emphasized by the orientation of east at the top. The discovery of the New World in the fifteenth century, together with the rise of independent nation-states and the advent of a more scientific approach to cartography in the sixteenth century, changed this model. Through careful projection, an orientation placing north at the top, and the addition of the New World on the map, in 1569 Dutch mapmaker

see Richard Helgerson, *Forms of Nationhood: The Elizabethan Writing of England* (Chicago, 1992), 107–114 (quotation on 111).

Gerard Mercator placed Western Europe at the center of the world. In doing so, the ancient world centers were reduced physically and ideologically in stature. By deliberately placing the equator well below the midpoint on the map surface and exaggerating the space between latitude lines in the Northern Hemisphere, Mercator increased the relative size of Northern Europe, the North Atlantic, and North America, the latter a vast arena for extensions of sovereignty and possession. This message contrasted with that currently being communicated by the Iberian countries (Spain and Portugal) and the Roman Catholic Pope, who assumed overlordship of all terra incognita through the papal bull *Inter Caetera* (1493) and the Treaty of Tordesillas (1494).[4]

Mercator's projection quickly became the leading cartographical model for world maps. It was employed, for example, by Edward Wright in his world map used to illustrate Richard Hakluyt's *Principall Navigations, Voiages, Traffiques, and Discoveries of the English Nation* (1598–1600, Figure 1). Unlike most other cartographers of the day, including Mercator and his equally famous contemporary Abraham Ortelius, Wright chose not to speculate about geographical information that was not yet known. Rather than complete the coastlines of the largely unexplored north and west parts of North America, Wright left these areas blank. This deliberate elision served two significant functions. First, it gave a stronger impression of the correctness of Wright's map, which also implied that the centrality of Europe in the world was a geographical fact rather than a cartographical fiction. Second, perhaps in order to fill the blank spaces created by limited knowledge, Wright placed a large and elaborate Tudor coat of arms in the empty region of North America. Not content merely to draw the standard shield, crown, and garter of the royal arms, Wright also included the lion and dragon heraldic supporters and the royal motto "Dieu et mon droit" (God and my right) within a large, decorated banner. Readers of Hakluyt's internationally renowned collection would not only gain the same impression of European centrality over the American peripheries communicated in Mercator's projection; they would also see the poten-

4. In Mercator's 1569 map, *Nova et Aucta Orbis Terrae Descriptio ad Usum Navigantium*, North America appears to cover approximately twice the land area as Africa. In fact, however, Africa (11.7 million square miles) covers nearly 20 percent more area than North America (9.5 million), a situation that the Peters projection, named for the German historian and journalist Arno Peters, attempted to rectify in 1973. On the bull and exclusive Spanish and Catholic claims to America, see MacMillan, *Sovereignty and Possession*, chaps. 2–3; James Muldoon, *The Americas in the Spanish World Order: The Justification for Conquest in the Seventeenth Century* (Philadelphia, 1994), especially chaps. 5–7; and Anthony Pagden, *Lords of All the World: Ideologies of Empire in Spain, Britain, and France, c. 1500–c. 1800* (New Haven, Conn., 1995), chap. 2.

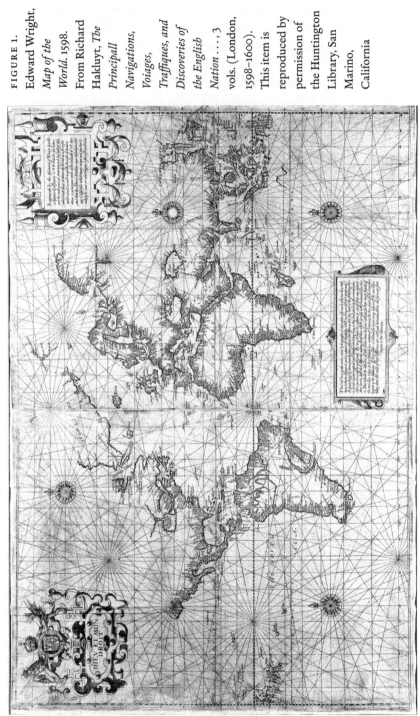

tial of English dominium and imperium in North America when these activities were barely under way.[5]

Although Mercator's and Wright's maps could demonstrate the potential of European and English colonization by emphasizing a new center-periphery relationship, their sheer geographical scope could less successfully portray actual activity in, and knowledge of, America. Perhaps this is why, especially in the first few decades of English settlement in America, most English-drawn maps focused on portions of individual colonies rather than on vast parts of the New World. One of the earliest such printed maps appeared in Theodore de Bry's popular edition of Thomas Hariot's *Briefe and True Report of the New Found Land of Virginia* (1590, Figure 2). De Bry represented the region of present-day Virginia and North Carolina from the mouth of the Chesapeake Bay south to Pamlico Sound. Better known to contemporaries and historians are the *Virginia* and *New England* maps of John Smith. The *Virginia* map, covering the region surrounding the Chesapeake Bay and the new colony of Jamestown, was folded into Smith's pamphlet entitled *A Map of Virginia* (1612, Figure 3). The popularity of this map led to the production of several derivatives, most notably Sir Thomas Cecil's commissioned map of Maryland (1635) and Ralph Hall's and John Farrer's maps of Virginia (1635 and 1651). Smith's *New England* map, published with *A Description of New England* (1616, Figure 4), shows the region of present-day Cape Cod in Massachusetts northward to Maine. John Mason's map of Newfoundland, which appeared in the work of Sir William Vaughan (1625–1630, Figure 5), focused on the island of Newfoundland itself. Significantly, most of these maps appeared in print several times, in various editions and languages, throughout the seventeenth century, which ensured wide distribution to both domestic and foreign audiences.[6]

5. Ortelius's map is the *Typus Orbis Terrarum*, which appeared in his 1570 atlas *Theatrum Orbis Terrarum*; see Lucia Nuti, "The World Map as an Emblem: Abraham Ortelius and the Stoic Contemplation," *Imago Mundi*, LV (2003), 38–55. On Wright's projection, see Lesley B. Cormack, *Charting an Empire: Geography at the English Universities, 1580–1620* (Chicago, 1997), 7–10.

6. Cecil's map appeared in Thomas Cecil, *A Relation of Maryland; Together, with a Map of the Countrey* ... (London, 1635). Hall's map is in several editions of Michael Sparke and Samuel Cartwright, *Historia Mundi; or, Mercator's Atlas* ... (London, 1635). Farrer's map is in the third edition of Edward William, *Virgo Triumphans; or, Virginia Richly and Truly Valued* ... (London, 1651). John Smith's *Virginia* and *New England* appeared in his popular *Generall Historie of Virginia, New-England, and the Summer Isles* ... (London, 1624). His *New England* also appeared in his *Advertisements for the Unexperienced Planters of New England, or Any Where* (London, 1631). Various states and deriva-

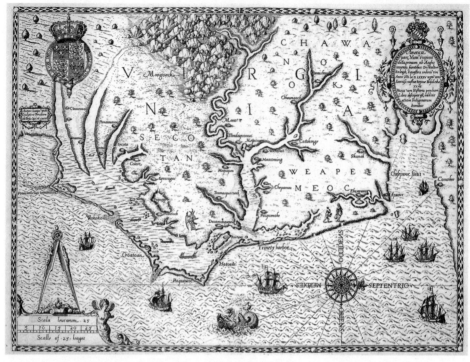

FIGURE 2. Theodore de Bry, *Americae Pars, Nunc Virginia Dicta, Primum ab Anglis Inventa*. . . . From Thomas Hariot, *A Briefe and True Report of the New Found Land of Virginia* . . . (Frankfort on the Main, 1590). This item is reproduced by permission of the Huntington Library, San Marino, California

With the exception of Mason's map of Newfoundland, which had easily defined boundaries, none of these maps depicted the entirety of the imperial claim as initially set out in the colonial charters. The geographical extent of Sir Walter Ralegh's patent for North America was broadly defined as "such re-

tives of *Virginia* were placed into Samuel Purchas, *Hakluytus Posthumus* . . . (London, 1625), the atlases of Johann Theodore de Bry (the son of Theodore de Bry) and Gerard Mercator the younger, and Levinus Hulsius's German translation of Smith's *Description of New England* . . . (London, 1616) *(Viertzehende Schiffart, oder, Gründliche und warhaffte Beschreibung dess Neuwen Engellandts einer Landschafft in Nordt Indien eines Theils in America unter dem Capitein Johann Schmidt* . . . [Franckfurt am Mayn, 1617]). Mason's map appeared in William Vaughan, *Cambrensium Caroleia* . . . (London, 1625) and Vaughan, *The Golden Fleece* . . . (London, 1626). See also Coolie Verner, *Smith's "Virginia" and Its Derivatives: A Carto-Bibliographical Study of the Diffusion of Geographical Knowledge* (London, 1967); and Fabian O'Dea, *The 17th Century Cartography of Newfoundland* (Toronto, 1971).

FIGURE 3. John Smith, *Virginia*. From John Smith, *A Map of Virginia*
(London, 1612). This item is reproduced by permission of the Huntington
Library, San Marino, California

mote, heathen and barbarous lands . . . not actually possessed of any Christian
Prince, nor inhabited by Christian People." By 1590, when de Bry's map was
printed, the general lack of European settlement north of Florida meant that
the English claim was potentially considerable, yet he portrayed only the re-
gion from 35° to 38° north latitude, at the bottom center of which (because the
map is oriented with west at the top) is shown Roanoke Island. Likewise, the
Virginia Company patent of 1606 awarded all land between 34° and 45°, yet,
instead of depicting this region of eastern North America, Smith's *Virginia*
(and its derivatives) shows only the portion from roughly 37° to 41°. Whereas
the New England patent of 1620 awarded North America from 40° to 48° from
"sea to sea," Smith's *New England* shows only the eastern coast between 41° and
44°. Why, at a time when the English crown was seeking to define and defend
vast New World territories against the competing claims of other European
colonizing powers, did these mapmakers show significantly smaller portions

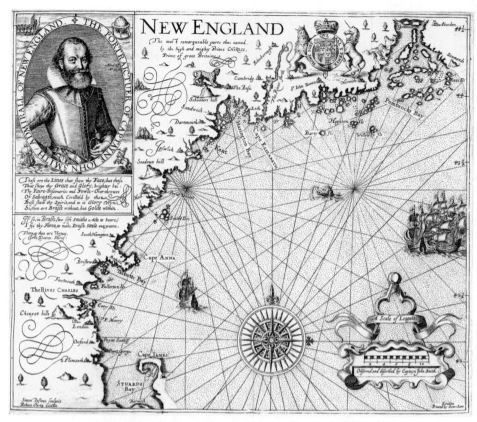

FIGURE 4. John Smith, *New England*. From John Smith, *A Description of New England* ... (London, 1616). This item is reproduced by permission of the Huntington Library, San Marino, California

of the North American peripheries than were claimed within the royal grants that brought these colonies into existence?[7]

One answer to this question lies in the delineation of the three concentric

7. Charter to Sir Walter Ralegh, Mar. 25, 1584, in Henry Steele Commager and Milton Cantor, eds., *Documents of American History*, I, *To 1898*, 10th ed. (Englewood Cliffs, N.J., 1988), 6. I propose one answer to this question in *Sovereignty and Possession*, chap. 5, where I argue that the crown's policy of secrecy regarding the precise location of its New World colonies, initiated by a desire to prevent other Europeans from gaining too much intelligence, inhibited the production of maps depicting larger regions. Another answer, based around the limited skill English cartographers brought to their task, is offered in Benjamin Schmidt, "Mapping an Empire: Cartographic and Colonial Rivalry in Seventeenth-Century Dutch and English North America," *William and Mary Quarterly*, 3d Ser., LIV (1997), 563–564.

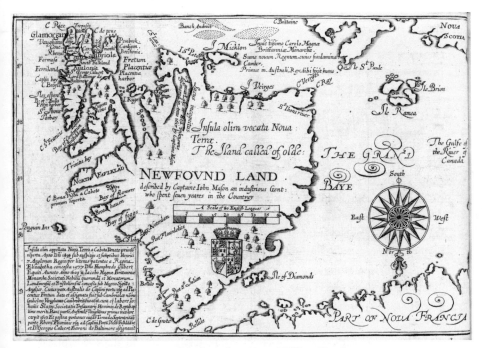

FIGURE 5. John Mason, *Newfound Land*. . . . From William Vaughan,
The Golden Fleece . . . (London, 1626). This item is reproduced by permission
of the Huntington Library, San Marino, California

zones recognized in center-periphery literature. The first is the zone of mas-
tery, or *ecumene,* the area over which European settlers, in this case English
colonists, successfully demonstrated effective occupation. An ecumene was
sufficiently settled and defended by the crown and its colonists to ensure nu-
merical, political, and sovereign supremacy in the region. When called upon
to do so, the settlers had the ability to defend the territory from potential
usurpation, which in the case of the American colonies was a tangible threat
from Dutch, French, and Spanish subjects throughout the seventeenth cen-
tury. Beyond the ecumene was a second and larger area, the zone of marginal-
ity. This was the *frontier,* where English central authority was only loosely
asserted, partly because limited settlement and weak defensive capabilities
decried mastery. Provided that other Europeans (foreign and domestic) did
not attempt actual settlement within regions granted by royal charter, there
was little effort made to control the region from interpenetration by visitors
who were there especially for the purposes of trade and commerce. The third
area was the zone of exchange, a *transfrontier* or "middle ground," which was
much larger than the previous zones and where there was European influ-

ence, particularly with regard to interaction with natives, but no real desire or ability to exercise authority. This zone was, in effect, beyond empire because the imperial claim, however it might have been defined in charters, was, in practice, too large to be defended physically, legally, or ideologically.[8]

De Bry, Smith, Mason, and the others depicted the central ecumenes and occasionally their surrounding frontiers, but not the peripheral trans-frontiers, even if the latter were technically part of the imperial claim. By focusing their maps on those regions where the English could legitimately demonstrate dominium, rather than showing the amorphous and ambiguous transfrontier over which a merely theoretical claim existed, these artists could show established English colonies and uncontestable mastery over those heavily populated areas where actual activity was taking place. These were the lands that the English colonists had specific knowledge of through the various reconnaissance voyages or colonizing efforts of men such as Philip Amadas, Arthur Barlowe, Humphrey Gilbert, Bartholomew Gosnold, Richard Gren-ville, Ralph Lane, George Weymouth, John White (who provided manuscript maps for de Bry's rendition), and John Mason and John Smith themselves. The artists could communicate personal knowledge of, and the perception of mas-tery over, those lands actually discovered and settled. Significantly, mirroring the language of the papal grant *Inter Caetera ("ex certa scientia"),* the English monarchs in their charters cited having "certain knowledge" when claiming parcels of land in North America. Because it was acquired through physical New World activity, this knowledge, as it was subsequently represented on maps, implied a right to settle and rule territory known by English travail. On the other hand, the Iberian nations could not communicate such messages of

8. These zones are described in Daniels and Kennedy, eds., *Negotiated Empires,* 2–3, 18–19, although I have taken certain liberties with their application. On Anglo-European challenges, see MacMillan, *Sovereignty and Possession,* chaps. 4 and 6; Eliza-beth Mancke, "Empire and State," in David Armitage and Michael J. Braddick, eds., *The British Atlantic World, 1500–1800* (New York, 2002), 175–195; and Mancke, "Nego-tiating an Empire: Britain and Its Overseas Peripheries, c. 1550–1780," in Daniels and Kennedy, eds., *Negotiated Empires,* 235–265. An excellent example of English concerns over foreign settlement within chartered limits is the Virginia Company's commis-sioning of Captain Samuel Argall to seek out and destroy other European settlements, which resulted in the razing of French colonies in Maine and Nova Scotia in 1613. On the other hand, the English generally overlooked Dutch and other French activities in mainland North America that involved the placement of transient trading posts in-stead of actual settlement. The idea of a "middle ground" was introduced by Richard White in the important *The Middle Ground: Indians, Empire, and Republics in the Great Lakes Region, 1650–1815* (Cambridge, 1991).

mastery over ecumenes and frontiers in their maps, because they held insufficient personal knowledge of the vast regions claimed under *Inter Caetera* and the Treaty of Tordesillas. Thus, by showing small portions of discovered and settled lands, the English artists could communicate effective occupation that the Iberians, regardless of their preemptive claims to the entirety of the New World, could not show.[9]

In Smith's *Virginia*, for example, knowledge and mastery of the region surrounding Jamestown is indicated through ample trees, hills, and rivers, showing detailed personal awareness of the local landscape. This message is accentuated by the representation of ten native tribes, 166 native villages, two dozen "Kings howses," and the placement of various crosses, beyond which are shown frontiers voluntarily described by the natives for the benefit of Smith and the English colonists. Not only do these semiotic devices attest to territorial mastery over the ecumene and further knowledge of the surrounding frontier, they also suggest that the many natives within this region (including, as Smith terms them, various "inferiour kings") have come under the control of the English. The overall message of this map and its derivatives— and no less so the maps of de Bry and Mason as well as Smith's *New England* and, to consider another, Richard Norwood's famous and widely distributed *Mapp of the Sommer Ilands Once Called the Bermudas* (1622)—was of undeniable English control over the depicted regions. Similarly powerful as signs of mastery are two of Smith's maps printed in his *Generall Historie of Virginia, New-England, and the Summer Isles* (1624). The first shows "Old Virginia," Ralegh's region of Roanoke, surrounded by five images of Smith's capture by the Powhatans. Smith's eventual release at the behest of Princess Pocahontas emphasizes, like *Virginia*, the Anglo-native symbiosis and centralized English authority that has occurred in the ecumene and frontier. The second map, depicting Bermuda, includes marginal drawings, cross-referenced by letter, of a

9. Although this was not the message communicated in the maps, any pretense to knowledge or mastery by force of numbers or arms was a fiction. In fact, no region of North America was established and heavily populated by the English before 1640. Alison Games estimates in *Migration and the Origins of the English Atlantic World* (Cambridge, Mass., 1999) that the English New World population was 9,500 in 1630 and, following the "Great Migration," 53,700 in 1640. On English explorations, see Andrews, *Trade, Plunder, and Settlement,* and the relevant volumes published by the Hakluyt Society, especially those edited by David B. Quinn. On English and Iberian distinctive methods, see Patricia Seed, "Taking Possession and Reading Texts: Establishing the Authority of Overseas Empires," *WMQ,* 3d Ser., XLIX (1992), 183–209; and John T. Juricek, "English Territorial Claims in North America under Elizabeth and the Early Stuarts," *Terrae Incognitae,* VII (1975), 7–22.

dozen heavily mounted fortifications placed around the island group, thereby emphasizing the ability of the English to retain mastery over the region.[10]

Even if the English wished to declare imperial mastery over greater regions than were shown on these maps, it would have been difficult to include sufficient rhetorical devices to show the necessary level of control. Had Smith and the others shown the entire portion encompassed within the royal patents, such as, in the case of New England, the portion of North America between 40° and 48° "from sea to sea," or of the entire continent, these messages would have been diminished to the point where the ecumene was a mere speck and the entire claim little more than a highly disputable, mentally divined transfrontier. Henry Briggs's map of North America, for example, which appeared in Samuel Purchas's *Hakluytus Posthumus; or, Purchas His Pilgrimes* (1625), though still serving certain functions by depicting, like Wright's map, the potential of the English empire in North America, could not adequately describe English zones of mastery. This map would have little utility in attempts to demonstrate dominium over substantial portions of North America. However, by centering the maps on the areas of actual settlement, showing the ecumenes and parcels of frontiers where dominium was established (over both land and natives), rather than showing the outlying peripheries where this message could not be communicated, the artists made a claim on behalf of the English crown to effective occupation of the depicted regions. When the various maps were seen by the same viewer, the existence of so many ecumenes gave the false but politically valuable impression of a large English empire in America.

Moreover, in depicting ecumenes and immediate frontiers while eliding the existence of outlying peripheries, the artists gave the colonies the appearance of numerous well-established islands, even though in fact most of the colonies were attached to mainland North America. This message, which through careful shading, detailing, and perspective was also communicated in the county atlases of William Camden, Michael Drayton, Christopher Sax-

10. John Smith, *A Map of Virginia; with a Description of the Countrey, the Commodities, People, Government, and Religion* . . . (Oxford, 1612), 36; Smith, *Generall Historie*, plates between 20–21 and 168–169. On the subject of Smith's map as a depiction of knowledge and mastery, see Lisa Blansett, "John Smith Maps Virginia: Knowledge, Rhetoric, and Politics," in Robert Appelbaum and John Wood Sweet, eds., *Envisioning an English Empire: Jamestown and the Making of the North Atlantic World* (Philadelphia, 2005), 68–91. Norwood's map also appeared in various versions of John Speed's *Prospect of the Most Famous Parts of the World* . . . (London, 1626) and became the standard map of Bermuda throughout the seventeenth century. See Margaret Palmer, *The Printed Maps of Bermuda* (London, 1965).

ton, and John Speed, could have had a significant impact on English viewers. Images of islands were visually appealing, instilled nationalistic sentiment, and reflected an ideologically defined center-periphery relationship between the macrocosmic "mother" island of Albion and the microcosmic "dependent" territories throughout the emerging Atlantic world. It was, perhaps, for similarly analogous reasons that many authors of utopian literature of the Tudor and Stuart period—Thomas More in *Utopia* (1516), Francis Bacon in *New Atlantis* (1626), and Henry Neville in *The Isle of Pines* (1668), for instance—used islands as the location of their fictional societies. More even included in his work a detailed map of the heavily settled island of Utopia, over which mastery had clearly been established.[11]

SEMIOTIC AND RHETORICAL DEVICES

In addition to detailing those colonial settlements over which mastery had been achieved, de Bry, Smith, Mason, and the others were conscious of the need to show the central authority that united the disparate colonies under a single, recognized, European imperial crown. In aid of this goal, one common feature on New World maps was the presence of the royal coat of arms. De Bry included the Tudor shield and garter surmounted by the royal crown, prominently displayed on the top left corner of his map. Smith's *Virginia* depicts the new Stuart arms centered at the top of the image, and Mason places the same arms on the island of Newfoundland. Lest there be any confusion over jurisdiction, Mason indicates that the region is under the control of "invictissimo Carolo Magnae Brittanniae Monarchae"—"mighty Charles, King of Great Britain." More elaborate arms are present on Smith's *New England,* which are surrounded by the lion and unicorn heraldic supporters. In Ralph Hall's derivative map of Virginia, the arms are surrounded, not by traditional supporters, but instead by the letters *C* and *R,* or "Carolus Rex," King Charles. More prominent still are the royal arms drawn on an early state of Cecil's map of Baltimore. Taking up nearly one-sixth of the map surface, the royal arms contain not only the standard shield, garter, and crown but also England's royal motto ("Dieu et mon droit") and an armorial helmet, all crested by an imperially crowned lion, whose role is to stand guard over the entire imperial

11. On the work of other artists, see Helgerson, *Forms of Nationhood,* 116–119. April Lee Hatfield has demonstrated in *Atlantic Virginia: Intercolonial Relations in the Seventeenth Century* (Philadelphia, 2004), 219–220, that Virginia was often referred to as an island by contemporaries who were well aware of North American geography. On the utopian texts and the island analogy, see Susan Bruce, ed., *Three Early Modern Utopias* (Oxford, 1999).

monarchy. Here, Edward III's famous utterance, emblazoned on the garter portion of the royal coat of arms—"Honi soit qui mal y pense," or, "Shame on him who thinks evil of it"—attains an intriguing New World significance. All of these coats of arms are located, not simply on a convenient location on the map surfaces, but on the landmass being depicted, thereby emphasizing royal authority over the ecumene, the zone over which mastery is being asserted. As in Saxton's county maps, the message is clear: this is the crown's land, ultimately controlled, not by trading companies, proprietors, and colonial assemblies, but by the imperial center.[12]

A second common feature on these drawings is the presence of national symbols, such as textual cartouches, English flags, and aristocratic arms. In de Bry's map, for example, the royal coat of arms is visually balanced by an oval cartouche, on the top of which rests Sir Walter Ralegh's arms. Within the oval, Latin text indicates the depicted territory was discovered by Ralegh in 1585, under the lawful authority of Elizabeth I. Likewise, in his map of Virginia and surrounding area, John Farrer, mistakenly assuming that the Pacific Ocean could be accessed in "ten days' march" from Jamestown, included in his drawing a picture of Sir Francis Drake and a brief account of his taking possession of Nova Albion (California / Oregon) for Queen Elizabeth. Also prominent on the de Bry and Farrer maps are English merchant ships, some of which are flying the national flag of Saint George, the English ensign (which has a red cross on a white background). Certain states of both Smith's *Virginia* and *New England* maps contain Smith's arms, and the latter map, in particular, shows a flotilla of eight ships, all flying the ensign, arriving from the east, presumably England. On the map of Maryland, Lord Baltimore's arms—though appropriately less prominent than the royal arms—are displayed. On Mason's map of Newfoundland, a plain but lengthy Latin cartouche recites the history of the colony, beginning with John Cabot in 1497 and ending with seventeenth-century patentees; all of these men, Mason assures his viewers, were authorized to undertake their activity in the region by a royal letter patent under the Great Seal of England. In explaining the royal authority under which these colonies were established—which was emphasized through display of the English ensign—and the activities, patronage, and governance of colonial

12. The unicorn, a traditional symbol of strength and honor in Scotland, replaced the dragon supporter of the Tudor arms after the "British" union of 1603. The traditional imperial crown worn by independent European sovereigns is closed, symbolically depicting hegemonic control over an empire. It was first used in England in 1488, after Henry VII "reunited" medieval "Britain" (David Armitage, *The Ideological Origins of the British Empire* [Cambridge, 2000], 34.)

agents who were members of the aristocracy, and thus deputies of the crown, these various national symbols further demonstrated the continued relationship between the imperial center and colonial peripheries.[13]

A third common feature on these maps is the presence of royal, aristocratic, and traditional British toponyms. Emblazoned across the maps of de Bry, Smith, and its derivatives is the eponymic "Virginia," named after Elizabeth I. Other seventeenth-century colonial regions were also named for monarchs or their close relations and would be represented on maps. These included the first permanent colony in America, Jamestown in 1607, for James I; Maryland in 1632 for Charles I's queen, Henrietta Maria; Carolina in 1663 for Charles II; and New York in 1667 for the duke of York and Albany, the future James II. The most obvious act of toponymic homage was Smith's naming of New England, for what demonstrated imperial control over the ecumene more than a name reflecting that of the mother country? At this time, various European maps already showed New France, New Spain, and New Netherlands. The creation of New England on the map was, therefore, consistent with European conventions and could better lead to recognition of English claims to sovereignty and possession.[14]

This renaming also began the systematic eradication of native place-names. Whereas numerous native names will be found in de Bry's map, and English names will be found alongside native names on Smith's *Virginia*, most native names were thereafter deliberately removed from maps. After the preparation of his *New England*, Smith sent a manuscript copy to the fifteen-year-old Prince Charles, which included native names for key places along the coast. "My humble sute is," Smith wrote to Charles, "you would please to change their Barbarous [Indian] names, for such English, as Posterity may say, Prince Charles was their Godfather." After Charles completed this task, Smith had another engraving of the map made, including a notation that "the most remarkable parts [are] thus named by the high and mighty Prince Charles, Prince of Great Britain." The new map, now devoid of native names, contained various royal toponyms such as Cape James for the prince's father; Cape Anna for his mother, Anna of Denmark; Cape Elizabeth for his sister;

13. John Farrer, *A Mapp of Virginia Discovered to ye Hills,* in Edward Williams, *Virgo Triumphans; or, Virginia Richly and Truly Valued . . .,* 3d ed. (London, 1651). On the importance of some of these devices, see G. N. G. Clarke, "Taking Possession: The Cartouche as Cultural Text in Eighteenth-Century American Maps," *Word and Image,* IV (1988), 455–474.

14. On the importance of such naming conventions to international disputes, see Schmidt, "Mapping an Empire," *WMQ,* 3d Ser., LIV (1997), 550–562.

Charles River for himself; and Stuart's Bay for the ruling dynasty. Others of Charles's toponyms also emulated those of Albion: Bristol, Cambridge, Dartmouth, London, Oxford, Plymouth, and even Aberdeen and Edinburgh, a homage to the royal family's Scottish heritage. These were clear references to the continuing influence of the central mother country on the peripheral colonies.[15]

Although few of Charles's place-names would survive into the eighteenth century, this form of renaming became a common feature on subsequent maps. On Norwood's 1622 map of Bermuda will be found the names of various aristocratic English "tribes," including those of Hamilton, Pembroke, Sandys, Smith, Somerset, Southampton, and Warwick, and some islands, such as Saint George's, which, appropriate to its being named after the patron saint of England, was the seat of Bermudian government. Mason's map of Newfoundland includes dozens of settlements with distinctive English and Welsh toponyms, such as Cardigan, Ferryland, and Pembroke, and regions named after the principal patentees, Baltimore (after George Calvert), North Falkland (after Henry Cary, viscount Falkland), and Vaughan's Cove (after Sir William Vaughan). The renaming of New World settlements implied that the English settlers, on behalf of the crown and patentees, had clearly established mastery over the ecumene, an important political and perhaps military message for foreign audiences viewing the maps. Just as the taking away of native names is a deliberate act of dispossession, so, too, is the giving of familiar, domestic, and royal or aristocratic names a deliberate act of sovereignty and possession, one that was mirrored by all European colonizing powers.

Like on Saxton's county maps, the cumulative effect of these various semiotic and rhetorical devices—royal and aristocratic arms, national symbols, and "British" toponyms—was to give an impression of continued central control over these disparate colonial peripheries. The regions depicted were joined by a common cultural, ideological, and political entity, the English crown, while representations of local magnate, legislative, and trading-company authority are largely omitted. The title page of John Smith's *Generall Historie* (Figure 6) provides a preeminent example of this broader message. At the top of the image, Smith has shown the regions from "Old Virginia," the North Carolina Outer Banks, north to "Virginia Now Planted," where the Virginia Company settled, and farther north to "New England." Placed directly on top of these

15. J. B. Harley, "New England Cartography and the Native Americans," in Harley, *New Nature of Maps,* ed. Laxton, chap. 6; Smith, *Description of New England,* sig. 2r; Smith, *Generall Historie,* plate between 202–203. In states of the map published after 1625, the phrase "Prince of Great Britain" is replaced with "now King of Great Britain."

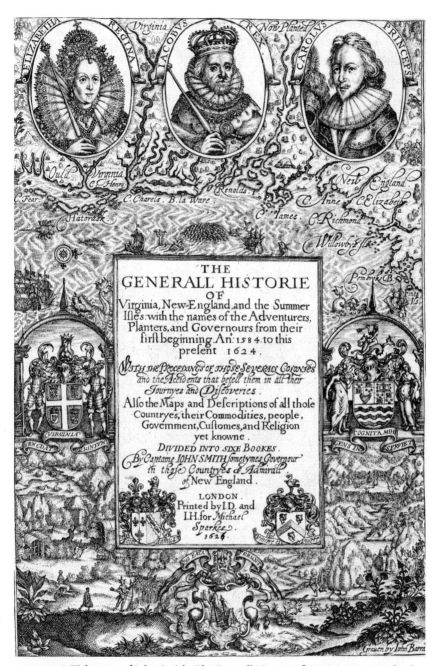

FIGURE 6. Title page of John Smith, *The Generall Historie of Virginia, New-England, and the Summer Isles . . .* (London, 1624). This item is reproduced by permission of the Huntington Library, San Marino, California

three regions are regal images of, respectively, Elizabeth I, James I (both of whom are shown in crown and scepter), and Prince Charles, the three royal personages most directly responsible for the establishment of the English empire in America. There could be little doubt to the audiences of Smith's often-printed work that the imperial center, the exclusive holder of imperium in England, remained firmly in control of the colonial peripheries and that the ecumenes thrived under this English sovereignty and royal patronage.

This message of imperial hegemony and continued overlordship was not merely self-aggrandizing. According to certain nascent principles of supranational law at the time, demonstrating that land was merely under effective occupation of Europeans (dominium) through displays of territorial knowledge and mastery, though important, was insufficient to establish a complete legal claim. In order to gain a virtually unassailable right to the land by the laws of nature and nations *(ius naturae et gentium)*—which declared that no land could exist outside a state of sovereignty (a principle sometimes used to justify the dispossession of native peoples)—it was necessary to prove that the land was under the sovereignty of a Christian prince who held imperium, or the right to rule territory. Importantly, between 1604 and 1667, the English crown managed through various treaty negotiations with France, the Netherlands, Portugal, and Spain to gain international recognition for its colonial holdings in America. Although the extent to which maps played a role in these negotiations is unclear, these concessions were based largely on England's right to hold imperium and dominium in the New World using the legal principles of effective settlement of territory and continued imperial control. In these various negotiations, the English often pointed out that other monarchs had not demonstrated sufficient levels of sovereignty and authority to justify their right to territory, which rendered their claims in America incomplete and subject to challenge. As we have seen, these were the key messages that the popular and internationally distributed English maps of America, through their displays of mastery over various colonial ecumenes and a continued center-periphery relationship between the crown and colonies, succeeded in communicating.[16]

16. For relevant laws of territorial possession, see Justinian on the "Acquisition of ownership of things" in the *Digest,* one part of the *Corpus Iuris Civilis,* the "body of civil law" (Justinian, *Digest,* Latin text ed. Theodor Mommsen, English translation ed. Alan Watson [Philadelphia, 1985], chap. 41). On imperium, see Pagden, *Lords of all the World,* chap. 1; and Armitage, *Ideological Origins,* 29–36. The treaties of greatest relevance are the Anglo-Spanish Treaty of London (1604), the Anglo-French Treaty of Saint Germain-en-Laye (1632), the Anglo-Dutch Treaty of Breda (1667), the Anglo-

Explicit messages of territorial mastery and central imperial oversight continued to be effectively transmitted in maps toward the end of the first century of colonial activities. As numerous historians have pointed out, it was only under Charles II (1660–1685) that the crown took active interest in colonial governance. After several false starts between 1622 and 1675, the Committee for Trade and Plantations was established to oversee the wider empire, which quickly came under the control of the formidable William Blathwayt. Among Blathwayt's achievements as imperial secretary was his amassing, between 1675 and 1685, of forty-eight manuscript and printed maps of the English overseas empire, a collection known to historians as the *Blathwayt Atlas*. Of the nineteen printed maps of English origin in the collection, we are already familiar with two: a later version of Wright's 1599 Mercator projection and John Farrer's 1651 Virginia map. Most of the printed maps are extracted from the atlases of contemporary artists John Seller (the English royal hydrographer), his business partner, John Thornton, and their associates. Consistent with modern conventions, and because many of these maps were printed from plates designed by Dutch masters such as Willem Blaeu, Johannes Jansson, and Nicolas Visscher, these maps are generally of superior cartographical quality to their predecessors. Prepared more for the use of ship's pilots than the general public, they contain more navigational and hydrographical details, including compass roses, sandbars, rock shoals, and latitude and longitude references.[17]

The "accuracy" of these maps is accentuated by the greater amount of land

Portuguese Treaty of Westminster (1654), and the Anglo-Spanish Treaty of Madrid (1667). On these treaties and the legal arguments involved in the negotiations, see MacMillan, *Sovereignty and Possession*, chap. 6; and Frances G. Davenport, ed., *European Treaties Bearing on the History of the United States and Its Dependencies*, 4 vols. (Gloucester, Mass., 1967), I, 315–323, II, 31–35, 94–109, 119–142.

17. Stephen Saunders Webb, "William Blathwayt, Imperial Fixer: From Popish Plot to Glorious Revolution," *WMQ*, 3d Ser., XXV (1968), 3–21; and Webb, "William Blathwayt, Imperial Fixer: Muddling through to Empire, 1689–1717," ibid., XXVI (1969), 373–415. The atlas was retained by Blathwayt when he left the secretaryship in 1696 and is now in the John Carter Brown Library; see Jeannette Black, "The Blathwayt Atlas: Maps Used by British Colonial Administrators in the Time of Charles II," *Imago Mundi*, XXII (1968), 20–29; and Black, ed., *The Blathwayt Atlas . . .* , 2 vols. (Providence, R.I., 1970–1975). John Seller and John Thornton are best known for the four-volume *English Pilot* (1671–1689) and the *Atlas Maritimus* (1672). Other printed English maps in the *Blathwayt Atlas* were prepared or distributed by William Berry, Philip Lea, and Robert Morden. See Black, ed., *Blathwayt Atlas*, II.

depicted. By the time the *Atlas* was being compiled, much more was known about the eastern coast of North America and the West Indies through additional English reconnaissance, chartering, and settlement. Whereas the English empire in America before midcentury was tightly localized in a few colonial centers in Bermuda, New England, Newfoundland, Maryland, and Virginia—which were not easily represented together on maps without showing vast regions beyond empire—thereafter additional colonies were founded in Carolina, New Jersey, New York, and Pennsylvania, not to mention various Caribbean colonies, such as Jamaica. By essentially completing the late-sixteenth-century project of placing English settlements between Greenland and Guiana, the ecumenes were larger and more numerous, and the maps could represent greater geographical regions while still emphasizing territorial mastery. In comparison, for example, to the limited detail that could be shown on the eastern North American portion of Wright's world map, John Thornton's version of 1683, which appeared as the first map in the *Atlas,* lists dozens of colonies, capes, and rivers that were known and named by the English. This message of English mastery over large portions of America and the West Indies was even better communicated in several more maps within the *Atlas,* each of which—though still privileging certain regions over others—depict four or more colonies without showing areas outside the frontier concentric zone. Whereas earlier maps showing the same area, regardless of whether the region was part of a royal charter, would have portrayed mostly unknown and amorphous transfrontiers, by the 1680s maps could depict numerous zones of mastery and frontier. These later maps offered a more complete, holistic, and interdependent view of the colonial peripheries at a time when the English crown was endeavoring to oversee Atlantic activities more effectively.[18]

In addition, despite pretenses to greater scientific accuracy, the semiotic and rhetorical devices that characterized the early-seventeenth-century maps of Smith and the others were still to be found in the *Atlas.* Royal coats of arms are present on eight of the printed maps, declaring English sovereignty and possession of lands ranging from Hudson's Bay and Labrador in the north to various islands in the Caribbean and the Strait of Magellan in the south. Some of these coats of arms are the simple crown, shield, and garter, but others

18. On English desires for imperial expansion under Elizabeth I, see Richarde Hakluyt, *A Particuler Discourse . . . Known as the Discourse of Western Planting* (1584), eds. David B. Quinn and Alison M. Quinn (London, 1993), esp. chap. 18; and Ken MacMillan with Jennifer Abeles, eds., *John Dee: The Limits of the British Empire* [1577–1578] (Westport, Conn., 2004), 43–49; Black, ed., *Blathwayt Atlas,* maps 2–4 and 10–12.

are more elaborate. On the map of Montserrat, the arms are held aloft by a human-headed sea creature, and on that of Barbados they are supported in the arms of both Lady Britannia and Saint George. On the map of Jamaica, they are nestled within an impressive bouquet of laurel branches, sails, and cannons, and on that of Magellan Strait they are resting on the knee of Saint George, whose right hand grips the crown of the arms while his gaze is directed toward the mainland. These elaborate displays convey an impression not only of continued imperial sovereignty but also of the military and agricultural strength of Anglo-American plantations. Several maps in the *Atlas* also show aristocratic coats of arms, often in homage to patrons; ships in the sea displaying the English ensign (the map of Montserrat shows ten such ships); the thoroughness of knowledge and settlement through images of trees, animals, houses, mountains, and rivers on the mainland (of which the maps of Barbados and Jamaica are perhaps the best examples); and the presence of innumerable British toponyms and consequent elision of most native place-names.[19]

Thus, like the English printed maps produced under Elizabeth and the early Stuarts, those that made up the *Blathwayt Atlas,* though more cartographically refined and showing greater geographical areas, communicated the same fundamental messages. The artists emphasized both territorial mastery over ecumenes and immediate frontiers and the continued authority of the imperial center over the colonial peripheries.

ACCENTUATING THE CENTER

As Jack Greene and others have argued, the extension of "vigorous and systematic" central authority over the colonial peripheries after 1675 by Blathwayt and his plantation committee was met almost immediately with opposition from legislative assemblies, governors, and settlers, who believed that their original charters offered constitutional guarantees of peripheral independence from central intrusion. This tension led to an attenuated empire in which the colonies defended their right to substantial local agency and independence from the center, believed they had the option of consent and negotiation to any efforts of the center to become involved in colonial affairs, and in the process learned the value of a federated constitution that presaged that drawn up in 1789. As this essay has demonstrated, however, little of this attenuated relationship between the center and periphery was to be found on English printed maps of America before 1685. Conversely, the message

19. Black, ed., *Blathwayt Atlas,* maps 3, 4, 10, 13, 30 (Montserrat), 32 (Barbados), 34 and 36 (Jamaica), 42 (Magellan Straight).

of a strong and functioning center-periphery relationship was accentuated through the use of various rhetorical and semiotic devices.[20]

One reason for the accentuation of the center-periphery message is that all of the maps discussed were distributed widely enough to be seen by foreign audiences. In this context, carefully incorporated messages could help the crown gain tacit acquiescence and formal recognition for the English empire in America from its European competitors. The depiction of well-populated ecumenes over which the English had clear knowledge and mastery plus the inclusion of coats of arms and other national symbols were cartographical devices that were directed, to a significant degree, toward foreign competitors. As a result of these displays of sovereignty and possession, this international recognition of the English empire in America had been largely achieved by 1667 but was not completed until the several treaties of Utrecht of 1713. The continuation of these messages in printed maps thus remained essential into the eighteenth century, and, in the legalities of demonstrating English dominion over distant territories, claims to local autonomy or attenuation from the metropolitan center had to be omitted—or, to use Brian Harley's language, "silenced"—in favor of messages of territorial hegemony and continued imperial oversight. Even the most stalwart defenders of independence in the colonies must have recognized the advantages that such messages communicated to a European audience of often belligerent and better-equipped Atlantic competitors.[21]

A second reason for the generally positive center-periphery message was that the maps were produced, not in America, but in England by individuals who often had personal experience in America but who were, by the time the maps were drawn, residing back in England. These metropolitan artists and their patrons—sometimes the crown itself—recognized the royal origins of the American colonies and the continued English subjecthood of their inhabitants. Like Saxton's representation of crown authority over English counties that had considerable autonomy from the center, these artists imposed similar notions onto maps of American colonies. This message did not function as a challenge to local autonomy or invite adversarial reaction from the peripheries any more than it did on Saxton's maps of England, on John Speed's 1611 maps in *The Theatre of the Empire of Great Britaine,* or on many contemporary

20. See the citations of Greene's work in note 1, above; quotation in Greene, *Peripheries and Center,* 13.

21. On the legalities of acquiescence and recognition, see MacMillan, *Sovereignty and Possession,* chap. 6; J. B. Harley, "Silences and Secrecy: The Hidden Agenda of Cartography in Early Modern Europe," in Harley, *New Nature of Maps,* ed. Laxton, chap. 3.

maps of other European states. As Kenneth Andrews has remarked, England was "a largely self-governing society—under the crown," which, despite the constitutional crises of the seventeenth century, was an essential characteristic of English empire building and state formation beyond 1700. Likewise, in the wider British composite monarchy of diverse political states, each realm held considerable autonomy, different laws, and varying viceregal powers, although the whole body was, in David Armitage's words, "cemented under a single, recognized sovereign authority." Whatever their feelings about peripheral independence, few in the sparsely populated regions of America questioned the ultimate authority of the crown, whose imprimatur was present both on the charters that brought the colonies into existence and, frequently, on the names of the colonies themselves. In the absence of the supracolonial, federated governmental structure that would later characterize the United States, the English crown was still the locus of authority for the American colonies, an essential thread that kept the web of this imperial diaspora from disentangling into a muddled pile.[22]

A final reason for the strong center-periphery message relates to the nature of central involvement in the period under examination. Especially in the early decades of this activity, the center rarely intruded into the mundane internal affairs of the peripheries, trusting that each colony would make effective regional decisions based on the needs of its unique society. When the crown did get involved in America, particularly in international disputes, it was often seen as advantageous to the fledgling colonies, who gained internal security from competitors, more fruitful trading opportunities, and a greater likelihood of success, without losing much internal independence. Even toward the end of the seventeenth century, the development of more intrusive central measures did not mean an unwillingness to recognize the continued crown authority that united the disparate overseas English colo-

22. Andrews, *Trade, Plunder, and Settlement,* 17; Armitage, *Ideological Origins,* 22. On John Speed, *The Theatre of the Empire of Great Britaine* . . . (London, 1611), see Helgerson, *Forms of Nationhood,* chap. 3. On the use of similar conventions in contemporary European cartography, see, for example, Peter Barber, "Maps and Monarchs in Europe, 1500–1800," in Robert Oresko, G. C. Gibbs, and H. M. Scott, eds., *Royal and Republican Society in Early Modern Europe: Essays in Memory of Ragnhild Hatton* (Cambridge, 1997); Buisseret, ed., *Monarchs, Ministers, and Maps;* and Harley, "Maps, Knowledge, and Power," in Harley, *The New Nature of Maps,* ed. Laxton, chap. 2. On the role of the center with regard to the wider empire, see the work by Elizabeth Mancke cited in note 8, above; and Braddick, *State Formation,* part 5. On composite monarchies, see J. H. Elliott, "A Europe of Composite Monarchies," *Past and Present,* no. 137 (November 1992), 48–71.

nies into an emerging Atlantic community. As Brendan McConville has recently shown, far from challenging the constitutionalism of central authority, from 1688 onward the colonists of "royal America" frequently sought the direct intervention of the "benevolent monarch" to bring about a restoration of the original imperial constitution. This center and periphery relationship involved a certain degree of reciprocity, in which the colonists continued to recognize their subjecthood and allegiance to the crown in exchange for both independence and royal protection from all aggressors, both foreign and domestic, the latter in the form of the British parliament. The reciprocal contract between the crown and its colonies was precisely the message communicated on seventeenth-century maps. Through various rhetorical and semiotic devices, the maps could emphasize both the peripheries' allegiance to the center and the center's obligation to protect the peripheries, without diminishing the notion of peripheral independence and without making the center appear to be exercising tyrannical overlordship.[23]

23. The nature of early imperial involvement is shown in W. L. Grant, James Munro, and Almeric W. Fitzroy, eds., *Acts of the Privy Council of England*, Colonial Series, I, *A.D. 1613–1680* (Hereford, 1908). This activity is discussed briefly in MacMillan, *Sovereignty and Possession*, 100–105; and in greater detail in Ken MacMillan, *The Atlantic Imperial Constitution: Center and Periphery in the English Atlantic World* (New York, 2011). The idea of reciprocity derives from Sir Edward Coke's decision in Calvin's Case (1608); see Daniel J. Hulsebosch, "The Ancient Constitution and the Expanding Empire: Sir Edward Coke's British Jurisprudence," *Law and History Review*, XXI (2003), 439–482; David Martin Jones, "Sir Edward Coke and the Interpretation of Lawful Allegiance in Seventeenth-Century England," in Allen D. Boyer, ed., *Law, Liberty, and Parliament: Selected Essays on the Writings of Sir Edward Coke* (Indianapolis, Ind., 2004), 86–106; Mark L. Thompson, "'The Predicament of Ubi': Locating Authority and National Identity in the Seventeenth-Century English Atlantic," in Mancke and Shammas, eds., *Creation of the British Atlantic World*, 72–73. See also Brendan McConville, *The King's Three Faces: The Rise and Fall of Royal America, 1688–1776* (Chapel Hill, N.C., 2006); and, for critical engagement with McConville's thesis, see Eric Hinderaker, "The King's New Clothes," *Reviews in American History*, XXXV (2007), 184–190.

A COMPASS TO STEER BY

JOHN LOCKE, CAROLINA, AND THE POLITICS OF RESTORATION GEOGRAPHY

Jess Edwards

In the fifth chapter of his *Second Treatise of Government* (composed circa 1680–1682; first published 1689), titled "Of Property," the philosopher John Locke sets out his famous labor theory of ownership and economic value. Locke accepts that the world was originally "given . . . to Mankind in common" and concerns himself with the question of how, in this case, any individual might claim a private property, or "dominion." The answer is, through the addition of labor, or "improvement": *"As much Land* as a Man Tills, Plants, Improves, Cultivates, and can use the Product of, so much is his *Property*. He by his Labour does, as it were, inclose it from the Common."[1]

Historians of the English experience in America often look at the colonial period through Lockean spectacles. We think of a Lockean labor theory of value, and a Lockean notion of property founded on the improvement of vacant or at least neglected land, as both the philosophy and the ideology of American colonization and, ultimately, of American independence. Over the course of the seventeenth century, writes Bruce McLeod, "a labor theory of value was inexorably becoming the justification for expropriating land inhabited by others. . . . Thus wilderness and commons alike were essentially up for grabs since both lacked the organizing principle of private property." Since the 1980s advent of the new, "critical" history of cartography, pioneered most conspicuously by J. B. Harley, we have tended to think of early American maps as the expressions of this philosophy and the tools of this ideology of expansive individualism. In Harley's own words, seventeenth-century cartography "fostered the image of a dehumanized geometrical space . . . whose places could be controlled by coordinates of latitude and longitude" and served as

1. John Locke, *Two Treatises of Government*, ed. Peter Laslett (Cambridge, 1960), II, sect. 25, 32. All references to this edition will be by treatise and section number.

a means whereby colonial land "could be appropriated, bounded, and sub-divided." "Maps with their empty spaces," writes Harley of seventeenth-century New England, "can be, and were, read as graphic articulations of the widely held doctrine that colonial expansion was justified when it occurred in 'empty' or 'unoccupied' land." Harley's reading of cartographic "empty space" is broadly congruent with another highly influential thesis on the politics of early modern cartography that emphasizes precisely the opposite aesthetic characteristic. At the end of his chapter in *Forms of Nationhood* on the Elizabethan chorographies of William Camden and his peers, with their profusion of local specificity, Richard Helgerson asks: "Is there a natural and inevitable antagonism between mapping and chorographical description on the one hand and royal absolutism on the other? Are maps and descriptions of place . . . always Whiggish in their ideological effect?" Like Harley's empty spaces, Helgerson's detailed local geographies construct a spatial field that is open to the endeavors of the expansive and possessive individual.[2]

These influential theses on the Lockean, or liberal, nature of seventeenth-century geography need considerable qualification if they are not to misrepresent its relationship with the cultures of colonization and economic reform. In this essay, I will suggest that, rather than working to erase the past, one of the most important functions of geography in the later seventeenth century was to forge a rhetorical compromise between old and new, traditional and progressive social visions. If geographers prosecuted the new worldview of the Lockean improver, they often did so by articulating an accommodation between a liberal ethos of individual endeavor and a conservative one of stable, hierarchical community and aristocratic social stewardship.

Even if Helgerson is right about the politics of place in the pre–Civil War period, by the Restoration things appear to have changed. Charles II chose John Ogilby, a dancing teacher turned geographer, to choreograph his coronation procession. Ogilby responded with a series of arches allegorizing the service of geography to the crown, and his subsequent geographic work maintained this service unwaveringly, as Robert Mayhew has described. The same generic forms that Richard Helgerson has taught us to consider "inherently Whiggish" were nonetheless perceived not just as palatable but as serviceable to Restoration monarchy. If they recorded the centrifugal energies of English

2. Bruce McLeod, *The Geography of Empire in English Literature, 1580–1745* (Cambridge, 1999), 91–92; J. B. Harley, "Maps, Knowledge, and Power," in Harley, *The New Nature of Maps: Essays in the History of Cartography*, ed. Paul Laxton (Baltimore, 2001), 187–188, 190; Richard Helgerson, *Forms of Nationhood: The Elizabethan Writing of England* (Chicago), 146.

locality and commerce, they were able to recuperate these energies to the imperial center. Most important, the royalist geographies of the 1660s and 1670s responded to the contemporary Whig challenge to royal absolutism. They presented royal empire as a loose, tolerant, and profoundly un-French affair, accommodating commercial energy and local difference through attraction and willing tribute rather than arbitrary power. Even Tory propagandists in this period presented royal power as absolute yet, paradoxically, limited—by custom and rational law—and therefore no threat to ancient liberties. The cartographic language they often used to express these limitations—the language of measure and proportion, of bounds and limits—is bodied forth in the actual cartographies of the period, with their curiously mixed message of patriarchal power and liberal individualism.[3]

This essay is concerned with a colonial example of this kind of mixed message: one that we might well presume would fit Helgerson's and Harley's paradigms of a Whiggish, individualist geography. In 1671, the same year that he became royal cosmographer, John Ogilby published *America*, a licensed translation of Arnoldus Montanus's *De nieuwe en onbekende Weereld* with some additions. Among these additions was a new map and verbal description of Carolina, recently settled by English colonists (Figure 1). Research by cartographic historian William Cumming some time ago indicated that part of the responsibility for this particular colonial geography rested with none other than John Locke. Cumming's research was driven by questions of sources and authorship, and my own curiosity has been piqued by a set of "post-Harleyan" questions about the politics of the colonial map. Why did Locke contribute to a geography of Carolina? What kind of relationship might exist between this colonial geography and Locke's articulation, a few years later, of a liberal philosophy of individual rights? What contribution might this Lockean geography have made to the royalist accommodation achieved by Ogilby? What, in short, are the politics of a genuinely Lockean geography? In addressing these questions, I want to offer a theorization of the political function of Anglo-American geography in the later seventeenth century and, at the same time, to contribute to a lively current debate on the relationship between Locke's liberal political philosophy and his involvement with colonial America. I will begin by reviewing this debate before considering the nature and the poli-

3. Charles W. J. Withers, "Ogilby, John (1600–1676)," *Oxford Dictionary of National Biography* (New York, 2004); Robert J. Mayhew, *Enlightenment Geography: The Political Languages of British Geography, 1650–1850*, Studies in Modern History (Basingstoke, Hampshire, U.K., 2000). See also Tim Harris, *Restoration: Charles II and His Kingdoms, 1660–1685* (London, 2005), 220–237 (esp. 235).

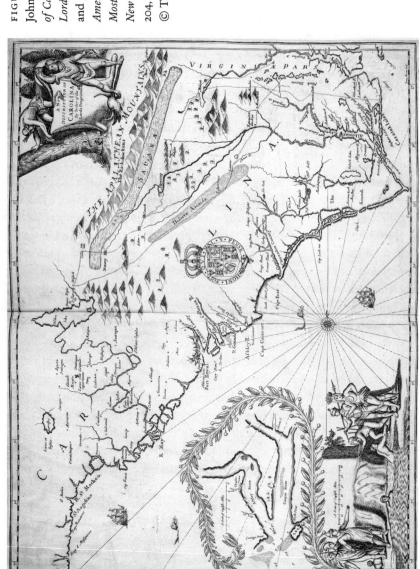

tics of Locke's relationship with Carolina and the place of geography in this relationship.[4]

AMERICA IN LOCKE

Until recently, the most authoritative scholarship on Locke's *Two Treatises* has focused on their relation to the political circumstances of England in the 1680s. Many scholars now agree that the *Two Treatises* were in large part a response to the "exclusion" crisis of the 1670s and 1680s that saw the formation of a party, ultimately christened Whig, to oppose the succession of Charles II's Catholic brother James, duke of York. Locke's patron Anthony Ashley Cooper was the leading light in this campaign, and it is suggested that Locke wrote to justify opposition to the king, constructing his argument against that theorization of absolute monarchy presented in Robert Filmer's recently published *Patriarcha*. Filmer had argued that God's original grant of dominion over the earth to Adam was inherited by kings ruling by divine right. To deny this grant and this inheritance, suggested Filmer, was to argue that God granted the earth to all men in common and thus to present private property as theft. Hence the centrality of property to Locke's political theory. Locke's ingenious response to Filmer, and to the defense of the succession on Filmer's absolutist grounds, is to construct a theory of individual dominion, and thus the right of individuals to resist monarchic tyranny, that poses no threat to property. The result is a labor theory of value. Although God gave the world to man in common, argues Locke, this condition of true commonality ends with the passage of human communities from the natural to the civil state as they obey a divine injunction to subdue the earth. As individuals add the value of their labor to the soil, they extend to it the dominion that even natural man possesses over his own body and form constitutions and governments to regulate and protect their individual dominion. Far from threatening the principle of private property, Locke's thesis presents resistance to monarchic tyranny as a defense of that constitution that preserves the individual dominion of every subject.[5]

4. Arnoldus Montanus, *De nieuwe en onbekende Weereld, of, Beschryving van America en 't zuid-land* . . . (Amsterdam, 1671); John Ogilby and [Arnoldus Montanus], *America: Being the Latest, and Most Accurate Description of the New World* . . . (London, 1671).

5. See, in particular, Peter Laslett's scholarship dating the composition of the *Two Treatises* in Locke, *Two Treatises of Government*, ed. Laslett. See also Richard Ashcraft, *Revolutionary Politics and Locke's Two Treatises of Government* (Princeton, N.J., 1986); Robert Filmer, *Patriarcha; or, The Natural Power of Kings* (London, 1680); David McNally, "Locke, Levellers, and Liberty: Property and Democracy in the Thought of the First Whigs," *History of Political Thought*, X (1989), 17–40.

America crops up fairly often in Locke's *Two Treatises of Government,* and more or less half of all references are concentrated in the "Property" chapter of the *Second Treatise.* These references, emblematized in the famous phrase "In the beginning all the world was *America,*" generally offer an illustration of the original, natural state from which civil society has emerged and have traditionally been treated as abstract accessories in the articulation of Locke's English political concerns. If a Lockean labor theory of value was drawn into discourses and practices of American colonization, convention states that it was largely *post facto,* or in colonial applications of proto-Lockean theories. Some scholars, however, pointing to Locke's work during the 1670s as secretary both to the Lords Proprietors of Carolina and to the Council of Trade and Foreign Plantations, have argued that the personal involvement of Locke in national and private colonial ventures was a primary motor for his formulation of theories of property and value designed to "trump" the rights of indigenous inhabitants and rival colonial states. Locke, they suggest, wrote to serve the interests of his patron, Ashley, one of eight Lords Proprietors of Carolina, developing "a theory of agrarian labour which would . . . specifically exclude the Amerindian from claiming land." As debate on the significance of his American interests has developed, Locke has become "a crucial link in the historical chain joining liberalism with colonialism." To understand the nature of this link, historians have looked ever more closely at the nature of Locke's work in Carolina, the geographic aspect of which will concern us here.[6]

LOCKE AND CAROLINA

Firstly, then, some facts about Locke and Carolina. On March 24, 1663, the crown issued to eight men a charter giving title to all the land between the east and west coasts of America, from the upper reaches of present-day North Carolina down to the lower ones of present-day Georgia. The grant was extended in 1665 to push farther into Spanish Florida and to include an existing settlement by Virginians at Albemarle Sound. It was intended to open up a new front in the continuing confrontation between England and Spain and to address the needs of West Indian planters clamoring for more land. The eight men who composed the Lords Proprietors of Carolina were all "intimately

6. See David Armitage, "John Locke, Carolina, and the Two Treatises of Government," *Political Theory,* XXXII (2004), 602–627 (esp. 603), for an overview of these references; Locke, *Two Treatises of Government,* ed. Laslett, II, sect. 49; Barbara Arneil, *John Locke and America: The Defence of English Colonialism* (Oxford, 1996), 64; James Tully, *An Approach to Political Philosophy: Locke in Contexts* (Cambridge, 1993), 139.

associated with the economic expansion of Restoration England." Some were investors in other colonial ventures, and six were members either of the Council of Trade or the Council of Foreign Plantations. The instigator of the Carolina project was Sir John Colleton, a Barbadian planter who had returned to London at the Restoration to be rewarded for his loyalty during the Interregnum. Although Colleton died in 1667, his son remained a leading light of the proprietorship, surpassed only by his colleague on the Council of Foreign Plantations Anthony Ashley Cooper.[7]

Locke had taken up residence in Ashley's household in 1667 as Ashley's personal physician and secretary, and a little later as tutor to his children. He was appointed secretary to the proprietorship in 1669 and held the appointment until 1675. In this role, he kept minutes of the proprietors' meetings and managed correspondence between England and Carolina. But Locke was far more than a mere amanuensis. He played a part both in shaping the political character of the colony and in helping to promote it. In 1669, as part of Ashley's energetic drive to breathe life into the Carolina venture, Locke helped his patron draft *The Fundamental Constitutions of Carolina*, a governmental framework designed to flesh out the founding principles of the colony and to attract settlers seeking stable government, religious liberty, and land. Throughout his period of service to the proprietorship, Locke's work would be driven by Ashley's determination that the colony should thrive and attract new settlers and by his equal determination that it should be shaped by that form of government defined in the *Fundamental Constitutions*. It was as a promoter of the Carolina defined in Ashley's *Fundamental Constitutions* that Locke turned geographer.

GEOGRAPHY AS PROMOTION

Promotion of the colony was a key part of Locke's job as secretary to the Lords Proprietors of Carolina, and geography was a key aspect of such promotion. David Armitage has suggested that we often overestimate the significance of the imperial ethos in seventeenth-century English culture and that we do so because we rely upon texts produced by secretaries whose social influence depended upon the talking up of empire on behalf of patrons looking to promote their investments. The same might be said of geography itself as a service provided by colonial middlemen to their employers. Locke was pre-

7. See M. Eugene Sirmans, *Colonial South Carolina: A Political History, 1663–1763* (Chapel Hill, N.C., 1966), 4–5. On the proprietorship, see also Charles H. Lesser, *South Carolina Begins: The Records of a Proprietary Colony, 1663–1721* (Columbia, S.C., 1995), 2–15.

cisely such a middleman. He was invested in the idea of English empire and its geography because his patrons required him to help promote it and because his own status as the client of powerful men depended upon his capacity to supply the tribute of geographic information. Locke worked as a professional geographic reader. John Harrison and Peter Laslett, who have catalogued the remains of Locke's considerable library, comment on the evidence it furnishes of the primacy of Locke's geographic interests. Locke collected a wide range of travel narratives and atlases relating to England, Hungary, Turkey, East India, and the English colonies in America. Together with a number of books on agricultural improvement, Locke's travel books are evidence of the intellectual interests he shared with his fellow Royal Society member Ashley. But they are also evidence of the working relationship between the two men. Locke's heavily marked and annotated travel books are the hardest worked resources in what Harrison and Laslett term a "working library." They furnish not just the rather abstract *exampla* of his philosophical works but also the tribute of a client to his patrons.[8]

In addition to this professional geographic reading, Locke's secretarial work also had an important geographic function. If Locke was paying his own geographic tribute to the proprietorship, he depended in doing so on the communications of various subclients in Carolina itself. For, if Ashley never went to Carolina, neither did Locke. The hunger of Ashley for information about his investment is aptly symbolized by his dogger *Edisto*, which crisscrossed the Atlantic exchanging instructions and supplies for the settlers for goods, rents, and information. Those who wrote to Ashley and the other proprietors did so in order to secure and improve their position and influence in the colony, using hard-won geographic intelligence to promote themselves much as the proprietors used it to promote their colony. Correspondence from the colonists tends to nourish the proprietors' hopes, to encourage them to keep faith with a settlement with good prospects for improvement, and to use geographic intelligence to jockey for position. The strategy of such would-be client geographers is summarized in a terse précis made by Locke of a letter from Henry Brayne for the proprietors: "Desires more power Prom-

8. David Armitage, "Literature and Empire," in *The Oxford History of the British Empire*, I, *The Origins of Empire*, ed. Nicholas Canny (Oxford, 1998), 99–123; John Harrison and Peter Laslett, *The Library of John Locke*, Oxford Bibliographical Society, *Publications*, n.s., XIII (Oxford, 1965), 4, 27–29. For an account of the Elizabethan John Dee as another professional reader who purchased influence through his geographic research, see William H. Sherman, *John Dee: The Politics of Reading and Writing in the English Renaissance* (Amherst, Mass., 1995).

ises a draught of the coost." As the colonists sent in their geographic trib-
utes and their bids for power, Locke sifted them, carefully extracting their
geographic information along with other intelligence and adding it to his
record of the colony's characteristics and needs. Much of the geographic in-
formation gathered was stored in verbal memoranda, which Locke regularly
digested and updated (Figure 2). Some intelligence was recorded in a simi-
larly provisional form of cartography. A manuscript archived in the British
Public Record Office among the Shaftesbury papers, and listed by Cumming
as "Locke 1671," was used to "keep up with current information about the
proprietary" (Figure 3). Alongside his "working library" of travel literature,
Locke's verbal and cartographic archive of geographic information was an im-
portant resource supporting his services to the Lords Proprietors.[9]

With these geographic resources at his disposal, it is no surprise that it was
to Locke that the proprietors turned when the opportunity came to promote
their colony through a new map and description of the province of Carolina.
In 1671, Sir Peter Colleton wrote a brief letter to Locke giving him the follow-
ing commission:

> Mr Ogilby who is printing a relation of the West India hath been often
> with me to gett a map of Carolina wherefore I humbly desire you to gett of
> my Lord those mapps of Cape feare and Albemarle that he hath and I will
> draw them into one with that of port Royall and waite upon my Lord for
> the nomination of the rivers etc. And if you would doe us the favor to draw
> a discourse to bee added to this map in the nature of a description such as
> might invite people without seeming to come from us it would very much
> conduce to the speed of settlement and be a very great obligation to your
> most faithful friend and servant.

On the back of Colleton's letter requesting information for Ogilby, Locke jot-
ted down notes that vaunt his unique capacity, as a professional reader, to
answer this request. These notes include a list of eleven "Writers of Carolina"
whose works "prove or allow the English right" there and more than twenty
English travelers whose expeditions reinforce this claim (Figure 4). They also
include a list of place-names for the map Ogilby was hoping to produce and a
set of generic categories for the description that would attend it:

9. Lesser, *South Carolina Begins*, 29; John Locke's Carolina Memoranda, in Langdon
Cheves, ed., *The Shaftesbury Papers and Other Records Relating to Carolina . . . prior to the
Year 1676*, South Carolina Historical Society, *Collections*, V (Charleston, S.C., 1897),
245–253.

FIGURE 2. Locke's Carolina Memoranda, British Public Record Office, *Shaftesbury Papers,* bdle. 48, no. 39. Courtesy, National Archives.

This page is from a digest provided to the proprietors by Locke of letters sent by leading colonists at the latter end of 1670. The digest foregrounds intelligence about the local Indians and the neighboring Spanish and summarizes the capabilities of the settlement for defense, navigation, and cultivation. This extract notes in succession the fair dealing of local Indians with the settlers and the extortionate practices of first surveyor general to the colony Florence Sullivan, a man described elsewhere in Locke's notes as an "Ill natured buggerer of children" (Locke's Carolina Memoranda, bdle. 48, no. 53). The letter Locke is digesting here was sent by Stephen Bull, who would himself be appointed surveyor general in July 1673.

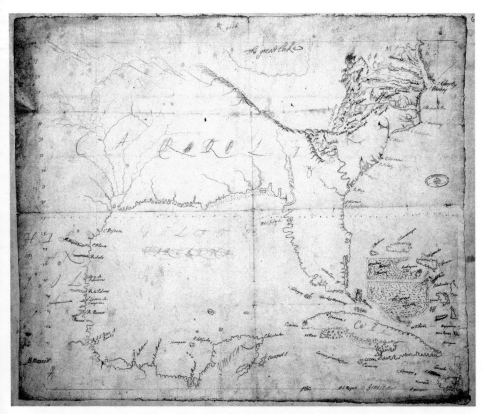

FIGURE 3. "Locke 1671," British Public Record Office, *Shaftesbury Papers*, M.P. 1/11. Courtesy, National Archives.

Locke's cartographic information bank brings together current knowledge about Carolina and places the colony in relation to Mexico and the West Indies.

> Situation Discovery Soyle and shore Subterranea Fossilia Aire and Temperature Water Rivers Lakes Fish Plants and Fruits Insects Birds Beasts Inhabitants number Bodys Abilitys of mind Temper and inclinations Morality and customs Religion Economy.[10]

Ogilby was able to include a new description of Carolina in his first editions of *America;* the new map arrived a little later, and by the circuitous route that has preoccupied cartographic historian William Cumming. The *First Lords Proprietors' Map,* engraved by James Moxon, is dated circa 1672 by Cumming and appeared in later English editions of Ogilby's *America.* It has several iden-

10. Sir Peter Colleton to John Locke, 1671, in Cheves, ed., *Shaftesbury Papers,* S.C. Hist. Soc., *Colls.,* V (1897), 264–266.

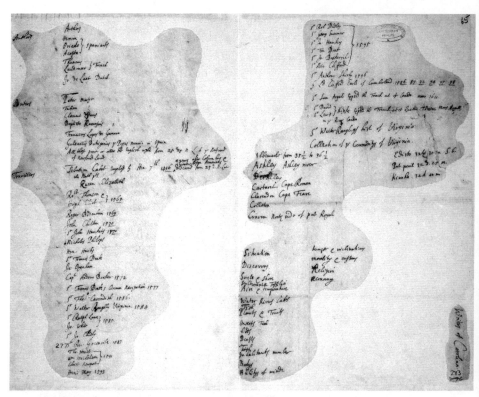

FIGURE 4. John Locke, "Writers of Carolina," *Shaftesbury Papers*, bdle. 48, no. 82.
Courtesy, National Archives.

These memoranda were written by Locke on the two inside pages of Peter
Colleton's letter to him.

tifiable sources, but the bulk of its geographic information is derived from ex-
peditions made by the German scholar John Lederer. In 1669 and 1670, Led-
erer had been commissioned by Virginia governor Sir William Berkeley to
explore the region south of the Virginia tidewater and to find a path through
the Appalachian Mountains. Lederer's report and map of his three journeys,
discussed in Gavin Hollis's essay in this collection, was published by Maryland
governor Sir William Talbot in 1672, and Locke would ultimately add this vol-
ume to his collection of American travelogues. He must also have had access
to Lederer's information in some form already, however, because "Locke 1671"
clearly draws upon the information generated by Lederer's journey and might
itself have been used as a "rough early draft for Ogilby's map." If John Led-
erer's rather fanciful geography enjoyed a substantial afterlife through Ogilby,

it was owing, perhaps, in no small measure to the work of Ashley's secretary John Locke.[11]

The nature of the promotional geographies that Locke was so intimately involved in producing encourages the idea of a link between Locke's colonial work and his liberal political philosophy with its keynote labor theory of value. It was clear to the proprietors from the outset what aspects of Carolina would sell to prospective emigrants. In 1663, the Barbadian William Hilton explored coastal Carolina, and in 1664 he published *A Relation of a Discovery Lately Made on the Coast of Florida*, an account of his expedition at the encouragement of the Lords Proprietors. Hilton's Barbadian sponsors had successfully sued to the Lords Proprietors for a grant to buy a thousand acres of land from the Indians, and, on Hilton's return to Barbados, agents acting for the proprietors produced a set of proposals that could function not just to define this grant but also as a foundation for and means to promote wider settlement. These proposals, like the more fully worked out *Fundamental Constitutions* that would follow them, defined a liberal system of land granting and tenure and emphasized "freedome of Trade, Immunity of Customes, and Liberty of Conscience." Hilton's pamphlet narrates his adventures, prints the proposals, and gives a favorable description of land that begs for the attentions of English improvers: "The Indians plant in the worst Land, because they cannot cut down the Timber in the best . . . although the Land be overgrown with weeds through their lazinesse, yet they have two or three crops of Corn a year." In its emphasis on Carolina's improvability and liberal frame of government, Hilton's *Relation* established a pattern for a succession of more tailor-made promotional geographies. When the opportunity came in 1671 to promote Carolina through a brief descriptive passage in Ogilby's *America*, the passage that Locke composed was able to follow an already familiar pattern. The Carolina described in Ogilby "wants nothing but Inhabitants." It is "a Countrey wherein Nature shews how bountiful she can be without the assistance of Art," since its native inhabitants live "without forecast or toil" and "without the continual trouble of Tillage and Husbandry," depending on

11. For Cumming's assessments of the sources of Ogilby-Moxon 1672, see William P. Cumming, *The Southeast in Early Maps, with an Annotated Check List of Printed and Manuscript Regional and Local Maps of South-Eastern North America during the Colonial Period* (Princeton, N.J., 1958), 33, maps 60, 63, 65, 66, 68; William Talbot, ed. and trans., *The Discoveries of John Lederer, in Three Several Marches from Virginia, to the West of Carolina, and Other Parts of the Continent: Begun in March 1669, and Ended in September 1670; Together with a General Map of the Whole Territory Which He Traversed; Collected and Translated out of Latine from His Discourse and Writings* (London, 1672).

the "natural and spontaneous Growth of the Soil for their Provisions." So un-improved is this naturally fertile country that there is no need for conflict in its settlement, since settlers can simply buy from the natives "the waste Land they make no use of." Moreover, the laws that have been made for Carolina are "all contriv'd and design'd for the good and welfare of the People."[12]

Just as it precedes Locke's description, the liberal rhetoric of liberty and improvement runs seamlessly into the writing of his secretarial successor. Geo-graphic promotion remained the responsibility of the secretary to the Lords Proprietors beyond Locke's tenure in the post. When Ogilby's *First Lords Pro-prietors' Map* was succeeded by the second, in 1682, the production and pub-lication of the second map was overseen by a later secretary, Samuel Wilson. Much as Colleton had asked Locke to do, Wilson corresponded with Caro-linans who were able to supply geographic information and paid Joel Gas-coyne and a printer for the production of the map (Figure 5). And like Locke, too, Wilson wrote his own, this time extensive and freestanding, promotional description. Wilson's account rehearses the usual litany of Carolina's fertility and its liberties of conscience and of tenure, describing in detail the means by which land is granted, surveyed, and registered. Ten years on from Ogilby, it is in a position not just to advertise the opportunities for improvement and social advancement that liberal Carolina affords in its fertile, untilled meadows and its liberal constitution but also to chart the actual progress of such develop-ments: "Many persons who went to Carolina Servants, being Industrious since they came out of their times with their Masters, at whose charge they were Transported, have gotten good Stocks of Cattle, and Servants of their own." Well might Joyce Chaplin write that, as the seventeenth century progressed, plantations came to be conceived "within the terms soon to be identified with John Locke, [as] a landscape remarkably transformed by English hands and a demonstration that a civil people could create property out of nature."[13]

INDIAN GEOGRAPHY: EMPIRE AND DOMINION

In 1682, when Samuel Wilson produced and distributed the new official geog-raphy of Carolina, Locke was helping the Lords Proprietors to redraft the

12. William Hilton, "A Relation of a Discovery," in Alexander S. Salley, Jr., *Narra-tives of Early Carolina, 1650–1708*, Original Narratives of Early American History, no. 5 (New York, 1959), 31–61 (esp. 33–36, 44, 57–61); Ogilby and [Montanus], *America*, 205, 207, 210, 212.

13. Cumming, *The Southeast in Early Maps*, 78; Lesser, *South Carolina Begins*, 28; Samuel Wilson, "An Account of the Province of Carolina," in Salley, ed., *Narratives of Early Carolina*, 167; Joyce E. Chaplin, *Subject Matter: Technology, the Body, and Science on the Anglo-American Frontier, 1500–1676* (Cambridge, Mass., 2001), 231.

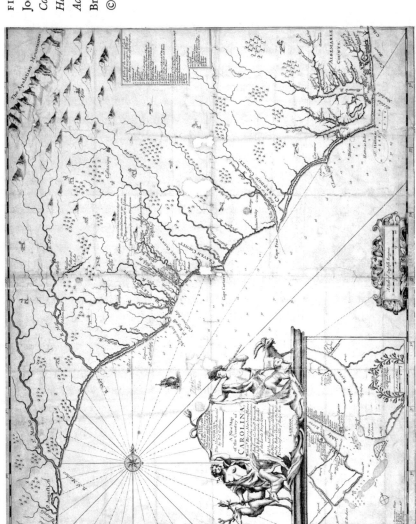

FIGURE 5.
Joel Gascoyne, *A New Map of the Country of Carolina: With Its Rivers, Harbours, Plantations, and Other Accommodations* . . . (London, 1682), British Library Maps 71965.(3.). © The British Library Board

Fundamental Constitutions with similarly promotional ends in mind, augmenting its emphasis on religious toleration and the rights of freemen. Sixteen eighty-two is also—suggests David Armitage—the mostly likely date of composition for the "Property" chapter of Locke's *Second Treatise*. The tenor of the promotional geographies with which Locke was involved as secretary to the Lords Proprietors appears to support those theses suggesting strong and direct links between Locke's colonial work and his labor theory of value, constructing as they do an America waiting—in the words of one letter written to the Lords Proprietors—to be "refined from the Dross of Indian Barbarisme." And it would certainly be possible to read the *First* and *Second Lords Proprietors' Maps* as part of this process of refinement. Ogilby-Moxon, produced at an early stage of settlement and exploration, fits Harley's model of blank space waiting to be filled, and Gascoyne marks the aesthetic progress of Richard Helgerson's Whiggish particularities. The cartouche boasts origins in "the latest surveighs and best Informations," and indeed the area around Charles Town shown in the Ogilby-Moxon inset is now, in Cumming's words, "heavily dotted with names and plantations." There are still Indian names on the map, but they are considerably outnumbered by the English ones, and the ornamental Indian scenes from Montanus have been replaced by a single native couple, surrounded by animals characteristic of "the chase." These scenes, together with corresponding icons scattered near clumps of trees on the interior regions of the map, recall the Indians of Locke's *Two Treatises*. They reduce America's natives to a sparse and mobile hunter-gatherer presence, precisely the opposite of white agrarian settlement, illustrating a passage in secretary Samuel Wilson's promotional account: "The Woods abound with Hares, Squirrels, Racoons, Possums, Conyes and Deere, which last are so plenty that an Indian hunter hath kill'd nine fatt Deere in a day all shott by himself, and all the considerable Planters have an Indian hunter which they hire for less than twenty shillings a year."[14]

But the *First* and *Second Lords Proprietors' Maps* tell only half the story of Carolinan geography. William Cumming lists a series of English maps that convey substantial information about Indian tribes and their settlements. In the case of a 1685 manuscript map by surveyor general Maurice Mathews and its printed derivates, this information is remarkably extensive. The various

14. Lesser, *South Carolina Begins*, 8, 28; Armitage, "John Locke, Carolina, and the Two Treatises of Government," *Political Theory*, XXXII, no. 5 (2004), 602; Robert Sandford, "A Relation of a Voyage on the Coast of the Province of Carolina," Wilson, "Account of the Province of Carolina," both in Salley, ed., *Narratives of Early Carolina*, 108, 170; Cumming, *The Southeast in Early Maps*, map list 92.

forms of verbal geography that mapped Carolina for an English readership were often similarly detailed. Locke's own notes for a description of Carolina indicate the attention a geographer of Carolina was expected to devote to its natives: "Inhabitants number Bodys Abilitys of mind Temper and inclinations Morality and customs Religion Economy." So why are Carolinan maps not more confidently and consistently "Lockean"? Why do they not discount Carolina's Indians?[15]

Part of the answer is that the political philosophy informing early American colonization was, in reality, far from straightforward and consistent. "By the end of the seventeenth century," writes Barbara Arneil, the principle of imperial sovereignty "was almost entirely divorced from the right of ownership." English writers rarely invoked a principle of "dominium" through improvement of a waste and empty land without simultaneously invoking a principle of "imperium" rooted in the willing subjection of a civil, or at least potentially civil, people to the English crown. The crown itself took the view that the Indians were sovereign peoples with whom colonial governments must establish and maintain appropriate relations and saw allegiances with local tribes as a key strategy in securing England's territorial claims against those of its rivals. In general, the Lords Proprietors of Carolina marched in step with the crown position on native sovereignty and expected their deputies to forge alliances with local Indians that would help to shore up the legitimacy, the security, and the livelihood of their settlement. Correspondence between the settlers and the proprietors describes the advancement of these alliances. Encouraged by the reports of explorers and colonists, the Lords Proprietors assured themselves that Carolina was not only susceptible to improvement but—to use the words of Sir William Talbot in his dedication of John Lederer's report to Ashley—"ambitious of subjection." Talbot's dedication evokes not just the eastern coast and the half-known territories of Lederer's report but "unlimited Empires" beyond the Appalachians, all of which would "stoop" to the "noble Government" "projected" and "established" by Shaftesbury for Carolina. And this noble scheme of government—the *Fundamental Constitutions of Carolina*—itself made room for Carolina's Indians, inscribing a patriarchal relationship between the imperial stewards of Carolina and their native charges. Article 97, which deals with the key constitutional tenet of religious liberty, states that, though "the natives of that place, who will be concerned in our plantations, are utterly strangers to Christianity," their "idolatry, ignorance, or mistake gives us no right to expel or use them ill."[16]

15. Cumming, *The Southeast in Early Maps,* 90.
16. Arneil, *John Locke and America,* 7–8, 75; Talbot, ed. and trans., *The Discoveries*

When we turn back to Locke's promotional account of Carolina for Ogilby, we find evidence of an ideology of dominion through improvement, certainly, but also some confirmation of a parallel imperial, patriarchal vision of a Carolina full of willing native subjects. "At the coming of the English to settle there," he writes, "the several little Kingdoms strove with all the Arts and Arguments they could use, each of them to draw the English to Plant in their Dominions." Note the supposed compatibility of Indian dominion here with English empire, of an Indian content of "several little kingdoms" with a generous English frame. Samuel Wilson's promotional account of 1682 reinforces the centrality of fair dealing with the Indians to Carolina's government, in stark contrast to the consideration he gives to the condition of Negro slaves:

> Negros By Reason of the mildness of the Winter thrive and stand much better, than in any of the more Northern Collonys, and require less clothes, which is a great charge sav'd.
>
> With the Indians the English have a perfect freindship *[sic]*, they being both usefull to one another. And care is taken by the Lords Proprietors, that no Injustice shall be done them; In order to which they have established a Particular Court of Judicature . . . to determine all differences that shall happen between the English and any of the Indians, this they do upon a Christian and Moral Consideration, and not out of any apprehension of danger from them.[17]

We might well think we can read the same inclusive, patriarchal, imperial relationship in the *First Lords Proprietors' Map.* The Indian figures that ornament Ogilby-Moxon seem to confirm an assurance of Carolina's "willing subjection," as even does the looser arrangement of the Appalachians than in Ogilby's chief source, Lederer's map, which opens up the prospect of "unlimited Empires" to the west. As Peter Colleton proposed, Lederer's inland geography of Indian communities is framed by a coastline, rivers, and counties bearing the names of the Lords Proprietors. Anthony Ashley Cooper is graced, for instance, in Ashley and Cooper Rivers and in an Ashley Lake. Locke himself is honored

of *John Lederer,* [ii]; "The Fundamental Constitutions of Carolina," in Mark Goldie, ed., *Locke: Political Essays,* Cambridge Texts in the History of Political Thought (Cambridge, 1997), 160–181 (esp. 178). For an account of the complexities of "dominium" and "imperium," see David Armitage, *The Ideological Origins of the British Empire* (Cambridge, 2000).

17. Ogilby and [Montanus], *America,* 210; Wilson, "Account of the Province of Carolina," in Salley, ed., *Narratives of Early Carolina,* 172–173.

in Locke Island. These English toponyms, like the entities they name, snake over or around the landscape, framing it and stamping their authority upon it like the royal coat of arms that features throughout the English territories of Ogilby's atlas, without entirely erasing its native content.

THE FUNDAMENTAL CONSTITUTIONS OF CAROLINA:
A WHIG ACCOMMODATION

The link between Locke's liberal theory of property and his relationship with colonial Carolina is beginning now to look rather more complicated. A doctrine of patriarchal stewardship over a population of willing native subjects must at the very least sit uncomfortably alongside one of expanding individual dominion over an unexploited, empty space. Yet an accommodation between these two doctrines was at the heart of early Whiggism and at the heart of Locke and Ashley's Carolina project, and geography had a role to play in articulating this accommodation.

The Fundamental Constitutions of Carolina is key to the question of the relationship between Locke's work in America and the evolution of his political philosophy. As secretary to the Lords Proprietors, Locke was substantially implicated in the production, the implementation, and the promotion of the *Fundamental Constitutions* and thereby in its very distinctive political tenor. This implication has rendered the *Fundamental Constitutions* indigestible even to Locke's admirers and objectionable to his critics. For the *Fundamental Constitutions* can look like a very un-Lockean document. In its opening remarks, the document pledges its commitment to an aristocratic dominion that maintains the balance between monarchy and democracy. The constitutions are designed for "establishing the interest of the lords proprietors with equality, and without confusion; and that the government of this province may be made most agreeable unto the monarchy under which we live, and of which this province is a part; and that we may avoid erecting a numerous democracy." After this prefatory disavowal of "democracy," the earliest of the 111 articles of the *Fundamental Constitutions* install a hereditary aristocracy whose proportion of the land of the colony cannot be alienated and impose a strict economy of rank and territory, descending from the eight Lords Proprietors and the province itself via layers of landgraves, cassiques, baronies, and counties, to local manors and their lords. For those who admire Locke's revolutionary defense of individual human rights in the *Two Treatises of Government,* written and published fewer than two decades later, the *Fundamental Constitutions* can certainly prove a riddle. In Armitage's words: "How can this [the social conservatism of the *Fundamental Constitutions*] be reconciled

with the more egalitarian, democratic, liberal Locke of the 1680s found in the *Two Treatises of Government?*"[18]

Yet in reality the *Fundamental Constitutions,* no less than the *Two Treatises of Government,* is a logical expression of the political and economic thought of those early Whigs whose champion, Anthony Ashley Cooper, spearheaded the settlement of Carolina. Ashley and his associates believed above all in the principle of a mixed constitution that balanced powers between monarchy, aristocracy, and democracy. Ashley's resistance to the king in the exclusion crisis, his defense of the judicial powers of the House of Lords, and even his notorious "tacks and turns" between factions in the English Civil War demonstrate consistently his perception that the greatest threat to the common good lay in any distortion of this delicate balance, whichever faction it came from. The *Two Treatises* and the *Fundamental Constitutions of Carolina* may "tack" differently in response to different circumstances, but the same ethos of constitutional balance underscores both documents, and the *Two Treatises,* like its predecessor, sets patriarchal limits to the potentially democratic energies of individual improvement. God intended the earth, states Locke in the *Two Treatises,* for the use of the "Industrious and Rational" of mankind. Like Ashley—although he certainly believed in protecting the integrity of all individual dominion, however small—Locke presumed that the industrious and rational part of society were most likely to be those patriarchs who already enjoyed property and leisure: improving landlords such as Ashley himself. Guaranteeing these patriarchs their generous proportion of property, as the *Fundamental Constitutions* sought to do, and allowing them a proportionately generous stake in government was the surest guarantee of a balanced constitution in which the dominion of all estates in society could be regulated and defended: the purpose of any social contract.[19]

FAIR FRAMING AND EQUAL BALANCE

The distinctively Whiggish accommodation sought by Locke and Ashley between patriarchal stewardship and individual enterprise and dominion

18. "Fundamental Constitutions of Carolina," in Goldie, ed., *Locke,* 161–163; Armitage, "John Locke, Carolina, and the Two Treatises of Government," *Political Theory,* XXXII (2004), 610.

19. Locke, *Two Treatises of Government,* ed. Laslett, II, sect. 34. On Locke and Ashley's constitutionalism and characteristically Whiggish accommodation of a positive view of commerce within patriarchal social limits, see McNally, "Locke, Levellers, and Liberty," *History of Political Thought,* X (1989); Steve Pincus, "Neither Machiavellian Moment nor Possessive Individualism: Commercial Society and the Defenders of the English Commonwealth," *American Historical Review,* CIII (1998), 705–736.

rested, in part, upon geographic practices and rhetorics. The Lords Proprietors of Carolina placed a heavy burden of responsibility on the surveyors they employed. Surveying in the colony was, on the one hand, part of a system of efficient management, laying the foundation for a return in rents on the lords' investments and providing for what Locke describes in a letter to the Carolina council of May 1672 as "the prevention of differences and inconveniences which hereafter may happen for want of knowledge of the true bounds and limits of lands." On the other hand, beyond these pragmatic considerations, surveying was, in the words of the same letter from Locke to the council, a key means for "the better reducing the settlement of this Province to the Rules of the Lords Proprietors instructions." Not only did outbreaks of unlicensed land claiming in the colony threaten harmonious relations among the settlers and between settlers and natives; they threatened what Ashley called "that proportion of Land upon wch the balance of the Settlemt principally depends."[20]

At the same time as they used surveying to try to maintain constitutional balance in their colony, Ashley and Locke used a highly geographic and mathematical rhetoric to characterize their constitutional design. In a letter written to Maurice Mathews in 1672, Ashley urged that the settlers regard the *Fundamental Constitutions* as "the compasse . . . to steere by," a "frame" by which "noe bodys power noe not of any of the Proprietors themselves were they there, is soe great as to be able to hurt the meanest man in the Country." Locke's promotional account of the *Fundamental Constitutions* for Ogilby uses mathematical rhetoric in typical fashion to accommodate individual desires for free dominion (blank spaces to carve up and improve) within an overall vision of proportion, balance, and constraint. The *Fundamental Constitutions*, he suggests, are "all contriv'd and design'd for the good and welfare of the People" and are "so well put together, and in such equal proportion balance each other, that some judicious Men who have seen it, say, it is the best and fairest Frame, for the well-being of those who shall live under it, of any they have seen or read of." Locke reduces the original 120 articles of the *Fundamental Constitutions* to a mere 7, chosen and rephrased to give a new emphasis to the liberty and the equality of ordinary settlers. The original document progresses from the top downward, through successive layers of rank, privilege, and authority. The digested version in Ogilby begins with a geometric divi-

20. Council Journals, May 16, 1672, in Cheves, ed., *Shaftesbury Papers*, S.C. Hist. Soc., *Colls.*, V (1897), 393. For accounts of surveying and land title in the colony and of the surveyor general's office, see Sirmans, *Colonial South Carolina*, 30–33; and Lesser, *South Carolina Begins*, 435–441.

sion of the land that emphasizes the position of "the people" as equal owners of the soil. Yet, if these ambitious individuals may look forward, mathematically, to the expansion of their possessions, this prospect is always moderated by Ashley's patriarchal geometry of proportion:

> Every County is to consist of forty square Plots, each containing twelve thousand Acres. Of these square Plots each of the Proprietors is to have one. . . . Eight more of these square Plots are to be divided amongst the three Noble-men of that County. . . . The other twenty four square Plots, call'd *Colonies*, are to be in the Possession of the People: And this method is to be observ'd in the Planting and Setting out of the whole Countrey; so that one Fifth of the Land is to be in the Proprietors, one Fifth in the Nobility, and three Fifths in the People.[21]

CONCLUSION

When John Locke put his mind to mapping Carolina, he evoked, on the one hand, an artless and empty land. For almost a century, promoters of settlement in America had been telling the same story of a land of empty space and infinite potential that simply awaited the inscription of English art and knowledge. This rhetoric was designed, according to Allan Kulikoff, to appeal to the aspirations of the middling, yeoman class of small investors who increasingly formed the majority of those who crossed the Atlantic in the seventeenth century and whose "desire for communal rights, familial self-sufficiency, and independence" was thwarted in the domestic economic climate and stoked by the fantasy of free American land. But it was never the whole of what people believed about America or even of how they formulated their policies in dealing with it. Locke's famous labor theory of value figured in the Carolinan geographies of the 1660s, 1670s, and 1680s as bait to draw out land-hungry potential settlers. Yet, if it informed an ethos of possessive individualism founded on free dominion over empty lands, this ethos was accommodated and constrained within an overarching vision of patriarchal stewardship that recognized the rights of willing native subjects of the English king. This accommodation is the true link that binds Locke's Whiggish political theory to his involvement with Carolina. What is truly radical about the "Lockean" geographies of the Anglo-American seventeenth century, what helps to prepare the way for the revolution in cartography and property of the century to come, is not that they clear away the imperial arcana of English

21. Anthony Ashley Cooper to Maurice Matthews, June 20, 1672, in Cheves, ed., *Shaftesbury Papers*, S.C. Hist. Soc., *Colls.*, V (1897), 399; Ogilby and [Montanus], *America*, 212.

monarchs and Indian kingdoms in favor of blank spaces primed for expansive individualism. Rather, it is that they are able to present colonial commerce and improvement as energies that can be contained by and reconciled with the existing social order. Hence the ease with which John Locke's Carolina map finds its place within royal cosmographer John Ogilby's geography of America. Both sides in the political crisis of the 1670s and 1680s sought to demonstrate that their positions posed no threat to property, to commerce, or to the rights of all estates in the realm. And as they did so, they looked to geography as a language of negotiation and accommodation.[22]

22. Allan Kulikoff, *From British Peasants to Colonial American Farmers* (Chapel Hill, N.C., 2000), 17.

REBELLIOUS MAPS

JOSÉ JOAQUIM DA ROCHA AND THE PROTO-INDEPENDENCE MOVEMENT IN COLONIAL BRAZIL

Júnia Ferreira Furtado

PARADISE LOST

In 1789, after discovering a plot of rebellion in the captaincy of Minas Gerais, Portuguese commissioners named one of their star cartographers, José Joaquim da Rocha, as one of the possible instigators of a nascent independence movement. Rocha became a suspect after several co-conspirators had declared his maps to be a practical guide for coordinating the movement's plans. For Rocha's maps to be thus accused came as a surprise to the political establishment and the Brazilian mapmaking community. It was only a decade ago in 1778 that Rocha had produced, to much official acclaim, five maps of the Minas Gerais region. Using the same scientific protocols that informed imperial land surveys and map publications sponsored by Spain, France, or England, these maps transposed local knowledge into a global archive in which Portuguese names, geographic coordinates, and topographical symbols reified Minas Gerais as a Portuguese possession while making, to use the words of Bruno Latour, "domination at a distance feasible."[1] It was a great surprise for Portuguese administrators to discover that the same maps celebrated for adhering to the protocols of empire building could be perceived as agents of separation and empire wrecking.[2]

1. Captaincies were the larger political subdivisions of the Brazilian territory during the colonial period. The captaincy of Minas Gerais is the forerunner of the modern (eponymous) state located in central eastern Brazil. See Bruno Latour, *Science in Action: How to Follow Scientists and Engineers through Society* (Cambridge, Mass., 1987), 223.

2. Kenneth Maxwell, *Conflicts and Conspiracies: Brazil and Portugal, 1750–1808* (Cambridge, 1973); Joao Pinto Furtado, *O manto de Penélope: História, mito e memória da Inconfidência Mineira de 1788–9* (Sao Paulo, 2002); and Luciano Figueiredo, "Painel Histórico," in Domício Proença Filho, ed., *A poesia dos inconfidentes: Poesia completa de Cláudio Manuel da Costa, Tomás Antônio Gonzaga e Alvarenga Peixoto* (Rio de Janeiro, 1996), xix–l.

In 1778, the assertion that Minas Gerais was a part of the Portuguese empire had become of vital interest to royal authorities. Since the 1494 Treaty of Tordesillas, all boundaries separating Portuguese from Spanish possessions in America had come to hinge on a geographic line arbitrarily drawn from north to south, parallel to and not far from the Brazilian coast (the line approximates the forty-sixth meridian west of Greenwich). For centuries, this artificial line had been the visual and legal tool for upholding the political balance among the principal territorial rivals, with Spain laying claim to lands lying west of the line and Portugal receiving the much smaller territories located east of it. Successive generations of maps perpetuated the illusion of mutual coexistence between the South American colonies and the imperial centers. Using European models of representation, cartographic documents—whether of Portuguese, Dutch, French, or other origin—habitually painted Brazil as a loosely bounded region that was framed by a detailed coastline to the east and an uncharted and vaguely bounded empty space to the west. During the sixteenth century, mapmakers covered the maps' emptiness and their ignorance about Brazil with images of cannibals, acephalous (headless) monsters, and exotic animals. When cartographers started to pay more attention to Brazil's interiors during the seventeenth century, they shifted their pictorial inserts toward a more biblical rather than classical depiction of mythology; allusions to Paradise replaced those to Strabo's natural history. By the end of the seventeenth century, cartographers had furthermore turned to indigenous myths of an inner lake to give Brazil's imagined interior more definition. The discovery of gold in the captaincy of Minas Gerais during the late seventeenth century triggered perhaps the most significant cartographic display of local myths: depicting the imaginary encounter of the Amazon River with a basin-like interior, maps of Brazil added to the legends of El Dorado by showing images of this lake of gold (Figure 1).[3]

In each of these allegorical representations—be it as Terra Incognita, Para-

3. The treaty established a line distant from Cabo Verde archipelago but did not specify from which island. On the history of the Treaty of Tordesillas and its consequences, see *Congreso internacional de historia, el Tratado de Tordesillas y su época* (Valladolid, Spain, 1995). For the changes in the cartographic representations of Brazilian territory, see Neil Safier, "The Confines of the Colony: Boundaries, Ethnographic Landscapes, and Imperial Cartography in Iberoamerica," in James R. Akerman, ed., *The Imperial Map: Cartography and the Mastery of Empire* (Chicago, 2009), 133–184. These images were also reminiscent of the paradisiacal descriptions of the area common in reports of voyagers, priests, pilots, and authorities from the earliest narratives. See Sérgio Buarque de Holanda, *Visão do paraíso: Os motivos edênicos no descobrimento e colonização do Brasil*, 6th ed. (São Paulo, 1994).

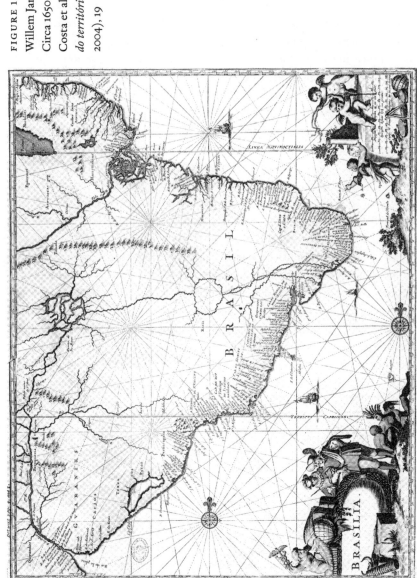

FIGURE 1.
Willem Janszoom Blaeu, *Brasilia.*
Circa 1650. From Antônio Gilberto
Costa et al., *Cartografia da Conquista
do território das Minas* (Lisboa,
2004), 19

dise, or El Dorado—the interior of Brazil was encircled by a chain of rivers, especially the Rio São Francisco. This fluvial depiction put the image of central Brazil in line with two specific mythical places promising wealth: Paradise, which early modern maps showed to be enclosed by a river system, and Egypt, which in Ptolemy's maps is encircled by the Nile. For Portuguese administrators, however, the circular water image was of particular strategic interest because it allowed Brazil to be presented as an island. In this definition, Brazil's interior, and especially the captaincy of Minas Gerais, became conceptually removed from the physical confines of the South American continent and thus ceased to constitute a geographical entity that was subject to the Treaty of Tordesillas. As if adhering to "the myth of continents," an intellectual stance that prevented early modern geographers from imagining vast meta-spaces, the insular depiction left the whole of Brazil open to interpretation while inviting more intensive colonization of Minas Gerais.[4]

The insular representation of Brazil's interior appeared in Portuguese maps during the period of the Iberian Union, when Spanish and Portuguese monarchies were joined for six decades (1580–1640). During the Iberian Union, with Spain dominating Portugal, the demarcation line established by the Treaty of Tordesillas ceased to be the insurmountable boundary and source of territorial conflict. The Spanish desire for tapping Brazil's wealth in precious metals and stones unleashed expeditions responsible for the first wave of depictions showing Brazil's interior unbounded by the treaty line or other geopolitical divisions. It was not by chance that in this context many maps began to show Brazil as a place containing a massive gold lake, called the *"Xarais."* From this lake to the north and south, the Amazon and Plate Rivers emerged as natural dividing lines separating the Portuguese possessions from those of the Spanish. With rivers providing a natural divide from inside Brazil's hinterland, Portuguese nobility, investors, and colonists not only found a new justification for enacting colonial schemes separate from Spain but also were now motivated to aggressively pursue and acquire administrative positions in Brazil.[5]

Portuguese mapmakers abandoned the insular image of Brazil around 1640. But by then the double images of a partitioned Brazil entailing an interior island and gold lake had spread to Dutch, Italian, English, and other maps,

4. On the political and aesthetic logic of declaring places to be insular rather than continental, see Martin W. Lewis and Kären E. Wigen, *The Myth of Continents: A Critique of Metageography* (Berkeley, Calif., 1997). For a graphic depiction of implied insularity, see Nicolas de Fer's map, *Le Brasil* (1719), cited in Safier, "The Confines of the Colony," in Akerman, ed., *The Imperial Map*, 144.

5. See Joao Teixeira Albernaz, *Carta Atlântica* (Lisbon, 1640).

where they continued to shape European and Portuguese attitudes toward Brazil.[6] By the early eighteenth century, the cartographic image of Brazil, sponsored by governmental agencies and publishing houses, had come to revolve around two conflicting representations and agendas: myth and power. In continuation with New World mythology, travel writers now claimed to have identified the real El Dorado inside Minas Gerais. Spurred by the residual image of a land-locked island containing a lake filled with gold, Portuguese colonists poured into central western Brazil—a region that historically was a cartographic blank—creating in Minas Gerais an uncharted network of corridors and enclaves similar to those springing up along the Amazon River in the north and the "Colonia do Sacramento" in the south.[7]

At the same time, however, the Portuguese crown sought to demystify Brazil by reframing its territory. Whereas in previous maps the mythical chain of rivers provided a soft, natural boundary between the Portuguese and Spanish territory, the crown now called for maps showing the establishment of hard, bureaucratic borders based on scientific land surveys and antipictorial, Enlightenment modes of cartographic representation. Such borders would do more than reestablish legal boundaries between Portugal and Spain in South America. Portuguese officials claimed the new borders by applying the legal terms of *uti possidetis*, which, similar to the logic of *vacuum domicilium*, required the actual occupation and "improvement" of land by farmers or miners in order to turn legally unclaimed (that is, vacant) land into personal property or geopolitical provinces. To accelerate colonization, Portuguese officials called for the survey of Brazil's interior in the hope that better cartographic representations would attract more settlers, which in turn would justify the crown's demands for territories that historically had been claimed by Spain.

Rocha's mapping expedition came in response to a newly focused imperial agenda of Portugal. By the 1770s, European land surveyors and mapmakers

6. For the endurance of this representation in the Portuguese tradition, see Júnia Ferreira Furtado, "The Indies of Knowledge, or the Imaginary Geography of the Discoveries of Gold in Brazil," in Daniela Bleichmar et al., eds., *Science in the Spanish and Portuguese Empires, 1500–1800* (Palo Alto, Calif., 2009), 178–197. Portuguese colonial actions were preceded by, if not modeled on, Dutch colonization schemes in northeastern Brazil, which also relied on Dutch-made maps portraying Brazil as an island. See, for example, Frans Post, in Casparis Barlaei, *Rerum per Octennium in Brasilia Et alibi nuper gestarum* (Amsterdam, 1647).

7. C. R. Boxer, *The Golden Age of Brazil, 1695–1750: Growing Pains of a Colonial Society* (Berkeley, Calif., 1964). For a discussion of British ideas about the location of El Dorado, see D. Graham Burnett, *Masters of All They Surveyed: Exploration, Geography, and a British El Dorado* (Chicago, 2000).

had begun to take measure of the continental depths of North and South America with the declared goal to fill in abstract geopolitical units with concrete geographic information. When read in these terms, Rocha's maps offer one more glimpse into the way in which imperial surveyors established control over distant places. Each map set a new standard for Luso-Brazilian cartography. The uniform application of coordinates and grid lines placed the region inside a matrix calculated by a European standard of science rather than local knowledge. Similar to European topographical land surveys, these maps asserted the region's colonial affiliation with Portugal, not by showing allegorical placards and mythical creatures, but by inscribing Minas Gerais with Portuguese names and increasingly standardized symbols.

But when we compare the ideals informing imperial map production to actual consumption of maps in the colonies, the reception of Rocha's maps suggests that the century-old cartographic recipe for inventing and controlling territories for imperial gain seems to have gone awry. By closely examining the records surrounding the production of Rocha's maps of Minas Gerais, this essay shows, on the one hand, how the territorial demarcation of the Minas Gerais captaincy involved the consolidation of divergent forms of geographical knowledge. By the same token that Rocha's maps shaped Luso-Brazilian cartography according to emerging scientific paradigms, the representation of a myth-free Minas Gerais put an end to the traditional cartographic interplay of myth and power. But whereas in previous maps this interplay tightened the crown's sway over the Minas Gerais captaincy, Rocha's maps unexpectedly engendered visions of a colonial geographical space that threatened to dissolve the ideological links that in the past had successfully tied Portugal's richest colony to the imperial metropolis.

THE CAPTAINCY OF MINAS GERAIS

From the moment the people from the São Paulo captaincy—the *paulistas*—discovered gold and diamonds at the end of the seventeenth century, the territorial demarcation of the captaincy of Minas Gerais became a pressing concern in the continuing disputes between Portugal and Spain over the Amazon River region, the Colonia do Sacramento, and the far western frontier. These discoveries had pushed settlers deep into the Brazilian interior, into a region of new colonization, where mapping Minas Gerais became necessary to carry out mineral exploration in a more effective manner. Although several maps were made with this economic purpose in mind, mapping the captaincy was essential for political reasons as well. Establishing proper boundaries was crucial for enforcing administrative and ecclesiastic control over a population that was expanding at a rapid pace. Minas Gerais was an interior captaincy,

and, as its settlements developed in a radial fashion, establishing its inner borders with the other captaincies was fundamental for the organization of its local administration and of the colony's overall model of captaincy subdivisions.[8]

That said, for much of the first half of the eighteenth century maps coming from European shops were unable to draw accurate images of Brazil's interior because Portuguese authorities made every effort to keep geographical knowledge about Minas Gerais secret. One of the reasons for this secrecy was the government's fear of foreign invasions owing to other nations' interest in gold and precious metals. Government officials also realized that they were occupying what would be, according to the Treaty of Tordesillas, purportedly Spanish territory. The vague representation of the area surrounding Minas Gerais thus consistently clouded European knowledge about Brazil's true shape. European countries, even Spain, were by and large unable to depict these locations accurately. It was impossible for them, for instance, to measure properly a Brazilian meridian and to establish the real distances between the geographical locations amid the meridian lines. At that time, even in the Portuguese maps, the captaincy of Minas Gerais was represented only in very rough terms, emphasizing the captaincy's paradisiacal character and the idea that the area was enclosed in a chain of rivers and mountains that kept it isolated. But it is possible to observe in these earlier maps the presence of Portuguese settlers in Minas Gerais, marked by the representations of the first villages and roads in the area. In this case, the information displayed by cartographers allows us to understand the area's colonization.[9]

By the 1720s, Portugal started a policy specifically aimed at increasing cartographic knowledge of Minas Gerais. Military engineers, officers, and clerks—in particular Jesuit priests—were designated to measure the land and design increasingly accurate maps of the area. These cartographers used older maps and reports made by the first settlers to the region, the paulistas. The paulistas' maps were rough sketches; they were usually designed in simple black lines as guides for future expeditions. But these maps could also be rep-

8. For a concise history of Minas Gerais, see Júnia Ferreira Furtado, *Chica da Silva: A Brazilian Slave of the Eighteenth Century* (Cambridge, 2009), preface.

9. This fear of invasion was stoked in particular by French invasions of Rio de Janeiro in 1710 and 1711. The secrecy surrounding the geography of Minas Gerais was one of the reasons that made the huge cartographic production by the Portuguese poorly known among foreign scholars. For an example of one of the earlier maps depicting the region, see Manuel Francisco dos Santos Soledade, *Roteiro Ilustrado de terras minerais do Brasil* (circa 1720), no. do Catálogo 55, Instituto de Estudos Brasileiros, Universidade de São Paulo.

resented as a text, written reports forming a mental map of the land. Historians today often find this kind of geographic text enclosed in the wills of these pioneers.[10]

In the 1730s, the Portuguese sent two Jesuits, Diogo Soares and Domingos Capassi, to map Brazil in a more precise way. The "mathematical priests," or *padres matemáticos,* as they later became known, took measurements and established the Rio de Janeiro meridian as the baseline for all their maps. Most Portuguese cartography of Brazil after this period was based on this Rio de Janeiro meridian. These priests created very important cartographic documents, especially Diogo Soares, whose maps of Minas Gerais are more detailed than previous maps. Frequently drawing on the paulistas' knowledge and reports, they also created topographical surveys that for the first time fleshed out the region by adding geographical elements that included rivers, villages, roads, and many other features of the land.[11]

In 1746, four years before the diplomatic negotiations with Spain over the boundaries in America ended in the Treaty of Madrid (1750), the governor of Minas Gerais and Rio de Janeiro, Gomes Freire de Andrade, asked Portuguese mapmakers to sum up their collective knowledge about Brazil in the most precise map to date, the *Descripçam do Continente da America Meridional.*[12] In 1750, however, when the Portuguese were ready to negotiate with Spain, officials consulted a different map made by the order of the secretary of the king, Alexandre de Gusmao. The so-called *Mapa das Cortes* (1749) (Figure 2), base map for the Treaty of Madrid, reflected Brazil's image in a way that the Portuguese wanted it to be seen. The map presents several distortions toward the east, and there are many controversies about whether these distortions were intentional, as previous maps (such as the *Descripçam do Continente da America Meridional*) did not have many of these same mistakes. Regardless of this debate (and I support the idea that these misunderstandings were not made by chance), the map is the most important celebration of Portuguese dominance in South American geographical knowledge, enabling Portuguese negotiators to inject most of their terms into the treaty.[13]

10. The best collection of these maps is in the Biblioteca Nacional in Rio de Janeiro.

11. For the "mathematical priests," see André Ferrand de Almeida, *A formaçao do espaço brasileiro e o projecto do Novo Atlas da América Portuguesa (1713–1748)* (Lisboa, 2001).

12. "Descripçam do Continente da America Meridional que nos pertence com os rios e montes que os certanejos mais experimentados dizem ter encontrado, cuja divisao se faz" (from the private collection of the Guita and José Midllin Library). The map's authorship is uncertain. It was made in Brazil and sent to Lisbon.

13. The first to assert that the mistakes were intentional was Jaime Cortesao in

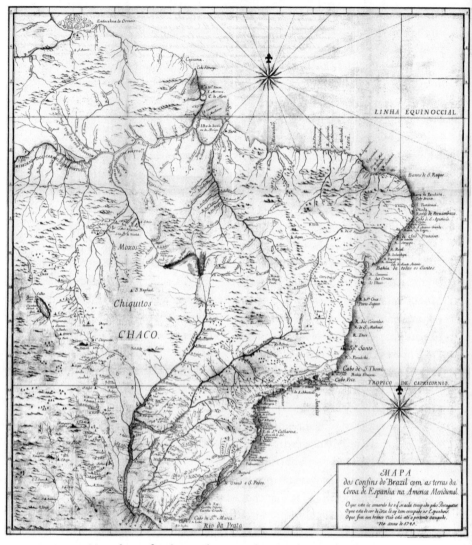

FIGURE 2. *Mapa dos confins do Brazil as terras da Coroa de Espanha na America Meridional,* known as *Mapa das Cortes.* 1749. Marcos Carneiro de Mendonça's facsimile, in the author's possession

124

The Treaty of Madrid, which stipulated that the Portuguese empire in South America could extend no farther west than the forty-sixth meridian, ended up legitimizing not only Portugal's colonization project but inscribed the colony's borders that, with only minor modifications, were valid after the treaty and are still valid today. By the end of the century, maps had ceased to depict Brazil's interior as one of the last remaining paradises on earth as mapmakers expunged pictorial inserts of any kind. Instead, Brazil's interior was represented using modern geographical information on rivers, mountains, roads, and so forth. But the myth of a Brazilian paradise was not lost; rather, it had become resituated, as in the case of the maps of the Minas Gerais captaincy produced by the military engineer, José Joaquim da Rocha. Although outwardly the maps were representative examples of the way in which the space of Minas Gerais (and, by extension, Brazil) hinged on scientific cartographic production, the maps' internal depiction of the gold and diamond regions continued to reflect profoundly unscientific, mythical conceptions of the region.

THE MILITARY CARTOGRAPHER

José Joaquim da Rocha was a Portuguese military engineer and geographer who benefited from the changes in the nature of geographical training in Portugal that had taken place in the first half of the eighteenth century. These changes, most of which occurred during Dom Joao V's reign (1713–1750), included the publication of training manuals that instructed engineers in a more universal cartographic language, using standardized symbols for towns, villages, mountains; more recognizable measurements; and a uniform application of scale. Foremost among these manuals were the *Tratado do modo o mais fácil eo mais exacto de fazer as cartas geográficas* (1722) and *O engenheiro portuguez* (1729), both by Manoel de Azevedo Fortes.[14]

As a military student in the classes of the Aula Régia de Arquitetura Militar (Academy for Military Engineering) in the second half of the century, Rocha was trained in these new methods of map design. Little is known of his early

História do Brasil nos velhos mapas (Rio de Janeiro, 1971), II, 251. More recently, Joao Carlos Garcia made this argument in a paper presented at the International Seminar "Luzes nos Trópicos," São Paulo, 2004. New information that sustains the idea of an intentional manipulation of the map can be found in Mário Clemente Ferreira, "O Mapa das Cortes e o Tratado de Madrid: A cartografia a serviço da diplomacia," *Varia Historia*, XXIII, no. 37 (January–June 2007), 51–69.

14. Beatriz Piccolotto Siqueira Bueno, "Desenho e desígnio: O Brasil dos engenheiros miliatres (1500–1822)" (doctoral thesis, Universidade de São Paulo, 2003).

life in Portugal. He was born around 1740, in São Miguel da Vila de Souza, south of Aveiro, an important coastal town in northern Portugal, in the Bishopric of Estremadura. He arrived in Minas Gerais when Luís Diogo Lobo da Silva was governor (1763–1768) and stayed there until his death in 1804. He was a cabo-de-esquadra (corporal or regiment chief) until 1778, when he was dismissed from military service. While in Minas Gerais, he served in the cavalry and worked as a military engineer on several plans to fortify entry points to the captaincy. These activities required him to make several expeditions that enabled him to know the area very well. This knowledge was also used to draw up five important maps of the captaincy.[15]

He wrote three *memórias,* or reports, about Minas Gerais. The first one, a manuscript entitled *Geografia histórica da Capitania de Minas Gerais* (1780), was dedicated to the newly appointed governor Dom Rodrigo de Meneses. In his dedication, Rocha wrote that his *Geografia* brought together all the information useful for the governor in carrying out his responsibilities. The custom of dedicating these kinds of writings to figures of authority was a common political gesture by authors seeking favors from the court in the form of patronage. Although Rocha touted his *Geografia* as an instrument of the state, offering knowledge and thus power, the exchange of knowledge in the form of books and reports was aimed at career promotion. Rocha saw his efforts rewarded with an appointment by Dom Rodrigo José de Meneses in 1782 as sergeant in Minas Novas do Araçuaí, a village in the northeast of Minas Gerais.[16]

The second text, entitled *Descrição geográfica, topográfica, histórica, e política da Capitania de Minas Gerais,* was with minor modifications almost exactly the same as the first text. It was written in 1783 and dedicated to the new governor of the captaincy, Dom Luís da Cunha Meneses. The text contained an additional section on the government of Dom Rodrigo José de Meneses. Finally, *Memória histórica da Capitania de Minas Gerais,* the last of three manuscripts, was written in 1788 and largely followed the same strategy. Similar to *Descrição geográfica, Memória* also contains a brief account of civil governance, describing the rule of Dom Luís da Cunha Meneses and the first months of Luís José de Meneses, Visconde de Barbacena's new government.

These texts not only served as a panegyric to the governmental authorities

15. He himself provided this biographical information when he was prosecuted. See *Autos de devassa da Inconfidência Mineira,* 11 vols. (Belo Horizonte, Brazil, 1976–2001), IV, 105; José Joaquim da Rocha, *Geografia histórica da Capitania de Minas Gerais: Descrição geográfica, topográfica, histórica e politica da Capitania de Minas Gerais: Memória histórica da Capitania de Minas Gerais* (1780), ed. Maria Efigênia Lage de Resende (Belo Horizonte, Brazil, 1995); Resende, "Estudo crítico," ibid., 19.

16. Resende, "Estudo crítico," in Rocha, *Geographia histórica,* ed. Resende, 22.

but also contained precious information about the local administration, such as lists of taxes, populations, priests, officers, and so forth. Although Rocha copied several older texts practically verbatim as the basis for his memórias (intellectual property functioned according to different rules in the eighteenth century), the few differences that do exist between his text and those that he used are small in number but great in significance. The first difference relates to the description of the discovery of gold and other minerals. Rocha was the first to claim that the paulistas had the privilege of being the first to enter the region, as they were the ones who penetrated the wilderness at the cost of their own effort and blood.[17] The second and more important difference was the interpretation that he gave to the War of the Emboabas (1709–1711), a military conflict that, in the first years of the region's colonization, emerged between the paulistas and the Portuguese (called *emboabas* by the paulistas) over the control of Minas Gerais. Rocha argued that the paulistas had the right to challenge the Portuguese and, above all, accused the latter of betraying them. Until this point, all of the historical interpretations of the War of the Emboabas had favored the Portuguese. In contrast, Rocha's treatise was a radical reformulation of this event's historical meaning, effectively reconstructing and redefining Brazil's colonial past. In subsequent decades, in particular in the aftermath of Brazilian Independence, Rocha's interpretation would serve as the basis for Brazil's national history. Rocha was creating the idea of a colonial, albeit sovereign, subject in opposition to the figure of the colonizer. Minas Gerais, its citizens, and its wealth of resources were fundamental to this process, which, at root, linked colonial ideology to an inchoate sense of nationality that emerged in Brazil by the end of the eighteenth century.[18]

THE INCONFIDÊNCIA MINEIRA

To understand Rocha's view of Brazilian history, it is necessary to study his participation in an uprising, the *Inconfidência Mineira,* that would took place in Minas Gerais in 1789.[19] Understanding this event will allow us to better

17. The same idea appeared in the poem *Vila Rica* (1773), by Cláudio Manoel da Costa, a friend of Rocha. See Cláudio Costa, *A poesia dos Inconfidentes: Poesia completa de Cláudio Manoel da Costa, Tomás Antônio Gonzaga, e Alvarenga Peixoto,* ed. Domício Proença Filho (Rio de Janeiro, 1996), 356–446.

18. Maria Efigênia Lage de Resende, "A disputa pela história: Traços inscritos na memorialística histórica mineira dos finais do setecentismo," *Varia Historia,* no. 20 (March 1999), 60–77.

19. For an interpretation of the movement, see Maxwell, *Conflicts and Conspiracies.* In Brazil, the book was translated as *A Devassa da Devassa.* Inconfidência was a crime directly against the king's power; it was a crime against the majesty of the king and his

assess and reinterpret his cartographic production. At the time the conspiracy's plans were discovered in 1789, Maria I was trying to enforce stricter economical and political policies. That meant, among several other reforms, the removal of local-born elites from administrative posts, the closing of all manufactures in the colonies, and the prohibition of universities overseas. Minas Gerais was the focus of many of these measures because the crown blamed local elites for the decline in the gold and diamond production, a major threat not only to the empire's prosperity but also to its security. But singling out the local elite of Minas Gerais for economic reasons was just the surface of the policy. The measures were leveled against Minas Gerais just as France became the stage for the most significant revolutionary movement of modern times and when it was suspected that revolutionary conspirators were meeting in the gold-mining interior of Minas Gerais to map their own seditious plans for independence. The crown feared that local rebels looked to the example of the newly independent United States of America and were inspired by the writings of the French Enlightenment as well as by a Portuguese political philosophy that argued that the legitimacy of the monarch was to be based primarily, if not exclusively, upon the consent of the governed—the ideological base of the Portuguese Monarchy after 1640. According to this philosophy, the divine right of the king could, in fact, in a situation of tyranny, be legitimately challenged by the people, even by people living as far removed from the imperial center as local miners in Minas Gerais.[20]

Yet, as much as the crown feared the independence movement, known as Inconfidência Mineira, the revolution never occurred because the movement was discovered and brutally repressed before it even began.[21] The ideas put

right to govern. In the 1760s, during Dom José I's government, a very strict criminal code was instituted to punish the crimes of the Inconfidência. This legislation established a difference between a rebellion and an inconfidência whereby only the latter was interpreted as a direct assault on the king's power.

20. Kenneth Maxwell, *Pombal: Paradox of the Enlightenment* (Cambridge, 1995). The Portuguese political philosophy was called *Segunda escolástica*, and the most important philosopher was the Jesuit Francisco Soares, who wrote *De legibus* . . . (1612) and *Defensio Fidei* . . . (1613).

21. The accusations presented to the presiding governor of the captaincy, the Visconde de Barbacena, by two participants of the movement were responsible for the crown's ordering the suspects' immediate imprisonment, before the movement could break out. The collection of late taxes in the captaincy *(derrama)* would have been used as the fuse for the uprising. (The main tax was the "quinto," which was the equivalent of a fifth of the gold that was found in the captaincy, and after 1750 it should have amounted to at least one hundred arrobas each year, which was not the case after the

forth by the members of the movement, the so-called *inconfidentes,* were so threatening to the imperial policy in Brazil that the authorities secretly prosecuted the defendants well in advance of any revolutionary action. The movement accused Portuguese authorities of draining local resources with heavy taxes; the crown, in turn, believed the local elites, by developing the economic resources of the captaincy, would use their economic power to establish a new and independent nation. To break up the movement, the authorities pursued exemplary punishments. One of the revolutionary conspirators, Joaquim José da Silva Xavier, also called "Tiradentes," was hanged. The rest were exiled to Africa, with the exception of clergymen, who were confined to Portuguese monasteries. Rediscovered by historians in the middle of the nineteenth century, the Inconfidência Mineira became the reference point for tracing the origins of Brazilian nationalism. The main defendant, Tiradentes, is celebrated as a national martyr, and the day he was hanged—April 21—is now a national holiday.[22]

Over time, many authors have looked into the history of this preemptively suppressed movement in order to understand its motivations, ideas, projects, inspirations, and the extent of the plans for revolt. The principal source for examining the movement has been legal documents, the *Autos de devassa,* that Portuguese authorities had used to launch a criminal investigation. A discourse formulated by the powerful for the powerful, the *Autos de devassa* reveals a series of legal affidavits designed to prevent the rebuilding of the movement. But the strategy of many of the defendants to keep silent as well as the decision of the authorities not to arrest all of the suspects—some of the most prominent civil authorities were probably involved—ultimately ensured the rebellion's diversity of interpretations.[23]

1760s.) The governor immediately ordered that the derrama should be suspended, although he had arrived in the captaincy with the mission of collecting all the late taxes. The poet Cláudio Manoel da Costa, one of the most important of the rebels and the author of the poem *Vila Rica,* died in prison. It is not clear whether he was murdered or whether he committed suicide—but either way he was silenced. See Maxwell, *Conflicts and Conspiracies.*

22. The nickname "Tiradentes" referred to Joaquim José da Silva Xavier's practice as a dentist—"take out" (tira) "the teeth" (dentes). The Inconfidência Mineira is today considered the foundational event in the establishment of a republic in Brazil. In several key moments, politicians have claimed their heritage from that movement's leaders, calling themselves "the new inconfidentes."

23. Since the nineteenth century, the Inconfidência Mineira has been a subject of historical studies. For the historiography of the Inconfidência, see Robert Southey, *History of Brasil,* 3 vols. (London, 1810–1819); Francisco Adolpho Varnhagen, *História*

Among several other clues, the *Autos de devassa* suggests the strong influence of the early French Enlightenment. Found in the defendants' confiscated libraries were such writings as *L'esprit des Lois* by Montesquieu, the *Encyclopédie* by Diderot and D'Alembert, the texts of the Abbé de Mably as well as those of Turgot, Raynal, and others. The recent and successful rebellion of the British colonies also exerted a strong influence. In the *Autos de devassa*, several witnesses testified that the book *Recueil des Lois Constitutives des Etats Unis de L'Amerique* by Regnier was always in Tiradentes's pocket, and, not knowing French, he insisted that others translate it for him.[24]

The participation of a younger, educated generation was decisive. This generation was composed of the sons of the mining elite who studied at European universities, particularly in Coimbra and Montpellier. The influence of their experiences as students, especially at the University of Coimbra, was so significant in these students' lives that they returned to Minas Gerais in the last quarter of the eighteenth century full of new ideas and bold aspirations. Although the university reforms introduced by the Marquês de Pombal suffered a major setback with the ascension of Maria I to the Portuguese throne, many new ideas emerging from the Enlightenment philosophers, especially those privileging the use and power of reason and rational government, still persisted. As a result, teaching was greatly restricted, and textbooks were censored. At the same time, the nonacademic life of the registered students became radicalized. The students met in secret groups where they discussed everything having to do with freedom. In Coimbra, several elements converged: liberalism, freemasonry, and Enlightenment philosophy, supplying the basis for religious, moral, and political criticism.[25]

da independência do Brasil: Até ao reconhecimento pela antiga metrópole, compreendo, separadamente, a dos sucessos ocorridos em algumas províncias até essa data (São Paulo, 1940); Maxwell, *Conflicts and Conspiracies*; and Furtado, *O manto de Penélope*.

24. On the connection between books and ideas of rebellion in the eighteenth century, see Robert Darnton, *Édition et sédition: L'univers de la littérature clandestine au XVIIIe siècle* (Paris, 1991). On the books possessed by the rebels, see Eduardo Frieiro, *O diabo na livraria do cônego . . .*, 2d ed. (São Paulo, 1981); Luiz Carlos Villalta, "O diabo na livraria dos Inconfidentes," in Adauto Novaes, ed., *Tempo e história* (São Paulo, 1992), 367–395; and Villalta, "Os cléricos e os livros nas Minas Gerais da segunda metade do século XVIII," *Acervo*, VIII, nos. 1–2 (1995), 19–52.

25. Pombal expelled the Jesuits from the Portuguese empire in 1759 and after that secularized the school system. In 1772, the University of Coimbra was opened to intellectual experimentation. See A. H. Oliveira Marques, *História da maçonaria em Portugal* (Lisboa, 1990), I, 68–69. The author shows how libertinism, freemasonry, and Enlightenment ideas spread among Coimbra's students at the end of eighteenth century; they met in secret clubs, and many were prosecuted by the Inquisition. Members of

The influences of these Brazilian students in the gestation of the uprising are evident in the *Autos de devassa*. The initial planning of the Inconfidência Mineira began some years before, in Coimbra, where twelve of these students, inspired by the ideals of the American Revolution, swore to bring these same ideals to Brazil. The lawyer José Pereira Ribeiro, his nephew Diogo de Vasconcelos, José Joaquim da Maia e Barbalho, Domingos Vidal de Barbosa Lage, José Alvares Maciel, and José Mariano da Câmera were part of this group.[26] When Ribeiro returned to Brazil in 1788, he brought with him Raynal's *Historie philosophique et politique des establissiments et du commerce des Européens dans les Deux Indes*. It circulated extensively among the revolutionary conspirators, who saw in the book a model providing an explanation of colonial independence in North America as well as justification for all colonies to react against oppression by intolerable taxes. The gold tax was at the center of the rebellion's complaints, and the antitax argument by British colonists strongly inspired the Inconfidencia's movement. The other text shaping the opinions of the movement was the *Recueil des Lois Constitutives des Etats Unis de L'Amerique*, which informed Barbalho's mission of making contact with the new North American republic and which was debated—along with Raynal's work—by Ribeiro and Barbosa Lage during the long sea voyage returning from Montpellier.[27]

But native Brazilians were not the only ones involved in the conspiracy. Many Portuguese also took part in the plans. Some occupied important posts in the captaincy's administration, such as the *ouvidor* Tomás Antonio Gonzaga. Even the governor, the Visconde de Barbacena, who later became one of the chief investigators, was suspected of involvement. Since some of the de-

this generation were students of Professor Domingos Vandelli, known as the one who brought freemasonry to Coimbra.

26. Francisco Adolpho de Varnhagen, "Idéias e conflitos a favor da independência em Minas," in Varnhagen, *História Geral do Brasil: Antes da sua separação e independência de Portugal*, IV (Rio de Janeiro, 1948), 311. José Alvares Maciel had arrived in 1785 as corresponding member of the Royal Academy of Sciences in Portugal. José de Sá Bittencourt e Accioli studied philosophy and natural history and was a colleague of José Alvares Maciel.

27. While José Joaquim da Maia Barbalho was a student of medicine in Montpellier, he used the pseudonym "Vendeck" to write several letters to the U.S. ambassador in France, Thomas Jefferson. He asked for support and financial resources for the rebellion as well as advance recognition of the future nation-state. His appeal was based on the two countries' shared American identity. The two men met twice at Nimes, in the south of France, in March and May 1787. Jefferson was evasive at the encounters, and he affirmed that he did not have the authority to negotiate such support and commercial commitments with the rebels.

fendants were ardent supporters of the monarchical regime, they tried to persuade the governor to take up the crown himself and become king of a new nation to be founded this time in Minas Gerais.[28] Several tax collectors were also involved. In the Portuguese empire it was a regular practice to grant private citizens the right to collect taxes. The work was leased by temporary contracts, and taxes were paid only at the end of each period. The degree to which the captaincy's tax collectors were in debt explains to a large extent their participation in the uprising. They hoped that the region's independence would bring with it the end of their debts. By the same reasoning, it is no wonder that the movement's main informant was also a tax collector.[29]

The turning point that created the conditions for this rebellion was the arrival of Dom Luís da Cunha Meneses as governor of the captaincy (1783–1788). The governor arrived with his own coterie of courtiers that took up the posts that other families in the captaincy had held for generations, including those responsible for the collection of taxes. Emblematic of this conflict was the dispute between Meneses and the ouvidor Tomás Antonio Gonzaga, who, as it turned out, was the one in charge of planning the political and administrative system after a successful revolution. Many of these disputes also involved complicated questions related to contraband, since a number of the individuals displaced from their responsibilities by Meneses had become increasingly involved in illegal trade within the captaincy. This political and economic instability within the captaincy became the subject of a famous series of satirical poems known as the *Cartas chilenas,* which depicted in humorous fashion the activities of a fictional "Fanfarrao Minesio" (a nickname that can be translated as "Mining Clown") who governed according to his own whims and followed no laws that were not of his own invention. Not surprisingly, the *Cartas chilenas* were later attributed to Gonzaga, who also composed poetry in his free time and came to be considered an important poet.[30]

It should also come as no surprise that the only governor denigrated by José Joaquim da Rocha in his last *Memória histórica da Capitania de Minas Gerais* (1788) was Luís da Cunha Meneses. In this case, the mapmaker's acerbic language reflected the frustration of someone who, like some other inconfidentes, was not compensated for his efforts through promotion. Five years

28. The rebels were split between monarchists and republicans and were not unanimous about the end of slavery because all were slaveowners.

29. For the golden tax, see A. J. R. Russell-Wood, "The Gold Cycle," in Leslie Bethell, ed., *Colonial Brazil* (Cambridge, 1987); Adriana Romeiro and Angela Vianna Botelho, *Dicionário histórico das Minas Gerais: Período colonial* (Belo Horizonte, Brazil, 2003).

30. Maxwell, *Conflicts and Conspiracies;* Tomás Antônio Gonzaga, *Cartas chilenas* (São Paulo, 1995).

earlier he had dedicated his *Descrição geográfica* to governor Meneses in the hope that this gesture would promote his military career. But, during Meneses's governorship, Rocha failed to receive a promotion despite the maps and other writings that he had produced praising the governor's exceptional qualities. We can thus begin to understand why Rocha favored the Inconfidência Mineira. The movement brought together these classes of individuals. The first consisted of an optimistic generation of young people influenced by the ideals of the Enlightenment. The second group was composed of disaffected military officers, clerks, and administrators who had become frustrated with the pace of political change within the captaincy and the third of the tax collectors who were in debt. Idealism, anger, fear, and frustration, despite being contradictory sentiments, were in the end indispensable for the conflagration that erupted.

For the second group, two solutions were possible: either independence of the captaincy or the arrival of a new governor who would bring the situation of the captaincy back to normal and reinstall the traditional families and beneficiaries of administrative favors to their rightful place. It becomes clear, then, why the first words of the memória of 1788, directed to the recently arrived governor, the Visconde de Barbacena, were so full of praise. These words reflected Rocha's hopes that his compilatory work (as expressed both within the memórias and within his maps produced during the 1770s and 1780s) would be recognized in the most appropriate way. For Rocha, Barbacena demonstrated "in his initial activities that he was the perfect governor."[31]

THE REBELLIOUS MAPMAKER

Rocha was never officially prosecuted for any crimes because his involvement with the Inconfidência Mineira was never completely proven. For investigating officials, however, his association with the movement was anything but tenuous. The military officer Basílio de Brito Malheiro, one of the individuals who denounced the movement, formally accused Rocha of being in constant contact with the rebels, and especially with Tiradentes, who frequently visited Rocha at his home. When Tiradentes was interrogated about these meetings, he said that it was true that he had spoken to Rocha on several occasions about the rebellion, but he said that Rocha was opposed to the idea and had warned Tiradentes about its inherent dangers. But Tiradentes also informed the authorities that he was very curious about some secret documents that Rocha possessed and had added to his memórias. One such document was a population map—a kind of a census—that showed the number

31. Rocha, *Geografia histórica*, 159.

of people living inside the captaincy, their distribution among the towns and villages, and their biosocial status as black, mulatto, white, free, or enslaved.[32]

Considering the more general definition of maps as "graphic representations that facilitate a spatial understanding of things, concepts, conditions, processes, or events in the human world," as J. B. Harley and David Woodward have suggested, then Rocha's population map not only conforms to this definition but becomes an instance of "cartography as inventory." Valued for its strategic importance, this kind of information was traditionally kept secret by the Portuguese crown. It could be used not only for administrative control of the population but also to organize a rebellion. In fact, upon possession of this document the rebels became aware of the necessity of starting the movement in the south of the captaincy—the most populated area. Many other documents by Rocha likely had been in the hands of the rebels, such as tax lists and geographical maps. The tax burden was an important point of tension between the crown and the population of Minas Gerais and would become the major unifying factor in exposing local dissatisfaction and creating unanimity in favor of the rebellion, just as it had in the British American independence movement. In order to guarantee the movement's success, it was imperative that the leaders of the rebellion knew precisely where the population lived, who paid taxes, and how much they paid.[33]

When Rocha came before the tribunal, he was evasive in his testimony. He said he met Tiradentes by chance and had seen no danger in lending him the population map, since he was a fellow officer (Tiradentes was a cavalry *alferes-*

32. *Autos de devassa*, IV, 116–117. For census maps and their importance, see Safier "The Confines of the Colony," in Akerman, ed., *The Imperial Map*, 155–160.

33. J. B. Harley and David Woodward, eds., *Cartography in Prehistoric, Ancient, and Medieval Europe and the Mediterranean*, vol. I of *The History of Cartography* (Chicago, 1987), xvi; Safier, "The Confines of the Colony," in Akerman, ed., *The Imperial Map*, 159; *Autos de devassa*, IV, 88; Resende, "A disputa pela história," *Varia Historia*, no. 20 (March 1999), 72. Until the end of the eighteenth century, population maps focused on a city, a village, a part of the captaincy, or a sector of the society; rarely did they show the entire captaincy. Because José Joaquim da Rocha had the opportunity to deal with several of these documents, he was the first to sum up this information about Minas Gerais in a single map. What is called a population map is in fact a statistical table displaying the population by ethnic categories. In Portuguese society, the distinction between whites, blacks, and *mestiços* was very strict as was that between the enslaved, the freed, and people born free. There are several maps of the enslaved and freed population in the Minas Gerais captaincy created for tax purposes, because, according to the tax legislation of 1736, slaveowners paid for their enslaved, and the freed population paid their own tax. See Resende, "A disputa pela história," *Varia Historia*, no. 20 (March 1999), 72, 75.

second lieutenant). Although Rocha was not prosecuted, the authorities had no doubt that he was aware of the plans for rebellion, which they mentioned in the final document of accusation against Tiradentes. The criminal proceedings of the *Autos de devassa* contain several clues suggesting Rocha's involvement with the independence movement. But the first clues pointing to Rocha's revolutionary ideology could have been found long before the trial, in his map of the Minas Gerais captaincy entitled *Mapa da capitania de Minas Geraes com a devisa de suas comarcas* (1778; Figure 3), and his geographical history of Minas Gerais, *Geografia histórica*.[34]

An initial examination of the *Mapa da capitania de Minas Geraes* (and the four county maps that provided its basis) quickly reveals that Rocha was aware of the new cartographic techniques introduced in Portugal by Manoel de Azevedo Fortes's textbook lessons. Rocha followed the modern conventions intended to make uniform geographical representations through the use of universal signs: the roads are traced *(tracejadas),* the villages are represented by a cross over a little ball, the towns are recognized by a church symbol, the country areas are covered by small trees, the rivers are traced by two parallel lines, the mountains appear in three dimensions, their shadows are hachured from the left to the right, and so forth. Furthermore, unlike many other contemporary maps, his geodetically surveyed maps promised the much desired mathematical correspondence between physical reality and the image of the land. Cities, villages, roads, bridges, and borders appeared in their exact positions and proportions. In all of Rocha's maps, a scale emphasized the correspondence between the real space and the representation of that space. Given these features, Rocha's *Mapa da capitania de Minas Geraes* is the quintessential "enlightened map," reflecting modern scientific control

34. *Autos de devassa,* IV, 116, VII, 205. Rocha prepared five maps. Four maps show the districts or counties of Serro do Frio, Sabará, Rio das Mortes, and Ouro Preto (at that time, Minas Gerais was subdivided into these four administrative counties). The fifth map shows the entire captaincy. The Portuguese word *comarca* initially meant an ecclesiastic division that was incorporated by civil government in order to organize the local administration. He named one of them Vila Rica County, although Vila Rica was in fact the capital of the county named Ouro Preto.

Rocha's introduction to the first *Geografia histórica* and one letter he addressed to the Portuguese overseas minister, Martinho de Melo e Castro, indicate that his activities as a geographer and historian were interconnected. Both developed concomitantly and culminated in 1778, when he was discharged from his military service. In that same year, he drew the five maps and started writing the first version of his geographical and historical text. See *Autos de devassa,* V, 48–49; Resende, "Estudo crítico," in Rocha, *Geographia histórica,* ed. Resende, 44.

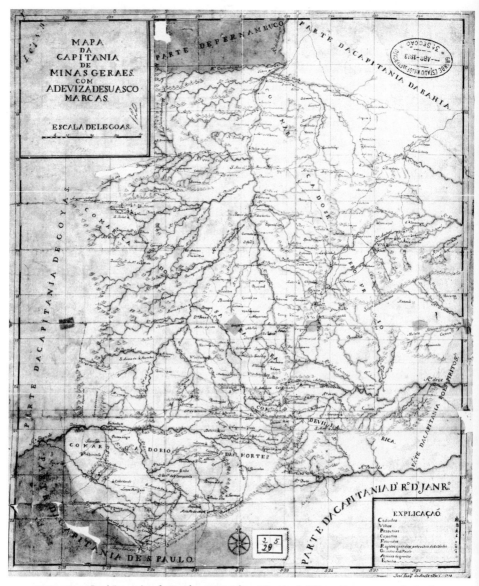

FIGURE 3. José Joaquim da Rocha, *Mapa da capitania de Minas Geraes com a devisa de suas comarcas*. 1778. Courtesy, Arquivo do Exército, Rio de Janeiro

over primitive unruly nature. But, as with all representations produced during the Enlightenment, the map's scientific posture contains a political and even revolutionary dimension.[35]

What is unique about the *Mapa da capitania de Minas Geraes* is that it shows the captaincy of Minas Gerais as an autonomous entity. Although numerous maps showing Minas Gerais had appeared over the course of the eighteenth century, not a single map had ever before represented the captaincy as a single unit and thus as potentially separate from the Portuguese colonies in Brazil. The map signaled a separatist agenda by tracing the limits between the inner counties in blue and the outside borders in red. Thus demarcated, Minas Gerais became visually separated from the captaincies of São Paulo, Rio de Janeiro, Bahia, Pernambuco, and Goiás. Once understood as a bid for regional if not national autonomy, the map easily served imperial as well as revolutionary agendas. Imperial officers who had craved cartographic knowledge finally received a map that not only showed places and distances in their correct geodetic location but also connected roads and rivers with known locations throughout the captaincy. But the same map also revealed secret information to potential revolutionaries, such as the location of military forces and fortifications. Even Indian villages—the maxacalis, the monaxós, the capoxes— were marked on the *Mapa da capitania de Minas Geraes,* completing the cartographic vision of an independent republic. Including the native centers of population denoted a paradigmatic shift in Rocha's representation of Minas Gerais. His Serro do Frio county map was dismissive of native Americans, for example describing the native population near the river Piauí as cannibals "who eat most of the other nations." By contrast, the map of the captaincy changed the text to, "where they exploited the stones *grizalitas* [sic]." By shifting the map's informational content from the imperial to the local, and the ethnographic to the economic, Rocha portrayed the natives, not as savages, but as future subjects and placed the cultural identity of the Minas Gerais captaincy in opposition to its political neighbors, the other captaincies of Brazil. This shift in regional identity is made complete in Rocha's historical geographies or memórias, where territory, population, and wealth in gold and diamonds (visible in the tax collection and in some references in the maps) would become intertwined, making the captaincy unique in relation to the

35. Bueno, "Desenho e desígnio"; Beatriz Piccolotto Siqueira Bueno, "O engenheiro artista: As aquarelas e as tintas nos mapas do novo mundo," in Júnia Ferreira Furtado, ed., *Sons, formas, cores e movimentos na modernidade Atlântica: Europa, Américas e África* (São Paulo, 2008), 375–383; Martin Brückner, *The Geographic Revolution in Early America: Maps, Literacy, and National Identity* (Chapel Hill, N.C., 2006).

rest of the Portuguese empire. These three elements—sketched out first in Rocha's maps and then elaborated in his histories—give Minas Gerais at once cohesion and a sense of identity founded on geographic alterity (otherness).[36]

Rocha finalized the cartographic formation of the captaincy as a closed territorial space separate from the rest of Brazil by abandoning the meridian of Rio de Janeiro, which had been used since the mathematical priests in the beginning of the eighteenth century as the basis for Portuguese cartographic knowledge. During the eighteenth century, European nations had established national prime meridians for locating and justifying their territories' sovereignty on maps. The British had established the meridian of Greenwich, France the meridian of Paris, Portugal the meridian of Lisbon in Europe and Rio de Janeiro in America. Attempting to use a more universal cartographic language, and in a rebellious fashion, Rocha employed instead the meridian of Ferro (Hierro) Island of the Canary Islands. In choosing this prime meridian for Minas Gerais, Rocha—wittingly or not—tested two interrelated polemical messages. In the first, by using the Ferros meridian he relocated the captaincy outside the realm of Portuguese cartographic authority and inside a much larger and explicitly international community of savants, many of whom included his rebel friends. In the second, because the Ferro's meridian was located midway between the Old and New World, Rocha's map redefined Minas Gerais as a discrete political constituent of the western hemisphere. In both readings, the meridian performed the work of nation building, much in the same way that the meridian of Philadelphia provided a symbolic measure of independence for North American mapmakers seeking to project the former British colonies as a new nation-state.[37]

As it was customary during the eighteenth century, Rocha included pictorial elements in the margins in order to fashion the map's political message. It was common to illustrate the borders of maps with colorful designs and allegorical cartouches containing the map title, the name of the mapmaker, and the scale. In the Sabará county map, entitled *Mappa da Comarca do Sabara* (Figure 4), the cartouche shows the formulaic image of a savage Indian, partly hidden behind a tree, pointing his bow and arrow at a mapmaker who, in turn, appears entirely oblivious of the threat posed by the scene. The cartographer dressed in military garb—the art of cartography was a military affair in the Portuguese empire—is focused exclusively on the task of drawing his map, in this case with a compass as his instrument. By combining standard repre-

36. José Joaquim da Rocha, *Mappa da Comarca do Serro do Frio* (1778), Arquivo Histórico do Exército," Rio de Janeiro.

37. See Brückner, *Geographic Revolution*, 118.

sentations of the pastoral and the scientific, the cartouche suggests a standoff between European and American civilization.

On the one hand, Rocha's map motifs obliquely hint less at the epistemological tensions and more at the political ones that were haunting Enlightenment sciences. All rational study of nature, including that of the land surveyor, provided the basis for religious, moral, and political criticism. In the captaincy of Minas Gerais, as in other places throughout Europe, Enlightenment ideologies spurred antireligious and liberal arguments, as doubt and skepticism were seen as integral parts of knowledge production. Jean de Senebier advised the philosophers of his time that "dogmatism was the worst enemy of observation." In the *Essai sur l'art d'observer et de faire des expériences* (1802), he affirmed that "philosophical doubt should extend to everything that exists about the object of study, from the ideas of others, up to those of great men, whose authority is generally irresistible." As the image of the Indian facing the cartographer suggests, it was not only a question of knowledge but also one of political authority. Hidden in the idyllic scene of Rocha's cartouche was the unspoken question: Who owns the land?[38]

Viewed as a whole, the map of Minas Gerais and the four county maps ostensibly conferred the land to the Portuguese monarchy. All maps were produced by military officers (like Rocha), who were in the employ of the crown and acting on the order of imperial authorities in Brazil. Looking at Rocha's thematic cartouche in the *Mappa da Comarca do Sabará*, however, the locus of authority is distinctly shifted away from the crown and toward the land surveyor occupying the land. Failing to display any of the conventional insignia that invoke imperial power, Rocha seems to suggest that the land should be owned by those who mapped and plotted it and that the act of taking possession should rely, not on the use of force, but on the use of reason. In the case of the map of Minas Gerais, it is the local elite and their youthful counterparts— the experienced local administrators and the university-trained intelligentsia of Coimbra—who are the implied owners of the territory. Read in this way, we see an entirely different kind of image emerging from what has traditionally been seen as an emblematic representation either of the advent of modern Luso-Brazilian cartography or of what Bruno Latour has called "science in action." Instead of establishing order or a center "making domination at a distance feasible," Rocha's maps transpose the colonial geographical space into a locally defined, decentralized entity no longer dependent on the metropolis.[39]

38. Jean Senebier, *Essai sur l'art d'observer et de faire des expériences*, 2d ed. (Genève, 1802), 97, 101 (translations in the text are mine).

39. Latour, *Science in Action*, 223.

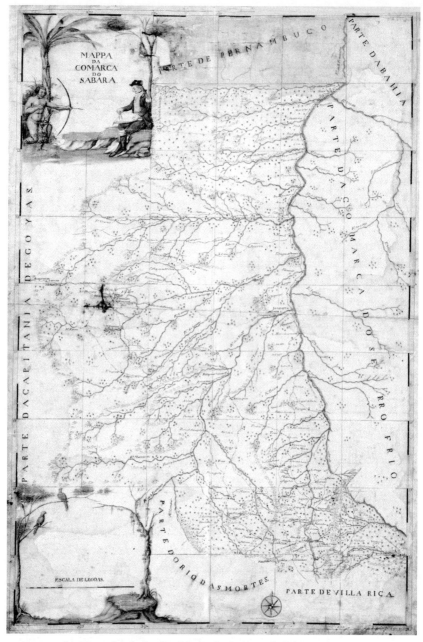

FIGURE 4. José Joaquim da Rocha, *Mappa da Comarca do Sabará*. 1778.
Courtesy, Arquivo Público Mineiro, Belo Horizonte

If the testimonies of the defendants in the *Autos de devassa* could not prove whether José Joaquim da Rocha was involved in the 1789 Inconfidência Mineira, the maps he made give us important clues. The paradise, dislocated to the border illustration that decorated the *Mapa da capitania de Minas Geraes,* refers to the diamond and gold wealth of the Minas Gerais captaincy. But this wealth was to be disputed between the Portuguese administration and the local population, and independence was one of the solutions to this conflict. Presenting the captaincy as a single unit, separated from the rest of the colony, giving all the information that the rebels would need to start a movement, using the Ferro Island meridian to orient the map, and so forth are just some of the clues that reveal the revolutionary impulse of Rocha's maps. In the end, we can say that, while the paradisiacal view of Brazilian nature was replaced by a mathematical one, the primary practice by which cartographers came to understand and represent the land showed the first signs of national self-understanding.

PART TWO

CARTOGRAPHIC ENCOUNTERS
AND LOCAL KNOWLEDGE

THE WRONG SIDE OF THE MAP?

THE CARTOGRAPHIC ENCOUNTERS OF JOHN LEDERER

Gavin Hollis

*I have not rested satisfied with a verbal Discription of the
Country from the Indians but have often made them trace
the Rivers on the Floor with Chalk, and also on Paper, and
it is surprizing how near they approach to our best Maps.*
—*Governor James Glen of South Carolina to Thomas
Robinson, 1754*

We learn to see a thing by learning to describe it.
—*Raymond Williams,* The Long Revolution

THE LIMITS OF ETHNOCARTOGRAPHY

The map has long been recognized as both a practical and ideological appara-
tus of empire. Since J. B. Harley proclaimed that early colonialist maps served
"to prepare the way for European settlement," it has become commonplace
to note that maps were instruments of possession, displacement, and domina-
tion. As Harley (and many others since) argued, "Potential settlers see, on the
map, few obstacles that are insurmountable," because mapmakers neglected
to "reflect the presence of indigenous peoples and their imprint on the land."
The presentation of a vast but cultivatable wilderness encouraged European
readers to imagine foreign lands as unclaimed, uninhabited, and submissive,
just waiting for their arrival. Harley himself was concerned not just with the
mechanics of colonialism but also with their effects on native populations. As
Matthew Edney has pointed out, Harley's last pieces indicate that the em-
phasis of his work was shifting from the hidden agenda of cartography (its
silences and secrecies) to the experiences of those affected by cartography. In

Thanks to Valerie Traub, Susan Scott Parrish, Charlotte Boulay, and the Early Mod-
ern Colloquium at the University of Michigan for reading, hearing, and commenting
upon prior versions of this essay.

the context of English settlement in Virginia and New England, Harley wondered whether "Indians saw and understood the English maps of the seventeenth century or [whether] those who saw reacted to the obliteration of their own geography." He argued that it was possible, indeed necessary, "to imagine what it was like to be on the wrong side of the map, to see the English place-names advancing across the map, or to feel the sharpness of the boundary as it cut through the ancient territory of an Indian nation."[1]

To facilitate this kind of imagining, Harley attempted to establish the groundwork for an "ethnocartographic history," particularly in relation to early colonial America—groundwork that sadly was never completed because of Harley's death in 1991. Harley never defined precisely what he meant by ethnocartographic history, but he did outline its process. It required two steps: "The first is to accept the existence of an indigenous cartography in many American cultures from the time of Columbus onward." This step is in stark contrast to an older school of cartographic historiography that denied that there was such a thing as indigenous cartography, typified for Harley by one historian who claimed "as recently as 1981" that the mapping of the New England region was characterized by "an almost complete lack of a cartographic or abstract literacy in Algonquian culture." This acknowledgement requires a broader definition of the term "map" (a word that has no equivalent in native American languages pre-contact) that includes maps made from a variety of materials, ephemeral maps, cognitive maps, and mappings as performance. Having acknowledged that native Americans produced maps (even before the Columbus era, albeit few examples of pre-contact cartography survive), Harley outlined the second step, which involved trying "to reconstruct the Indian contribution to the 'European' maps of the New World." That is, native American cartographies were instrumental to European representations of, and conceptualizations of, American landscapes, and historians of cartography have been remiss in excluding these collaborations, which took place both on and off maps.[2]

1. J. B. Harley, "Silences and Secrecy: The Hidden Agenda of Cartography in Early Modern Europe," and "New England Cartography and the Native Americans," both in Harley, *The New Nature of Maps: Essays in the History of Cartography,* ed. Paul Laxton (Baltimore, 2001), 83–107 (quotations on 105), 169–195 (quotations on 195); Matthew H. Edney, "The Origins and Development of J. B. Harley's Cartographic Theories," Monograph 54, *Cartographica,* XL, nos. 1–2 (Spring–Summer 2005), 109.

2. Harley, "New England Cartography and the Native Americans," in Harley, *The New Nature of Maps,* ed. Laxton, 170–171. I am using here the broader definition of cartography outlined by David Woodward and G. Malcolm Lewis in their volume in *The History of Cartography* series: "In this book the very terms 'map' and 'cartography,' with

Harley was right that "the Indian contribution was a major one," and he was probably not overstating the case that "most European maps . . . disguise a hidden stratum of Indian geographical knowledge." European mapmaking in the Americas was heavily indebted to native American knowledge. As Gregory Waselkov points out, "For a century and a half, information imparted by means of ephemeral maps scratched in the sand or in the cold ashes of an abandoned campfire, sketched with charcoal on bark, or painted on deerskin was incorporated directly into French and English maps, usually enhancing their accuracy." There are numerous examples of this kind of information exchange, and, although many explorers denied or obscured the natives' contributions, many others did not disguise them but recorded them, some with the patronizing air of Governor James Glen in this essay's epigraph, others with far more graciousness. Although the English seem to have been more dismissive of indigenous customs and behavior than the French, who adopted and adapted them readily, a number of English and Anglo-American cartographers and explorers openly acknowledged the usefulness of native mapping, and a handful of examples remain where native mapping is evident.[3]

One of the most famous and influential examples of the native contribution to European cartography is John Smith's map of the Chesapeake, published in 1612 (Figure 1), which, as John Hébert points out, "remained the only cartographic item based on an original survey to depict the entire bay until the appearance in 1673 of Augustine Herrman's 1670 map of Virginia and Maryland." Throughout the account that forms part of *A Map of Virginia,* Smith acknowledges the influence of his native guides and draws his readers' attention to the importance of indigenous knowledge in creating the map,

their strong Western overtones, need some elaboration. There is no cross-cultural, generally agreed definition of these terms, and none of the cultures described here apparently had a word for 'map,' let alone 'cartography,' before contact with the West. If the purpose of our definition is pragmatic rather than semantic, however, using 'map' as a general term can be helpful. Although an Australian aboriginal toa, a Marshall Islands stick chart, an Inka *khipu,* and a Luba *lukasa* memory board are very different in form and function, they all depict a people's world in a way that enhances spatial understanding." See Woodward and Lewis, "Introduction," in Woodward and Lewis, eds., *Cartography in the Traditional African, American, Arctic, Australian, and Pacific Societies,* vol. II, book 3 of *The History of Cartography* (Chicago, 1998), 1–10 (quotation on 1).

3. Harley, "New England Cartography and the Native Americans," in Harley, *The New Nature of Maps,* ed. Laxton, 171; Gregory A. Waselkov, "Indian Maps of the Colonial Southeast," in Peter H. Wood, Waselkov, and M. Thomas Hatley, eds., *Powhatan's Mantle: Indians in the Colonial Southeast* (Lincoln Nebr., 1989), 292–343 (quotation on 292).

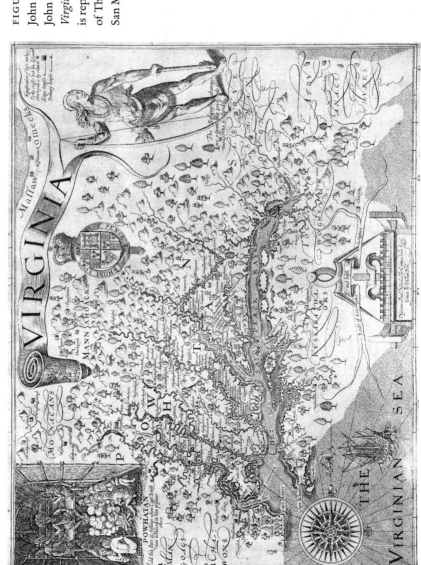

FIGURE 1.
John Smith, *Virginia*. From John Smith, *A Map of Virginia* . . . (1612). This item is reproduced by permission of The Huntington Library, San Marino, California

encouraging them to "observe this [on the map], that as far as you see the little Crosses on rivers, mountaines, or other places have beene discovered; the rest was had by information of the Savages, and are set downe, according to their instructions." The map includes the names of the Powhatans, Mangoags, Chowans, Monacans, Mannahoaks, Massowomes, Susquehannoks, Atquanachukes, Tockwoohs, and Kuskarawaocks, more than two hundred native American villages, and sixteen native names of rivers. The map presents, not a blank space inviting an effortless English dominion, but a landscape filled with place-names and a pre-contact history, with a "gyant-like" Susquehannok warrior towering over it in the top right-hand corner. Smith's reliance on his guides might have been even greater than the map lets on. By closely reading Smith's various accounts of his explorations of the Chesapeake, Waselkov has argued that Smith and his fellow settlers seem to have only visited fifty-eight of the two hundred plus villages: "So, aside from the cartography of piedmont regions beyond the Tuscan crosses, openly acknowledged by Smith as derived from Indians, we can also attribute to Indian informants considerable data on village locations, place-names, and chiefs' habitations in the coastal plain."[4]

Colonial authorities frequently relied on native sources to determine boundaries and locate hitherto unknown peoples, resources, and paths. John Lawson, surveyor general of North Carolina in the early eighteenth century, wrote how he often "put a Pen and Ink into a Savage's Hand, and he has drawn me the Rivers, Bays, and other Parts of a Country, which afterwards I have found to agree with a great deal of Nicety." A map drawn by the Towasa Indian Lamhatty, which dates from 1708, one by an unnamed Catawba in 1721, and a Chickasaw-drafted map from 1723 provide further evidence that Lawson was not alone among colonial surveyors in relying on indigenous mapmakers. Maps such as these have been important in gaining an understanding of European comprehensions of the territory to which they laid claim in

4. John R. Hébert, "The Westward Vision: Seventeenth-Century Virginia," in Richard W. Stephenson and Marianne M. McKee, eds., *Virginia in Maps: Four Centuries of Settlement, Growth, and Development* (Richmond, Va., 2000), 3–45 (quotation on 10); John Smith, *A Map of Virginia . . .* , in Philip L. Barbour, ed., *The Complete Works of Captain John Smith*, 3 vols. (Chapel Hill, N.C., 1986), I, 151; Coolie Verner, "Smith's *Virginia* and Its Derivatives: A Carto-Bibliographic Study of the Diffusion of Geographical Knowledge," in R. V. Tooley, ed., *The Mapping of America* (London, 1980), 135–172 (esp. 145–147); Gregory A. Waselkov, "Indian Maps of the Colonial Southeast: Archaeological Implications and Prospects," in G. Malcolm Lewis, ed., *Cartographic Encounters: Perspectives on Native American Mapmaking and Map Use* (Chicago, 1998), 205–221 (quotation on 213).

the early period of transatlantic colonization and of the transference of land rights that occurred in the later colonial period. They have also been used to establish certain traits of native American cartography. According to Waselkov, the maps of the American southeast in the colonial period can be divided into two types; the first "related village locations to river courses, paths, and other landscape features," and the second "conveyed primarily social and political relationships." We might add to this list maps that had little to do with wayfinding but instead displayed native American cosmography.[5]

There are, however, two major limitations to ethnocartographic historiography. First is the lack of tangible examples of native American maps. As G. Malcolm Lewis points out, native maps were often "ephemeral gestures," designed to convey messages or instructions for pathfinding. Spatial knowledge was less likely to have been recorded in material form for future use or posterity but was carried down orally between people and across generations: graphic maps (such as maps etched onto birchbark or painted onto exposed bark along a route, maps assembled from sticks or rocks, and maps drawn with chalk or marked on the ground) were formed more to aid the transmission of information than to act as storehouses for it. Although there are a number of instances of explorers and cartographers recording their use of native maps to accrue geographical information, few such maps survive before 1700 (and even post-1700 the archive is patchy). Those maps that have survived were drawn specifically for European audiences, some under duress, and often for treaties that ultimately deprived the native populations of their centuries-held land rights. Many were transcriptions drawn by Europeans and thus subject to considerable mediation. Useful though these maps are (in Mark Warhus's words) as "picture[s] of Native American perceptions and experience and documentation of their interactions with western peoples," they may not be fully representative of native American spatial epistemology.[6]

Second, ethnocartographic history tends to stress the recovery of the

5. John Lawson, *A New Voyage to Carolina; Containing the Exact Description and Natural History of That Country: Together with the Present State Thereof; and a Journal of a Thousand Miles, Travel'd Thro' Several Nations of Indians* . . . (London, 1709), 205; Waselkov, "Indian Maps of the Colonial Southeast," in Lewis, ed., *Cartographic Encounters*, 206–207. On the Lamhatty, Catawba, and Chickasaw maps, see G. Malcolm Lewis, "Maps, Mapmaking, and Map Use by Native North Americans," in Woodward and Lewis, eds., *Cartography*, vol. II, book 3 of *The History of Cartography*, 51–182 (esp. 96–106).

6. G. Malcolm Lewis, "Frontier Encounters in the Field: 1511–1925," in Lewis, ed., *Cartographic Encounters*, 9–32 (quotation on 11); Mark Warhus, *Another America: Native American Maps and the History of Our Land* (New York, 1997), 9.

"contribution" of indigenous mapping to the history of cartography. Understanding native American spatial epistemology undoubtedly enables a better understanding of how European maps of the Americas—and Euro-American understanding of the space of the Americas—came into being. Yet to privilege the contribution to European cartographic development is limiting because it reinscribes a cartographic hierarchy, as if all that native American cartography can be used for is to better understand European maps and their authorship. This emphasis reifies the teleology of European mapping, even as it critiques this teleology, by perpetuating the narrative of the history of cartography as the movement from social mapping to geometrical, scientific mapping—that is, as a developmental model in which the science of cartography superseded "primitive" spatiality. As Barbara Belyea has argued, "To recognize the distinctiveness of Amerindian maps and to understand their role in the scientific mapping of North America, we must resist the temptation to translate their signs into ours, and accept that these maps constitute a complete and valid cartographic convention without recourse to 'accuracy' or explanations in scientific terms." The desire to see from the wrong side of the map ascribes "mapness" as a form of spatial organization available only to European cartography. Indeed, even though Harley suggested the importance of "contribution" to ethnocartography, in an essay published posthumously he added a caveat about the "danger, when attempting to write cartographic history from an ethnographical perspective, of treating the Indian contribution as passive compliance with European requests for information, or believing that the Indians were the unresponding victims of the map." After all, how can native Americans be on the wrong side of "the" map if they, too, make maps? Positing an instrument called "the" map denies the multiplicity and polyvalence of maps.[7]

7. Barbara Belyea, "Inland Journeys, Native Maps," in Lewis, ed., *Cartographic Encounters*, 135–155 (quotation on 140); J. Brian Harley, "Rereading the Maps of the Columbian Encounter," in Karl W. Butzer, ed., *The Americas before and after 1492, Annals of the Association of American Geographies*, LXXXII, no. 3 (1992), 522–536 (quotation on 527). Although this essay is indebted to cartographic historians of early colonial America whose work has come before, especially those like Lewis, Waselkov, and de Vorsey who have read back from the archive of available maps to reconstruct native American cartographies and spatial epistemologies in the pre-contact and contact periods, the hierarchies of Euro-American cartographic collaboration often remain unchallenged, as is evident in the following titles: G. Malcolm Lewis, "Indian Maps: Their Place in the History of Plains Cartography," *Great Plains Quarterly*, IV (1984), 91–108; Lewis, "Native North Americans' Cosmological Ideas and Geographical Awareness: Their Representation and Influence on Early European Exploration

Two methodologies might halt the inclination to treat (and potentially to dismiss, even if an unintended consequence) native American cartography of the early colonial period as subordinate to European cartography. One is the study of individual maps known to have been drawn by native Americans or maps that have a number of features common more to native representational practices: the tendency not to differentiate between waterways and paths on land, the use of regular geometric forms to represent tribes and peoples rather than landmarks, the representation of routes in terms of journey time rather than distance traveled. This methodology requires a sureness of touch to resist the temptation of translating "their signs into ours" and of reducing native maps to sources for European maps. Indeed, the very act of reading back from the surviving archive creates the possibility of simplifying, generalizing, or totalizing native American spatial epistemology. This methodology also suffers from circular argumentation, as much of the evidence that has been used to establish the tenets of native American cartography comes from the postcontact era. A separation of European and native American cartographies therefore presupposes that there is a readily identifiable thing called native American cartography, even though the bases for this identification frequently emanate from Euro-American collaborations.

Such challenges do not warrant dismissing this methodology—indeed, this essay could not have been written without ethnocartographic work that has used the archive available—but suggest the need for it to be supplemented with a second methodology. This methodology draws on literary analysis and its proficiency for "reading the gaps" for what is not explicitly there. This might be a way for literary scholarship, which has borrowed from cartographic historiography (and Harley in particular) so frequently in recent years, to repay the debt. This methodology focuses on the examples of map-moments in colonialist texts where native guides bequeath geographical knowledge to Europeans but where no map survives. As Harley points out, "Our knowledge of Indian mapmaking is . . . largely of a textual rather than graphic nature." Many essays about cartography from the colonial period begin with these examples to prove that native Americans had maps and that these maps were important for Europeans (stage one of Harley's schema for ethnocartographic history). From these traces it is possible to reconstruct the maps behind the maps, not just to find out how native Americans might

and Geographical Knowledge," in John Logan Allen, ed., *North American Exploration: A New World Disclosed,* I (Lincoln Nebr., 1997), 71–126; Louis de Vorsey, "Amerindian Contributions to the Mapping of North America: A Preliminary View," *Imago Mundi,* XXX (1978), 71–78.

have influenced European mapmakers but also what kind of information they might have contained, how that information might have been transmitted, and what they might say about native mappings before and after contact.[8]

However, these map-moments are rarely analyzed in any great depth. Of particular interest here is what happens when we think less in terms of what makes it on to European maps and more about what gets left off them. As Belyea suggests, assigning native American cartography a contributive role ignores how difficult, indeed impossible, Europeans found it to translate their spatial epistemology. Native contributions were veiled in European maps not simply because European mapmakers deemed their knowledge to be substandard but also because they could not put the maps that they encountered and the routes and landscapes that were narrated to them into their own cartographic vernacular—that is, their representational practices and ways of experiencing space. Sometimes natives deliberately mislead the Europeans. Sometimes the information was lost in translation because of key differences in the ways in which Europeans and native Americans experienced their worlds and represented and related that experience visually, orally, or both. By examining these textual traces—or, as I will come to call them, "descriptions"—we may begin to imagine what it was like to be on the other side not just of European maps but also of native American maps as well.

JOHN LEDERER'S DISCOVERIES

We now turn to the cartographic encounters of John Lederer, a German explorer and surveyor, who lived in the English North American colonies in the 1660s and 1670s. It is not entirely clear when Lederer crossed the Atlantic from his native Hamburg, and not much is known about his life while he was in America, but what little is known shows someone with great interest and investment in native American–English relations. He caught the attention of Virginia governor William Berkeley, who in 1670 commissioned him to explore to the south and west of the colony in a bid to discover a passage to the Pacific and to open up the fur trade. Commission in hand, Lederer ventured

8. Harley, "Rereading the Maps of the Columbian Encounter," in Butzer, ed., *The Americas before and after 1492*, 524. In the last few decades, there have been numerous articles and monographs within the field of sixteenth- and seventeenth-century Anglophone literature on maps and mappings. Influential works include Richard Helgerson, *Forms of Nationhood: The Elizabethan Writing of England* (Chicago, 1992); Garrett A. Sullivan, Jr., *The Drama of Landscape: Land, Property, and Social Relations on the Early Modern Stage* (Stanford, Calif., 1998); Bernhard Klein, *Maps and the Writing of Space in Early Modern England and Ireland* (New York, 2001); Rhonda Lemke Sanford, *Maps and Memory in Early Modern England: A Sense of Place* (New York, 2002).

into North and South Carolina, explored the piedmont and the Blue Ridge Mountains, and encountered various hitherto unrecorded groups in that region.

Despite the favor he received from the governor, the resulting expeditions did not make Lederer a popular man, and he seems to have left Virginia under something of a cloud. What exactly transpired in Jamestown in late 1670 is not entirely clear, but it moved another prominent English colonialist, William Talbot, secretary of the Province of Maryland and nephew of Governor Cecilius Calvert, second Lord Baltimore, to translate from the Latin Lederer's account of his three expeditions and to publish it in London in 1672. In the address to the reader in *The Discoveries of John Lederer,* Talbot expressed his dismay that Lederer's accomplishment of traversing "those Parts of the American Continent where Englishmen never had been" was looked upon "as so great an insolence" that, upon his return, "instead of Welcom and Applause, [he] met nothing but Affronts and Reproaches." Talbot pushed the *Discoveries* into print (although "it was never by him [that is, Lederer] designed for the Press") because this "modest ingenious person, and a pretty Scholar," deserved "an occasion of vindicating himself"—although Talbot's dedication of the volume to "the Right Honourable Anthony Lord Ashley," future first earl of Shaftesbury and one of the Lords Proprietors of Carolina, indicates that he saw translating Lederer's account as an opportunity to cozy up to the most important promoter of transatlantic colonialism at Charles I's court.[9]

Although Lederer's time in Virginia was disastrous for him personally, the impact of his expeditions was considerable, at least in the short term. Encouraged by Lederer's findings, fur trader Abraham Wood sponsored two expeditions, one in September 1671 by Thomas Batts, Robert Fallam, Thomas Wood, Jack Weason, and Perecute, a Patawomeck Indian, and the other two years later by James Needham and Gabriel Arthur, both of which opened up Cherokee and Catawba trade routes to the settlers. *A Map of the Whole Territory Traversed by John Lederer in His Three Marches* (Figure 2), which was printed in the *Discoveries* and which Talbot insisted was "copied from his [that is, Lederer's] own hand," was also influential. John Ogilby's *First Lords Proprietors' Map* of 1672 incorporated Lederer's findings, as did the 1676 edition of John Speed's *Theatre of the Empire of Great Britaine.* Lederer's influence on English

9. William Talbot to Anthony Lord Ashley, and Talbot, "To the Reader," in John Lederer, *The Discoveries of John Lederer* . . . , ed. William P. Cumming (Charlottesville, Va., 1958), 4–7. On Lederer's biographical details, see William P. Cumming, "Notes and Comments," ibid., 69–107; Dieter Cunz, "John Lederer: Significance and Evaluation," *William and Mary Quarterly,* 2d Ser., XXII (1942), 175–185.

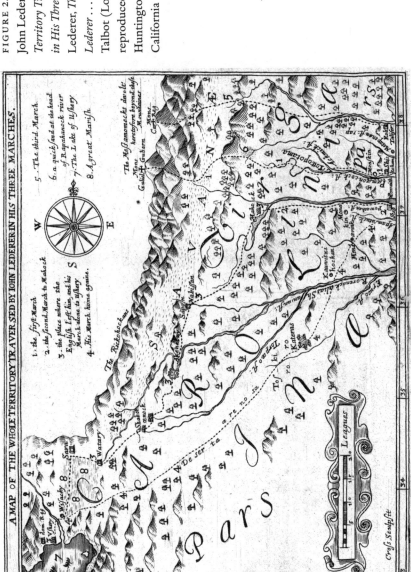

FIGURE 2.

John Lederer, *A Map of the Whole Territory Traversed by John Lederer in His Three Marches.* From Lederer, *The Discoveries of John Lederer . . .*, ed. and trans. William Talbot (London, 1672). This item is reproduced by permission of The Huntington Library, San Marino, California

cartography did not last long: Joel Gascoyne's *Second Lords Proprietors' Map* of the Carolinas (1682) expunged Lederer's journey, and Gascoyne's map was appropriated by John Lawson in his authoritative *History of Carolina* (1709). William Cumming notes that John Senex, who engraved Lawson's 1709 map, himself published *A New Map of America from the Latest Observations* in 1719, which included Lederer's findings. Although Senex's map was the last appearance of Lederer's information in English maps, atlases of the Americas by the Frenchman Guillaume de L'Isle and the German Johann Homann persisted with the information well into the eighteenth century.[10]

Lederer's *Discoveries* includes invaluable ethnographic information about groups with which he conversed or about whom he heard—the Chickahominys, the Monacans, the Manahoacs, the Saponis, the Hanahaskys, the Occaneechis, the Recahecrains, the Enos, the Shoccorees, the Xualas, the Waxhaws, the Yuchis, the Tuscaroras, the Meherrins, and the Nottoways. Nevertheless, he has been afforded little more than a footnote in the history of American exploration, and that is usually devoted to the mistakes he seems to have made. He asserted that at the farthest point reached on his first expedition he "had a beautiful prospect of the *Atlantick*-Ocean washing the *Virginian*-Shore" from somewhere near the top of the Blue Ridge Mountains. On the second expedition, he claimed to have discovered Lake Ushery, which features on his map and Ogilby's, but no one since has managed to locate this body of water. His twelve-day trek through the "barren Sandy desert, where I suffered miserably for want of water" (marked on his map as *"Deserta Arenosa"*), is baffling, since, as Cumming points out, "there are stretches of sandy pine barrens in the state of North Carolina, but none where one can go for twelve days in a *northeasterly direction* without crossing rivers." Many scholars have used these bizarre mis-mappings to doubt Lederer's veracity, proclaiming him a Baron Munchausen–style fantasist. Defenses of Lederer have ranged from pointing out that it was commonly believed in the period that a substantial body of water lay to the west of Jamestown—indeed, Talbot informed Lord Ashley in his address at the beginning of the *Discoveries:* "It is clear [from Lederer's account] that the long looked-for discovery of the *Indian* Sea does nearly approach"—to the somewhat ludicrous claims of his nineteenth-century German translator H. A. Ratterman, who believed that Lake Ushery was actually Lake Miccosukee, Florida. Even most of his defenders have con-

10. Talbot, "To the Reader," in Lederer, *Discoveries,* ed. Cumming, 6, Cumming, "Notes and Comments," 94. On Ogilby's map, see Jess Edwards, "A Compass to Steer by: John Locke, Carolina, and the Politics of Restoration Geography," in this volume.

ceded that Lederer's imagination might have gotten the better of him at certain points during his travels or during the composition of his account.[11]

Lederer's printed map has rarely been discussed in terms of the relationship between native American and European spatial epistemologies. *A Map of the Whole Territory Traversed by John Lederer in His Three Marches* is a typical colonialist map as it was designed to open up territories to European appropriation. It is criss-crossed with the three routes he took, allowing the reader to follow his progress side by side with the account and to recreate his journey. There is inviting white space at the top of the map, with a compass placed directly over it, suggesting the direction toward which the English should venture next and the open terrain that they will find. However, this map was the product of collaboration. In his narrative, Lederer is open about how heavily he was dependent on his guides. Not only did he owe his life to them on a number of occasions (for example when a "Mountain spider" [a tarantula] bit him and "an Indian suckt out the poyson") but also he greatly valued their knowledge. He encouraged his readers not to "conclude [the Indians] wholly destitute of Learning and Sciences: for by these little helps which they have found, many of them advance their natural understandings to great knowledge in Physick, Rhetorick, and Policie of Government." Although this list does not note the native American facility with mapmaking, it is clear that Lederer regularly consulted them to acquire an understanding of the lay of the land, directing his course "by the Indians instruction." Indeed, Lederer might well have picked up from his native guides the practice of making a "notch [in] the trees as you go along with your small Hatchet, that in your return you may know when you fall into the same way which you went." As Lewis argues, maps were "painted or drawn on the exposed wood of trees whose inner and outer bark had been stripped away." "A conspicu-

11. Lederer, *Discoveries*, ed. Cumming, 19, 32, Cumming, "Notes and Comments," 85–86, Talbot to Ashley, 4. On the numerous and various tribes that Lederer encountered, see Douglas L. Rights and W. P. Cumming, "The Indians of Lederer's *Discoveries*," ibid., 111–126. On the possible untruths of Lederer's account, see Clarence Walworth Alvord and Lee Bidgood, *The First Explorations of the Trans-Allegheny Region by the Virginians, 1650–1674* (Cleveland, Ohio, 1912); and Cyrus Thomas, "Was John Lederer in Either of the Carolinas?" *American Anthropologist*, n.s., V (1903), 724–727. Alvord and Bidgood claim that Lederer deliberately set about deceiving his readership (63). Thomas goes further, proclaiming the whole "journey into the Carolinas . . . a myth" (727). Ratterman's German translation was published in the Cincinnati-based German periodical *Der Deutsche Pionier (The German Pioneer)* in 1877. On Ratterman, see Cunz, "John Lederer," *WMQ*, 2d Ser., XXII (1942), 180.

ous tree on the route was blazed so the mark would be seen as the intended recipients of the message arrived." Lederer's map does limit the native contributions to some degree—the legend denotes one path that he followed as "the place where the English left him, and his March alone to Ushery," even though Lederer's account indicates that he journeyed in the company of "one *Sasquesahanough-Indian* [Susquehannock], names *Jackzetavon*," and hence not "alone" at all. Otherwise, the map does not mask its collaborative nature. It features native names and habitations, approximately thirty in all, and in the top left corner natives are depicted rowing canoes on (the probably fictional) Lake Ushery. The natives are not removed from the map, and their input was invaluable to its construction.[12]

These collaborations might have confused Lederer, however, more than enlightened him. What is interesting about Lederer's *Discoveries* is less how indigenous knowledge enabled the construction of the map than how it blurred his understanding of geography. Some of Lederer's errors seem like wishful thinking. His claim that he could see the Atlantic from atop the Blue Ridge Mountains can be attributed to his desire to shrink the distances between places for his patron, Governor Berkeley, to encourage him that the distances he had traveled would not be impossible to retrace. That Berkeley was willing him to find the Pacific Ocean on the other side of the mountains might have led him to exaggerate the size (or even presence) of Lake Ushery. Other errors can be traced to moments of information exchange with his guides. Despite stating that Ushery was "about ten leagues broad," Lederer "could neither learn or guess" how far the lake stretched to the west or what its boundaries were. Consulting his native guides did not illuminate the distances, in part because they did not measure distance by "leagues." Lederer's insistence that "the Indian Ocean does stretch an Arm or Bay from *California* into the Continent as far as the *Apalataean* Mountains" was, of course, what Berkeley wanted him to say, but it is telling that he "gathered [this information] from the stranger Indians at *Akenatzy*," who told him "of their Voyage by Sea to the very Mountains from a far distant Northwest Country." This sounds like it could have been an origin story—in the description of the mountains that begins the *Discoveries*, Lederer notes that the Appalachian Mountains are called "in Indian *Paeotinck*, (or the origine of the Indians)," but in this later passage Lederer uses this information to prove that the Indian Ocean is close by. Some of Lederer's errors originate in his desire to please his paymaster, but others

12. Lederer, *Discoveries*, ed. Cumming, 14, 22, 24, 36, 39; Lewis, "Maps, Mapmaking, and Map Use by Native North Americans," in Woodward and Lewis, eds., *Cartography*, vol. II, book 3 of *The History of Cartography*, 87.

extend from his inability to translate native American spatial epistemology into his own cartographic vernacular, despite his willingness to absorb and represent it.[13]

THE MAP IN THE DUST

A second map recorded in Lederer's *Discoveries* has not survived. In his account, Lederer describes how he set out on his second expedition in May 1670 accompanied by Major William Harris, with "twenty Christian Horse, and five *Indians*." Two days into the expedition, the party stopped by a village to orient itself. Lederer asked "an ancient Man" what path he should take to approach the mountains. The man "described with a staffe two paths on the ground; one pointing to the *Mahocks*, and other to the *Nabyssans*," thus creating an ephemeral map of the local landscape in the earth. Lederer was happy to follow the ancient man's directions. However, reported Lederer, "My *English Companions* slighting the *Indians* direction, shaped their course by the Compass due West." Harris's insistence on English technologies of wayfinding led them astray:

> And therefore it fell out with us, as it does with those Land-Crabs, that crawling backwards in a direct line, avoid not the Trees that stand in their way, but climbing over their very tops, come down again on the other side, and so after a days labour gain not above two foot of ground. Thus we obstinately pursuing a due West course, rode over steep and craggy Cliffs, which beat our Horses quite off the hoof. In these Mountains we wandred from the Twenty fifth of *May* till the Third of *June*, finding very little sustenance for Man or Horse; for these places are destitute both of Grain and Herbage.

Tension arose from Harris's obstinacy, and, as the expedition continued, relations between Lederer and Harris deteriorated. By June 3, when Lederer declared his desire to push on, "the rest of the Company were so weary of the enterprize, that crying out, *One and All*, they had offered violence to me, had I not been provided with a private Commission from the Governour of *Virginia* to proceed, though the rest of the company should abandon me; the sight of which laid their fury." On June 5, the English party left Lederer and came back to Jamestown; Lederer writes that he believed they were parting as "good friends," although when he returned he found that Harris had reported "strange things in his own praise and my disparagement ... [and] with so much industry procure[d] me discredit and odium." According to Talbot,

13. Lederer, *Discoveries*, ed. Cumming, 11, 31, 37–38.

the unfriendly reception that Lederer received in Jamestown, which resulted in his being "not safe in *Virginia*" and "[f]orced by this storm into *Maryland*," stemmed in part from the spite of Harris and company who "forsook him in the Expedition" and decided "to procure him discredit that was a witness to theirs." The parting of the ways also imperiled Lederer for the rest of the expedition, subject as he was to harsh conditions, wild animals, and the whims of his guides: Harris left him with a gun, "believing me a lost man."[14]

Harris and Lederer initially came to blows over a native map. Harris's slight of the ancient man's information possibly reflected his belief in the superiority of European technologies of space. What could be more reliable than a compass, and what less than the rudimentary scrawls of a savage? We may also assume that Harris did not much like the idea that he was being directed toward the Manohoacs ("Mahocks"), whom he feared. Taking the long crab-like way around might have seemed like the sensible option, even if it damaged the horses' hooves and caused a rift in the party. But, according to Lederer, Harris had little feel for the landscape through which he was traveling: before they parted, Harris proclaimed that the bend in the James River they had reached was in fact "an Arm of the Lake of *Canada*," a declaration that Lederer considered "vainly imagined." Lederer paints Harris as a coward who would have "raised a Pillar to the Discovery [to the Lake of Canada], if the fear of the *Mahock Indian*, and want of food had permitted him to stay." Lederer, by contrast, recognized that relying on a compass would not suffice in this case. He was content to rely on native knowledge—knowledge that, as he reported in his remarks "Of the Manners and Customs of the *Indians* Inhabiting the *Western* Parts of *Carolina* and *Virginia*" at the beginning of the *Discoveries,* "hath been conveyed from former ages to posterity," including "by Tradition delivered in long Tales from father to son." Who better to rely on than one such "father" figure? The old man knew the lay of the land, knowledge that Lederer understood to have been passed down from generation to generation, whereas the English party was traveling quite literally without maps.[15]

However, Lederer's printed map does not seem to include the information that the ancient man gave to him. Instead, the map marks out where Lederer "traversed," despite the acknowledgment in his account that the route he and Harris took was far from ideal. It would therefore be impossible for anybody using Lederer's map to follow the safer and quicker trail. Likewise, Lederer's account does not detail the ancient man's map beyond saying that it was described with a stick. The information was not recorded, so any Europeans

14. Ibid., 19–22, Talbot, "To the Reader," 5–6.
15. Ibid., 11, 12, 20–21.

attempting to open up fur-trade routes to the west of Virginia or to break through the Appalachians to California would not be able to benefit from this information. Instead, they would follow Lederer's map, read his account, be liable to make the very same mistakes, and have to take the crablike way around.

There are a number of possible reasons why Lederer did not record the route that the ancient man set out. That map might have been a botched attempt to render the path legible to Harris and Lederer in terms that they would have understood. As Governor Glen's comment shows, we know that the English taught guides to draw maps with ink on paper, and there is a possibility that the ancient man might have known what kind of map his visitors required and tried to draw one in this style. Even in Lederer's sparse account, however, we can identify certain characteristics of native American mapping from this period. As ethnocartographers such as G. Malcolm Lewis, Gregory Waselkov, and Louis de Vorsey have itemized, native American maps tended to be itinerary-based rather than what Harris and Lederer would have understood as geometrical representations of landscape. They stated where one should go and whom one should expect to encounter en route. They tended to be more concerned with social relations and social hierarchies within space than with attempting to objectively represent the land. It is therefore unsurprising that the ancient man points the way to other tribes. Lederer, it seems, encountered a map that he could not read, even though he scorned Harris for not even trying to read it and "obstinately" sending the party off on a dangerous path. This map-moment is indicative of the other points in Lederer's *Discoveries* (outlined in the previous section) where (to borrow from Martin Brückner) he gets "lost in space"—when his reliance on his guides effectively disabled him from understanding his surroundings because he could not translate their maps.[16]

16. Martin Brückner examines a similar phenomenon in relation to the Lewis and Clark expedition. The geographical information acquired from the Mandan and Hidatsa tribes in Missouri disoriented Lewis and Clark because, "in transcribing the maps offered by Big White and others, [they] assumed the Mandan and Hidatsa maps were part of a universal writing system shared by both the native population and Anglo-American geographers," an assumption that led to the expedition's becoming "lost in space": "Rivers didn't show up where they were supposed to be; distances were off by hundreds of miles; projected villages were regularly missing because they had long since ceased to exist. The expedition's progress and its literary project were fundamentally disrupted from the moment when Lewis realized not only that he had misread the Native American maps but that he and his fellow note takers had no recourse to a geographical lexicon or mode of representation by which to decipher the

Lederer's account also suggests key differences in the ways that Europeans and native Americans related their experiences of geography to one another. Although Lederer's understanding of what was around him was aided by conversing with his guides, his experiences were almost always mediated by vision. On his first expedition, he saw "a Rattle-snake of an extraordinary length and thickness" that he "judged . . . two yards and a half or better from head to tail." On his second expedition, he "saw great store of Pearl" among the Nahyssan Indians. He "was an eye-witness of" an Ushery man who stood "bare-foot upon burning coals for near an hour, and then recovering his senses, leap[t] out of the fire without hurt, or signe of any." This emphasis on sight seems logical—it would seem to be the preeminent sense for the cartographer—but it was not the only means by which he experienced the landscape, nor was it the primary mode by which his guides communicated spatial relations. He could comprehend his surroundings fully only through the information given to him by his native guides, who knew the landscape far better than he did but for whom sight might not have been the privileged sense of geographical experience, nor, indeed, of mapmaking.[17]

Lederer noted that the cultures he encountered on his expeditions were predominantly oral. As Paul Rodaway suggests, the role of sound in cultures such as the ones Lederer encountered "suggests a geographical experience less dominated by the visual, more multisensual and often more acutely tuned to the peculiar properties of sound in the environment." This "auditory geography" extended not just to the senses but also to the transmission of that sense data from voice to ear rather than from image to eye. European cartography "for them was quite alien since . . . [t]his was an auditory world of events, processes and actions, not the visual world of places, patterns and objects." I here extend Rodaway's argument to contend that indigenous cartography was frequently alien to European observers because, put simply, they were observers, not auditors. Although Lederer records what he saw in his three expeditions, he is less certain about what he hears—at no point in his narrative does he record what he heard beyond the stories that his guides told him. His personal, or sensual, experience of the landscape is predominantly visual rather than aural. Indeed, he sometimes distrusts things that he has not seen and of which he only has reports from his guides. He refuses to believe the Indians that the aforementioned rattlesnake scared their squirrel-prey to

Mandans' and Hidatsas' thick description of the land, a land constructed in terms of time as well as space." See Brückner, *The Geographic Revolution in Early America: Maps, Literacy, and National Identity* (Chapel Hill, N.C., 2006), 223, 226–227.

17. Lederer, *Discoveries*, ed. Cumming, 15, 24, 31.

death, preferring to "believe what I have heard from others, that these Serpents climb the trees, and surprise their prey in the nest." In this case, it is not clear whether Lederer means "other" Indians or Europeans. Lederer restrains himself from commenting on the "rich Commodities and Minerals there are undoubtedly in these parts" because, "having tied my self up to things onely that I have seen in my Travels, I will deliver no Conjectures." But at other points he admits that conjecture is vital to his account. Lederer's confused methodology is perhaps best illustrated when he claims that the Blue Ridge Mountains run parallel to the Atlantic, "according to the best of my observation and conjecture." Despite his wariness about commenting on what he has not seen, he is forced to do so: to be able to conjecture, he must consult his guides and translate their cartographic vernacular into his own, because their knowledge of the land far exceeds his own, even if they do not communicate this knowledge in ways that he can always translate.[18]

Which brings us back to the Indian village, Major Harris, and the ancient man's map. Lederer states that the man "described" the route with his stick. The word "describe" suggests that the figure that the man drew was accompanied by a narrative account of the journey. The map was both oral and visual, with the drawn component designed, not to record information for future circulation and use, but as a provisional "document" that was expected to be memorized along with its narrative—and subsequently reproduced only when the information was to be passed on again. The material object—the map—was transient, because the transmission of the information was spoken, not written. However, Lederer and Harris do not seem to have been able to understand this narrative element fully—Harris because he rejects it, Lederer because he doesn't record it—and hence they were unable to interpret the ancient man's "description." They might have listened to the narrative, they might have witnessed the man drawing the lines on the ground, but, because they were restricted by their understanding of maps as written, material constructs and because they were unable to extend this understanding to incorporate alternative cognitive cartographies, they could not *hear* the map. We might remember again Governor Glen, who refused to trust the "Discriptions" of the Indians but praised their detailed graphic maps as nearly approaching "our best maps." As far as European explorers were concerned, a map was drawn roughly to scale on a flat sheet of paper—with some indication of direction and clearly established landmarks—which could be folded up and carried with them. The ancient man's map had few of the trappings of

18. Paul Rodaway, *Sensuous Geographies: Body, Sense, and Place* (London, 1994), 109–110; Lederer, *Discoveries*, ed. Cumming, 9, 16, 29.

European cartography. There are none of the tools that enabled the translation of map space to "actual" measurable space. All Lederer and Harris could see were two lines drawn on the ground.

DESCRIPTIONS, MAPS, ARCHIVES

Lederer's account, his mis-mappings of the landscape, and his inability to map the ancient man's description point to wider issues in ethnocartography. Not all indigenous mapping could be incorporated by European cartography. Native Americans and Europeans experienced, recorded, and transmitted geographies in different ways. If we look only at the maps that survive, we will always get a skewed vision and will be liable to conflate collaboration with contribution, not just because most of these maps were drawn by Europeans but also because we overemphasize the visual aspects of cartography and ignore alternative ways in which a landscape might be mapped. Our archives—even those of oral cultures—tend to privilege material objects. We lack records of oral geographies from this period, which makes the reconstruction of such cartographic encounters difficult.

To begin to re-imagine native American cartographies not as the ur-maps for colonial cartographers, I propose a new archive of maps that did not survive in material form but of which we have descriptions. I use the word "description" because it suggests both written and spoken modes of recording and transmitting information: even though this archive would rely on textual traces from European explorers' accounts, these traces combine both the graphic (as they were recorded in writing) and the verbal (as they were the result of oral or oral / visual mapping). This archive would enable the reconstruction of the origins of certain European maps and provide records of other maps that have not survived; indeed, an examination of these descriptions is the primary way that ethnocartography has itemized otherwise lost maps. More important, it will enable us to wrestle with the native-European cartographic encounters that were formed on the hoof using ephemeral materials and that were not preserved for posterity. Of course, we would again be reliant on European recorders, their biases, and their modes of experiencing space. But, by analyzing these descriptions, we may also detect exchanges of information that were not understood by their European recorders, evident in the case of Lederer because he did not record the ancient man's path on his map and also in other sources where the ways in which the exchanges are written about may indicate a lack of comprehension. We might get a better understanding of the sheer untranslatability of different cultures' mappings, as the archive would gather moments of cartographic exchange where something gets lost in the exchange, where Europeans do not incorporate the in-

formation, where they seem to have misheard the information given to them, and where there seems to be confusion and disorientation.

This archive would include the exchange between Hernando de Alarçon and a Halchidhoma Indian in 1540, from which the maps have not survived. In his account of his expedition translated in Richard Hakluyt's *Principal Navigations*, the Spanish explorer asked his elderly guide to "set me downe in a charte as much as he knew concerning that River [the Colorado], and what maner of people those were which dwelt upon the banckes thereof of both sides"; in exchange, "he requested me that I would describe my countrey unto him, as he had done his unto me. And for to content him, I caused a draught of certaine things to be made for him." The effect of the European description of home on the Halchidhoma goes unrecorded—de Alarçon simply says that it was done to "content" the man, and maybe the man did feel "content" with this information exchange. The effect of the "chart" on the Europeans is also difficult to trace, but, shortly after describing the map exchange, he reported, "I could not attaine to the knowledge of that which I sought for," and as a result "determined to returne unto my ships." The Spanish turned back down the Colorado River, rather than pressing on, which suggests that they were given a "chart" of the Colorado River that had limited use, and perhaps was even of limited legibility. Whatever the elderly Halchidhoma described, de Alarçon did not put it into practice.[19]

The archive would include the map drawn for the French explorer Jacques Cartier at the Lachine Rapids on the Saint Lawrence River in 1541. Cartier and his party were searching for a way through to the third "Sault [Fall]" and then on to Saguenay, and four young Iroquois men "as well by signes as wordes" gave them directions: first they "shewed us and gave us to understand, that wee were at the second Sault"; however, "the River was not navigable to goe to Saguenay." The Iroquois described a prospective path with "certaine little stickes, which they layd upon the ground in a certaine distance, and afterward layde other small branches betweene both, representing the Saults. And by the sayde marke, if their saying be true, it can be but six leagues by land to passe the sayd Saults." Lewis is no doubt correct that "the placing of the 'little stickes' modeled the three Lachine Rapids and the St. Lawrence River for an undetermined distance beyond." No map has survived to prove Lewis's

19. "The Relation of the Navigation and Discovery Which Captaine Fernando Alarchon Made by the Order of the Right Honourable Lord Don Antonio de Mendoça Vizeroy of New Spaine, Dated in Colima, an Haven of New Spaine," in Richard Hakluyt, *The Principal Navigations, Voyages, Traffiques, and Discoveries of the English Nation* . . . , IX (Glasgow, 1904), 279–318 (quotation on 315–316).

point: the account as published in Hakluyt's *Principal Navigations* boasts, "Here after followeth the figure of the three Saults," but no graphic representation is present in the edition, and no reason is given for the omission. In the account of Cartier's expedition in Hakluyt, the French party does not put this map into practice to get to the third "Sault" by land. The account ends abruptly shortly after the description of the map, with Hakluyt explaining that "The rest [of the account] is wanting," but the *Principal Navigations* supplements the account with letters dated June 19, 1587 (nearly five decades after the expedition), from Jacques Noël, nephew of Cartier, who was with his uncle during these cartographic exchanges. In the letter, Noël complains to his addressee about "a Mappe printed at Paris" on which "the River of Canada [the Saint Lawrence] . . . is not marked as it is in my booke, which is agreeable to the booke of Jaques Cartier: and that the sayd Chart doth not marke or set downe The great Lake, which is above the Saults, according as the Savages have advertised us, which dwell at the sayd Saults." The Paris-published map did not incorporate the Iroquois stick map, much to Noël's chagrin. However, Nöel's interpretation of the Iroquois map does not agree with the account of the map that precedes it: according to his recollection, the distance to the third sault "is not above five leagues journey," rather than the previously advertised six. Moreover, when Noël goes on to describe the distance between the third sault and the Great Lake, which according to the Iroquois is "ten dayes journey," he then admits, "We know not how many leagues they make to a dayes journey." As with Lederer's trying to describe Lake Ushery in the following century, confusions seem to stem from differing senses of measurement. Noël and Cartier's recorder in 1541 use a European measurement (a league is approximately three miles) and apply it to a native map, even though they do not know exactly what scale their Iroquois cartographers are using—which begs the question: How exactly could Nöel expect the Paris map to incorporate the stick map when scale cannot be established?[20]

The archive would include other John Smith maps—not the ones that he produced with his own hand, such as the 1612 map of Virginia with which I began this essay—but those that were drawn for him in his various encounters. In one example, Algonquian Virginians made a three-dimensional cosmographical map on the ground in Smith's presence during a three-day cere-

20. "The Third Voyage of Discovery Made by Captaine Jaques Cartier, 1540; unto the Countreys of Canada, Hochelaga, and Saguenay," in Hakluyt, *Principal Navigations*, VIII, 263–274 (quotations on 270–273); Lewis, "Maps, Mapmaking, and Map Use by Native Americans," in Woodward and Lewis, eds., *Cartography*, vol. II, book 3 of *The History of Cartography*, 68.

mony, and they even included, on the outer limits of the map, Smith's home country. Although Smith did not represent the map graphically, his detailed description has allowed ethnographers to reconstruct what the map might have looked like. Smith, however, did not always know what to do with the information he was given. In his later account *The Generall Historie of Virginia, New-England, and the Summer Isles* (1624), Smith recalls how, during the "coronation" ceremony of the Powhatan chief Wahunsunacawh in 1608, he was corrected about their being "any salt water beyond the mountaines" and informed that "the Relations you have had from my people are false." Wahunsunacawh then "began to draw plots upon the grounds (according to his discourse) of all those Regions," describing for Smith what his territory looked like and pointing out the errors that his previous cartographic encounters had instilled in him. We have seen that the belief that the Pacific Ocean was on the other side of the Appalachians persisted well beyond Smith's day; Lederer was convinced of it in the 1670s, as was his patron Governor Berkeley and his champion William Talbot. What is interesting, and puzzling, here is that Smith did not include Wahunsunacawh's geographical correction on his map. The 1612 map was reprinted, with minimal additions, in the 1624 *Generall Historie,* and the large body of water to the west of Jamestown remained mapped at the top (and hence most western point) (see Figure 1). Smith ignored the Powhatan map that had been described to him by Wahunsunacawh, even though elsewhere in his *Map of Virginia* he acknowledged his indebtedness to native knowledge.[21]

The three examples I have included in this section are not meant to be exhaustive. Indeed, the archive of cartographic descriptions could also include other oft-quoted, but little analyzed, examples, such as the map drawn in chalk for Bartholomew Gosnold in New England in 1602; the map constructed from pebbles by either Pawtuckets or Massachusetts for Samuel de Champlain in 1605; the map drawn on the ground by a guide with his foot for the newly arrived English in Virginia in 1607; a map drawn with chalk by a Munsee Delaware in the Upper New York Bay in 1619. Some of these cartographic encounters appear to have been effortless, even though we may be skeptical about the ease with which these exchanges of information took place; others, like the maps described in accounts of expeditions by de Alarçon, Cartier, Smith, and Lederer, betray their fault lines, either because graphic representations of the native American maps are not included or, perhaps more so, because the information being communicated remains unread, misread, or misappro-

21. John Smith, *The Generall Historie of Virginia, New-England, and the Summer Isles . . .* (1624), in Barbour, ed., *Complete Works,* II, 184.

priated. We may from these instances (and others like them) not only be able to partially reconstruct native American mappings but also to reimagine the processes by which spatial knowledge was exchanged and not exchanged—what maps were described by native Americans, what got incorporated by Europeans, what did not, and why. Through the cracks in the narratives, we might also be able to hear, as well as see, these cartographic encounters more clearly, even if the recorders of these encounters did not.

AN IMAGE TO CARRY
THE WORLD WITHIN IT

PERFORMANCE CARTOGRAPHY
AND THE SKIDI STAR CHART

William Gustav Gartner

Nawa Attias,	*Father,*
Ri tukawa skituk	*I'm praying to you*
Wi tihrak chiksti huru	*We are happy*
Tat ta ruu cha a'hu	*I am praising you*
A chiks ka pakis	*You have given blessings*
Ti rus ka ha rat rirut	*Thank you.*
nawa iri.	

It is only proper that cartographic historians ask permission and seek guidance when trying to understand indigenous maps on their own terms. However, scholars should realize the enormous burden that we place on all indigenous peoples through our research, even when we seek informed consent before publication. We ask much of indigenous peoples and give very little in return.

One important issue for many American Indians is that the pursuit of knowledge often undermines cultural self-determination. Maps such as the Skidi Star Chart are a graphic index of a cultural system. The act of publication disrupts traditional networks of knowledge sharing, privileges certain "knowable" components of that cultural system over others, and permits readers to use that published information in any way. My analysis may provide some insights concerning how the Skidi Star Chart works, but it is fragmentary and incomplete at best. Although the image is widely disseminated on the internet and in other media, any interpretation or use of the Star Chart gives it a life independent of Skidi concerns. The Skidi Star Chart is a sacred living artifact, and the Skidi Pawnee have precious few heritage artifacts left.

At their band meeting in May 2011, the elders of the Skidi Pawnee gave us permission to publish an extant image of the Skidi Star Chart and forwarded editorial requests. I am truly grateful to all those members of the Pawnee Nation of Oklahoma who took the time to consider this essay and our petitions concerning the Skidi Star Chart.

* * *

Cartographic historians have documented many examples of American Indian mapping and mapmaking in the aftermath of the Columbian encounter.[1] Although maps embody and shape the societies that produce them, there have been few attempts to understand American Indian maps on their own terms.[2] Many Western scholars find the distinction between mapping, or ana-

Many people have contributed to this essay over the years. First and foremost, I'd like to thank James Murie, Roaming Scout, and the other members of the Pawnee Nation who labored to keep Pawnee traditions alive during a time of indescribable sorrow. Malcolm Lewis, Mary Pedley, Matthew Edney, and Martin Brückner offered helpful comments and insights on early drafts. Yi-fu Tuan provided helpful suggestions and kindly paid the fees associated with this publication. The Field Museum of Chicago supplied the image of the Skidi Star Chart. The thoughtful comments and diligent review of Von Del Chamberlain immeasurably improved this essay. Finally, my sincerest thanks to Virginia Montijo and Fredrika Teute for all of their cultural simpatico, hard work, and expert editorial advice. Few editors would have done so much for an author.

This essay is dedicated to the memory of my dear friend David Woodward (1942–2004). The initial version of this essay was written in the early 1990s when I enrolled in David's History of Cartography class at the University of Wisconsin-Madison. Portions of that unpublished paper have been excerpted by various authors over the years. I promised David that I would revise and publish the essay in its entirety. Please absolve the individuals and organizations above for all errors or omissions, as I alone am responsible for any blunders that are surely contained herein.

1. Comprehensive catalogs of American Indian maps have been assembled by G. Malcolm Lewis, "Maps, Mapmaking, and Map Use by Native North Americans," in David Woodward and Lewis, eds., *Cartography in the Traditional African, American, Arctic, Australian, and Pacific Societies, History of Cartography,* vol. II, book 3 of *The History of Cartography* (Chicago, 1998), 51–182; and Mark Warhus, *Another America: Native American Maps and the History of Our Land* (New York, 1997). Louis De Vorsey, "Amerindian Contributions to the Mapping of North America: A Preliminary View," *Imago Mundi,* XXX (1978), 71–78, showed that American Indians were often sources of geographic information during the Euro-American mapping of eastern North America. On American Indians' often providing Euro-Americans with detailed geographic information throughout the continent, see Lewis, "Maps, Mapmaking, and Map Use," in Woodward and Lewis, eds., *Cartography,* 71–79, 95–108, 112–115, 125–129, 143–145; Lewis, "First Nations Mapmaking in the Great Lakes Region in Intercultural Contexts: A Historical Review," *Michigan Historical Review,* XXX, no. 2 (Fall 2004), 7–26; Martin Brückner, *The Geographic Revolution in Early America: Maps, Literacy, and National Identity* (Chapel Hill, N.C., 2006), 204–227; and John Rennie Short, *Cartographic Encounters: Indigenous People and the Exploration of the New World* (London, 2009).

2. Peter Nabokov, "Orientations from Their Side: Dimensions of Native American Cartographic Discourse," in G. Malcolm Lewis, ed., *Cartographic Encounters: Perspectives on Native American Mapmaking and Map Use* (Chicago, 1998), 241–269, provides a concise and insightful essay on the many dimensions of American Indian maps, which

logical expressions of spatial knowledge, and mapmaking to be a useful one. They typically privilege the inscription over all other forms of spatial knowledge and divorce the artifact from rituals, oral traditions, and other aspects of

may be inscribed on various media, and their links with cosmography, cartographic performance, and the paths of everyday life. Lewis, "Maps, Mapmaking, and Map Use," in Woodward and Lewis, eds., *Cartography*, 57–62, 79–94, 109–112, 166–176, also documents the diverse media used by American Indians to make maps. American Indian maps often structured geographic information topologically, rather than by means of a geographic coordinate system or projective geometry. In addition, American Indians often ordered geographic categories on the basis of cultural relevance rather than by the magnitude of a physical property on an absolute scale. For details and examples, see G. Malcolm Lewis, "Indian Delimitations of Primary Biogeographic Regions," in Thomas E. Ross and Tyrel G. Moore, eds., *A Cultural Geography of North American Indians* (Boulder, Colo., 1897), 94; and Lewis, "Intracultural Mapmaking by First Nations Peoples in the Great Lakes Region: A Historical Review," *Michigan Historical Review*, XXXII, no. 1 (Spring 2006), 2–14. R. A. Rundstrom, "The Role of Ethics, Mapping, and the Meaning of Place in Relations between Indians and Whites in the United States," *Cartographica*, XXX, no. 1 (Spring 1993), 22–23, 25, and Rundstrom, "A Cultural Interpretation of Inuit Map Accuracy," *Geographical Review*, LXXX (1990), 155–168, both suggest that many native North Americans privileged the naming of places and repetitive acts of "environmental mimicry" over geographic inscription. Klara Kelley and Harris Francis, "Traditional Navajo Maps and Wayfinding," *American Indian Culture and Research Journal*, XXIX, no. 2 (2005), 85–111, shows the importance of Diné oral traditions for both terrestrial wayfinding and the interpretation of related cosmographic maps.

Alex M. Carroll, M. Nieves Zedeño, and Richard W. Stoffle, "Landscapes of the Ghost Dance: A Cartography of Numic Ritual," *Journal of Archaeological Method and Theory*, XI (2004), 127–156, interprets the Northern Paiute ghost dance as a cartographic performance that fused ritual, material culture, and topography into a liturgical order. Cartographic encounters between Euro-Americans and American Indians well illustrate the diverse and conventional nature of all cartography as detailed by Barbara Belyea, "Amerindian Maps: The Explorer as Translator," *Journal of Historical Geography*, XVIII, no. 3 (July 1992), 270–275; Belyea, "Mapping the Marias: The Interface of Native and Scientific Cartographies," *Great Plains Quarterly*, XVII (1994), 165–184; Brückner, *The Geographic Revolution*, 204–227; G. Malcolm Lewis, "Frontier Encounters in the Field, 1511–1925," in Lewis, ed., *Cartographic Encounters*, 11–26; Lewis, "First Nations Mapmaking," *Michigan Historical Review*, XXX, no. 2 (Fall 2004), 7–26; and Rundstrom, "The Role of Ethics," *Cartographica*, XXX, no. 1 (Spring 1993), 21–28. Both Belyea, "Amerindian Maps," *Journal of Historical Geography*, XVIII, no. 3 (July 1992), 270–275, and Matthew Sparke, "Between Demythologizing and Deconstructing the Map: Shawnadithit's Newfound-land and the Alienation of Canada," *Cartographica*, XXXII, no. 1 (Spring 1995), 1–21, note the many problems of interpreting American Indian maps as images of the world whose meanings are fixed at the moment of production or at the time of Euro-American acquisition.

social life.[3] Yet the distinction between mapping and mapmaking constrains the types of critical knowledge, not to mention perspectives, that permit a more holistic and accurate reading of native maps.

The Star Chart, an image of the heavens painted by the Skidi band of the Pawnee of south-central Nebraska sometime before 1867, has been interpreted in many different ways (Figure 1). An older generation of scholars argued that the Skidi Star Chart was a reference map of the night sky—a highly accurate spatial inventory of celestial objects and movements that showed "a knowledge of astronomy comparable to that of the early white men." Today, many view the Skidi Star Chart as a conceptual portrait of the heavens—a mnemonic device employed during certain rituals and the narration of cosmologic tales. The extent to which the Skidi Star Chart represents actual astronomical phenomena, as opposed to purely conceptual or mythological entities, is a matter of considerable debate. There is one point of general consensus. Most researchers approach the Skidi Star Chart from the perspective of an earth-bound viewer looking up at the heavens (Figure 2).[4]

3. Denis Wood, "The Fine Line between Mapping and Mapmaking," *Cartographica*, XXX, no. 4 (Winter 1993), 56. Before Wood's influential essay, Robert A. Rundstrom, "Mapping, Postmodernism, Indigenous People, and the Changing Direction of North American Cartography," ibid., XXVIII, no. 2 (Summer 1991), 2–5, presciently argued that the preoccupation of Western academics with text precluded any engagement with indigenous cartography, as many non-Western peoples do not separate the performative aspects of mapping from the geographic inscriptions upon an artifact.

4. Ralph N. Buckstaff, "Stars and Constellations of a Pawnee Sky Man," *American Anthropologist*, XXIX (1927), 285; Matthew W. Stirling, "Indians of Our Western Plains," *National Geographic*, LXXXVI, no. 1 (July 1944), 105; Von Del Chamberlain, *When the Stars Came Down to Earth: Cosmology of the Skidi Pawnee Indians of North America* (Los Altos, Calif., 1982), 185–206; Douglas R. Parks, "Interpreting Pawnee Star Lore: Science or Myth?" *American Indian Culture and Research Journal*, IX, no. 1 (1985), 58–59, 63–64; Donald Blakeslee, review of *When the Stars Came Down to Earth: Cosmology of the Skidi Pawnee Indians of North America*, by Von Del Chamberlain, *Plains Anthropologist*, XXX, no. 107 (February 1985), 78; Lewis, "Maps, Mapmaking, and Map Use," in Woodward and Lewis, eds., *Cartography*, 123–125. I use the term "Pawnee" in a general sense throughout this essay. The Pawnee Nation is a long-standing confederacy between the formerly independent, yet closely related, Skidi, Chawi, Kitkahahki, and Pitahawirata bands. James Murie used the term "Skiri," rather than the more modern "Skidi," in his writings. Martha Royce Blaine, *Pawnee Passage, 1870–1875* (Norman, Okla., 1990), xii, notes that "Skiri" is linguistically correct, because there is no *d* sound in the Pawnee language. She further indicates that the term "Skidi" became common in historic documents and is now used by most Pawnee peoples today. The noted linguist Douglas Parks retained the use of "Skiri" in his commentaries on James Murie's manuscript. Since Pawnee peoples today prefer the term "Skidi," I use it throughout this essay except in direct quotations.

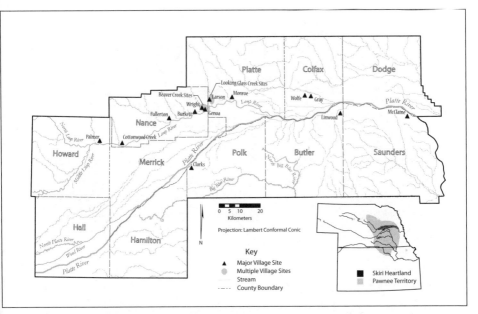

FIGURE 1. The Skidi Pawnee Heartland in Eastern Nebraska, circa AD 1500–1876. Drawn by William Gustav Gartner. Compiled from Waldo Rudolph Wedel, *An Introduction to Pawnee Archaeology* (Washington, D.C., 1936); Douglas R. Parks, "Bands and Villages of the Arikara and Pawnee," *Nebraska History*, LX (1979), 214–239; John M. O'Shea, "Pawnee Archaeology," *Central Plains Archeology*, I (1987), 49–107; David J. Wishart, *An Unspeakable Sadness: The Dispossession of the Nebraska Indians* (Lincoln, Nebr., 1994); and Nebraska Geospatial Data Center, http://dnr .ne.gov/databank/geospatial.html (accessed March 2011).

The map shows the major Lower Loop phase (AD 1500–1750) and selected historic Pawnee village sites before the forced removal of the Pawnee from 1874 through 1876

Scholarly interpretations of the Skidi Star Chart differ markedly in terms of function, meaning, and spatial accuracy. Such differences are not surprising. The arrangement of signs on the Skidi Star Chart intuitively appeals to Western spatial sensibilities. Yet, at first glance, it is difficult to reconcile the spatial arrangement of signs on the Skidi Star Chart with ethnographic snapshots of its use. Skidi peoples ostensibly used the Skidi Star Chart as a flag or beacon during the Thunder Ceremony and carried it as a baton in a race during the Great Washing Ceremony. Maize cobs, rather than people, consulted the Skidi Star Chart during the Shelling the Sacred Ear of Corn Ceremony. These are curious uses for a map from a Western perspective! Given that few scholars appreciate the cultural richness embodied by the term "map," it

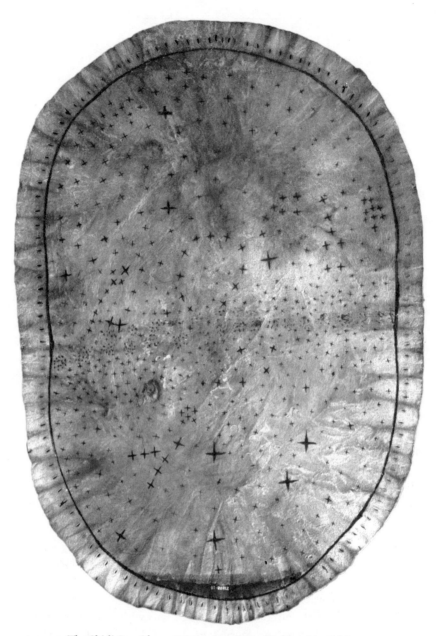

FIGURE 2. The Skidi Star Chart. Orientation: West (Golden Sunset) is at top. By kind permission of the Skidi band of the Pawnee Nation of Oklahoma. Image source: © The Field Museum, #CSA16231c

is not surprising that the Skidi Star Chart is often characterized as a "mnemonic device."[5]

The Skidi Star Chart offers a remarkable opportunity to understand native maps on their own terms. Ethnographic accounts document Skidi use of the Star Chart in 1867. As detailed below, however, its initial conception, if not its material origins, predates sustained contact between Pawnee peoples and Euro-Americans.[6] A large corpus of exemplary archaeological, astronomi-

5. In my opinion, the classification of the Skidi Star Chart as a "mnemonic device" raises more questions than it answers. How does the Skidi Star Chart facilitate memorization and storytelling? What are the associated narratives? The boundary between maps, artifacts, and mnemonic devices is a fuzzy one, even in Euro-American contexts. Yi-Fu Tuan, "The Significance of the Artifact," *Geographical Review*, LXX (1980), 462–472, argues that people establish a sense of self through heirloom, heritage, and other artifacts as they evoke particular places, times, and narratives. Preciosities often embody narratives of distant places and exotic geographies, as argued, for example, by Mary W. Helms, *Ulysses' Sail: An Ethnographic Odyssey of Power, Knowledge, and Geographical Distance* (Princeton, N.J., 1988). Denis Wood and John Fels, *The Natures of Maps: Cartographic Constructions of the Natural World* (Chicago, 2008), 104–110, 208–211, characterizes the U.S. Geological Survey topographic map as "garrulous." I suspect that before the impersonal relations engendered by global capitalism and mass production, most artifacts and maps were mnemonic and didactic devices to some degree.

6. Gene Weltfish, *The Lost Universe: Pawnee Life and Culture* (Lincoln, Nebr., 1965), 84–85, 151–156, details the role of the Skidi Star Chart in several ceremonies during 1867. A "traditional map" is difficult to operationalize for reasons detailed in Notes 2 and 3, above, and because the timing and extent of European contact are debatable. The Lower Loup phase (circa AD 1500–1750) is an archaeological taxon equated with the protohistoric Skidi. Archaeologists excavated historically documented Pawnee villages of the late eighteenth and early nineteenth centuries and then used the assemblage of unique traits to link specific Pawnee bands with older villages. See Waldo Rudolph Wedel, *An Introduction to Pawnee Archaeology* (Washington, D.C., 1936); Wedel, *The Direct-Historical Approach in Pawnee Archeology*, Smithsonian Institution, *Miscellaneous Collections*, XCVII, no. 7 (Washington, D.C., 1938); William Duncan Strong, *An Introduction to Nebraska Archaeology*, ibid., XCIII, no. 10 (1935), 55–68; and John M. O'Shea, "Pawnee Archaeology," *Central Plains Archeology*, I (1987), 49–107. Karl H. Schlesier, "Commentary: A History of Ethnic Groups in the Great Plains, A.D. 150–1550," in Schleiser, ed., *Plains Indians, A.D. 500–1500: The Archaeological Past of Historic Groups* (Norman, Okla., 1994), 347–356, reviews the many different proposals for Skidi ancestors in the archaeological record before sustained Euro-American contact. The precise date for first contact between Pawnee and European peoples is contentious. Some Pawnee oral traditions suggest that they moved to Nebraska from the Southwest in Pre-Columbian times, as detailed by Roger C. Echo-Hawk, "Ancient History in the New World: Integrating Oral Traditions and the Archaeological Record in Deep Time," *American Antiquity*, LXV (2000), 283–285. He also excerpts two Pawnee

oral traditions, collected by Blaine, that detail specific sixteenth-century contacts between the Pawnee and the Spanish in the *Enchanted Mirror: When the Pawnees Became Indians,* http://www.echo-hawk.com/roger (May 2007), 26–27 (accessed March 2011). A Pawnee delegation probably visited Francisco Vázquez de Coronado when he resided with neighboring Wichita peoples in central Kansas during the summer of 1541. See Mildred Mott Wedel, "The Ethnohistoric Approach to Plains Caddoan Origins," *Nebraska History,* LX (1979), 190–191; Waldo R. Wedel, "Some Reflections on Plains Caddoan Origins," ibid., 278; and Wedel, *Introduction to Pawnee Archaeology,* 9–11. Mildred Wedel, "Ethnohistoric Approach," *Nebraska History,* LX (1979), 187–189, suggests that Jaramillo, a member of the Oñate expedition of 1599–1601, might have seen Pawnee villages and maize fields when he traveled to the "end of Quivara," which is most likely the modern-day Smoky Hill River. Caddoan peoples, including the Pawnee, obtained horses through trade and raiding early in the seventeenth century, though there is some debate about the cultural impact of horses to Pawnee life. See Blaine, *Pawnee Passage,* 49–54; Clark Wissler, "The Influence of the Horse in the Development of the Plains Culture," *American Anthropologist,* LVII (1914), 1–3, 6, 10–11, 14–16, 19, 21–22; Richard White, "The Cultural Landscape of the Pawnees," *Great Plains Quarterly,* II (1982), 31–40; and Donna C. Roper, "Documentary Evidence for Changes in Protohistoric and Early Historic Pawnee Hunting Practices," *Plains Anthropologist,* XXXVII, no. 141 (November 1992), 353–366. The Pawnee ("Paniassa") are shown as one of the major nations of the Missouri River on Jacques Marquette's 1673 map of the Mississippi River, published by Melchisédech Thévenot as *Carte de la découverte faite l'an 1673 dans l'Amérique septentrionale* in *Recueil de voyages . . .* (Paris, 1681) and are subsequently mentioned in the *Jesuit Relations.* Strong, *Nebraska Archaeology,* in Smithsonian Institution, *Miss. Colls.,* XCIII, no. 10 (1935), table 1 and 14–29, analyzes the location of the Pawnee and their neighbors on historic Euro-American maps dating from the late seventeenth to the early nineteenth centuries. Steven R. Holen and Danial R. Watson, "Skidi-French Interaction: Evidence from the Stobaco Site," in Holen and John K. Peterson, eds., *The Stobaco Site: A Mid-Eighteenth-Century Skidi Pawnee Town on the Loup River,* Nebraska Archaeological Survey Technical Report 95-01 (Lincoln, Nebr., 1995), 211–217, report French trade goods from the late-eighteenth-century Stobaco site, a Skidi village located on the Loup River. Details about Pawnee lands and life emerge in multiple French and Spanish documents after the 1680s. See summaries by Echo-Hawk, *Enchanted Mirror,* 27–31; Wedel, "Ethnohistoric Approach," *Nebraska History,* LX (1979), 191–194; Wedel, *Introduction to Pawnee Archaeology,* 11–16; and Douglas R. Parks, "Bands and Villages of the Arikara and Pawnee," *Nebraska History,* LX (1979), 229–235; and Lewis, "Maps, Mapmaking, and Map Use," in Woodward and Lewis, eds., *Cartography,* 124. Unfortunately, early-eighteenth-century historic accounts are cursory at best, as exemplified by Etienne Véniard, sieur de Bourgmont, "Etienne Véniard de Bourgmont's 'Exact Description of Louisiana,'" Missouri Historical Society, *Bulletin,* XV (1958), 17. The consequences and extent of eighteenth-century culture contact between Europeans and Pawnee peoples are debatable. Wedel, "Ethnohistoric Approach," *Nebraska History,* LX (1979), 191, notes that all known historic accounts of the Skidi before circa AD 1800 appear to be secondhand reports of ephemeral contacts.

cal, ethnographic, and historic research shows that the real and conceptual worlds depicted on the Skidi Star Chart unite Skidi peoples and practices through time. In addition, both emic and etic accounts of Skidi social life are readily available. The writings of James Murie—a member of the Skidi band of the Pawnee nation who had anthropological training and facilitated the transfer of the Star Chart to the Chicago Field Museum in 1906—are particularly notable. Murie rarely received credit for his remarkable work, even though he frequently worked as an interpreter for other ethnographers and also wrote extensively about the social and ceremonial life of his people during the late nineteenth and early twentieth centuries. Although Skidi peoples had been uprooted from their traditional home in east central Nebraska by 1876, knowledgeable elders informed Murie about traditional Skidi social life before their forced removal. As a member of the Skidi band, he also participated in many of their ceremonies. Gene Weltfish, a Boasian trained anthropologist who was fluent in the Skidi dialect, compiled the reminiscences of Pawnee elders. She assembled a lifetime of research in her remarkable ethnography of Skidi daily life in the year 1867.[7]

The remainder of this essay represents my rather thin attempt to understand the cartography of the Skidi Star Chart. I believe that the Skidi Star Chart is a map. However, in my opinion, the Skidi Star Chart is not simply a spatial inventory of the heavens as an earth-bound viewer would see the stars. The Skidi Star Chart is an astronomical projection that graphically facilitates a spatial understanding of Skidi worlds. Yet, Skidi worlds are far more complex and multidimensional than typically imagined. In addition, the Skidi Star Chart employs ancient cartographic conventions in ways that both complicate and expand upon modern Western notions of spatial relationships and geographic understanding.

MAP FORM, CONTENT, AND CONTEXT

The late David Woodward outlined a research strategy for interpreting maps based on a semiotic analysis of map signs and a contextual analysis of cartographic elements and operators. An important goal of his research strategy was the attempt to understand maps on their own terms by integrating the form, content, and context of the artifact itself. Map form includes a physi-

Yet there are dramatic changes in Pawnee sociopolitical organization, artifact assemblages, and settlement patterns after AD 1750, as detailed in Note 25.

7. See Douglas R. Parks, "Biography of James R. Murie," in James R. Murie, *Ceremonies of the Pawnee,* ed. Parks (Lincoln, Nebr., 1989), 21–28, and Weltfish, *The Lost Universe,* 480–482, for accounts of James Murie's life and his work.

cal analysis of materials as well as the structural organization of map signs. A cultural analysis of signs and their referents is the basis for interpreting map content. Map context details how people use the map as well as how the map both reflects and shapes the history and society of which they are a part. Integrating map form, content, and context provides a "thick description" of the artifact and its geographic meaning. There is, metaphorically speaking, a recursive dialogue between ancillary information and the propositional logic of the map. Any insights garnered from one dialogue are applied to all other dialogues, and then return to the "definiendum" that created them. Ideally, integration reveals the meaning and significance of the map and also exposes the biases of the interrogator. Woodward employed this strategy in his exemplary analysis of the Francesco Roselli world map of 1508.[8]

We cannot begin to comprehend American Indian maps unless we attempt to see them from American Indian eyes. Although Woodward's analytical structure is useful, it cannot simply be transferred to the study of American Indian maps without modification. Many textual and other productions extend the map's geographic arguments in Western contexts, such as titles, legends, scales, directional indicators, projection metadata, accompanying text, and so forth. Denis Wood and John Fels eloquently show the importance of these paramap elements for establishing the propositional logic of modern Western maps.[9] Skidi peoples used the Star Chart in conjunction with gestures, rituals, dances, songs, and oral traditions. I believe that these cartographic performances establish the propositional logic of the Skidi Star Chart and extend its geographic arguments. Another modification to Woodward's research strategy is that the analytical boundaries between map form, content, and context are diffuse and ephemeral here. For example, the raw materials used to make the Skidi Star Chart—buckskin and pigments—are also important sign vehicles. Discussions of map content and meaning, therefore, are scattered throughout this essay. Finally, Skidi rules for cartographic signification differ from modern Western ones in ways that complicate analyses of map content and context.

MAP FORM AND THE SKIDI STAR CHART
The analysis of map form in this section primarily consists of general descriptions of map signs and spatial references as well as an account of production

8. David Woodward, "Theory and the History of Cartography," 36–41, and "Starting with the Map," 78–90, in Woodward, Catherine Delano Smith, and Cordell D. K. Yee, eds., *Approaches and Challenges in a Worldwide History of Cartography* (Barcelona, 2001).
9. Wood and Fels, *Natures of Maps*, 8–12.

details. The section concludes with speculations on the age of the Skidi Star Chart.

Cartographic Signs and Miscellaneous Symbols
The dominant visual elements on the Skidi Star Chart are the hundreds of variably sized black crosses framed by a black ellipse (Figure 2). As detailed in the section below on map content, the black crosses represent stars, planets, asterisms, constellations, and other celestial objects (Figure 3, Appendix). Skidi artists painted most four-pointed crosses with two short and precise strokes that intersect at near right angles. Some larger crosses, such as those representing Great Star (most often Mars), Big Black Meteoric Star (Vega), and White Dwelling Star (Sirius), consist of heavy or multiple overlapping strokes that taper toward the four endpoints of the cross (Figure 2). The superpositioning of strokes on the image suggests that the Skidi Star Chart was painted in multiple sittings and that some geographic meanings were not permanently fixed at the time of production.

Intersecting lines, such as those on the Skidi Star Chart, seem to have great antiquity in the archaeological record (Figure 4a). In contrast, Pawnee peoples commonly used multipointed polygons to represent stars on nineteenth-century media in the decades following sustained Euro-American contact (Figures 4b, 4c, and 4d). The cosmogram painted on the rawhide container (Figure 4b) shows that graphic "figures of speech" convey meaning in traditional Pawnee art. At first glance, the image seems to be a representation of the sun. Yet, as shown by the identification of individual shapes in Figure 4b, a single ray of starlight depicted as a triangle signifies the star as a whole. Each triangle is essentially a graphic synecdoche. Likewise, at first glance, the black and yellow colors seem to be little more than a decorative background. However, color is used in place of a literal representation of a specific astronomical phenomena, in this case darkness (sunset) and daylight (sunrise). The color palate used to paint this rawhide container is a form of graphic antonomasia, where one descriptive visual variable substitutes for the object or phenomena as a whole. The four pointed crosses on the Skidi Star Chart likewise use graphic figures of speech to convey meaning, as we shall see in a later section that details color directional symbolism.

Other celestial symbols on the Skidi Star Chart include a crescent painted over a faded circle that represents the moon and red or red-and-yellow pigment bands that signify dawn and a sunset (Figure 2, 3a, 3b, Appendix). In addition to celestial symbols, there are several small red icons and the remnants of faint pigment "washes" on the Skidi Star Chart (Figure 2).

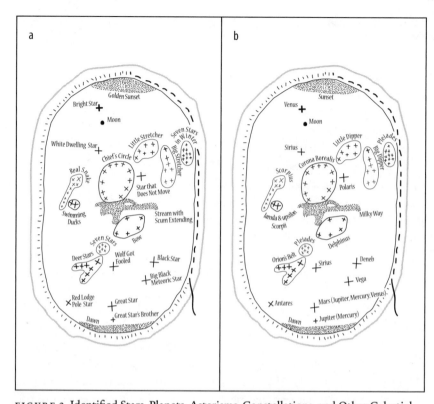

FIGURE 3. Identified Stars, Planets, Asterisms, Constellations, and Other Celestial Objects Depicted on the Skidi Star Chart. Drawn by William Gustav Gartner. (a) English translations of the Skidi Names for the identified celestial objects on the Skidi Star Chart. The translations follow the annotations of Douglas R. Parks, in James R. Murie, *Ceremonies of the Pawnee,* ed. Parks (Lincoln, Nebr., 1989), although I have retained Murie's unlikely translation of *u pirit raruhu ru katitkucu* as Big Black Meteoric Star (39) for reasons of precedence and convention. (b) The Western equivalents of the celestial objects identified on the Skidi Star Chart. See the Appendix for a summary of selected cultural and natural referents for each identified celestial object. After ibid., 96, with supplemental identifications from the annotations of Parks, and Von Del Chamberlain, *When the Stars Came Down to Earth: Cosmology of the Skidi Pawnee Indians of North America* (Los Altos, Calif., 1982), 203–205, 229–244

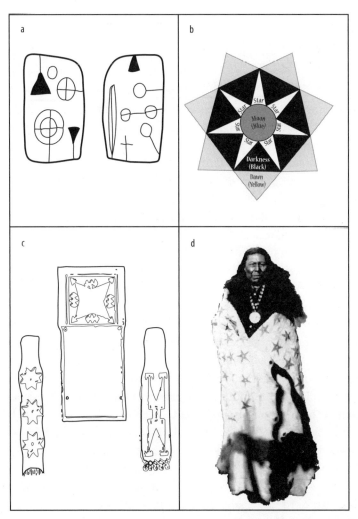

FIGURE 4. Selected Pawnee Representations of Stars. Drawn by William Gustav Gartner. (a) Cross and cross-in-circle motif on incised tablets from the Linwood site. After Waldo Rudolph Wedel, *An Introduction to Pawnee Archaeology* (Washington, D.C., 1936), 79. (b) Cosmogram on a rawhide container. After Gene Weltfish, *The Lost Universe: Pawnee Life and Culture* (Lincoln, Nebr., 1965), 215. (c) Beaded cradle boards. After Natalie Curtis, *The Indians' Book: An Offering by the American Indians of Indian Lore, Musical, and Narrative, to Form a Record of the Songs and Legends of Their Race* (New York, 1907), facing 102. (d) Robe of Raruhcakure sa ru. After Smithsonian Institution, National Anthropology Archives, Image ID: BAE GN 01285 06250400.

Polygonal depictions of stars are far more common in the ethnographic and historic records than the quincunx crosses found on artifacts excavated at protohistoric archaeology sites and used in the Skidi Star Chart

A General Spatial Syntax

Maps fuse signs with a unique location in order to create a geographic refer-
ence system or spatial syntax. The pigment bands along the longitudinal ends
of the image, the dense clusters of tiny black crosses comprising a bifurcated
band in the middle of the image, and the black elliptical frame around the
image provide a geographic reference system for the remaining map signs on
the Skidi Star Chart. The bands of pigment that abut the major axial endpoints
of the ellipse serve to orient the chart. Murie identified the band of yellow pig-
ment as representing sunset and signifying west. A band of red plus a band of
yellow pigment represents sunrise on the opposite end of the chart and signi-
fies east. East is often associated with Great Star, the male principal, and the
place where creation was planned in Skidi rituals and oral traditions. West is
often associated with Bright Star, the female principal, and the place where
creation was carried out. The proximity of Great Star to Dawn and Bright
Star to Golden Sunset on the Skidi Star Chart probably signifies this common
duality in Skidi social space as well as the spatiality of celestial phenomena
in the night sky. Near the center of the image are approximately twenty-five
tightly packed clusters of tiny crosses that form a bifurcated strip represent-
ing the Milky Way, known to the Skidi as the Stream with Scum Extending.[10]
The clusters are circular and contain a variable number of crosses (Figure 2).

Most Western planispheres and maps of the night sky represent the shape
of the horizon as a circle. The Skidi also conceived of the horizon as circular
and incorporated this symbolism into the architecture of the earth lodge.[11]
However, Skidi artists cut the hide for the Skidi Star Chart into an ellipse mea-
suring approximately fifty-six by thirty-eight centimeters. The painted ellipse
that frames the celestial objects on the Skidi Star Chart visually reinforces the
cut elliptical shape of the hide. (Although Plains Indians commonly cut hide
into geometric shapes to make shields, clothing, drums, and miscellaneous
artifacts such as parfleche, they generally used the entire hide for a canvas.)

A geometric ellipse is not a common shape in Pawnee art, and thus we have
little guidance about its symbolic significance in painted media.[12] It was, how-

10. Murie, *Ceremonies of the Pawnee*, ed. Parks, 41, 96; George A. Dorsey, *Traditions
of the Skidi Pawnee* (Boston, 1904), 3; Alice C. Fletcher, "Star Cult among the Pawnee—
a Preliminary Report," *American Anthropologist*, IV (1902), 733–734.

11. Weltfish, *The Lost Universe*, 63.

12. Plains Indians often, but not always, used the entire hide as a canvas. See, for ex-
ample, John Canfield Ewers, *Plains Indian Painting: A Description of Aboriginal Ameri-
can Art* (Stanford, Calif., 1939), 1–2 and plates 3–14, 17, 19–26. Christina E. Burke, "Win-
ter Counts in the Smithsonian," in Candace S. Greene and Russell Thornton, eds., *The
Year the Stars Fell: Lakota Winter Comes at the Smithsonian* (Washington, D.C., 2007),

ever, an important shape for the spatial organization of Skidi summer hunting camps. People from multiple Skidi villages embarked on a midsummer bison hunt after the maize crop sprouted. The spatial organization of nineteenth-century Skidi summer hunting encampments had cosmological significance, for village leaders pitched their tents to reflect the relative positions of their patron stars in the night sky.[13] As shown in Figure 5a, an ellipse "frames" the summer hunting encampment, just as the ellipse frames the heavens depicted on the Skidi Star Chart. For reasons detailed later in this essay, both ellipses represent a liminal zone between earth and sky when the viewer is in motion. The choice of an ellipse over a circle to represent the horizon is a curious one, for a supposed reference map of the night sky as an ellipse accentuates spatial distortions of area and direction between celestial objects.

The Canvas
At first glance, the Skidi Star Chart appears to use the same materials and production procedures as other Plains Indian maps of the heavens. It was painted on the hide of "buckskin," most likely elk or deer, though antelope has also been suggested by some. The buckskin was prepared by traditional Pawnee tanning techniques, a laborious and exacting process that potentially included the use of elm bark, animal brains, volatile oils, and soured milk to keep the buckskin supple.[14]

15–22, shows that Lone Dog and other Lakota artists often used the entire hide for painting winter counts and other images with celestial referents. Nabokov, "Orientations from Their Side," in Lewis, ed., *Cartographic Encounters*, 249–257, shows that circles signifying horizons, the heavens, or the shape of time are far more common in American Indian maps and architecture than ellipses. A particularly germane example to the present paper is Amos Bad Heart Bull's map of North Dakota, which shows the Black Hills as a mirror image of the circular Lakota asterism known as the Sacred Hoop, which is composed of Sirius, Procyon, Castor, Beta Aurigae, Capella, the Pleiades, and Rigel. See Lewis, "Maps, Mapmaking, and Map Use," in Woodward and Lewis, eds., *Cartography*, 121–123, for details. Since even the skin from a fawn would provide plenty of canvas for the Skidi Star Chart, the cutting of the hide and the elliptical shape of the chart is meaningful.

13. Weltfish, *The Lost Universe*, 157–237 (esp. 165–166).

14. Lewis, "Maps, Mapmaking, and Map Use," in Woodward and Lewis, eds., *Cartography*, 123–125; Christine Danziger cited in Chamberlain, *When the Stars Came Down*, 188; Weltfish, *The Lost Universe*, 369–372. John K. Peterson, Danial A. Watson, and Amy Goedert, *A Pawnee Bone Grease Processing Area: Site 25HW75, Howard County, Nebraska*, Nebraska Archaeological Survey Technical Report 93-01 (Lincoln, Nebr., 1993), provides archaeological evidence for the use of bison bone marrow and other compounds in tanning.

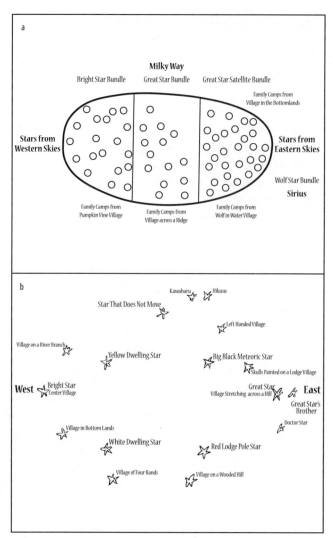

Milky Way

Bright Star Bundle · Great Star Bundle · Great Star Satellite Bundle

Family Camps from
Village in the Bottomlands

Stars from
Western Skies

Stars from
Eastern Skies

Wolf Star Bundle

Sirius

Family Camps from
Pumpkin Vine Village

Family Camps from
Village across a Ridge

Family Camps from
Wolf in Water Village

a

b

Kawaharu · Hikusu

Star That Does Not Move

Left Handed Village

Village on a River Branch

Yellow Dwelling Star

Big Black Meteoric Star

Skulls Painted on a Lodge Village

West · Bright Star
Center Village

Great Star
Village Stretching across a Hill · **East**

Great Star's
Brother

Village in Bottom Lands

Doctor Star

White Dwelling Star

Red Lodge Pole Star

Village of Four Bands

Village on a Wooded Hill

FIGURE 5. Pawnee Settlements. Drawn by William Gustav Gartner. (a) A sketch map of a mobile Pawnee hunting camp in 1867. Families set up their individual camps so that their relative positions in the settlement corresponded to the location of their village's patron star in the night sky. After Gene Weltfish, *The Lost Universe: Pawnee Life and Culture* (Lincoln, Nebr., 1965), 166. (b) A Pawnee map showing the conceptual locations of bundle-holding villages. The location of villages across the Skidi homeland approximates the pattern of posts and selected earthen architectural features in a plan view of a Pawnee earth lodge (compare with Figure 11). After Alice C. Fletcher, "Star Cult among the Pawnee—a Preliminary Report," *American Anthropologist*, IV (1902), 734; and Von Del Chamberlain, *When the Stars Came Down to Earth: Cosmology of the Skidi Pawnee Indians of North America* (Los Altos, Calif., 1982), 125

The selection of cervid buckskin for the canvas suggests that the Skidi Star Chart is much more than a spatial inventory of the heavens. Oral traditions and ceremonies indicate that the spots on a wildcat skin symbolized the heavens in Pawnee material culture. Yet the Skidi Star Chart was not painted on a wildcat skin but rather on the skin of a cervid. Cervids have many symbolic associations in Skidi oral traditions and ritual. The right leg of the regalia worn by the culture hero Pahukatawa was made from elk skin. Deerskin is painted black and red and made into leggings, in imitation of those belonging to culture heroes, during the ceremonial renewal of war bundles (bundles are a collection of interrelated sacred artifacts that are wrapped up together when they are not in use). According to an oral tradition of the Kitkahahki band, the fifth deer shot by Wonderful Being was the sun who carried night upon its back. Both deer and elk are among the many primeval creatures who may bestow doctors with curative and magical powers. This transfer of power from cervids to humans happened in primordial animal lodges, which eventually formed unusual topographic features in modern-day Nebraska and Kansas.[15] These are but a few examples of the symbolic importance of cervid skin in Pawnee culture. My impression from the above sources is that buckskin is symbolic of success in warfare, protection from disease, renewal, prosperity, and fertility for the Skidi. If so, the cervid skin might have reminded the Skidi of the importance of the stars in realizing the above ideals.

One curious attribute of the Skidi Star Chart is that small skin patches and tufts of fur occur on the same side of the buckskin as the image. Thus, unlike many other Plains Indian hide paintings, the Skidi Star Chart was painted on the outside, rather than on the inside, of the buckskin. The noted anthropologist Ralph Linton suggested that the tanner was unskilled, but this conclusion ignores an obvious question.[16] Why remove animal fur to paint an image

15. Murie, *Ceremonies of the Pawnee*, ed. Parks, 45, 64, 66, 197; Weltfish, *The Lost Universe*, 19; George A. Dorsey, *The Pawnee Mythology* (Washington, D.C., 1906), 55; Dorsey, *Traditions of the Skidi Pawnee*, 194–199, 280–283; James R. Murie, *Pawnee Indian Societies*, American Museum of Natural History, *Anthropological Papers*, XI, part VII (New York, 1914), 602–603; Dougals R. Parks and Waldo R. Wedel, "Pawnee Geography: Historical and Sacred," *Great Plains Quarterly*, V (1985), 152–153. See Richard Bradley, *An Archaeology of Natural Places* (New York, 2000), for a book-length treatment of oral traditions and votive offerings associated with unusual topographic features in the archaeology and ethnography of northwest Europe. On bundles, see Preston Holder, *The Hoe and the Horse on the Plains: A Study of Cultural Development among North American Indians* (Lincoln, Nebr., 1970), 42–44.

16. Linton cited in Murie, *Ceremonies of the Pawnee*, ed. Parks, 180; Christine Danziger cited in Chamberlain, *When the Stars Came Down*, 188.

of the heavens, unless the depiction of the heavens on the outside of a cervid skin is an important part of the message? Perhaps the Skidi Star Chart is not an image of the heavens per se; rather, it is a projection of the heavens onto the back of a cervid—a visual reminder that it is the stars that guide life and provide nature's bounty.

The edge of the Skidi Star Chart is perforated and, at one time, was threaded with a buckskin string. Numerous creases (Figures 2) indicate that the Skidi Star Chart was used as a pouch, and, at one time it apparently held two stones and perhaps other objects. These stones might have symbolized "meteorites," buffalo maw stones, or the rocks used to heat a sweat lodge. Ethnographic accounts further indicate that the drawstring was long enough to attach the chart to a pole.[17]

The Pigments

The astronomer Von Del Chamberlain arranged to have the pigments on the Skidi Star Chart analyzed by polarized light microscopy at the McCrone Research Institute in Chicago. The microscopists identified three mineral sources for the pigments. Lignite—a fibrous and carbon-rich rock that forms from partially metamorphosed peat—is the primary source for all black-colored pigment samples. The yellow-colored pigments are derived from limonite, an amorphous earthy mass generally composed of clay minerals and hydrated iron oxides colloquially known as "yellow ocher." Hematite, known as "red ocher" when found as an earthy mass instead of its more common mineral form, is the primary source for red-colored pigments on the Skidi Star Chart. A likely source for these minerals is an area of Lower Cretaceous and upper Pennsylvanian bedrock that outcrops below the junction of the Platte River and Salt Creek.[18]

Polarized light microscopy is well suited for the identification of aniso-tropic solids such as minerals, fibers, composite substances, and crystalline or highly organized biological materials such as wood or DNA. It is less effective at identifying other substances with more uniform physical properties.

17. Murie, *Ceremonies of the Pawnee*, ed. Parks, 73, 96–97; Murie cited in Chamberlain, *When the Stars Came Down*, 187; Weltfish, *The Lost Universe*, 154; George A. Dorsey and James R. Murie, *Notes on Skidi Pawnee Society*, ed. Alexander Spoehr, Anthropological Series, Field Museum of Natural History, XXVII, no. 2 (Chicago, 1940), 90. Christian Jacob, *The Sovereign Map: Theoretical Approaches in Cartography throughout History*, ed. Edward H. Dahl, trans. Tom Conley (Chicago, 2006), 83–84, 262, argues that map creases and the act of folding maps are meaningful in Western contexts.

18. Chamberlain, *When the Stars Came Down*, 188; Raymond R. Burchett, *Mineral Resource Map of Nebraska* (Lincoln, Nebr., 1987).

This is an important distinction because pigments are often complex mixtures of various compounds, and they are very powerful substances in Pawnee oral traditions and rituals. For example, the bodies of warriors are painted with a mixture of white clay and sage during the renewal of the Wonderful Leggings bundle. The same compound protects people from celestial power when opening a meteorite bundle. Offering sticks are painted with red pigment made from earth and buffalo fat during the Thunder Ceremony. This pigment mixture is also used during the Shelling of the Sacred Ear and New Fire Ceremonies. A particularly powerful pigment, used as a base for blue war paint and other pigments, was made from special muds, earth, and the urine from the bladder of "a hermaphrodite or merely a barren cow [bison]."[19]

Pigment compounds are important sign vehicles in many respects, though some may be known only to the artists that painted the images. Colored clays embody the symbolism of their source areas, which, as noted above, may be exotic to the Skidi homeland. The ingredients of pigment compounds are often mentioned in Skidi oral traditions concerning world origins and have specific symbolic associations. Most important, many American Indian cultures throughout the Great Plains, the American Southwest, and Meso-America associated specific colors with cardinal (north, south, east, and west) or intercardinal (northeast, southeast, southwest, northwest) directions. This fusion of color and directional symbolism formed the spatial syntax for many cosmologies, including the Skidi, as detailed in the sections on map content and map context below. The four pointed crosses representing celestial bodies on the Skidi Star Chart are likely a synecdoche for the fusion of color and direction.[20]

Application Techniques
Skidi artists painted the various symbols on the Skidi Star Chart with at least two tools, one of which left deep indentations on the hide canvas. The use of multiple tools is well illustrated by the two prominent semicircular red objects located between the Deer Stars (Orion's Belt) and Stream with Scum Extending (the Milky Way). Neither object was identified by Murie (Figure 6). Although it probably says more about me than the Skidi artists who painted

19. Murie, *Ceremonies of the Pawnee*, ed. Parks, 59, 65, 70, 73, 100, 144, 148. The World Quarter Stars bestowed upon all living things a vitalizing force. Any animal that had not reproduced retained this vitalizing force. Skidi hunters identified hermaphroditic bison by their rapid and unusual movements through the herd.

20. Dorsey, *Traditions of the Skidi Pawnee*, 8–10, 27, 46, 55–56, 68–69, 70; Dorsey, *Pawnee Mythology*, 38, 56; Robert L. Hall, *An Archaeology of the Soul: North American Indian Belief and Ritual* (Urbana, Ill., 1997), 86–101.

the Star Chart, the first red object looks like an oblique angle representation of a skull with a symbol painted on the frontal bone. The skull seems to lie within a red circle. The second red object, a red circle framed by a second circle of black crosses, was applied with a sharp instrument that left deep indentations beneath red pigment.[21] Indentations forming points and lines, often with faint traces of red pigment, appear across the chart. Some indentations may be a form of underpainting or serve to add a textural dimension to the image. Although the indentations are not randomly distributed, many indentations seem to have little connection with the painted image of the heavens.

The superpositioning of symbols, pigment patches, and tool marks suggest that the Skidi Star Chart was painted in multiple sittings and perhaps over long periods of time. Some indentations are superimposed on black crosses (Figure 6). Other tool marks are beneath the black crosses, as, for example, the linear indentation beneath the Big Stretcher (Ursa Major) asterism. Most black crosses, however, are not associated with tool marks at all. Remnants of red and yellow pigment, perhaps a wash or slip of some sort, appear across the Skidi Star Chart, though much of this paint has worn away. Some red pigment patches occur beneath the black crosses, as, for example, beneath certain stars comprising the asterism of the *Bow* (Delphinus). Other red patches are superimposed on top of the black crosses, as, for example, on some of the small stars between Red Lodge Pole Star (Antares) and Great Star (most often Mars). There are also several examples of symbol superpositioning. The Big Black Meteoric Star was drawn twice in the same location (Figure 2). A black crescent representing the moon appears to have been drawn on top of a faded circle representing a full moon (Figure 2). Murie drew the underlying symbol, or the circle, in his visual identification of features in the Skidi Star Chart (Figure 3a). Superpositioning suggests that the Skidi Star Chart was painted at different times and that each individual act of production was meaningful.

The Age of the Skidi Star Chart
The numerical age of the Skidi Star Chart is unknown. Those researchers that suggest an older relative age typically cite oral traditions, the identification or position of celestial objects on the chart, and the buckskin's "extensive wear." The astronomer Forest Ray Moulton, for example, believed that the inspiration for the Big Black Meteoric Star was a 1572 supernova visible in Cassio-

21. Linton cited in Murie, *Ceremonies of the Pawnee*, ed. Parks, 180, suggested that the Skidi used a hot bone awl to make the indentations. If so, the bone was not hot enough to significantly singe the hide.

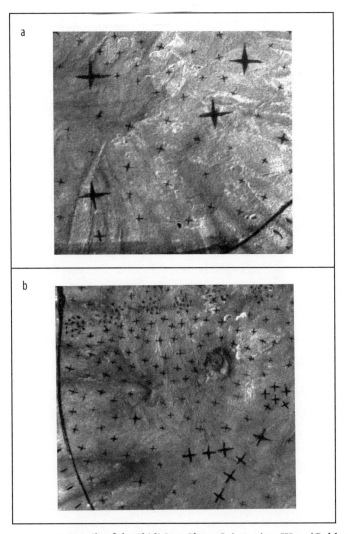

FIGURE 6. Details of the Skidi Star Chart. Orientation: West (Golden Sunset) is at top. By kind permission of the Skidi band of the Pawnee Nation of Oklahoma. Image source: © The Field Museum, #CSA16231c.

Maps are often revised through time. A high-resolution scan of the Skidi Star Chart shows different superpositioning relationships between tool marks, faded pigment patches, and the smaller black crosses. In addition to the superpositioning noted above, there are also (a) multiple overlapping brush strokes comprising Great Star (most often Mars), Big Black Meteoric Star (Vega), Black Star (Deneb), and Wolf Got Fooled Star (Sirius), and (b) a faded icon between the Stream with Scum Extending (the Milky Way), the Deer Stars (Orion's Belt), and the Seven Stars in summer (the Pleiades).

peia, which, if true, would provide a terminus post quem for its depiction on the map.[22] John Paul Goode, of *Goodes Atlas* fame, suggested that the Skidi Star Chart may date to the time of Columbus, based on a discussion with George A. Dorsey and the relative positions of the planets and constellations. The noted anthropologist Ralph Linton was undoubtedly aware of the assessments by Moulton and Goode when he offered a terminus ante quem age of three hundred years during his tenure as curator of North American Indian collections at the Field Museum from 1922 to 1928. Others question the antiquity of the Skidi Star Chart, noting that the buckskin is still supple and that it was associated with a brass artifact.[23]

The arguments above are all flawed. Age assessments based on the identification and positions of celestial objects assume that the Skidi Star Chart is akin to a photograph, rather than an exegesis, of the night sky. The association of the Skidi Star Chart with a brass meteorite says nothing about the former's age, as artifacts were both added to and removed from bundles over time. Excessive wear is a qualitative assessment and may happen quickly or over a long period of time, depending on storage and use. The supple leather of the Skidi Star Chart is not surprising given Skidi techniques for tanning hides noted above, the special care and storage of all bundles, and the presence of buffalo fat in the Big Black Meteoric Star bundle.[24]

Age assessments of the Skidi Star Chart will be controversial in the absence of Skidi oral traditions, historical documents, or numerical dating. Ethnography shows that the Skidi Star Chart was clearly an important part of the social and ceremonial life of mid-nineteenth- and early-twentieth-century Skidi peoples, and it retains this importance to the present day. How much older is the artifact than the ethnographic record? My belief is that we may assign a terminus ante quem date of AD 1750 for the age of the Skidi Star Chart, which is the end of the protohistoric Lower Loup phase (AD 1500–1750), and

22. Forest Ray Moulton cited in Chamberlain, *When the Stars Came Down*, 227. This supernova is sometimes called Tycho's Supernova, since this "Stella Nova" so captured the interest of Tycho Brahe. See Forest Ray Moulton, *An Introduction to Astronomy* (New York, 1916), 153, 523.

23. Paul J. Goode, "The Map as a Record of Progress," *Annals of the Association of American Geographers*, XVII, no. 1 (March 1927), 2; Buckstaff, "Stars and Constellations," *American Anthropologist*, XXIX (1927), 279; Waldo R. Wedel, "Native Astronomy and the Plains Caddoans," in Anthony F. Aveni, ed., *Native American Astronomy* (Austin, Tex., 1977), 133–134.

24. Dorsey and Murie, *Notes on Skidi Pawnee Society*, ed. Spoehr, 76; Murie, *Ceremonies of the Pawnee*, ed. Parks, 36–37, 70–71, 95; George Bird Grinnell, "Pawnee Mythology," *Journal of American Folklore*, VI (1983), 119–120.

that we should be open to an earlier age for the artifact. This belief is based on several tangential or presumptive arguments. Pawnee peoples commonly depicted stars as polygons on nineteenth-century media. The crosses on the Skidi Star Chart are stylistically similar to older motifs in the archaeological record (Figure 4). The depiction of the Chief's Circle on the Skidi Star Chart (Figures 2 and 3) has more crosses than its counterpart in the night sky, Corona Borealis, has stars. Chamberlain suggests that the Skidi added selected stars from the adjacent Boötes constellation. One possible reason for adding crosses to the Chief's Circle is that they reference the number of bundle-holding villages in the Skidi confederation rather than the number of stars in the Corona Borealis constellation. If so, the eleven crosses on the Skidi Star Chart fall within the narrow range of Skidi villages described in early-eighteenth-century French accounts, but not the thirteen to nineteen Skidi villages documented in the late eighteenth through the nineteenth centuries. Archaeology shows a significant change in Pawnee settlement patterns and material culture after AD 1750. The form and content of the Skidi Star Chart do not reflect the syncretic discourses of culture contact that became part of Pawnee daily life after that date.[25] All maps, whether of real or imag-

25. Von Del Chamberlain, "The Chief and His Council: Unity and Authority from the Stars," in Ray A. Williamson and Claire R. Farrer, eds., *Earth and Sky: Visions of the Cosmos in Native American Folklore* (Albuquerque, N.M., 1992), 233–235. The number of Skidi villages varied through time, often owing to European contact and Plains Indian geopolitics. O'Shea, "Pawnee Archaeology," *Central Plains Archeology*, I (1987), 61–66, suggests that once autonomous Skidi villages became more integrated with European contact. Historic accounts document eight to twelve Skidi villages from 1700 to 1725 and thirteen to nineteen Skidi-dominated villages from the late eighteenth century to 1874. See Parks, "Villages of the Arikara and Pawnee," *Nebraska History*, LX (1979), 231–232. The eleven stars of the Chief's Circle may, therefore, reference the number of villages comprising the Skidi confederation during the early eighteenth century, if not earlier. Robert T. Grange, "The Pawnee and the Impact of Euro-American Cultures: Three Centuries of Contact and Change," *Revista de Arqueología Americana*, XII (1997), 87–111, chronicles changes in Pawnee artifact assemblages owing to European contact from the early sixteenth to the middle of the eighteenth centuries. Different aspects of Pawnee material culture were affected at different times over three centuries as shown by Grange's ceramic analysis in "An Archaeological View of Pawnee Origins," *Nebraska History*, LX (1979), 135–139; LuAnn Hudson's research on the adoption of metal tools in "Changes in Pawnee Lithic Economy in the Eighteenth and Nineteenth Centuries" (master's thesis, University of Iowa, 1982); and John Ludwickson's summary of changing tool assemblages through time in "Historic Indian Tribes," *Nebraska History*, LXXV (1994), 139–143. Wedel, "Native Astronomy and the Plains Caddoans," in Aveni, ed., *Native American Astronomy*, 139–140, notes that Pawnee earth lodges exhibit

ined worlds, have cultural relevance because they work.[26] It is difficult to see how the Skidi Star Chart could have worked without deep historical roots. Indeed, it is probable that the Skidi Star Chart at the Field Museum is merely the latest version of an ancient map.

MAP CONTENT AND THE SKIDI STAR CHART

Map content is largely an exploration of the relationships between cartographic signs and their referents. These referents may be objects, concepts, conditions, and processes in real or imagined worlds. The task of linking cartographic signs with their referents is complicated. All maps embody local knowledge, practices, and culturally specific rules for signification and association. In some instances, the Skidi Star Chart conforms to Western cartographic protocol in the sense that one sign will be fused with a specific referent and a unique location. In many instances, however, cartographic signs have multiple referents on the Skidi Star Chart. The referent is not simply a celestial object in the night sky; it is the personification of those celestial entities in Skidi oral traditions and rituals. A final complication is that geographic position may be independent of the signification process.

In this section, I will try to link the internal logic of the Skidi Star Chart's

greater variation in orientation and construction techniques after AD 1750. Wedel concludes in *Prehistoric Man on the Great Plains* (Norman, Okla., 1961), 122–125, that traditional Pawnee society began to unravel between AD 1750 and 1800. Archaeological and historic evidence for early-nineteenth-century demographic collapse is provided by O'Shea, "Pawnee Archaeology," *Central Plains Archeology*, I (1987), 58–61. The archaeology summarized above is often, but not always, consistent with the detailed accounts of migration, geopolitics, confederation, and sociopolitical change in Pawnee oral traditions, as detailed by Roger Echo-Hawk, *Keepers of Culture: Repatriating Cultural Items under the Native American Graves Protection and Repatriation Act* (Denver, 2002), 62–64, and Echo-Hawk, *Enchanted Mirror*, 26–85. David J. Wishart, *An Unspeakable Sadness: The Dispossession of the Nebraska Indians* (Lincoln, Nebr., 1994), documents the Pawnee loss of their Nebraska homeland in the nineteenth century owing to treaties (60–68, 81–83), intertribal warfare and disease (90–94), early reservation life (124–132), and the process of allotment and American settlement (174–202). Martha Blaine, *Some Things Are Not Forgotten: A Pawnee Family Remembers* (Lincoln, Nebr., 1997), shares personal Pawnee accounts of allotment (28–50) and Pawnee-white relations (80–114) during the nineteenth century. She also chronicles moving stories of loss and resilience from annuities (181–201) and acculturation programs (143–180) in *Pawnee Passage*. That Murie was able to document certain components of traditional Skidi culture in the late nineteenth and early twentieth centuries speaks volumes about cultural resilience during times of significant political and economic upheaval.

26. Denis Wood and John Fels, *The Power of Maps* (New York, 1992), 1–2.

graphic argument with generally known aspects of the Skidi cultural system. The indexical qualities of the Skidi Star Chart provide a means for navigating a world both strange and wonderful. However, my limited knowledge of the myriad referents indexed by the Skidi Star Chart also reveals my own precepts, expectations, and ignorance. At best, I can only provide a fleeting glimpse into a small portion of the content and meaning of the Skidi Star Chart.

Primary Sources for the Identification of
Celestial Objects on the Skidi Star Chart
On the evenings of July 1 and 2, 1906, George Dorsey of the Chicago Field Museum arranged for astronomer Forest Ray Moulton to interview a visiting delegation of five Pawnee Indians under the stars. James Murie was the interpreter between Moulton and the Pawnee delegation, which included such luminaries as Captain Jim, chief of the Pitahawanita band when they shared territory with the Skidi; Seeing Eagle, who also shared knowledge of the Sacred Pipe and White Beaver Ceremonies with Murie; and Good Eagle, an errand man in the Doctors Dance and participant in rituals employing the Morning Star and Big Black Meteoric Star bundles. They discussed at least eighteen celestial objects important to the Pawnee over the course of those two evenings. Moulton was able to correlate, with varying degrees of certainty, fourteen asterisms and constellations, stars, and planets identified by the Pawnee with their modern Western astronomical counterparts. Murie also interviewed Roaming Scout—an elder Skidi priest who participated in the Thunder Ceremony and other rituals before the forced removal of the Skidi from their Nebraska homeland—in the presence of the Skidi Star Chart and other objects from the Big Black Meteoric Star bundle. Murie drew upon both of the above experiences when he identified twenty-two celestial objects depicted on the Skidi Star Chart. The astronomer Von Del Chamberlain concurs with nearly all of the celestial identifications of Murie and Moulton and has suggested additional identifications based on his exemplary historical and astronomical research. The Appendix and Figures 2, 3a, and 3b summarize the identifications of Murie and Chamberlain.[27]

27. Chamberlain, *When the Stars Came Down,* 37, 185, 194–202, 226–228; Murie, *Ceremonies of the Pawnee,* ed. Parks, 96. Good Eagle also appears in the narrative of Weltfish, *The Lost Universe,* 302, and gave an oral tradition entitled "The Wonderful Boy" to George Dorsey (see Dorsey, *Pawnee Mythology,* 95). Parks, "Interpreting Pawnee Star Lore," *American Indian Culture and Research Journal,* IX, no. 1 (1985), 59–61, argues that Chamberlain often confuses astronomical and conceptual entities in his volume and that he fails to embrace the many dimensions of ritual and oral tradition. Blakeslee, re-

As part of my own efforts to understand the Skidi Star Chart, I simulated hundreds of night skies over south-central Nebraska during the Lower Loup phase (AD 1500–1750) through the middle of the nineteenth century with the shareware planetarium programs *Stellarium, Sky View Café,* and *Alcyone Ephemeris* (Appendix). I know from first-hand experience that virtual skies pale in comparison to the celestial pageantry that unfolds nightly over the Great Plains. Despite its many limitations, however, the process of generating virtual skies shows that it is not possible to duplicate the image of the Skidi Star Chart solely by the tenets of Western scientific astronomy and observation. There are points of correspondence to be sure, but clearly the Skidi Star Chart is not simply a reference map of the night sky.

The Star Chart and Skidi World Creation
The Skidi Star Chart was part of the Big Black Meteoric Star bundle. Murie received this bundle from the Skidi priest Roaming Scout, whom Murie interviewed during the transfer of the bundle to the Chicago Field Museum. Chamberlain discovered Murie's audio recordings and his unpublished transcriptions of the bundle transfer in the archives of the Field Museum. Roaming Scout repeatedly refers to world creation and various bundle ceremonies as he describes the content of the Skidi Star Chart to Murie. Eighteen of the twenty-two identifiable celestial objects on the Skidi Star Chart are specifically named in Skidi oral traditions (Appendix). Dorsey classified most oral traditions listed in the Apppendix as "cosmogonic tales" or as "true stories of heavenly beings"—narratives that detail the creation of the Skidi world—in the table of contents of his compilations of Pawnee mythology.[28]

Skidi world creation is complicated because there are different versions that consist of multiple episodes. Although the general narrative of world creation was shared by most Skidi, only a few would have had access to all versions and episodes of such a powerful body of knowledge. I can offer little more than a brief synopsis of Skidi world creation based on published accounts. I do so because it is not possible to understand the many ways that the Star Chart graphically facilitates a spatial understanding of the Skidi world without a passing familiarity of world creation.

view of *When the Stars Came Down,* by Chamberlain, *Plains Anthropologist,* XXX, no. 107 (February 1985), 77, felt that Chamberlain was "reasonably accurate and appropriately cautious," though he also augments Chamberlain's discussions of the cultural significance of asterisms and color symbolism with several cross-cultural examples.

28. Chamberlain, *When the Stars Came Down,* 194–202; Dorsey, *Traditions of the Skidi Pawnee,* vii–ix. Dorsey details his general taxonomy for Pawnee oral traditions in *Pawnee Mythology,* 9–12.

In brief, the paramount Skidi deity is Tirawahat, or the Universe and Everything Inside, an amorphous expansive power who resides above all and has existed since the earth and the heavens were one. Tirawahat can also materialize as a discrete being and travel across the universe, most notably as Wonderful Being in Skidi rituals and oral traditions. His spouse is Atira, or Comes from Corn, who takes the form of the vault of the heavens. Tirawahat's primordial journey across the vault of the heavens brings into being the other celestial deities, who then carry out the details of world creation upon Tirawahat's instructions. The most important of these celestial deities are, in ranked order of importance, Bright Star (Venus) and Great Star (most often Mars), the World Quarter Stars (possibly Vega, Sirius, Antares, and Capella), the Sun and the Moon, and, finally, those stars that "look after the world." During the course of council deliberations, Tirawahat assigns the deities their positions in the heavens and also details their responsibilities. Bright Star (Venus) is the "mother of all Skidi," even though she resists the idea of human creation. Through her union with Great Star "all things were created." She stands in the west with her errand deities known as the Clouds, Winds, Lightening, and Thunders. Great Star, most often Mars, is a warrior who stands in the east. Once Great Star completes particular tasks and overcomes certain obstacles, including Bright Star's vaginal teeth, he mates with a reluctant Bright Star. This union gives rise to both the world and also the first woman. The Sun and the Moon later give birth to the first man. The World Quarter Stars stand at the semicardinal points and hold up the heavens. Each World Quarter Star embodies a suite of color and directional symbols (Figure 7a). In order to provide people with a suitable home, the World Quarter Stars raise the land from beneath a primordial sea with war clubs. Bright Star's errand deities shape the land. Stars do not walk upon the earth for long, so they created supernatural animals that live in primordial earth lodges to act as earthly intermediaries. After many wanderings, the first woman and the first man meet, have a child, and build the first home. The World Quarter Stars bestow songs and a sacred bundle upon this first family so that they might know the workings of the world and survive. From this first family comes the "first village," and from the first village comes all other villages. Thus, every Skidi village has a patron star from which it receives its sacred bundles and songs.[29]

29. This brief summary, which does not do justice to the richness of Skidi oral traditions, is compiled from Natalie Curtis, *The Indians' Book: An Offering by the American Indians of Indian Lore, Musical, and Narrative, to Form a Record of the Songs and Legends of Their Race* (New York, 1907), 99–104; Dorsey, *Traditions of the Skidi Pawnee*, esp. 3–14, 20–23; Murie, *Ceremonies of the Pawnee*, ed. Parks, esp. 12, 34–35 (table 1), 38–39, 43–61;

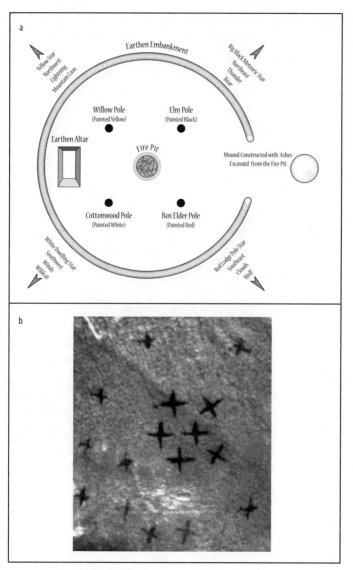

FIGURE 7. The Skidi Star Chart as a Map of Ceremonials and the Night Sky.
Orientation: East (Dawn) is at right. (a) The ritual stage of the Four Pole Ceremony,
a dramatic reenactment of Skidi world origins. After James R. Murie, *Pawnee Indian
Societies*, American Museum of Natural History, *Anthropological Papers*, XI, part VII
(New York, 1914), 553. (b) The Seven Stars in summer from the Skidi Star Chart. The
spatial pattern of the Seven Stars in summer duplicates the spatial logic of features
within the circular embankment of the Four Pole Ceremony ritual stage. By kind
permission of the Skidi band of the Pawnee Nation of Oklahoma. Image source:
© The Field Museum, #CSA16231c

Skidi oral traditions and bundle ceremonials outline a celestial hierarchy based in part on the role of the celestial deity in world creation. Skidi bundle ceremonials often include references to, and dramatic reenactments of, world creation. As mentioned previously, the Skidi Star Chart was part of the Big Black Meteoric Star bundle. Murie identified multiple crosses on the Skidi Star Chart as bundles, rather than stars, including the cross representing the Big Black Meteoric Star. Many of the identified stars on the Skidi Star Chart gave bundles to the founders of Skidi villages at the beginning of Pawnee times. Artifacts in the Big Black Meteoric Star bundle played a leading or supporting role in ceremonies associated with the spring planting and the fall harvest. These ceremonies were ostensibly religious, but they also coordinated subsistence and other activities essential to Skidi survival. Bundle ceremonies maintained the unique historical identity of each village, even as they integrated the separate Skidi villages into the ceremonial organization of the band as a whole. It is difficult to fully appreciate the power and significance of a sacred village bundle to Skidi peoples. Preston Holder likened the civic-ceremonial importance of sacred village bundles to the remarkable temple and plaza complexes of Mississippian peoples in the southeastern United States.[30]

A Conceptual Portrait of the Heavens

The Skidi Star Chart is not merely a reference map of the night sky, because Skidi artists depicted some asterisms in a highly conceptual manner. For example, there are seven prominent stars in the Corona Borealis (Chief's Circle) that range in their apparent magnitude from about 2.2 to around 6.0 (Appendix), yet there are eleven equal-sized crosses that represent its counterpart on the Skidi Star Chart (Figures 2, 3a, and 3b). Six or seven stars of varying magnitudes may be seen within the Pleiades (Seven Stars) cluster on most evenings suitable for stargazing, though ten or more stars may be seen under optimal viewing conditions. Despite the name, the Skidi did not represent the Seven Stars with seven crosses on the Star Chart. Instead, the Pleiades are shown twice on the Skidi Star Chart—once in their summer position with six crosses and once in their winter position with ten crosses. The spacing of the

and Weltfish, *The Lost Universe*, 79–87. See Murie, *Ceremonies of the Pawnee*, ed. Parks, 179 n. 16, for a discussion of the capacity of Tirawahat to exist as an all-expansive power and a discrete being.

30. Murie, *Ceremonies of the Pawnee*, ed. Parks, 30–39, 96; Martha Royce Blaine, "The Pawnee Sacred Bundles: Their Present Uses and Significance," *Papers in Anthropology*, XXIV (Norman, Okla., 1984), 145–156; Dorsey and Murie, *Notes on Skidi Pawnee Society*, ed. Spoehr, 77; Weltfish, *The Lost Universe*, 84–85, 86–87; Holder, *Hoe and the Horse*, 42.

core stars differs in the summer and winter manifestations on the Skidi Star Chart, even though the position of their stellar counterparts remain constant as they make their annual sojourn across the heavens. Although the apparent magnitude of the core stars of the Pleiades ranges from about 2.86 to less than 5.65 in the night sky (Appendix), they are all drawn to the same size on the Skidi Star Chart.

The depiction of the Seven Stars, the Chief's Circle, and other star groups on the Skidi Star Chart may not be errors of observation or transcription. Perhaps the modifications are deliberate and suggest that the Skidi Star Chart is more than a spatial inventory of the stars. An analysis of map content shows that the Skidi Star Chart has many geographic referents. However, the documentation of geographic referents does not resolve the issue of whether the Skidi Star Chart is a map or a mnemonic device, as content alone does not reveal the spatial logic of the image. Skidi oral traditions and ethnography offer some insights on the spatial logic to be sure. Yet they also suggest that there are multiple relationships between cartographic signs, referents, and geographic positions on the Skidi Star Chart.

The Seven Stars: From One Cartographic Sign Come Many Referents
Modern Western maps typically fuse one cartographic sign with a single referent and a unique location. The Skidi Star Chart is far more complex. The Seven Stars, and every other object on the Skidi Star Chart, is a visual index of multiple referents. As detailed below, the spatial arrangement and depiction of stars comprising the Pleiades in their summer position reference oral traditions detailing world creation, the Four Pole Ceremony, the origins and planting of maize, and seemingly mundane acts such as gambling. As exemplified by this brief analysis of the Seven Stars in summer, cartographic signs on the Skidi Star Chart are polyvalent in the sense that there are multiple and varied bonds between cartographic signs, geographic positions, and their referents.

The Pleiades (Seven Stars) are an open star cluster consisting of hundreds upon hundreds of stars, ten or more of which may be seen by the naked eye beneath clear winter skies. Although the details vary, the association of the Pleiades with agriculture is widespread in the Americas, in part because the Pleiades are a readily identifiable feature of the night sky that approximates a portion of the arc of the ecliptic, the apparent annual path of the sun. The apparent descent of the Seven Stars was one of the visual cues for setting the Thunder Ceremony, which was performed just before the March equinox. Only after the Thunders had been properly greeted could the preparations for the spring planting begin. After a brief absence in the heavens, the Pleiades seem to reappear in Nebraska's eastern skies in mid-June (Appendix). One

visual cue for the Corn Planting Ceremony was the Seven Stars' ascent of the heavens just after sunset in late winter.[31]

The apparent magnitudes of multiple stars within the Pleiades cluster approximate the limits of what can be seen by the naked eye. As a result, there are many cultural explanations for the variable number of visible stars within the Pleiades.[32] For the Pawnee, the representation of the Seven Stars with six crosses on the Skidi Star Chart may recall the gift of agriculture. According to a Kitkehahki band oral tradition, in the beginning of Pawnee times a girl fleeing a malevolent rattling skull came upon a lodge belonging to six young brothers, some of whom were not home. The brothers bested the rattling skull, and, as a token of her appreciation, the young girl planted a garden of maize, beans, and squash for them. It turns out that the six brothers were not human; they were earthly incarnations of the stars, who eventually decide to adopt the girl after the harvest: "After the girl had lived with them for some time the brothers decided to take her with them on their nightly journey through the sky country. At night she may be seen as the seventh star of the Pleiades."[33]

The six crosses representing the Pleiades in its summer position on the Skidi Star Chart may reference the six brothers in the above oral tradition before they adopted the girl who gave them maize, beans, and squash. Since the optical path length for light through the atmosphere is longer when a star is near the horizon rather than overhead, it is generally more difficult for the Skidi to see the seventh star of the Pleiades until the crops are mature.

The Seven Stars in summer is as much a map of the ritual stage of the Four Pole Ceremony as it is of the open star cluster known as the Pleiades. Roaming Scout stated that the six crosses representing the Pleiades in summer on the Skidi Star Chart references the Four Pole Ceremony, though he offered no additional details. The Four Pole Ceremony is a dramatic reenactment of world creation that includes the construction of an earthen altar and a fire pit as well as the raising and the painting of four poles within an earthen enclosure (Figure 7a). This ritual stage is in imitation of the primordial lodge, itself a model of the cosmos and Atira's womb, where creation was planned

31. Lynn Ceci, "Watchers of the Pleiades: Ethnoastronomy among Native Cultivators in Northeastern North America," *Ethnohistory*, XXV (1978), 301–317; Murie, *Ceremonies of the Pawnee*, ed. Parks, 53, 76; Weltfish, *The Lost Universe*, 79–80; Chamberlain, "The Chief and His Council," in Williamson and Farrer, eds., *Earth and Sky*, 229–231.

32. See, for example, E. C. Krupp, *Echoes of the Ancient Skies: The Astronomy of Lost Civilizations* (New York, 1983), 84–90; Jean Guard Monroe and Ray A. Williamson, *They Dance in the Sky: Native American Star Myths* (Boston, 1987), 1–14.

33. White Sun quoted in Dorsey, *Pawnee Mythology*, 122.

and carried out. As shown in Figures 7a and 7b, the critical components of the ritual stage described above exhibit the same spatial relationships as the six crosses representing the Pleiades on the Skidi Star Chart.[34]

The Seven Stars also figures prominently in the basket dice game, a gambling rite with cosmological significance because the basket represents the container that carried the earth and stars during creation. In "Origin of the Basket Dice Game," Dorsey indicated that some decorated plum-seed dice in this game represented the Pleiades. A description of the painted dice may be found in another oral tradition entitled "Scabby-Bull, the Wonderful Medicine-Man":

> I have in my hand six plum-stones that have no marks upon them, and these my daughter wants marked, and she has asked that Scabby-Bull make the marks upon the stones. . . . One of the stones had a new moon pictured on it, and a little black star on the decorated side. The next stone bore a half-moon in black. The next stone was decorated with a full moon; and the next one had upon it just one great star, which reached from one point of the stone to the other. The next stone had two stars painted upon it; while the last one had seven stars painted upon it. According to the people, the man took the stones outside, held them up, and through the power of the moon and the stars the stones were painted black.

Unfortunately, we do not know the spatial organization of the Seven Stars painted on Scabby Bull's plum-seed dice. The celestial objects on the plum-seed dice described above, like the stars on the Skidi Star Chart, are all painted in the sacred color of black.[35]

The Seven Stars asterism likely references each ritual and oral tradition above—and probably others that have either been lost or are unknown to us. These referents are not as disparate as they seem, for all are inspired by nature's patterns and cycles that came into existence during world creation. The correlation of celestial movements in the heavens with biological cycles on earth, "astrobiology" as the geographer Paul Wheatley called it, is an integral part of establishing and verifying worldviews—the cultural ideas through

34. Roaming Scout quoted in Chamberlain, *When the Stars Came Down*, 195–196; Murie, *Pawnee Indian Societies*, American Museum of Natural History, *Anthropological Papers*, XI, part VII (1914), 551–554; Murie, *Ceremonies of the Pawnee*, ed. Parks, 107–111.

35. Weltfish, *The Lost Universe*, 401; Dorsey, *Pawnee Mythology*, 44; Wonderful Sun quoted in Dorsey, *Traditions of the Skidi Pawnee*, 235. The Skull bundle may be important to the narrative here, as it plays a leading role in the Four Pole Ceremony as well as the spring Corn Planting Ceremony. Among its contents are Mother Corn and plum-seed dice. See Murie, *Ceremonies of the Pawnee*, ed. Parks, 76–77, 107–108.

which individuals interpret and interact with their surroundings. Once an astrobiological correlation is established, it may be extended to other, seemingly unrelated, parts of the cultural system.[36]

Worldviews are not only articulated during ceremonies, but they are also manifest in the daily paths of life. The simple act of planting maize, for example, recalls the role of the heavens and the Seven Stars in guiding the life cycle of annual crops. Gene Weltfish noted that Skidi women planted four to six maize kernels around the sides of a corn hill and one kernel in the center. This seemingly mundane act has several possible references on the Skidi Star Chart. If four maize kernels are planted around the perimeter of the circular planting surface and one in the center, the pattern replicates the quincunx point pattern of stars on the Skidi Star Chart (Figure 2). It also duplicates the temporal and spatial pattern of the Skidi bundle ritual scheme. When five kernels are planted along the periphery of the hillock and one in the middle, the pattern duplicates the Seven Stars in summer as they are depicted on the Skidi Star Chart. Six kernels planted along the edge of a corn hill and one in the middle potentially duplicates the pattern of the Seven Stars painted on Scabby Bull's plum-seed dice. References to agriculture may also explain why the Seven Stars are represented by ten crosses in winter, a time when the earth sleeps and the essence of Mother Corn journeys to the heavens. Skidi ethnoclassifications of maize are based on color and color patterns. There are different Skidi classification schemes for maize. The most complete one recognizes ten maize varieties, which is the same number of crosses representing the Seven Stars in winter on the Skidi Star Chart. Chamberlain suggests that Seven Stars, the Chief's Circle, and the Star That Does Not Walk Around are all symbols of unity and consensus management. Such symbolism is essential for the control and management of both common and open-access subsistence resources.[37]

In sum, each cartographic sign for the Seven Stars on the Skidi Star Chart has multiple referents in Skidi life, from seemingly mundane acts like gambling and planting maize to cosmological explanations of how the heavens and earth came to be. The depiction of the Seven Stars in two different posi-

36. Paul Wheatley, *The Pivot of the Four Quarters: A Preliminary Enquiry into the Origins and Character of the Ancient Chinese City* (Chicago, 1971), 411–476 (esp. 414).

37. Weltfish, *The Lost Universe*, 102, 123; Murie, *Ceremonies of the Pawnee*, ed. Parks, 86, 104; Chamberlain, "The Chief and His Council," in Williamson and Farrer, eds., *Earth and Sky*, 230–232. On Skidi classification schemes for maize, compare Murie, *Ceremonies of the Pawnee*, ed. Parks, 37; George F. Will and George E. Hyde, *Corn among the Indians of the Upper Missouri* (Saint Louis, Mo., 1917), 308–309; and Weltfish, *The Lost Universe*, 121–122.

tions on the Skidi Star Chart forges a bond between the sacred and profane by detailing the rhythms and cycles of stars rising and setting, of the seasons coming and going, of biological birth and death. Every celestial entity on the Skidi Star Chart is, in part, a graphic exegesis of the night sky and its myriad relationships to life on earth. It is sobering to realize that only a few Skidi referents for the Seven Stars are available in English and that every celestial object on the Skidi Star Chart has a similar index of referents. In this sense, the Skidi Star Chart is a map of all that we cartographers do not know.[38]

The Occasional Independence of Cartographic Signs, Referents, and Location
Although oral traditions are critically important for understanding the meanings of native maps, they often raise difficult questions, in part because Western cartographers often have different expectations of narrative and of geographic relationships from their native counterparts. Native maps, such as the Skidi Star Chart, often exhibit a greater flexibility in their cartographic signification than modern Western maps. Sometimes native maps combine cartographic signs with a referent and a unique location. Skidi informants and Moulton linked fourteen cartographic signs on the Skidi Star Chart with their counterparts in the night sky (Appendix). Other times, however, the referent and the location are independent sign vehicles for a single object. This flexibility is well illustrated by the representation of the World Quarter Stars and the multiple identities of both Sirius and Great Star in the night sky and on the Skidi Star Chart.

Color and directional symbolism are an important part of Pawnee cosmology as well as those of many other native peoples across the Great Plains, in the American Southwest, ancient Mexico, and elsewhere.[39] For the Skidi, the World Quarter Stars embody this color and directional symbolism (Figure 7a). Despite their importance in Skidi oral traditions and ritual, only three of the four World Quarter Stars are shown on the Skidi Star Chart: Big Black Meteoric Star in the northeast, White Dwelling Star in the southwest, and Red Lodge Pole Star in the southeast. There is no cross representing Yellow Dwelling Star on the Skidi Star Chart (Figure 2). In addition, there is little

38. A less literal reading of Pawnee oral traditions would markedly expand the number of referents. For example, an oral tradition entitled "The Origin of the Loon Medicine Ceremony" describes the movements of paired swimming ducks across a primordial pond that may be a metaphor for the movement of the Swimming Ducks asterism across the night sky. See Buffalo quoted in Dorsey, *Pawnee Mythology*, 258; and Murie, *Ceremonies of the Pawnee*, ed. Parks, 167.

39. Hall, *Archaeology of the Soul*, 86–101.

differentiation in cross sizes where Yellow Dwelling Star should be located. The northwest portion of the Skidi Star Chart is comparatively bland with respect to the rest of the image. Emptiness can be meaningful. The World Quarter Stars show that certain geographic positions on the Skidi Star Chart may serve as a cartographic sign and its referent, whether or not a symbol occupies the position on the canvas.

Neither Murie nor Roaming Scout was able to identify the World Quarter Stars in the night sky. Indeed, Roaming Scout suggested that many celestial deities were "distant and dim and hard to see." Most modern analysts discount Roaming Scout's statement. After all, why would anyone select a faint, ordinary star to represent a powerful celestial deity? Chamberlain evaluated different proposals for the identity of the World Quarter Stars and suggested the following schema: Vega for the Big Black Meteoric Star in the northeast, Sirius for the White Dwelling Star in the southwest, Capella for the Yellow Dwelling Star in the northwest, and Anatres for the Red Lodge Pole Star in the southeast. Chamberlain's proposal proved controversial for reasons of methodology and because of its culture historical implications. As previously noted, both Murie and Weltfish indicated that Sirius is the celestial manifestation of Wolf Got Fooled.[40]

Roaming Scout's statement can be interpreted in a different way, however. Some celestial deities, including the World Quarter Stars, may manifest themselves as bright objects in the night sky. The World Quarter Stars are probably the stars identified by Chamberlain, since their paired risings and settings in the night sky are congruent with Skidi cultural logic—at least sometimes. Computer simulations show, however, that Vega, Sirius, Capella, and Anatares would not all be in the proper positions on every night of every year (Appendix). For the cosmology of the Skidi to work in daily life, these stars had to stand in their geographic positions every time the Skidi needed them. What if no star was in the proper position? What if a star is in the proper position at one point in time but not in another? The occasional independence of cartographic signs, referents, and positions solves the problem of capturing a dynamic world on a static image.

One could argue that Sirius, the brightest star in the night sky, should have two identities on the Skidi Star Chart because it moves through the night sky,

40. Chamberlain, *When the Stars Came Down,* 98–103 (quotation from Roaming Scout on 99); Blakeslee, review of *When the Stars Came Down,* by Chamberlain, *Plains Anthropologist,* XXX, no. 107 (February 1985), 78; Parks, "Interpreting Pawnee Star Lore," *American Indian Culture and Research Journal,* IX, no. 1 (1985), 58–59; Murie, *Ceremonies of the Pawnee,* ed. Parks, 41; Weltfish, *The Lost Universe,* 277, 328.

whereas the intercardinal directions where the World Quarter deities stand are fixed points on the horizon (Figures 7a and 11). The other World Quarter Stars can also manifest themselves solely as geographic positions in the night sky. After all, the World Quarters are conceptual and thus "distant and dim and hard to see."

The World Quarter Stars embody color and directional symbolism as well as a set of associations (Figure 7a). Any characteristic associated with the World Quarter Stars is a synechdoche in the sense that any part may represent the whole set of associations. Thus, any visual variable, such as hue or shape, or geographic position referencing the World Quarter Stars signifies the whole suite of meanings associated with them.

The notion that a part may represent the whole explains a supposed issue concerning the color of the World Quarter Stars on the Skidi Star Chart. Skidi artists had a full palate of colors to represent the stars, either as they appeared in the night sky or as conceived in terms of cosmology and directional symbolism. All of the night stars on the Skidi Star Chart, however, are painted black. Why are the World Quarter Stars not represented in their sacred colors? Chamberlain concurred with Murie that a blue or bluish-white pigment on the Skidi Star Chart was obscured by dirt or perhaps worn away. Perhaps the other colors have also worn away. Another possibility is that the sacred colors of the semicardinal directions are signified by a different visual variable than hue.[41]

During the Hako ceremony, the Pawnee version of a pan-continental ritual of adoption and mourning, the leader of the ceremony paints four blue lines on Mother Corn to represent the four paths of World Quarters. Celestial powers descend to earth upon these paths, which are guarded by the attendant winds of Bright Star (Venus), to help people. Each semicardinal direction is associated with a specific color, yet only blue is used to represent the four semicardinal directions during the Hako rite, because the Pawnee see the four sacred colors walking upon the paths after the ceremonial leader touches Mother Corn: "The blue paint came down one of these paths. . . ." Four lines, coupled with a song and gesture, convey color directional symbolism rather than the color of the lines. Blue paint is also used to draw the dome of the sky upon the face of a child in a powerful part of the ceremony that we shall return to later in this essay.[42]

41. Murie cited in Chamberlain, *When the Stars Came Down*, 204.
42. Alice C. Fletcher with the assistance of James R. Murie, *The Hako: Song, Pipe, and Unity in a Pawnee Calumet Ceremony*, music transcr. Edwin S. Tracy, intro. Helen Myers (Lincoln, Nebr., 1996), 45–46, 230–235. Rituals of adoption and reincarnation were widespread in native North America. See Hall, *Archaeology of the Soul*, 32–67.

Skidi oral traditions state that the celestial deities sang into existence the very colors that ultimately appear on the Star Chart as a gift for the "first man": "We shall also give him paints,—burnt grass to turn into black paint, the red paint and yellow paint." Different colors thus come from a single ingredient. Similarly, Skidi performers sing into existence the sacred colors that walk along the World Quarter paths in the Hako rite.[43]

On the Skidi Star Chart, all nighttime objects are painted black. Dawn is represented with red and yellow bands, and sunset is represented by a yellow band. A red sky, of course, may be seen at both sunrise and sunset. Why, then, is red associated with dawn? During the Hako ceremony, an elder prepares red pigment by mixing red clay with running water to put upon the face of a consecrated child. The red pigment "symbolizes the red clouds of the dawn, the coming of the new day, the rising sun, the vigor of life." "The power of the new day, the new life, is now standing before the child." During the song that accompanies the rite of face painting, the elder carries the pigment in the right half of a clam shell and approaches the child in the same manner as the dawn approaches the earth. Gesture and the song convey the meaning of the color and the movement of the heavens, not the color of the pigment.[44]

The expectation that hue, value, and chroma are the sole visual variables expressing color directional symbolism is a modern Western expectation. For the World Quarter Stars, any part may represent the whole. Songs, stories, and gestures can convey the geographic narratives embodied by a cartographic sign or a geographic position on the Skidi Star Chart. Those who recognized the World Quarter Stars by map sign or position on the Skidi Star Chart could further refine the spatiality of other map signs.

The occasional independence of cartographic signs, referents, and location is also shown by the depiction of Great Star on the Skidi Star Chart. Another suitable star or planet in the proper position could take the place of Mars, if the red planet was not in the proper place when the Skidi needed Great Star. The so-called Morning Star Sacrifice illustrates this principal of substitution. Both Murie and Weltfish provide emic accounts of the Morning Star Sacrifice, summarized below, which are far less sensational than historic accounts of the ceremony.[45]

Great Star (most often Mars) occasionally asked the Pawnee for a human sacrifice as a reward for his role in world creation and also to renew earthly

43. Dorsey, *Traditions of the Skidi Pawnee*, 8; Fletcher, *The Hako*, 45–46.

44. Fletcher, *The Hako*, 222, 228, 229, 352–353.

45. Murie, *Ceremonies of the Pawnee*, ed. Parks, 114–136; Weltfish, *The Lost Universe*, 106–118.

fertility. The rite was triggered by the appearance of Great Star in a warrior's dream. Once the Great Star priest sanctified the dream, the warrior captured a suitable victim—often, but not always, a young woman. The captive lived comfortably among the Skidi until the following spring, when preparations for the Morning Star Sacrifice began. For four days before the sacrifice, Skidi priests and ritual performers detailed the many primordial feats of Great Star in a village earth lodge. Just before dawn on the fifth day, the captive's entire body was painted in the sacred colors of red (right side) and black (left side), representing the dualism embodied by Great Star and Bright Star respectively.

The sacrifice took place on the outskirts of the village on a carefully prepared stage that represented the cosmos. Skidi errand men built an east-facing scaffold from each of the four species of timber associated with the World Quarter Stars (Figure 7a). They also excavated a pit representing Bright Star's garden below the scaffolding. A solemn procession followed the captive to the consecrated area. The captor induced the captive to move across the stage, their motions in imitation of Great Star's pursuit of Bright Star. A ritual impersonator for Wolf Got Fooled induced the painted captive to willingly ascend the scaffold (Wolf Got Fooled was himself tricked into experiencing death in the beginning of Skidi times). The captive was then tied to the scaffolding, with arms and legs extended in Vitruvian fashion. Just before dawn, beneath the watchful gaze of Great Star, a volley of arrows returned the captive's vitalizing force to the earth. The captive's blood provided sustenance for Bright Star's garden and also signified that Great Star had received the first girl.

Multiple Skidi informants described Great Star as "red," "bright," and "following Bright Star" in the night sky. Mars certainly fits this description. Historic accounts indicate that the Skidi performed the Morning Star Sacrifice during April in 1817, 1818, 1827, and 1838. Mars occupied the Morning Star position in 1817 but was not in this position on the remaining dates. Jupiter (Great Star's Brother) would have been high in the morning sky in 1818. Venus (Bright Star) occupied the Morning Star position in 1827 and 1838, though the sun and an invisible Mars rose together in 1838. If Mars only occasionally occupied the Morning Star position during this most powerful of sacrificial rites, who, then, is Great Star?[46]

46. Murie, *Ceremonies of the Pawnee*, ed. Parks, 129, 182 n. 62; Melburn D. Thurman, "The Timing of the Skidi-Pawnee Morning Star Sacr[i]fice," *Ethnohistory*, XXX (1983), 157–159; Chamberlain, *When the Stars Came Down*, 71–80. The captive was either ransomed or rescued during the 1817 and 1818 rites. An attempted rescue ended tragically during the 1827 rite. The last known individual to die during the Morning Star Sacri-

The question of Great Star's identity has led to competing proposals about the celestial harbingers for the Morning Star Sacrifice. Chamberlain's observation that Mars had completed its apparent westward journey across the night sky on most dates of the Morning Star rite is compelling, as this means that Great Star followed Bright Star across the night sky. However, Mars was rarely visible in the morning sky on the known dates of the sacrifice. Murie cryptically noted that the Skidi Star Chart may help resolve the dilemma of Great Star's identity during the Morning Star Sacrifice, but he offered no details. He also suggested that one star may substitute for another "when in the proper place."[47]

The Skidi Star Chart shows Great Star between the pigment bands representing Dawn and the cross representing Wolf Got Fooled (Figure 2). This arrangement seemingly references the ritual scene in the Morning Star Sacrifice when the Wolf Got Fooled impersonator coaxes the captive to ascend an east-facing scaffolding as Great Star rises above dawn's first light. The only other large cross on the Skidi Star Chart in this area is Great Star's Brother, whose celestial counterpart in the night could be either Mercury or Jupiter, according to Skidi informants (Appendix).[48] Some have interpreted the uncertainties over the identity of Great Star's Brother as a problem of identification or lost tradition. Perhaps, but this interpretation assumes a single identity for each star depicted on the Skidi Star Chart. The fluid identity of Great Star's Brother is a reminder that one star may substitute for another "when in the proper place." The Skidi name for Mercury or Jupiter, Great Star's Brother, shows that objects in the heavens have kinship relations. The Hako ceremony introduced above is a form of ritual reincarnation, where the essence of one person is symbolically transferred to another. This transfer provides both continuity and flexibility, a welding of the old and the young across generations. The multiple manifestations of Jupiter as an imperfect Great Star in 1818 and as Great Star's Brother at other times suggest that a similar transfer is possible for the stars. The significance for the Skidi Star Chart is that such flexibility is only possible if the cartographic sign, its referent, and its geographic position are conceptually independent.

The Morning Star Sacrifice was not based on a calendar or the caprices

fice was a Siouan girl named Haxti in 1838. An attenuated form of the ceremony was performed without human sacrifice in 1902, 1906, and 1915.

47. Chamberlain, *When the Stars Came Down*, 79–81; Thurman, "Skidi-Pawnee Morning Star Sacr[i]fice," *Ethnohistory*, XXX (1983), 159; Murie, *Ceremonies of the Pawnee*, ed. Parks, 182 n. 62.

48. Murie, *Ceremonies of the Pawnee*, ed. Parks, 41, 114, 182 n. 62.

and whims of Skidi elite. Rather, the sacrifice to Great Star occurred during times of severe social stress.[49] The sacrifice to Great Star was an attempt to restore balance—to make the territory and the night sky conform to the cultural ideals represented on the Skidi Star Chart. If Mars was not in the proper position when the Skidi needed him, another celestial body would have to do. In sum, the position of Dawn, Wolf Got Fooled, Great Star, Great Star's Brother, and possibly other objects on the Skidi Star Chart are as much a map of the Morning Star Sacrifice as they are of the night sky.

Does Size Matter?

The hierarchy of cross size on the Skidi Star Chart defies simple explanation. Ralph N. Buckstaff suggested five size classes for the crosses, a typology accepted by later scholars. Although one may quibble with the number of size classes, it is clear that the crosses are drawn to different sizes. Some have suggested that cross size was proportional to stellar magnitude. This is clearly not the case.[50] Sirius is the brightest star in the night sky. Yet, the crosses referencing Sirius (White Dwelling Star or Wolf Got Fooled), Vega (Big Black Meteoric Star), and Polaris (Star That Does Not Walk Around) are all the same size on the Skidi Star Chart, even though the apparent brightness of these stars differs by more than three orders of magnitude. Venus (Bright Star) is often several orders of magnitude brighter than Sirius, yet both are approximately the same size on the Skidi Star Chart. The brightest object in the night sky is the moon. On the Skidi Star Chart, the icon for the moon is a crescent superimposed on a circle that is about the same size as the other large crosses (Figure 2, Appendix).

All maps, including modern Western ones, are selective graphic arguments. Modern road maps, for example, greatly exaggerate the width of interstates and other major roads in order to facilitate route planning. Many American

49. Ibid., 114, 115. The Pawnee signed their first treaty with the United States in 1818. Epidemics and warfare, particularly warfare with the Sioux, decimated Pawnee peoples over the next twenty years.

50. Buckstaff, "Stars and Constellations," *American Anthropologist*, XXIX (1927), 279, 281; G. Malcolm Lewis, "Indian Maps: Their Place in the History of Plains Cartography," *Great Plains Quarterly*, IV (1984), 93–94. On cross size as proportional to stellar magnitutde, see Chamberlain, *When the Stars Came Down*, 192–193; Lewis, "Maps, Mapmaking, and Map Use," in Woodward and Lewis, eds., *Cartography*, 125. Signs, of course, can embody more than one referent. John B. Dunbar, "The Pawnee Indians: A Sketch," typescript, State Historical Society of Wisconsin, in his discussion of Pawnee calendars, suggests that a crescent moon may be a symbol for a lunar month and the passage of time rather than an object in the night sky.

Indian cartographers exaggerated the size of culturally important icons on their maps or placed them at the center of the image.[51] Perhaps the hierarchy of icon sizes on the Skidi Star Chart represents the cultural importance of the celestial object to Skidi peoples. If so, Pawnee oral traditions might explain the hierarchy of cross sizes and the other discrepancies noted above.

Some stars are clearly more important than others for world creation. Not surprisingly, some bundles and bundle-holding priests are more important than others during particular ceremonies. Yet an appeal to the celestial hierarchies so clearly outlined in Skidi oral traditions and rituals fails to explain the hierarchy of cross sizes on the Skidi Star Chart. Apart from Tirawahat, who is often amorphous, Bright Star (Venus) and Great Star (most often Mars) are the most powerful and important celestial entities in Skidi oral traditions and rituals. Bright Star is the mother of all earthly things and, as detailed in the next section, has a paramount role in the ritual that set the Pawnee calendar—the Thunder Ceremony. As noted above, Great Star occasionally asked the Pawnee for a human sacrifice as a reward for his role in world creation and the birth of the first person. He is the only star that can make this demand. The priests who retain the knowledge associated with the Bright Star and Great Star bundles take leading roles in the most important Skidi ceremonies. Murie stated that Big Black Meteoric Star (Vega), the patron star of the bundle containing the Skidi Star Chart, was third in power among the celestial deities. He later noted that Black Star (identity unknown), whose main purpose was to assist with the control of animals on Earth, was one of the last objects placed in the heavens.[52] Yet, on the Skidi Star Chart, the crosses representing Bright Star, Great Star, and Big Black Meteoric Star are no larger than those of Black Star, who is one of many deities that merely "look after the world." Wolf Got Fooled (Sirius) was excluded from one of the councils that planned the world yet is the same size as other celestial deities who participated in the council. The Moon, who gave birth to the first man, is likewise no larger on the Skidi Star Chart than Black Star or Wolf Got Fooled.

Skidi artists purposefully depicted stars with crosses of different sizes. Thus, the visual variable of size must have meaning. Perhaps, however, the hierarchy of cross sizes is a cultural convention that is more important to Western cartographers than Skidi peoples. In either case, cross size is a visual reminder of all that we still do not know about the Skidi Star Chart.

51. Lewis, "Indian Delimitations," in Ross and Moore, eds., *A Cultural Geography,* 94; Lewis, "Maps, Mapmaking, and Map Use," in Woodward and Lewis, eds., *Cartography,* 53.

52. Murie, *Ceremonies of the Pawnee,* ed. Parks, 34–35 (table 1), 38–39, 40–42, 43.

A Curious Spatial Syntax

Modern Western star charts and planispheres often separate time and space. They also generally depict time and space as discrete and scalar phenomena. This is not the case with the Skidi Star Chart, which fuses time and space and renders them at multiple scales. The Skidi Star Chart accomplishes this remarkable conceptual feat by altering stellar positions, representing on the same canvas celestial entities that are only visible at different times, and showing the same celestial entity in different seasonal positions.

The depictions of sunrise and sunset help orient the Skidi Star Chart. They also provide an obvious reference to the daily passage of time. Another visual cue to the daily passage of time is suggested by the rendering of the Stretcher asterisms on the Skidi Star Chart, selected stars that have had their positions altered to suggest circular motion. According to a Pitahauirat band oral tradition, the Little Stretcher (Little Dipper) asterism carries a child, and the Big Stretcher (Big Dipper) carries a sick old man. It is said that the Big Stretcher and the Little Stretcher asterisms will circle the Star That Does Not Walk Around (Polaris) until the South Star captures them and the world comes to an end. The stellar positions of the Stretcher "attendants" (the tails of Ursa Major and Ursa Minor) on the Skidi Star Chart have been subtly altered from their appearance in the night sky. If so, the overall visual effect suggests the nightly circular motion of the Stretchers around the Star That Does Not Walk Around, as documented by Pitahauirat band oral tradition.[53]

The representation of the Seven Stars (the Pleiades) in both its summer and winter positions explicitly shows the seasonal passage of time. Longer periods of time are suggested by the depiction of celestial entities on the same canvas that are only visible at vastly different times of the year. For example, early autumn is the most common time for the occurrence of Stream with Scum Extending (the Milky Way) as shown on the Skidi Star Chart, yet the position of the Swimming Ducks (Lamda and Upsilon Scorpii) asterism suggests a late winter or early spring scene (Figure 3a and 3b, Appendix).

Dawn (east), Golden Sunset (east), and Stream with Scum Extending (center) together provide a spatial reference system for interpreting the Skidi Star Chart. As noted previously, the red and yellow hues used to depict Dawn and Golden Sunset reference the human life cycle and reincarnation rites. Skidi oral traditions suggest that Stream with Scum Extending also referenced the human life cycle. Skidi peoples conceived of Stream with Scum Extending as a forked celestial river and as a forked celestial pathway for the dearly departed. In the later conception, those that lived a long life took the bright fork of the

53. Young Bull quoted in Dorsey, *Pawnee Mythology*, 135–136.

Milky Way, whereas those that died in battle took the dim portion. The Milky Way is also a seam for the two half spheres that compose the night sky. The position of the Milky Way in the middle of the Skidi Star Chart seemingly references the notion of a seam that divides the heavens. A complex object such as the Milky Way can be drawn in many ways. Pawnee oral traditions describe the celestial pathway for the dead as being forked toward the south, just as it is on the Skidi Star Chart.[54]

At first glance, asterisms or constellations such as the Big Dipper (Big Stretcher), the Little Dipper (Little Stretcher), the Pleiades (Seven Stars), Corona Borealis (Chief's Circle), and Orion's Belt (Deer Stars) are readily identifiable (Figures 2, 3a, 3b). Each appears to be in their correct relative position with respect to one another in the night sky. Yet they are all reversed from how they appear in the night sky (Figures 8, 9, 10). Some suggest that this discrepancy stems from an error of transposition during mapmaking.[55] This conclusion seems unlikely, because a transposition error should manifest itself in all map objects and their spatial relationships, rather than selected ones. The reversal of star groups on the Skidi Star Chart is, in my opinion, purposeful and meaningful. The reasons for reversal, however, require some explanation of how the Skidi used the Star Chart.

MAP CONTEXT: PERFORMANCE CARTOGRAPHY

At this point, the reader may be wondering why I continue to use the word "map" in this essay. The Star Chart references the night sky and components of Skidi world creation. Yet, it is not at all clear how the image furthers a spatial understanding of celestial or primordial worlds. Rather than a spatial understanding of the phenomena depicted on the Skidi Star Chart, we have a number of cartographic conundrums, including the elliptical shape of the chart, its rendering on the fur side of a hide, the fusion of time and space at multiple scales, asterism and constellation modification and reversal, the unexplained hierarchy of cross sizes, and the polyvalent bonds between map signs, referents, and geographic position. Perhaps the Skidi Star Chart is merely an illustration and a mnemonic device with no cartographic significance.

The aforementioned discussion of color and the Hako ceremony shows

54. Murie, *Ceremonies of the Pawnee,* ed. Parks, 41; Dorsey, *Traditions of the Skidi Pawnee,* 57; Curtis, *The Indians' Book,* 99; Weltfish, *The Lost Universe,* 400–401; William Gustav Gartner, "Mapmaking in the Central Andes," in Woodward and Lewis, eds., *Cartography,* 260–261, 272. Dunbar, in a brief paragraph devoted to astronomy in "The Pawnee Indians," states that the Pawnee conceive of the Milky Way as "the line where the two hollow hemispheres that form the sky close together."

55. Chamberlain, *When the Stars Came Down,* 205.

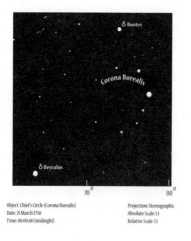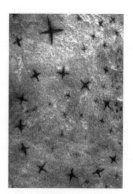

Object: Chief's Circle (Corona Borealis)
Date: 21 March 1750
Time: 00:00:00 (midnight)

Projection: Stereographic
Absolute Scale: 1:1
Relative Scale: 1:1

FIGURE 8. Chief's Circle: A Comparison of the Corona Borealis (Chief's Circle) Constellation from a Computer-Generated Image of the Night Sky over the Pawnee Homeland in AD 1750 and the Constellation's Depiction on the Skidi Star Chart. Orientation: East (Dawn) is at right. Stellarium, v 10.5; and by kind permission of the Skidi band of the Pawnee Nation of Oklahoma. Image source: © The Field Museum, #CSA16231c.

Skidi artists not only reversed the depiction of the Chief's Circle on the Skidi Star Chart from its appearance in the night sky but also added additional stars. The number of stars comprising the Chief's Circle on the Skidi Star Chart may reference the number of bundle-holding villages in the Skidi federation at the time the image was produced or used

the importance of songs and rituals for conveying geographic information. In this section, I shall argue that analogical expressions and performances of spatial knowledge are critical to understanding the cartographic significance of the Skidi Star Chart. Skidi people relied on performance cartography to convey the geographic arguments of the Star Chart in much the same way that modern Western maps rely on legends, directional indicators, metadata statements, geographic coordinate systems, and other paramap elements to extend their geographic arguments.[56]

56. Wood and Fels, *Natures of Maps*, 8–12, define the paramap and show its importance for understanding modern Western maps throughout their volume.

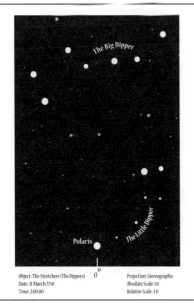
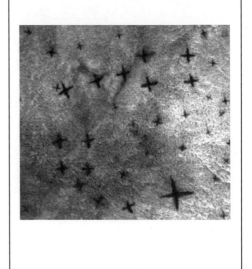

FIGURE 9. The Stretchers: A Comparison of the Big Dipper (Big Stretcher) and the Little Dipper (Little Stretcher) from a Computer-Generated Image of the Night Sky over the Pawnee Homeland in AD 1750 and Their Depiction on the Skidi Star Chart. Orientation: North is at top (on the Skidi Star Chart, east [Dawn] is at right). Stellarium, v 10.5; and by kind permission of the Skidi band of the Pawnee Nation of Oklahoma. Image source: © The Field Museum, #CSA16231c.

The Stetchers are reversed on the Skidi Star Chart from their appearance in the night sky. On the Skidi Star Chart, subtle changes in the spatiality of the Stretchers are a visual cue suggesting the circular motion of the Stretchers around the Star That Does Not Move, as detailed in Pawnee oral traditions

Fortunately, ethnographic accounts provide details on how the Skidi used the Star Chart. Priests opened the Big Black Meteoric Star bundle during the Thunder Ceremony. They then instructed errand men to tie the Skidi Star Chart to a pole outside the earth lodge for the remainder of the ritual. The Skidi Star Chart also played a critical role in the Great Cleansing Ceremony—as the lead baton in a footrace to a stream. How can the Skidi Star Chart possibly be a map of the heavens if it is used as a beacon and as a baton? As strange as it may seem to those who conceive of maps solely as artifacts for wayfinding or recording spatial inventories, these acts show that the Skidi Star Chart is a map. In order to understand how this is so, we need to consult Skidi rituals and other acts of performance cartography.

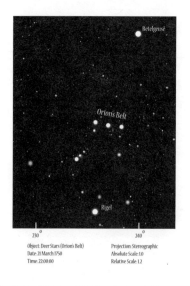
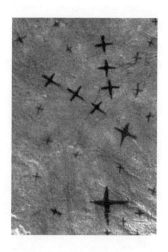

FIGURE 10. The Deer Stars: A Comparison of the Orion's Belt (Deer Stars) Asterism from a Computer-Generated Image of the Night Sky over the Pawnee Homeland in AD 1750 and the Asterism's Depiction on the Skidi Star Chart. Orientation: West (Golden Sunset) is at right. Stellarium, v 10.5; and by kind permission of the Skidi band of the Pawnee Nation of Oklahoma. Image source: © The Field Museum, #CSA16231c.

The Deer Stars depicted on the Skidi Star Chart are the mirror image of their appearance in the night sky

Performance Cartography: The Big Black Meteoric Star Bundle

Although the Skidi Star Chart is often analyzed as a solitary artifact, it is one of many items that Skidi peoples wrapped together into the Big Black Meteoric Star bundle. When the Chicago Field Museum accessioned the Big Black Meteoric Star bundle in 1906, the Pawnee priest Roaming Scout indicated that multiple artifacts were of cartographic significance: "In the scalp he said was a heavenly chart. This brass thing [meteorite], [Roaming] Scout told us, went with the chart. He said the chart was the heavens, while the brass [meteorite] represented the earth."[57]

In addition to the Skidi Star Chart, Murie listed two white ears of Mother Corn, four owl skins, one otter collar, one hawk skin, one or two scalps, reeds,

57. From an unpublished note written by Dorsey, excerpted in Chamberlain, *When the Stars Came Down*, 186.

pigments, clam shells, tobacco, buffalo meat and fat, miscellanea, and a "meteorite" as the sacred artifacts wrapped up inside the Big Black Meteoric Star bundle. At one time, the Big Black Meteoric Star bundle also contained a sacred scapula hoe used in the Ground Breaking Ceremony, a coyote skin, hemlock war clubs similar to those used by the World Quarter gods during Pawnee world creation, and a short, round stake that was used in conjunction with the Skidi Star Chart to alleviate a woman's pain during childbirth.[58]

The cover for the Skidi Star Chart was made from the intact hide of a buffalo head with the skull and horns removed. The choice of buffalo hide symbolized the Big Black Meteoric Star himself, which, according to Murie, was "sometimes spoken of as a buffalo bull who holds up the heavens on his back." Roaming Scout also stated that the wrap symbolized "the star itself; that is, the star is supposed to sit in darkness, from the depths of which its bright eyes gleam. From the black depths of this star comes the night." The Skidi Star Chart was occasionally tied onto the outside of the Big Black Meteoric Star bundle.[59]

The meteorite in the Big Black Meteoric Star bundle was a "disk made of pounded brass." Like the Skidi Star Chart, the disk was perforated with two holes for buckskin string. Meteorites are highly conceptual and symbolic artifacts for the Skidi and need not be an actual object that fell from outer space. Any unusual object "in the shape of a turtle" and exhibiting unusual colors or iridescence could be a meteorite. For example, the mineral pyrite represented a meteorite in a bundle housed at the American Museum of Natural History. Pyrite has physical similarities to brass in terms of color, luster, and a relatively high specific gravity. Meteorites were either regarded as the children of Tirawahat or as part of Great Star and thus offered great protection and good fortune for its owners. The power of meteors is such that everyone in the presence of an opened meteor bundle had to be covered with white clay for their own protection.[60]

All artifacts within the Big Black Meteoric Star bundle have cosmological

58. Murie, *Ceremonies of the Pawnee*, ed. Parks, 34, 95–96; Weltfish, *The Lost Universe*, 97; George A. Dorsey, "One of the Sacred Altars of the Pawnee," in *Proceedings of International Congress of Americanists, Held in the American Museum of Natural History, New York, October 20 to 25, 1902, Thirteenth Session* (Easton, Pa., 1905), 69; Dorsey cited in Chamberlain, *When the Stars Came Down*, 185; Curtis, *The Indians' Book*, 103; Dorsey and Murie, *Notes on Skidi Pawnee Society*, ed. Spoehr, 90.

59. Murie, *Ceremonies of the Pawnee*, ed. Parks, 42, 96; Dorsey, *Traditions of the Skidi Pawnee*, 115, 347.

60. Chamberlain, *When the Stars Came Down*, 151, 152–153; Murie, *Ceremonies of the Pawnee*, ed. Parks, 40, 67–70; Dorsey, *Pawnee Mythology*, 61–62.

referents detailed in Skidi oral traditions too numerous to recount here. It is the specific placement of multiple bundle artifacts during ceremonies that constitute the basic building blocks of performance cartography. The spatial relationships between bundle artifacts as well as their associations with specific components of the ritual stage create an ephemeral map of geographic relationships between sky and earth and fuse a primordial past with a bountiful future.

Performance Cartography: The Earth Lodge as a Ritual Stage
Traditional Skidi earth lodges consisted of an immense post, beam, rafter, and plank structure built upon a prepared subterranean surface. The dome-shaped structure was overlaid by brush and sod blocks. Traditionally, Skidi earth lodges had long entryways oriented due east. The earth lodge sheltered Skidi families from the climatic extremes of the Central Plains and provided hearth and home for the mundane pathways of everyday life. Skidi architecture also fused the mundane with the sacred. Murie explicitly linked the ritual stage of the Four Pole Ceremony, a dramatic reenactment of world creation, to the plan of the domestic Pawnee earth lodge. He also recited a blessing for an earth lodge domicile in 1905 that well illustrates the blending of the sacred and the mundane: "Let us stand in this lodge as Tirawa [Tirawahat] stood when he created the Earth."[61]

Earth lodge architectural plans are an amalgam of design rules and symbols that codified Skidi worldviews (Figure 11). Roger Echo-Hawk's integration of oral traditions and archaeology show that traditional earth lodges also embody ancient and complex social histories of migration, culture contact, and culture change.[62] As detailed below, Skidi performances of ritual and song within an earth lodge explicitly link an architectural repository with the geographic symbolism embodied by sacred bundle artifacts and their spatial arrangement.

Many Skidi rituals, including the Thunder Ceremony discussed below,

61. Murie, *Pawnee Indian Societies,* American Museum of Natural History, *Anthropological Papers,* XI, part VII (1914), 551–554; W. J. Perry, "Dramatic Element in Ritual," *Folklore,* XXXIX (1928), 43–44; Murie cited in Peter Nabokov and Robert Easton, *Native American Architecture* (New York, 1989), 138.

62. Nabokov and Easton, *Native American Architecture,* 126–140; Fletcher, "Star Cult among the Pawnee," *American Anthropologist,* IV (1902), 735; Fletcher, *The Hako,* 33–34 and lodge diagrams; Weltfish, *The Lost Universe,* 63–64, 71–75, 88–94; Murie, *Ceremonies of the Pawnee,* ed. Parks, 1, 14; William G. Gartner, "Archaeoastronomy as Sacred Geography," *Wisconsin Archeologist,* LXXIV, nos. 3–4 (July–December 1996), 130–131; Echo-Hawk, "Ancient History in the New World," *American Antiquity,* LXV (2000), 281–285.

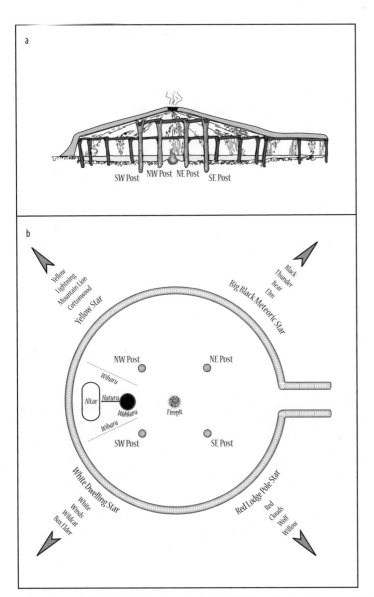

FIGURE 11. A Skidi Earth Lodge. Drawn by William Gustav Gartner. (a) The earth lodge in cross section. (b) A plan view of the earth lodge showing the color directional symbolism embodied by the four central posts. After James R. Murie, *Ceremonies of the Pawnee,* ed. Douglas R. Parks (Lincoln, Nebr., 1989), 45, 110; Gene Weltfish, *The Lost Universe: Pawnee Life and Culture* (Lincoln, Nebr., 1965), 89, 112; and Peter Nabokov and Robert Easton, *Native American Architecture* (New York, 1989), 139; and modified from William G. Gartner, "Archaeoastronomy as Sacred Geography," *Wisconsin Archeologist,* LXXVII, nos. 3–4 (July–December 1996), 132, 139

were timed to coincide with the position of certain stars with respect to the earth lodge. The earth lodge provided a set of fixed reference points with respect to the stars in order to set the ritual calendar:

> The position of the stars was an important guide to the time when this [Thunder] ceremony should be held. The earth lodge served as an astronomical observatory and as the priests sat inside the west, they could observe the stars in certain positions through the smoke hole and through the long east-oriented entranceway. They also kept careful watch of the horizon right after sunset and just before dawn to note the order and position of the stars.[63]

Chamberlain carefully analyzed the architectural dimensions and orientation of a typical Skidi earth lodge with respect to the movement of the stars. Skidi peoples living in Nebraska could track the movements of many celestial objects depicted on the Star Chart from certain vantage points within a traditional earth lodge. They could see the Star That Does Not Walk Around (Polaris), for example, through the smoke hole near the sleeping bunks or walls of the earth lodge. From the same positions, they also could track the movements of the Chief's Circle (Corona Borealis) and the Seven Stars (Pleiades) during certain times of the year. The heliacal rise of the Deer Stars could be viewed through the entryway of an east-facing earth lodge in late July. Skidi peoples gazing upon eastern skies from the entryway surely reveled in the propitious appearance of Bright Star (Venus) and Great Star (Mars) above the horizon.[64]

Although we tend to think of performance as ephemeral, many of the material components necessary for Skidi ritual have considerable longevity in the archaeological record. Key architectural components for cartographic performances such as the Thunder Ceremony include an east-facing entryway, an earthen altar on the west end of the lodge, earthen architectural features such as a rectangular pit and a circle and line incised upon the floor, a central fireplace pit, and four central support posts at the intercardinal directions. Approximately 88 percent of Lower Loop phase (AD 1500–1750) earth lodges that have been identified and studied are oriented due east. Nearly

63. Murie, *Ceremonies of the Pawnee*, ed. Parks, 41; Weltfish, *The Lost Universe*, 79.

64. Chamberlain, *When the Stars Came Down*, 173–181; Chamberlain, "The Chief and His Council," in Williamson and Farrer, eds., *Earth and Sky*, 224–232; Von Del Chamberlain, "The Skidi Pawnee Earth Lodge as an Observatory," in A. F. Aveni, ed., *Archaeoastronomy in the New World: American Primitive Astronomy: Proceedings of an International Conference Held at Oxford University, September, 1981* (Cambridge, 1982), 187–189.

80 percent of these east-facing earth lodges have the remaining architectural components necessary for cartographic performances.[65] Archaeological evidence for earth lodge rituals employing bundle artifacts dates to the fourteenth century in eastern Nebraska and northeastern Kansas. Archaeologists excavated eagle, owl, woodpecker, and blue jay bones from a storage pit at the C. C. Witt site, a Smoky Hill phase settlement in northeastern Kansas. This assemblage of bird bones is more likely to appear in a bundle rather than on a dinner plate. Catlanite elbow pipes, similar to the one in the Bright Star bundle, appear at several Nebraska phase sites at about this same time.[66]

Performance Cartography: The Thunder Ceremony
The Thunder Ceremony initiated the Skidi year. Its purpose was to awaken the earth from its long winter sleep by dramatically reenacting world creation and revitalizing the sacred bundles from the oldest villages of the Skidi confederation. The ritual was repeated for each of the twelve leading bundles. The bundle of Bright Star played a leading role in this ceremony, with the Great Star and Big Black Meteoric Star bundles playing important supporting roles.[67] Most celestial entities depicted on the Skidi Star Chart are referenced in songs and stories performed during the Thunder Ceremony. Many, but not all, are also visible in the night sky during this late winter rite of reawakening.

The Thunder Ceremony was performed in early March. Priests searched for signs of the earth's stirring once the Swimming Ducks (Lamda and Upsilon Scorpii) appeared near the Stream with Scum Extending (Milky Way) in late February. Among the more important signs was the movement of the Seven Stars (Pleaides) across the smoke hole of the earth lodge just after dusk.

65. Waldo R. Wedel, "House Floors and Native Settlement Populations in the Central Plains," *Plains Anthropologist*, XXIV, no. 84 (May 1979), 86–87. John Kenneth Ludwickson, "The Loup River Phase and the Origins of the Pawnee Culture" (master's thesis, University of Nebraska, 1975), 98, characterizes traditional Skidi architecture as "remarkably homogeneous," particularly with respect to the due east orientation of an extended entryway and the use of four posts around a central fireplace. Photographs of historic Skidi earth lodges and excavated Lower Loup phase houses are illustrated in Wedel, *Introduction to Pawnee Archaeology*, plate 1; and Wedel, *The Direct-Historic Approach*, Smithsonian Institution, *Misc. Colls.*, XCVII, no. 7, plates 1, 2, 3.

66. Patricia J. O'Brien, "Prehistoric Evidence for Pawnee Cosmology," *American Anthropologist*, LXXXVIII (1986), 940–941; Murie, *Ceremonies of the Pawnee*, ed. Parks, figure 7c; Donald J. Blakeslee, "The Origin and Spread of the Calumet Ceremony," *American Antiquity*, XLVI (1981), 763–765.

67. Murie, *Ceremonies of the Pawnee*, ed. Parks, 43, 59–60; Weltfish, *The Lost Universe*, 79, 80–83.

When a deep rumbling thunder originated in the west and rolled around the circuit of the heavens, the time for the ceremony was at hand.[68] Preparations included cleaning the lodge, building a small mound outside the earth lodge entryway from fireplace ashes, readying ritual paraphernalia, preparing food, and sending messengers to notify the bundle holders in distant villages.

The Thunder Ceremony took all night to perform. Murie summarized the ceremonial procedure as follows: (1) world creation, (2) the smoke offering to Tirawahat, (3) the vitalization of the earth by Wonderful Being, (4) the people going out over the earth, (5) pipe smoking, and (6) the feast. Songs, dances, and offerings are essential parts of the Thunder Ceremony and are richly geographic in their form and content.[69]

Each song consisted of a male stanza and a female stanza, though the priests of the leading bundles often sang both parts. Each stanza was composed of multiple steps—nearly identical, multiline musical passages where one word replaces another until the theme of the song has been fully articulated. For example, the first of the five songs detailing Skidi world creation had two stanzas. The female stanza consisted of twenty-six steps and included references to the celestial councils that created the world, the creation of life and certain topographical features, agricultural cycles, and the symbolism of hearth and home. The male stanza consisted of thirty steps and included references to Tirawahat and the celestial powers, Mother Corn, and other entities embodied by bundle artifacts, pigments, and various components of the color directional symbolism illustrated in Figure 7a and 11b. The theme of this first song was that germination on earth and in the heavens is the fundamental principle of creation. Ritual performers sang more than twenty-eight hundred individual lines to complete the five songs that detailed Skidi world creation before the smoke offering to Tirawahat (the second ceremonial procedure listed above).[70]

Stars figured prominently in the songs, stories, and performances comprising the Thunder Ceremony. Weltfish conveniently identified ten major episodes in the performance of the Thunder Ceremony that are of geographic significance: (1) the origin of the cardinal point stars, (2) the origin of the World Quarter Stars and bundles, (3) the actions of the Clouds, Winds, Lightnings, and Thunders in the heavens and on earth, (4) the World Quarter Stars raising the world from beneath watery depths and shaping it with war clubs,

68. Murie, *Ceremonies of the Pawnee*, ed. Parks, 53; Weltfish, *The Lost Universe*, 79–80; Chamberlain, *When the Stars Came Down*, 177.

69. Murie, *Ceremonies of the Pawnee*, ed. Parks, 43, 53–62.

70. Ibid., 43–46, 48.

(5) the creation of life, (6) the creation of timbers and underbrush, (7) the creation of landforms associated with fresh water, (8) the creation of cultivated seeds, (9) the council deliberations to create people, (10) ancestral Skidi wanderings and the founding of bundle-holding villages.[71]

The sacred geography recounted in Thunder Ceremony songs and stories were often augmented by gestures, dances, and reenactments. Murie, for example, provided a detailed description and summary diagram of a leading priest's dance that recreates Wonderful Being's annual journey to revitalize the world (the third ceremonial procedure listed above). The dance began outside the earth lodge, near the ash mound, which represented the primordial earth lodge where the celestial deities planned world creation (Figure 12b). Wonderful Being's ritual impersonator eventually entered the east-facing earth lodge, an architectural expression of the visible universe (Figure 11), to the sounds of other leading priests singing. The ritual impersonator stepped upon a circular floor representing the earth and moved beneath a dome-shaped ceiling symbolizing the arching sky as well as Atira's womb. He continued past the eastern intercardinal posts signifying the physical incarnations of the World Quarter Stars and their sacred color-directional symbolism. Wonderful Being's ritual impersonator then moved around the central fireplace that represents the sun, past the western intercardinal posts, and around a ground drawing representing the abode of the ancestors (Figure 12a). His destination was the realm of Bright Star, as revealed by the bundle artifacts upon the western earthen altar. Wonderful Being's impersonator passed in front of the earthen altar, and then exited the earth lodge by retracing his entry route.[72]

It is difficult to imagine how the cartographic richness of this performance could be captured on a static two-dimensional map. As the ritual impersonator moved from east to west across the earth lodge, he replicated the motions of the sun and the stars as well as the annual sojourn of Tirawahat in his manifestation as Wonderful Being. Every step upon the ritual stage was a movement in space, both real and imagined, as well as time, both past and present. Every gesture upon the ritual stage had the geographic efficacy of a graticule. Although the dramatic reenactment of Wonderful Being's annual journey to revitalize the world seems ephemeral, certain topological structures are replicated in other parts of the Thunder Ceremony.

The earth lodge structured the annual journey of Wonderful Being to revitalize the world (Figure 12b). Other ritual acts performed during the Thun-

71. Weltfish, *The Lost Universe*, 80–83.
72. Murie, *Ceremonies of the Pawnee*, ed. Parks, 49–51.

der Ceremony also created the shape of an earth lodge. The abode of the ancestors—the ground drawing of a circle and line representing "the wise sayings of the ancestors" and "the throat or the mouthpiece for knowledge" respectively—formed the plan of an earth lodge as viewed from above (Figure 12a). Priests instructed errand men on the precise planting of offering sticks outside the earth lodge during the Thunder Ceremony (Figure 12c). The first seven offering sticks—those for two cardinal stars, the World Quarter Stars, and the earth—very nearly abutted the earth lodge. The remaining offering sticks were primarily for entities, celestial or otherwise, in the mythologized history of the Skidi. As shown in Figure 12b, the placement of offering sticks connoted the image of nested earth lodges. Song and story related the founding of the original villages comprising the Skidi confederacy in the last part of the Thunder Ceremony. In the beginning, village positions reflected the position of the stars that had given them their bundles and ceremonies. Before the social and territorial upheavals of the nineteenth century, the original villages of the Skidi confederacy were, in essence, projections of their patron stars in the night sky.[73] As shown in Figure 12d, the Skidi conceived of the reflected picture as the plan of an earth lodge. The earth lodge was truly a microcosm, a world in miniature, of the Skidi universe. Geographic relationships were not a function of distance in this universe. Rather, the key cartographic operator was topology, the shapes and sequences of spaces.

Cartographic performances, like maps, must work to have any cultural relevancy. Skidi participants in the Thunder Ceremony had to demonstrate to "these powers above" that they had an accurate knowledge of the workings of the world.[74] They also had to properly commemorate the efforts of celestial entities, cultural heroes, and the ancestors on their behalf. Only then could they reawaken the earth and revitalize the bundles. How could the Skidi know if they were successful in this enormous task?

As detailed above, the Skidi performed the Thunder Ceremony sometime in March. At the latitude of central Nebraska, a spectacular alignment between earth lodge architecture and the rising sun signaled the finale of the Thunder Ceremony. This alignment occurred twice in a solar year, at times bracketing the vernal and the autumnal equinoxes. The window of opportunity for each alignment is about three weeks. It took all night to perform the Thunder Ceremony. As Skidi participants wound down the ceremony and contemplated their sacred geography, they saw the first light of dawn

73. Ibid., 44; Fletcher, "Star Cult among the Pawnee," *American Anthropologist*, IV (1902), 732.

74. Fletcher, "Star Cult among the Pawnee," *American Anthropologist*, IV (1902), 732.

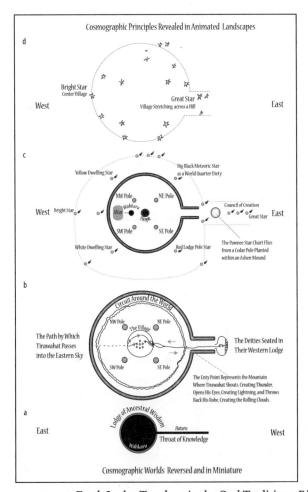

Cosmographic Principles Revealed in Animated Landscapes

d

Bright Star
Center Village

Great Star
Village Stretching across a Hill

West East

c

Yellow Dwelling Star

Big Black Meteoric Star
as a World Quarter Deity

NW Pole NE Pole

Wahkaru

West Bright Star Altar Council of Creation
 Tirawa Great Star East

SW Pole SE Pole

White Dwelling Star Red Lodge Pole Star

The Pawnee Star Chart Flies
from a Cedar Pole Planted
within an Ashen Mound

b

Circuit Around the World

NW Pole NE Pole

The Village

The Path by Which
Tirawahat Passes
into the Eastern Sky

The Deities Seated in
Their Western Lodge

SW Pole SE Pole

The Enty Point Represents the Mountain
Where Tirawahat Shouts, Creating Thunder,
Opens His Eyes, Creating Lightning, and Throws
Back His Robe, Creating the Rolling Clouds.

a

Lodge of Ancestral Wisdom

East Haturu West
 Wahkaru Throat of Knowledge

Cosmographic Worlds Reversed and in Miniature

FIGURE 12. Earth Lodge Topology in the Oral Traditions, Rituals, and Songs Performed during the Thunder Ceremony. Drawn by William Gustav Gartner. (a) The abode of the ancestors, an excavated feature near the western altar. After James R. Murie, *Ceremonies of the Pawnee*, ed. Douglas R. Parks (Lincoln, Nebr., 1989), 45. (b) A ritual impersonator reenacts Tirawahat's journey to create the world during the "Song to Wonderful Being," carefully noting the correspondence between earth lodge architecture and the landscapes of world creation. After ibid., 49. (c) Offering sticks dedicated to the celestial deities form an earth lodge when viewed from above. After ibid., 59. (d) The indigenous map shown in Figure 5b that depicts the location of major bundle-holding villages comprising the Pawnee federation at an unknown time. After Alice C. Fletcher, "Star Cult among the Pawnee—a Preliminary Report," *American Anthropologist*, IV (1902), 734.

Note the reversal in earth lodge orientation when the ritual frame of reference shifts from the cosmographic to the mundane. The Pawnee earth lodge is a microcosm that structures time and space in real and imagined Pawnee worlds at different scales

fill the entryway of the east-facing earth lodge. The rays of the sun gradually bathed the ritual stage of the earth lodge with light. Dawn's rays illuminated the World Quarter posts, symbolically ignited the fireplace (the sun), and irradiated the "wise sayings of the ancestors" and the "throat or the mouthpiece for knowledge." Skidi participants in the Thunder Ceremony watched as sunbeams reached the earthen altar and the bundles, or the realm of Bright Star. They saw the sun's rays travel along the same path that Wonderful Being's ritual impersonator had traversed only hours before. For a few fleeting moments, priests near the earthen altar experienced geographic reality in its totality as they gazed along a sun beam, a solar axis mundi, which stretched from the earth lodge to the horizon and beyond.[75]

In a system of earth-centered astronomy, the apparent movement of the sun with respect to the horizon is greatest at the time of the equinoxes. For the Skidi, it was not coincidence that, shortly after the Thunder Ceremony, the sun moved northward with respect to the horizon by nearly one solar diameter each day. It was also not coincidence that plants and animals reappeared as the sun hastened its movements northward. The sun moved quickly and the earth reawakened because the Skidi had properly greeted the Thunders.

After a morning feast, Skidi participants in the Thunder Ceremony emerged from the earth lodge to greet the new day. Only then did they see the first bundle artifact to receive the rays of the sun. For there, in front of the entryway to the earth lodge, was the Skidi Star Chart hanging from a cedar pole.[76]

The Thunder Ceremony and the Skidi Star Chart

All maps are selected representations of reality designed for a specific audience. From the moment of their unfolding, maps situate and inform the user. Why is the Skidi Star Chart unfolded during the Thunder Ceremony? How could the Skidi Star Chart possibly be used as a spatial inventory of the night sky if it is hung outside the earth lodge during the Thunder Ceremony? Who, except the stars, could read a map hung from the top of a cedar pole at night?

Perhaps the Skidi Star Chart, like the Thunder Ceremony itself, was not

75. Chamberlain, *When the Stars Came Down*, 171; Murie, *Ceremonies of the Pawnee*, ed. Parks, 44.

76. Murie, *Ceremonies of the Pawnee*, ed. Parks, 95. It is unlikely that the Skidi Star Chart was tied to an ordinary pole. The Sun Dance and the Omaha Sacred Pole Rite are two of the better-known Plains Indian ceremonials that linked poles with astronomical and cosmological referents. See Hall, *Archaeology of the Soul*, 102–108; and Robert L. Hall, "The Cultural Background of Mississippian Symbolism," in Patricia Galloway, ed., *The Southeastern Ceremonial Complex* (Lincoln, Nebr., 1989), 267–276.

only for the Skidi but also "those powers above." Bundle artifacts, as gifts from patron stars, embodied the powers of those stars. When properly arranged upon a ritual stage, these powers could be directed by song, story, and ritual to fulfill Skidi needs. The proper arrangement was not a function of the measured linear distances between geographic objects or events, but rather their sequence in a mythologized time and a topological space that, in part, duplicated Skidi perceptions of the natural world. Parallels in the content and spatial syntax of the Thunder Ceremony and the Skidi Star Chart indicate that the latter was not a map of the night sky per se; it was a graphic representation of a ritualized geography that linked world creation, Skidi history, and the natural world to celestial entities.

As previously detailed in the sections on map form and map content, it is not possible to see all of the objects depicted on the Skidi Star Chart at the same time. However, eleven of the nineteen identifiable objects on the Skidi Star Chart are specifically referenced in ethnographic accounts of the Thunder Ceremony. Some celestial objects on the Skidi Star Chart served as harbingers of the Thunder Ceremony (Swimming Ducks, Seven Stars, Stream with Scum Extending). Others are mentioned in Thunder Ceremony songs and stories that detail world creation (Bright Star, Great Star, Star That Does Not Walk Around, Sun, Moon, Big Black Meteoric Star, Red Lodge Pole Star, White Dwelling Star). Published ethnographic accounts of the Thunder Ceremony are fragmentary. Some of the remaining objects on the Skidi Star Chart such as Big Stretcher, Little Stretcher, Chief's Circle, and the Deer Stars are congruent with the Thunder Ceremony in the sense that they are visible in late-winter skies and are mentioned in cosmogonic tales (Appendix). The latter two asterisms exhibit alignments with a traditional east-facing earth lodge during the period that the Thunder Ceremony was performed. Priests might have noticed, just before dawn, that the Chief's Circle (Corona Borealis) followed the path blazed by Seven Stars (Pleiades) across the smoke hole. They might also have caught a fleeting glimpse of the Deer Stars (Orion's Belt) in the entryway.[77]

There are certain parallels in spatial syntax between the Thunder Ceremony and the Skidi Star Chart. Consider, for example, the spatial sequence of offering sticks to nighttime celestial objects (Figure 12c) with their counterparts shown on the Skidi Star Chart (Figure 2). The spatial sequence of Great Star, Big Black Meteoric Star, Star That Does Not Walk Around, Bright Star, Moon, White Dwelling Star, and Red Lodge Pole Star is the same for both.

77. Murie, *Ceremonies of the Pawnee*, ed. Parks, 40, 42, 53, 58; Weltfish, *The Lost Universe*, 79–80; Chamberlain, *When the Stars Came Down*, 175, 177.

Topology is the cartographic operator for the map and the associated cartographic performance when preternatural forces manifest themselves as celestial objects or positions in the night sky.

However, the Thunder Ceremony cannot account for all objects and their arrangement on the Skidi Star Chart. There are no explicit references to Black Star (Deneb?), Bow (portions of Delphinus), or Snake (portions of Scorpio) in the published accounts of the Thunder Ceremony or in oral traditions detailing Skidi world origins. Snake is clearly a summer asterism (Appendix).[78] More important, the Thunder Ceremony, by itself, does not resolve the cartographic conundrums mentioned earlier in this essay. Any interpretation of the Skidi Star Chart must account for the elliptical shape of the chart, its rendering on the fur side of a hide, the fusion of time and space at multiple scales, constellation and asterism modification and reversal, the unexplained hierarchy of cross sizes, and the polyvalent meanings of selected celestial objects.

The Reawakened World: Maize Ceremonials

Once the Thunder Ceremony brought the world back to life, it initiated a ritual calendar that coordinated people's lives with one another, the rhythms of nature, and external events.[79] Artifacts from the Big Black Meteoric Star bundle played a supporting or leading role in four rituals related to the early life cycle of maize, roles germane to resolving the cartographic conundrums listed above.

One of the two northern World Quarter Stars always led the Shelling the Sacred Ear of Corn rite. The remaining World Quarter Stars and Bright Star played important supporting roles. The Big Black Meteoric Star bundle took the leading role every other year, given the intricacies of the Skidi bundle rotation scheme. In many ways, this rite built on the principles of world creation set forth in the Thunder Ceremony. The Shelling the Sacred Ear of Corn rite, like the Thunder Ceremony, was performed within an earth lodge. As with the Thunder Ceremony, an amalgam of rules dictated the seating positions of visiting bundle-holding dignitaries, including village location, the position of the patron star in heaven, mythologized history, and sociopolitical rank. The garden of Bright Star was likewise an important locus for cartographic performance. The garden of Bright Star was not painted on a bison skull, however, as it was during the Thunder Ceremony. For the Shelling the Sacred Ear of Corn rite, the garden of Bright Star was signified by a rectangular pit excavated near the western earthen altar. Bundle holders tied their respective

78. Weltfish, *The Lost Universe*, 277–278.
79. Ibid., 86.

ears of Mother Corn to offering sticks during the Shelling the Sacred Ear of Corn rite and placed them in Bright Star's garden. The placement of offering sticks in Bright Star's garden was not random. Rather, "the ears of corn are in the regular order of their seats." Thus, the Shelling the Sacred Ear of Corn rite produced an ephemeral map of village location, the positions of patron stars, mythologized history, and sociopolitical relationships.[80] The position of each offering stick embodied multiple referents, with a spatial syntax based on topology rather than linear distance. Kernels from Mother Corn may be distributed only after this sacred geography is performed.

Once the Seven Stars assumed a certain position and the willow leaves appeared, it was time for the Ground Breaking Ceremony. This ritual was related to the Four Pole Ceremony (see Figure 7a), as the Skull bundle played a leading role in both of these world creation rites. The Ground Breaking Ceremony emphasized a different episode in Skidi world creation from the Thunder Ceremony. In the beginning of Skidi times, Tirawahat moved across the universe with a basket containing the soil from which the earth was first created. During the apex of the Ground Breaking Ceremony, the leading dancer carried a specially prepared coiled basket about the ritual stage "in a waving or twinkling manner" as singers detailed the animation of the earth and Skidi fields by Bright Star. The lead dancer was followed by four women who held the bison scapula hoes from the World Quarter Star bundles. They, in turn, were followed by additional performers, who hoed the air in order to "shake the earth." There was a great deal of bawdy interaction between the performers and the audience during the Ground Breaking Ceremony, which Weltfish likened to a pantomime.[81]

In terms of the Skidi Star Chart, however, it is the decoration of the skull from the Skull bundle during the Ground Breaking Ceremony that is of primary interest. The skull was painted, adorned with downy feathers, and otherwise prepared in the likeness of Tirawahat. The leading priests selected a pure young man, one who had no enemies and had never killed another human, to paint the skull with the symbol of Tirawahat: "He first painted the face red and on it a line design in blue, bow-shaped and extending across the fore-

80. Ibid., 84–85; Murie, *Ceremonies of the Pawnee*, ed. Parks, 56, 72–76. See Murie, *Pawnee Indian Societies*, American Museum of Natural History, *Anthropological Papers*, XI, part VII (1914), 52, and Chamberlain, "The Skidi Pawnee Earth Lodge," in Aveni, ed., *Archaeoastronomy in the New World*, 189, for a general discussion of the symbolism of Skidi seating arrangements.

81. Murie, *Ceremonies of the Pawnee*, ed. Parks, 76, 77, 79–83, 107, 180; Weltfish, *The Lost Universe*, 95–105. Tirawahat's creation of the earth from a basket of soil is an important referent in the basket dice game discussed earlier in this essay.

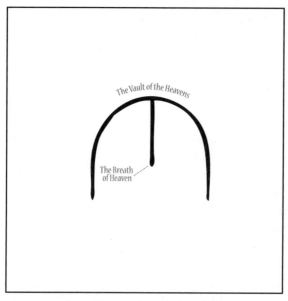

FIGURE 13. A Small Painted Symbol Representing the Vault of the Heavens and the Breath of Heaven. Drawn by William Gustav Gartner. After Alice C. Fletcher with the assistance of James R. Murie, *The Hako: Song, Pipe, and Unity in a Pawnee Calumet Ceremony*, music transcr. Edwin S. Tracy, intro. Helen Myers (Lincoln, Nebr., 1996), 233; and Gene Weltfish, *The Lost Universe: Pawnee Life and Culture* (Lincoln, Nebr., 1965), 98.

The parabola signifies the vault of the heavens and Atira's womb. The line emanating from the parabola signifies the breath of heaven and originates from the zenith. This symbol is used during reincarnation ceremonies such as the Hako and renewal rituals including the Shelling of the Sacred Corn

head and down the cheeks, representing the vault of the heavens, and a blue line down the center and along the nose for the breath of Heaven descending from the zenith, passing down the nose to the heart and giving life to the child." The design is shown in Figure 13. It is identical to the aforementioned symbol of Tirawahat painted on a child during the Hako ritual of mourning and adoption.[82] As we shall see, this symbol suggests a means for situating the viewer in order to interpret the Skidi Star Chart.

The World Quarter priests prepared a young maize plant for her role as Mother Corn in the Young Corn Plant Ceremony, one of the most impor-

82. Weltfish, *The Lost Universe*, 97; Murie, *Ceremonies of the Pawnee*, ed. Parks, 79; Fletcher, *The Hako*, 233.

tant rites in the Skidi ceremonial calendar. Major bundle holders met at an earth lodge that belonged to a southern World Quarter Star priest. The customary amalgam of village location, patron star position, and sociopolitical rank dictated the seating assignments of the visiting dignitaries. Singers and dancers recreated the primordial journey and exploits of Paruksti, a personification of the Clouds, Winds, Lightnings, and Thunders who embodied the self-renewing powers of the earth. Afterward, the leading priests led a procession to the maize fields. The four World Quarter priests stood in their respective positions around the conical hillock that nurtured Mother Corn. A person blessed by the Bright Star priest stood west of the quincunx formed by the sacred corn hill and the World Quarter priests. When viewed from above, the six loci of this ritual stage formed a familiar spatial pattern—one replicated by the arrangement of the central fireplace, intercardinal posts, and earthen altar within an earth lodge (Figure 7a and 11b) and the Seven Stars in summer on the Skidi Star Chart (Figure 2). Subsequent pipe offerings duplicated the topology of the offering sticks during the Thunder Ceremony (Figure 12c). The remaining rites and songs often equated the life cycles of maize and humans, both of which are governed by the stars.[83]

The Great Washing Ceremony

Murie described the Great Washing Ceremony as "peculiar." Weltfish believed that this rite was a summary of all Pawnee beliefs and practices related to the realms of sky, earth, and water. This purification rite was performed after the maize fields had been weeded, just before Skidi peoples left their villages for the summer bison hunt. The climax of this ceremony was a footrace from an earth lodge to a stream, where bundle artifact and people were ritually cleansed. Whoever led the mad dash to the stream carried the Skidi Star Chart, for this map of the heavens always led the way.[84]

The Great Washing Ceremony was performed under the auspices of the Big Black Meteoric Star. In the bundle rotation scheme of the Skidi, however, the Big Black Meteoric Star could not lead a summer rite. Cultural ideals are complex and cannot always accommodate the messy reality of life, so a ritual was performed to allow a temporary change in bundle leadership. The symbolism of the Big Black Meteoric Star, the pillar of the northeast, trumped the principles of bundle rotation. Purification, it seems, required a ritual expres-

83. Weltfish, *The Lost Universe*, 124, 125, 126; Murie, *Ceremonies of the Pawnee*, ed. Parks, 84, 85, 86–90.

84. Murie, *Ceremonies of the Pawnee*, ed. Parks, 95; Weltfish, *The Lost Universe*, 151, 152.

sion of how the cosmos works and how it came to be. The Big Black Meteoric Star was the logical choice to lead this ceremony:

> In mythohistory [the Big Black Meteoric Star] was a sort of master of general ceremonial procedure. He was also the patron of knowledge as indicated in the star chart attached to his sacred bundle, and also patron of the knowledge of the earth and the waters and the doctors, who took care of this aspect of man's life. He controlled the coming of the night, the animals, and, particularly, the buffalo.

The Great Washing Ceremony was performed twice each year, once when work shifted from the maize fields to the summer bison hunt, and then after the Skidi returned to their bountiful fields from their summer sojourn. Subsistence transitions were not easy. Success depended on purity of heart and soul for both the Skidi and their animated bundle artifacts.[85]

There was a long preamble to this ceremony, but, on the fourth day, the Skidi wove together the elements of a truly grand cartographic performance. Within an earth lodge, the four World Quarter priests excavated a rectangular pit between the central fireplace and the western earthen altar and lined it with soft, downy feathers. This pit represented the garden of Bright Star (Venus). They then placed both ears of Mother Corn from each bundle into the garden. The priests then built another model that symbolized the primordial sea and the aquatic animal life pertaining to the doctors' ceremonies. Once the ephemeral maps of primordial worlds were completed, preparations for the great race began.[86]

Four men tied the Skidi Star Chart and four smooth stones, symbolizing meteorites and buffalo maw stones, to a wooden staff. They then carried the staff, a sacred pipe, and buffalo fat offerings outside the earth lodge. The staff was planted in a mound near the entryway, most likely in a manner reminiscent of the Thunder Ceremony, when the Skidi Star Chart dangled from a pole. Songs about "scanning the heavens and the earth" filled the air. After an offering and several rites of sympathetic magic, the Big Black Meteoric Star priest selected a chief to carry the bundle pipe and a warrior to carry the Skidi Star Chart. Bundle artifacts were distributed to the spectators. A signal was given, and the great race began. If someone overtook the race leader, he snatched the Skidi Star Chart from the warrior's hands. Thus, the Skidi Star Chart always led the frenzied dash to the stream. The race itself was a car-

85. Murie, *Ceremonies of the Pawnee*, ed. Parks, 72, 95; Weltfish, *The Lost Universe*, 152.
86. Weltfish, *The Lost Universe*, 154.

tographic performance of sorts, for "the sound of many feet running to the water reminds one of thunder." Once they reached their destination, people holding bundle artifacts assembled in four rows along the stream bank. The chief who carried the pipe from the Big Black Meteoric Star bundle was the last to arrive. He symbolically washed himself and the pipe with water before he led the purification rite for the rest of the bundle artifacts and people.[87]

In sum, the Skidi Star Chart guided the Skidi from the village to a stream. It was not, however, a wayfinding device, but rather a baton in a footrace.

PERFORMANCE CARTOGRAPHY AND THE INTEGRATION OF MAP FORM, CONTENT, AND CONTEXT

Reconciling ethnographic accounts of Skidi peoples using the Skidi Star Chart with modern preconceptions of maps and map use seems difficult. We do not customarily employ celestial maps or planispheres as beacons and batons in religious ceremonies. Although analyses of form and content demonstrate that the Star Chart has many referents to the Skidi world, I have not yet demonstrated how the Skidi Star Chart graphically facilitates a spatial understanding of real or imagined worlds through an overarching geographic framework. Rather than graphically facilitating a spatial understanding, this essay has identified many cartographic conundrums on the Skidi Star Chart, including its elliptical shape, the use of the fur side of a hide as a canvas, the fusion of time and space at multiple scales, asterism modification and reversal, the polyvalent meanings of selected stars and asterisms, and the occasional separation of purported map signs from their referents and a unique geographic location.

Some feel that the Skidi Star Chart must be a map, given the similarities in appearance between it and our star maps. Most people recognize the familiar celestial objects on the Skidi Star Chart such as the Big Dipper (Big Stretcher) and Little Dipper (Little Stretcher) asterisms, even if Skidi artists modified their appearance from how they appear in the night sky. Given similar depictions of familiar objects, we approach the Skidi Star Chart with our modern conventions and expectations. When the Skidi Star Chart does not live up to our expectations, we feel compelled to explain the discrepancies. Perhaps the Skidi made mistakes. The ravages of time possibly degraded both the artifact and the transmission of information across generations.

Others argue that the Skidi Star Chart was wholly constructed within a past cultural system that is closed to modern eyes. The Skidi Star Chart is

87. Ibid., 154, 155–156, 174; Murie, *Ceremonies of the Pawnee*, ed. Parks, 96, 97–98.

nothing more than a conception of the heavens as an ancient Skidi priest saw it and a mnemonic device for stories long forgotten.[88] If so, we can do little more than argue endlessly over the Skidi Star Chart's status as a map or a mnemonic device, since, sadly, the meanings embodied in the Skidi Star Chart supposedly died with their makers.

Are the Skidi really a people without a cartography? I do not believe so. The Skidi Star Chart was wholly constructed within a cultural system that is very different from modern Western ones. It does recount the mythohistorical origin of the Skidi world. Although mere fragments of traditional Skidi culture are available to naive English-speaking academics such as myself, there is an undeniable holism and an internally consistent cultural logic that is graphically expressed in spatial terms on the Skidi Star Chart. In order to see the Skidi Star Chart from Skidi eyes, we must become aware of, and then transcend, modern Western ways of mapping the world.

The first step in reading any map is situating the viewer. Since the Skidi Star Chart looks like our celestial maps, we approach it from an earth-bound perspective. More likely, however, the view of the heavens depicted on the Skidi Star Chart was never intended for someone on the ground looking up at the sky. Rather, the image depicted on the Skidi Star Chart is from a vantage point upon the vault of the heavens looking down through the celestial sphere.

As noted previously, Murie interviewed the Skidi priest Roaming Scout during the transfer of the Big Black Meteoric Star bundle to the Field Museum. Roaming Scout stresses the importance of viewer orientation when he tells Murie about the Skidi Star Chart and the other objects from the Big Black Meteoric Star bundle: "That which I have given you, that which you now hold, . . . originated from the Father, *who is setting on top* . . . it was *in the Heavens* that these things came; and *you see the Heavens are setting in it*. Now you have it sitting here."[89]

Roaming Scout indicates that "the Father," Tirawahat, is above all. This position is also mentioned in the very first line of a Skidi oral tradition detailing the origin of the world: "Over all is *Tirawa [Tirawahat]*, the One Above, changeless and supreme."[90] We may well ask ourselves what the universe

88. Chamberlain, *When the Stars Came Down*, 193, 205; Parks, "Interpreting Pawnee Star Lore," *American Indian Culture and Research Journal*, IX, no. 1 (1985), 63–64.

89. Chamberlain, *When the Stars Came Down*, 193–203 (Roaming Scout quoted on 194 [emphasis added]).

90. Murie (Coming Sun) quoted in Curtis, *The Indians' Book*, 99. The etymology of the Skidi word *kaahuraarikitakus*, "to have a world above, as does Tirawahat," re-

looks like from the vantage point of "the Father, who is setting on top," the one who is "over all." Quite simply, to Tirawahat, the universe looks a lot like it is depicted on the Skidi Star Chart.

Only Tirawahat, or his designated representatives, can see the universe as an ellipse. Recall that the Thunder Ceremony commemorates the journey of Wonderful Being, who Murie notes is Tirawahat incarnate, across the vault of the heavens to the earth, a sojourn that if properly reenacted by the Skidi reawakens the world from its winter sleep. During the Thunder Ceremony, a ritual impersonator traverses the entire lodge during the Song to Wonderful Being (Figure 12b) in the same way that "Wonderful Being made the initial journey to the world" and in the same way that the "power of life is sent forth anew by the thunders every spring."[91] Figure 13 shows a symbol drawn during the Hako and the Ground Breaking Ceremony that represents the vault of the heavens as an arch or dome, a shape that duplicates the cross-section of an earth lodge (Figure 11). If Wonderful Being and the Spring Thunders are in motion across the vault of the heavens, as clearly indicated by the Thunder Ceremony and Skidi oral traditions, then the one who is "over all" — except for one brief instance above the north celestial pole — sees the celestial sphere as an ellipse. An ellipse is a shape that forms whenever a truncated cone, in this case the arch or dome representing the vault of the heavens, is cut by an oblique plane that does not intersect the base in its entirety (Figure 14). Skidi artists cut the hide of the Star Chart into an ellipse and further emphasized this shape by drawing a heavy, thick, black ellipse to frame all other celestial objects represented on the map. The ellipse signifies motion and a viewer position atop the dome of the heavens. The notion that the ellipse represents the universe when viewed from above is corroborated by the settlement plan of the Skidi summer hunting camps (Figure 5), when the tents of the bundle holders reflected the positions of their patron stars.

If Skidi artists painted the Star Chart to replicate the vantage point of Wonderful Being and the Spring Thunders from above, many of the remaining cartographic conundrums noted throughout this essay disappear. Asterisms and constellations are not reversed on the Skidi Star Chart if the viewer is "setting on top" looking down from the vault of the heavens. An earthbound viewer's understanding of the cosmos is limited to a linear unfolding of time and space within the experiences of daily life. An entity traveling across the vault of the heavens can experience the fusion of space and time

inforces the notion that Tirawahat resides above all else (AISI Skidi Pawnee Dictionary Database, *http://zia.aisri.indiana.edu/~dictsearch* [accessed March 2011]).

91. Murie, *Ceremonies of the Pawnee*, ed. Parks, 49.

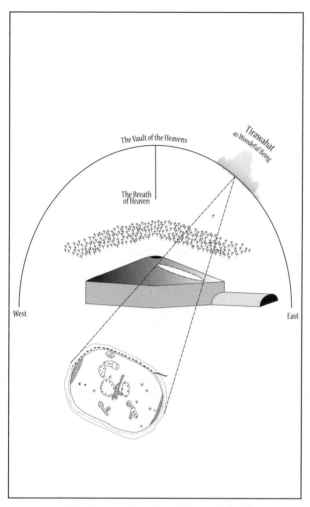

The Vault of the Heavens

Tirawahat
as Wonderful Being

The Breath
of Heaven

West

East

FIGURE 14. The Integration of the Map and the Paramap through Performance Geography. Drawn by William Gustav Gartner.

The vault of the heavens recalls the shape of the earth lodge in cross section, which becomes an architectural model of both the universe and the primordial world during ceremonies. The breath of heaven emanates from Tirawahat in his guise as an expansive amorphous power who resides above all (the zenith). The annual arrival of the Spring Thunders offers an opportunity to revitalize the world after its long winter slumber. Skidi peoples channel the revitalization powers of the Spring Thunders in part by commemorating and reenacting the primordial journey of Wonderful Being, who is but a partial manifestation of Tirawahat, to the earth. As Wonderful Being looks down from his journey across the vault of the heavens—his journey across Atira's womb—he gazes through the plane of the stars and the roof of the earth lodge and creates the spatial logic of the Skidi Star Chart

in its totality. This entity can simultaneously view sunrise and sunset, asterisms from all seasons, and the Seven Stars in two positions—just as they are depicted on the Skidi Star Chart. The view from above also explains why the Skidi Star Chart had to be painted on the fur side of a hide. Someone traveling across the vault of the heavens sees starlight projected upon all living things. The tufts of fur on the Skidi Star Chart remind the map user of the view from above and also reinforce one of the central messages of the Thunder Ceremony and other Skidi rituals: it is the stars that guide all living things.

Only Tirawahat could see the Skidi Star Chart during much of the Thunder Ceremony, because it was not visible to the performers inside the earth lodge. Surely Tirawahat does not need a map. So, why did the Skidi attach the Star Chart to a cedar pole beneath the stars? It is surely no accident that the number and position of stars on the Skidi Star Chart have been subtly altered from their appearance in the night sky in ways that reference Skidi oral traditions and rituals. It is likewise no accident that topological sequences of celestial bodies depicted on the Skidi Star Chart duplicate that of ritual impersonators and bundle artifacts in various Skidi ceremonies. The Skidi Star Chart is as much a map of the spatial syntax of Skidi rituals and oral traditions as it is a map of the night sky. Perhaps the Skidi had to demonstrate to their patron stars that they had an accurate knowledge of the workings of the world and how it came to be. For then, and only then, could the Skidi channel celestial forces to bring about a bountiful world. In this sense, the Skidi Star Chart was a graphic argument concerning cartographic performances in the earth lodge. As Murie states, "The powers in the heavens are sung down to the lodge and back again to their seats above."[92] The Skidi Star Chart transcendentally guided the Skidi to a cultural ideal—Tirawahat's view of the universe and an accurate knowledge of astrobiology—just as the Skidi Star Chart literally led the Skidi to a stream during the Great Washing Ceremony.

SUMMARY STATEMENT

Maps are conventional by their very nature. The analysis of non-Western maps is all the more difficult because cartographers must become aware of their own conventions as well as understand those from another time, place, and culture. David Woodward proposed a methodology for interpreting maps, one that recursively examined the image through the integration of map form, content, and context. Ideally, this recursive approach reveals the conventions of the mapmaker as well as the map viewer. I hope that I have

92. Ibid.

shown that his approach is a fruitful one for understanding American Indian maps on their own terms.

The Skidi Star Chart is a dynamic map of how it all came to be, a transcendental expression of geography "from the Father, *who is setting on top*" and a geographic argument concerning astrobiological cycles. It is a map of Tirawahat's view from above and the movements of Wonderful Being and the Spring Thunders. It is a view from above, not a spatial inventory of the night sky from below. The Skidi Star Chart is a systematic, though nonalgorithmic, projection of starlight upon the back of a cervid that symbolizes the roles of the stars in guiding all life on earth. As such, the Skidi Star Chart is one of the most remarkable intellectual achievements in the history of cartography. Cartographers and social theorists can no longer claim that maps incorporating a systematic view from above are peculiar to the political and economic discourses of Europe.[93]

Skidi phrases for the term "map" — *kaahuraara,* or "a drawing of the world," and *(ur +) kaahuraaraah,* or "to carry the world" — suggest both similarities and differences between the Skidi Star Chart and Western maps. "A drawing of the world" is a graphic argument about the things, concepts, conditions, and processes of our surroundings, whether real or imagined. In this sense, the Skidi Star Chart is similar to Western maps. But "to carry the world" suggests a purpose for the Skidi Star Chart well beyond the discourses typically embodied in Western maps and map use. The Skidi Star Chart carries the world in the sense that its recursive relationships with the powers above bring the Skidi world into being.[94] The conventions for Skidi map reading and production differ from modern Western rules in at least five ways. First, the analytical categories of form, content, and context are themselves conventional and, to a certain degree, impose a linear structure on the image. The raw materials used to make the Skidi Star Chart, for example, are also important sign vehicles that convey geographic meaning. It was convenient to discuss the meaning of the hide and pigments in the section on map form in this essay, but they could have been discussed elsewhere. I hope that I have shown the atomization of map elements into constituent categories is not as important as their holistic reintegration at the end of the analysis.

A second difference is that the analogical expressions of spatial knowledge, or performance cartography, are critically important for understand-

93. Wood, "The Fine Line," *Cartographica,* XXX, no. 4 (Winter 1993), 50.

94. AISRI Skidi Pawnee Dictionary Database, *http://zia.aisri.indiana.edu/~dictsearch* (accessed March 2011).

ing the content and context of the Skidi Star Chart and, I suspect, American Indian maps in general. Oral traditions, rituals, songs, and other aspects of cartographic performance define and extend the geographic arguments embodied in the map image. In other words, cartographic performance is the paramap for Skidi cartography. The Skidi Star Chart cannot be understood in the absence of oral tradition and ceremony. My understanding of Skidi performance cartography is woefully inadequate, limited to English translations of a fragmented ethnohistory. Yet, even a cursory perusal of what little is available in English shows that the Skidi Star Chart does not simply depict a starry sky. The rendering of the Big Stretcher (Big Dipper) and the Little Stretcher (Little Dipper) asterisms on the Skidi Star Chart, for example, are congruent with Skidi oral traditions concerning world creation. They do not simply mimic the appearance of the Dippers in the night sky. The Seven Stars in summer show the ritual stage of the Four Pole Ceremony, a rite that dramatically reenacts Pawnee world origins. The topological sequence of Dawn (Sunrise), Great Star's Brother (most often Jupiter or Mercury), Great Star (most often Mars), and Wolf Got Fooled (Sirius) on the Skidi Star Chart does not portray a known astronomical event so much as it duplicates the spatial syntax of the penultimate act of the so-called Morning Star Sacrifice. This sequence also suggests that Skidi rules of adoption and reincarnation apply to the stars. In sum, songs, oral traditions, rituals, dance, gesture, and other "traditional" and "ephemeral" acts capture a dynamic world in ways that a static image cannot. Perhaps ancient Skidi artists have much to teach practitioners of Cartography 2.0 about capturing a dynamic world.

Third, cartographic signification is far more flexible in Skidi cartography than in modern Western cartography. On modern Western maps, cartographic signs fuse a referent and a unique location. Some cartographic signs on the Skidi Star Chart also embody a single referent and a unique location, but others do not. Some stars have multiple manifestations on the Skidi Star Chart; Sirius, for example, is both Wolf Got Fooled and White Dwelling Star. Some crosses on the Skidi Star Chart have multiple manifestations in the night sky. Great Star on the Skidi Star Chart was often Mars in the night sky, but he could also be Jupiter, Venus, or Mercury, depending on circumstances. The World Quarter Stars may be signified by either a position or a map sign occupying that position on the Skidi Star Chart. For Skidi peoples, if circumstances demand it, cartographic signs, referents, and locations can be independent from one another.

Fourth, the fusion of a cartographic sign with a referent and a location conveys a narrow range of related concepts on modern Western maps. Each

cartographic sign on the Skidi Star Chart is indexical; that is, each one has multiple and varied intersections with the Skidi cultural system as a whole.[95] The depictions of the Seven Stars (Pleiades) on the Skidi Star Chart, for example, have referents in sacred oral traditions that detail world creation and mundane acts like planting maize and gambling. Indexical relations are a two-edged sword for map interpretation. On the one hand, only fragments of past cultural systems are available to us. Indexical relations permit an articulation of the image with those known fragments. On the other hand, they serve as a reminder of all that we will never know.

Finally, time and space are typically depicted as disparate and univariate entities on most modern Western maps. The Skidi Star Chart fuses time and space and depicts them at multiple scales, as shown by the portrayal of Dawn and Golden Sunset, the Seven Stars (Pleiades) in both their summer and winter positions, and the overall assemblage of celestial entities on a single image.[96]

The Skidi Star Chart is a map of a transcendental ideal, a projection of star-light upon the earth's bounty as viewed from the vantage point of the vault of the heavens. A view from above explains the reversed orientation of ephemeral maps depicting cosmographic worlds (Figure 12) as well as the seating arrangements for bundle-holding dignitaries during the Shelling of the Sacred Ear of Corn rite. Skidi peoples brought a bountiful world into being by demonstrating "to those who are above" their geographically accurate knowledge of astrobiology and world creation. In order to do so, they consulted the Skidi Star Chart and also used it as a beacon during the Thunder Ceremony, a planting guide during maize ceremonials, and a baton in the Great Washing Ceremony. Although the ceremonies and geographic narratives embodied by the Star Chart are specific to the Skidi, the idea of a two-dimensional projection of starlight upon the earth to represent a three-dimensional transcendental ideal is more common on native North American maps than commonly realized. Amos Bad Heart Bull's map of North Dakota, for example, shows the Black Hills as a mirror image of the circular Lakota asterism known as the Sacred Hoop. Both the name of the Black Hills, I"ya" Kaga, and the triangles on the image are cues for the idea of projection as it relates to world creation.[97]

95. David Turnbull, *Maps Are Territories: Science Is an Atlas: A Portfolio of Exhibits* (Chicago, 1989), 19–27, shows that maps from Western and non-Western societies function in part as a spatial index of cultural referents.

96. The fusion of time and space is almost universal in traditional cartography, as documented in nearly all chapters of Woodward and Lewis's edited volume, *Cartography*.

97. Murie, *Ceremonies of the Pawnee*, ed. Parks, 73; Chamberlain, "The Skidi Pawnee

The content and purpose of the Skidi Star Chart may seem strange, though wonderful, to most modern Western eyes. It should not. The graticules on the beautiful celestial and terrestrial globes of Vincenzo Coronelli (1698), which are approximately the same age as the Skidi Star Chart, link the movement of the heavens with the cycles of life on earth in European contexts. Coronelli drew a zodiac upon the celestial sphere to invoke mythologized histories and wondrous stories. Yet the Skidi cartographers who created the Star Chart could have taught their European contemporaries something about cartographic efficiency—namely, how to convey the maximum amount of geographic information with a minimum amount of ink. Coronelli had to construct two globes, the diameters of which are the height of a child, to convey less information than Skidi cartographers who drew a two-dimensional drawing of the vault of the heavens upon a hide measuring fifty-six by thirty-eight centimeters.

Academic essays typically end with a conclusion. I cannot do so in this essay. I believe that we should try to see the Skidi Star Chart through Skidi eyes. We should also listen to its geographic arguments through Skidi ears. Clearly, this is an impossible task. At best, we may catch a fleeting glimpse of the Skidi world, or perhaps detect a barely audible whisper. The writings of James Murie and the exemplary interdisciplinary research on Skidi land and life in general permit an articulation of the Skidi Star Chart with the Skidi cultural system. It is, however, only a partial articulation, for the archaeological, historical, ethnographic, and scientific records cited in this essay are but fragmentary palimpsests of a complex Skidi world. The Skidi Star Chart is, and always will be, a graphic reminder of all that we do not know.

Nevertheless, it speaks volumes about the power of Skidi cartography that mere facsimiles of the Skidi Star Chart and simple English translations of Skidi song and story still inspire people from different times, places, and cultures. My understanding of the Skidi Star Chart is merely a coup d'oeil. Yet the attempt to see the Skidi Star Chart through Skidi eyes, and hear it through Skidi ears, has produced an experiential thread that transcends the confines of time, place, and culture. My daughter and son now ask to hear stories beneath the stars. For this, I will always be grateful to Skidi cartographers.

Earth Lodge," in Aveni, ed., *Archaeoastronomy in the New World*, 189; Lewis, "Maps, Mapmaking, and Map Use," in Woodward and Lewis, eds., *Cartography*, 121–123; Linea Sundstrom, "The Sacred Black Hills: An Ethnohistorical Review," *Great Plains Quarterly*, XVII (1997), 168–169.

Pawnee celestial object	Probable Western equivalent	Creation order, ceremonies, and bundle characteristics	Selected Pawnee oral traditions	Apparent magnitude	Star Chart position and object visibility period, circa 1750
Big Black Meteoric Star (Big Black Star)	Vega (star)	Creation order: seventh Ceremonies: Shelling of the Sacred Corn; Great Washing Ceremony; Mother Corn; Gathering Corn Plants; Scalp Offering Bundle characteristics: male; gift of knowledge; animals; third leader in winter	"The Morning Star and the Evening Star" "Dispersion of the Gods and the First People" "Origin of the Basket Dice Game" "The Squash Medicine"	0.03	PSC: east FV: mid-November MC: late June LV: early February
Big Stretcher	Ursa Major (asterism)	—	"How the World is to Come to an End" (P)	up to 1.76 (Ursae Majoris)	PSC: overhead Circumpolar asterism
Black Star	Deneb (star)	Creation order: tenth? Bundle noted	—	1.25	PSC: east FV: early December MC: late July LV: mid-March

Bow	Delphinus (constellation)	—		up to 3.63 (Rotanev)	PSC: overhead FV: early February MC: late July LV: late January
Chief's Circle (Camp Circle)	Corona Borealis (constellation)	—	"The Boy Who Discovered the Stars" "Origin of the Basket Dice Game"	up to 2.23 (Alphekka)	PSC: overhead FV: late October MC: early May LV: mid-December
Dawn	Sunrise	Creation order: first	"The Morning Star and the Evening Star" "Origin of the Chaui" (C) "The Origin of the Pipe-Stick Ceremony"	—	PSC: east
Deer Stars	Orion's Belt (asterism)	—		up to 0.12 (Rigel)	PSC: east FV: mid-July MC: mid-December LV: mid-May
Duck Stars (Swimming Ducks)	Lambda and Upsilon Scorpii (asterism; the tail and stinger of Scorpius)	—	"The Origin of the Loon Medicine Ceremony" [?] "How Evening Star's Daughter was Overcome" [?]	Lambda = 1.62 Upsilon = 2.70	PSC: east FV: late January MC: early to mid-June LV: late October

Pawnee celestial object	Probable Western equivalent	Creation order, ceremonies, and bundle characteristics	Selected Pawnee oral traditions	Apparent magnitude	Star Chart position and object visibility period, circa 1750
Bright Star (White Star)	Venus (planet)	Creation order: third Ceremonies: Thunder, Good Fortune Bundle characteristics: female; giver of songs and rituals	"The Morning Star and the Evening Star" "Dispersion of the Gods and the First People" "Lightning Visits the Earth" "How Evening Star's Daughter was Overcome" "The Daughter of the Evening Star" "Origin of the Basket Dice Game" "The Origin of the Pipe-Stick Ceremony" "The Grain of Corn Bundle"	up to -4.7	PSC: west Venus began AD 1750 as an "evening star" before becoming a "morning star" in late March. It continued as the "morning star" before disappearing in dawn's light in mid-December.
Golden Sunset	Sunset	Creation order: first	"The Morning Star and the Evening Star" "Origin of the Chaui" (C) "The Origin of the Pipe-Stick Ceremony"	—	PSC: west

Little Stretcher	Ursa Minor, excluding Polaris (asterism)	—	"How the World is to Come to an End" (P)	up to 2.07 (Ursae Minoris)	PSC: overhead Circumpolar asterism
Stream with Scum Extending	Milky Way (galaxy)	—	"The Morning Star and the Evening Star" "The Milky Way" "The Man Who Visited Spirit Land"	—	PSC: overhead Object spans the night sky, intersecting celestial meridian
Moon	Moon	Creation order: second	"The Morning Star and the Evening Star" "Dispersion of the Gods and the First People" "How the Buffalo Went South" "The Moon Medicine" "Origin of the Chaui" (C) "Contest between the Morning Star and the Moon" "Origin of the Basket Dice Game" "The Basket Game or the Woman on the Moon"	up to -12.6	PSC: west

Pawnee celestial object	Probable Western equivalent	Creation order, ceremonies, and bundle characteristics	Selected Pawnee oral traditions	Apparent magnitude	Star Chart position and object visibility period, circa 1750
Great Star (Big Star)	Mars (also Mercury, Jupiter, or Venus) (planet)	Creation order: fourth Ceremonies: Morning Star Sacrifice Bundle characteristics: divided into multiple bundles (both male and female); human sacrifice and creation	"The Morning Star and the Evening Star" "Dispersion of the Gods and the First People" "Lightning Visits the Earth" "Contest between the Heavenly and Earthly Gods" "The Morning Star Bundles" "How Evening Star's Daughter was Overcome" "Contest between the Morning Star and the Moon" "The Meteorite People" "The Poor Boy Who Turned into an Eagle"	up to -2.9	PSC: east Mars began AD 1750 as an "evening star" before disappearing in mid-June. The first visibility for Mars in AD 1750 was late September, and it continued to be a "morning star" for the remainder of the year.
Great Star's Brother (Big Star's Brother)	Mercury (also Jupiter) (planet)	—	"The Morning Star and the Evening Star" "Contest between the Heavenly and Earthly Gods"	up to -2.0	PSC: east Mercury had three periods of evening visibility and three periods of morning visibility in AD 1750

Name	Identification	Ceremonial/Bundle Information	Associated Myths	Magnitude	Sky Position
Star That Does Not Walk Around	Polaris (star)	Creation order: fifth; Ceremonies: Chief's Society Ritual; Burnt Offering	"Dispersion of the Gods and the First People" "Lightning Visits the Earth"	1.97	PSC: overhead; Circumpolar star
Red Lodge Pole Star (Red Star)	Antares (star)	Creation order: ninth; Ceremonies: Mother Corn; Gathering Corn Plants; Scalp Offering; Bundle characteristics: male; fourth leader in summer	"The Morning Star and the Evening Star"	up to 0.96	PSC: east; FV: mid-December; MC: late May; LV: early November
Seven Stars (summer)	Pleiades (open star cluster)	—	"Origin of the Basket Dice Game" "Pursuit by Rattling Skull" (K)	up to 2.86 (Alcyone A)	PSC: east; FV: early to mid-June; MC: mid-November; LV: early May
Seven Stars (winter)	Pleiades (open star cluster)	—	"Origin of the Basket Dice Game" "Pursuit by Rattling Skull" (K)	up to 2.86 (Alcyone A)	PSC: overhead; FV: early to mid-June; MC: mid-November; LV: early May
Snake	Scorpius (asterism; head and upper body of Scorpius, possibly excluding Antares)	—	See Dorsey, *Pawnee Mythology*, 428 See Weltfish, *The Lost Universe*, 278	up to 2.29 (Dschubba? given exclusions)	PSC: overhead; FV: early to mid-December; MC: mid-May; LV: late October

Pawnee celestial object	Probable Western equivalent	Creation order, ceremonies, and bundle characteristics	Selected Pawnee oral traditions	Apparent magnitude	Star Chart position and object visibility period, circa 1750
White Dwelling Star (White Star, Spirit Star)	Sirius (star)	Creation order: sixth Ceremonies: Mother Corn; Gathering Corn Plants; Scalp Offering Bundle characteristics: female, second leader in summer	"The Morning Star and the Evening Star" "Dispersion of the Gods and the First People"	-1.46	PSC: overhead FV: early to mid-August MC: late December LV: mid-May
Wolf Got Fooled	Sirius (star)	Bundle noted	"Lightning Visits the Earth" See Dorsey, *Pawnee Mythology*, 428	-1.46	PSC: east FV: early to mid-August MC: late December LV: mid-May

Note: All oral traditions are Skidi band in origin, except those marked with a (C) for Chawi band, (K) for Kitkehahki band, and (P) for Pitahawirata band.

Stars, including the sun, seem to rise in the east and set in the west owing to the earth's rotation. Since the sidereal day is about four minutes shorter than the solar day, a star will rise and set at a progressively earlier time each night. With the exception of the circumpolar stars, which are always above the horizon at night, there are brief periods of time when celestial objects are not visible, as they are only above the horizon during the day. First visibility (FV) is the heliacal rise of a star, or the date of the first appearance in the pre-dawn sky on the eastern

horizon after a period of invisibility. Last visibility (LV) is the heliacal set of a star, or the date of the last appearance in the evening sky after sunset. The meridional crossing, also known as the point of upper culmination, is the date when a celestial object reaches its highest altitude above the observer's horizon.

I have calculated the dates for objects on the Skidi Star Chart by means of several shareware planetarium computer programs, Stellarium 10.5 (*www.stellarium.org*, last accessed October 2010) and Alcyone Ephemeris 4.1 (*http://www.alcyone.de/index.htm*, last accessed October 2010). The year of observation is AD 1750, the suggested terminus ante quem date for the Skidi Star Chart.

The visibility period is arbitrary, as we do not know the precise observational conditions for past Pawnee astronomy and can only make inferences about traditional Skidi perceptions of stellar motion and its articulation with the Pawnee cultural system. For example, horizon roughness influences the time and location of a star's apparent rise or set. Thus, a village's location within a river valley influences the apparent rise and set of a star with respect to the horizon. Asterisms and constellations are, by definition, groups of stars that span large segments of the night sky. At what point can we say that Scorpius or Delphinus has risen or set if part of the constellation is above the horizon and another part below? I selected the brightest star in a Pawnee constellation or asterism to set a date for first visibility, last visibility, and the meridional crossing. I am not suggesting that Skidi astronomers calibrated their observations in the same way or were concerned with these astronomical measures.

Traditional Pawnee astronomers did not share the penchant for precision and predictability that preoccupied their Western contemporaries. Skidi astronomers viewed the night sky in order to establish a worldview grounded in astrobiological cycles, ritual, and oral tradition. Western astronomers were often concerned with cosmography, timekeeping, and navigation. Given differences in astronomical purpose and the vagaries noted above, I have listed general periods, rather than exact dates, to avoid imposing a false sense of precision upon the reader. Precision is not the same thing as accuracy. I have no doubts about the accuracy of Skidi astronomy, which fulfilled their needs for centuries, if not longer.

My purpose in generating visibility dates is to promote the idea that the Skidi Star Chart is a dynamic, rather than a static, map and to give the reader some sense of the various time scales that are depicted on the image.

Sources: James R. Murie, *Ceremonies of the Pawnee*, ed. Douglas R. Parks (Lincoln, Nebr., 1989), 30–39, 41, 96; Von Del Chamberlain, *When the Stars Came Down to Earth: Cosmology of the Skidi Pawnee Indians of North America* (Los Altos, Calif., 1982), 191–193, 203–205, 226–227, 229–245; George A. Dorsey, *Traditions of the Skidi Pawnee* (Boston, 1904), esp. 3–14, 20–23; Dorsey, *The Pawnee Mythology*, I (Washington, D.C., 1906). Apparent magnitudes for individual stars, or the brightest star within an asterism or constellation, are from the VizieR database at the Centre de Données astronomiques de Strasbourg (*http://cdsweb.u-strasbg.fr/*, last accessed October 2010).

CLOSING THE CIRCLE

MAPPING A NATIVE ACCOUNT
OF COLONIAL LAND FRAUD

Andrew Newman

1. THE DIDO MOTIF

Over generations, descendants of the Algonquian peoples who once inhabited the region of New York Harbor have recalled that the first Dutch colonists asked for as much land as the hide of a bullock (or cow) could cover, then claimed as much land as that hide, cut into strips, could encircle. Yet I believe that this fantastical story preserves the memory of an actual event. Moreover, it threads the history of the founding of New Amsterdam together with those of other, far-flung maritime colonial outposts, and it offers a window into the cultural history of early modern European imperialism.[1]

This episode with the bullock's hide is the culmination of a longer historical tradition about "The Arrival of the Whites." The first written version of this tradition is in an 1801 letter from the Moravian missionary John Heckewelder to the historian Samuel Miller. Heckewelder, who spent decades living among these Indians in the late eighteenth century, explained to Miller that he transcribed the account from field notes taken "near 40 years ago"—"verbatim as was related to me by Aged and respected Delawares; Monseys and Mahicanni." The first part of the tradition may preserve native American

I am grateful to the organizers of and participants in the conference "Early American Cartographies" at the Newberry Library in 2006, the conference "The Netherlandish Seventeenth Century and Its Afterlives" at Duke University in 2007, and the Columbia University Seminar in Early American History and Culture, where I presented a version of this essay in 2009. Particular thanks to Roger Abrahams, Matt Cohen, Evan Haefeli, Mira Gelley, Jaap Jacobs, Matthew Kremer, Ned Landsman, Mark Meuwese, Ayesha Ramachandran, James Rementer, Susan Scheckel, Fredrika Teute, and Martin Brückner.

1. John Bierhorst, *Mythology of the Lenape: Guide and Texts* (Tucson, Ariz., 1995), nos. 17, 22, 28, 40, 83, 203, 215; Brian Swann, ed., *Algonquian Spirit: Contemporary Translations of the Algonquian Literatures of North America* (Lincoln, Nebr., 2005), 55–61.

memories of Henry Hudson's entry into New York Harbor. It was on the return visit that some Europeans "proposed to stay":

> Familiarity daily increasing between them and the Whites, the latter now proposed to stay with them, asking them for only so much Land as the Hide of a Bullock would cover (or encompass) which Hide was brought forward and spread on the Ground before them—That they readily granted this request; whereupon the Whites took a Knife and beginning at one place on this Hide, cut it up, to a Rope not thicker than the finger of a little Child; so that, by the time this Hide was cut up there was a great heap—That this Rope was drawn out to a great distance and then brought round again so that both ends might meet—That they carefully avoided its breaking, and that upon the whole it encompassed a large piece of Ground—That they (the Inds) were surprised at the superior wit of the Whites, but did not wish to contend with them about a little Land, as they had enough—That they and the Whites lived for a long time contentedly together, altho' those asked from time to time more Land of them; and proceeding higher and higher up the Mahicanituck (Hudson River) they believed they would soon want all their Country, and which at this time was already the case.[2]

Scholars who comment on the story of the bullock's hide assume that it can only have an allegorical or figurative relation to the Indians' experience. Indeed, it almost precisely parallels the legend of the foundation of Carthage by the Phoenecian queen Dido, which was familiar to early modern Europeans, if not to their native American contemporaries. It was referred to by Virgil's *Aeneid* and elaborated on by vernacular translations of the epic's "prose counterpart," Livy's *Romane Historie:* "'Tis believed *Dido* purchased no more ground then *[sic]* might be compassed with the hide of a Bull or Ox, which being cut into very slender thongs contained a larger space, then *[sic]* the sellers did imagine, and it was sufficient whereon to Erect a Castle, which from thence is thought to be called *Byrsa*." *Byrsa*, the name for the site of Dido's citadel, means "animal hide" in Greek and resembles the Phoenecian word for "citadel." In another version of the Algonquian tradition, which appeared in Heckewelder's *Account of the History, Manners, and Customs of the*

2. Evan Haefeli, "On First Contact and Apotheosis: Manitou and Men in North America," *Ethnohistory*, LIV (2007), 407–443; Paul Otto, *The Dutch-Munsee Encounter in America: The Struggle for Sovereignty in the Hudson Valley* (New York, 2006), 44–47; John Heckewelder to Samuel Miller, Feb. 26, 1801, Samuel Miller Papers, 1790–1814, I, New-York Historical Society.

Indian Nations, Who Once Inhabited Pennsylvania and the Neighboring States, the Dutch used the site they acquired for a purpose corresponding to a citadel. They had asked for only a spot of land on which to plant "greens" but instead used the hide trick to found a military base: they "planted great guns; afterwards they built strong houses [and] made themselves masters of the Island."[3]

Along with the Delaware tradition, the Dido story belongs to an identified folkloric motif (K185.1, "Deceptive Land Purchase: 'Ox Hide Measure'") and tale type (927C). Folklorists have catalogued numerous variants of the motif in stories throughout Europe and Asia. Its apparent Old World provenance makes it seem obvious that it could not be an authentic element of a native American tradition. Instead, it might seem that Indians borrowed it from Europeans and grafted it onto their retrospective account of a historical encounter in order to allegorize their cumulative experience of colonialism. Indeed, for the Delawares, the nation to which most of the recorded American versions of the hide story are attributed, there was a likely allegorical referent: the 1737 Pennsylvania Walking Purchase, a historical land transaction that itself seems to resemble folklore. The story of the Pennsylvania proprietors' optimization of the land measure of a day and a half's walk could fit easily in the general K185 category of motifs, "Deceptive Land Purchase."[4]

3. James Axtell, *After Columbus: Essays in the Ethnohistory of Colonial North America* (Oxford, 1988), 138; Denys Delâge, "La tradition orale de l'arrivée des Européens à New York," in Jaap Lintvelt, Réal Ouellet, and Hub Hermans, eds., *Culture et colonisation en Amérique du Nord: Canada, États-Unis, Mexique,* Nouveaux cahiers du CÉLAT, no. 9 (Sillery, Quebec, 1994), 209; John B. Harrison and Richard E. Sullivan, *A Short History of Western Civilization* (New York, 1975), 198; Livy, *The Romane Historie Written by T. Livius of Padua* (London, 1659), supplement 6:40; John Heckewelder, *An Account of the History, Manners, and Customs of the Indian Nations, Who Once Inhabited Pennsylvania and the Neighboring States* (Philadelphia, 1819), 59–60 (as cited in eHRAF World Cultures). The backstory to the founding of Rome involving Dido, including the hide trick, had been related in Livy's lost "second decade," books 11–19, which survived only in summaries by Lucius Florus. The story was restored as a supplement by vernacular translators, who drew from other sources such as Justinus's *Epitome of the Philippic History of Pompeius Trogus.* See Amy Golahny, *Rembrandt's Reading: The Artist's Bookshelf of Ancient Poetry and History* (Amsterdam, 2003), 161.

4. Stith Thompson, *Motif-Index of Folk-Literature: A Classification of Narrative Elements in Folktales, Ballads, Myths, Fables, Mediaeval Romances, Exempla, Fabliaux, Jest-Books, and Local Legends,* rev. and enl. ed. (Bloomington, Ind., 1957), 251; Hans-Jörg Uther, *The Types of International Folktales: A Classification and Bibliography, Based on the System of Antti Aarne and Stith Thompson,* FF Communications, no. 284 (Helsinki, 2004), 566–567. On the Walking Purchase, see Francis Jennings, *The Ambiguous Iroquois Empire: The Covenant Chain Confederation of Indian Tribes with English Colonies from*

In native American traditions, the hide story does become associated with the Walking Purchase, and the preservation and propagation of the motif in North America might owe something to this association. My hypothesis, however, is that the motif was introduced into the Algonquian traditions by a party of Dutch colonists who, as related above, asked for as much land as the hide of a bullock (or related animal) could cover and then claimed all the land that hide, cut into strips (or one long thong) could encompass. In the same manner, European colonists introduced the K185.1 motif at other sites of empire: among the documented instances are several that belong to what should be considered a distinct subset—accounts about Europeans establishing imperial outposts. A survey of folkloric and historical scholarship, mostly from the late nineteenth and early twentieth century, produces a fascinating distribution map: stories attribute the hide trick to the Portuguese in Ceylon (Sri Lanka), Malaysia, Cambodia, and Burma; Spaniards in the Philippines; and the Dutch in New York, Java, Cambodia, Taiwan, and South Africa (Figure 1). According to Charles Lemire, because of the Portuguese use of "the ruse of Dido's companions" to acquire land for a Catholic mission (he dates it to 1553) in Cambodia, the natives gave Europeans the epithet *"the people from the country of the stretched-out hide."*[5]

Its Beginnings to the Lancaster Treaty of 1744 (New York, 1984), 388–397; Steven Craig Harper, *Promised Land: Penn's Holy Experiment, the Walking Purchase, and the Dispossession of Delawares, 1600–1763* (Bethlehem, Pa., 2006).

5. For overviews, see René Basset, "La Légende de Didon," *Revue de traditions populaires,* VI (1891), 335–338; Henri Cordier, "La Légende de Didon," ibid., II (1887), 295–296; J. G. Frazer, "Hide-Measured Lands," *Classical Review,* II (1888), 322; and Berthold Laufer, "The Relations of the Chinese to the Philippine Islands," Smithsonian Institution, *Miscellaneous Collections,* L (1908), 282–284. Individual accounts appear in the following sources: Johann Jacob Saar, *Reise nach Java, Banda, Ceylon und Persien, 1644–1660* (Haag, 1930), 66, 68; "a number of Malay texts, including the popular *Hikayat Hang Tuah,*" cited by Anthony Reid, "Early Southeast Asian Categorization of Europeans," in Stuart B. Schwartz, ed., *Implicit Understandings: Observing, Reporting, and Reflecting on the Encounters between Europeans and Other Peoples in the Early Modern Era* (Cambridge, 1994), 291; Charles Lemire, *Exposé chronologique des relations du Cambodge avec le Siam, l'Annam et la France* (Paris, 1879), 8; Zhang Xie, *Dong xi yang kao (Account of the Eastern and Western Oceans)* (1618) (Beijing, 2000), 89; J. S. Furnivall, "The History of Syriam," *Journal of the Burma Research Society,* V (1915), 53; Heckewelder, *Account of the History, Manners, and Customs, of the Indian Nations,* 59–60; Thomas Stamford Raffles, *The History of Java,* II (London, 1817), 153–155; Adolf Bastian, *Die voelker des oestlichen Asien,* IV (Jena, Germany, 1868), 367–368; *T'ai-wan fu chi (Gazeteer of the Prefecture of T'ai-wan),* cited by Laufer, "Relations of the Chinese to the Phillipines," Smithsonian Institution, *Misc. Colls.,* L (1908), 282; T. Arbousset, *Relation d'un voyage*

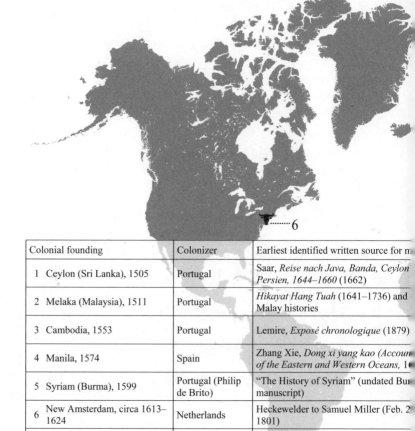

Colonial founding	Colonizer	Earliest identified written source for m...
1 Ceylon (Sri Lanka), 1505	Portugal	Saar, *Reise nach Java, Banda, Ceylon Persien, 1644–1660* (1662)
2 Melaka (Malaysia), 1511	Portugal	*Hikayat Hang Tuah* (1641–1736) and Malay histories
3 Cambodia, 1553	Portugal	Lemire, *Exposé chronologique* (1879)
4 Manila, 1574	Spain	Zhang Xie, *Dong xi yang kao (Accoun... of the Eastern and Western Oceans,* 1...
5 Syriam (Burma), 1599	Portugal (Philip de Brito)	"The History of Syriam" (undated Bu... manuscript)
6 New Amsterdam, circa 1613–1624	Netherlands	Heckewelder to Samuel Miller (Feb. 2... 1801)
7 Batavia (Jakarta), 1619	Netherlands	"The Javan Historians," cited by Raffl... *The History of Java* (1817)
8 Cambodia, circa 1620	Netherlands	Bastian, *Voelker des oestlichen Asien (1866)*
9 Taiwan, 1620	Netherlands	*T'ai-wan fu chi (Gazetteer of the Prefecture of Tai-wan,* 1694)
10 South Africa (vicinity of Cape of Good Hope), 1652	Netherlands	Arbousset, *Relation d'un voyage* (184...

FIGURE 1. "Deceptive Land Purchase: 'Ox Hide Measure' (Motif K185.1) in Association with European Imperialism." Image by Mira Gelley, background map by VectorWorldMap.com, submitted to the public domain

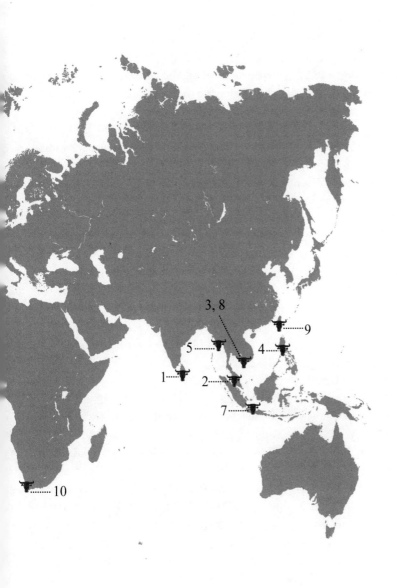

In what follows, I will refer to stories in which European colonists practiced the hide trick as instances of the "Dido motif," with the premise that they have a much more direct relationship to the Dido story than they do, for example, to the account in the ancient Indian sacred text *Shatapatha Brahmana* (in which an oxhide is used to divide the world). The best explanation for the appearance of the Dido motif in the Delaware tradition, and its counterparts from other sites of empire, is that these accounts record an arcane European "ceremony of possession," in Patricia Seed's phrase, in which the Europeans emulated a ruse from classical history. If we consider the appearance of multiple native traditions from disparate sites attributing the same curious ruse to European colonists as a phenomenon to be explained, then I will demonstrate that this explanation is the least unlikely of those that have been put forward. Moreover, I will establish that this question of the historicity of this native tradition is important, because it concerns the possibility that oral traditions can furnish information not only about the subjective experiences of the peoples who share them but also about the actors and actions they depict. In this case, the apparent lack of corroboration by colonial documents—a principal objection to be raised against the tradition's historicity—is what makes it potentially valuable: viewed collectively, these stories may tell us something that the Portuguese, Spanish, and Dutch colonists do not about their relations with their classical heritage, with one another, and with native peoples around the world.[6]

The Dido motif within the Algonquian traditions is certainly intelligible as an allegory in which the primary level of signification—the hide trick—has a specific referent, such as the Walking Purchase, or makes general reference to dispossession. The question is whether the story of the hide trick is also a description of a historical event. Is it a different form of expression than, for example, Heckewelder's translations and transcriptions of Delaware accounts of relations with William Penn or of the Walking Purchase? For that matter, is it different in kind from the more seemingly realistic account of first contact, from which historians have silently lopped it off? The historians who have analyzed the tradition of first contact in relation to Hudson's 1609 voyage omit mention of the Dido motif. The single exception is the most famous and inventive of all historians of New Netherland: Washington Irving, who adapts his hide story for his satirical *Knickerbocker's History of New York* (1809).

d'exploration au nord-est de la colonie du Cap de Bonne-Espérance, entrepris dans les mois de mars, avril et mai 1836 par mm. T. Arbousset et F. Daumas (Paris, 1842), 49.

6. Uther, *Types of International Folktales*, 566; Patricia Seed, *Ceremonies of Possession in Europe's Conquest of the New World, 1492–1640* (New York, 1995).

Of course, Diedrich Knickerbocker claims, it is not a true story: "The learned Dominie Heckwelder *[sic]*" imported the "old fable . . . from antiquity." The "true version" is that the Dutch cannily "bargained for just so much land as a man could cover with his nether garments." Once the unsuspecting native grantors agreed to the deal, the Dutch trotted out "Mynheer Ten Broeck," a "bulbous-bottomed burgher" whose layers of underwear "covered the actual site of this venerable city."[7]

Irving wittily plays on the issue of cultural translation—the native conceptions of underwear "had never expanded beyond the dimensions of a breech clout"—and he ironically suggests the continuing figurative applicability of the story. But he, or Knickerbocker, was wrong about its provenance. The idea that the hide story is an ethnographic imposture cannot account for the global phenomenon. It is impossible that Heckewelder and all his unrelated counterparts, including the British colonial official writing about the Dutch colonization of Java, the French missionary writing about the Dutch colonization of South Africa, and Zhang Xie, writing about the Spanish founding of Manila in his bureaucratic *Dong xi yang kao (Account of the Eastern and Western Oceans*, 1618), all decided to surreptitiously embellish native traditions in precisely the same way.[8]

As I will discuss further, it is also difficult to believe that the native inhabitants of all of these sites of colonization would have borrowed a European story in precisely the same way. Indeed, upon consideration, there is no explanation for the parallel occurrences that does not challenge belief. Yet an examination of the native American instance illustrates that the stakes are significant. When the hide story is understood as a mere metaphor, then it suggests something about how the late-eighteenth-century Delawares came to understand their history: they teleologically construed the onset of Dutch colonization as "the beginning of their end." When, however, it is accepted as a literal representation, then it has implications for our understanding as colonialist scholars of the initial phase of Dutch colonization. For example, it would make little sense to consider the first settlers as an "alongshore people" who intended to touch down lightly but, by expanding and encroaching, "betrayed themselves—their ideals and values—and the indigenous people." Instead, expansion and encroachment were embedded, surreptitiously, in the first and paradigmatic land transaction. They established relationships with a view toward exploitation, negotiated agreements with the aim of taking

7. Washington Irving, *Knickerbocker's History of New York* (New York, 1928), 54, 57.
8. Ibid., 54; Zhang Xie, *Dong xi yang kao*, 89; Arbousset, *Relation*, 49; Raffles, *History of Java*, 153–155.

advantage. Their forts and batteries, ostensibly facing seaward to protect their interests against colonial rivals, were, in the experience of the natives, directed inland, as a means to establish dominion. In short, the Dutch initiated their presence in North America with a remarkable gesture of bad faith. Moreover, this gesture was not a singular act—carried out, say, by a rogue landing party—but a customary element of early modern European maritime imperialism, implemented at colonial beachheads around the world.[9]

Each instance of the Dido motif is embedded within a local, diachronic history of colonial relations and also within the synchronic, global context of the Iberian and Netherlandic maritime empires. Generally, colonialist historians have viewed it within the former, considering only the particular occurrence of the motif that comes within their purview, whereas folklorists have recognized the multiple parallels but considered these apart from history. This essay, cross-referencing the history and the folklore, focuses on the synchronic axis, which has more value toward an explanation of how the Dido motif came to appear in a native American tradition. This native American instance, in turn, offers a useful point of entry for understanding the global phenomenon.[10]

Four sections follow. Section 2 argues that the notion that Indians borrowed a European story to represent their own historical experience underestimates the integrity of native American oral traditions. Somewhat paradoxically, the diffusion of the story among other native American groups supports the view that it had a single point of entry into North America, as an "epitomizing event" experienced by the former inhabitants of New York Harbor. Section 3, similarly, argues that the attribution of numerous parallel instances of the Dido motif to oral transmission of the story by European sailors depends upon a facile understanding of colonial cultural exchange, taking for granted what itself would be a remarkable and unlikely facet of the encounter—the colonists' repeated compulsion to tell natives the story of Dido and her oxhide. Section 4 establishes the prominence of the Dido story within early modern European culture, and especially its centrality to imperialism; Dido's foundation of Carthage offered a plausible template for latter-day colonists. The concluding section addresses the problem of verisi-

9. Thomas A. Janvier, *Dutch Founding of New York* (Port Washington, N.Y., 1967), 9; Donna Merwick, *The Shame and the Sorrow: Dutch-Amerindian Encounters in New Netherland* (Philadelphia, 2006), 3, 7.

10. Haefeli, similarly, shows how "a close analysis of one incident—Hudson's 1609 voyage—can help frame thinking about first contact globally" ("On First Contact and Apotheosis," *Ethnohistory*, LIV [2007], 410).

militude. Might an oxhide, cut into strips, encircle enough land on which to found a colonial fort?

2. A COLONIAL EPITOME

Those scholars who refer to the native American hide story have suggested that Indians heard the tale from Europeans and, recognizing its relevance, incorporated it into their oral traditions retroactively to make sense of the loss of their land. The story was indeed relevant. When they told it, the Delawares referred not only to their initial contact with the Dutch but to the course of their relations with "the white man." In a version told by the Delaware Captain Pipe in 1824, the trick with the bullock's hide was followed by another involving a chair seat: "The bottom of the chair, which was composed of small cords, was taken out and like the hide, stretched around the lands." According to Captain Pipe, "This second deception determined them never to give more lands without fixing some boundary understood by both parties distinctly." In 1849, similarly, the Munsees wrote a letter to President Zachary Taylor reminding him not only of the hide trick but of a second transaction, for "as much land as a middling sized lad could travel around a tract of land in one day's journey." In 1978, the Delaware Bessie Snake explained that the Lenapes immediately protested the hide trick: "Then they said, 'You did not say, "I want to cut it up!"' Then he [white man] said, 'Now you have already finished signing this paper!' Now that is where our money now comes from that we receive, and we are still fighting it." Thus, the hide became a figure for the entire history of dispossession they suffered at the hands of European colonists and American settlers.[11]

Apparently, this figure was featured in "Indian tales of colonial trickery" told not only by Delawares and Munsees but also by Yuchis, Creeks, and Wyandots. This proliferation may seem to argue against the notion that it represented an actual event experienced by a particular native American group. Charles Marius Barbeau describes the story as a "parable" without specific reference to "historical facts": "It seems to characterize in a symbolic manner the whole problem of the spoliation of the Indian's rights by the white invader." Yet, if the hide trick was an "epitomizing event," it was not necessarily also a "nonevent." John R. Swanton, observing that the motif "dates back as far at least as Virgil," supposes that it was "reinjected into Indian thought, ap-

11. Swann, *Algonquian Spirit*, 58–60; Gideon Williams et al., "To His Excellency Zachary Taylor President of the United States of America," Mar. 29, 1849, 336, microcopy no. 234, Letters Received by the Office of Indian Affairs, 1824–1881, roll 303, Fort Leavenworth Agency, 1824–1851, 1849–1851, 333–342, National Archives.

parently from a modern schoolbook." But the suggestion that Indians might hear (or read) a European story, appreciate its allegorical possibilities, and incorporate it into their history as an event their own ancestors experienced greatly exaggerates the porousness of oral traditions. There are indeed examples of syncretism, especially with the incorporation and adaptation of biblical motifs, but the hide story is different in kind. It is not an account of a heroic event in *illo tempore;* it is a description attributing a specific action to historical actors at a specific historical juncture.[12]

Thus, the idea that native storytellers swapped out Dido and the Tunisian king Hiarbas and inserted the Europeans and themselves is potentially offensive. Jim Rementer, the director of the Lenape Language Preservation Project for the Delaware Tribe of Indians, tells how a late mentor, the Lenape elder Nora Thompson Dean, recounted the story of the Dutch colonization of New York at an event at the State University of New York at Purchase. According to Rementer, "Someone in the audience during Q and A got up and said in a smart-aleck way that was the same old Queen Dido story and what did she think about that. Her reply was, 'Nothing.'" In other words, the implication that the Lenape story was based on the classical one questioned the validity of native traditions. Rementer recalls that the archaeologist Herbert Kraft, who was also in attendance at the event, anticipated my argument by suggesting that the Dutch might have been emulating Dido's foundation of Carthage through their actions.[13]

Actually, the various versions of the native American "cowhide purchase" story would provide a fascinating subject for a study on the changeability and consistency of oral traditions. A comparison suggests that the story did originate with the Delawares and closely related groups—the ancestors of Hecke-

12. Stuart Banner, *How the Indians Lost their Land: Law and Power on the Frontier* (Cambridge, Mass., 2005), 67; C. M. Barbeau, *Huron and Wyandot Mythology* . . . , LXXX, Anthropological Series, no. 11 (Canada, 1915), 268 n. 3. Jason Baird Jackson suggests that the motif "comes to symbolize the entire history of Indian-European relations from the Yuchi perspective." He helpfully classifies it, borrowing a term from Raymond D. Fogelson, as an "'epitomizing event,' an account of an event, real or imagined, that attempts 'to encompass and make intelligible seemingly impersonal, inevitable, and insidious processes of change'" (Jackson, *Yuchi Ceremonial Life: Performance, Meaning, and Tradition in a Contemporary American Indian Community* [Lincoln, Nebr., 2003], 22–23). See Fogelson, "The Ethnohistory of Events and Nonevents," *Ethnohistory,* XXXVI (1989), 143; John R. Swanton, "Social Organization and Social Usages of the Indians of the Creek Confederacy," *Forty-Second Annual Report of the Bureau of American Ethnology* (Washington, D.C., 1928), 76.

13. Jim Rementer, e-mail message to author, Feb. 25, 2007.

welder's informants—and was transmitted with relative integrity to other tribes. Only those nations with ancestral ties to the lower Hudson region tell the story as something that happened in their own past. The Wyandots are quite clear in identifying "the Delawares" as the native grantors, in effect blaming them for the breach in the native sovereignty of North America. In the telling, the story is indeed presented as an epitomizing event: "'So it is, and so shall it always be! The white fellow shall always undermine the Indian until he has taken away from him his last thing.' This was a kind of prediction." In a Yuchi version, the transaction takes place between "the red people" and "pale faced White people" on an "island"—Manhattan?—"somewhere under the rising sun." The Creek versions recorded by Swanton are less specific, but one of them contains a detail about drunkenness and capture that is reminiscent of a scene in the tradition about the first contact (and in Juet's account) as well as a promise "that they would treat the Indians right as long as the streams ran and water lasted"—phrasing that sounds a lot like the traditions about the so-called Great Treaty with William Penn. As with other instances, the Wyandot tradition recorded by Henry Schoolcraft presents a series of "figures of speech" to exemplify the "cession of territory and its renewal at other epochs": an uncaned chair, "a bull's hide," and "a man walking." Schoolcraft's informant identified the original grantors as the "Lenapees [sic]; alluding to the cognate branches of this stock, who were anciently settled at the harbour of New York, and that vicinity."[14]

The Delawares' history, then, supplied a number of "epitomizing event[s]," not only the hide purchase but also Penn's treaty and the Walking Purchase. They would have shared these stories with other Indians throughout their westward migration and dispersal; their paths intersected with the Wyandots in Ohio, Indiana, Ontario, and again in Oklahoma, where they continue to participate in a "broader system of Woodland ceremonialism" that includes the Creeks and the Yuchis. Thus, the pattern of distribution of the Dido motif in native American traditions—unlike the global pattern, as I shall discuss below—is consistent with a single point of introduction.[15]

14. Barbeau, *Huron and Wyandot Mythology*, 270; Jackson, *Yuchi Ceremonial Life*, 22. Swanton does mention, using indirect speech, that one informant "had heard that the Americans were formerly out upon the ocean and at first the Muskogee would not let them land." However, it is unclear whether Swanton or the informant introduced the ethnic identification, and in any case he attributes the hide story to "another informant" ("Social Organization and Social Usages of the Indians of the Creek Confederacy," *Forty-Second Annual Report of the Bureau of American Ethnology*, 75–76). For the Schoolcraft version, see Barbeau, *Huron and Wyandot Mythology*, 299–300.

15. Jackson, *Yuchi Ceremonial Life*, 137.

This claim rests on the basis of recorded instances, which may just be the tip of the iceberg. It is theoretically possible that the motif appears or appeared in traditions among peoples who had no part in the Woodland discursive network. It is also possible that the motif existed in native American folklore before the arrival of the Europeans and that the Indians used it to allegorize colonial land transactions. Such explanations, however, would strain to account for the global parallels as well as the degree of parallelism.

3. THE STORY OF EMPIRE

Like their Americanist counterparts, historians of other regions where the Dido motif occurs have mostly either ignored or been ignorant of it. Those who do refer to the motif, assuming it to be "a classical tale lifted from the Aeneid," discount "its particular validity" as a historical account. Only a few nonacademic writers, like Heckewelder, accept the story at face value, although they are generally unaware that it has precise parallels elsewhere. By contrast, folklorists have collected many instances of the motif, yet they have been surprisingly incurious about the story's pattern of distribution and its relation to colonial history. For example, among the six stories of "Hide-Measured Lands" listed by Sir James Frazer, three—from South Africa, Cambodia, and Java, all sites where the Dutch established colonies or trading stations—attribute the hide trick to Dutch colonists securing land to build forts. Yet Frazer does not wonder about the relationship of the story to the Dutch maritime empire.[16]

Frazer's logic is typical of the understanding of the transmission of folklore: stories, perhaps preserving a vestigial relationship to a distant reality, beget stories, perhaps presenting a figurative relationship to current events. The appearance of the Dido motif at diverse sites of colonization, however, challenges this conventional understanding. For example, Sir Anthony Reid, a prominent historian of Southeast Asia, observes that natives used the hide story to explain how the Portuguese and Dutch gained "enough ground for them to build a great fort" in founding their colonies at Melakka (Malaysia) and Jakarta (which the Dutch named Batavia, in Java), respectively. The

16. Stefan Halikowsi-Smith, "'Insolence and Pride': Problems with the Representation of the South-East Asian Portuguese Communities in Alexander Hamilton's 'A New Account of the East Indies' (1727)," *Journal of the Royal Asiatic Society of Great Britain and Ireland*, 3d Ser., XIX (2009), 213–235 (esp. 225); Frazer, "Hide-Measured Lands," *Classical Review*, II (1888), 322. In *The Golden Bough*, Frazer adds the South African example to the five he previously cited; see James George Frazer, *Adonis, Attis, Osiris; Studies in the History of Oriental Religion* (New Hyde Park, N.Y., 1962), 249–250.

story might have helped to explain "how a handful of people coming from the other side of the world, ostensibly to trade, could have ended by making themselves impregnable and strangely powerful." Reid finds the "borrowing of stories" between Malaysia and Java to be likely enough, but he has "no explanation" for how the "exact same story" might appear in Burma, where the hide trick is attributed to the Portuguese adventurer Felipe de Brito. He speculates that the tale might have spread from the West through "the long-established Middle Eastern connection" or that it might have been brought to Southeast Asia by the Portuguese. Yet, if it is "surprising" that the story has traveled as far as Burma, how about South Africa? Or America?[17]

The sinologist Berthold Laufer, who presents an appendix on "The Dido Story in Asia" in his "Relations of the Chinese to the Philippine Islands" (1907), suggests that the story is an aberrant instance of the upstream migration of folklore: "It affords one of the few examples of a Western tale spreading to the extreme East, while as a rule the stream of folk-lore flowed from east to west in the old world." According to Laufer, the story is also unusual in that "it shows that the transmission of folk-lore still goes on, even in recent times, by mere oral accounts." Unlike European stories with Asian origins, there is no "written testimony for the legend of Dido in any Asiatic literature to which, as the starting-point, all the current versions could be reduced." Laufer theorizes that the motif's "occurrence in southern and eastern Asia is due to the oral stories of European sailors and merchants, who had probably imbibed it during their school-days, while its propagation in Siberia seems to have emanated from the mouths of vagrant Russian adventurers."[18]

Laufer ridicules a historian who accepts the story about the Dutch using the hide trick to found Fort Zealand in Formosa (Taiwan) as "an actual historical event." He writes: "It is certainly far from this. In the Dutch sources regarding the history of Formosa, nothing of the kind is found. We have here nothing more than a simple tale, which has spread over almost the entire continent of Asia; and it is most curious to note that in nearly all cases the Asiatic peoples with whom the story is found make the tricksters some European nation who were then invading their country." Laufer is unimpressed that the event is recounted in the *T'ai-wan fu chi*, just as the Spanish founding of Manila with the hide trick is detailed in the *Dong xi yang kao* and the *Ming Annals*. These early written records only serve as evidence "of a comparably

17. Reid, "Early Southeast Asian Categorizations of Europeans," in Schwartz, ed., *Implicit Understandings*, 290–291.
18. Laufer, "Relations of the Chinese to the Philippine Islands," Smithsonian Institution, *Misc. Colls.*, L (1908), 283–284.

recent story-migration, which is further evidenced by its absence in any Asiatic literary records of an earlier date."[19]

What makes Laufer, and most other commentators, so confident that the story is not historical? The two principle objections are the lack of documentation by the colonists themselves and the lack of verisimilitude. Perhaps the only European account of the hide trick appears in the German Johann Jacob Saar's travelogue of his service for the Dutch East India Company (VOC); in 1662, he reported learning of the "fraudulent pretext" ("betrüglichen Praetext") the Portuguese had employed a century and a half earlier in securing the site for the "Black Fort" they raised in Ceylon. They asked the King of Candi "to grant them as much land as could be comprised within the limits of a cow's or bullock's hide" and then "cut up a bullock's hide into small strings, and fastening them together, enclosed a space large enough to build a fort." That there is no extant record in which the Portuguese or the Dutch themselves report the use of Dido's stratagem does not prove that such a document never existed. The Dutch, for example, kept copious records, but a large proportion of the East and West India Company archives were dispersed and destroyed. Moreover, it is difficult to assign a value to such negative evidence: colonists had ample motives not to document any bad-faith transactions.[20]

As for the second objection, the Dido motif does seem almost magical. The story of the Dutch founding of Taiwan appears not only in an official history but also in a collection of fantastical stories compiled by P'u Sung-ling in the mid-seventeenth-century *Liao-chai chih-i*. In that version, the Dutch use a very stretchable carpet instead of a hide. The Delaware version, similarly, has been classified as folklore rather than history. Although it appears attached to otherwise conventional and plausible accounts, generally compatible with European histories, the Dido motif seems like one of those moments in accounts of colonial contact in which the narrative veers sharply away from verisimilitude. The first premise in this manifestly folkloric motif, that the grantors and grantees negotiated the transfer of a spot of land the size of an intact hide, seems even less plausible than the second, that the grantees cut the hide into strips and claimed as much as they could encompass and that

19. Ibid., 282–284; E. Bretschneider, "Chinese Intercourse with the Countries of Central and Western Asia in the Fifteenth Century," *China Review; or, Notes and Queries on the Far East*, V (1876), 585–586.

20. See J. C. M. Pennings, "History of the Arrangement of the VOC Archives: Archival Management by the Ministry of Colonies," *TANAP [Towards a New Age of Partnership]*, http://www.tanap.net/content/voc/history/history_ministry.htm (accessed May 2006); Saar, *Reise nach Java, Banda, Ceylon und Persien*, 66, 68 (translated by Martin Brückner).

that area would be sufficient for a fort. It does seem unlikely at best that such a sequence of events took place once, much less on numerous disparate occasions.[21]

Even more incredible, however, is the presumptive explanation for the distribution of the Dido motif: that colonists systematically decided to recount the story of an ancient colonial ruse to native peoples; that in each case the story crossed the cultural barrier relatively intact; that in each case, perhaps in the space of a few generations, native storytellers grafted the story into their historical traditions as an event that had occurred to them, perpetrated, perhaps, by the very people who told them the story. Indeed, the assumption that the story could only have spread by word of mouth relies on a false distinction between discourse and event that diminishes the status of storytelling as an event—in this case, an unlikely and undocumented one. As far as I know, there is no documentary record of colonists recounting to bemused natives the story of Dido's founding of Carthage. Similarly, the notion that the natives then considered the Dido story as something that happened to them is contrary to research on collective memory, which finds that memories typically have a factual basis, however much those facts are distorted. A single instance of such an artificial tradition would be highly unusual; multiple, independent, parallel instances are unaccountable.[22]

Some commentators have at least considered taking the story at face value. Apparently, early Malaysian, Burmese, German, and Chinese chroniclers, unaware of the Dido story per se, did so. In the nineteenth century, Franz Kottenkamp, discussing the Delaware instance, wondered whether "a white ex-

21. Laufer asserts that P'u Sung-ling's version is independent of the written versions of the Dido story, set in the Philippines and Taiwan, that first appeared in 1618 and 1694; "an oral popular variant must have been afloat at the same time; it is the latter which was recorded by P'u Sung-ling" ("Strange Stories from a Chinese Studio," trans. and annot. Herbert A. Giles, *Journal of American Folklore*, XXXIX [1926], 89–90). An example of an episode in a native history that conflicts with Western notions of verisimilitude would be the Cheyenne account according to which the leader Stone Forehead transformed his men into buffalo in order to escape from U.S. soldiers. See Arnold Krupat, *Red Matters: Native American Studies* (Philadelphia, 2002), 53.

22. According to Roy F. Baumeister and Stephen Hastings: "Outright fabrication of collective memory is rare. The implication may be that collective memories are to some extent constrained by the facts. Facts may be deleted, altered, shaded, reinterpreted, exaggerated, and placed in favorable contexts, but wholesale fabrication seems to lie beyond what most groups can accomplish" ("Distortions of Collective Memory: How Groups Flatter and Deceive Themselves," in James W. Pennebaker, Dario Paez, and Bernard Rimé, eds., *Collective Memory of Political Events: Social Psychological Perspectives* [Mahwah, N.J., 1997], 282).

ploited in such a way the tradition of Dido which he had learned in school, by transforming poetry into prose and serious reality." Similarly, the popular travel writer Harry A. Franck, in *Glimpses of Japan and Formosa* (1924), also assumes that the "Hollanders" knew the story of Carthage from school: "Perhaps the verb 'to cover' is not identical in the two languages; or possibly international honor was not so perfect during those dark days as in the present model age. At any rate the Dutch took what must have been the hide of a dinosaur, or at least of its modern prototype, a water-buffalo, cut it as the Chinese to this day cut a hide, in one narrow strip, and inclosed space for the building of Fort Zelandia." Franck, a self-described "vagabond," brings to bear none of Laufer's scholarly authority; neither does he make the same assumptions as folklorists and classicists about the transmission of stories.[23]

Of course, the notion that the colonial grantees were emulating a ruse from classical antiquity cannot account for all the instances of motif K185.1—for example, the attribution of the hide trick to a "Divine virgin" in the founding of a temple in Nepal, or to a female slave in the founding of a city in Burma. The story may be associated etymologically with Moscow and Calcutta, just as the Dido story itself explains the name Byrsa. Typically, such "etymological legends" come into existence as explanations of the way things came about, not as accounts of events. What Frazer, Laufer, and others overlook, however, is the ambivalent exchange between stories and history. Stories can be descriptive or prescriptive. They can represent events that happened—or that did not happen—and they can also become precedents or models for future events, which in turn can inspire stories. The Dido motif might have originated in folklore, and it definitely participates in it, but its appearance in the *Aeneid* and related texts, founding documents of Western civilization, positioned it to be a historical factor. With the landings of Europeans on the coasts of Africa, Asia, and the Americas in the fifteenth, sixteenth, and seventeenth centuries, the story came full circle.[24]

23. F. Kottenkamp, *Die Ersten Amerikaner im Westen: Daniel Boone und seine Gefährten; (Die Gründung Kentucky's) Tecumseh und dessen Bruder*, 2d ed. (Stuttgart, 1858), 382. The translation is provided by Laufer, although he misattributes the quote to Friedrich Pott, who cites Kottenkamp ("Relations of the Chinese to the Philippine Islands," Smithsonian Institution, *Misc. Colls.*, L [1908], 284). See also Harry A. Franck, *Glimpses of Japan and Formosa* (New York, 1924), 168–169; and www.harryafranck.com.

24. "Vierge divine," in Sylvain Lévi, *Le Népal: Étude historique d'un royaume Hindou* (Paris, 1905), 7 (my translation); Frazer, "Hide-Measured Lands," *Classical Review*, II (1888), 322. The linguist Friedrich Pott, citing Kottenkamp, mentions the Dido motif and the Delaware instance in his "Etymologische Legenden bei den Alten," *Philo-*

4. THE DIDO STORY IN EUROPE

More so than we do today, early modern Europeans experienced the inter-action between story and history. Famously, the English Puritans walked in the steps of Old Testament figures as they founded the New Jerusalem in New England. Similarly, the Portuguese, Spaniards, and Dutch sailed through the discursive milieu of imperial Rome as they established their rival far-flung em-pires. They compared their exploits, sometimes favorably, to classical heroes and compared the peoples and civilizations they encountered to ones of the ancient world. The story of the foundation of Rome by the Trojan Aeneas, especially, served as a key template. This narrative was construed, not as myth, but as history, and the European adventurers and colonists were acting in the same story line as it unfolded in a different time and place. For example, João de Barros (1496–1570), "the Portuguese Livy," and Luis de Camões (1524–1580), "the Portuguese Virgil," both participants as well as chroniclers of the Portuguese imperial enterprise, modeled their respective prose and verse epics after *Ab urbe condita* and *The Aeneid*.[25]

Classical history furnishes examples of both Roman valor and "Punic in-genuity," masculine prowess and feminine guile. Hernán Cortés, scuttling his ships to prevent retreat, might have compared himself to Julius Caesar crossing the Rubicon, but for Dutch merchant seamen and other colonizers who arrived on foreign shores in underwhelming numbers, Dido's founding of Carthage might have been a more appropriate precedent. Niccolò Machia-velli, in his *Discourses on Livy*, offers "Aeneas, Dido, [and] the Massilienses"— the founders of Rome, Carthage, and Marseilles, respectively—as examples of refugees who "are obliged to occupy some location with cunning and, once it has been occupied, to maintain themselves there by means of allies and confederations."[26]

logus, II, no. 3 (1863), 258–259. On the relationship of the classical instance to folklore, see annotations by Arthur Stanley Pease: Virgil, *Publi Vergili Maronis Aeneidos Liber Quartus* (Cambridge, Mass., 1935), 232–233.

25. According to David Armitage, "all of the European empires . . . looked back to classical Rome as an inspiration and an aspiration"; see Armitage, "Introduction," in Armitage, ed., *Theories of Empire, 1450–1800* (Aldershot, Eng., 1998), xv. See also Sabine MacCormack, *On the Wings of Time: Rome, the Incas, Spain, and Peru* (Princeton, N.J., 2007); David A. Lupher, *Romans in a New World: Classical Models in Sixteenth-Century Spanish America* (Ann Arbor, Mich., 2003); William B. Greenlee, "A Descriptive Bibli-ography of the History of Portugal," *Hispanic American Historical Review*, XX (1940), 505; George Monteiro, "Camões Os Lusíadas: The First Modern Epic," in Catherine Bates, ed., *Cambridge Companion to the Epic* (Cambridge, 2010), 119.

26. Marcus Junianus Justinus, *Epitome of the Philippic History of Pompeius Trogus,*

Early modern Europeans might have found Dido a "more compelling" figure than Aeneas himself. A work that pithily illustrates the connection between European and Roman imperialism, the *translatio,* the *Aeneid* generally, and Dido specifically is the Spanish poet Garcilaso de La Vega's "Soneto a Boscán desde la Goleta." Written from the vantage point of the Spanish reinvasion of North Africa, the sonnet envisions the Roman Empire "flourish[ing] once again in this region." It revisits the Roman sacking of Carthage, but the last line identifies the speaker, not with the Romans, but with a victim of empire, Dido, who, spurned by Aeneas, tragically immolated herself: "In tears and ashes I am undone." Even as the sonnet expresses an ambivalence about imperialism, as part of Garcilaso's oeuvre it participates in the project of *translatio studii,* the establishment of a vernacular European language as a legitimate medium for classical literature. Vernacular translations of the *Aeneid* and of Livy's *History of Rome* served the same function.[27]

Although Dido's popularity was mostly due to her tragic love story—as in Christopher Marlowe's *Tragedie of Dido Queene of Carthage* (1594)—there was a written and pictorial tradition relating her foundation of Carthage with the oxhide. Illustrations of the scene appeared in historical accounts: these included a woodcut by Tobias Stimmer in a German translation of Livy (1574) and an engraving by Matthäus Merian the Elder in Johann Ludwig Gottfried's *Historische chronica* (1630) (Figures 2 and 3). These, in turn, seem to have been models for a drawing by Rembrandt or one of his followers (Figure 4). "The appearance of this rare motif of the Dido story in Rembrandt," writes one art historian, "raises the question of its source and significance for him . . . whether it had some contemporary political or moralistic meaning." The Rembrandt Studio painting is evidently that of a colonial encounter. Another art historian observes that the painting updates the Stimmer woodcut by placing the European-looking Dido under a parasol and by dressing "two of the surrounding soldiers in feathered headdresses. Perhaps he confused early representations of the American Indians with the natives of Africa." Or perhaps he did not confuse these representations so much as associate them. Inasmuch as

trans. J. C. Yardley (Atlanta, Ga., 1994), 157; Niccolò Machiavelli, *Discourses on Livy,* trans. Julia Conway Bondanella and Peter Bondanella (New York, 1997), 175.

27. Richard Helgerson suggests that Dido's celebrity induced the sixteenth-century poets Henry Howard, earl of Surrey, and Joachim du Bellay "to translate book 4 of the *Aeneid* as the showpieces for their new vernacular poetics" (Helgerson, *A Sonnet from Carthage: Garcilaso De La Vega and the New Poetry of Sixteenth-Century Europe* [Philadelphia, 2007], 54). See also Gary K. Waite, "The Holy Spirit Speaks Dutch: David Joris and the Promotion of the Dutch Language, 1538–1545," *Church History,* LXI (1992), 47–59 (esp. 49).

FIGURE 2. Tobias Stimmer, "Dido Cutting the Ox-Hide." Woodcut. From Titus Livius and Lucius Florus, *Von Ankunfft unnd Ursprung des Romischen Reichs* . . . (Straszburg, 1575), fol. 220. Courtesy of Houghton Library, Harvard University. [OLC.L765.En575]

during the span of Rembrandt's career the Dutch were landing on coasts all across the globe and engaging in transactions with the natives, it seems likely that the motif did indeed have contemporary meaning.[28]

The most famous Renaissance allusion to Dido is in *The Tempest*. In Shakespeare's comedy, Gonzalo compares King Alonso's daughter Claribel, whom they had just seen married to the king of Tunis, to the "Widow Dido," thus conflating the contemporary north African city with ancient Carthage, whose site was nearby. Shakespeare does not directly refer to the founding of Carthage, but by linking classical and early modern colonial sources and contexts, his play participates in the same triangulated intertextuality as the native stories. Two of the sources for *The Tempest* do allude to the hide trick: the

28. Ebria Feinblatt, "'Dido Divides the Ox-Hide' by Rembrandt," *Master Drawings*, IX (1971), 39–89, esp. 40; Golahny, *Rembrandt's Reading*, 161.

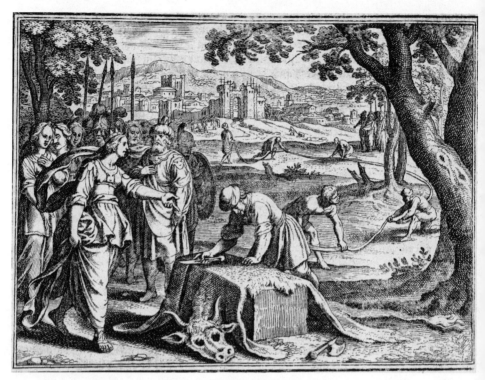

FIGURE 3. Matthäus Merian, Queen Dido Founding Carthage. 1630. From Johann Ludwig Gottfried, *Historische chronica* (Frankfurt am Main, 1657). Permission, Rare Books Division, The New York Public Library, Astor, Lenox and Tilden Foundations

Aeneid, of course, and William Strachey's account of the 1609 Bermuda shipwreck, the *True Reportory of the Wracke, and Redemption of Sir Thomas Gates, Knight.* Strachey describes the potential site for a fort near Jamestown: "A low levell of ground about halfe an Acre, or (so much as Queene Dido might buy of King Hyarbas, which she compassed about with the thongs cut out of one Bull hide, and therein built her Castle of Byrza)." It is noteworthy that the edifice in consideration is a fort—as in the native traditions.[29]

Although Strachey's allusion suggests the currency of the Dido story in the context of New World colonization, such instances are rare. References to Virgil, Livy, and Roman history, however, are profuse, especially in the

29. David Scott Wilson-Okamura, "Virgilian Models of Colonization in Shakespeare's Tempest," *ELH: English Literary History,* LXX (2003), 709–737 (esp. 716–718); Samuel Purchas, *Hakluytus Posthumus; or, Purchas His Pilgrimes* (Glasgow, 1906), XIX, 5–72 (esp. 55–56).

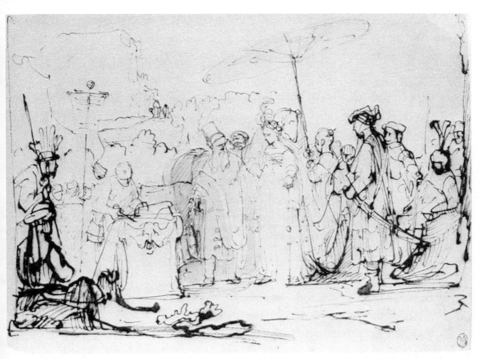

FIGURE 4. Rembrandt Studio, "Dido Cutting the Ox-Hide." Drawing. 1640–1650. Private Collection, Milan

sixteenth- and seventeenth-century political theoretical writings that provided the rationales for the conquest of foreign peoples and the competing claims of rival imperial powers. Among the most influential of the progenitors of this international law, whose ranks included Samuel Pufendorf and John Locke, was the Dutch Jurist Hugo Grotius, who was directly involved in policy development on behalf of the VOC. In 1608, Grotius anonymously published *Mare Liberum (The Freedom of the Seas)*, the twelfth chapter of *De Jure Praedae (The Law of Prize and Booty)*, "a brilliant vindication" of the VOC's privateering campaign in the East Indies, especially its capture of a Portuguese ship in 1603.[30]

30. Dido also figures prominently in an episode of Alonso de Ercilla's sixteenth-century epic about the conquest of Chile, *La Araucana*. See Karina Galperin, "The Dido Episode in Ercilla's *La Araucana* and the Critique of Empire," *Hispanic Review*, LXXII (2008), 31–67; Craig Kallendorf, "Representing the Other: Ercilla's *La Araucana*, Virgil's *Aeneid*, and the New World Encounter," *Comparative Literature Studies*, XL (2003), 394–414; Richard Waswo, *The Founding Legend of Western Civilization: From Virgil to Vietnam* (Hanover, N.H., 1997), 137–138; Martine Julia Van Ittersum, *Profit and*

In an early passage in the *Mare Liberum,* Grotius asserts the universal right to land and to engage in commerce on foreign shores, citing a precedent for this "law of hospitality" from the *Aeneid:*

What men, what monsters, what inhuman race,
What laws, what barbarous customs of the place,
Shut up a desert shore to drowning men,
And drive us to the cruel seas again.[31]

Aeneid I:539–540 is part of an episode that begins with the arrival of the Trojans in Carthage and includes the story of the city's founding. The quotation, apparently something of a commonplace in the emerging discourse of international law, is from a speech by Ilioneus, who invokes "hospitable rights" and "human laws" to urge Dido to make an exception to common practice and afford the Trojans safe harbor:

Permit our ships a shelter on your shores,
Refitted from your woods with planks and oars,
That if our prince be safe, we may renew
Our destined course and Italy pursue.

As with the Europeans who sought succor on foreign shores throughout the age of exploration, the descendants of the Trojans were already fated, according to the retrospective afforded by Virgil's Augustan moment of composition, to repay their hostess's kindness by conquering the colony she had founded and building their own on the same site.[32]

If with Grotius we see a direct link between Virgil and VOC policy, we can perhaps see the fruits of this relationship as echoes of the above-cited passage in the hide stories from Taiwan and Java. A Dutch captain shipwrecked off Taiwan in 1620, "no doubt with intention of turning the mishaps which had befallen him to some advantage," asked the Japanese who had colonized the island for as much land as an ox skin would cover, on which to build "a sort of depot." Then the "wily Dutchman with an old trick in mind proceeded to cut the ox-skin in very long narrow strips." A year earlier, according to the British East India Company official Thomas Stamford Raffles, a Dutch cap-

Principle: Hugo Grotius, Natural Rights Theories, and the Rise of Dutch Power in the East Indies, 1595–1615 (Leiden, 2006), xix.

31. Hugo Grotius, *The Freedom of the Seas; or, The Right Which Belongs to the Dutch to Take Part in the East Indian Trade* (New York, 1916), v–vi, 8; Virgil, *Vergil's Aeneid and Fourth ("Messianic") Eclogue in the Dryden Translation* (University Park, Pa., 1989), 22.

32. Virgil, *Vergil's Aeneid and Fourth ("Messianic") Eclogue,* 22–23. On other uses of *Aeneid* I:539–540, see Waswo, *Founding Legend,* 137–138.

tain scuttled his own vessel at Jakarta to supply a pretext to impose on the hospitality of a local prince. He then employed the hide trick to obtain the site for a fort. On their plot of land, the Dutch first planted "a garden for vegetables," explaining "that it was not the custom of the Dutch to live and eat like the Javans." Then, in a maneuver that recalls the Delawares' recollection that the Dutch "planted great guns" instead of "greens," the Dutch raised batteries upon which "they planted cannon." It is impossible to say whether this catachrestic metaphor—planting guns—can be attributed to the natives or to the translation. In either case, in light of the significance of agriculture to the *Aeneid* and to the early modern discourse of colonialism, the Dutch captain's cultural distinction and the vegetable gardens themselves seem less than innocent, if less belligerent than the artillery.[33]

The sequence containing the Dido motif, as it occurs in Carthage and in sites from New Amsterdam to Taiwan, includes the solicitation of friendship with the natives, the request for land, the use of the animal hide to obtain more than the colonists "had apparently bargained for," and the erection of a fort (or, more grandly, a citadel). As illustrated by these 1608 orders to Willem Pieterzoon Verhoef, VOC company policy, based on Grotius's theories, explicitly accounts for every feature but the hide trick: "In the principal places where you conclude friendships and alliances, we recommend that you establish fortresses with the consent of the Indians, in order that we may secure these places and defend them as our possessions, keeping their trade for ourselves alone and excluding the Portuguese and all others." Like nearly all their practices, the VOC would have copied this modus operandi from the Portuguese. Portugal, Spain, and the Netherlands were intimately and antagonistically related throughout the period in which the Dido motif is set, with active commercial and political ties. Portugal was brought under the Spanish Habsburg umbrella in 1580, ten years after the Dutch republic began its long struggle to get out from under it. The chronology suggests that the Portuguese began to employ the hide trick in the early sixteenth century, that the Spaniards borrowed it for the taking of Manila in 1574, and that the Dutch took it up in the seventeenth century. That none of the instances of the motif attributes the trick to French, English, or other European colonists strengthens the argument that it was not, as least in its inception, a general metaphor for colonization.[34]

33. James W. Davidson, *The Island of Formosa, Past and Present: History, People, Resources, and Commercial Prospects* (1903) (Oxford, 1988), 12–13; Raffles, *History of Java*, 154. On agriculture and the *translatio*, see Waswo, *Founding Legend*, 15–20.

34. Justinus, *Epitome of the Philippic History of Pompeius Trogus*, 157; Van Ittersum,

Excepting the hide trick, most of the elements in the native stories of the first colonial settlements, then, correspond to established practices and to European accounts of colonial encounters. Indeed, the French missionary Thomas Arbousset, who records a Hottentot version of the hide story, notes its curious parallels with "the history of the Cape colony," which includes the eventual transfer of "a piece of land, stretching three miles along the shore." The implication, carried especially by the participle "stretching" *(s'étendant)*, is that the tract is the one measured with the thong.[35]

Similarly, even the skeptical Laufer allows that a comparison of the story of the Spanish founding of Manila in the *Ming Annals* to the account in Antonio de Morga's chronicle *Sucesos de las Islas Filipinas* shows that the former "is not quite without foundation in some details." The source for the version in the *Ming shi* (1736) was probably Zhang Xie's *Dong xi yang kao*, which appeared in 1618, a mere nine years after Morga's account. According to that version, the Franks (Spaniards) determined that the island of Luzon was vulnerable, plied the local king with gold, and

> sought land the size of a buffalo hide, in order to build houses. The king was trusting and allowed this. The *Franks* then took the buffalo hide and cut it into strips, joining them together, which they then extended as a perimeter around a piece of land and they asked for the land to be given as promised. The king was in a dilemma, but did not want to lose the trust of the distant foreigners. He thus eventually gave them the land, with a monthly tax levied in accordance with the laws of their tribe. The *Franks* obtained the land, built walls and barracks and arrayed their cannons and weapons in abundance. After a time, they surrounded Luzon, killed the king, drove him into the hills and Luzon gradually came to be controlled by the *Franks*.

The Chinese account combines the almost magical feature—the hide trick—with a mundane detail that is more typical of the text: "a monthly tax."

Profit and Principle, 158–159; I. N. Phelps Stokes, *The Iconography of Manhattan Island, 1498–1909: Compiled from Original Sources and Illustrated by Photo-Intaglio Reproductions of Important Maps, Plans, Views, and Documents in Public and Private Collections,* 6 vols., I (New York, 1915), 7; A. J. F. Van Laer, ed. and trans., *Documents Relating to New Netherland, 1624–1626, in the Henry E. Huntington Library* (San Marino, Calif., 1924), xi. According to Seed, the "Dutch mariners initially borrowed all their means to overseas empire from the Portuguese" *(Ceremonies of Possession,* 149).

35. Arbousset and Daumas, *Narrative,* 25; T. Arbousset and F. Daumas, *Relation d'un voyage d'exploration au nord-est de la colonie du Cap de Bonne-Espérance: Entrepris dans les mois de mars, avril et mai 1836* (Paris, 1842), 50.

Potentially, it supplements rather than contradicts the Spaniards' perspective: Morga's narrative has the Spaniards entering the land through force of arms, then establishing terms of "peace, friendship and obedience"; the local leader Rajamora donated to the Governor Miguel López de Legazpi the land on which to build his city, and the conquistador, preserving the native name Manila, "took as much land as he needed for the city."[36]

The Philippine instance, in which the account of the colonist seems basically compatible with the alternative history, is not very close to an actual corroboration of the story. The absence of documentary evidence is not necessarily surprising, because the colonists were concerned with establishing the legality of their actions, even as they themselves defined the terms of that legality: they would not want to attest to cheating the natives. In the case of the Dutch, Grotius helped to establish a legal framework that was overwhelmingly favorable to the interests of the VOC, in part by advocating the use of written contracts and holding native leaders to their terms under natural law. Yet elsewhere he insisted that contracts were only valid "if no fraud has been used, nor any necessary information withheld." Was the use of the hide trick fraud? With reference to the Roman jurist Pomponius Secundus, Grotius allows "that in a bargain and sale, one man may NATURALLY overreach another" — a circumstance that admits "no legal remedy."[37]

In New Netherland, colonists were instructed in 1624 to "take especial care, whether in trading or in other matters, faithfully to fulfill their promises to the Indians or other neighbors and not to give them any offense without cause as regards their persons, wives, or property, on pain of being rigorously punished therefor." This injunction was seconded the following year in orders to company director Willem Verhulst, who was told that the Indians should be "shown honesty, faithfulness, and sincerity in all contracts, dealings and intercourse, without being deceived by shortage of measure, weight, or number." They were to conduct land transactions without "craft or fraud." Such instructions may suggest, as one scholar argues, that the West India Company

36. Laufer, "Relations of the Chinese to the Philippine Islands," Smithsonian Institution, *Misc. Colls.*, L (1908), 258–259; Zhang Xie, *Dong xi yang kao*, 89. "La paz, amistad y obediencia"; "tomó lo que bastó del terreno para la ciudad" (Antonio de Morga, *Sucesos de las Islas Filipinas*, Crónicas y memorias, no. 3 [Madrid, 1997], 27, my translation). My thanks to Geoffrey Wade of the Asia Research Institute at the University of Singapore for locating the passages in the *Dong xi yang kao* and the *Ming shi* and for his translations. According to Wade, the word he translated as "buffalo" could also be rendered as "ox" or "cow."

37. Hugo Grotius, *The Rights of War and Peace: Including the Law of Nature and of Nations*, trans. A. C. Campbell (Washington, D.C., 1901), 158–159.

"sincerely and programmatically" intended to do right by the Indians. However, that would make the Dutch colonists, in Irving's phrase, "very unusual in the history of colonization." Rather, the instructions constitute a tacit acknowledgment of an existing state of affairs—that the beginnings of New Netherland were hardly characterized by scrupulous dealings. The use of the word "craft" is especially suggestive of a gray area between forthrightness and fraud—one in which "Punic ingenuity" would have room to operate.[38]

How much room? Is the Dido motif one of those characteristic features of oral traditions that exceeds the limits of "physical possibility"? This question is the mathematical "Dido's Problem," and it is one occasionally addressed by high school students, who may cut a sheet of paper into strips and lay them out in a room or cut up a bedsheet and lay it out on a football field. The solution to the isoperimetric problem of which shape takes in the greatest area is a circle; even better is a semicircle, in which one boundary is not the thong but a body of water. (For this reason, mathematicians typically recall Dido laying out the thong in a semicircle on the beach, although there is no indication of this shape in the classical sources.) Stefan Hildebrandt and Anthony Tromba, in *The Parsimonious Universe*, suggest that the length of Dido's thong (and therefore the circumference of the circle) might have been "between 1,000 and 2,000 yards if we assume that the width of the strips was as small as $\frac{1}{10}$ inch."[39]

Two thousand yards would not be capacious enough to enclose the legendary proportions of the site for the Byrsa at Carthage, which Servius Grammaticus reports at 22 stadia, or approximately 4,450 yards. Such a thong would be more than sufficient, however, to encompass an impressive colonial fort: the instructions for Fort Amsterdam sent to the engineer Cryn Fredericksz specify a "circular circumference" of 3,150 Dutch feet, or about 975 yards. It may be,

38. Nederlandsche West-Indische Compagnie, "Provisional Regulations for the Colonists," "Instructions for Willem Verhulst," and "Further Instructions for Willem Verhulst and the Council of New Nertherland," in Van Laer, ed. and trans., *Documents Relating to New Netherland*, 17, 39, 106; Benjamin Schmidt, *Innocence Abroad: The Dutch Imagination and the New World, 1570–1670* (New York, 2001), 247; Irving, *Knickerbocker's History of New York*, 58.

39. Robert H. Lowie, "Oral Tradition and History," *American Anthropologist*, n.s., XVII (1915), 598; Chris Shore, "Princess Dido and the Ox Skin," *Math Projects Journal* (2003), http://www.mathprojects.com/Downloads/Geometry/PrincessDido.pdf (accessed June 2007); John P. Curtis, "Complementary Extremum Principles for Isoperimetric Optimization Problems," *Optimization and Engineering*, V (2004), 417–430; Stefan Hildebrandt and Anthony Tromba, *The Parsimonious Universe: Shape and Form in the Natural World* (New York, 1996), 64–65.

however, that the length of the hypothetical thong proposed by Hildebrandt and Tromba is exaggerated. Given an intact hide with an area of 40 square feet (the size of a large cowhide rug) cut into strips "not thicker than the finger of a little Child" (the width specified in Heckewelder's version of the Lenape account), Frank Morgan, an expert on questions of optimization, suggests a width for the thong of ⅓ of an inch and a length of 1,600 feet, or about 533 yards. This length would still have been more than sufficient to encompass the sites for forts less ambitious than Fort Amsterdam—the provisional strongholds the colonists established in the initial expeditions described in the native accounts.[40]

Most previous readers of the Delaware tradition regarding the bullock's hide were presumably unaware of its counterparts from Asia and Africa and of the relationship of the classical histories containing the story of the foundation of Carthage to early modern European imperialism. In a sense, it is *the* story of colonial land transactions, not only in North America but also around the world, and not only during the Golden Age of Portuguese, Spanish, and Dutch imperialism but also in subsequent periods. That is, the story has both historical and allegorical significances—as history generally does. Even if we treat the native accounts skeptically and construe them as stories borrowed from European colonists by many otherwise unrelated native peoples and subsequently taken down in writing by many otherwise unrelated ethnographers and travel writers (as well as by seventeenth-century Asian historians), we may still consider all of these separate tellings, borrowings, retellings, translations, and transcriptions as revelatory of a fascinating aspect of early modern colonial encounters and their aftermath: one that comes to our attention through non-European sources. The idea that the story is a literal representation of an actual colonial practice, however, is more in accordance with the logical principle of Occam's razor: it is simpler and leaves less to account for. This happenstance might lead us to question our assumptions about oral traditions that have no such parallels, to be open to the capacity of native histories to shed new light on the colonial period.

40. Servius, *Servii Grammatici Qui Feruntur in Vergilii Carmina Commentarii*, II (1881; rpt. Hildesheim, 1961), 124; Nederlandsche West-Indische Compagnie, "Special Instructions for Cryn Fredericksz," in Van Laer, ed. and trans., *Documents Relating to New Netherland*, 135. On early New Netherland forts, see Otto, *Dutch-Munsee Encounter in America*, 54–55; Van Laer, ed. and trans., *Documents Relating to New Netherland*, 260 n. 8. For my own conversions, I used onlineconversion.com; Frank Morgan, e-mail message to author, Aug. 27, 2006.

COMPETITION OVER LAND, COMPETITION OVER EMPIRE

PUBLIC DISCOURSE AND PRINTED MAPS OF THE KENNEBEC RIVER, 1753–1755

Matthew H. Edney

One of the many curiosities among the cartographies of colonial North America is a set of three maps of land grants along the Kennebec River, in the Eastern District of the colony of Massachusetts Bay, or present-day Maine, that were printed in Boston and London in 1753 and 1755. It was rare for maps of such geographically precise land grants to be printed. It was truly exceptional for three maps of the same small area to be printed in such quick succession. Two of the maps made overt reference to a dispute over conflicting land grants. Historians have hitherto taken this dispute to be sufficient causal explanation for all three maps by assuming that all three were prepared and published in conjunction with lawsuits or to shape public opinion concerning the dispute. Yet no one has explained how the maps contributed to any such lawsuits or why the public in either Boston or London would have had an interest in the dispute. This failing is all the more significant when it is realized that the parties to this particular dispute reached a compromise in June 1757 without ever pleading before a court in Boston or the Privy Council in London. Nor, for that matter, do these maps possess the characteristics of maps that were printed as addenda to legal briefs.[1]

A version of this essay was presented at Brown University in April 2006. Susan Danforth, of the John Carter Brown Library, Brown University, has very kindly permitted her unpublished research findings to be included here. I am very grateful to Martin Brückner for his thoughtful comments on this essay and for accepting it for the larger collection.

1. Lawrence C. Wroth, "The Thomas Johnston Maps of the Kennebeck Purchase," *In Tribute to Fred Anthoensen, Master Printer* (Portland, Me., 1952), 77–107; Gordon E. Kershaw, *The Kennebeck Proprietors, 1749–1775: "Gentlemen of Large Property and Judicious Men"* (Portland, Me., 1975), 159–161; William P. Cumming, "The Colonial Charting of the Massachusetts Coast," in Philip Chadwick Foster Smith, ed., *Seafaring in Colonial Massachusetts* (Boston, 1980), 67–118 (esp. 97–98 and 114–118, where he mis-

So why were the three maps printed? This question has very rarely been asked of maps, because modern cartographic ideology has construed the printing of maps to be an almost ineluctable act: how else can maps be widely disseminated and so fulfill their moral duty to guide human action in space? But several intellectual vantage points—Foucauldian discourse analysis, actor network theory from the sociology of science, and the history of the book's emphasis on the circulation of inscribed material objects—have given rise to an appreciation for the precision with which inscriptions move both socially and geographically. In this respect, we must recognize that manuscript and oral reproduction both possess a continued significance in the face of print; we must variously distinguish social groups by what they read and by how they read; and we must accept that text, graphics, and cartographics are deeply intertwined modes of representation. In short, we can achieve a social history of map culture, to paraphrase David Hall.[2]

To understand why the three maps of the Kennebec were printed therefore requires the recovery of the precise history of the maps as artifacts by tracing their particular trajectories from manuscript to print without any a priori presumption of their necessary interrelatedness. Such recovery permits the identification of the spatial discourses within which each printed map was deployed and so a sense of the maps' probable meanings within those discourses. The value of this study is that the Kennebec maps manifested variant configurations and degrees of sophistication of public discourse on either side of the Atlantic. The two maps printed in 1755 need to be understood as elements of politically motivated public discourses concerning the growing tensions between the British and French over their respective territorial claims in North America. In this, the maps' references to competition for lands in the Kennebec valley served to analogize the larger competition for empire and reduce it to more humanly appreciable terms. Moreover, both Boston-published maps contributed to the continuing development of a new publicity in that city in the 1750s. This new publicity rested on new forms of sociability and literacy paralleling those that had already developed in Brit-

read Kershaw [190] to suppose that the dispute had in fact gone before the Privy Council). On maps printed for legal cases in London, see Matthew H. Edney, "Printed but Not Published: Limited-Circulation Maps of Territorial Disputes in Eighteenth-Century New England," in Paula van Gestel-van het Schip and Peter van der Krogt, eds., *Mappae Antiquae: Liber Amicorum Günter Schilder; Essays on the Occasion of His 65th Birthday* ('t Goy-Houten, Neth., 2007), 147–158.

2. David D. Hall, *Cultures of Print: Essays in the History of the Book* (Amherst, Mass., 1996), 1. In general, see the crucial essays by D. F. McKenzie in *Bibliography and the Sociology of Texts* (Cambridge, 1999).

ain; within this new community, an emergent Boston public laid claim to a right to pronounce on affairs of religion, state, and culture even as it sought to stifle more popular dissent. The new public's discourse rested on a rhetoric of disinterest, truthfulness, and rationality that was exemplified and sustained by mapping practices. Overall, this study reminds us that the act of printing is contingent, that the cultural significance of printing has been historically variable, and that maps were deployed as crucial elements in the eighteenth century's critical public discourse.[3]

THE BROADSIDE 1753 BOSTON MAP:
MANUSCRIPT CIRCULATION AND TRADITIONAL PUBLICITY

The two Boston-based groups involved in the property dispute were the Plymouth Company (also known as the proprietors of the Kennebec Purchase) and the Brunswick Proprietors (also known as the proprietors of the Pejepscot Company).[4] The origins of the Plymouth Company lay with a group of Boston merchants who had in 1661 purchased a huge tract of land along the Kennebec River from the cash-strapped Plymouth Colony. This tract measured some fifty miles long by thirty miles wide, fifteen miles to either side of the Kennebec River. Yet the company proved unable to develop the land and soon became moribund.

Some decades later, in 1714, another group of Boston investors, calling themselves the Pejepscot Company, received a relatively large grant of land running along the Maine coast. The new company was unconcerned about any potential overlap of its lands with those of the still inactive Plymouth

3. The literature on the early modern public is huge. In addition to the basic texts by Jürgen Habermas (*The Structural Transformation of the Public Sphere: An Inquiry into a Category of Bourgeois Society,* trans. Thomas Burger and Frederick Lawrence [Cambridge, Mass., 1989]) and his critics—esp. Craig Calhoun, ed., *Habermas and the Public Sphere* (Cambridge, Mass., 1992), and Harold Mah, "Phantasies of the Public Sphere: Rethinking the Habermas of Historians," *Journal of Modern History,* LXXII (2000), 153–182—I have been especially helped and influenced by McKenzie, *Bibliography and the Sociology of Texts;* Steve Pincus, "'Coffee Politicians Does Create': Coffeehouses and Restoration Political Culture," *Journal of Modern History,* LXVII (1995), 807–834; Michael Warner, *The Letters of the Republic: Publication and the Public Sphere in Eighteenth-Century America* (Cambridge, Mass., 1990), esp. 1–72; and David Zaret, *Origins of Democratic Culture: Printing, Petitions, and the Public Sphere in Early-Modern England* (Princeton, N.J., 2000).

4. Although it is common to refer to the Kennebec proprietors rather than to the Plymouth Company, I use the latter, formal term to limit my use of "proprietors" and so prevent the essay from becoming overburdened.

Company. According to the Pejepscot Company's understanding, the Kennebec River was the freshwater, nontidal stream above Merrymeeting Bay, the flooded, inland delta formed by the confluence of the Kennebec, Androscoggin (or Amoroscoggin), and other rivers; the same tradition held that the tidal reach south from Merrymeeting Bay to the sea was properly called the Sagadahoc River. Because the Plymouth Company's lands straddled the Kennebec, they had to be inland of the Pejepscot Company's tract (see Figure 1, below). Confident of the uniqueness of its land claim, the Pejepscot Company quickly organized its tract into a number of towns and by 1720 had begun to sell off lots to individual settlers. The easternmost of the Pejepscot towns was Brunswick, which covered some thirty-six square miles between the coast to the south, the Androscoggin to the north, and the Sagadahoc to the east.[5]

In 1748, with the end of King George's War (that is, the War of Austrian Succession), the heirs to the Plymouth Company resurrected their claim to the huge Kennebec Purchase and began actively developing the tract. The company hired John North in 1750 to survey and to delimit the bounds of its claim according to its interpretation of the original charters. That interpretation depended upon an alternate but equally viable toponymic tradition that the Kennebec River encompassed the tidal reach and the Sagadahoc River was another name for the Androscoggin. The southern limit of the Plymouth Company's lands was therefore, not Merrymeeting Bay, but the coast itself. The Plymouth Company thus laid claim to the same land on which the Pejepscot Company had organized the town of Brunswick. The stage was set for a complex dispute. Agents of the Plymouth Company worked aggressively to persuade the Pejepscot Company's tenants in Brunswick to recognize the company's claims. In response, the Pejepscot proprietors presented themselves as the "Brunswick Proprietors," which is to say, as just the owners of a small town who were beset by the bullying owners of a much greater tract.[6]

The proprietors on both sides of the dispute had easy access to the relevant

5. See Joseph Heath, *A Discription of Kennebec River,* May 16, 1719, Maine Historical Society, Special Collections, Coll. 60, map no. 54a (the Plymouth Company's copy of Heath's initial mapping of the Pejepscot Company's limited interpretation of the Plymouth Company's lands); *A Draught of the Purchases on the River Kennebeck Navigable for Small Vessells, 1731,* Maine Historical Society, Special Collections, Coll. 60, map no. 35.

6. John North, *Plan of a Tract of Land Lying 15 English Miles on Each Side of Kennebeck River,* 1751 (366 cm. × 274 cm.), Maine Historical Society, Special Collections, Map R 10, Bin 34. A number of reduced copies of this plan survive from the later eighteenth century.

maps, charters, and deeds. To judge from the brief pamphlet war generated by
the publication by the Brunswick Proprietors of the first of the printed Ken-
nebec maps in 1753 (Figure 1), such documents circulated in manuscript quite
freely among Boston's landowning elites. For example, several copies were
evidently available of the "ancient plan" owned by Edward Hutchinson that
served as the primary basis for the first printed map. One of the proprietors
of the Plymouth Company could criticize the validity and worth of Hutchin-
son's map because he had himself taken a copy (second-generation) of the
map some years previously and could now demonstrate its flaws and inade-
quacies. However, the Brunswick Proprietors had access to the same copy, or
more likely another copy thereof (third-generation); comparison of that with
the original manuscript showed that the second-generation copy was incom-
plete and had also been modified, so that the Brunswick Proprietors could ar-
gue that the Plymouth Company's complaints were quite misplaced. Further-
more, the Plymouth Company's archives contain two manuscript maps that
are very closely related to the map printed for the Brunswick Proprietors.
Each side circulated position documents among themselves in manuscript,
and these inevitably filtered to the opposition. This manuscript discourse was
essentially legal and archival in character: it adduced materials drawn from
official, proprietary, and personal archives as possessing a certain legal stand-
ing. It was, moreover, a constrained and essentially private discourse, limited
to the proprietors and colonial officials who were privy to the processes of
investment.[7]

The archival and legal discourse excluded the settlers who had bought indi-
vidual lots of land. Such individual lots were legally defined by monuments

7. Pamphlets: *Remarks on the Plan and Extracts of Deeds Lately Published by the Pro-
prietors of the Township of Brunswick (as They Term Themselves) Agreable to Their Vote of
January 4th 1753* ([Boston], 1753), 5; *An Answer to the Remarks of the Plymouth Company,
or (as They Call Themselves) the Proprietors of the Kennebeck Purchase for the Late Colony
of New-Plymouth, Published by Virtue of Their Vote of 31st of January Last; on the Plan
and Extracts of Deeds Published by the Proprietors of the Township of Brunswick* (Boston,
1753), 7n, 20–21; and *A Defence of the Remarks of the Plymouth Company, on the Plan and
Extracts of Deeds Published by the Proprietors (as They Term Themselves) of the Township
of Brunswick; Being a Reply to Their Answer to Said Remarks, Lately Published, according
to Their Vote of March 28. 1753* (Boston, 1753). See Wroth, "Thomas Johnston Maps," *In
Tribute to Fred Anthoensen*, nos. 15, 17, 18. Maps: Maine Historical Society, Special Col-
lections, Coll. 60, maps no. 56-2-1 (with the same cartouche design as on the printed
map, but without the title and also with different compass roses, and so perhaps a neat
manuscript copy of the printed map), and no. 347 (*A Discription of Kenebeck River*,
which seems to be more of a working document).

located in the land (notably piles of rocks and blazed trees) tied together by verbal metes-and-bounds descriptions; they were sustained by further monumentation (stone walls, etc.) and regular perambulations. Graphic plans of individual lots became common in New England after 1720 but were never compulsory. The settlers who had purchased title to land from the Brunswick Proprietors accordingly lacked the larger spatial framework necessary to withstand the forceful overtures from the Plymouth Company's agents, who argued that the settlers should recognize the Plymouth Company as holding original title to the land.[8]

The Brunswick Proprietors therefore sought to advertise their formal understanding of the legal situation to their otherwise ignorant tenants. They published a broadside in May 1751 with a précis of the Plymouth Company's deeds and a brief statement of their interpretation of the Plymouth Company's tract as being confined to the interior. The broadside's preamble indicated that the intent of the Brunswick Proprietors was "to open the Eyes of People, and to undeceive those Persons that have been unwarily led to take up under the *Plymouth* Company's Claim, to Lands in Kenebeck River, . . . [and] to prevent any ignorant Persons being deluded thereby." This first broadside seems to have had little effect, so the Brunswick Proprietors subsequently voted on January 4, 1753, to reprint it together with a map prepared by the Boston engraver Thomas Johnston from a number of the manuscript maps then in private circulation (Figure 1). This map clearly demonstrated the argument that the deeds underpinning the Plymouth Company's grants all lay well inland. The map would therefore provide a "general View" that "would conduce very much to illustrate" the passages extracted from the deeds and

8. On the legal requirements for the delineation of real property, see *The Acts and Resolves, Public and Private, of the Province of Massachusetts Bay: To Which Are Prefixed the Charters of the Province . . .* , 21 vols. (Boston, 1869–1922), esp. I, 64–68, 716. Until a careful study of land surveying in colonial New England can be written, reference should be made to: David Grayson Allen, *"Vacuum Domicilium:* The Social and Cultural Landscape of Seventeenth-Century New England," in Jonathan L. Fairbanks and Robert F. Trent, eds., *New England Begins: The Seventeenth Century* (Boston, 1982), I, 1–52; Peter Benes, *New England Prospect: A Loan Exhibition of Maps at the Currier Gallery of Art, Manchester, New Hampshire* (Boston, 1981); Brian Donahue, *The Great Meadow: Farmers and the Land in Colonial Concord* (New Haven, Conn., 2004); and Margaret Wickens Pearce, "Native Mapping in Southern New England Indian Deeds," in G. Malcolm Lewis, ed., *Cartographic Encounters: Perspectives on Native American Mapmaking and Map Use* (Chicago, 1998), 157–186; and Pearce, "Encroachment by Word, Axis, and Tree: Mapping Techniques from the Colonization of New England," *Cartographic Perspectives,* no. 48 (Spring 2004), 24–38.

AT a Meeting of the Proprietors of the Township of *Brunswick* in the County of *York*, duly warned according to Law, by Adjournment, on *January* 4th 1753 ; the following Vote was passed.

WHEREAS *in Order to open the Eyes of People, and to undeceive those Persons that have been unwarily led to take up under the Plymouth Company's Claim, to Lands in Kenebeck River, it seems necessary that the respective Deeds or Extracts of their Bounds, and of the Abutters both above and below their said Bounds, both from original Deeds and attested Copies, be printed together with the annexed Plan, the same being a very True survey of Sagadahock and Kenebeck Rivers, with the Lands adjacent, to prevent any ignorant Persons being deluded by the said Plymouth Company's Claim.* Voted, That the sundry Extracts with the aforesaid Plan, be forthwith printed at the Expence of this Propriety.

A true Copy examined, By BELCHER NOYES, Proprietors Clerk.

Extract from the Plymouth *Pattent, dated January* 16th 1629, *viz.*

" ALL that Tract of Land or Part of *New-England* in *America* aforesaid, which lieth within or between, and extendeth it self " from the utmost Limits of *Cobbaseconte* alias *Comaseconte*, which adjoyneth to the River of *Kenebeck*, alias *Kenebeckike*, " TOWARDS the Western Ocean ; and a Place called the Falls at *Negumbike* in *America* aforesaid ; and the Space of fifteen " English Miles on each Side of the said River, called *Kenebeck* River ; and all the said River called *Kenebeck*, that lies within the " said Limits and Bounds, Eastwards, Westwards, Northwards, Southwards, last abovementioned. And all Lands, Grounds, " Soils, Rivers, Waters, Fishings, Hereditaments and Profits whatsoever, scituate lying and being, arising, happening or accru- " ing, or which shall arise, happen or accrue, in or within the said Limits and Bounds, or either of them together, with free " Ingress, Egress and Regress, with Ships, Boats, Shallops and other Vessels, from the Sea commonly called the Western Ocean, " to the River called *Kenebeck*, and from the said River, to the said Western Ocean.

Note, Said Pattent does not bound them on, or upon the Western Ocean.

Extract of an Indian Deed to the Plymouth *Colony, appointed to be recorded by the said Colony of* Plymouth, *dated* August 8. 1648, *viz.*

" ALL the Lands on both Sides of the River *Kenebeck*, from *Cushenoc* upwards to *Wesserunsett* : To have and to hold to " them, their Heirs and Assigns for ever. *invented afterwards in Plimouth Colony Deed to Boys & Company.*

Note, It is to be observed from *Cushenoc* upwards, but not down said River of *Kenebeck* nor *Sagadahock.*

Extract of an Indian Deed to the Plymouth *Colony, appointed to be recorded by the said Colony of* Plymouth, *dated* September 10. 1653, *viz.*

" ALL that Tract of Land from *Cobbasecontu* unto a Place where I now dwell, called *Usserunscutt. it happened to be left out of ye* " *Note,* It may be supposed *Wesserunsett* and *Usserunscutt* to be one and the same Place. *with colony deed to Boys & Company*

Extract of the Plymouth *Colony Deed to Messieurs, Antipas Boyes, Edward Tyng, Thomas Brattle, and John Winslow, now called the* Plymouth *Company, dated* October 27. 1661, *not Sealed nor Delivered 'till June* 15. 1665, *nor Recorded 'till* October 22. 1719, *viz.*

" ALL those our Lands lying and being in the River *Kenebeck*, bounded as follows, viz. All that our Tract of Land in " *America*, which lieth in or between, and extendeth from the utmost Bounds of *Cobbasseconti*, alias *Comasseconti*, which " adjoineth to the River *Kenebeck*, alias *Kenberkike*, towards the Western Ocean, and a Place called the Falls at *Neguambeck*, " in *America* aforesaid ; and the Space of fifteen English Miles on both Sides said River, commonly called *Kenebeck* River. And " all the said River called *Kenebeck*, that lieth within the said Limits and Bounds, Eastward, Westward, Northward and " Southward : And all Lands, Grounds, Soils, Rivers, Tradings, Fishings, Hereditaments and Profits whatsoever, lying or be- " ing within said Limits and Bounds, together with free Ingress, Egress and Regress, with Ships, Boats, Shallops or other Vessels " from the Sea commonly called the Western Ocean, to the said River called *Kenebeck*, and from the said River to the said " Western Ocean. As also all the Lands from *Cushens* upwards to *Wesserunsick*, bought by us of *Monquine*, alias *Nattahanida*, " as appears by a Deed dated *August* 8. 1648, and consented unto by *Essemonosque, Agado Demago,* and *Tassuck,* chief Men " of the Place, and Proprietors thereof."

Note, Which Description comprehends no more than the Lands lying in or between *Cobbasseconte* and *Negumkike* Falls, or *Nequambeck*, and fifteen Miles on each Side the River.

Extract of an Indian Deed to said Plymouth *Company, dated,* July 8. 1665, *explaining and confirming the Bounds of their Deed from the* Plymouth *Colony, which was given one Month after they bought of the Colony of* Plymouth, *viz.*

" ALL the Lands upon both Sides of *Kenebeck* River, from the lower End of *Cobbasseconte* to the upper Side of *Wesserunsick.* " To have and to hold to them their Heirs for ever." *ye same with ye Deed to Plimouth Colony of Sep. 10 1653 ; but*

Note, Compare this Deed with the above *Indian* Deed, dated *September* 10. 1653, it appears that *Cobbasseconte,* is the *lowermost Bounds of said Company's Claim.*

The above is the whole of the Plymouth *Company's Title truly stated.*

The following is the Title of Sir *Byby Lake,* deceased, *Edward Hutchinson,* Esq; deceased and others, below *Cobbasseconte,* and above *Negumkike* Falls or *Nequambeck,* being one and the same Place.

Extract of an Indian Deed to Christopher Lawson, *dated* October 10. 1649, *sixteen Years before said* Antipas Boyes *and others, bought of the* Plymouth *Colony, now owned by Deed from said* Lawson, *dated* July 2nd 1650. *above One Hundred Years since, viz.*

" A Certain Parcel of Land scituated and lying upon the River *Kenebeck*, which Bounds and Limits extends from the Nor- " thermost Part of a certain Place commonly called, and known by the Name of *Caperscconty,* and on both Sides of " the aforesaid River of *Kenebeck,* reaching ten Miles into the Woods on each Side of the River East and West, and so ex- " tending Southward unto a certain Place called *Swan-Alley,* which is about four Leagues in Length North and South ; together " with all Ponds, *&c.*

Note, By this it appears that *Cobbasseconte* is the Bounds between the *Plymouth* Company, and Sir *Byby Lake,* and others.

Extract of an Indian Deed to said Lawson *and others, dated* May 24. 1653, *now owned by Sir* Byby Lake *deceased, and others, viz.*

" ALL that Land lying and being on both Sides of the River of *Kenebeck,* as followeth ; namely, From the lower End of a " certain Place called by the Name of *Neguamkett,* which is a little below some Islands that are in the River, and so " going up the River four Miles above the Falls of *Tecomck,* and reaching ten Miles into the Woods, of both Sides of the River " (with the like Privileges as we formerly granted to *Christopher Lawson,* of the Land about *Neoumphee,* as by our Deed of " sale appears.)---------- There are also other *Indian* Deeds, mentioned on the Plan annexed.

Note, This determines where *Neguamkett* is.------

So that the foregoing Extracts sufficiently demonstrate, that the Claim of the *Plymouth* Company begins at *Cobbasseconte,* and goes up the River of *Kenebeck,* and cannot extend below said *Cobbasseconte,* which is their lowermost Bounds towards the Western Ocean.--------

FIGURE 1. *At a Meeting of the Proprietors of the Township of Brunswick in the County of York . . . January 4th 1753 . . .* (Boston, [1753]). Broadside, 35 cm. × 44 cm., including intaglio map: *A True Coppy from an Ancient Plan of E Hutchinson's Esqr; and from*

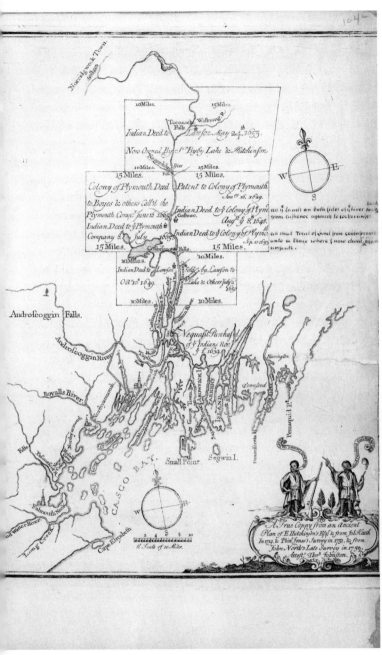

Jose. Heath in 1719. and Phins: Jones's Survey in 1731. and from John North's Late Survey in 1752. Attestr: Thos Johnston. 28.5 cm. × 21.0 cm. Courtesy of the Massachusetts Historical Society (Bdses 1753 Jan. 4)

would therefore "give those People into whose Hands they might fall, a tolerably good Idea of the Places mentioned in the *Extracts,* and that the People, (especially those in the Eastern Parts) might see how grossly they had been imposed upon, and deluded by *the Plymouth Company,* in every Thing that respected *their sham Claim.*" That is to say, the Brunswick Proprietors intended the cartographic broadside to counteract the differential access to information of, on the one hand, the mercantile elites who invested in land and, on the other, settlers who bought land from the investors.[9]

In their physical form and structure, the Brunswick Proprietors' broadsides manifested a traditional form of publicity. They embodied, not the "civic conversation *of* the people," but rather the "words of the authoritative few *to* the people." In colonial New England, traditional publicity was represented in print primarily by two products of the press. Sermons written by Puritan ministers were printed as extensions of their preaching, to permit easier sharing than was possible with manuscript copies; printed sermons did not engage with their readers as anonymous and disinterested equals but, like their oral progenitors, constituted addresses to sinful members of a congregation, in which the preachers pronounced on any number of social and cultural as well as religious issues. Broadsides were widely used by the civil authorities to promulgate new laws; broadsides were "easy to post in traveled areas or on tavern walls" and so could easily reach a wide readership who would, once again, be very much aware of a difference in authority between themselves and the broadside's creators. The broadsides printed and distributed by the Brunswick Proprietors were no different in this respect. From their position of social and economic authority, they could dictate legal interpretations to a less authoritative, unequal, and specifically targeted audience. It is impossible

9. First broadside: *Advertisement: At a Meeting of the Proprietors of the Township of Brunswick in the County of York . . . on May 15th 1751* ([Boston], [1751]). Second broadside: *At a Meeting of the Proprietors of the Township of Brunswick in the County of York . . . on January 4th 1753 . . . with A True Coppy from an Ancient Plan of E Hutchinson's Esqr; and from Jose. Heath in 1719. and Phins: Jones's Survey in 1731. and from John North's Late Survey in 1752. Attestr: Thos Johnston* ([Boston], [1753]). The broadsides are described by Worthington Chauncey Ford, ed., *Broadsides, Ballards etc. Printed in Massachusetts, 1639–1800,* Massachusetts Historical Society, *Collections,* LXXV (Boston, 1922), nos. 931, 966; Wroth, "Thomas Johnston Maps," *In Tribute to Fred Anthoensen,* 83–91, and nos. 7 and 12; and (map only) James Clements Wheat and Christian F. Brun, *Maps and Charts Published in America before 1800: A Bibliography,* rev. ed. (London, 1978), nos. 161–162. See also *Remarks on the Plan and Extracts of Deeds,* 5–6 (compilation), 7n (criticism); *Answer to the Remarks,* 3–4, 5 (second quotation), 27 (explaining the map's second state).

to know, however, how the Brunswick Proprietors' broadsides circulated and whether they actually reached the intended audience among the settlers in the frontier town of Brunswick.[10]

Yet aspects of the cartographic broadside suggest that the Brunswick Proprietors sought to create, or at least to engage in, something of a "civic conversation." Whereas the 1751 broadside had presented the evidence and the conclusion drawn by authority, the addition of the map to the 1753 broadside invited the reader to engage in an act of critical reasoning. The reader could parse the spatial referents in the charters and deeds and compare them with the map's geographical delineation: there is the Sagadahoc River, with its opening to the ocean near Atkins Bay, so the Kennebec River can only lie in the interior, and the Brunswick Proprietors are indeed in the right. It was an invitation that implicitly construed the broadside's readers to be the intellectual and perhaps even the social equals of the proprietors. Importantly, two further phenomena strongly suggest that this more engaged readership did not include frontier settlers, with their traditional intensive reading practices, as David Hall has delineated them, but was constituted by those Boston residents and investors who engaged in extensive, literate reading practices that depended on costly books imported from Europe.[11]

The presence on the 1753 broadside map of a decorative title cartouche (Figure 2) indicates that the broadside was intended for the public that was then emerging among New England's literate and sociable elites. The cartouche bears a partisan message. Rather than encoding sentiments obviously agreeable to the New England public, it presents two native Americans who were aggressively posed (one with a gun, the other a war club) and who declare, "God hath Planted us here" and "God Decreed this Land to us." The warning to the Plymouth Company's proprietors and agents is clear. We might even say that the cartouche construes the Brunswick Proprietors and their clients as the indigenous people of the lower Kennebec, plain and honest and truthful, yet set upon and usurped by the Plymouth Company. In this, the cartouche replicates the sense of Robert Beverley's 1705 assertion that he was "an *Indian*," without pretense to sophisticated or ornamental language but with a claim to "Plainness," "Honesty," and truthfulness. The figures

10. Christopher Grasso, *A Speaking Aristocracy: Transforming Public Discourse in Eighteenth-Century Connecticut* (Chapel Hill, N.C., 1999), 4 (first quotation; original emphasis); Warner, *Letters of the Republic*, 19–26, 59 (second quotation). See also Hall, *Cultures of Print*, 105.

11. Hall, *Cultures of Print*, 36–78, 151–168, crucially distinguished between "literate" and "traditional" reading practices in colonial New England.

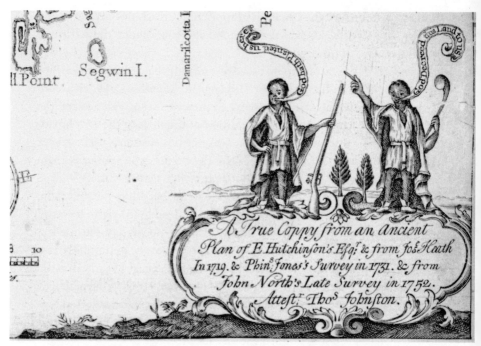

FIGURE 2. Detail of the cartouche from Thomas Johnston, *A True Coppy from an Ancient Plan of E Hutchinson's Esqr; and from Jose. Heath in 1719. and Phins: Jones's Survey in 1731. and from John North's Late Survey in 1752. Attestr: Thos Johnston* (Boston, [1753]). Courtesy of the Massachusetts Historical Society (Bdses 1753 Jan. 4)

themselves were derived from John Verelst's 1710 portraits of the four Iroquois sachems who had traveled to London in 1709 to seek English assistance against the French; the figures in the cartouche do not have exactly the same poses as the sachems in Verelst's paintings, suggesting that they were derived via intermediary images. In other words, the cartouche drew on images that were already part of a literate and urban culture.[12]

12. [Robert Beverley], *The History and Present State of Virginia; in Four Parts* (London, 1705), vii. I am indebted to Susan Danforth of the John Carter Brown Library, whose unpublished findings on the cartouche are presented here with her kind permission. Kevin R. Muller, "From Palace to Longhouse: Portraits of the Four Indian Kings in a Transatlantic Context," *American Art*, XXII, no. 3 (Fall 2008), 26–49. The left figure in the cartouche is certainly derived from Verelst's portrait of the Mohawk sachem Sa Ga Yeath Qua Pieth Tow (or Brant), even down to the fold of cloth over the exposed elbow; the connection between the right figure and the Mohawk sachem Etow Oh Koam (or Nicholas) is less immediate.

Within the political hothouse of colonial Boston, the opposition to the Brunswick Proprietors took up the invitation to critical reaction and debate proffered by the map; moreover, they carried it out in print as a civic conversation. The Plymouth Company's proprietors issued a pamphlet in which they engaged in a sustained critique of the Brunswick Proprietors' position. This critique included a sworn affidavit by Johnston explaining how he had been directed by members of the Brunswick Proprietors to omit key elements of his source maps from his compilation and how the sources that the proprietors had provided to him did not seem completely authentic. The Brunswick Proprietors retaliated, of course, and proclaimed their innocence before the Plymouth Company sought the last word in a third pamphlet. Aimed at Boston's literate and sociable public, these pamphlets were probably not read by the frontier settlers for whom the broadsides were ostensibly directed. They all adhered self-consciously to the critical standards and rhetorical disinterest learned from European texts as being ideally expected of public discourse, even as each side accused the other of fraudulent, vengeful, and hypocritical actions. Within the pamphlets, the broadside map was construed as being a truly public document, made in a plain and factual manner and addressed to an indeterminate audience ("those People into whose Hands [it] might fall"). Even so, the significant thing about this brief spasm of public discourse was, not the map itself, but rather the metacartography in which the map was alternately critiqued and defended. The broadside map was therefore both a pragmatic tool intended to persuade the political allegiance of settlers and a vehicle for debating abstract principles of truth, evidence, and propriety.

THE LARGE 1755 BOSTON MAP:
UNSOPHISTICATED PUBLIC DISCOURSE

Lawrence C. Wroth established the hitherto accepted narrative of the publication of Thomas Johnston's second printed map of the Kennebec Valley. Printed from two plates on two sheets, and about two-and-a-half times larger than the map on the 1753 broadside, the second map bears an imprint date of 1754 (Figure 3). Wroth argued that, once the Plymouth Company's proprietors had persuaded Thomas Johnston to disown his cartographic work on behalf of the Brunswick Proprietors, they then commissioned him in 1754 to make a number of manuscript maps. Unfortunately, there is no explanation in the surviving records for why the maps were commissioned. We do know, however, that they included "a large plan [of] Kennebeck" (for 12s.) and a "small plan [of] Kennebec" (for 2s. 8d.). In October 1754, the Plymouth Com-

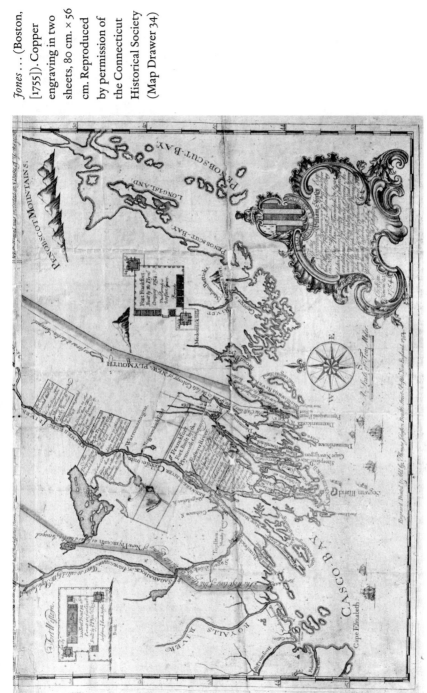

Jones . . . (Boston, [1755]). Copper engraving in two sheets, 80 cm. × 56 cm. Reproduced by permission of the Connecticut Historical Society (Map Drawer 34)

pany also paid Johnston £1 6s. 8d. for "drawing [a] plan in order for Engraving"; the expense associated with this neat drawing suggests that the map to be engraved was the large plan of the Kennebec. Moreover, a memorandum, transcribed in 1881 but now lost, also recorded a payment to Johnston in November 1754 of £4 "for copperplates to engrave the plan on." The plural, "copperplates," suggests that two or more plates were needed to print the large plan. These archival traces understandably led Wroth to suggest that the map in question was Johnston's large map of the Kennebec. Tying the later map to the property dispute, Wroth accordingly concluded that in Johnston's large map "one recognizes . . . a publication designed specifically to counteract the effect" of the 1753 broadside map. With the earlier map, "the Brunswick Proprietors had sought to display the Kennebeck Purchase as an isolated back-country manor," but the later map depicted the Plymouth Company's lands as constituting "a kingdom by the sea, richly forested, watered by splendid rivers, and boasting a noble shoreline broken by bays and harbors almost without number."[13]

Yet the map's narrative should not be so easily construed. To begin with, the dispute between the Plymouth Company and the Brunswick Proprietors seems to have died down somewhat during 1753; the three pamphlets focusing on the 1753 broadside and its map were in fact the last commentaries on the dispute to be printed by either side. The Plymouth Company had also become embroiled in other disputes over the extent of its property claims. As a result, its proprietors grew increasingly concerned with the validity of their entire claim and so were less inclined to engage piecemeal in disparate disputes. They had decided by December 1754 to seek confirmation of their title to all their lands from the Privy Council. To that end, they sent manuscript copies of the relevant documents and maps to their agent in London. Their agent, the proprietor Florentius Vassall, in turn referred the materials to the opinion of the attorney general. The attorney general eventually delivered his

13. The full title of Thomas Johnston's map is *To His Excellency William Shirley Esqr: Capt: General and Governour in Chief in and over His Majesty's Province of the: Massachusetts Bay in New England; This Plan of Kennebeck and Sagadahock Rivers, and Country Adjacent, (Whereon Are Delineated the Boundaries of Several Ancient Grants) Being Taken from Actual Surveys Made by Joseph Heath Esq: Mr: Phineas Jones John North Esqr and Mr: Ephraim Jones, Is Most Humbly Inscribed by Yor: Excellency's Most Obedt: and Humble; Servt: Thos: Johnston; Boston Novemr: 20, 1754; Engrav'd Printed and Sold by Thomas Johnston Brattle Street Boston New England 1754.* The map is described by Wroth, "Thomas Johnston Maps," *In Tribute to Fred Anthoensen*, 91–96, 98 (quotation), and no. 20; and Wheat and Brun, *Maps and Charts Published in America*, no. 163.

opinion in September 1755. Only then did Vassall lodge the Plymouth Company's case with the Board of Trade; however, there is no indication that the case ever left the Board for the Privy Council, presumably because by then the outbreak of new hostilities with the French meant that everyone in London had far more pressing concerns.[14]

These points suggest that the Plymouth Company's proprietors had little, if any, need to have Johnston's large map printed. By the end of 1754, they had ceased to be concerned about public opinion in New England, such as it was, and were looking to a legal solution in London. Moreover, as Wroth admitted, other evidence suggests that Johnston did not actually prepare the map as printed for the Plymouth Company. First, there is no record of the company paying Johnston either to engrave or to print the map, nor for the significant cost of the paper needed to receive the printing. Second, the large map was not advertised in the Boston newspapers until May 1755. Third, as we will see from the advertisement and from the map's content, Johnston intended the map as much for a more general public discourse concerning Anglo-French imperial rivalries in North America as for any specific public interest in the Plymouth Company's property claims. We can therefore conclude that Johnston published the map in May 1755—not in late November 1754 as the map's imprint states—and that he did so on his own account and without the company's backing. Johnston's large map was thus only indirectly connected to the dispute with the Brunswick Proprietors.[15]

Much of Johnston's large Kennebec map accords well with the Plymouth Company's strategy to enforce its entire claim, which suggests that it originated in the maps that Johnston had compiled for the company. Its upper-right quadrant was filled by a summary history of the primary land grants in the area, starting with the original grants to the Plymouth Colony, "the said River Kennebeck running thro' the whole length thereof." The map accordingly indicated the extent of the Plymouth Company's lands, edged in green, complete with the six townships that the company had laid out and was then in the process of settling. Johnston also explicated the original grants of Maine (edged in yellow), the duke of York's grant (red), and a further grant made by the Plymouth Colony at Pemaquid (blue), which lay within the duke

14. Kershaw, *Kennebeck Proprietors*, 175–178, 194 n. 8; Florentius Vassall to the Plymouth Company, Oct. 30, 1755 (with postscript of Nov. 3), Kennebec Purchase Papers, Maine Historical Society, reprinted in Cumming, "Colonial Charting," in Smith, ed., *Seafaring in Colonial Massachusetts*, 116–117.

15. Wroth, "Thomas Johnston Maps," *In Tribute to Fred Anthoensen*, 97–98.

of York's grant. Significantly, the western border of the duke of York's grant was defined, not by the Kennebec (as it should have been), but by the eastern edge of the Plymouth Company's claims, thereby distancing the company from any claims that their eastern lands were in fact part of unallocated crown lands. All this is to say that Johnston sought to depict *all* of the company's claims, not just those relating to the dispute over Brunswick.

At the same time, the large map possessed a more general, political sentiment of particular and momentary interest to the Boston public. The year 1755 was, of course, when the growing Anglo-French tensions in North America exploded once again into conflict, when the English launched three campaigns against three of the principal French "encroachments" on English territory: Fort Duquesne (modern Pittsburgh), Fort Niagara at the outflow of the Niagara River into Lake Ontario, and Fort Saint Frédéric at Crown Point at the head of Lake Champlain. The May 1755 advertisement for the map emphasized exactly this point of public interest:

> May 14, 1754. [sic]
> Just Published
>
> A Map of *Kennebeck* and *Sagadahoc* Rivers, and of Part of the Eastern Coast of the *Massachusetts,* lying between *Cape Elizabeth* and *Penobscot*. Also, a small Map of Part of *North America* on the same Sheet with the foregoing, exhibiting a general comprehensive View of the Territories of the *English* and *French,* and the Forts possessed by each in this Part of *America*. — Sold by *Thomas Johnson* [sic], in Brattle-Street, near the Rev'd Mr. *Casper's* Meeting House, at half a Dollar.

The advertisement made no mention of the map's depiction of the territories of the Plymouth Company and instead emphasized its inset map (Figure 4). The inset bore its own explanation: "This Map is intended to exhibit a General View of the Principal Rivers to the North and West of the Massachusetts; and the Situation of the French therefrom. It is Chiefly taken from Monsr: Bellin's Map of North America Published at Paris 1745 Several material Errors of his being Corrected, and some Improvements made." Below the inset, a block of text explained the need to counter the threat posed to English settlement by the French. The commentary was conventional in its tone and themes. Johnston even followed the established trend in anti-Gallic sentiment and singled out the French fort at Crown Point as the exemplar of the French encroachments. To reinforce the point for any contemporary reader in Boston, Johnston dedicated the map, not to any of the proprietors of the Plymouth Company, but to William Shirley, the governor of Massachusetts Bay, who was then

FIGURE 4. Detail of inset map from Thomas Johnston, *To His Excellency William Shirley Esqr: Capt: General and Governour in Chief in and over His Majesty's Province of the: Massachusetts Bay in New England; This Plan of Kennebeck and Sagadahock Rivers, and Country Adjacent, (Whereon Are Delineated the Boundaries of Several Ancient Grants) Being Taken from Actual Surveys Made by Joseph Heath Esq: Mr: Phineas Jones John North Esqr and Mr: Ephraim Jones* . . . (Boston, [1755]). Reproduced by permission of the Connecticut Historical Society (Map Drawer 34)

taking a prominent role in agitating against the French in North America and more particularly in the defense of New England and New York.[16]

Johnston also added to the map detailed plans of three forts that had been built in 1754 on the eastern bank of the Kennebec to guard against French incursions from the north and east. Two, Fort Western (Augusta) and Fort Frankfort (Dresden), had been built by the Plymouth Company, the third, Fort Halifax (Waterville-Winslow), by the government of Massachusetts Bay. Together with the placement of the Kennebec on the inset map (see Figure 4), these forts highlighted the character of the Kennebec as the frontier of English settlement and the bulwark against French hostility. We do not need to presume that Johnston had special access to these fortification plans: they circulated on both sides of the Atlantic in manuscript and in print.[17]

It is therefore highly probable that Johnston engraved and published the large map of the Kennebec on his own account, to take advantage of the increasing public interest in Boston for political and military events. The several corrections he made to the map's lengthy text passages perhaps indicate that he engraved the map in something of a hurry, as if he sought to get his map onto the market to feed a public desire for imagery as England once again went to war with France over their respective territorial claims. The presence of the inset map and its explanatory text suggests that public discourse was still relatively diffuse and unspecialized in New England: the commentary met a public demand that Johnston seems to have thought was unfulfilled by newspapers, pamphlets, and other printed media. After all, the small New England economy could support neither a large public nor a substantial trade in print; note that map publishing, indebted to public interest, was highly sporadic in colonial North America.[18]

16. *Boston Weekly News-Letter*, May 15, 22, 29, 1755; *Boston Gazette, or Country Journal*, June 16, 23, 30, 1755. On Shirley's role, see T. R. Clayton, "The Duke of Newcastle, the Earl of Halifax, and the American Origins of the Seven Years' War," *Historical Journal*, XXIV (1981), 571–603 (esp. 588–589).

17. The two forts built by the Plymouth Company were included by John Indicott in his *To the Honourable John Winslow Esqr. Major General and Commander in Chief of the Forces Raisd for the Defence of the Eastern Frontiers of the Province of Massachusetts Bay This Plan of Kennebeck River and the Forts Thereon Built by the Said Forces, Is Drawn and Presented by His Honours Most Oblig'd and Obedient Humble Servant John Indicott Boston New England Novem. 12th. 1754*, British Library maps k.top.120.23. All three forts were depicted and described in *Gentleman's Magazine*, XXV (May 1755), 226, and in a French atlas, as reproduced by Seymour I. Schwartz, *The French and Indian War, 1754–1763: The Imperial Struggle for North America* (New York, 1994), 34.

18. Generally, consider the data provided by Wheat and Brun, *Maps and Charts Pub-*

The dispute between the Brunswick Proprietors and the Plymouth Company and the company's overall territorial claims were undoubtedly of interest to some people, but they manifestly did not resonate with the larger concerns of the New England public except as a possible metaphor for the larger territorial dispute between the English and French. Johnston might have yoked together these small and large disputes as a matter of opportunism, building upon a map of the Kennebec that he had already prepared and that he could easily finish off by adding the larger geopolitical context. He might have intended the conjunction to personalize the Anglo-French dispute for the New England public, to bring it home to New Englanders, as it were. There also remains the distinct possibility that this same conjunction had actually been sought by the Plymouth Company's proprietors when they commissioned several maps from Johnston during 1754. But, whatever the cause—whether accidental, intended by the Plymouth Company, or intended by Johnston—the combined image of land and imperial disputes must be understood as placing the printed map squarely within the scope of an emergent and as yet unsophisticated public discourse in Boston.

THE SMALL 1755 LONDON MAP:
SOPHISTICATED PUBLIC DISCOURSE

The third printed map of the Kennebec was also published in May 1755, but in London (Figure 5). It has been the subject of some confusion. Several historians have presumed it was prepared for legal reasons although, as with the second Boston map, it was produced well before the Plymouth Company's legal suit ever reached the Board of Trade or the Privy Council. The prominent reference to Thomas Johnston in its title has meant that, since 1766, it has been consistently attributed to Johnston; however, it was actually designed by the London geographer, John Green. Moreover, because much of its content clearly derived from the same sources that Johnston had used, commentators have supposed that the third map was based directly on Johnston's manuscript map(s). Indeed, several have conflated the second and third printed

lished in America. More particularly, see David Bosse, "The Boston Map Trade of the Eighteenth Century," in Alex Krieger, David Cobb, and Amy Turner, eds., *Mapping Boston* (Cambridge, Mass., 1999), 36–55; and Bosse, "Maps in the Marketplace: Cartographic Vendors and Their Customers in Eighteenth-Century America," *Cartographica*, XLII (2007), 1–51. The claim by Sinclair Hitchings, "Thomas Johnston," in Walter Muir Whitehill, ed., *Boston Prints and Printmakers, 1670–1775* (Boston, 1973), 83–132 (esp. 110), that the large map of the Kennebec "became one of Johnston's staple and salable products" cannot be sustained.

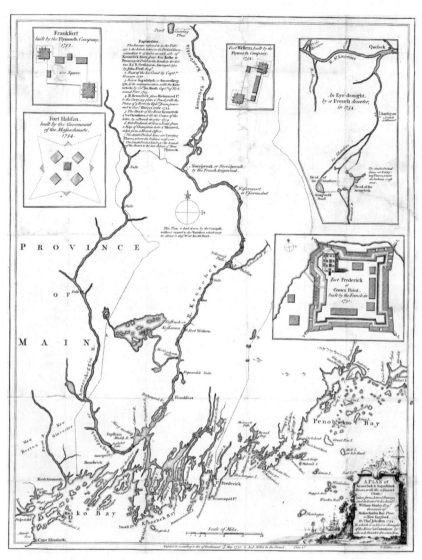

FIGURE 5. [John Green], *A Plan of Kennebek and Sagadahok Rivers, with the Adjacent Coasts: Taken from Actual Surveys, and Dedicated to His Excely: William Shirley Esqr. Governor of Massachusetts Bay Prov: in New England; by Thos: Johnston 1754; to Which Is Added a Draught of the River La Chaudiere by a French Deserter the Same Year* (London, 1755). Engraved by Thomas Kitchin. Copper engraving, 41.5 cm. × 32 cm. Courtesy of the Osher Map Library, University of Southern Maine (OS-1755-1)

maps. Yet the two maps are significantly different, both in their respective sizes and in the manner in which the London map incorporated a number of other materials in addition to Johnston's source maps. Such differences indicate that the third map cannot be treated as simply a London copy, reduced in size, of Johnston's large map.[19]

The third map's origins are revealed by some correspondence much later in 1755 between Florentius Vassall, the Plymouth Company's agent in London, and John Green, the map's author. Green, a former gambler and jailbird, was employed by various London map sellers and booksellers to design or edit geographical texts and maps, rarely receiving (or taking) credit for his work. His correspondence with Vassall was occasioned by the placement on the map of the label "Sagadahoc R." at the mouth of the Kennebec. As a critical geographer well versed in the literature of English discovery and exploration, Green knew a number of sources that glossed "Sagadahok" as "mouth of the River," so he had placed that toponym at the very mouth of the river. When the map was published, however, the "R." of "Sagadahok R." lay well within the river itself, undermining the Plymouth Company's position. Vassall noted the problem immediately. So did the company's proprietors in Boston when they eventually saw the map: they thought that Green had been subverted by someone connected to the Brunswick Proprietors or one of the company's other rival corporations. Green adamantly denied this accusation and blamed the engraver, in Thomas Kitchin's workshop, for moving the label.[20]

19. The full title of the third printed map of the Kennebec is [John Green], *A Plan of Kennebek and Sagadahok Rivers, with the Adjacent Coasts: Taken from Actual Surveys, and Dedicated to His Excely: William Shirley Esqr. Governor of Massachusetts Bay Prov: in New England; by Thos: Johnston 1754; to Which Is Added a Draught of the River La Chaudiere by a French Deserter the Same Year* (London, 1755). For presumptions that the map was prepared for an actual legal case, see Wheat and Brun, *Maps and Charts Published in America*, no. 163; Cumming, "Colonial Charting," in Smith, ed., *Seafaring in Colonial Massachusetts*, 98. Works that confuse the second and third printed maps include Hitchings, "Thomas Johnston," in Whitehill, ed., *Boston Prints and Printmakers*, 100; Kershaw, *Kennebeck Proprietors*, 71, 106, 171 n. 46; and Susan Danforth, *The Land of Norumbega: Maine in the Age of Exploration and Settlement* (Portland, Maine, 1988), no. 88. The first (mis)attribution to Johnston was in *St. James's Chronicle or the British Evening Post*, June 21, 1766, and *General Evening Post*, July 8, 1766, in advertisements by Millar's successor for *Johnson's* [sic] *Plan of Kennebek, Sagadahok, and La Chaundiere* [sic] *rivers*.

20. John Green to Florentius Vassall, Oct. 16, 1755, and Vassall to Plymouth Company, Oct. 30–Nov. 3, 1755, Kennebec Purchase Papers, Maine Historical Society, reprinted in Cumming, "Colonial Charting," in Smith, ed., *Seafaring in Colonial Massachusetts*, 115–

The correspondence demonstrates that neither Vassall nor Green controlled the map's production. Vassall had not reviewed Green's design before it was engraved; neither man had supervised the engraving or had reviewed proof prints; and neither had the power to correct the map once it was in print. Moreover, the letters reveal that Green was far removed from the Plymouth Company's concerns: Green distanced himself somewhat from the company when he acknowledged to Vassall, "I know there was a dispute between the proprietors of Lands," and Vassall also encouraged Green to believe that the proprietors' objections actually came from Johnston, in such a manner as to suggest that Green did not think that he was working for either side. We can conclude that Vassall and Green were both *reacting* to the published map and that Vassall consulted with Green as an interested rather than as a responsible party. The correspondence contains no outrage that the Plymouth Company's money had been misspent, no anger that its legal arguments had been corrupted. There was only an inchoate concern on the part of the proprietors that the map might affect them negatively, a concern that Green was quick to dismiss. What is not evident is a necessary, or even probable, direct, causal connection between the Plymouth Company and the production of the London map.[21]

The map instead appears to have been a strictly commercial undertaking by its publisher, the bookseller Andrew Millar. In the contemporary economics of publishing in London, the booksellers controlled capital, generally owned and traded copy, commissioned and bought new texts, and contracted with engravers and printers. It is safe to presume that Millar hired Green to

117. Green cited John Smith—probably one of the issues of Smith's *Generall Historie of Virginia, New-England, and the Summer Isles* ... (London, 1624) —and Samuel Purchas's *Hakluytus Posthumus; or, Purchas His Pilgrimes* ... (London, 1625), IV, 1874, in support of his contention that "Sagadahoc" meant the mouth of a river. *Answer to the Remarks,* 28–29, had also cited Smith's *Generall Historie* and a series of other works in a similar vein. In a work reliably attributed to Green from August 1755 — *Explanation for the New Map of Nova Scotia and Cape Britain, with the Adjacent Parts of New England and Canada* (London, 1755), 8—Green also noted this specific meaning before observing, "However, many give the Name of *Sagadahok* to the united Stream of both Rivers; although others will allow it no other than that of *Kennebek*." See Cumming, "Colonial Charting," in Smith, ed., *Seafaring in Colonial Massachusetts*, 97 n. 7, on modern etymologies. See G. R. Crone, "John Green: Notes on a Neglected Eighteenth Century Geographer and Cartographer," *Imago Mundi,* VI (1949), 85–91; and Crone, "Further Notes on Braddock Mead, alias John Green, an Eighteenth Century Cartographer," *Imago Mundi,* VIII (1951), 69–70.

21. Cumming, "Colonial Charting," in Smith, ed., *Seafaring in Colonial Massachusetts,* 115.

make the design and Kitchin to engrave it. As the principal hack geographer then working in London, Green had developed something of an expertise concerning North America; Kitchin had been engraving works for Millar since the 1740s. Millar was the one who could have had the plate altered, had he been sufficiently concerned to have done so, but he was not.

Millar presumably wanted a map that spoke to the metropolitan public's interest in North American affairs. Yet that public interest was fickle. If we take the maps issued in the monthly periodicals as a representative gauge of public interest in geography, we can quickly conclude that the British (London) public was interested in particular aspects of North America and the Caribbean only in times of actual war. At other times, public interest was constrained to the Continental scale of English-French-Spanish geopolitical rivalries. Maps of individual colonies were rare outside promotional tracts. In 1754 and early 1755, in the buildup to war, London publishers provided a rich diet of general maps of North America, notably John Mitchell's large wall map and its numerous derivatives. But once open war began, several map sellers successfully worked to meet the public's momentary obsessions with specific theaters of war by publishing more spatially focused maps. For example, William Douglass's posthumous *Plan of the British Dominions of New England*, a speculative venture by Douglass's heir that was published in London in May or June 1755, evidently failed to find a market; yet an equally large and detailed derivative map found success in the marketplace when it was published at the very end of November 1755, after hostilities had begun in July, because it referred specifically to a campaign that then briefly dominated the newspapers and magazines.[22]

Given these conditions, we can presume that a successful publisher as sensitive to the public's moods as Millar would have had a specific reason for producing such a spatially focused map of just one small portion of a colony in May 1755. He seems to have been motivated by a brief flash of public interest in London in the construction of the three new forts on the eastern bank of the Kennebec River in 1754. They featured prominently in John Huske's

22. Matthew H. Edney, "New England Mapped: The Creation of a Colonial Territory," in Diogo Ramada Curto, Angelo Cattaneo, and André Ferrand Almeida, eds., *La cartografia europea tra primo Rinascimento e fine dell'Illuminismo: Atti del Convegno internazionale "The Making of European Cartography" (Firenze BNCF-EUI, 13–15 dicembre 2001)* (Florence, 2003), 155–176 (esp. 171–175). The patterns of English geographical consumption are evident from the data provided by David C. Jolly, ed., *Maps in British Periodicals*, 2 vols. (Brookline, Mass., 1990–1991); see also John R. Sellers and Patricia Molen Van Ee, eds., *Maps and Charts of North America and the West Indies, 1750–1789: A Guide to the Collections in the Library of Congress* (Washington, D.C., 1981).

timely tract, published in late April or May 1755, on the North American situation, in which they were glossed as the reason the French and their Indian allies had not already attacked New England. Moreover, the May 1755 issue of the *Gentleman's Magazine* contained a brief account of the forts, complete with woodcuts of each, that discussed the twofold significance of the Kennebec: it was the frontline of potential conflict with the French and their Indian allies; it was also a potential avenue of attack into Quebec via a short portage from its upper waters to the Chaudière River, albeit a far less important route than the Hudson / Champlain corridor between New York and Montreal. (It is unlikely that Millar commissioned the map to accompany this short article: Kitchin only engraved for the *Gentleman's Magazine*'s principal competitor, the *London Magazine.*) Millar apparently pursued the work as a further manifestation of this particular geopolitical moment. Green repeated the insets of the three Kennebec forts, perhaps deriving them from a source other than Johnston's manuscripts, to emphasize the Kennebec's status as a frontier threatened by the French, and he added an "Eye-draught, by a French deserter, in 1754," of the route from the head of the Kennebec, across the portage, and down the Chaudière River to Quebec.[23]

Green's map was not completely focused on the Kennebec, however, and it did address the broader geographical scope of the Anglo-French imperial rivalry. By omitting the towns the Plymouth Company had established and by expunging all reference to any dispute over the company's claims, Green reconfigured the company's specific grant into a general statement of an active English claim to contested territory as well as a spatial frame for the river itself. Most important, Green condensed the whole Anglo-French rivalry within another new inset, this one of Fort Saint Frédéric. The French had built this fort in 1731 to control the Hudson / Champlain corridor; it had then served as the base for raiding parties that had ranged freely over much of northern New York in the 1740s. British commentators routinely hailed the fort as the exemplar of "French encroachments" onto English territory in North America. William Shirley had, for example, identified it in 1754 as a specific threat to Maine and Massachusetts when he had urged the construction of new forts on the Kennebec. References to the fort abound in English publications throughout 1755. Its appearance in an inset on Green's map of the Kennebec had nothing to do with the Kennebec but everything to do with the English under-

23. [John Huske], *The Present State of North America, etc., Part I,* 2d ed. (London, 1755), 59–60 (see Lawrence C. Wroth, *An American Bookshelf, 1755* [Philadelphia, 1934], 134–135, on its dating); *Gentleman's Magazine,* XXV (May 1755), 226; Jolly, *Maps in British Periodicals,* I, 22–23.

standing of the broader geopolitical situation in North America. Overall, the map construed the Kennebec valley as a metaphor for the British colonies generally, as British territory actively threatened by French encroachments.[24]

Furthermore, Millar advertised the map, on the front page, no less, of the *Public Advertiser,* by relating it to general public concerns. In order to clarify the map's significance, the advertisement explained that the Kennebec lay "in the Borders of New-England." It also presented the map as the perfect accompaniment to the *State of the British and French Colonies in North America,* yet another work that denounced French aggression, albeit with no reference to the situation along the Kennebec. (This pamphlet can also be reliably attributed to Green.)[25] The advertisement reads:

> This Day is published, Price 1 s.
> (Proper for illustrating several Matters contained in the State of
> the British and French Colonies in North America,
> A Plan of KENNEBEK and SAGAHADOK RIVERS (in the Borders of New-England) with the adjacent Coasts (from Cape Elizabeth to Mount Desert Island) taken from actual Surveys in 1754, and embellished with Plans of Franckfort, Fort Western, and Fort Halifax. Dedicated to William Shirley, Esq; Governor of Massachusets Bay.
> To which are added,
> The Course of the River Chaudiere (from the Head of the Kennebek to St. Lawrence River near Quebek) and a Plan of the French Fort at Crown-Point in New-York.

24. Address by William Shirley to both houses of the Massachusetts Bay Legislature, Mar. 28, 1754, transcribed in (among other places) *French Policy Defeated: Being, an Account of All the Hostile Proceedings of the French, against the Inhabitants of the British Colonies in North America, for the Last Seven Years* (London, 1755), 75–81.

25. [John Green], *State of the British and French Colonies in North America, with Respect to Number of People, Forces, Forts, Indians, Trade, and other Advantages . . .* (London, 1755). Vassall wrote that Green had made both the map and an associated book or pamphlet. The book features Green's idiosyncratic usage of *k* for hard *c* in toponyms derived from indigenous sources: whereas all the Boston and most English publications spelled "Kennebec" and "Sagadahoc" with *ck* at the end (*c* being the modern orthography), Green routinely spelled them with just *k* (he spelled "Casco Bay" as "Kasko," and so forth). A full-text search of Eighteenth-Century Collections Online reveals just three published works in the 1750s with the odd spelling of "Kebek" for "Quebec," a hallmark of Green's maps, specifically this book and two others that are securely attributed to Green: *Explanation for the New Map of Nova Scotia* and *The Conduct of the French, with Regard to Nova Scotia; from Its First Settlement to the Present Time* (London, 1754).

Printed for A. Millar, in the Strand.
Where may be had,
The State of the British and French Colonies in North America, Price
2 s. 6 d.

Given that Millar had not needed to advertise the *State of the British and French Colonies* in the newspapers when he had first published it in the previous month, it would seem that the advertisement was indeed intended to promote a work that was sufficiently on the edge of public interest that it could not "sell itself." Millar would again advertise the two works in order to extend their active life within the marketplace just a few months later in August, when conflict had become certain. This time, however, he inverted their relationship: the key work was the book, to which the map was now merely an ancillary element; the advertisement ended with the telling comment, "N.B. The Pamphlet may be had either with or without the Plan." Some copies of the book can be found in original bindings with the map bound in, but the map had become little more than an afterthought once its originating moment had passed.[26]

Returning to the technicalities of the map, we do not need to posit any special relationship between Green and Vassall to explain his access to Johnston's manuscripts. Green evidently took his two new insets from materials that were then circulating in London. The plan of Fort Saint Frédéric, like all of the plans of that fort published in 1755, stemmed from an inset on a manuscript map of Lake Champlain from about 1740. Green himself was well connected to those in Britain who were interested in the geography of North America and who kept and distributed among themselves various manuscript maps produced by a variety of governmental surveys. It is quite probable that Green accessed Johnston's manuscript map in a similar manner. For his 1755 map of Nova Scotia, which has a very similar depiction of the Kennebec (although at a much smaller scale), Green recorded that he had used the surveys by Joseph Heath and John North and did not mention Johnston at all. Indeed, Green seems to have originally approached Vassall only as another avenue through which to acquire detailed geographical information concerning New England. More generally, there is sufficient evidence for the transatlantic cir-

26. *Public Advertiser* (London), May 22, 23, 24, 1755 (quotation); *Whitehall Evening Post*, May 20, 22, 24, 1755; *London Evening Post*, May 22, 1755. On the date of the pamphlet, see "The Monthly Catalogue for April, 1755," *London Magazine*, XXIV (April 1755), 191; Wroth, *American Bookshelf*, 41 n. 54. See also *London Evening Post*, Aug. 28, 30, 1755. The review of *State of the British and French Colonies in North America* in the *Monthly Review*, XII (June 1755), 483–484, made no reference to the map.

culation of geographical maps in manuscript in the middle of the eighteenth century that we do not have to give credit to special, proprietary channels to explain the dissemination of particular maps.[27]

But moving those manuscript maps into print required the anticipation of public interest and a conscious will to meet and exploit that interest. Green's map of the Kennebec is clearly a product of an active and sophisticated public discourse within which a great deal of printed material was produced to feed the public's critical faculties (or, rather, the public's desire to be seen to be critical). Green did not have to belabor the political tensions between the English and the French on his map—as Johnston had done in Boston—because those tensions were already thoroughly explored and studied and critiqued in numerous newspapers, magazines, pamphlets, books, and other maps. He needed only to use the graphic shorthand of Fort Saint Frédéric to allude to the larger issues that were dealt with more fully in a wide variety of letter-press works. In particular, in drawing an explicit analogy between the property claims of a proprietary company and the territorial claims of the British empire, Green relied on a long-established analogy of estate to state. As such, Green's map points to a certain degree of functional specialization and articulation for geographical representations within a fully developed public discourse supported by an expansive economy and a large middling sort with genteel aspirations.

CONCLUSIONS

The eighteenth-century mapping of the Kennebec River was, by and large, carried out and disseminated in manuscript. The notes to this essay indicate a number of such maps found in official, proprietary, and personal archives

27. British Library maps k.top.120.16 is probably a late copy of the *French Draught of Lake Champlain and Lake George; with Remarks of an English Prisoner, Who Return'd from Quebec to Fort Edward by the River St. Lawrence River Sorrelle, and These Lakes Touch'd at Fort Chamblay Fort St. Johns Crown Point and Ticonderoga* (circa 1740), with a detailed inset plan of the fort at Crown Point. See Green, *Explanation for the New Map of Nova Scotia*, 3 (on his intellectual connections), 8 (on sources for the Kennebec). Green to Vassall, Oct. 16, 1755, Kennebec Purchase Papers, Maine Historical Society, reprinted in Cumming, "Colonial Charting," in Smith, ed., *Seafaring in Colonial Massachusetts*, 115–116, requested Vassall to *repeat* a previous request to Boston for precise figures for latitude and longitude of any part of northeastern North America. Matthew H. Edney, "John Mitchell's Map of North America (1755): A Study of the Use and Publication of Official Maps in Eighteenth-Century Britain," *Imago Mundi*, LX (2008), 63–85 (esp. 64, 69–70), criticized assumptions of "special access" to official archives awarded to certain map publishers.

on both sides of the Atlantic. The constrained circulation of these maps in part sustained a legal discourse that was concerned with the creation and maintenance of real property along the frontier of Massachusetts Bay's Eastern District. Yet, no less than three times, and then in quick succession, these private maps broke into print. Historians have hitherto explained this curious sequence of maps as having all pertained in some manner to a property dispute between the Brunswick Proprietors and the Plymouth Company. Yet only the first actually did so. A more satisfactory explanation is provided by considering the contribution of each of the three printed maps to public discourse. The maps represent three cultural configurations through which they attained particular significance for the wider, political concerns of the publics in New England and London.

The first printed map, on the 1753 broadside, is perhaps the most complex of the three, sitting as it did on the divide between an older, traditional publicity and a newer public discourse: in the one, the Brunswick Proprietors lectured those who had settled on their lands and warned off the rival Plymouth Company; in the other, the map emphasized ideals of rational criticism, inviting the literate participants in public discourse to engage with the facts of the dispute. The second map, Johnston's large map of 1755, was shaped around the Plymouth Company's interpretation of its charters but ended up using them to construct a local parallel with the greater Anglo-French imperial tensions. The third map, Green's map published in London in 1755, discarded the Plymouth Company's presence almost entirely and made no overt reference to any uncertainty concerning the company's lands; instead, the map transformed the Kennebec into a line of potential conflict with the French. That wider conflict was explicated at length on the second map, with a large map and detailed text, but, given the existing widespread discussion of the impending war in London, it could be reduced for the London public to a single, iconic reference to the French encroachment at Crown Point.

The problem with the traditional narrative concerning these three maps is that it defined their historical significance and meaning solely by their content. This exercise in historiographic and cartographic reevaluation demonstrates that the nature of these maps—and, by extension, of all maps—was determined, not by what they show, nor even by how they show it, but rather by the discourses in which they were produced and consumed. The broadside map should legitimately remain within the context of the property dispute. But the other two maps belong in the context of the public discourses on either side of the Atlantic, still nascent and evolving in New England—being little more than thirty years old in 1755—but going strong after a hundred

years in Britain. This is a conclusion of fundamental importance to the history of cartography: it requires us to shed one of the key components of modern cartographic ideology, that the map is the territory, and to consider spatial discourses very carefully and to delineate them very precisely before we can understand the contributions that maps have variously made to them.

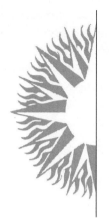

BUILDING URBAN SPACES
FOR THE INTERIOR
THOMAS PENN AND THE
COLONIZATION OF EIGHTEENTH-
CENTURY PENNSYLVANIA

Judith Ridner

In 1751, Governor James Hamilton journeyed westward from Philadelphia and across the Susquehanna River into the colony's interior to visit the new town of Carlisle, a village he had assisted the colony's proprietor, Thomas Penn, in founding. Upon his return, he noted that it had "exceeded my Expectations in all respects." Although the 312 lots of the town's recently surveyed grid were mostly vacant and its population was too small and "poor" to "think of building a Court House or Market for some time," he saw significant signs that Carlisle would not only persist but thrive.[1]

With "near fifty Houses" already "built and building," the town's first colonists, he noted, were rapidly constructing an urban infrastructure. This was a first step. Then, too, there was its location. The Cumberland Valley, a ten- to twenty-mile-wide lowland nestled between the North (or Blue or Kittatinny) and South Mountains, was known for its fertile limestone soils that had attracted first native peoples and, more recently, Euro-American traders and farmers to its bounds. Hamilton thus knew that with such "exceeding good Land and Meadows about it," much of it "well timbered," according to another official, Carlisle possessed the natural resources needed to sustain its growth. In fact, the town already had a growing agricultural hinterland being developed by squatters, farmers, and speculators such as provin-

Parts of this essay are reproduced from chapters 1 and 2 of my book, *A Town In-Between: Carlisle, Pennsylvania, and the Early Mid-Atlantic Interior* (Philadelphia, 2010). I wish to thank the University of Pennsylvania Press for permission to reprint sections of these chapters. I also wish to thank Martin Brückner and the anonymous reader for the Omohundro Institute of Early American History and Culture for their helpful comments in guiding revisions of this work.

1. James Hamilton to Thomas Penn, Nov. 29, 1751, Thomas Penn Papers, Official Correspondence, V, 193, Historical Society of Pennsylvania, Philadelphia (hereafter cited as Penn OC), Apr. 17, 1753, VI, 37.

cial secretary Richard Peters, who had eagerly invested in an "abundance of Land" nearby.[2]

Finally, and of greatest significance to Hamilton and proprietor Thomas Penn, the town had commercial potential. Carlisle was located to take best advantage of the Valley's function as a major migration corridor to the southern and western interiors. Hamilton thus assumed that migrants would bring considerable business to town. Most important, though, was Carlisle's potential to serve the lucrative colonial fur and skin trade. The town stood at a crossroads of trade paths linking native hunters and trappers of the Ohio country with the merchants and markets of Philadelphia and the Atlantic world. It thus promised to become a trade nexus linking west with east in the mid-Atlantic. And for this reason, more than any other, Hamilton was optimistic, even enthusiastic, about its prospects. Contrasting it with other Pennsylvania towns that "flourish for a Season, . . . and then come to a Stand," he concluded that "if any" town of the colony "ever comes to be considerable, . . . Carlisle stands the best chance, as it must allways be a great thorough fare to the back Countries, and the Deposit[o]ry of the Indian Trade."[3]

For Thomas Penn, Pennsylvania's principal proprietor at midcentury, Hamilton's assessments were welcome news. Town founding was a hallmark of his management of his colony, and he wanted his towns to succeed. Carlisle was one of six "proprietor's towns" he founded with help from his officials in the colony between 1741 and 1772 (the others were York, laid out in 1741; Reading in 1748; Easton in 1752; Bedford in 1766; and Sunbury in 1772). All of these towns shared essential characteristics; they were located in newly opened areas of his colony's interior, were county seats, and housed land offices. Founded to be local centers of law, politics, and land dealing, these towns embodied Penn's desire to serve his own and his family's multiple interests in the colony. His actions as proprietor were thus quite typical of other self-interested elites of his time. But that was not all; there was more at work here. Thomas Penn was no ordinary speculator, after all, but proprietor of one of mainland British North America's most important colonies in the eighteenth century. As such, he had a broader vision of his administrative role in the colony and of the functions of his towns. Indeed, to Penn founding towns

2. Hamilton to Penn, Nov. 29, 1751, Penn OC, V, 193, Richard Peters to Penn, n.d. (1750?), V, 31. See also *History of Cumberland and Adams Counties, Pennsylvania* (Chicago, 1886), 4–5.

3. Hamilton to Penn, Apr. 17, 1753, Penn OC, VI, 37. See also, Whitfield J. Bell, Jr., "Carlisle to Pittsburgh: A Gateway to the West, 1750–1815," *Western Pennsylvania Historical Magazine*, XXXV (1952), 156–166; Henry Glassie, *Pattern in the Material Folk Culture of the Eastern United States* (Philadelphia, 1968), 1–33.

was like performing a part for his colony. Casting himself as a kind of stage designer, he planned his towns as settings for the kind of sociability, civility, and, most of all, productivity among colonists that would privilege commerce and thereby foster broader development of the colony. Penn's towns thus served more than just his interests; they were also intended to benefit the colony and its colonists.[4]

Carlisle was a central piece of the urban infrastructure Penn planned for his colony's interior. Its pivotal location on the west side of the Susquehanna River, on a major migration corridor, and nearly halfway between the Delaware and Ohio River valleys, meant that its prospects to attract colonists and commerce were good. But, because the town was only recently surveyed and was still just a hamlet under construction, its future was uncertain. And no amount of praise and optimism from Governor Hamilton could change that fact. For Penn, many questions remained about it: Who were the colonists settling this town? What were their goals and aspirations? What ideas did they have about how to construct this stage that they would live their lives upon? And, as we will see, the answers to these questions sometimes posed challenges for Penn. Carlisle's pioneers, he found, had their own interpretations of where the town should be located and what it should become, and their ideas did not always fully coincide with his own. For Penn, this meant that even his best laid plans had to remain flexible. If he was to succeed in building the kind of urban, commercial infrastructure he wanted for himself and his colony, he had to adapt his plans to suit local needs and aspirations. Town building in the interior, he discovered, was a dynamic and often unpredictable process.

■ By the early decades of the eighteenth century, Penn had powerful incentives to strengthen his family's claims to its colony's interior. Much was in flux. Pennsylvania was no longer the eastern-centered colony of his father, William Penn, but was rapidly expanding into something altogether different as population, resources, and—through time—economic and political power spread beyond the Delaware Valley. Demographically, the colony was larger and more pluralistic. The native peoples and predominantly Quaker colonists

4. James T. Lemon, *The Best Poor Man's Country: A Geographical Study of Early Southeastern Pennsylvania* (Baltimore, 1972), chap. 5 (esp. 122–140); Donna Bingham Munger, *Pennsylvania Land Records: A History and Guide for Research* (Wilmington, Del., 1991), 57–60, 88–89. For towns and cities as settings for specific cultural styles or behaviors, including entrepreneurial activity, see Sylvia Doughty Fries, *The Urban Idea in Colonial America* (Philadelphia, 1977), 11–31; Christopher E. Hendricks, *The Backcountry Towns of Colonial Virginia* (Knoxville, Tenn., 2006), xiii–xxii.

of William Penn's time had been joined by a diverse group of immigrants, including large numbers of Scots-Irish and German colonists, both indentured and free, as well as smaller numbers of African slaves. Because many of these European immigrants, arriving at the Delaware ports of Philadelphia or New Castle, lacked the financial resources needed to make their way in the east, they looked to the interior for available lands on which to build new, American lives. Yet, because they preferred Pennsylvania over Virginia or the Carolinas, they were willing, said one official, to "risque any thing rather than go there." The Penn family thus had many motives to encourage these settlers to remain in the colony. They assumed that those who found the land or opportunity they sought might stay for a time. But ensuring colonists' presence had a price. Settlers would not populate disputed lands, police Pennsylvania's borders, develop the colony's agricultural hinterlands, or build the urban infrastructure Thomas Penn was then contemplating for his colony's interior without sufficient incentives. For Penn, the question thus became: How might he best serve the colony by making his interests more compatible with their own?[5]

Then there was also the colony's contentious political climate. Although Pennsylvania was known for its factional politics, political strife among ethno-religious groups and among the proprietor, his officials, and the Assembly intensified through time. Thomas Penn thus faced daunting political challenges too. As Pennsylvania's population expanded and diversified ethnically and religiously, different groups vied for political power. The upshot by midcentury was that Penn—an Anglican convert—and his mostly Anglican supporters in the council found themselves embroiled in an increasingly con-

5. Peters to Penn, Mar. 16, 1752, Penn OC, V, 217. As Peters noted, many colonists, especially the Irish, left Pennsylvania each year. After falling into debt, with "but a little Money is left" and with "no vacant Land to take up near them, nor indeed any comfortable Place anywhere within the Part of the Province purchase of the Indians," they moved "off to Virginia or Carolina." Peters estimated that at least three hundred families had left the year before, and he expected more would do so unless Pennsylvania provided secure and inexpensive lands for them to purchase.

For Pennsylvania's eighteenth-century demographic and cultural climate, see Joseph E. Illick, *Colonial Pennsylvania: A History* (New York, 1976), chap. 5; Lemon, *Best Poor Man's Country*, chap. 1; Patrick Griffin, *The People with No Name: Ireland's Ulster Scots, America's Scots Irish, and the Creation of a British Atlantic World* (Princeton, N.J., 2001), chaps. 3–4; Sally Schwartz, *"A Mixed Multitude": The Struggle for Toleration in Colonial Pennsylvania* (New York, 1988), chap. 4; Marianne S. Wokeck, *Trade in Strangers: The Beginnings of Mass Migration to North America* (University Park, Pa., 1999), esp. xxx, 37–51, 167–183.

tentious struggle for control with the Quaker dominated Assembly, which had a long history of resistance. Penn thus turned to the interior as an outlet for his political ambitions. He cultivated patronage connections to non-Quakers in the colony by rewarding select Anglican or Scots-Irish Presbyterian colonists who were then settling newly opened areas of his colony with political appointments and access to land and trade deals. In return, these "proprietor's men" became loyal political stalwarts and, as members of the "proprietary party," eventually posed a formidable political challenge to the colony's Quaker political establishment. Still, patronage politics had costs. Proprietor's men expected rewards for their loyalty. In Carlisle, for example, proprietor's man John Armstrong was willing to relocate to the town from nearby York to "promot[e] the Peace of the County" and "serv[e] the Proprietary Family," but he expected something in return; namely, he sought a lucrative position as a surveyor and the "Encouragement" of favorable lease or purchase terms for the "Plantation" he was building just outside Carlisle. His allegiance was not free.[6]

Penn thus had multiple reasons to focus his attentions on his colony's interior; development there clearly served his interests and those of his colony. But why did he choose town founding as a key tool for such development? Retaining immigrant colonists and securing the loyalty of proprietor's men could be done by offering them access to agricultural lands, after all. Why did interior Pennsylvania need towns? The most obvious reason, to be sure, was that it was in Penn's power to found them. In Pennsylvania, only the Assembly had the power to establish counties, but the proprietor's prerogative powers included founding towns. But still, Penn needed sufficient cause to act. Like any entrepreneur, he would not proceed if he did not think towns would serve his interests. Nor would he, as proprietor, take the trouble to found towns if

6. For quotations regarding Armstrong, see Peters to Penn, Nov. 6, 1753, Penn OC, VI, 113–115. For more about him, see Robert Grant Crist, "John Armstrong: Proprietors' Man" (Ph.D. diss., Pennsylvania State University, 1981), vii–40. For Pennsylvania politics during William Penn's time, see Gary B. Nash, *Quakers and Politics: Pennsylvania, 1681–1726* (Princeton, N.J., 1968). For politics under Penn's sons, including Thomas, see James H. Hutson, *Pennsylvania Politics, 1746–1770: The Movement for Royal Government and Its Consequences* (Princeton, N.J., 1972); chap. 1; Illick, *Colonial Pennsylvania*, chap. 4; Schwartz, *"A Mixed Multitude,"* chaps. 3–4, 6; Alan Tully, *Forming American Politics: Ideals, Interests, and Institutions in Colonial New York and Pennsylvania* (Baltimore, 1994), chap. 7; Tully, *William Penn's Legacy: Politics and Social Structure in Provincial Pennsylvania, 1726–1755* (Baltimore, 1977), chaps. 1–3; G. B. Warden, "The Proprietary Group in Pennsylvania, 1754–1764," *William and Mary Quarterly*, 3d Ser., XXI (1964), 367–389.

he did not think they would advance his colony's development. And he certainly would not found towns if they did not have a chance to thrive. Acting without cause was foolish speculation. So what factors pushed Thomas Penn in this direction? The colony's shifting demographic and political fault lines certainly turned his attention toward the interior. It was the colony's interests in the fur trade, however, that offered one of the most compelling incentives for *urban* development, particularly the founding of Carlisle.[7]

Competition was rife among colonies and empires in eighteenth-century North America. As colonies expanded, and the French and British empires spread deeper into the interior, territorial and commercial boundaries grew more fluid and contentious. This pattern was especially pronounced in the mid-Atlantic, where rival colonies and the British and French empires competed to control the land, peoples, and trade of the interior. In Pennsylvania, competition manifested itself in several areas. Colonists from Connecticut and rival proprietors from Maryland disputed the location of the colony's northern and southern borders. More important to Carlisle's history, however, was the future of the fur trade of the Ohio Valley and what colony — or empire — might control it. Much was at stake. The mid-Atlantic fur trade was an increasingly complex, competitive, and distant entity at midcentury. The number and variety of players competing for furs, and increasingly often, deerskins, expanded through time. Just as significant, the trade, which during William Penn's time focused on the Susquehanna Valley, had shifted westward with the migration of native peoples to the more distant reaches of the Ohio Valley and beyond by the 1720s. In increasing the distances goods and pelts traveled, this shift dramatically increased the trade's logistical challenges.[8]

7. Illick, *Colonial Pennsylvania*, 174; Lemon, *Best Poor Man's Country*, 24–26, 123.

8. For competition between colonies, empires, and peoples, see W. Neil Franklin, "Pennsylvania-Virginia Rivalry for the Indian Trade of the Ohio Valley," *Mississippi Valley Historical Review*, XX (1934), 463–480; Eric Hinderaker, *Elusive Empires: Constructing Colonialism in the Ohio Valley, 1673–1800* (New York, 1997), chaps. 1–4; James H. Merrell, *Into the American Woods: Negotiators on the Pennsylvania Frontier* (New York, 1999); Jane T. Merritt, *At the Crossroads: Indians and Empires on a Mid-Atlantic Frontier, 1700–1763* (Chapel Hill, N.C., 2003), esp. chaps. 1, 2, 5; Richard White, *The Middle Ground: Indians, Empires, and Republics in the Great Lakes Region, 1650–1815* (New York, 1991), chaps. 5–6. For the fur trade at midcentury, see also Stephen F. Auth, *The Ten Years' War: Indian-White Relations in Pennsylvania, 1755–1765* (New York, 1989); Stephen H. Cutcliffe, "Indians, Furs, and Empires: The Changing Policies of New York and Pennsylvania, 1674–1768" (Ph.D. diss., Lehigh University, 1976), 249–257; Larry L. Nelson, *A Man of Distinction among Them: Alexander McKee and the Ohio Country Frontier, 1754–1799* (Kent, Ohio, 1999), 30–60.

Even so, proprietors like Thomas Penn had plenty of economic incentives to encourage their colony's traders to participate. There was much to be gained from the effort. As Richard Peters confirmed in 1749, "Since the Treaty held at Lancaster" in 1744, which sealed Pennsylvania's relationship with the Miamis—at least temporarily—"there has been a very large extension of the Indian Trade." Suddenly, Pennsylvania had the advantage, but their hold was tenuous. He knew others would challenge them. "Vigorous Efforts," Peters assumed, for instance, "will be made by the French to regain this important Nation." Then there was Virginia. That colony, too, was "about to establish an Indian Trade on [the] Ohio." If Pennsylvania was to head them off, the colony needed "to build a couple of Villages for the good of the Trade." Indeed, "having a Settlement somewhere on the East Side of Allegheny Hill to which a Waggon Road may be made for the easy Carriage of the Goods," Peters reckoned, "wou[l]d far outdo Virginia." New towns were thus imperative to preserving whatever advantage Pennsylvania had in this trade. Only towns, after all, offered the warehouse space needed to store goods and pelts, the packhorses and barrels necessary to carry traders' goods, and the craftsmen and laborers needed to sustain commerce. Penn had no choice; if his colony was to remain a major player in the fur trade, towns had to be essential components of his designs for the interior. Only with a network of urban places across the interior would Penn have the midpoints needed to keep this trade in motion.[9]

■ All of which brings us back to Carlisle, the proprietor's town Governor Hamilton believed had the best chance of succeeding. Carlisle was a pivotal place. Founded in 1751, it was the seat of Cumberland County, Pennsylvania's sixth, westernmost, and largest county, which had been created by legislative fiat the year before. Because Cumberland encompassed nearly the entire southwestern half of the colony from the Susquehanna westward toward the Ohio before 1771, it would serve as the de facto capital of nearly two-thirds of his colony. The town's founding thus necessitated careful planning, which was possible because Penn and his officials brought experience to the task. They

9. Peters to Penn, July 5, 1749, Penn OC, IV, 219, May 16, 1749, IV, 213. Pennsylvania was not the only colony where this was so. See, for example, Joseph A. Ernst and H. Roy Merrens, "'Camden's Turrets Pierce the Skies!': The Urban Process in the Southern Colonies during the Eighteenth Century," *WMQ*, 3d Ser., XXX (1973), 550–574. The colonial fur trade had long association with colonial towns. See Donna Merwick, *Possessing Albany, 1630–1710: The Dutch and English Experiences* (New York, 1990), chap. 2 (esp. 104–107).

had knowledge of the region, which dated back to the 1680s. And because Carlisle was the third town they founded, and the second one located west of the Susquehanna, they had know-how on their side too. Founding Carlisle was not an impulsive move, therefore; it was a carefully calculated one.[10]

Thomas Penn's knowledge of this region was extensive, some of it derived from his father. William Penn had shown interest in the lower Susquehanna Valley, its native inhabitants and trade even before his arrival in the colony in 1682. The lower Susquehanna had much to offer the colony, by William's reckoning. There were fertile lands for agricultural development, to be sure, but William was more interested in the revenue to be gained from its trade. The Valley, then home to the Susquehannocks, sat at one of the most important transportation crossroads in the mid-Atlantic; as such, it was an early center of the colonial fur trade. Needing funds for his colony, and eager to unseat New York's hold on the trade, William targeted this region for development. He purchased the lower Valley from the local native peoples in 1683, a purchase that took fourteen years to confirm. He also called for the founding of a new city along the river's banks. He envisioned it as the future center of the mid-Atlantic fur trade; all western trade, he believed, would funnel through it. Although war and imperial politics blocked this settlement from coming to fruition, Pennsylvania's role in the fur trade nonetheless expanded dramatically. A treaty of amity with the Susquehannocks helped in this enterprise. So, too, did the work of his provincial secretary, James Logan. During the first decades of the eighteenth century, Logan was instrumental in harnessing the trade to serve Penn's—as well as his own—interests. He did so by licensing traders, granting land for trade posts, and managing credit and imported goods markets. According to historian Francis Jennings, he was "the man who created a lucrative and lasting Indian trade in Pennsylvania." In these ways, William Penn's, and by extension James Logan's, actions in the lower Susquehanna Valley set important precedents for Carlisle; their moves demonstrated how trade, rather than agriculture, could be the driving force of development in this region.[11]

10. Beginning in 1771, with the creation of Bedford County, and then continuing until 1783, with the formation of three additional counties, Cumberland lost two-thirds of its territory. Before 1770, it was the largest county, encompassing two-thirds of the province. See Robert G. Crist, "Cumberland County," in John B. Frantz and William Pencak, eds., *Beyond Philadelphia: The American Revolution in the Pennsylvania Hinterland* (University Park, Pa., 1998), 107; Crist, "John Armstrong," 26.

11. Francis Jennings, "The Indian Trade of the Susquehanna Valley," American Philosophical Society, *Proceedings*, CX (1966), 406–424 (quotation on 410); Illick, *Colonial*

Thomas Penn also had his own firsthand experiences in the region to draw upon, but they were different from his father's. By the 1720s, the lower Susquehanna Valley, particularly the area west of the river where Carlisle would stand, was changing rapidly. The Susquehannocks remained, but defeat by the Iroquois in the late seventeenth century dramatically reduced their numbers; they were no longer the dominant peoples in the region. Instead, new groups of displaced Shawnees, Delawares, and other multi-ethnic native peoples established their own village communities there in the Valley. Many of them traded furs and skins with the French Huguenot, James LeTort, a trader licensed by Logan who operated a trade post about twenty miles west of the river, along a creek that would later bear his name and serve as Carlisle's eastern boundary. This pattern did not hold for long, however. By the late 1720s, most of these native peoples and the traders who lived among them "moved away to and Settled and have ever Since lived in severall Towns low down upon the Ohio" River. They were pushed out by the arrival of the first Euro-American colonists in the region.[12]

Arriving in the colony in 1732, Thomas Penn was there to witness the effects of these shifts firsthand. Surely, he was not happy to see the fur trade move farther west; that complicated this intercultural commerce. Yet he recognized, as one of his surveyors observed, that it was still in "thy Interest to keep fooling on the west side of [the] Susquehannah." This region offered

Pennsylvania, 28–29, 109–111; Gary B. Nash, "The Quest for the Susquehanna Valley: New York, Pennsylvania, and the Seventeenth-Century Fur Trade," *New York History*, XLVIII (1967), 3–27 (see, esp., 19–24 for the city he planned on the river).

12. "Copy of the Warrant to Resurvey the Manor of Lowther," Cadwalader Family Papers, Genl. Thomas Cadwalader Collection, box 186.11, HSP. For the region's native peoples, see Francis Jennings, "'Pennsylvania Indians' and the Iroquois," in Daniel K. Richter and James H. Merrell, eds., *Beyond the Covenant Chain: The Iroquois and Their Neighbors in Indian North America, 1600–1800* (Syracuse, N.Y., 1987), 75–91; Barry C. Kent, *Susquehanna's Indians*, Anthropological Series no. 6 (Harrisburg, Pa., 1989); Kent, Janet Rice, and Kakuko Ota, "A Map of 18th Century Indian Towns in Pennsylvania," *Pennsylvania Archaeologist*, LI, no. 4 (December 1981), 3–4; Michael N. McConnell, *A Country Between: The Upper Ohio Valley and Its Peoples, 1724–1774* (Lincoln, Nebr., 1992), 9–15. See also Ives Goddard, "Delaware," Francis Jennings, "Susquehannock," Charles Callender, "Shawnee," all in Bruce G. Trigger, ed., *Handbook of North American Indians*, XV (Washington D.C., 1978), 213–239, 362–367, 622–635. For LeTort, see Evelyn A. Benson, "The Huguenot LeTorts: First Christian Family on the Conestoga," *Journal of the Lancaster Historical Society*, LXV (1961), 92–105; George P. Donehoo, *A History of the Cumberland Valley in Pennsylvania*, 2 vols. (Harrisburg, Pa., 1930), I, 33; Theodore B. Klein, "Early History of Carlisle," *Early History and Growth of Carlisle* (Harrisburg, Pa., 1905), 1–2.

many opportunities for the continued development of land and trade; he and his officials did not lose all hope for its prospects when native peoples moved west. Penn simply had to adjust his "foolings" to accommodate these new circumstances. Initially, he responded defensively to protect his interests by collecting revenue for himself and his family. To do so, he took control of the land office and had his surveyors lay out a series of proprietary manors. Next, he convinced the Assembly to do a better job of collecting quitrents due his family. Then, things got thorny, for such "foolings," he knew, meant nothing without colonists. Colonists, after all, would patronize the land office, pay quitrents, and establish trade connections with the native peoples of the Ohio Valley. The improvements they made to the land would also help resolve the border dispute with Maryland, and might even pressure the Iroquois for a land sale. Settlers were thus critical components of any colonial development scheme west of the river. But their presence had consequences. As one member of Penn's inner circle noted, in order to attract colonists, it would "be Necessary by all Civil means to protect and Encourage those who are brought into trouble by maintaining" the colony's claims. Colonists would demand inducements to remain in Pennsylvania.[13]

Penn did not oppose offering colonists such encouragements; doing so fit the role of colonial manager in which he cast himself as proprietor. Thus, in 1734, with tensions on the colony's southern border heightening, and in anticipation of obtaining legal title from the native claimants, Penn took new action that was favorable to colonists—and himself. In an expedient move that heralded a more aggressive kind of colony building, Thomas reversed his father's custom of prohibiting settlement on Indian lands and boldly authorized one of his surveyors, Samuel Blunston, to grant "Licenses" (a kind of temporary land title) to "those Persons settled [or settling] on the other side" of the river. For these settlers, an estimated four hundred—mostly Scots-Irish—families by the early 1730s, granting them licenses moved them closer to obtaining full title for their lands; it was a powerful lure for squatters, especially, to remain in the colony. Penn expected their loyalty in return, however; developing the interior was a two-way process. Specifically, he anticipated that those who had recently sided with Maryland would be grateful for privileges he was granting them with these licenses. As he told his surveyors, they must "caution" these settlers "to behave well as a return for our accept-

13. Samuel Blunston to Penn, July 25, 1733, Penn Papers, Unbound Letters, HSP; Illick, *Colonial Pennsylvania*, 178–179; Lorett Treese, *The Storm Gathering: The Penn Family and the American Revolution* (University Park, Pa., 1992), chaps. 1–2 (esp. 10–11, 208); Tully, *William Penn's Legacy*, 8, 11–15.

ing them after they had so long sided with that fellow Cressap," an agent of the Maryland proprietors. As he saw it, Pennsylvania was doing them a favor in welcoming them into the colony. And, in this case, his actions paid off. Colonists rewarded him some years later when they "courageously and unanimously" refused to pay Maryland taxes and "disown[e]d their Jurisdiction" to that colony.[14]

The presence of colonists, even when loyal, could accomplish only so much, however. Penn needed formal title to these lands if he was going to remake the region to serve his colonial interests. To do so, he departed in yet another way from his father's practices, and, instead of negotiating a land deal with the various native claimants to the region, he and his officials targeted the Six Nations for a purchase. His goal was to extinguish the remaining Shawnee and Delaware claims to the region and obtain title to these lands. This purchase happened in 1736, at a treaty conference in Philadelphia, when twenty-three Iroquois chiefs exchanged two million acres of land, much of it west of the river and south of the North Mountain, for a vast assortment of trade goods.[15]

Penn had won a major victory. Using his diplomatic prerogatives as proprietor, he gained formal possession over a large swath of the lower Susquehanna Valley for his colony (the remaining portions would become part of the colony in treaties in 1749 and 1754). When added to an earlier purchase of lands along the river completed in 1718, the 1736 purchase gave the Penn family control of the entire southern end of the Susquehanna Valley to the Maryland line as well as extensive swaths of territory on the eastern and western sides of the river. Such a purchase had profound ramifications. The licenses that his surveyor issued would be converted to titles, thereby securing

14. Penn to Blunston, Jan. 10, 1734, Penn Papers, Unbound Letters; [Peters?] to Penn, n.d. [1750?], Penn OC, V, 31. For the context of the time, see Wayland F. Dunaway, *The Scotch-Irish of Colonial Pennsylvania* (Chapel Hill, N.C., 1944), 56–64; Charles Desmond Dutrizac, "Local Identity and Authority in a Disputed Hinterland: The Pennsylvania-Maryland Border in the 1730s," *Pennsylvania Magazine of History and Biography*, CXV (1991), 35–62; Treese, *The Storm Gathering*, 10–11; Tully, *William Penn's Legacy*, 8–1. For evidence of Penn's anticipation of obtaining these lands, see Thomas Penn's permit to Benjamin Burges, Oct. 22, 1733, Simon P. Gratz Collection, Croghan Etting Papers, I, 2, HSP. For the Penn family's relationship to the colony's surveyors, including Samuel Blunston, see John Barry Love, "The Colonial Surveyor in Pennsylvania" (Ph.D. diss., University of Pennsylvania, 1970), 7–14, 67, 200.

15. Illick, *Colonial Pennsylvania*, chap. 7; Jennings, "'Pennsylvania Indians,'" in Richter and Merrell, eds., *Beyond the Covenant Chain*, 89; Tully, *William Penn's Legacy*, chap. 1. For the treaty, see *Pennsylvania Archives*, 1st Ser., 12 vols. (Philadelphia, 1852–1856), I, 494–497.

Penn's—and by extension his colonists'—claims to these lands. Penn would thus gain money from land sales and quitrents, while colonists won formal titles to lands they had settled and improved. Formal possession also paved the way for the extension of provincial government. Much of this purchase formed the core of the new county of Cumberland. Equally important, this land purchase gave Penn the claim he needed to force the hand of the Calverts. With Pennsylvania in control of much territory along the border, Maryland's proprietors agreed to put aside their long-standing border dispute with the Penn family and negotiate a temporary boundary line between their colonies in 1737. Thomas Penn had gambled and won big. What remained to be seen was whether he could preserve and advance these gains by encouraging further development.[16]

Development took time, however. Penn's departure from the colony in 1741 only complicated matters further. Management from afar meant greater reliance on his officials in the colony. It also did not help that many Assembly members, most of them Quakers, opposed his policies and resented his absence. Yet Thomas Penn persisted and by the early 1740s began to found his towns. He was not alone in his efforts. According to one scholar, the mid-eighteenth century was an urban "boom" period in Pennsylvania when a remarkable forty-nine towns were founded in the colony. York and Reading were Penn's first efforts in 1741 and 1748; both of these places he established boldly and speculatively, in advance of their counties: York County was established in 1749, and Berks in 1752. Then came Carlisle and Easton in the early 1750s; Penn took a more conservative approach to their creation, locating and planning them after their counties were founded. Last were Bedford and Sunbury, in 1766 and 1772; they originated as frontier forts that Penn resurveyed as towns.[17]

Founding towns was an uncertain undertaking. If they were to grow, these settlements had to be carefully located and planned to attract colonists. In the case of Carlisle, planning began shortly after the county's founding in 1750 when Penn sent one of his surveyors, Thomas Cookson, to recommend an appropriate site for the seat. Cookson complied, and, venturing into the backwoods, he "viewed the several Places spoke of as commodious Situations for the Town." He finally endorsed the location on LeTort Spring, where James

16. Edward K. Muller, ed., *The Concise Historical Atlas of Pennsylvania* (Philadelphia, 1989), 82; Illick, *Colonial Pennsylvania*, 175–178; Treese, *The Storm Gathering*, 9, 12, 168–169; Tully, *William Penn's Legacy*, 8–11.

17. Illick, *Colonial Pennsylvania*, 174–178; Lemon, *Best Poor Man's Country*, 122–123, 132–140; Munger, *Pennsylvania Land Records*, 88–99; Treese, *The Storm Gathering*, 11, 20.

LeTort's trading post had stood not long before. This site, about twenty miles southwest of the Susquehanna River and Harris's Ferry (the future town of Harrisburg), was "the properest place" for the new town. With "a fine Stream of Water" and "a Body of good Land on each side" of it, along with plenty of timber and meadow, it had all the resources necessary to support a town. That the nearby creek was already "thick settled" with Euro-Americans, whom Cookson incorrectly assumed would be easily persuaded to sell or exchange their lands for others, was further evidence that this was the best place to situate the town. If colonists were already there, would not many others be likely to follow? Cookson was so confident that the answer was yes that he "mark'd" two thousand acres on the map he drew to indicate a space "serviceable to accommodate the Town."[18]

As Cookson's use of the word "serviceable" suggests, he perceived that the LeTort Spring site had certain advantageous qualities that other sites lacked. A town there, evidence suggested, would grow to be the kind of interior center of land dealing, politics, and trade Penn intended. To Cookson, who read the land and drew his conclusions, this site made sense. Penn corroborated the pragmatic approach of his surveyor. Writing to Richard Peters, he noted that he was "govern'd" as proprietor by no other "views but that of the General Service of the Publick" in selecting the site for the town. This was a revealing declaration. In suggesting that his views were guided by colonists' interests as well as his own, he acknowledged his dependence on settlers to make this new town work. Yet this admission also confirmed his role as planner of the urban setting upon which they would act. But still, he needed evidence to decide what this plan should be. Then, too, there were other questions: What were colonists' interests? Were they compatible with his own?[19]

Cookson's observations suggested that colonists' interests were not that far from Penn's. In surveying sites for the town, Cookson assumed that traders would form a core of Carlisle's pioneers. Thus, the LeTort Spring site's "most convenient" location was of particular interest to him because it had ready access to points west. "[T]his place," as he explained, was "convenient to the

18. Thomas Cookson to James Hamilton, Mar. 1, 1749, *Pennsylvania Archives*, 1st Ser., I, 42–43; James Hamilton, "Instructions to Nicholas Scull, Esq., Surveyor General," Apr. 1, 1751, Carlisle Town Map Folder, no. 48-3, Pennsylvania Historical and Museum Commission, Harrisburg, Pa. (hereafter cited as PHMC); Hamilton to Penn, Sept. 24, 1750, Penn OC, V, 55. See also Love, "Colonial Surveyor," 196–205, for information about Nicholas Scull, the surveyor general who oversaw Cookson and was ultimately responsible for laying out York, Carlisle, and Easton.

19. Penn to Peters, May 30, 1750, Penn Papers, Penn Letterbooks, II, 309, HSP (hereafter cited as Penn Letterbooks).

New Path to Allegheny," one of the two principal overland pathways that the colony's fur traders then used to reach their native American trade partners in the Ohio Valley. Others confirmed his assessment. As another official noted, the pass that traders thought to be "the best in the Ridge" was only four miles away from the proposed town site. Carlisle's convenient situation would thus attract traders to town. Yet, in order to grow and prosper, the town also needed a variety of professionals, retailers, craftsmen, and laborers among its ranks, and they required access to eastern markets to sustain themselves. For that reason, as others reminded Penn, this location was also ideal because of its accessibility to the Delaware Valley. Being situated along the "great Road leading from Harris'[s] Ferry to [the] Patowmec [Potomac],"—the northern branch of the Great Wagon Road leading from Philadelphia into the Shenandoah Valley and points south—"most of their Trade," others assured Penn, "will be carried on with Philadelphia." For these reasons, LeTort Spring was the best location for the county seat. Only a town at this site would encourage settlers to carry on "Trade, both with the Indians and with the City of Philadelphia."[20]

Not all of the colonists then living in Cumberland County agreed with Cookson's interpretation of where the town should be located, however. And they "got into wrangling about the Location of this Town," because they knew how much was at stake, as Cookson himself confirmed: "The Inhabitants of the different Parts of the County," he noted, "are generally partial from the Advantages that would arise from a County Town in their own neighbourhood." County seats were critical urban places in colonial America. These towns guaranteed a steady flow of people coming to do business in the courts and thus fueled the fortunes—or at least the subsistence or competency—of their residents. In Pennsylvania's interior, where Philadelphia was distant, county towns also served as important secondary markets for goods and services. The location of Cumberland's seat thus put the economic lives and livelihoods of many colonists on the line; they had much to lose or gain in its location.[21]

Objections to the LeTort Spring site came from several quarters. Some in the county, for example, argued that the town of Shippensburg, located about sixteen miles southwest of LeTort Spring and first settled in 1730, should be

20. Hamilton, "Instructions to Nicholas Scull," Apr. 1, 1751, Carlisle Town Map Folder, no. 48.3; Cookson to Hamilton, Mar. 1, 1749, *Pennsylvania Archives*, 1st Ser., II, 42–43; Hamilton to Penn, Sept., 24, 1750, Penn OC, V, 55. See also Penn to Peters, May 30, 1750, Penn Letterbooks, II, 309.

21. Hamilton to Penn, Apr. 30, 1751, Penn OC, V, 135; Cookson to Hamilton, Mar. 1, 1749, *Pennsylvania Archives*, 1st Ser., II, 42–43. For the importance of county seats, see Hendricks, *Backcountry Towns*, 14–15; Lemon, *Best Poor Man's Country*, 132–134; Munger, *Pennsylvania Land Records*, 88–89.

the seat; it was an established village and "nearest the centre" of the county. Edward Shippen, the town's proprietor since 1738, agreed; he lobbied hard to have his town made the seat, offering to sell or exchange one hundred acres for that purpose. Although Penn "thank[ed]" his friend Shippen for his offer—he was, after all, one of Penn's proprietary gentry—he dismissed Shippensburg for its lack of water. This village, he implied, did not have the resources needed to support a large, commercial town.[22]

More significant were the objections raised by colonists from other areas of the county, which they presented in ways carefully gauged to raise proprietary anxieties. When residents of the western reaches of the county petitioned the governor to argue for a more centrally located seat, for instance, they warned that the town's location might sway their political and economic loyalties against Penn. Indeed, playing upon long-standing border tensions, they feared that it was likely that some of their frustrated neighbors were "in danger of leaveing us and Joining themselves to the Provance of Maryland." Others, meanwhile, targeted Penn's chief concern—namely, protecting and expanding Pennsylvania's role in the fur trade. They noted that they would be "much discouraged from improveing . . . the town" and cautioned that they might even take "advantage" to "Cariey [carry] away our tread [trade] but Espacally [especially] the Indian tread" to merchants in other colonies. Do not take them for granted, they warned.[23]

Still others in the county were "exceedingly anxious" that the existing settlement at the southwestern end of the county, along Conogocheague Creek and near the Maryland border (soon to be the town of Chambersburg), be made the seat. Playing again upon the proprietor's angst, particularly regarding the role the county town would play in the fur trade, and challenging Penn's ability to assess their interests, they argued this location was "more convenient for the Indian Trade" and closer to "a shorter and better Passage thro' the Mountains." Thomas Cookson adamantly disagreed, however. As he argued to Penn, if the Conogocheague settlement was made the seat, it would actually pose a threat to Pennsylvania's hold over the "Indian Trade," as "it wou'd be no Advantage to our Philadelphia Merchants too [sic] have their seat of Trade too near that of their neighbours." The situation, he argued, would

22. Peters to Penn, Mar. 12, 1750, Penn OC, IV, 197; Penn to Peters, May 30, 1750, Penn Letterbooks, II, 310; Cookson to Hamilton, Mar. 1, 1749, *Pennsylvania Archives*, 1st Ser., II, 43.

23. "Petition from the Inhabitants of the West Part of Cumberland County . . . to Governor James Hamilton, March 24, 1750," Penn Papers, Receipts for Beaver Skins for Tenure, etc., XII, 40, HSP.

"only give the People concern'd the Choice of two Markets, . . . in which we cannot possibly be any Gainers." After all, as Cookson noted, "having already the Bulk of the Trade in our Hands," the colony had to work hard to prevent the "risque . . . [of] loosing some Part of it." Penn concurred. In expressing his opinion, he reiterated the central role commerce, and particularly the fur trade, was to play in this town's development. The Conogocheague settlement was "not so proper a Place," he stated. As he reasoned it: "I cannot think it will be of any advantage to have the Town so near those . . . to be Laid out by Mr[.] Dulany [in Maryland] and my Lord Fairfax [in Virginia]." In this case, protecting his colony's interests did not fully serve his colonists. Colonists, after all, might well benefit from the lower prices a choice of markets might generate, but Penn and his colony would not. Trade with Frederick or Winchester would serve his rival proprietors' interests, not his own. Here, then, was where the proprietor's, the colony's, and colonists' interests fractured. Despite all objections, Penn made his decision, choosing the LeTort Spring site as Cumberland's new seat. In response, Cookson purchased some twelve hundred to thirteen hundred acres of land from four Scots-Irishmen settled there, and "the Town . . . to be called Carlisle" was ready for survey in 1751.[24]

■ Thomas Penn was now set for the next step essential in founding the town — designing its plan. And here, too, he balanced multiple goals when making his choices. His most obvious aim in planning Carlisle, like all of his towns, was to decide how it should look, which meant designing a visible landscape of roads, town lots, and other structured spaces, like out-lots, that would be surveyed and regulated by law. In this way, designing a town was a public act. Carlisle would be drawn on maps of the colony as an artifact of his colonial vision. Yet it also had to appeal to the colonists who would settle it. Penn assumed that precisely delineated and administered town spaces would best attract settlers because they guaranteed security on one's investment. He also offered buyers incentives. "To encourage People to settle in the Town," for example, he thought it "prudent" to grant fifty to one hundred lots in fee simple, the term most favorable to residents. He was even willing to forgo the collection of rents for two years so that pioneers might establish themselves.

24. Peters to Penn, Apr. 5, 1750, Penn OC, V, 47; Cookson to Hamilton, Mar. 1, 1749, *Pennsylvania Archives*, 1st Ser., II, 43; Penn to Peters, May 30, 1750, Penn Letterbooks, II, 309. For Cookson's instructions to purchase the lands, see Hamilton to Scull, "Instructions," Carlisle Town Map Folder, no. 48.3. See also Hamilton to Penn, Feb. 3, 1750, Penn OC, V, 129; Cookson to Penn, June 8, 1752, *Pennsylvania Archives*, 2d Ser., VII (Harrisburg, Pa., 1896), 256–258.

His second objective in planning Carlisle was more abstract. Town spaces also had to be carefully designed to foster the growth of an equally important, but invisible, landscape of values, attitudes, and behaviors that would determine how the town functioned. In a town like Carlisle whose future depended on commerce, Penn knew his design must encourage sociability, civility, and productivity among colonists; only their actions, after all, could make Carlisle the hub of trade he desired.[25]

To implement his goals in Carlisle (as well as in all of the other towns he founded), Penn chose the grid survey as his model. Working mostly from his home in London, with much input from his officials in the colony, he called for the survey of a compact, gridiron pattern of streets and alleys punctuated by a central square. Two eighty-foot-wide main streets, the north-south Hanover (or York) and the east-west High (or Main), would dominate the town, ushering residents and visitors alike toward the political, commercial, and spiritual structures to be situated prominently on a central square, the feature that would dominate the town. From there, the grid initially extended only two blocks in each direction, bounded by the descriptively named North, South, East, and West Streets. Town space was further subdivided into 312 lots—each one measuring a long and narrow 60 by 240 feet. Finally, with the call for an extensive grid of out-lots for agriculture—and speculation—to frame the town's outskirts, Penn's plan for Carlisle was complete (Figure 1).[26]

25. Penn to Peters, May 30, 1750, Penn Letterbooks, II, 308, July 17, 1752, III, 152. For theoretical studies of town planning and its relation to power, see Michel Foucault, *Discipline and Punish: The Birth of the Prison*, trans. Alan Sheridan (New York, 1979), 135–169; Zeynep Celik, Diane Favro, and Richard Ingersoll, eds., *Streets: Critical Perspectives on Public Space* (Berkeley, Calif., 1994), 1–5; A. P. Cohen, *The Symbolic Construction of Community* (New York, 1985), 12–38; John Brinckerhoff Jackson, *Discovering the Vernacular Landscape* (New Haven, Conn., 1984), 7–8; John A. Jakle, *The Visual Elements of Landscape* (Amherst, Mass., 1987), 3–5; Dell Upton, "European Landscape Transformation: The Rural Residue," in Paul Groth and Todd W. Bressi, eds., *Understanding Ordinary Landscapes* (New Haven, Conn., 1997), 174–179; and Upton, "The City as Material Culture," in Anne E. Yentsch and Mary C. Beaudry, eds., *The Art and Mystery of Historical Archaeology: Essays in Honor of James Deetz* (Boca Raton, Fla., 1992), 51–74. For town as artifact, see Anthony N. B. Garvan, "Proprietary Philadelphia as Artifact," in Oscar Handlin and John Burchard, eds., *The Historian and the City* (Boston, 1963), 177–201 (esp. 177–178).

26. Penn to Peters, May 30, 1750, Penn Letterbooks, II, 309, Penn to Hamilton, July 29, 1751, III, 78. For more information about the town's plan, see Milton Embick Flower and Lenore Embick Flower, *This is Carlisle: A History of a Pennsylvania Town* (Harrisburg, Pa., 1944), 3; Illick, *Colonial Pennsylvania*, 174–175; Lemon, *Best Poor Man's Country*, 134.

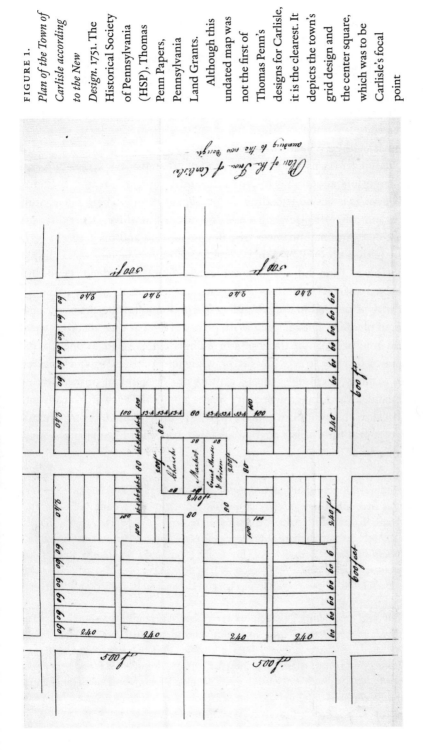

FIGURE 1.
Plan of the Town of Carlisle according to the New Design. 1751. The Historical Society of Pennsylvania (HSP), Thomas Penn Papers, Pennsylvania Land Grants.

Although this undated map was not the first of Thomas Penn's designs for Carlisle, it is the clearest. It depicts the town's grid design and the center square, which was to be Carlisle's focal point

The symmetry of Penn's grid lent a measure of order and perhaps elegance to Carlisle. Yet it was not a unique, original, or innovative plan. The grid was a ubiquitous design with a long history that dated back to Roman times. In the Pennsylvania context particularly, Carlisle's grid followed what geographers call a typical "Pennsylvania" or "Philadelphia" plan, one that mimicked the geometry, symmetry, and rationality of Philadelphia, the first sizable North American city laid out on a grid.[27]

Thomas's father, William, originally envisioned Philadelphia as a new and what one scholar terms "unorthodox" kind of urban place; it was to be a city where large lots containing houses surrounded by gardens and orchards would serve as a serene backdrop for a utopian colony where persecuted Quakers and other displaced dissenters might seek new lives. Its reality was far more conventional, however. The design William and his surveyor general, the Irish-born Quaker Thomas Holme, chose for the city was a simple grid borrowed from European precedents (Figure 2). Indeed, Penn and Holme used ancient models, as well as Renaissance ideals of city planning most clearly expressed in the rebuilding of London following the Great Fire of 1666, in planning Philadelphia. With plenty of land at their disposal, their only real innovations were the large size of Philadelphia's grid, its open, park-like squares, its wide streets, and its sprawling lots. Yet these unique features did not manifest themselves until a century of development pushed settlement inland, away from crowded city spaces along the Delaware waterfront. Thus, because Philadelphia was more derivative than original, Thomas Penn's choice of a grid for Carlisle aligned his town, too, with European planning traditions.[28]

27. Hildegard Binder Johnson, *Order upon the Land: The U.S. Rectangular Land Survey and the Upper Mississippi Country* (New York, 1976), 25–42; Wilbur Zelinsky, "The Pennsylvania Town: An Overdue Geographical Account," *Geographical Review*, LXVII (1977), 127–147. See also Richard V. Francaviglia, *Main Street Revisited: Time, Space, and Image Building in Small-Town America* (Iowa City, Iowa, 1996), 99; John W. Reps, *Town Planning in Frontier America* (Princeton, N.J., 1969), 204–223, 426–428; Thomas R. Winpenny, "The Nefarious Philadelphia Plan and Urban America: A Reconsideration," *PMHB*, CI (1977), 103–113.

28. Garvan, "Proprietary Philadelphia as Artifact," in Handlin and Burchard, eds., *The Historian and the City*, 177–201 (esp. 189 [quotation], 190–195). See also Fries, *Urban Idea in Colonial America*, 83; Edward T. Price, *Dividing the Land: Early American Beginnings of Our Private Property Mosaic* (Chicago, 1995), 265; Reps, *Town Planning in Frontier America*, 141–154; Beth A. Twiss-Garrity, "Double Vision: The Philadelphia Cityscape and Perceptions of It," in Catharine E. Hutchins, ed., *Shaping a National Culture: The Philadelphia Experience, 1750–1800* (Winterthur, Del., 1994), 2–4.

FIGURE 2.
Thomas Holme,
*A Portraiture of the
City Philadelphia
in the Province of
Pennsylvania in
America.* Circa
1812 reproduction
of 1683. Courtesy,
The Library
Company of
Philadelphia.
This map,
drawn by William
Penn's surveyor
general, Thomas
Holme, was the
original plan for
Philadelphia,
which was one of
the first colonial
American cities
planned on a grid

That was not all. The grid also had broader meaning as a colonial design that the British (and others) employed as a symbol of conquest. Ireland set the precedent; it was the first colony where the English put the grid to use. Town planning was an integral component of the British conquest of Ireland, especially in Ulster, where towns served as what one scholar characterizes as "the focal point of British settlement." As centers of defense, government, Protestantism, and commerce, British-founded towns were meant to secure and organize the landscape the Irish earls were compelled to forfeit. With their symmetrical grid-plan designs drawn by English surveyors, these new urban centers imposed a rationality that the British perceived as lacking in Ireland's landscape. Rural Ireland existed as a reminder of Ireland's wildness. By contrast, English-designed urban places, populated by merchants, professionals, and artisans recruited from England and Scotland stood as models of civilization; they projected forward in time, heralding what Ireland might become under English management.[29]

The Irish precedent is an important one for understanding the context of Pennsylvania's grid-patterned towns and some of the motives of the two Penns, father and son, who designed them. Although Pennsylvania and Ireland were undeniably different sorts of pales, they were both English colonial places whose planters or proprietors shared a similar desire to found highly regular grid-patterned towns as mechanisms to guide subsequent development of a frontier. Grid towns projected the future. As a design that planners imposed on a space with little regard for topography or culture, they embodied a quest to control land and people by ordering them into precisely defined and regularly delineated urban spaces. As one scholar confirms, the grid was "the simplest form, . . . for initiating man's control of land wherever it is flat and fairly uniform in quality."[30]

29. Nicholas Canny, *Making Ireland British, 1580–1650* (New York, 2001), 348 (quotation). See also T. C. Barnard, "New Opportunities for British Settlement: Ireland, 1650–1700," in Canny, ed., *The Origins of Empire: British Overseas Enterprise to the Close of the Seventeenth Century,* vol. I of Wm. Roger Louis, ed., *The Oxford History of the British Empire* (Oxford, 1998), 318; Gilbert Camblin, *The Town in Ulster: An Account of the Origin and Building of the Towns of the Province and the Development of Their Rural Setting . . .* (Belfast, 1951), chap. 3; Anthony N. B. Garvan, *Architecture and Town Planning in Colonial Connecticut* (New Haven, Conn., 1951), 18–40 (esp. 31–35); Raymond Gillespie, "The Origins and Development of an Ulster Urban Network, 1600–41," *Irish Historical Studies,* XXIV (1984), 15–20; Reps, *Town Planning in Frontier America,* 19–22, 212; Twiss-Garrity, "Double Vision," in Hutchins, ed., *Shaping a National Culture,* 3.

30. Johnson, *Order upon the Land,* 30 (quotation). Peirce F. Lewis, "The Northeast and the Making of American Geographical Habits," in Michael P. Conzen, ed., *The*

The "Pennsylvania" or "Philadelphia-style" plan was thus not simply convenient; nor was it an innocuous adaptation of European or English Renaissance design. Rather, it was an explicitly colonial plan, one that William certainly, but, by extension, Thomas too, adapted from English examples in Ireland like Londonderry, surveyed in the early seventeenth century (Figure 3). Such borrowing was no accident. The Penn family knew Ireland well. William's father (Thomas's grandfather) had aided in the Cromwellian conquest. William spent time in the 1660s managing his family's Irish lands. And the Irish-born Quaker Thomas Holme, surveyor of Philadelphia, was involved in town surveying in northern Ireland. Scholars argue that Londonderry was one of his primary models in designing Philadelphia. Such connections raise significant questions about the Penns' intentions for their colony: How much control did they intend to exercise? More specifically: Was Thomas Penn being disingenuous when he said that he was "govern'd" by no other "views but that of the General Service of the Publick" in planning Carlisle? How did he define this "service"? What balance did it ultimately strike between his interests and those of his colonists?[31]

Colonization is an undeniably complex notion. At its most basic, it is a top-down process whereby one culture or people seeks to dominate or assert their authority over another land or people. In Ireland, this proved no easy task for the British, who waged a violent armed conquest against Ireland and its native Catholic inhabitants over several centuries. In this way, British towns in Ireland symbolized the violence that created them. Towns like Londonderry were surrounded by walls to protect their English and Scottish colonists from the native inhabitants. Yet in Pennsylvania, William and then Thomas Penn used diplomacy, rather than warfare, to acquire native American lands. Consequently, there were no walls surrounding their colonial towns (although some Pennsylvania towns did build fortifications for protection from native and French raiders during the Seven Years' War). Still, although Pennsylva-

Making of the American Landscape (Boston, 1990), 90, notes that southeast Pennsylvania "has an abundance of towns that look more British than any others in America." He also notes that the grid was an especially flexible plan, which meant it was easily copied and could be laid out in advance of settlement (97).

31. Nicholas Canny, "The Irish Background to Penn's Experiment," in Richard S. Dunn and Mary Maples Dunn, eds., *The World of William Penn* (Philadelphia, 1986), 139–156; Mary K. Geiter, *William Penn* (London, 2000), 21–27. For Holme's connection to Londonderry, see Garvan, "Proprietary Philadelphia as Artifact," in Handlin and Burchard, eds., *The Historian and the City*, 190–191; Love, "Colonial Surveyor," 186; Reps, *Town Planning in Frontier America*, 145–146; Twiss-Garrity, "Double Vision," in Hutchins, ed., *Shaping a National Culture*, 3.

FIGURE 3.
The Plat of the Cittie of Londonderrie as It Stand Built, and Fortyfyed. From the Carew Papers. Courtesy, The Trustees of Lambeth Palace Library, London.

Londonderry was a walled, grid-patterned town founded by the English in Ulster, Ireland, in the early seventeenth century

nia's planned towns were not emblems of violent conquest, they did express their proprietors' desire to dominate or at least control key aspects of their colony's land and its people. The Pennsylvania example demonstrates colonial dominance or how control can be expressed in nonviolent but still equally forceful ways.

In the case of Carlisle, Thomas Penn's plan for the town was a response to colonial circumstances specific to eighteenth-century Pennsylvania, its expanding interior, and the immigrant colonists settling there. As proprietor at midcentury, the land he sought to control was the less accessible geography of Pennsylvania's interior, particularly the Susquehanna Valley. Founding new counties, and especially their seats, was essential to meeting this goal. Still, though, his situation was not unique. Rather, like other colonizers of his time, one of Thomas Penn's primary goals remained controlling the survey and sale of land. During Carlisle's planning, for example, Penn cautioned surveyors not to neglect "to secure some large quantity of land for our use." And, in the town, he ordered surveyors to reserve every fourth or fifth lot for him and his family.[32]

Managing land was one thing; overseeing colonists was another matter. Carlisle's pioneers were mostly immigrants, who in Cumberland County were mostly of Scots-Irish ancestry. Indeed, unlike eastern Pennsylvania, with its large populations of English Quakers and Anglicans, or other interior counties, like Lancaster, York, or Berks that had large numbers of German settlers, Cumberland County was an especially Irish place in the eighteenth century. One estimate suggests that all but fifty of the families settled in and near Carlisle were either Scots or Scots-Irish. For Penn, these colonists posed challenges. Because many were poor, they did not purchase land, but they often squatted, thus reducing Penn's revenues from land sales in the colony. Then, too, they competed for land with the region's remaining native peoples, often heightening intercultural tensions.[33]

32. Penn to Peters, Aug. 27, 1750, Penn Letterbooks, III, 21, Feb. 24, 1750, III, 38.

33. For colonial Cumberland County's Scots-Irish settlers, see Dunaway, *Scotch-Irish of Colonial Pennsylvania*, 59; Donehoo, *History of the Cumberland Valley*, 2 vols. (Harrisburg, Pa., 1930), I, 32; *History of Cumberland and Adams Counties*, 15–16; Kerby A. Miller et al., eds., *Irish Immigrants in the Land of Canaan: Letters and Memoirs from Colonial and Revolutionary America, 1675–1815* (New York, 2003), 146. For ethnic patterns later in the century, see Owen S. Ireland, *Religion, Ethnicity, and Politics: Ratifying the Constitution in Pennsylvania* (University Park, Pa., 1995), 211, 214; Thomas L. Purvis, "Patterns of Ethnic Settlement in Late Eighteenth-Century Pennsylvania," *Western Pennsylvania Historical Magazine*, LXX (1987), 115. For the cultural composition of other counties, see Laura L. Becker, "Diversity and Its Significance in an Eighteenth-Century Pennsyl-

Could Penn rely on these colonists to build his town and make it profitable? Governor Hamilton thought it doubtful. The only hope for Carlisle, said Hamilton, was that the more industrious "Dutch" (Germans) might "get a footing in Cumberland County," which would ensure Carlisle's "becoming a Considerable Town." After hearing the governor's concerns, Penn was wary. He even suggested that allotting money for a schoolmaster "to teach the Dutch English" might give "them [the Germans] some Encouragement" to settle in Carlisle. But that was unlikely to work; there were already too many Scots-Irish there. If Carlisle was to develop, as Hamilton observed, it would have to "flourish under the management of the Irish"; they held the key to its future. But how could Penn get these Scots-Irish colonists, whom another one of his officials described as "the most stubborn and perverse people" in the colony, to take up constructing and managing his town? How might his town plan shape their attitudes and choices?[34]

Order was one quality Penn emphasized in response. His "general service" focused on setting an ordered stage on which colonists would act, preferably in predictable and profitable ways for the colony. The plan for Carlisle's central square best exemplifies this approach (Figure 4). Carlisle's square "was intended," as Penn explained, "to be Like the Squares in Philadelphia." It was also an almost exact replica of the English town square in Londonderry. This "inverted Square of about the size of the common ones" (a rectangle), as Penn described it, would serve as home to a "Court House . . . in the middle of one side," a "Gaol . . . any place near," and a "Market" in the "Middle of the Center." As discussions continued, the Anglican convert Penn innovated the design by also including a spot for an Anglican church. Thus, with spaces designated for the public buildings of law, commerce, and religion—the built symbols of authority in colonial America and Britain—Penn clearly intended that Carlisle's square align the community in a real and metaphoric way with his colony— and the British empire. On the local level, these structures, which would function as community centers of sorts, were intended to draw residents together, encouraging them to abide by the law, use the courts, patronize the market, and worship at the church. In this way, Penn's design of the square encouraged Carlisle's residents to embrace the kind of sociability and civility that

vania Town," in Michael Zuckerman, eds., *Friends and Neighbors: Group Life in America's First Plural Society* (Philadelphia, 1982), 197 n. 6; Paul E. Doutrich III, "The Evolution of an Early American Town: Yorktown, Pennsylvania, 1740–1790" (Ph.D diss., University of Kentucky, 1985), 62; Jerome H. Wood, Jr., *Conestoga Crossroads: Lancaster, Pennsylvania, 1730–1790* (Harrisburg, Pa., 1979), 7.

34. Hamilton to Penn, Nov. 29, 1751, Penn OC, V, 193, Peters to Penn, Mar. 16, 1752, V, 217; Penn to Hamilton, Jan. 9, 1753, Penn Letterbooks, III, 180.

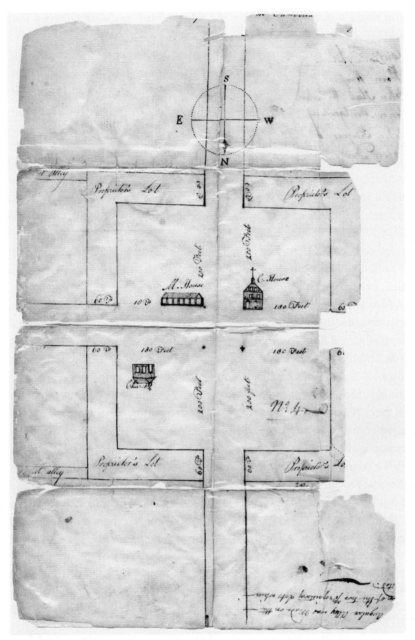

FIGURE 4. Center Square of Carlisle. From the Bureau of Land Records, Records of the Land Office, Record Group 17. Courtesy of Pennsylvania Historical and Museum Commission, Pennsylvania State Archives, Harrisburg.

This undated map offers a conjectural view of the town's center square and its key structures of law, commerce, and religion

would foster peace and growth, while also perhaps modeling behavior that would preserve peace.[35]

Penn did not stop there. He also ordered town spaces through naming. After all, naming—or renaming—was another nonviolent mechanism European colonizers had long used to order colonial peoples and spaces. In Cumberland County, where there were townships named Antrim, Derry, and Donegal in homage to the Ulster origins of many colonists, Thomas Penn stated forthrightly that he "would not have Indian[,] Dutch[,] or Irish names given" for streets in this or his other county towns; rather, in a place where he was concerned about order, English names were given preference. As he instructed in reference to several towns he was planning at midcentury, "You may from the Names of the Streets in London give names to the Towns to be Laid out." When walking down Carlisle's streets, colonists thus would be reminded of Britain's capital city, the exemplary urban place of the empire. In this symbolic way, Penn signaled to settlers that they and their town were a critical part of the British Atlantic world.[36]

Additionally, unlike his father, whose Quaker beliefs discouraged him from glorifying individuals by naming streets for them, Thomas Penn also embraced more traditional English naming patterns. Surely, it was no coincidence that, just as Thomas severed his association with the Quakers and embraced the Church of England with his new wife, he celebrated English royal and aristocratic authority in his colony. Whereas Philadelphia had streets named for local trees (Cedar, Pine, Spruce, and so forth) or they were numbered, Carlisle, by contrast, had Hanover, Pitt, and Lowther Streets—names explicitly associated with English authority. York, founded two years before, followed a similar pattern. There, he demanded that there be George, King, Princess, Duke, and Philadelphia Streets. Easton, another town he planned in 1750 and laid out in 1752, honored the family of his new bride, Lady Juliana Fermor, the daughter of Lord Pomfret. The town name Easton was named for "my Lord Pomfret's House"; both Carlisle and Easton also shared Pomfret Streets.[37]

35. Penn to Hamilton, July 29, 1751, Penn OC, III, 78; Edward T. Price, "The Central Courthouse Square in the American County Seat," *Geographical Review*, LVIII (1968), 30–36. See also Charles Gilber Beetem, *Colonial Carlisle: Plans and Maps for the Design of Its Public Square* (Carlisle, Pa., 1959).

36. Penn to Peters, May 30, 1750, Penn Letterbooks, II, 309; Fries, *Urban Idea in Colonial America*, 25. For naming as a colonial practice, see Stephen Greenblatt, *Marvelous Possessions: The Wonder of the New World* (Chicago, 1991), 82–85.

37. Penn to Peters, May 30, 1750, Penn Letterbooks, II, 309, Penn to Hamilton, 1751, III, 87. See also A. D. Chidsey, Jr., *A Frontier Village: Pre-Revolutionary Easton* (Easton,

Thomas Penn even went so far as to celebrate English imperial—and even military—authority in his towns. The county name Cumberland, the town name Carlisle, and the street (and later town) name of Bedford all referenced the war Scottish Jacobite rebels waged on the English borderlands in the 1740s. Specifically, these names celebrated the rebels' defeat by the duke of Cumberland at the battle of Culloden in 1746, an especially well-known event in the British Isles and America, and one that, depending on one's viewpoint, either confirmed the power of British authority or raised anxieties about its brutality. Thus, Penn's associating street names in Carlisle with this rebellion and its outcome was clearly meant to convey important messages to settlers about the authority and righteousness of the English state—and by extension his enterprise in Pennsylvania. Carlisle belonged not just to its colonists, or to him, but also to a broader British heritage, one that was sometimes defended with violence. With the force of this English history behind him, he hoped that settlers would make Carlisle a success. After all, much like its namesake, the ancient English fortress town of Carlisle that stood at the narrow lowland entry into England from Scotland and the place where the duke of Cumberland had one of his first and most decisive victories in the war, Carlisle, Pennsylvania, was to be an outpost of his colony and a transition point from one cultural and economic world (that in and near Philadelphia) into another (the Ohio Valley and beyond).[38]

Colonization also had broader implications in Pennsylvania, as in Ireland or Britain. It is a notion with many facets of meaning, which include not only asserting political or legal hegemony over another place or people but also more subtle, though equally devastating, forms of cultural and economic imperialism. These forms of colonization played out, too, in planned, grid-patterned towns in both Ireland and America. Britain's Irish towns were not utopian model cities; they were pragmatically designed centers of law and commerce that would encourage industrious Protestants to manufacture and trade for their own and Britain's benefit. William Penn also had real estate development in mind when he planned Philadelphia. The regular lines and lots of his city's grid, Penn and Holme knew from European precedents, were easy

Pa., 1940), 19; Richard Pillsbury, "The Street Name Systems of Pennsylvania before 1820," *Names,* XVII (1969), 214–222; Treese, *The Storm Gathering,* 17.

38. Geoffrey Plank, *Rebellion and Savagery: The Jacobite Rising of 1745 and the British Empire* (Philadelphia, 2006), 40–52, and chap. 6. For Carlisle, England, and its connection to the uprising, see *Gentleman's Magazine: and Historical Chronicle* (1745), XV, 675, XVI, 233.

to survey and distribute. Philadelphia's plan was thus a tool to attract investors and settlers who would make the city productive.[39]

By the time Thomas planned his towns in the eighteenth century, American town proprietors had adopted the grid as their preferred urban plan. They did so largely because of its perceived economic advantages. Town plans, though not identical, varied little during this century. Most towns—the majority of them located in the interior—were laid out on a grid and, like Carlisle, incorporated a single central square as a focal point of their designs. In Pennsylvania, examples included Lancaster, which was founded by Governor Hamilton's father, Andrew, in the 1730s; Allentown, founded in 1761; as well as all of the five other towns planned by Thomas Penn. The grid was also employed by town planners in eighteenth-century Virginia (including Winchester, another important town of the Valley), in North Carolina, in upstate New York (including William Cooper's town), and, by the early nineteenth century, in Tennessee too.[40]

Although some of these rectilinear plans were linked to utopian idealism, as in the communitarian settlement of the Moravians in Bethlehem, most proprietors favored the grid because it was a highly conscious plan that could be used to order development in advance of settlement. It was also easy to survey and expand, and thus set the stage for future growth. Densely packed lots, meanwhile, fostered interaction—and hopefully commerce—among resi-

39. Hannah Benner Roach, "The Planting of Philadelphia: A Seventeenth-Century Real Estate Development, I," *PMHB*, XCII, (1968), 3–47; Roach, "The Planting of Philadelphia . . . , II," ibid., 143–194. See also Garvan, "Proprietary Philadelphia as Artifact," in Handlin and Burchard, eds., *The Historian and the City*, 180; Lewis, "The Northeast and the Making of Geographical Habits," in Conzen, ed., *The Making of the American Landscape*, 97; Love, "Colonial Surveyor," 2–8, 157–159; Reps, *Town Planning in Frontier America*, 141–155.

40. For Pennsylvania examples, see Doutrich, "Evolution of an Early American Town," 16–18; Bernard L. Herman, *Town House: Architecture and Material Life in the Early American City, 1780–1830* (Chapel Hill, N.C., 2005), 80–82; Liam O'Boyle Riordan, "Identities in the New Nation: The Creation of an American Mainstream in the Delaware Valley, 1770–1830" (Ph.D. diss., University of Pennsylvania, 1996), 37–38; Wood, *Conestoga Crossroads*, chap. 1. For Virginia, see Warren R. Hofstra, *The Planting of New Virginia: Settlement and Landscape in the Shenandoah Valley* (Baltimore, 2004), chap. 7; Hendricks, *Backcountry Towns*, 18. For New York, see Alan Taylor, *William Cooper's Town: Power and Persuasion on the Frontier of the Early American Republic* (New York, 1995), 200–205. For Tennessee, see Lisa C. Tolbert, *Constructing Townscapes: Space and Society in Antebellum Tennessee* (Chapel Hill, N.C., 1999), chap. 1. See also Dan Stanislawski, "The Origin and Spread of the Grid-Pattern Town," *Geographical Review*, XXXVI (1946), 105–120.

dents. Grids also offered flexibility, which generated revenue. Because lots on a grid were easily divisible into half or quarter parcels, colonists could acquire only what they needed and could afford. For proprietors, subdivided lots meant faster disposal. Grid towns were thus conducive to speculation. In Carlisle, for example, Thomas Penn even suggested ways that the lots around the square might be redrawn to "accommodate a far greater number of houses." He assumed that colonists would be eager to claim these central lots for their shops. By the eighteenth century, in short, the grid was perceived as an essential tool of development. Penn confirmed these presumptions when he remarked how "well pleased" he was to find that "so much land had been surveyed about the Town [Carlisle], which tho' not valuable in itselfe," he noted, "wil[l] become so by its situation if the Town encreases." Planning Carlisle on a grid thus gave Penn confidence in its future—and he had the weight of experience behind him.[41]

■ In the end, plans for Carlisle did not initially go according to Penn's wishes; plans were one thing; reality was another. First, there were problems caused by the surveyor Cookson. His delays in purchasing the townsite from settlers cost Penn more than he had anticipated and delayed the town's survey. More significant were modifications made to the town's design. Surveyors made mistakes on the square, for instance. From the start, it was not laid out as intended. House lots did not front it. There was no street encircling it. Instead, it was just a big, open, and mostly empty space that was resurveyed in the 1760s so that the two main streets bisected it and divided it into four separate quarters (Figure 5). Penn, though perhaps disappointed, took these changes in stride. Writing from London, he conceded quite willingly to these modifications, "thinking it most for our private Interest to do so." From his perspective, all hope for the square's importance and centrality was not lost as there was still "ground enough Left for all Publick Buildings and a Market Place."[42]

But progress on Carlisle's public buildings and market was stalled too.

41. Penn to Peters, Sept. 28, 1751, Penn Letterbooks, III, 97, Mar. 18, 1752, III, 123; see also Penn to Hamilton, July 29, 1751, III, 78. For more on the uses and interpretations of the grid, see Fries, *Urban Idea in Colonial America*, 26–28; David Hamer, *New Towns in the New World: Images and Perceptions of the Nineteenth-Century Urban Frontier* (New York, 1990), 85–90, 204–223; Johnson, *Order upon the Land*, 27, 178; Blake McKelvey, *The City in American History* (New York, 1969), 28; Reps, *Town Planning in Frontier America*, 210–223; Stanislawski, "Origin and Spread of Grid-Pattern Town," *Geographical Review*, XXXVI (1946), 105–107.

42. Penn to Hamilton, Feb. 25, 1750, Penn Letterbooks, III, 58, July 13, 1752, III, 142; Hamilton to Penn, Apr. 30, 1751, Penn OC, V, 135.

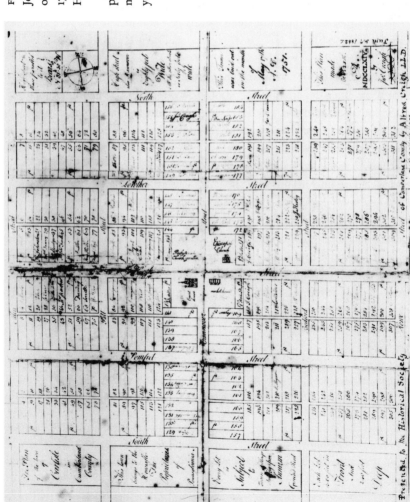

There were no plans for a market house; townspeople did not erect one until the nineteenth century. Markets could always be held on the street, if necessary. The courthouse and prison were not going anywhere fast either. Colonists needed homes first rather than public buildings; local courts could meet in someone's dwelling or shop. But there was likely another issue at work here too. Courthouses and prisons, as any colonist knew, were symbols of colonial order and authority. In both America and Ulster, from where so many of Carlisle's pioneers hailed, the British used town planning, central squares, and the erection of public buildings as ways to assert their power over the land and people. Carlisle's pioneers, like their ancestors—the Scottish beneficiaries of this urban system—were readily aware of how such symbols of authority could affect their lives. Their ancestors had pioneered these British-created Irish towns in the late sixteenth and early seventeenth centuries. Many of them had prospered as professionals, retailers, or artisans. Yet they had also suffered from economic setbacks and from armed attacks by angry Irish Catholics in uprisings like the one in 1641.[43]

Surely, colonists' cultural memories of the Old World British colonization of Ireland informed their reactions to Penn's plans. Structures of authority, like courthouses, market houses, and prisons, they knew, could work to one's benefit in asserting order in situations of chaos. Many of these colonists' ancestors in Ireland had in fact benefited from the order of law and commerce these structures fostered. But as Britain's eighteenth-century treatment of these same Protestant dissenters proved, they could also work to one's detriment; British law could grant one privileges, or, as the discriminatory treatment of Ulster's Scots Presbyterian settlers in the eighteenth century proved, take those privileges away. British-based political and legal power often cut two ways, having a double-edged quality. Moreover, in colonial Pennsylvania these structures were also the hallmarks of a proprietary establishment that many in Cumberland County mistrusted. Colonists did not always see Penn's interests as their own. In these contexts, therefore, even though a prison was said to be "much wanted" by many in the town and county, its construction one block from the square did not get under way until 1753, two years after the town's survey.[44]

Then there was the issue of the church. Penn's plan called for an Anglican church on the square. Carlisle's pioneer colonists, by contrast, were mostly Scots-Irish Presbyterians. As such, they were the first to mark their presence

43. Canny, *Making Ireland British*, chaps. 7–8.
44. Peters to Penn, July 5, 1753, Penn OC, VI, 73. For the Irish context, see Dunaway, *Scotch-Irish of Colonial Pennsylvania*, 2–3; Griffin, *People with No Name*, chaps. 2–3.

in town. By 1757, there was one Presbyterian meetinghouse located one block south of the square. Soon thereafter, another congregation moved to town, and they met one block north of the square. By the 1760s, these Presbyterians laid claim to the northwest corner of the square. There, they erected a large stone meetinghouse that one observer said was "the most conspicuous, and the best built" of any church in Carlisle, and which still stands today. Although the town's Anglicans claimed their spot on the square, too, with the erection of a small cabin for their services in 1762, they did not erect St. John's church on the northeast corner of the square until later in the 1760s.[45]

In the end, then, Penn's plans for Carlisle did not work the way he intended. The town's design, as we have seen, did not develop quite the way he had planned it. Penn's grid plan structured the town's spaces, to be sure, but within it residents made choices about how to build on their lots, use the square, and which public buildings to construct. Just as significant was the pattern of its economic development. Carlisle did become an important midpoint in the fur and skin trade with the native peoples of the Ohio Valley—in this Penn succeeded. But residents did so on their own terms, not the proprietor's. They forged economic connections with native peoples in the west but, to the great chagrin of provincial officials, often engaged in illegal trade practices like selling liquor to the Indians. At the same time, they linked themselves to a number of Philadelphia merchants with strong ties to Ireland, rather than the English-directed trade Penn sought. Indeed, despite all attempts to regulate their behavior, Carlisle's pioneers proved themselves to be a remarkably independent lot.

Even so, the story of Carlisle's founding remains intriguing for what it reveals about planning activities of colonial America's eighteenth-century proprietors and the ways they sought to regulate space to make their development schemes work. As Carlisle's history reveals, Thomas Penn and his officials sought to set the stage for a commercially productive town whose prosperity would benefit the proprietor, the colony, and the people who populated it.

45. John Penn, "John Penn's Journal of a Visit to Reading, Harrisburg, Carlisle, and Lancaster, in 1788," *PMHB*, III (1879), 292 (quotation); Guy Soulliard Klett, *Presbyterians in Colonial Pennsylvania* (Philadelphia, 1937), 69–74; Merkel Landis, *The "English" Church in Carlisle* (Carlisle, Pa., 1949), 4–5; St. John's Episcopal Church, *The Spire on the Square: A History of St. John's Episcopal Church, Carlisle, Pennsylvania, 1752–2002: In Celebration of the 250th Anniversary of the Parish* (Carlisle, Pa., 2002), 6–8; Conway P. Wing, *A History of the First Presbyterian Church of Carlisle, Pa.* (Carlisle, Pa., 1877), 14–16, 41, 66–70, 88–89.

MAPPING HAVANA IN THE GENTLEMAN'S MAGAZINE, 1740–1762

Scott Lehman

"We have taken out several Poems to make room for our PLANS, *judged more entertaining at this Juncture."*
—Gentleman's Magazine, *X (March 1740), 141*

In the opening scene of *Control Room* (2004), a documentary about the Al Jazeera Television Network and the war in Iraq, Samir Khader, senior producer of Al Jazeera argues: "You cannot wage a war without rumors, without media, without propaganda. Any military planner that prepares for a war, if he does not put media propaganda at the top of his agenda is a bad military planner." As if to confirm Khader's statement, in a later scene the camera zooms in on a detailed map of Iraq that has been haphazardly spread across a computer console. Brooding over the map, an Iraqi dissident explains to Al Jazeera producers how Coalition Forces claim to have captured a bridge over the Tigris River, although the only bridge over the Tigris can be found "here," he explains pointing to the map, "in El Kut," a city still occupied by the Iraqi army. His remarks incite a lively discussion among the producers, and above the din of voices an observer exclaims: "Let's get our graphics producer and summarize this live on our show!" The movie soundtrack then rises to a crescendo as the venerated graphics producer strolls in, casually glances over the map, and with a few easy keystrokes produces a number of digitally enhanced cartographic images of central Iraq and the Tigris River to be displayed behind the Al Jazeera anchorman on international television. Several minutes later the anchorman explains to viewers that Coalition Forces could still be as far as one hundred kilometers from Baghdad. Rest assured, he argues by pointing to the map, they would not capture the city. Or, to put it differently, with the

I would like to thank Martin Brückner for his support and assistance with this essay.

knowledge that a map is providing the visual background he makes the tacit promise that the city will not fall.[1]

Shown inside the visually enhanced, noisy, and performative space of the postmodern newsroom, the televised city map of El Kut is but the latest incarnation of propaganda maps in the history of modern news dating back to the early eighteenth century. For today's map-savvy audiences, the map of El Kut calls attention to the way in which the representation of cartographic knowledge inevitably produces tacit knowledge. On the one hand, the Al Jazeera newscast hints at the traditional understanding of maps as stable and accurate representations; considered to be an objective and truthful representation of the city, the city map emerges as sole evidence in support of the newscast's message: the bridge Coalition Forces claim to have captured does not exist; they are much farther away from Baghdad than we think. On the other hand, the producers of this newscast demonstrate how maps are easily manipulated to fit public opinion; a slight shift of a cartographic symbol here, a discreet change in map scale there, and danger is averted or victory declared. From the perspective of modern media studies, the television episode surrounding the map of El Kut amply illustrates not only "how to lie with maps" but also the extent to which actors and audiences expect maps to fulfill the demagogical hermeneutics of propaganda during times of war.[2]

What this map episode calls attention to—and what is easily overlooked today—is not so much the strategic deployment of maps by newscasters but that, in the modern media landscape, the very concept of news is intertwined with, if not even codependent on, the map as such. Without the cartographic image, the Al Jazeera anchorman's narrative of a bumbling Coalition army would lack the credibility needed to convince its viewers. Or, simply put, without the map there would be no news to tell. This essay examines the origins of this symbiotic relationship between maps and news by tracing "journalistic cartography" to its origins as a mass print phenomenon. In particular, it focuses on the application of propaganda maps, using the example of maps showing the harbor town of Havana in eighteenth-century British newspapers.[3]

1. *Control Room*, directed by Jehane Noujaim (Magnolia Pictures, 2004).

2. On the manipulation of map knowledge and on maps as propaganda tools, see J. B. Harley, *The New Nature of Maps: Essays in the History of Cartography*, ed. Paul Laxton (Baltimore, 2001); Mark Monmonier, *How to Lie with Maps* (Chicago, 1996); John Pickles, "Texts, Hermeneutics, and Propaganda Maps," in Trevor J. Barnes and James S. Duncan, eds., *Writing Worlds: Discourse, Text, and Metaphor in the Representation of Landscape* (London, 1992), 193–230; and Denis Wood and John Fels, *The Power of Maps* (New York, 1992).

3. Walter W. Ristow coined the term "journalistic cartography" in *Surveying and*

Before 1700, city maps like the one showing El Kut were frequently the commercial by-product of military siege maps. Plans showing the sieges of Malta (1565) or Vienna (1683) were published amid a general outpouring of literature and portraiture intent on limning everything from individual acts of heroism to panoramic representations of war settings. Half map and half picture, the early city plans told the story in a mixed-media format. While charting the city using a bird's-eye perspective, they depicted the cities' surroundings rather descriptively, using the technique of landscape painting and the compositional perspective of the genre painter. Such maps tended to be elaborate woodcuts, produced in single sheets for decorative purposes and for insertion into folio books. Usually published after the siege, these city maps served commemorative as well as celebratory functions. But, given their costly nature of production, they were rarely able to reach large audiences, not to mention become defined as news. This situation changed with improvements in printing technology in the late seventeenth century, with the development of popular forms of newsprint like the newspaper and the magazine, and the rise of geographic literacy among the middle class. By the early eighteenth century, the *Gentleman's Magazine; or, Monthly Intelligencer* was one of the first periodicals to popularize siege maps by illustrating news reports from the New World with select city plans.[4]

When the young entrepreneur Edward Cave printed the first issue of the *Gentleman's Magazine,* he declared that his periodical would "treasure up, as in a *Magazine,* the most remarkable Pieces . . . , or at least impartial Abridgments thereof." Unlike the other early-eighteenth-century periodicals, Cave's was a miscellany, an "impartial" collection of "all Matters of Information and Amusement." Although a variety of original contributions were made to the *Gentleman's Magazine,* it was the modus operandi of the magazine to crib popular articles and other various sorts of information from periodicals

Mapping, XVII (1957), 369–390. Studies of new maps concentrate on nineteenth- and twentieth-century mass media. See Mark Monmonier, *Maps with the News: The Development of American Journalistic Cartography* (Chicago, 1989); Patricia Gilmartin, "The Design of Journalistic Maps: Purposes, Parameters, and Prospects," *Cartographica,* XXII, no. 4 (Winter 1985), 1–18.

4. For cartographic conventions in eighteenth-century depictions of cities, see, for example, James Elliot, *The City in Maps: Urban Mapping to 1900* (London, 1987). For early American city maps, see the classic account of John W. Reps, *The Making of Urban America: A History of City Planning in the United States* (Princeton, N.J., 1965). On "news" as a genre and discourse in the early eighteenth century, see Lennard J. Davis, *Factual Fictions: The Origins of the English Novel* (Philadelphia, 1997); and Thomas C. Leonard, *News for All: America's Coming-of-Age with the Press* (Oxford, 1995).

and books printed during previous months and then offer these materials to British readers in an abridged form, delivering, as the title page to each issue proclaimed, "more in Quantity, and greater Variety, than any Book of the Kind and Price." Price was key. Sold at a sixpence, Cave's magazine was affordable enough to allow almost everyone with disposable income, from those in the upper echelons of British society to the lower end of the middling sort, to gain access to the latest "true histories" or news reports drifting in from the four corners of the world.[5]

Cave's method proved successful, and throughout the 1730s the *Gentleman's Magazine* attracted thousands of patrons. In the years following, a number of other similar magazines were published, foremost among these the *London Magazine*, the *Scot's Magazine*, the *Universal Magazine*, and the *Political Magazine*. Competition with these other magazines, most notably the *London Magazine*, forced Cave to begin to include a wider range of information in his magazine. Beginning in the late 1730s, visual diagrams, including maps and battle plans, became an important part of Cave's revamped magazine and later his competitors' magazines.[6]

Although most of the maps included in eighteenth-century British magazines were thinly veiled reproductions of earlier charts and plans, often cut by unidentifiable engravers, they were among the first cartographic images designed to illustrate the news to Britain's rising middle class. The significance of these images, therefore, does not rest as much in their origins or authenticity as in the publishing vehicle in which they appeared. Considering that by 1746 Edward Cave could boast fifteen thousand subscribers to the *Gentleman's Magazine* alone, it seems plausible that by the mid-eighteenth century

5. See *Gentleman's Magazine; or Monthly Intelligencer,* I (January 1731), 48; and *Universal Spectator,* Jan. 30, 1731. On the flow of information during the eighteenth century and the role played by magazines, see Charles W. J. Withers, *Placing the Enlightenment: Thinking Geographically about the Age of Reason* (Chicago, 2007).

6. For more information about the *Gentleman's Magazine*, see C. Lennart Carlson, *The First Magazine: A History of the Gentleman's Magazine* . . . (Providence, R.I., 1938). For more on maps printed in British magazines, see David C. Jolly, ed., *Maps in British Periodicals, Part I: Major Monthlies before 1800* (Brookline, Mass., 1990); Jolly, ed., *Maps in British Periodicals, Part II: Annuals, Scientific Periodicals, and Miscellaneous Magazines Mostly before 1800* (Brookline, Mass., 1991); Jolly, ed., *Maps of America in Periodicals before 1800* (Brookline, Mass., 1989); Christopher M. Klein, *Maps in Eighteenth-Century British Magazines: A Checklist* (Chicago, 1989); E. A. Reitan, "Expanding Horizons: Maps in the *Gentleman's Magazine*, 1731–1754," *Imago Mundi,* XXXVII (1985), 54–62; Reitan, "Popular Cartography and British Imperialism: The *Gentleman's Magazine*, 1739–1763," *Journal of Newspaper and Periodical History,* II, no. 3 (1986), 2–13.

the British magazine had become one of the more significant sources of cartographic information to the public. By incorporating maps depicting current affairs, the *Gentleman's Magazine* and its competitors were not only working to increase geographic literacy among British readers—albeit unintentionally and according to the demands of the rising free market—but also to familiarize the public with Britain's developing interests abroad.[7]

The publication of cartographic information in the *Gentleman's Magazine* and other magazines was integrally tied to British military and mercantile interests in the Americas, particularly the West Indies. More cartographic images of the Americas were printed in magazines during the War of Jenkins's Ear, the Seven Years' War, and the American Revolution than at any other time in the eighteenth century. By the end of the century, nearly five hundred cartographic images of the Americas, and nearly two thousand maps of other regions throughout the world, had been printed in Britain's numerous and often short-lived magazines.[8]

Cartographic images of Havana and Cuba figured prominently in these materials. Between the War of Jenkins's Ear (1739–1748) and the Seven Years' War (1756–1763), British magazines printed eighteen maps and plans of Havana and Cuba, more than any other region in the Americas. The apparent popularity of Havana is not surprising given that it was generally recognized as one of the most valuable and strategically important harbors in the Americas. The climate and topography of the region was perfect for growing sugar and tobacco, and the "capacious and secure harbor" at Havana, as it was branded between the two wars, offered the only convenient layover along the Gulf of Florida, the exit route from Central America to Europe. An article printed in the August 1762 issue of the *Gentleman's Magazine* shortly before the British navy arrived off the coast of Havana states:

7. For a concise explanation of the rules (or lack of rules) governing cartographic copying and plagiarism in the eighteenth century, see Mary Sponberg Pedley, *The Commerce of Cartography: Making and Marketing Maps in Eighteenth-Century France and England* (Chicago, 2005), 96–119. Klein suggests that Cave most likely exaggerated the number of subscribers to his magazine by five thousand. Ten thousand is probably a more accurate number (Klein, *Maps in Eighteenth-Century British Magazines*, xii). Jolly also covers this issue in some detail in his introduction to *Maps in British Periodicals, Part I.* Other magazines could probably boast anywhere from one thousand to five thousand subscribers, though there were some exceptions.

8. This number is based on David Jolly's findings in *Maps of America before 1800.* Jolly documents 465 maps of the Americas but recognizes that more were printed during the eighteenth century.

The great value [the Spanish] put on [Cuba] is on account of its excellent port of the *Havannah*, which indisputably is one of the very best harbors in the world, and the city one of the largest in America. Here it is that the King of Spain builds a great many of his men of war: and in this port the flota, who brings to Spain immense treasures of *Mexico*, and *Peru*, from *Carthagena*, *Porto Bello*, and *Vera Cruz*, rendezvous, therefore it may properly be called the key of *Spanish America*.

Keywords such as "value" and "treasures" were code worthy of modern nightly news reports. They simultaneously invented and reified Havana's strategic role to be not only about controlling access to and from the Caribbean basin; rather, implicit to the rhetorical hints at security and territorial expansion, such terms were shorthand denotations representing British interest in developing and profiting from Cuba's sugar agriculture.[9]

The *Gentleman's Magazine* recorded these sentiments early in 1740, during Britain's conflict with Spain over mercantile rights in the region, or what is now popularly referred to as the War of Jenkins's Ear. Shortly after news arrived in London that Admiral Lord Edward Vernon had captured the small, shambling garrison at Porto Bello, Britain's only real victory of the War of Jenkins's Ear, Edward Cave made an announcement that marked the beginning of his use of battle plans as a source of news. By March 1740, Vernon's victory had become a matter of great excitement to the British public, and Cave, true to the self-declared mission of his magazine, began collecting a variety of articles, editorials, and poems that celebrated Britain's victory and berated Spain's trade monopoly in the West Indies. But in the very section in which the magazine usually printed a few poems, Cave printed a short note: *"We have taken out several Poems to make room for our PLANS, judged more entertaining at this Juncture."* And in place of the customary diatribes against the Spanish military, Cave included a battle plan outlining Vernon's victory at Porto Bello and, eight pages later, between a list of ecclesiastical preferments and the prices of stocks for March, printed *Plan of the City of Havanah* (see Figure 1, below).[10]

When Cave substituted the battle plans for the poems, replacing written text with cartographic material, he began what was to become a defining fea-

9. *Gentleman's Magazine*, XXXII (August 1762), 351–352. For a complete listing of the plans of Havana, see Jolly's *Maps of America in Periodicals before 1800*, nos. 5, 12, 188, 189, 192, 196, 200, 204, 206, 209, 213, 216, 225, 226. For more information on eighteenth-century perceptions of Havana, see J. H. Parry, P. M. Sherlock, and A. P. Maingot, *A Short History of the West Indies*, 4th ed. (London, 1987), 12.

10. *Gentleman's Magazine*, X (March 1740), 141, 149.

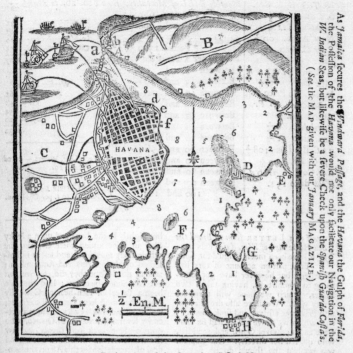

As *Jamaica* secures the *Windward Passage*, and the *Havana* the Gulph of *Florida*, the Possession of the *Havana* would not only facilitate our Navigation in the *W. Indian Seas*, but likewise be a severe Check upon the *Spanish Guarda Costa's*. (*See the* MAP *given with our January* MAGAZINE.)

Explanation of the foregoing PLAN.

A *The Battery called,* 12 Apostles.
B *The Road from the eastern Castle, which lies on the Coast* 5 *Miles from the Town.*
C *The River* Lagida, *which falls into the Sea near the western Castle at about* 5 *Miles distance.*
D *Nostra Sennora de la Regla.*
E *Venta, or Inn de Marimelena.*
F *Isla de mxgeres.*

G *La Doctora.*
H *Guanabacoa Village.*
a *The Boom and Chain a-cross the Harbour*
b *The Moro Castle of* 52 *Guns.*
c *Fort St Maria, or de la*Punta, *of* 30 *Guns.*
d *El Fuerte where the Governour resides with* 22 *Guns.*
e *The Mole.*
f *The point Gate and small Fort.*

The *Havana*, called by the *Spaniards* the *Key* of the *West Indies*, is Situated in the Island of *Cuba*, which is 700 Miles in length, and in some Places above 100 Miles broad, tho' in others not 50. This, like most other Islands, has about the Middle a Chain of lofty Hills extending from one End of it to the other, from whence issue several fine Streams watering a delightful plain Country, that stretches itself along the Coast from the Foot of these Hills. The Air is more temperate and healthy, than in most of the *American* Islands, and the Soil extremely fertile, yielding abundance of all those Spices, and other Commodities, produced in the *West Indian* Islands. They have a plentiful Breed of larger and better Cattle, than in any other Part of *America*, with Salt, Fowl, and Fish in no Scarcity.

The *Havana* is reckoned the strongest City in the *Spanish West Indies*, the Port inaccessible to an Enemy ; but the Town may be Bombarded from the Sea by some stout Ships that dare venture near the Forts; and if Possession be got of one of the Hills to the East (See B) to attack the Place by Land, at the same time, it could not hold out many Days.

7

FIGURE 1. *Plan of the City of Havanah, Gentleman's Magazine,* X (March 1740), 149.
Permission, The Sutro Library, the San Francisco branch of the California State Library

ture of the *Gentleman's Magazine* and nearly every other British magazine in the last half of the eighteenth century: the use of cartographic information to illustrate and often promote Britain's military endeavors in the Americas alongside and often in place of written texts. As these battle plans entered into the formal composition of news magazines, they affected the literary lives of the British reading public in two fundamental ways. On the one hand, editors of the *Gentleman's Magazine* and other British magazines deployed maps not only to illustrate written accounts of battle formations and sieges; they also caused the map and spatial representation (rather than the words and temporal notations) to become the primary vehicle for creating news. On the other hand, the increased use of maps in magazines allowed editors to loosely participate in an eighteenth-century aesthetic movement that Peter de Bolla has called "the education of the eye." Like print makers and painters, magazine editors experimented with perception theories. But, whereas the former sought to instruct audiences in the style of pictures and aesthetic appreciation, the latter juxtaposed "more entertaining" map views against news narratives as if training audiences to consume and perhaps even to privilege information by visual rather than verbal means.[11]

To illustrate how cartographic information was used in this manner, I will examine three plans of Havana printed in the *Gentleman's Magazine* during the War of Jenkins's Ear, when cartographic production was beginning to take root in the British magazine, and during the Seven Years' War, after maps had become a regular component of the *Gentleman's Magazine* and nearly every other British and American magazine. These plans contributed to the *Gentleman's Magazine*'s overall written commentary on Havana in a fashion that associated maps not only with news but with propaganda in the modern sense of the term: "the systematic dissemination of information, esp. in a biased or misleading way, in order to promote a political cause or point of view." By presenting a cartographic narrative that depicted the harbor as a penetrable, easily conquered space, the *Gentleman's Magazine* shaped public opinion in three stages: it provided the argument for the siege well before it happened; it rallied public support with depictions of the harbor during the siege; and it consolidated British imperial sentiments with city maps showing Havana after the fall.[12]

11. Peter de Bolla, *The Education of the Eye: Painting, Landscape, and Architecture in Eighteenth-Century Britain* (Stanford, Calif., 2003); *Gentleman's Magazine*, X (March 1740), 141.

12. This definition appears not until 1822. See *Oxford English Dictionary*, s.v. "Propaganda."

■ The *Gentleman's Magazine* released its first woodcut plan of Havana, a rough variant of the plan that appeared on George Foster's 1739 map of the West Indies, in March 1740, approximately twenty-two years before the invasion of the harbor actually occurred (Figure 1). Although the British War Cabinet considered sending the British fleet to Havana during the earlier stages of the War of Jenkins's Ear, they opted instead in March 1741 to capture Cartagena, a decision heatedly debated by British politicians, military officials, and the general public alike. Although many shared the feelings of Admiral Sir Charles Wagner, who publicly objected on a number of occasions to attacking Havana, arguing that the harbor was too strongly defended and the invasion would cost too many lives, many others agreed with William Pulteney, who wrote in August 1740: *"Cuba* is an Island that may be of such Importance, and the *Havannah* is a Port of such infinite Consequence, that the Conquest of them seems to be preferable to every Thing else. These we may take and hold, and these will give us the Key to the *West Indies."* Though the sentiments of Wagner eventually won out, and the British fleet was sent to Cartagena and later to southern Cuba instead, many still felt that Havana would have been a more appropriate and valuable target.[13]

Edward Cave's opinion of the proposed invasion of Havana remains unknown, but the battle plan printed in his magazine during the debate over the invasion presents a clear argument for it. On the upper left corner of the image, three oversized ships are shown to be casually bombarding the city, unmolested by the Spanish fortifications (represented by the letters *a, b,* and *c*). Two more British ships are waiting in the distance off "The Moro Castle of 52 Guns." The Spanish fortifications have been cut so small that they are almost unrecognizable, while the invading ships seem to be grossly out of scale, larger than the Spanish defenses, almost larger than the town itself. Here the point is unambiguous: despite the presence of the Spanish navy in the harbor, the British navy will easily overtake them. Look how close the ships can get to the city without being attacked, look how defenseless the harbor seems to be.[14]

Another more subtle visual detail appears below the scene of the attacking

13. George Foster, *The Seat of War in the West Indies, Containing New and Accurate Plans of the Havana, La Vera Cruz, Cartagena, and Puerto Bello ...* , 2d ed. (London, 1740); William Pulteney et al., *Original Letters to an Honest Sailor* (London, 1746), 24. For a detailed explanation of the objections to the invasion during both wars, see Richard Pares, *War and Trade in the West Indies, 1739–1763* (1936; rpt. London, 1963), 87–91. See also Philip Woodfine, *Britannia's Glories: The Walpole Ministry and the 1739 War with Spain* (Rochester, N.Y., 1998), 223; David Syrett, *The Siege and Capture of Havana, 1762* (London, 1970), xiii.

14. *Plan of the City of Havanah, Gentleman's Magazine,* X (March 1740), 149.

ships where the length of an English mile has been roughly carved into hills. At first this marker seems a rather innocuous indication of the scale of the plan; yet this marking also provides a measurement of the Spanish harbor in distinctly British terms. As G. N. G. Clarke suggests, the presentation of scale on many American maps was often "a measure of the ability to scale-down a wilderness and present it as a controlled image," which seems to be the case on this plan as well. Here we have the English mile imprinted on the landscape, thus stamping Spanish territory with a British icon and measure in anticipation of how the land might be arranged after the invasion.[15]

The argument for British supremacy over the landscape that appears on this plan extends from the visual text to the written narrative printed in the magazine along with the plan. Directly below the letter key, an explanation of the geography, topography, and agricultural fertility of the region declares that around Havana "the Air is more temperate and healthy, than in most of the *American* Islands, and the Soil extremely fertile, yielding abundance of all those Spices, and other Commodities"—an obvious reference to how British colonizers might capitalize on the fertility of the land surrounding the harbor after the invasion. To the right of the image, a written statement calls attention to the strategic importance of the harbor to British trade, claiming, "The Possession of the *Havana* would not only facilitate our Navigation in the *W. Indian* Seas, but likewise be a severe Check upon the *Spanish Guarda Costa's.*" Beneath this text appears a reference to the first map of the West Indies printed in the *Gentleman's Magazine,* which explains the importance of Havana in relation to other Spanish ports in the West Indies. And, in the last paragraph below the cartographic image, an explanation referring back to the ships describes how the town might easily be captured by British forces: "[T]he Town may be Bombarded from the Sea by some stout Ships that dare venture near the Forts; and if Possession be got of one of the Hills to the East (See B) to attack the Place by Land, at the same time, it could not hold out many Days." With this statement, the reader is directed to the letter key printed below the image, which, when read alphabetically, traces an invasive movement from the fortifications on the outside of the harbor *(A, a, b, c),* to strategic points in the city and on the outskirts of the bay *(B, C, d, e, f),* and eventually into the far reaches of the bay itself *(D, F, G).* In this way, the map viewer steps into the role of the armchair geographer who becomes the military planner sketching the course of British forces well in advance of the real invasion.[16]

15. G. N. G. Clarke, "Taking Possession: The Cartouche as Cultural Text in Eighteenth-Century American maps," *Word and Image,* IV (1988), 468.

16. *Plan of the City of Havanah, Gentleman's Magazine,* X (March 1740), 149.

On this plan, the drawings of the ships attacking the harbor, the letters printed on the image, and the written text printed around the image of the harbor all work together to create a detailed, multimedia polemic for the invasion. By including this image of the harbor in the presswork of the page—surely an inexpensive, makeshift alternative to printing a separate engraving—Cave was able to literally inscribe the image with written text calling for and justifying the British invasion. Here an argument for the invasion is not presented in a poem or a written proclamation from a military official; it is given through an amalgamation of visual and written text in the space of one single, easily viewed page. To the reader flipping through the pages of the magazine, this plan not only justified the siege of the harbor but also, considering the context of the magazine culture, it was a rhetorical gambit projecting the feasibility of the siege in order to persuade the public and to defer elaborately written counterarguments.

Evidently Cave's estimation that a cartographic representation of battle would be "more entertaining" than written text proved to be true, for in the months following the publication of this plan the *Gentleman's Magazine* released similar plans of Cartagena, Vera Cruz, Saint Augustine, and the Castle of San Lorenzo, and in the years following hundreds of other plans like them began to appear in a wide range of British and American periodicals. Despite the apparent success of Cave's new marketing scheme, the argument printed on his first map of Havana was more or less ignored by the British government. During the War of Jenkins's Ear, British forces did not attack Havana, and, by the signing of the Treaty of Aix-la-Chapelle (1748), which put an official end to the War of Jenkins's Ear, Britain had gained little ground in the Americas. Although the British navy managed to sack Porto Bello and repel Spanish forces from Georgia, several debacles, such as Admiral Vernon's haphazard attempt to capture Cartagena along with his failed expedition to Santiago de Cuba, sent the British War Cabinet back to the drawing board.

Not until fourteen years later did the British navy finalize a plan to seize Havana. On January 4, 1762, shortly after Spain entered into a secret alliance with France, Britain once again declared war on the Spanish empire. At this point in the Seven Years' War, the French empire in India, America, and the Caribbean lay in virtual shambles; to defeat the allied forces, Britain needed merely to attack a few critical points along Spain's trade network in Southeast Asia and the Americas in order to establish its maritime rule in the Atlantic theater. Tactical errors such as the invasion of Cartagena taught the British navy that being present in the Caribbean without strategic purpose led to certain defeat, as the Spanish army would merely hunker down and wait for the rainy season to arrive while British forces succumbed to disease. Unlike

Vernon's forces, which spent most of the War of Jenkins's Ear carelessly sailing from one military blunder to another, in late spring the British navy made a beeline for what was by this point universally considered Spain's most valuable and strategically important port in the West Indies: Havana. Approaching Havana along the north shore of Cuba through the Old Bahama Channel, the British navy caught the Spanish garrison by surprise and gradually laid siege to the fortifications along the outskirts of the harbor.[17]

Just before the British departed for the Old Bahama Channel, the *Gentleman's Magazine* published its next plan of Havana, a full-page copperplate engraving of the harbor and the surrounding countryside loosely based on Gabriel Bodenehr's 1720 nautical chart of the region (Figure 2). Unlike the battle plan printed two decades earlier, this new, detailed image is a more topographical plan of the city and its environs. Pictures of besieging ships are not present, and, aside from the letters marking several important military structures in the harbor, nothing about the image conspicuously advocates invasion or signifies an approaching attack. Instead, the harbor appears to be a tranquil, almost picturesque, setting, unmolested by the British navy, uninscribed by an argument for its assault.[18]

Although this image is not a siege map in the traditional sense, it offers its own unique imperative for invasion. Printed in the eighteenth century equivalent of real time, just weeks before the siege went into effect, this image reached the public at a critical point in Britain's military campaign in the West Indies. Considering that the public would have begun to hear news regarding the progress of military forces soon after the publication of the plan, this image of a visually tranquilized and static landscape offered the *Gentleman's Magazine* a particularly effective way to both encourage invasion and gloss over the unsavory aspects of it. In his analysis of topographical images of the Americas, John Crowley concludes that the depiction of the countryside often "sent a visual message—to the king, ministers and aristocrats, parliamentary politicians, fellow officers and officials, their families, the viewing

17. For detailed summaries of the invasion, see Syrett's introduction to *The Siege and Capture of Havana*, xiii–xxxv; Fred Anderson, *Crucible of War: The Seven Years' War and the Fate of Empire in British North America* (New York, 2000) 497–502. For an in-depth history of the siege, see Francis Russell Hart, *The Siege of Havana, 1762* (Boston, 1931).

18. Gabriel Bodenehr, *Neuer Plan der Stadt u. Hafens Havana, Atlas Curieux* (Augsburg, 1720); *Plan of the City and Harbour of Havanna*, Gentleman's Magazine, XXXII (April 1762), 408 (this plan originally appeared in the April 1762 issue of the *Gentleman's Magazine*, but subsequent binding instructions encouraged placing it in the September 1762 issue, closer to the next plan printed. This plan is therefore often found in the September 1762 issue).

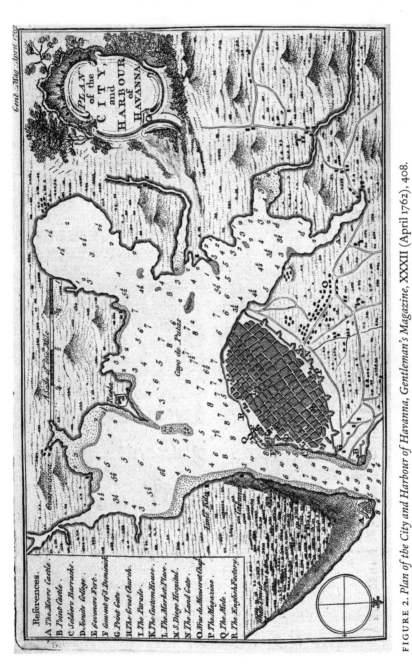

FIGURE 2. *Plan of the City and Harbour of Havanna, Gentleman's Magazine*, XXXII (April 1762), 408. Permission, The Sutro Library, the San Francisco branch of the California State Library

public at exhibitions—about a landscape whose scenic attractions and rustic tranquillity mitigated its appropriation by conquest." Much like on the topographical views of Havana composed during this time, the uninscribed landscape on this plan appears to be waiting to be controlled and cultivated, the rolling hills testifying "to a lack of possession, since it signifies land, rather than territory, earth rather than ownership." On this plan, the land begs to be taken because it appears to be sparsely populated and provides ample room for agricultural development. The cartouche, embossed with a verdant arrangement of Caribbean flora, trees, shrubs, and flowers sprouting up wildly from the landscape surrounding the city, harkens back to the description of the "fertile," "yielding" soil on the first plan and to what had become a common figure of representation in the mid-eighteenth century: the depiction of the Americas as a penetrable, quasi-feminine space. When compared to the first plan, the whole space seems completely benign, open and waiting, entirely vulnerable.[19]

The penetrability of the harbor is further reinforced by one of the most notable differences in the visual structure of this city plan and the 1740 siege map. With the selection of a nautical-style chart for this plan, the mouth of the harbor has been reoriented to the bottom of the page so that, when this image is placed on a flat surface in front of the viewer, the entrance point to the harbor now faces the viewer. This alteration establishes a conspicuously

19. John E. Crowley, "'Taken on the Spot': The Visual Appropriation of New France for the Global British Landscape," *Canadian Historical Review*, LXXXVI (2005), 1; Alfred Hiatt, "Blank Spaces on the Earth," *Yale Journal of Criticism*, XV (2002), 248. A number of cultural geographers and historians have suggested that early modern accounts of the fecundity of the New World have often been wrapped up in more subtle representations that implicitly link these "fertile" landscapes to the female body. See Alison Blunt and Gillian Rose, "Introduction: Women's Colonial and Postcolonial Geographies," in Blunt and Rose, eds., *Writing Women and Space: Colonial and Postcolonial Geographies* (New York, 1994), 1–28; Annette Kolodny, *The Lay of the Land: Metaphor as Experience and History in American Life and Letters* (Chapel Hill, N.C., 1975); Louis Montrose, "The Work of Gender in the Discourse of Discovery," *Representations*, no. 33 (Winter 1991), 1–41; Felicity A. Nussbaum, *Torrid Zones: Maternity, Sexuality, and Empire in Eighteenth-Century English Narratives* (Baltimore, 1995); Susanne Scholz, *Body Narratives: Writing the Nation and Fashioning the Subject in Early Modern England* (New York, 2000). Caterina Albano argues that cartographic representations of the New World often select "an image of femininity which can be conquered, subdued and handed over"; see Albano, "Visible Bodies: Cartography and Anatomy," in Andrew Gordon and Bernhard Klein, eds., *Literature, Mapping, and the Politics of Space in Early Modern Britain* (Cambridge, 2001), 101.

different relationship between the harbor and the viewer. Unlike the first plan of Havana, which, when placed flat in front of the viewer, forces the viewer to glance over the southeastern hillside before looking into the harbor, this chart provides an unobstructed, quasi-anatomical, and implicitly penetrative view into the bay. Havana does not appear closed off by Spanish fortifications; now, as the entry point to the harbor lies open to the viewer, it seems to beckon the viewer inside the bay, drawing the viewer into what appears to be a lush, welcoming safe haven. Announced in sensationalistic terms by the magazine's title page as "the most impregnable Fort in the West Indies," the 1762 city map suggests the exact opposite.[20]

In all, the relocation of the mouth of the harbor vis-à-vis the viewer and the depiction of Havana as a picturesque, fertile setting point to a different strategy in cartographic representation. Particularly interesting about this representation is that it is the only source of information about Havana printed in the April 1762 issue of the magazine. Aside from the brief note printed on the title page of the magazine, which states the map to be "an exact Plan of the City and Harbour of the Havana, the most impregnable Fort in the West Indies," no other text appeared in the magazine describing the plan, the places mentioned in the key, or the reason for its publication. The customary poems, essays, and battle proceedings that often accompanied magazine maps are absent from the issue. Whatever message the editors of the *Gentleman's Magazine* hoped to convey to the public about Havana they apparently felt could be delivered just as effectively through this plan. In one sense, the lack of written text on the map and written explanation in the pages of the magazine creates an opening similar to the concept of the *leerstelle* (empty placeholder) identified by Wolfgang Iser's theory of reception aesthetic. The missing information forces (or enables) readers or viewers to create meaning by projecting their imaginings. Without a clearly defined narrative on this image or elsewhere in the magazine, the plan's uncluttered setting begs map viewers to imagine the battle and to project their own fantasies of invasion as they wait to hear the outcome of the siege. In another sense, the manner in which cartographic information supersedes written text in this issue of the magazine suggests how magazine editors had come to adopt maps that initially were deemed "more entertaining" than written text but that now performed the cultural work of news by transmitting information as a visually enhanced sensational experience. Although the *Gentleman's Magazine* could

20. *Plan of the City and Harbour of Havanna, Gentleman's Magazine*, XXXII (April 1762), title page.

have easily included an essay that encouraged its readers to accept Havana as a legitimate military target, the sole inclusion of a printed plan of Havana provides a suggestive glimpse into the savvy media psychology surrounding the mid-eighteenth-century magazine.[21]

Three months after the *Gentleman's Magazine* printed its 1762 plan of the city, Havana fell into British hands, yielding three million pounds in gold and silver and a quarter of Spain's navy. When news of the successful invasion reached London, the editors of the *Gentleman's Magazine* released a barrage of printed materials celebrating the invasion. Essays outlining the articles of capitulation, letters from British military officials Sir George Pocock and George Keppel, third earl of Albemarle, an "accurate journal composed by an officer on the spot," and, of course, a new battle plan of the harbor were all cobbled together and printed in the September and October issues of the magazine. Despite the thousands of British and American soldiers that died between June and October 1762, the *Gentleman's Magazine* transformed the rather sloppy invasion into one of Britain's most successful military campaigns in the eighteenth century.[22]

The battle plan the *Gentleman's Magazine* published among the written ephemera celebrating the siege most likely appeared in the magazine under the auspices of Thomas Jefferys. Jefferys made a number of documented contributions to the *Gentleman's Magazine* in the 1750s and printed a similar copperplate engraving beside the frontispiece to *An Authentic Journal of the Siege of the Havana; by an Officer*, a short, first-hand account of the siege printed shortly after the invasion. A classic example of an eighteenth-century siege map, this new image includes a number of details that illustrate Britain's recent victory over the Spanish stronghold: an unadorned cartouche boldly announces it is not simply a plan of the town but *A Plan of the Siege of the Havana, Drawn by an Officer on the Spot;* prominent British phrases ("General Elliots Camp" and "BESIEGING CAMP") appear juxtaposed to the less noticeable Spanish toponymns; British soldiers now occupy the landscape outside the harbor, enclosing the bay left empty on the previous plan; dozens of British ships blanket the coastline while the Spanish fleet appears to be almost corralled in the harbor where besieging British forces fire upon it (Figure 3).

21. Ibid; Wolfgang Iser, *The Act of Reading: A Theory of Aesthetic Response* (Baltimore, 1978). Alfred Hiatt writes: "The blank of the map is here a space onto which various forms of fantasy can be projected—it is imbued with glory, glamour, and 'delightful mystery.'" See Hiatt, "Blank Spaces on the Earth," *Yale Journal of Criticism*, XV (2002), 223.

22. *Gentleman's Magazine*, XXXII (September 1762), 403–411, XXXII (October 1762), 459–468; Anderson, *Crucible of War*, 501.

Like most of the postinvasion printed matter released in other magazines, this image provides a laudatory emblem of Britain's power in the New World.[23]

When the *Gentleman's Magazine* printed this plan, the editors announced that it was designed to "illustrate" Patrick Mackellar's account of the invasion, one of the primary sources of news about the invasion printed with the letters of Pocock and the earl of Albemarle. Although this battle plan does elucidate the events outlined in the journal, it also presents its own narrative that can be read apart from it. Using the number key printed next to this plan as a guide (Figure 4), the viewer can trace the penetrative movement of British forces over the image in a numerical progression loosely corresponding to the progress of the British military into the harbor. Beginning with the number *1* printed in the bottom left corner of the image, the viewer locates the "Place where the troops landed *June 7*." From there one finds the number 2 marking the "March of the army after landing," then the place where the Dragon and the Cojimar fought *(3)*, the spot "Where the army first encamped" *(4)*, the place "Where the cannon, etc. were landed" *(5)*, and so on. As the British armies split up and simultaneously attack both sides of the harbor, their progress becomes more convoluted and difficult to follow. But, by reading the numbers in a sequential fashion, one can more or less piece together an encrypted narrative that charts the course of British forces over the landscape. Even read apart from Mackellar's journal, the plan provides a visual synopsis of the invasion that allows the viewer to survey the battlefield and the events that occurred in a matter of seconds. So, for those that had the time to read Mackellar's journal, this battle plan would have further reinforced the underlying invasive movement depicted in Mackellar's account; for those that did not read the journal—perhaps because it was published in two lengthy installments—the narrative printed on this battle plan would have provided a visual alternative to it.[24]

23. *A Plan of the Siege of the Havana, Drawn by an Officer on the Spot*, 1762, *Gentleman's Magazine*, XXXII (October 1762); Thomas Jefferys, *An Authentic Journal of the Siege of the Havana; by an Officer; to Which Is Prefixed, a Plan of the Siege of the Havana, Shewing the Landing, Encampments, Approaches, and Batteries of the English Army; with the Attacks and Stations of the Fleet* (London, 1762). For more on Jefferys's involvement with the *Gentleman's Magazine* and the map trade, see J. B. Harley, "The Bankruptcy of Thomas Jefferys: An Episode in the Economic History of Eighteenth Century Map-Making," *Imago Mundi*, XX (1966), 27–48. See also Mary Pedley, *The Map Trade in the Late Eighteenth Century: Letters to the London Map Sellers Jefferys and Faden* (Oxford, 2000).

24. "Explanation of the References to the Plan of the Siege of the Havannah, Inserted Here for the Illustration of the Engineer's Journal of That Siege," *Gentleman's Magazine*, XXXII (October 1762), 458.

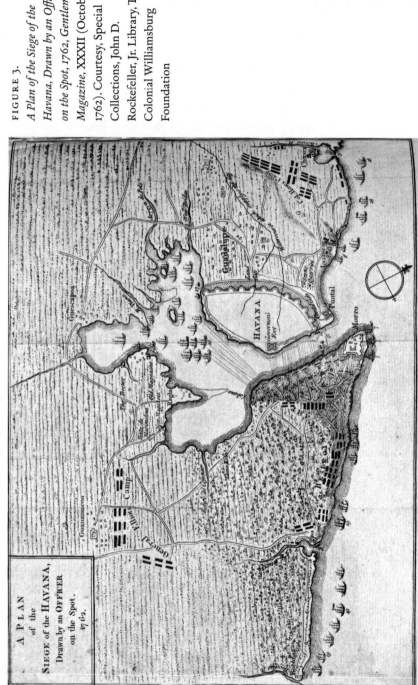

FIGURE 3.
A Plan of the Siege of the Havana, Drawn by an Officer on the Spot, 1762, Gentleman's Magazine, XXXII (October 1762). Courtesy, Special Collections, John D. Rockefeller, Jr. Library, The Colonial Williamsburg Foundation

fright us by the appearance of a new enemy, and to fow the feJds of diffention among us.

However that he, our enemies at home, in conjunction with our enemies abroad, have reprefented a peace as a bad meafure under Lord *Bute*; tho' it was univerfally acknowledged to be a good one under Mr *Pitt*. Mr *Pitt's* meafures are now purfued ; a war with *Spain* has commenced, and been carried on with vigour and fuccefs ; a peace, for which Mr *Pitt*, amidit the advantages acquired in his adminiltration,1 made overtures to *France*, is now negociating ; and the terms are proportionably better than thofe which Mr *Pitt* would have agreed to, as our advantages have been fince increafed. It therefore now depends upon ourfelves, how far we will be impofed upon ; how far this faction fhall prevail ; whether we will defert our country, relinquifh our own interefts, and ferve the views and purpofes of a diftreffed, defponding, inveterate enemy, by fuffering ourfelves to be divided under falfe and abfurd diftinctions, by withdrawing our natural and moral obligations and affections from our Prince, the conftitution, and one another ; or glorioufly act the reverfe.

Mr URBAN,

A S we have now once more a prince of *Wales*, permit me, by the chanel of your excellent Magazine, to endeavour to give the Public the true meaning of his Royal Highnefs's motto, ICH *DIEN. Thefe two words are underftood by none I ever converfed with in the principality, notwithftanding they are, in my humble opinion, pure genuine *Welfh*, abating the improper fpelling of the firft words ; it ought to be VCH. The antient *Britons* never admitted the V in their alphabet as a confonant, but it was always pronounced as U vowel, fo VCH to an *Englifhman* not knowing this, would not be pronounced ; and perhaps imagining that half the v was fuperfluous, and refolving to make a vowel of it, right or wrong, it is as we now find ICH. But the word VCH (pronouncing v as U) is daily ufed and underftood by the moft illiterate *Welfhman*, and the meaning is, *fuperior, higher, above, &c.* If this is granted, I fhall make very fhort work with DIEN. This word, though an o-

* See Dr *Davies's* dictionary for both words.

riginal, is obfolete, efpecially in *South Wales*, yet we have its derivatiye very common amongft us, *viz. Dibenydd*, which fignifies our departure from this world. DIEN, therefore, is by Dr *R. Davies*, translated *hora mortis, necis*, the hour of death. So with fubmiffion to gentlemen of fuperior knowledge, I fhall venture to tranflate ICH or properly VCH DIEN, *Triumphant in death*, a motto highly befitting a chriftian prince. *I am, &c.* C. EVANS. *Tregaer*, near *Monmouth, Sept.* 18,1762.

P.S. I am very fenfible *Ich Dien* is pretended to be *German*, and tranflated *I ferve*; but I cannot poffibly find out what occafion our firft *Britifh* princes had to ufe for their motto the language of foreigners, with whom they had then no connexion ; efpecially as they found a more excellent one in their own principality.

Mr URBAN,

A S I have an inclination to the *bark*, recommended for the Gout in your Magazine, *p.* 400, I fhould be glad to know, thro' the fame channel, how the *bark* is to be taken, whether in the fubftance, or tincture ? If in tincture, what the tincture is to be made with, and what quantity of either fubftance or tincture is to be taken at a time. *Yours, &c.* *Union Coffee-houfe, Oct.* 25. T. M.

Explanation of the REFERENCES *to the* PLAN *of the Siege of the* Havannah, *inferted here for the illuftration of the Engineer's Journal of that Siege.*

1 Place where the troops landed *June* 7
2 March of the army after landing.
3 The *Dragon* againft *Cojimar.*
4 Where the army firft encamped.
5 Where the cannon, *&c.* were landed.
6 Batteries againft the *Morro.*
7 The *Dragon, Cambridge*, and *Marlborough*, againft the *Morro.*
8 The bombs againft the *Puntal.*
9 The *Belleifle* againft *Chorera* fort.
10 Batteries againft the *Puntal.*
11 Batteries on the *Cavannos* hill.
12 Hoetzers againft the fhipping.
13 Three *Spanifh* men of war funk.
14 One company's fhip overfet.
15 The chain and bomb.
16 *Spanifh* admiral and fleet.
17 Two fhips on the ftocks.
18 Adm. *Pocock* with the men of war and tranfports.
19 Commodore *Keppel* with ditto.
20 Camp at the water mills.
21 Fortified houfes. 22 Head quarters.

From

FIGURE 4. "Explanation of the References to the Plan of the Siege of the Havannah, Inserted Here for the Illustration of the Engineer's Journal of That Siege," *Gentleman's Magazine*, XXXII (October 1762), 458. Permission, The Sutro Library, the San Francisco branch of the California State Library

The orientation of the plan to the southwest affects the narrative in several important ways. First, it situates the landscape in such a way that the movement of British soldiers over it, from the northeast to the northwest, can be easily read from left to right, in the conventional fashion of alphabetic literacy, rather than diagonally from the top right to the bottom left, as would occur if the plan were oriented cartographically to the north. In this way, viewers "read" the narrative that appears on this plan in almost the same way that they would read the written text accompanying it. Secondly, the orientation of this plan helps to alter the point of view from which this story is told. Like many of the written texts printed beside this plan that present the events of the siege from the perspective of a first-person narrator (Mackellar, Pocock, or Albemarle), this plan appears to have been drafted by an individual observer, or, as the cartouche announces, "by an Officer on the Spot." The phrase "on the Spot" not only lends the image a greater sense of authority, accuracy, and visual authenticity but also, as suggested by John Crowley, indicates that this battle plan (and the narrative that appears on it) has been focalized from the officer's perspective, or that these are the events the officer saw rendered in cartographic terms. So, in the same sense that the written texts published beside this plan represent the battle from Mackellar's, Pocock's, and Albemarle's points of view, this plan offers an image of the siege from the officer's own perspective. On this plan, the viewer's line of sight becomes filtered through the officer's, so the plot the viewer constructs while reading this cartographic narrative becomes a reflection of the same plot performed by the British army during the siege. As the viewer pieces together the events that form the story of the siege, he or she imaginatively occupies the invasive viewpoint and thus the position of imperial agency.[25]

Of course, there is nothing particularly unusual about this plan and the narrative that appears on it. Many eighteenth-century battle plans were composed in the same manner. This plan and the other two plans of Havana printed in the *Gentleman's Magazine* are not worth our attention because of their originality but because they were part of a much larger pattern generating and changing the production of news. Released to thousands of readers, who shared them with thousands of others readers in locations known for gossip and the trade of news (such as the tavern or the coffeehouse), the narrative that appeared on these plans reached an unprecedented number of viewers, many of whom may not have encountered images of Havana or other harbors outside the magazine. With the publication of these plans and many

25. Ibid.; Crowley, "'Taken on the Spot,'" *Canadian Historical Review*, LXXXVI (2005), 1.

others like them, cartographic propaganda began to operate on a much larger scale than in previous centuries, and in such a way that continues to exist today. The substitution of cartography and maplike constructs for history and narrative is a staple of visualizing information such that one picture is worth a thousand words and debate becomes moot. If only for this reason, these plans, and the many other cartographic images like them that over time have been dismissed as scientifically inaccurate or visually unappealing, deserve further consideration.

PART THREE

META-CARTOGRAPHIES:

ICONS, OBJECTS, AND

METAPHORS

NATIONAL CARTOGRAPHY
AND INDIGENOUS SPACE
IN MEXICO
Barbara E. Mundy

In the pages of Antonio García Cubas's *Atlas geográfico, estadístico é histórico de la República Mexicana,* viewers can still encounter the traces of an ambitious state undertaking of the nineteenth century. The atlas opens to a map of the country, and following it each of Mexico's thirty-one states appears on two-page spreads. The space of the nation thus unfolds and expands across its pages. Such atlases would have been quite familiar to audiences in the United States as well; armchair travelers in New York or Omaha, Nebraska, could choose to view their own nation thus in their national atlases. But an unusual feature of Mexico's atlas came in the closing pages of this modern image of nation. At the end of the volume appear two indigenous maps, both from the sixteenth century, both taking the form of itineraries, both showing the fabled journey of the Aztecs from their edenic home of Aztlan sometime in the dim reaches of the thirteenth century.[1]

I first opened these pages as a graduate student studying indigenous manuscripts, and I flipped directly to the back to find out what was, at that time, the best interpretation of one of those Aztec itineraries, the *Mapa de Sigüenza.* I never paused to think about the context of these indigenous maps, the oddity of their inclusion in an atlas of the republic, the strange juxtaposition of the

This work grows from a paper, *"Cemanauactli y machiyo:* The Image of the World and the Lure of the Local in Colonial Cartography," given at a conference, "Early American Cartographies," held at the Newberry Library, Chicago, March 2–4, 2006. The author thanks the organizers of that conference, Carla Zecher and Gordon Sayre; particular thanks to Martin Brückner, the editor of the present volume, for his insightful comments as well as those of an anonymous reviewer for the Omohundro Institute of Early American History and Culture.

1. Antonio García Cubas, *Atlas geográfico, estadístico é histórico de la República Mexicana* (Mexico, 1858). Following conventional usage, "Aztec" refers to the empire headed by the Mexica of Tenochtitlan, today's Mexico City.

sixteenth-century narrative map with the nineteenth-century geographical ones. But such cartographic coupling would have a well-worn familiarity to a late-nineteenth-century viewer: then, indigenous maps were not just in Mexico's national atlases; they were also shown at Mexico's international exhibitions—key sites for conjuring a national image for an international audience. The ambitious state undertaking in the *Atlas geográfico* was not only the creation of national maps, based on the best information at hand, but also, as I will show, the use of indigenous maps to support the authority of the new national cartography. The indigenous maps attested to the historical depth of national space and, by association, the legitimacy of the nation itself. But they were ambivalent signifiers in this new cartographic order. As a close reading of one map will suggest, indigenous maps destabilized emergent orderings of knowledge, presenting false histories and skewed topography. They also encoded local forms of spatial construction, implicitly countering a national cartography that was poised to subsume them.[2]

MAP AND STATE IN NINETEENTH-CENTURY MEXICO

In Mexico, the drive to create a national map in the nineteenth century, to give space "a stable signification, permitting it to be more effectively appropriated, transformed, and regulated," led to a burst of cartographic production in the closing decades of the century. Beginning in the 1850s with the production of the *Carta general de la República Mexicana*, government officials sought to create a unified image of a contested territory, one whose boundaries had been recently redrawn after the loss of all territories to the north of the Rio Grand, almost a third of national space, to the United States in 1848. The idea that "Mexico" was a fragile entity, less than a century old and at risk of imminent dissolution, could be countered by the solidity of its cartographic image: a visual bulwark. The Mexican elites who sponsored, made, and consumed these maps saw in them an index to the newly constituted national territory, the maps' authority a by-product of the compilations of geographical and sta-

2. Here I use "false," "skewed," and "local" as relational terms, that is, to mark the departure of these maps from the conventional or authoritative ways that historical, geographical, and national truth have been understood. My reconsideration of these maps is influenced by J. B. Harley, "Deconstructing the Map," in Harley, *The New Nature of Maps: Essays in the History of Cartography*, ed. Paul Laxton (Baltimore, 2001), 150–168, as well as by the epistemology of space presented by Henri Lefebvre, *The Production of Space*, trans. Donald Nicholson-Smith (Oxford, 1991), and by Walter D. Mignolo, "Colonial Situations, Geographical Discourses, and Territorial Representations: Toward a Diatopical Understanding of Colonial Semiosis," *Dispositio*, XIV, nos. 36–38 (1989), 93–140.

tistical facts used to create them. But most important was the mathematical model used to represent space—the end product of three centuries of cartography. Absolute and unbiased (or so it seemed), the mathematical model was implanted into the landscape through the survey, which could anchor space to the universal grid of latitude and longitude. And, since large-scale surveys were most often carried out under the auspices of the state's staking claim to that space, they and the maps they generated were inextricably connected to the possession of the territory they represented.[3]

Mexico was not alone in its cartographic projects. By the close of the nineteenth century, the geographic map and the ordering of knowledge, particularly spatial knowledge, was crucial to state formation in nations across the globe. Benedict Anderson identifies maps as part of a larger triumvirate that included census and museum. These entities "profoundly shaped the way in which the colonial state imagined its dominion—the nature of the human beings it ruled, the geography of its domain, and the legitimacy of its ancestry." Mexico, in the late nineteenth century, was not exactly a colonial state: once known as New Spain, the territory had been independent from Spain since 1821, when it took on the name Mexico. But it still retained some of the polarizing social divisions of the colonial period, which affected the national imagination. Censuses parceled out whites (people of European descent; most elites were of this group), *mestizos* (of European, indigenous, and sometimes African descent), and, farthest down the economic ladder, *indios* (indigenous peoples). Mexico's national museum followed suit in these divi-

3. The *Carta general* appeared in García Cubas, *Atlas geográfico*; the history of the project is covered by Raymond B. Craib, *Cartographic Mexico: A History of State Fixations and Fugitive Landscapes* (Durham, N.C., 2004), 8 (quotation), 19–53. I am indebted to Craib's excellent analysis. I was unable to consult Magali M. Carrera, *Traveling from New Spain to Mexico: Mapping Practices in Nineteenth-Century Mexico* (Durham, N.C., 2011). The survey was not just a product of the nineteenth century, although it took on particular importance then. See D. Graham Burnett, *Masters of All They Surveyed: Exploration, Geography, and a British El Dorado* (Chicago, 2000). On the connection between maps and the emergence of the modern state, see James R. Akerman, David Buisseret, and Arthur Holzheimer, *Monarchs, Ministers, and Maps: A Cartographic Exhibit at the Newberry Library* . . . (Chicago, 1985); and Buisseret, ed., *Monarchs, Ministers, and Maps: The Emergence of Cartography as a Tool of Government in Early Modern Europe* (Chicago, 1992). See also Antonio Lafuente and Antonio J. Delgado, *La geometrización de la tierra: Observaciones y resultados de la expedición geodesica hispanofrancesa al virreinato del Perú (1735–1744)* (Madrid, 1984); and Roger J. P. Kain and Elizabeth Baigent, *The Cadastral Map in the Service of the State: A History of Property Mapping* (Chicago, 1992). For mapping in colonial situations, see Matthew H. Edney, *Mapping an Empire: The Geographical Construction of British India, 1765–1843* (Chicago, 1997).

sions, dividing past artifacts between archaeology, history, and ethnography. Archaeology (and eventually anthropology) subsumed works by indigenous peoples, with emphasis on the great pre-Hispanic empires. History would eventually include collections devoted to the works of (largely) whites and mestizos in the colonial and independence periods. But, although these instruments of knowledge (census, museum) have been scrutinized in relation to social and ethnic divisions, the relation of national maps to indigenous ones has escaped notice.[4]

The matter of indigenous maps connects to the larger question of indigenous peoples within the national territory of Mexico itself, which is largely beyond the purview of this essay. Suffice it to say that indigenous peoples complicated modern space. Before independence, Spanish colonists configured them as both spatially and politically separate, members of an entity with its own rights and rules called the *república de indios* (Indian republic). In the nineteenth century, people living in indigenous communities maintained collective landholding patterns once formalized through their *república*, but, as the century progressed, these were increasingly at odds with national and capitalistic understandings of space. Elites saw privatization as key to the modernization of Mexico and largely abolished collective landholding in the reforms of the Ley Lerdo of 1856. And, although indigenous peoples remained in separate locales through the nineteenth century—small towns and rural communities—their long-standing participation in the market economy meant that they interpenetrated the urban spaces of white elites. So, by the late nineteenth century, their spatial status was uncertain.

That indigenous space was on the minds of elites is signaled in the pages of the 1885 *Atlas pintoresco e histórico de los Estados Unidos Mexicanos*, created by García Cubas, who was at the time Mexico's leading geographer. The *Atlas pintoresco* offered readers a series of elegant color lithographs wherein Mexico was shown according to different epistemic categories of the nation—its political history and its ecclesiastical establishments, for instance. Each is presented on its own sheet. But all the sheets are unified by format: at the center of each page is the map image of Mexico, and around its edges are smaller

4. Benedict Anderson, *Imagined Communities: Reflections on the Origin and Spread of Nationalism*, rev. ed. (London, 1991), 164; Enrique Florescano, "The Creation of the Museo Nacional de Antropología of Mexico and Its Scientific, Educational, and Political Purposes," and Shelly Errington, "Progressivist Stories and the Pre-Columbian Past: Notes on Mexico and the United States," both in Elizabeth Hill Boone, ed., *Collecting the Pre-Columbian Past: A Symposium at Dumbarton Oaks 6th and 7th October 1990* (Washington, D.C., 1993), 81–103, 209–249.

inset illustrations pertaining to the page's theme. The national map, seemingly constructed along a mathematical model, appears to naturalize the methods of its creation. What the French sociologist Michel de Certeau noted about modern geographic maps in general can easily be applied to this one: "The map, a totalizing stage on which elements of diverse origin are brought together to form the tableau of a 'state' of geographical knowledge, pushes away into its prehistory or into its posterity, as if onto the wings, the operations of which it is the result or the necessary condition. It remains alone on the stage." But in its epistemic divisions, the *Atlas pintoresco* comprises many tableaux. The first of these was the *Carta política (Political Map)*, but immediately following was the *Carta etnográfica (Ethnographic Map*, Figure 1), which dealt directly with Mexico's indigenous populations. Here, the interior space of Mexico is shown as a patchwork of different colors, each one representing a different ethnic group. Arranged around the edge of the page, as on all the pages of the atlas, are framed insets. In each inset on this page, a group of figures, often including a male-female couple wearing distinctive costumes, is identified only by ethnic type. Most correspond to one of the colored spaces within the national map. The neat caging of indigenous "types" on this map was the nation-builder's fantasy, yet the title of the *Atlas pintoresco* underscores the ambiguity of the project. Were Mexico's indigenous people part of the "picturesque"—that is, could they be subsumed as landscape, using one of the categories developed by Romantic theorists? Or were they historic, existing at some moment other than the present?[5]

While García Cubas attempted to contain indigenous space in the *Atlas pintoresco*, he was also engaged with indigenous cartography, in particular, exploring ways that indigenous maps could be combined into a "national" cartography. It was his *Atlas geográfico* that included the two sixteenth-century Aztec maps mentioned above. Some years later, in 1892, he would publish *Memoria para servir a la carta general del imperio Mexicano*, which began with "geográfica antigua," that is, sixteenth-century indigenous maps. In this work, he reproduced a few indigenous maps from the sixteenth century, discussing their distinct symbol systems and features. But, in his eyes, the lack of a mathematical basis for the maps made them largely useless to the contem-

5. Antonio García Cubas, *Atlas pintoresco e histórico de los Estados Unidos Mexicanos* (Mexico, 1885), sheet 2; Michel de Certeau, *The Practice of Everyday Life*, trans. Steven F. Rendall (Berkeley, Calif., 1984), 121. On the temporal ambiguity ascribed to indigenous peoples, see Johannes Fabian, *Time and the Other: How Anthropology Makes Its Object* (New York, 1983). Paired figures is a trope found on maps from the sixteenth century onward; indigenous maps use a similar trope.

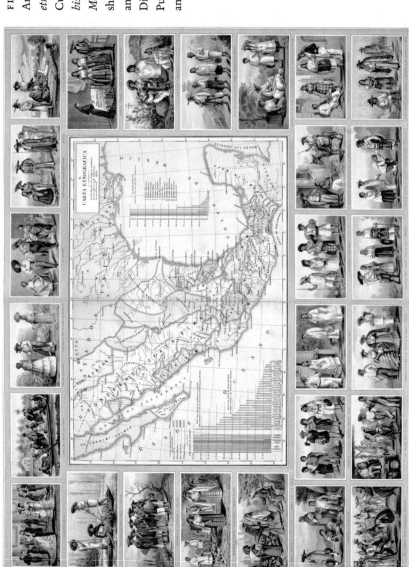

FIGURE 1.
Antonio García Cubas, *Carta etnográfica*. From García Cubas, *Atlas pintoresco e histórico de los Estados Unidos Mexicanos* (Mexico, 1885), sheet 2. The Lionel Pincus and Princess Firyal Map Division, The New York Public Library, Astor, Lenox and Tilden Foundations

porary geographer: "If we apply the term 'map' to these documents, it is to identify only their intent, not any system to their formation." García Cubas's response to indigenous maps was clearly ambivalent, as he included them in historical atlases but largely dismissed them as sources. Nonetheless, he recognized their importance. He, along with other Mexican geographers and their sponsors, could have followed the model of their neighbor to the north, leaving indigenous maps out of atlases or even any consideration of national geography, thus rendering them invisible. Instead, the opposite was true: at every opportunity, geographers and other intellectuals brought indigenous maps into public view, not only in atlases but also in the halls of international exhibitions.[6]

Capturing the Mexican cartographic project at a celebratory exhibition allows us to see both the highly self-conscious presentation that an exhibition entails paired with the unwitting abandon of the celebration. In 1892, to commemorate the four hundredth anniversary of Columbus's discovery (and it was unapologetically called "discovery" at that moment), Mexico had been asked, along with other former Spanish colonies, to create an exhibit for the Exposición Historica-Americana in Madrid. It was a signal moment for Mexico, especially vis-à-vis Spain. Seventy years before, Mexico had severed itself from three hundred years of viceregal rule. Although humiliated by the territorial losses of 1848, Mexico had aspirations to be an economic powerhouse in Latin America, particularly as a supplier of raw goods to Spanish and European markets. The country enjoyed political stability under the dictatorship of Porfirio Díaz, who played the role of enlightened despot with confidence. And so rapprochement between once-colonized Mexico and once-colonizing Spain was cause for satisfaction. Joaquín Baranda, one of the government officials spearheading the celebration, cast the event in providential terms: "Columbus was first to unite the globe 'physically and morally,' and Mexicans follow suit as they reunite Mexico with Europe."[7]

To create the Madrid exhibition, Díaz's government mustered a leading

6. García Cubas, *Atlas geográfico*; Antonio García Cubas, *Memoria para servir á la carta general del imperio Mexicano* . . . (Mexico, 1892). García Cubas's work on a national map and a geographic history followed that of his mentor, Manuel Orozco y Berra. See Orozco y Berra, *Geografía de las lenguas y carta etnográfica de México* . . . (Mexico, 1864); Orozco y Berra, *Materiales para una cartografía mexicana* (Mexico, 1871); and Orozco y Berra, *Apuntes para la historia de la geografía en México* (Mexico, 1881).

7. Joaquín Baranda and Justo Sierra, "Discurso y poesía leidos en la inauguración del monumento erigido á Cristóbal Colón por la Junta Colombina," *Antigüedades mexicanas publicadas por la Junta Colombina de México en el cuarto centenario del descubrimiento de América,* 2 vols. (Mexico, 1892).

historian, Francisco Paso y Troncoso, and promised him a significant budget. His charge was to show Mexico at the moment of Columbus's discovery, and, in carrying it out, he carefully framed a past for the Spanish and European spectators in Madrid. Most of the works displayed pertained to the late fifteenth century, including dozens of pre-Columbian sculptures found in Mexico's soil. The impressive visual display highlighted Aztec achievements, not only because this indigenous empire was at its apogee in 1492 but also because its territorial expanse was largely coterminous with the modern Mexican state. Dominating one room was the scale model of the temple of Cempoala, whose imposing authority was noted by the Spanish conquistadors in 1519. Another room featured a sculpture of Moteuczoma, the Aztec emperor at the time of the Spanish conquest, made for the occasion by students at the School of Fine Arts in Mexico City, thereby fusing past history with modern artistry into one seamless image.[8]

Among the objects that Mexico included in this signal exhibition were dozens of copies of indigenous maps—the pictorial documents created by native communities. That Paso y Troncoso would display copies, rather than originals, was often due to both the fragility and uniqueness of the manuscripts. Titled either "mapas" or "lienzos," these works were both set on the walls of the exhibition and in upright vitrines. Because many of them were quite large, they were visually significant within the exhibit. The *Relación geo-*

8. See Silvio Zavala, *Francisco del Paso y Troncoso: Su misión en Europa, 1892–1916* (Mexico, 1938). Mexico earmarked one hundred thousand dollars (U.S.) for the exhibition; see "In Memory of Columbus: Spain's Tribute to the Great Discoverer," *New York Times,* June 15, 1892. However, the silver crisis of 1892 might have meant less was actually spent; see Mauricio Tenorio-Trillo, *Mexico at the World's Fairs: Crafting a Modern Nation* (Berkeley, Calif., 1996). Overseeing Mexico's exhibition was the Junta Colombina, headed by Joaquín García Icazbalceta, Alfredo Chavero, José María Vigil, José María de Agreda y Sánchez, and Francisco Sosa. See Francisco del Paso y Troncoso, "Introducción," *Exposición histórico-americana de Madrid; catálogo de la sección de México: Catálogo de los objetos que presenta la República de México . . .* , 2 vols. (Madrid, 1892–1893), I, 5 (hereafter cited as Paso y Troncoso, *Catálogo*). On the exhibition, see also Barbara Mundy and Dana Leibsohn, "Of Copies, Casts, and Codices: Mexico on Display in 1892," *RES: Anthropology and Aesthetics,* nos. 29-30 (Spring–Autumn 1996), 326–343. On world fairs as sites for national representation, see Robert W. Rydell, *All the World's a Fair: Visions of Empire at American International Expositions, 1876–1916* (Chicago, 1984). Tenorio-Trillo, *Mexico at the World's Fairs,* offers a comparable analysis of Mexico's exhibitions at other world fairs, especially the 1889 Exposition Universelle de Paris. The exhibit included, among other works, life-size models of the Coatlicue, the Coyolxauhqui head of diorite, the Tizoc stone, and the Calendar stone, all considered today as major monuments of Tenochtitlan. See Paso y Troncoso, *Catálogo*.

gráfica map of Misquiahuala (Figure 2) was one of the works copied for the exhibition, and it gives us a sense of what viewers might have perceived. The map is large, measuring approximately seventy-eight by fifty-six centimeters at its largest sides. The original is on hide, and the copy gave some indication of its irregular contours. Like the other mapas and lienzos on display, all of which came from different regions across Mexico, it used pictographic glyphs to denote territory. This work has enough landscape features to make it readable as a map. A blue-green serpentine form runs across the center, marking a river. At the left border, a large irregular form represents the mountain adjacent to the town. In the center of the map, three seated human figures, who sit on high-backed reed seats and wear elaborate feather headdresses, depict the rulers of the region.[9]

Since the rebuslike glyphs on the Misquiahuala and on other maps were not perfectly readable to the nineteenth-century audience, the indigenous manuscripts included had a variable impact. They suggested, along with other artifacts on display, a high level of pre-Hispanic civility (measured along the developmental spectrum in use by historians at the time), because they showed a kind of writing (albeit pictographic) and the ability to translate territory into graphic form. At the same time, their inscrutable symbols must have also conveyed foreignness. Many of them contained human figures, further suggesting a history beyond the immediate grasp of the observer.[10]

While the inclusion of maps, like the one of Misquiahuala, reflected Paso y Troncoso's scholarly interest in indigenous manuscripts, it also came out of another trend in the work of Mexican nationalist intellectuals. Many clearly sought out, indeed excavated, the pre-Hispanic past to find the taproot of

9. The term "lienzo," roughly meaning "canvas" in Spanish, refers to the medium of many of these works because many indigenous manuscripts are painted on cotton cloth.

10. For contemporary ideas about historical development using an evolutionary scheme, see Lewis H. Morgan, *Ancient Society; or, Researches in the Lines of Human Progress from Savagery through Barbarism to Civilization* (New York, 1877); for a critical appraisal of this evolutionary model for the development of writing, see Elizabeth Hill Boone, "Introduction: Writing and Recording Knowledge," in Boone and Walter D. Mignolo, eds., *Writing without Words: Alternative Literacies in Mesoamerica and the Andes* (Durham, N.C., 1994), 3–26. The large exhibition catalog seems not to have been published in time for the exhibition, and it is unclear what kind of didactic information viewers had as they looked at the maps. But the historical narratives displayed on the maps must have been clear. For instance, a copy of the *Mapa de Cuauhtinchan*, a Nahua-speaking polity to the east of Mexico City, was on display, which showed figures (Cuauhtinchan's leaders) migrating from a primordial cave, and their journey is clearly marked with footprints along roadways on the map.

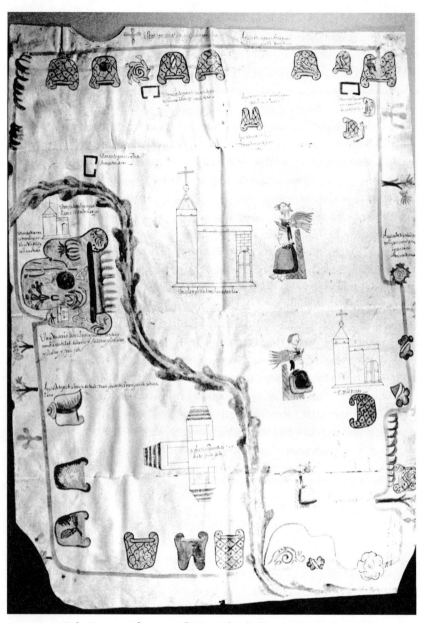

FIGURE 2. *Relación geográfica* map of Misquiahuala (Atengo). Circa 1580. Courtesy, Nettie Lee Benson Latin American Collection, University of Texas Libraries, The University of Texas at Austin

their own recently born nation, a historical pursuit that was supported by the Porfirian regime. One product of these historical labors were the atlases that covered historical geography, another was the five-volume *México a través de los siglos (Mexico through the Centuries)*. This history of the nation began, not in the early nineteenth century, when independent Mexico was founded, but with a survey of indigenous civilizations, with particular emphasis on the Aztecs in the first volume. Successive volumes took the reader through the nineteenth century. In this nationalist framework, indigenous history was both embraced and held at bay; although it dominates the first and second books (the latter being a narrative of the conquest), indigenous history and peoples were barely mentioned in successive volumes. Vicente Riva Palacio, its general editor, suggested why: only with the sixteenth century, which saw the fall of the Aztecs and the conquest by Spain, did Mexico (and the world) arrive at its historically destined path, "the century that, in a convulsive and bloody evolution, prepared both the world's geography and the state of its souls to receive the seed of modern civilization." Alfredo Chavero, who wrote the first volume of the series, seconded the idea by describing how Mexico's indigenous states were too imperfect in their political organization to give rise to the modern nation.[11]

The way that historians in *México a través de los siglos* parceled out the pre-Hispanic past into separate volumes and emphasized its "imperfection" echoes, of course, the way the geographer García Cubas dealt with indigenous maps. In contrast, the Madrid exhibition suggested a more coherent cartographic narrative. In an exhibition hall that would later become Madrid's anthropology museum, the single entrance from the building's vestibule led to a succession of five rooms along the building's east side that were allotted to Mexico, the first four being connected through a set of aligned doorways. These eastern rooms were devoted to works that, in Paso y Troncoso's words, "completely adhered to the styles that were used by the Indians in the pre-Hispanic era." The physical arrangement of the space meant that visitors were forced to follow a set exhibition route, this physical journey roughly parallel-

11. Vicente Riva Palacio, "Introducción," in Palacio, ed., *México a través de los siglos,* 2 vols. (Mexico, 1887–1889), II, iii. The text reads, ". . . que preparó con una evolución convulsiva y sangrienta, la geografía del mundo y el estado de los espíritus, para recibir la semilla de la moderna civilización." See also Alfredo Chavero, "Introducción," ibid., I, iii–lx. Vicente Riva Palacio was an early ally of Porfirio Díaz and a member of his first cabinet (1876–1880). On nationalist histories under Porfirio Díaz, see Enrique Florescano, *El nuevo pasado mexicano* (Mexico, 1991); Benjamin Keen, *The Aztec Image in Western Thought* (New Brunswick, N.J., 1971); and Daniel Schávelzon, ed., *La polémica del arte nacional en México, 1850–1910* (Mexico, 1988).

ing a temporal one. It was in these first rooms that the majority of indigenous maps and lienzos were hung. But, to reach the fifth room, visitors changed the axis of their trajectory, moving through a doorway set perpendicular to the preceding ones. Once in room five, visitors were presented, not with a determined route, but with choices: access to a large patio or to other exhibitions. It was here, this room with different spatial possibilities, that viewers would finally encounter objects that "carried the stamp of European civilization."[12]

In this final room, visitors encountered another map, one of the few explicit tokens of modernity at the 1892 exhibit. Although the catalog is vague on its identification, it was almost certainly the magnificent railroad map sponsored by the Ministry of Development and printed in Paris two years before the exhibition (Figure 3). This map is enormous, 122 × 183 centimeters, and its size would have rivaled some of the largest indigenous maps on earlier walls. It displays the national space of Mexico at its center. Its edges carefully mark the universal graticule of longitude and latitude, suggesting the government-sponsored surveys that were being carried out, albeit fitfully, in the previous decades. The mathematical model is reaffirmed in its pronouncement of a standard scale, 1:2,000,000, used in its composition. With this map, the space of the nation was not only united to the rest of the world by the imaginary lines of the graticule but also the steel lines of railroad tracks, their routes binding Mexico's mines and haciendas to the coastal ports, ready to bring Mexico's abundant raw materials from its interiors to port cities, and from there to international markets.[13]

12. Paso y Troncoso, *Catálogo*, II, 206. He wrote, ". . . se amoldan enteramente al estilo empleado por los indios en la época gentílica." On exhibition narratives, see Carol Duncan, *Civilizing Rituals: Inside Public Art Museums* (London, 1995); Errington, "Progressivist Stories," in Boone, ed., *Collecting the Pre-Columbian Past*, 209–249. Another theme of the exhibition was the military prowess of the Aztecs, with displays of weapons, insignia, and spolia. In the late nineteenth century, the memory of Aztec military prowess and bold leadership offered an attractive counterpoint to recent historical experience—which included territorial loss, the imposition of a French emperor (1864–1867), and fierce infighting between every change of regime.

13. Although railroad maps of Mexico were produced around this time, most were made by U.S. companies, with texts in English and emphasizing the U.S. rail networks, a comparison unflattering to Mexico and unlikely to have been included in a national exhibit. In contrast, Mexico published few railroad maps of its own territories; this seems be the only one published around the time of the exhibit. The 1890 railroad map was a version of a similar 1:2,000,000 scale map, entitled *Carta general de la Republica Mexicana formado en el Ministerio de Fomento con los datos más recientes por disposición del secretario del ramo, General Carlos Pachecho, 1890*. On the survey, see Craib, *Cartographic Mexico*, 127–161; Robert H. Holden, *Mexico and the Survey of Public Lands: The Manage-*

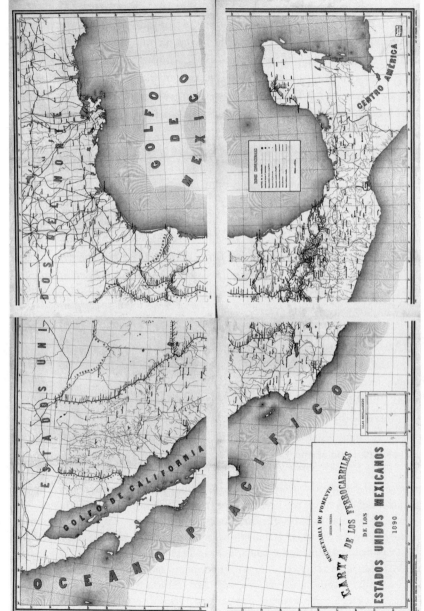

FIGURE 3. *Carta de los ferrocarriles de los Estados Unidos Mexicanos.* Paris, 1890. Courtesy, Geography and Map Division, Library of Congress. The map was printed as four sheets

The railroad map makes no explicit nod to indigenous cartography, but its position in the exhibition did, coming at the end of a sequence of maps that viewers were expected to experience as a temporal narrative—from indigenous past to modern present. The sequence thus proffered a kind of territorial history of the nation of Mexico, its deep historical roots signified (if not actually proved) by the presence of indigenous maps. This territorial sovereignty predated the Spanish colony in the same way that nationalist histories created a Mexico that reached back to before the sixteenth century. While offering closure to the narrative of indigenous maps through the railroad map, the exhibition also took up the related question of indigenous space. Not only was the *Carta etnográfica* on display, where indigenous spaces and peoples were neatly organized in relation to the national space of the central map (Figure 1), but there were also twenty-five photographs of *tipos de indios y campesinos* (types of Indians and peasants). The use of the term *tipos* suggests their ordering by the newly emergent discipline of ethnography, as does the use of photographic technology to document them.[14]

Thus, in the exhibit, like in the atlases of the same period, cartography was used to connect the indigenous past to the present nation as well as to contain indigenous space within the unfolding geographic discourse of the modern nation. Yet Paso y Troncoso and García Cubas were not the first to treat indigenous maps thus. In fact, a similar discourse framed indigenous maps in the sixteenth century, the history of which Mexico's late-nineteenth-century intellectuals were keenly aware.

SIXTEENTH-CENTURY NARRATIVES OF SPATIAL CONTROL

From the moment Spaniards first set foot on the mainland of the New World, they actively sought out geographic maps from the peoples they encountered. The Aztecs, who—along with other Nahuatl-speaking peoples of Central Mexico—had a long tradition of pictographic writing and manuscript painting, created maps of their world, maps whose form and content grew out of Aztec social and political arrangements. The evidence suggests that

ment of Modernization, 1876–1911 (DeKalb, Ill., 1994). On the construction of space vis-à-vis modern capitalism, see Lefebvre, *The Production of Space,* trans. Smith.

14. The conceit that Mexican space can be represented as a progression from indigenous maps to topographical maps continues in modern atlases. See, for example, Sonia Lombardo de Ruiz and Yolanda Terán Trillo, *Atlas histórico de la ciudad de México,* ed. Mario de la Torre (Mexico, 1996). Anderson, in *Imagined Communities,* 175, suggests a similar pattern in coeval Southeast Asia: "Through chronologically arranged sequences of such maps, a sort of political-biographical narrative of the realm came into being."

the Aztecs had a rich tradition of chorography and emblematic mapping, and well into the colonial period they kept highly detailed local cadastral records in the form of large-scale maps.[15]

For the Spanish conquistador, the indigenous geographic map was a strategic document, offering visual knowledge of alien territories. Such strategic maps were also known to the Aztecs, whose merchant class, called *pochteca*, often served as advance men for expansionistic Aztec armies. The Florentine Codex, an encyclopedia of Aztec life created under the auspices of a Franciscan in the 1560s and 1570s, documents one of the pochteca using a map to share strategic information as he reconnoiters with Aztec leaders. Spanish conquistadores would have been eager for such maps as they set out to traverse and possess an unknown continent after the fall of Tenochtitlan in 1521, following routes established by the pochteca. But when conquistadors used only native maps, they inevitably ended up lost. Instead, most were more likely to rely on native guides. When Álvar Núñez Cabeza de Vaca's compatriots landed on Florida, for instance, they quickly captured Amerindians whom they "kept" to serve as guides.

Instead of practical value, indigenous maps seemed to carry symbolic weight. Maps were among the gifts that Hernán Cortés (later named the marqués de Valle) after his first encounters with the Aztec emperor Moteuczoma sent to Charles V, the Spanish monarch. In a letter to Charles, Cortés specifically identified the two maps he sent as ones commissioned for him by Moteuczoma himself. He described one as "a cloth with all the coast painted on it." On their arrival in Spain, these maps drew the attention of the Italian humanist Peter Martyr, who was part of Charles V's court. These maps seem to have been among the sources, if not the source, that an unnamed artist in Nuremberg turned to in order to make the famous map of Tenochtitlan that accompanied the published letters of Cortés (Figure 4). The published map is a distinctly hybrid creation. The map of the Gulf Coast appears at left and

15. See Barbara E. Mundy, "Aztec Geography and Spatial Imagination," in Kurt A. Raaflaub and Richard J. A. Talbert, eds., *Cartography, Ethnography, and Perceptions of the World in Pre-Modern Societies* (Malden, Mass., 2010). The Aztec "empire" was actually a fragile coalition of tributary states—obliged to pay tribute to overlords, headed by the Mexica—in the Valley of Mexico. The emphasis on tribute, not territory, is reflected in Aztec images of empire. Indigenous cartography is surveyed in Mundy, *The Mapping of New Spain: Indigenous Cartography and the Maps of the Relaciones Geográficas* (Chicago, 1996), as well as in Mundy, "Mesoamerican Cartography," in David Woodward and G. Malcolm Lewis, eds., *Cartography in the Traditional African, American, Arctic, Australian, and Pacific Societies*, vol. II, book 3 of *The History of Cartography* (Chicago, 1998), 183–256.

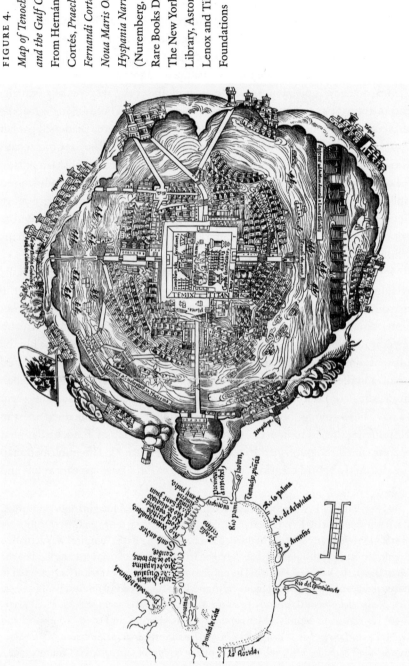

a map of the city of Tenochtitlan at right. In the radial arrangement of space, the centrality and attention paid to the central temples, it is clearly indebted to an indigenous prototype.[16]

The accompanying letter, written by Cortés to his king, makes clear that the symbolic value of the map that he sent as a gift to Charles overshadowed its practical use. In this narrative, Moteuczoma hands his map over to Cortés shortly before he agrees to peacefully turn over his kingdom to the great lord overseas, Charles. In order to accept this putative gift of the indigenous kingdom, Charles had to be reassured that Moteuczoma was, indeed, the natural lord of these proffered lands. Cortés would send a map, a physical token, as proof of the veracity of this transaction, much like the tokens that often accompanied first oral and then written reports in the medieval period. But the map also served as another kind of symbol, this one newly emergent in Europe at the time, a symbol of territorial control. Such an ideology framed the great cycles of maps decorating not only the Alcázar in Madrid but also the Vatican Palace. In short, the indigenous maps that Cortés sent to his own king were a sign that the Aztec participated in the same symbolic economy of state as did their Spanish counterparts. The maps were a powerful piece of evidence of the sovereign existence of an Aztec "kingdom," because the Aztec themselves had already recognized it by mapping it.[17]

After Cortés, European mapmakers continued to appropriate indigenous maps into the "epistemology of space," one of whose constitutive pillars was the mathematical rationalization of geographic forms. In a number of world maps from the sixteenth century, the image of the lake city of Tenochtitlan, itself based on an indigenous prototype, is lifted from the map printed with

16. See Barbara E. Mundy, "Mapping the Aztec Capital: The 1524 Nuremberg Map of Tenochtitlan, Its Sources and Meanings," *Imago Mundi*, L (1998), 11–33. The popularity of Cortés's letter is perhaps most easily gauged by the number of times it was published. The Latin version was published in February 1524, and two Italian editions came out in August of that year. Versions of the letter and the map would be incorporated into the narratives of Benedetto Bordone, Giovanni Battista Ramusio, Antoine Du Pinet, Thomaso Porcacchi, and Georg Braun and Franz Hogenberg, ensuring publication into the seventeenth century.

17. On the ways that sixteenth-century geographic narratives created a New World territory, see Ricardo Padrón, *The Spacious Word: Cartography, Literature, and Empire in Early Modern Spain* (Chicago, 2004); Richard L. Kagan, "Philip II and the Art of the Cityscape," *Journal of Interdisciplinary History*, XVII (1986), 115–135. On maps as territorial symbols, see Kagan, ed., *Spanish Cities of the Golden Age: The Views of Anton van den Wyngaerde* (Berkeley, Calif., 1989); Juergen Schulz, "Maps as Metaphors: Mural Map Cycles of the Italian Renaissance," in David Woodward, ed., *Art and Cartography: Six Historical Essays* (Chicago, 1987), 97–122.

the Cortés letter of 1524 and inserted into the space of central New Spain wholly out of proportion to other topographic features. Although this appropriation can be understood as yet another of the petty plagiarisms that fueled European map production in the early modern period, it can also be seen as another instance wherein indigenous cartography is circumscribed and controlled.[18]

INDIGENOUS SPATIAL NARRATIVES:
THE CASE OF SAN PEDRO IXCATLAN

We could read the nineteenth-century projects of atlas and exhibition as the last phase of the cartographic conquest of Mexico: indigenous productions were absorbed into a triumphant spatial regime of the nation, whose visible image was the geographic map. With its roots in the sixteenth-century project of conquest, this cartographic conquest can also be seen as part of a positivist trajectory traced in the 1892 exhibition itself. Here, indigenous maps, which deserved to be called such—as García Cubas cautioned—only for their intent, gave way to the modern railway map in the final room. In this final, large map image, Mexico's national space was clearly rationalized by measurement, marked by established boundaries, and connected to other national spaces by the universal graticule.

But an examination of one indigenous map, the *Lienzo de San Pedro Ixcatlan* (Figure 5), which is very similar to some of those on display in 1892, suggests why the indigenous map needed to be contained by the dominant cartographic discourse, especially that of the national cartography. For, when analyzed today, this map offers a particular ordering of knowledge that can be seen to destabilize "normative" history and geography. The map, instead of occulting the basis of its authority, explicitly portrays it. And it locates this authority, not in surveys or mathematical models, but, ultimately, in the local recollection and reenactment of events.

This map was named after San Pedro Ixcatlan for its presumed place of origin. It was a region of marginal importance during the colonial period, because it had almost no Spanish settlement and was populated by villages of Mazatec speakers, a small linguistic minority in New Spain and, later, Mexico. It is painted in colors on a large sheet of handspun cotton cloth, carefully

18. See, for instance, the sixteenth-century series of Mercator's *Atlas*, the codeform world map included in versions of Peter Apian's *Cosmographia* after 1544, and Paolo Forlani's *Universale eescrittione di tutta la terra conosciuta fin qui* (Venice, 1562), all of which cannibalize the Cortés map of Tenochtitlan.

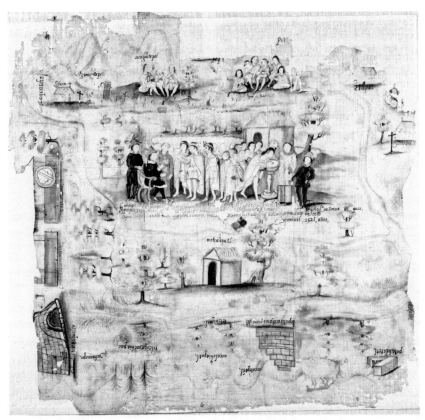

FIGURE 5. *Lienzo de San Pedro Ixcatlan.* Circa eighteenth century. Garrett Mesoamerican Manuscripts Collection No. 19, Manuscripts Division, Department of Rare Books and Special Collections, Princeton University Library

sewn together from two pieces to form a rough square about 128 × 138 centimeters. The original edges of the sheet are now largely gone, and the numerous repairs in the center zone, particularly along folds, suggest a life of steady use: folded and unfolded, hung from the corners, repaired along tears. It is not sized, and pigments—black, brown, blue-green, blue-grey, and yellow—have sunk into the tooth of the fabric and faded over time. Around the left, bottom, and right edges of the sheet are pictures of things or places, marking boundaries, and these are glossed in dark black with names in Nahuatl, the indigenous language of central Mexico. Its creation of space, not through a scale model, but by a ring of boundary place-names set along the edges of the cloth sheet is typical of indigenous maps. Another evocation of space occurs in the landscape painting: along the top and bottom edges of the sheet, moun-

tain ranges are visible, and across its center the paths of two rivers faintly flow toward the right edge.[19]

The combination of place-names and hydrographic features on the *Lienzo* are common to the geographic map, and the "mapness" of the *Lienzo* has been further underscored by one of the first contemporary scholars to write about it. The historian Howard Cline decoded the *Lienzo* by plotting its place-names on a contemporary map of the region of Ixcatlan. But to consider only the maplike parts of the *Lienzo* is to overlook the interaction of its cartography with other signifying elements in the work. The *Lienzo* seems to offer a signal example of the "figurations, [which] like fragments of stories, mark on the map the historical operations from which it resulted." The scenes on the center of the sheet show two founding events that occurred in towns and villages across New Spain and here are shown at Ixcatlan: first, the arrival of the Spanish conquistadores in the 1520s and, then, the conversion of the native community carried out by mendicant friars in the 1520s through 1540s in central Mexico. These narratives are clearly at odds with the construction of cartographic space through a scale model of geography. On the left, we see indigenous leaders, distinguished as such by their long decorated cloaks knotted at the necks and cloth headbands, approaching two figures in European dress, one of them seated on a distinctive chair. Adjacent is a standing figure dressed in the cassock of a Franciscan friar. The style of clothing (the black short belted tunics and leggings) and furniture (the distinctive curule chair) of the Spaniards all appear in indigenous manuscripts of the sixteenth century. Similar chairs served as markers of political authority, and tunics and loincloths were typical indigenous clothing of that period. A second scene unfolds on the right where an indigenous leader, perhaps one of those pictured at left, leans over a baptismal font with hands outstretched, either about to receive the sacrament of baptism or Holy Communion; over him, a tonsured

19. The map is held at the Princeton University Library (Garrett Meso. Ms. 19) as part of the Garrett Collection, which was donated to the library by a collector of catholic tastes in the late 1940s. The library has no other provenance information for the document. Howard Cline never examined this painting; instead, he studied a drawing of the map in the Harvard Library. See Howard F. Cline, "Colonial Mazatec Lienzos and Communities," in John Paddock, ed., *Ancient Oaxaca: Discoveries in Mexican Archaeology and History* (Stanford, Calif., 1966), 270–297. In this work, Cline outlines his reasons for a Mazatec designation. The phrase "ipaxiuitl, 1521 años" in the *Lienzo* states "year" in both Nahuatl and Spanish, a doubling typical of colonial-era Nahuatl documents. See other examples in James Lockhart, *Nahuas and Spaniards: Postconquest Central Mexican History and Philology* (Stanford, Calif., 1991).

Franciscan friar raises up a circular object, which could be the consecrated host or a baptismal ladle.[20]

The gloss below the figures, written in Nahuatl in the clear, blocky script favored by sixteenth-century scribes, seems to corroborate some of the visual information. It ends with the phrase "in the year 1521," which could be the date of the events above. Although parts of the glosses are barely readable, the phrases that are legible seem to mention the Spaniards and Hernán Cortés *(pañol yuá marques),* the Holy Word and an *encomendero* (holder of a crown grant) named de Nava, and a respected priest, Father Luis Valcojo *(Sancto doctrina yhuan comende[ro?] . . . [de?] naba yhua[n] totlatzin frai luis balcojo).*[21]

Cline accepted that the scenes transpiring on the map were historical events taking place around 1521 and attempted to correlate them to Spanish-authored chronicles, reports, and histories, which also center on conquest and evangelization as signal events of the era, in the same way that he correlated the map's space to that of a modern map. One of the textual fragments of the gloss matches official histories: members of the de Nava family were the encomenderos in the region into the seventeenth century. But, otherwise, divergence seems more characteristic. Cortés never seems to have passed through the region to consecrate local rulers (and certainly not in 1521, the year he was busy in central Mexico with the siege of Tenochtitlan), and Franciscans did not spearhead evangelization in the Ixcatlan region.

Although its individual "facts" may not line up with the Spanish historic record, the *Lienzo* does fit the pattern of indigenous histories that were produced in small towns and villages, written in Nahuatl and dating from the seventeenth and eighteenth centuries. These native histories, called *titulos pri-*

20. De Certeau, *Practice of Everyday Life,* trans. Rendall, 121. On chairs, see Lori B. Diel, "Painting Colonial Mexico: The Appropriation of European Iconography in Mexican Manuscript Painting," in Elizabeth Hill Boone, ed., *Painted Books and Indigenous Knowledge in Mesoamerica* . . . (New Orleans, La., 2005), 301–317.

21. The abundant Nahuatl glosses on the *Lienzo* seem to have been added after the work was finished in a different dark black ink that is clearly written over and around the images. This second scribe seems to have been unable to "read" the pictographic glyphs, for she or he has misidentified one glyph as "Cenhualcochimaliz" *(chimalli* is shield), but it is not the immediately adjacent glyph that bears the shield pictograph. That there was an order to the boundary names (or a corresponding list written somewhere else) is suggested by numbers, drawn in faint brown ink perhaps by the original artist of the *Lienzo,* that accompany some of the boundary pictographs. The likelihood that these boundaries could be reencountered today is slim owing to the construction of the Presa Miguel Alemán.

mordiales, depict, in words and pictures, archetypal beginnings or foundation events; their format is variable, and they can be either loose-bound books on paper or painted lienzos on sheets of cloth. They have been described as "folkloric," with their historical anomalies arising from their origins as oral histories. Many of these titulos recount similar (and similarly implausible) land grants being made by a well-known sixteenth-century historical figure, with don Antonio de Mendoza (the first viceroy of New Spain, r. 1535–1550), Charles V, and the "marqués" (Cortés) frequently named as the grant makers. Accounts of primary evangelization are also included. The archetypal foundation events and the content of the glosses all point to the *Lienzo de San Pedro Ixcatlan* as coming from the titulos primordiales tradition.[22]

Not only are the facts of histories challenged in titulos primordiales, so are their protocols. When indigenous copyists redrafted these works, their goal seems not to have been to ossify the information on the earlier versions, but to redraft and update, so that each copy was, in fact, a "new original." The *Lienzo de San Pedro Ixcatlan* is certainly one of these new originals, since the style of the figures and the condition of the cloth reveal, not sixteenth-century manufacture, but a much later one, perhaps in the eighteenth or nineteenth century (the Princeton Library assigns it a date of 1775–1850). But it should be emphasized that these titulos primordiales were rarely made with the intention of contesting official Spanish histories. Instead, as Stephanie Wood underscores, they were directed to a largely internal audience — often to rally the community against real or perceived threats. Marion Oettinger and Fernando Horcasitas traced the modern use of one such lienzo, the *Lienzo de Petlacala,* and found it to be a treasured community document, carefully displayed during yearly festivals. The *Lienzo de San Pedro Ixcatlan,* likewise, seems also to have been made for local consumption, lacking the seals and marks that were usually affixed to such works as they entered into the Spanish judicial system. In its oscillation between official history and local knowledge,

22. Charles Gibson described the titulos primordiales as "an individual or collective memory of lands possessed or once possessed and endangered"; see Gibson, *The Aztecs under Spanish Rule: A History of the Indians of the Valley of Mexico, 1519–1810* (1964; rpt. Stanford, Calif., 1975), 321. "Folkloric" comes from Stephanie Wood, "The Cosmic Conquest: Late-Colonial Views of the Sword and Cross in Central Mexican *Títulos,*" *Ethnohistory,* XXXVIII (1991), 176–195 (quotation on 178–179). For earlier work on the genre, see Wood, "Don Diego García de Mendoza Moctezuma: A Techialoyan Mastermind?" *Estudios de Cultura Nahuatl,* XIX (1989), 245–268. Lienzos are nicely surveyed in Marion Oettinger, Jr., *Lienzos coloniales: Una exposición de pinturas de terrenos comunales de México (siglos XVII–XIX)* (Mexico, 1983).

the *Lienzo* seems to be part of a larger indigenous pattern of integrating local (and thereby disempowered) languages into more powerful official ones.[23]

The *Lienzo*'s "folk history" has a parallel in its "folk cartography." A string, or itinerary, of boundary markers determines the extent of the space contained in the *Lienzo;* landscape painting, rather than symbol, denotes its characteristic topographical features. It includes peripheral settlements, but it is not scale that determines their placement. These settlements include two thatched-roof settlements visible at upper right and upper left, which are glossed as "S. Juan" and "Atilpat." Two distinct clusters of peoples between them suggest two additional communities, whose names have been truncated by the frayed border of the top edge. Their arrangement along the top edge of the sheet has little to do with strict orientation and distance. Instead, the *Lienzo*'s maker depicts space in hierarchical terms, with the most important figures (the historical leaders of Ixcatlan) and places pulled front and center and the occupants of subsidiary places pushed to the peripheries of the sheet. Thus, it is not any Euclidean projection system, like the scale model diminution of distance, but hierarchies of places that organize the space, another "way of seeing" that also lies at the root of alternative projective systems in art.[24]

The inclusion of narratives within cartographic space is hardly a singular phenomenon, and many writers on cartography have treated it as an early stage of cartographic development. De Certeau writes: "But the map gradually wins out over these figures; it colonizes space; it eliminates little by little the pictural figurations of the practices that produce it." He is echoed by the progressivist narrative about maps constructed on the walls of the Exposición

23. On relations of power between languages and the attendant mirroring in social structure, see Pierre Bourdieu, *Language and Symbolic Power,* ed. J. B. Thompson, trans. Gino Raymond and Matthew Adamson (Cambridge, 1991). Joanne Rappaport, *The Politics of Memory: Native Historical Interpretation in the Colombian Andes* (Cambridge, 1990), 2, writes of the attempt of an indigenous community in Colombia "[to integrate] their own brand of historical and cosmological thought within Western-style discourse." Information on the *Lienzo de Petlacala* is from Marion Oettinger, Jr., and Fernando Horcasitas, *The Lienzo of Petlacala: A Pictorial Document from Guerrero, Mexico* (Philadelphia, 1982). Rather than Mazatec, the *Lienzo* uses Nahuatl, the dominant indigenous language in Mexico both before and after the conquest.

24. Such political hierarchies, between "head towns" and their subjects, between doctrinal heads and *visita* churches, were well established in both political and religious networks. See Gibson, *Aztecs under Spanish Rule,* as well as Robert Haskett, *Indigenous Rulers: An Ethnohistory of Town Government in Colonial Cuernavaca* (Albuquerque, N.M., 1991).

Historica-Americana, where the maps with their "pictural figurations" belong to the indigenous past, and maps guided by "descriptive geometry" (arising from surveys) are the products of the new nation.[25]

But to read the *Lienzo de San Pedro Ixcatlan* as a record of past practices—events of 1521—is to further defuse its claims to authority. Why care about a vestigial form of cartography peopled by the long dead? And to call it "folk," although evocative, immediately recalibrates its measure of symbolic power. But if we reconsider the *Lienzo* in a different light, what we witness are present practices, or, rather, Janus-faced events, that both happen in the past as well as in the map's contemporary present. The authority of this image of space lies not only in past actions—the religious baptisms and political consecration that brought the space of San Pedro into existence—but also in present experience.

For instance, the central scene of baptism in the *Lienzo* was not only a past event but also a perpetually repeated performance; its inclusion here suggests that the attendant space was understood to be as much a set of practices as a particular territory. As early as the sixteenth century, native communities represented their towns as Christian churches, marking borders with crosses set atop the more traditional stone *mojones* (boundary markers), suggesting that their local spaces were constituted by the spread of Christianity. In the *Lienzo,* crosses appear to mark boundaries on the left and right of the sheet. For individuals, baptism was the point of demarcation that brought people out of the older "pagan" era (called *tiempos gentílcos* into the nineteenth century) and into the present Christian one, as was the acceptance of the Christian calendar, pegged to the birth of Jesus, along with its attendant annual rituals. But this initial demarcation, recorded in histories and depicted on this lienzo as the sixteenth-century baptism of the community's adult rulers, gained force over time through its continuing reenactment of the emergence from a state of sin (analogous to tiempos gentílicos) to the state of grace. Infant baptisms were done periodically during the liturgical year, and all viewers of this manuscript would have recognized in the *Lienzo*'s central scene a variation of the familiar baptismal rite, with adult godparents massed along one side of the town's stone baptismal font, priest on the other. They were also likely to have witnessed the baptism of distinctively dressed "pagans" like those in the *Lienzo* in the frequent spectacle of morality plays, widely performed during the colonial period and into the present, which often concluded with, or culminated in, scenes of adult baptism.[26]

25. De Certeau, *Practice of Everyday Life,* trans. Rendall, 121.
26. Dana Leibsohn, "Colony and Cartography: Shifting Signs on Indigenous Maps

Like the scene of baptism, the consecration scene was also reenacted. The *Lienzo* shows the encounter of the sixteenth-century ruling elite of the town with Spanish officials; fleshed out by other lienzos and titulos primoridiales, it is clear that here the authorities of the central government are recognizing the existence of the community as a distinct political unit, represented by the pictured leaders. Such public ceremonies were frequently held in towns during which native leaders would be sworn in for all assembled to see. And, although high officials, like the viceroy, would rarely (if ever) come to indigenous towns to reenact the scene shown on the *Lienzo,* throughout the colonial period native leaders would travel to see the viceroy in Mexico City after the election to be confirmed. Consecrations, in the form of swearings in and oaths of office, continue to be part of political protocol. Thus, the scene is both historic and contemporary, the past replayed as present.[27]

The boundaries, as well, signify both past and present. Indigenous colonial maps, as noted above, often include boundaries on their edges, these boundaries the result of historical territorial establishment. In some Mexican communities even today, walking community boundaries is an annual ritual; it is documented in the sixteenth century as well. Through this rite the space of the community is commemorated and, in its performance, created and recreated. And, finally, there is the material object of the *Lienzo* itself, the product of determined recopying—a physical process that brings the past into the present. The version discussed here may date to as late as the nineteenth century; another version in Harvard's library may be later still. Thus, the *Lienzo*

of New Spain," *Reframing the Renaissance: Visual Culture in Europe and Latin America, 1450–1650,* ed. C. Farago (New Haven, Conn., 1995), 264–281. On morality plays in the colonial period, see Robert Ricard, *The Spiritual Conquest of Mexico: An Essay on the Apostolate and the Evangelizing Methods of the Mendicant Orders in New Spain, 1523–1572,* trans. Lesley Byrd Simpson (Berkeley, Calif., 1974); Marilyn Ekdahl Ravicz, *Early Colonial Religious Drama in Mexico: From Tzompantli to Golgotha* (Washington D.C., 1970). Well-known performances that often included adult baptism were the "Moros y cristianos" plays, where defeated Muslims accept Christian baptism, as well as plays celebrating the feast of Saint John the Baptist. On the history and continuing performance of these plays, see Max Harris, *Carnival and Other Christian Festivals: Folk Theology and Folk Performance* (Austin, Tex., 2003); and Harris, *Aztecs, Moors, and Christians: Festivals of Reconquest in Mexico and Spain* (Austin, Tex., 2000).

27. Gibson, *Aztecs under Spanish Rule,* 179; such confirmations continued pre-Hispanic practices. Within the Aztec empire, leaders traveled to Tenochtitlan for confirmation. In the Mixtec region, local rulers sought consecration by powerful regional lords or priests. See Mary Elizabeth Smith, *Picture Writing from Ancient Southern Mexico: Mixtec Place Signs and Maps* (Norman, Okla., 1973); John M. D. Pohl, *The Politics of Symbolism in the Mixtec Codices* (Nashville, Tenn., 1994).

de San Pedro Ixcatlan, like others of its kind, is important because it points to alternate types of spatial construction and spatial authority, existing both within the frame of the map and outside it.

CONCLUSIONS

In the rich array of pre-Columbian works they assembled for their national exhibition, Mexican elites clearly meant to prove to Europe the glory of their pre-Hispanic past, an idea also expressed in the Paris exhibition three years before. And, in including so many maps, they were able to express the historical roots of the great map image of modern Mexico that greeted visitors in the final, and most European, room of the exhibition (Figure 3). This map had been carefully constructed and was laid out along a geometric graticule, its interior space, densely populated with cities and towns, connected to the international economy by the skeins of railroad lines running across its surface. But the harnessing of indigenous maps into national space, despite the determined wrestling of Mexico's geographers and historians with this cartographic material, was always problematic. For the desire of Mexican intellectuals to reclaim and celebrate the pre-Columbian past, thus marking their historical difference from Europe, was coincident with their aspirations to build a modern nation-state. And modernity meant effacing contemporary indigenous difference, a difference often construed in temporal terms (Indians as "backward") and spatial ones (Indians as *campesinos,* "countryside-dwellers"). In emphasizing only the historical nature of the "pictural figurations" in indigenous maps as well as evaluating them in terms of modern geographical maps, modern scholars have, unwittingly, contributed to this distancing. But, if we move away from seeing the mathematical grid as the definitively authorizing feature of cartography, we find that the *Lienzo de San Pedro Ixcatlan* authorizes space both in historical narratives and their contemporary parallels. Space is thus construed as practice, carried out by community members. That lienzos like *San Pedro Ixcatlan,* which lies carefully preserved in a university library, continue to be held and valued by communities in Mexico points to the ambivalent modernities that suffuse the national space.[28]

28. Néstor García Canclini, *Culturas híbridas: Estrategias para entrar y salir de la modernidad* (Mexico City, 1990).

THE SPECTACLE OF MAPS IN
BRITISH AMERICA, 1750–1800

Martin Brückner

When in February 1770, after a three-year subscription campaign, John Henry finally published *A New and Accurate Map of Virginia,* his first and only map invited public notice (Figure 1). Consisting of four sheets, the map measured when fully assembled an eye-catching thirty-eight by fifty-two inches. Minute graphic symbols marking mountains, rivers, and habitations asked for the closer reading of Virginia's geography. At the same time, the map's neoclassical title cartouche appealed to the discerning viewer versed in eighteenth-century graphic design and pictorial allegory. Blending cartographic and artistic representation, the Henry map competed with an older generation of large maps put on display in the British colonies, including Joshua Fry and Peter Jefferson's rococo-styled *Map of the Most Inhabited Part of Virginia.*[1]

Given the competition, the public took notice, but not in a way that was

Research for this essay was made possible by a 2009 National Endowment for the Humanities grant at the Winterthur Museum. I am indebted to Linda Eaton (textiles), Pat Halfpenny (ceramics), Joan Irving and John Krill (paper), Emily Guthrie (rare books), Jeannie Solensky (manuscripts), and Laura Johnson (curatorial intern) for their support and advice. Thanks also to Fredrika Teute, reader par excellence.

1. On the history of the Henry map, see Margaret Beck Pritchard and Henry G. Taliaferro, *Degrees of Latitude: Mapping Colonial America* (New York, 2002), 200–203; and David Bosse, "Maps in the Marketplace: Cartographic Vendors and Their Customers in Eighteenth-Century America," *Cartographica,* XLII (2007), 17. In 1770, Virginia audiences would have been able to purchase the 1768 edition of Joshua Fry and Peter Jefferson's *Map of the Most Inhabited Part of Virginia . . .* (1751; 31 × 49 inches). Other large maps that were owned and displayed in 1770 included third or fourth editions of Thomas Jefferys and Braddock Mead's *Map of the Most Inhabited Part of New England . . .* (1755; 41 × 39 inches), Emmanuel Bowen and John Gibson's *Accurate Map of North America* (1755; 40 × 46 inches), or John Mitchell's *Map of the British and French Dominions in North America . . .* (London, 1755; 53 × 76 inches). On particular map states, see Pritchard and Taliaferro, *Degrees of Latitude,* 154, 168, 177, 180.

FIGURE 1.
John Henry, *A New
and Accurate Map of
Virginia* . . . (London,
1770). Permission, The
Colonial Williamsburg
Foundation

much to Henry's liking. As with all conspicuous objects funded by private or public subscription, the map invited scrutiny and comment by the media. Between September 1770 and January 1771, the *Virginia Gazette* published a series of reviews that, in a two-punch approach, demolished the map's reputation and that of John Henry as a mapmaker. The first critique accused Henry of gross omissions and mistakes. As a review written under the pseudonym of "Geographus" observes, "He is mistaken in the breadth and courses of . . . Chesapeak, Potowmack, Rappahannock, York and James [rivers] . . . [N]one of the roads are laid down . . . Winchester, Fort Cumberland, and Dumfries, are not in the map . . . Norfolk is placed in Princess Anne . . . James Town [is] north of Williamsburg . . . and a few other such trifling mistakes." The second critique Henry himself sought to preempt when he acknowledged "inaccuracies . . . which regard . . . the situation of Gentlemens seats." As much as critics complained that rivers were mismeasured and whole towns misplaced, they were equally irked by Henry's failure to sufficiently document the manors and plantations of Virginia's propertied classes. This omission prompted one critic to sardonically suggest that accurate science was trumped by stylish aesthetics: it was "good Taste, which directed you to a better Disposition of Gentlemens Seats, and to assign more beautiful Dimensions and Courses to the Rivers, than those which Nature had allotted them."[2]

In reviews like these, Henry's critics applied some of the same evaluative principles that have been at the core of modern and postmodern responses to early American maps. In the first critique, maps are reviewed according to the utilitarian expectation that maps were scientific records providing a quasi-mimetic representation of physical and cultural landscapes. This expectation was raised by one of the more pervasive definitions of the term "map" — and this definition has not varied much between the mid-eighteenth and late twentieth centuries — according to which, quoting from *A Pocket Dictionary; or, Complete English Expositor* (1753), a map is "a representation of the whole, or a part of the earth, upon a plane superficies, describing the situation and form of countries, etc." From the moment maps were recognized as failing to describe a country because they lacked, misrepresented, and ultimately misguided the "situation" or "form" of any given geographic location, critics not only challenged a map's cartographic integrity but also categorically dismissed its use value.[3]

2. *Virginia Gazette*, Sept. 27, 1770 (Rind), Sept. 6, 1770 (Purdie and Dixon), Jan. 31, 1771 (Purdie and Dixon) (also cited in Pritchard and Taliaferro, *Degrees of Latitude*, 200–203).

3. Compare the 1753 definition of a map given by *A Pocket Dictionary; or, Complete*

Turning to the second critique, since much of the map's usefulness was riding on its ability to let readers find their place in both the material *and* the social world, Virginia reviewers objected to Henry's map and its omission of "Gentlemens Seats" because the map had not fulfilled certain ideological expectations. As postmodern definitions and approaches to maps have shown, maps were as much representations of places as they were "refracted images contributing to dialogue in a socially constructed world." The dialogue surrounding the Henry map indicates that literate Virginians understood maps to be full of cultural value judgments that had less to do with the mapmaker's accurate reproduction of the material world and more with the organization of the map users' social world. The Henry map rankled Virginia patrons because it was insufficiently ideological, depending on one's point of view. Considering that the map's primary sponsor was the newly appointed Lord Botetourt, the omission of country estates owned by the established Virginia gentry could easily be construed as a political slight and personal affront; at the same time, in the larger scheme of political representation such omissions not only misrepresented Virginia's social topography but also the spatial representation of kinship networks and centers of political power.[4]

Yet, before we dismiss the Henry map as the quintessential "bad" map, it is important to note that the barrage of criticism published in the *Virginia Gazette* ended on a surprisingly conciliatory note. In a final review, the

English Expositor (London) to this 1996 definition: "A representation, usually on a plane surface, of all or part of the earth or some other body showing a group of features in terms of their relative size and position"; see Norman J. W. Thrower's textbook, *Maps and Civilization: Cartography in Culture and Society* (Chicago, 1996), 254. Definitions like these evaluate maps through an empiricist paradigm applying modalities such as mathematical accuracy, proportional verisimilitude, and so forth. It continues to be the dominant paradigm found in textbooks, encyclopedias, and popular histories. See Helen M. Wallis and Arthur H. Robinson, *Cartographical Innovations: An International Handbook of Mapping Terms to 1900* (Tring, Hertfordshire, 1987); John Noble Wilford, *The Mapmakers: The Story of the Great Pioneers in Cartography — from Antiquity to the Space Age* (1982; rpt. New York, 2001).

4. J. B. Harley, *The New Nature of Maps: Essays in the History of Cartography*, ed. Paul Laxton (Baltimore, 2001), 53. Harley's work, influenced by Michel Foucault and Jacques Derrida, launched a paradigm shift in the way in which maps are today defined and analyzed. Concentrating on the textual / discursive nature of maps and how maps as texts shape social and political power relations, Harley has not only reshaped cartographic history but also studies on transatlantic and indigenous history, art history, cultural studies, and literature. On cartographic literacy, see Martin Brückner, *The Geographic Revolution in Early America: Maps, Literacy, and National Identity* (Chapel Hill, N.C., 2006).

critic—after complaining yet again about the mapmaker's "Ignorance" and "Mistakes"—undercuts most of his complaints by reminding readers that he "ha[d] often seen [their] Maps hung up in Houses, not because they were reckoned *useful*, but *ornamental*." By juxtaposing the terms "useful" and "ornamental," the author unexpectedly broadened the scope of map evaluation, blurring—if not inverting—the public's judgment about the functional value of maps. When all was said, the critic still praised the Henry map: it might be useless for finding geographical places, but it was quite useful when placed as an ornamental object inside Virginia houses.[5]

This distinction between useful and ornamental maps invokes two important map definitions familiar to Virginians (and the transatlantic world) in 1771 but largely unfamiliar to students of maps today. First, by emphasizing the "ornamental" value of maps, the author invokes a "picture" definition of maps that was not only popular but dominant during the second half of the eighteenth century. Lexicographers from Samuel Johnson to Thomas Sheridan to William Perry considered maps to be first and foremost "geographical pictures."[6] Secondary terms such as "description," "delineation," and "projection" fused the term "map" semantically to perspective theories and graphic practices. Be it textbooks, encyclopedias, or technical treatises, discussions associated maps less with the tools of empirical science and more with materials emerging from the studios and shops of painters, engravers, and printmakers. Indeed, variously called a "View," a "Prospect," or a "Portraiture," maps were not only categorized along with the visual arts in general but also, as demonstrated by William Guthrie's 1770 textbook analogy, with the fine arts in particular: "Maps differ from the globe in the same manner as a picture does from a statue."[7]

5. *Va. Gaz.* (Purdie and Dixon), Jan. 31, 1771 (emphasis added).

6. In 1755, Samuel Johnson declares a map to be "a geographical picture on which lands and seas are delineated according to the latitude and longitude" (*A Dictionary of the English Language* [London]). This picture definition was used in dictionaries by William Rider (1759), D. Fenning (1761), Frederick Barton (1772), Thomas Harrington (1775), William Kenrick (1773), Thomas Sheridan (1789), and, finally, by William Perry, who defines a map as "a geographical picture upon which lands and seas are delineated according to the longitude and latitude, a chart," in *The Synonymous, Etymological, and Pronouncing English Dictionary* . . . (London, 1805). On this definition, see J. H. Andrews, "What Was a Map? The Lexicographers Reply," *Cartographica*, XXXIII, no. 4 (Winter 1996), 1–11, which is based on a catalog of definitions of the word "map" published between 1649 and 1996.

7. William Guthrie, *A New Geographical, Historical, and Commercial Grammar* . . . (1770; rpt. Montrose, Scot., 1799), 29. Also quoted in Alan Downes, "The Bibliographic

In the second (and now mostly forgotten) definition, maps were evaluated in terms of visual aesthetics and in those of material culture. Having seen "ornamental" maps "often . . . hung up in Houses," the Virginia critic tapped into the emergent discourse of the decorative arts in which maps were described as decorative objects. According to English mapmaker Christopher Packe, a map was a "picture" because it showed "'the beautiful Distinction . . . and the exact Harmony of the whole Country' . . . *not as in a Map*, 'but as in a Landskip.'" Despite their planar projection, maps are here compared to landscape paintings offering perspective and spatial depth. Thus classified as pictures, Packe goes on to reclassify maps as objects by comparing a finished map to "a compleat House, adorn'd with all it's Furniture" (whereas the map's initial draft, the surveyor's plat, merely resembles the unfinished "Frame of any Building"). In this "House" analogy, Packe suggests that eighteenth-century map consumers associated maps with three-dimensional household goods. Viewed as a "Landskip," a map would be treated like other decorative objects hanging on walls, such as picture frames, mirrors, and curtains. Conceived as "Furniture," ornamental maps like the Henry map would not only "adorn" the house but also serve to establish, if not "the exact Harmony of the whole Country," at least the harmony of the "compleat House."[8]

In eighteenth-century definitions, then, we discover that the distinction between "useful" and "ornamental" maps evoked a cultural understanding in which a map's cartographic and aesthetic functions were valued as mutually constitutive and as integral to the aesthetics of material life. Modern and postmodern critical studies, by contrast, have dismissed or underestimated the map's ornamental function. Since the 1950s, when critical attention settled squarely on reading maps as products of empirical science, a map's pictorial quality was cause for its hasty dismissal from analytical discussion. According to Arthur Robinson's *The Look of Maps*, "fancy borders, ornamental cartouches [and] curvaceous lettering" may be considered a "source of pleasure" but were not expected to "add to the functional quality of a map."[9] During the 1980s,

Dinosaurs of Georgian Geography (1714–1830)," *Geographical Journal*, CXXXVII, no. 3 (September 1971), 383.

8. *Va. Gaz.* (Purdie and Dixon), Jan. 31, 1771; Christopher Packe, *Ankographia; sive, Convallium Descriptio: In Which Are Briefly but Fully Expounded the Origin, Course and Insertion, Extent, Elevation and Congruity of All the Valleys and Hills, Brooks and Rivers (as an Explanation of a New Philosophico-Chorographical Chart) of East-Kent* (Canterbury, Kent, 1743), 3 (also cited in Matthew H. Edney, "Reconsidering Enlightenment Geography and Map Making," in David N. Livingstone and Charles W. J. Withers, eds., *Geography and Enlightenment* [Chicago, 1999], 173).

9. Arthur H. Robinson, *The Look of Maps: An Examination of Cartographic Design*

map historians like Leo Bagrow and David Woodward began a critical move-
ment seeking to reevaluate early modern maps as "works of art." But their
efforts coincided with the ensuing decade's intellectual focus on the textual
analysis of maps, causing a limited engagement with, as G. N. G. Clarke writes,
the "subtle relationship between the scientific and decorative." Since then,
the few studies that have addressed a map's ornamental form and function
tend to favor maps produced *before* the eighteenth century. The ornamental
interpretation of maps produced after 1700 has been hindered by a biased
argument according to which sometime by midcentury, in the wake of what
has been called the "cartographic reformation," "maps ceased to be works of
art, the products of individual minds, and . . . craftsmanship was finally super-
seded by specialised science and the machine."[10]

Taking its cue from the Virginia map review of 1771, this essay seeks to re-
vive the prematurely dismissed ornamental understanding of maps. It asks

(Madison, Wis., 1952), 17. For an excellent survey of critical attitudes, see Matthew H.
Edney, "Cartography without 'Progress': Reinterpreting the Nature and Historical
Development of Mapmaking," *Cartographica*, XXX, nos. 2–3 (Summer–Winter 1993),
54–68.

10. On reconnecting cartography to art, see Leo Bagrow, *The History of Cartography*,
2d ed. (Cambridge, Mass., 1985), 20–25 (quotation on 22); David Woodward, ed., *Art
and Cartography: Six Historical Essays* (Chicago, 1987), which includes an extended ver-
sion of Svetlana Alpers's influential "The Mapping Impulse in Dutch Art" (51–96); and
Ronald Rees, "Historical Links between Cartography and Art," *Geographical Review*,
LXX (1980), 60–78. Overshadowed by the textual turn, only a few scholars focused
on what the previous generation of critics had rejected, namely the design of map ele-
ments such as title cartouches (the "visual register in which a map's cultural meaning
is suggested"), "visual calligraphy" (the lettering, color, thickness of lines, symbols),
or the map's cognitive *gestalt* (iconology, logo). See G. N. G. Clarke, "Taking Posses-
sion: The Cartouche as Cultural Text in Eighteenth-Century American Maps," *Word
and Image*, IV (1988), 455 (quotation), 471; Eileen Reeves, "Reading Maps," ibid., IX
(1993), 51–65; Brückner, *Geographic Revolution*, 98–141. What has gone unexamined is
that maps as texts or pictures were material objects.

As Woodward sums it up, anti- and pro-ornament schools of interpretation per-
petuate a general bias against ornamental maps by dividing the history of cartography
into "a decorative phase, in which geographical information was usually portrayed in-
accurately, and a scientific phase, in which decoration gave way to scientific accuracy"
(Woodward, *Art and Cartography*, 2). For examples of this self-imposed periodization,
see Peter Barber, "Necessary and Ornamental: Map Use in England under the Later
Stuarts, 1660–1714," *Eighteenth-Century Life*, XIV (1990), 1–28; and Barber, "Maps and
Monarchs in Europe 1550–1800," in Robert Oresko, G. C. Gibbs, and H. M. Scott, eds.,
*Royal and Republican Sovereignty in Early Modern Europe: Essays in Memory of Ragnhild
Hatton* (Cambridge, 1997), 75–124.

two basic questions: What are ornamental maps, and what kind of work do they perform in eighteenth-century America? To answer these questions, the essay steps outside conventional map criticism and approaches maps similar to the way in which W. J. T. Mitchell has proposed we ought to be "'address-ing' media," examining maps, "not as if they were logical systems or struc-tures[,] but as if they were environments where images live, or personas and avatars that address us and can be addressed in turn." In contrast to past ap-proaches, which if they explored the ornamental meaning of maps did so from *within* the map, this essay's approach is environmental; it opens up the map for analysis from the *outside*. In this approach, maps are not defined by what they represent. Rather, as Christian Jacob has argued, the map's meaning is contingent on the materiality surrounding its presentation; a map's content hinges as much on its internal composition as on the conditions of external display, its materiality and material surroundings, and by the way this shapes our ways of looking at maps. Or, to put it differently, in order for us to under-stand the ornamental use of maps like the Henry map, instead of looking at it exclusively as a complex text we must look at it more broadly as a "thing" whose meaning is "entangled with the world beyond its edges."[11]

In order to examine the spectacle of maps in America between 1750 and 1800, this essay pursues two lines of inquiry. The first line of inquiry is eco-nomic and statistical; its goal is to recover the genre of "display" maps, in par-ticular monumental or immobile maps, in the marketplace. The second line of inquiry recovers the staging of maps as decorative objects, exploring the way

11. W. J. T. Mitchell, *What Do Pictures Want? The Lives and Loves of Images* (Chicago, 2005), 203; Christian Jacob, *The Sovereign Map: Theoretical Approaches in Cartography throughout History,* trans. Tom Conley, ed. Edward H. Dahl (Chicago, 2006), 76–77; Robert Blair St. George, *Conversing by Signs: Poetics of Implication in Colonial New En-gland Culture* (Chapel Hill, N.C., 1998), 5. My question of what is "ornamental" about maps is informed by critical work summarily called "thing studies," which places ob-jects at the center of inquiries that track, for example, the biography of things, their status as cargo, or the literary adaptation of things as "It-narratives." For an introduc-tion to this mode of criticism, see work in anthropology, critical theory, and visual and literary studies: Arjun Appadurai, *The Social Life of Things: Commodities in Cultural Perspectives* (Cambridge, 1986); Bill Brown, "Introduction," *Things,* ed. Brown (Chi-cago, 2004); Brown, *A Sense of Things: The Object Matter of American Literature* (Chi-cago, 2003); Jennifer L. Roberts, "Copley's Cargo: Boy with a Squirrel and the Dilemma of Transit," *American Art,* XXI, no. 2 (Summer 2007), 21–41; Mark Blackwell, ed., *The Secret Life of Things: Animals, Objects, and It-Narratives in Eighteenth-Century England* (Lewisburg, Pa., 2007); Cynthia Sundberg Wall, *The Prose of Things: Transformations of Description in the Eighteenth Century* (Chicago, 2006).

in which maps were embedded—really and symbolically—in relation to the space of map displays (architecture), the decorative arts (ornaments), and the material culture of everyday life (furniture). Ultimately, this essay explores the spatial work of open-faced sheet maps (as opposed to bound and closed book maps) in order to reexamine the way in which maps carto-coded visual culture, sense perception, and social life in eighteenth-century America.

CONSPICUOUS COMMODITIES

What is fascinating about the hubbub surrounding the Henry map is that its publication coincided with the moment in American history when maps had become established as consumer goods. It is important to note that Henry's map entered the Virginia marketplace in the midst of expanding consumption.[12] Before the 1750s, large ornamental maps had not been widely available artifacts. Only during the second half of the eighteenth century did a fledgling American map trade develop into a potentially lucrative business. This business was initially driven by individual mapmakers, land speculators, and select colonial and imperial agencies. Political events, such as the first siege of Louisbourg in 1745, the onset of Anglo-French hostilities in 1755, or the defeat of the French in 1760, triggered periodic increases in topical map production and purchase. During these decades, maps emerged from an increasingly intricate import-export network consisting of American retailers and overseas wholesalers, printers, engravers, publishers, and sellers of printed goods. By the 1770s, the number of maps offered for sale in America—and these included reprints of antiquated maps and new maps promising the most accurate and latest information—had reached an unprecedented high mark, suggesting that the American map supply had become consistent with a burgeoning marketplace that was flush with consumer goods.[13]

12. T. H. Breen, "An Empire of Goods: The Anglicization of Colonial America, 1690–1776," *Journal of British Studies*, XXV (1986), 467–499; Breen, *The Marketplace of Revolution: How Consumer Politics Shaped American Independence* (Oxford, 2004); Cary Carson, Ronald Hoffman, and Peter J. Albert, eds., *Of Consuming Interests: The Style of Life in the Eighteenth Century* (Charlottesville, Va., 1994). For the transatlantic world, see Neil McKendrick, John Brewer, and J. H. Plumb, *The Birth of a Consumer Society: The Commercialization of Eighteenth-Century England* (Bloomington, Ind., 1982).

13. Business advertisements in the *Pennsylvania Gazette* (hereafter cited as *PG*) document periods of a cartographic boom coinciding with political events. During the 1740s, ads posted by bookstores, print shops, and general stores carried the word "map" in about three ads per year. After 1750, however, the average number per year doubled and even tripled, showing two distinct peaks in cartographic advertising: twenty-two ads were published in 1754–1755 and twenty-five ads in 1760–1761. Ameri-

Eighteenth-century advertisements vividly document the ascent of map commerce in British America, revealing three strategies that not only facilitated the dissemination of maps but also the acceptance of maps as decorative goods. The first strategy promoted maps as household objects appealing to the affluent consumer and people of lesser means. On the one hand, lists of conspicuous luxury items included maps: "neat japann'd tea-tables and corner-cupboards, newest fashion'd silver snuf-boxes, fine christal and garnet sleeve buttons set in silver and gold, best Hill's silver watches, maps of Canaan, England, London and Pensylvania, fine long whale bone, etc." On the other hand, maps appeared along with everyday household objects: "Irish linen and Lancaster sheeting; variety of maps and fishing tackle, English RED CLOVER SEED, with sundry other goods, too tedious to mention." Ads like these consider maps as general retail goods. They also indicate that the sale of maps began in venues that had little to do with printed goods. Or, as David Bosse writes, "In the colonies and the early republic, one might as readily purchase a map from an apothecary or hardware merchant as from a book- or print seller."[14]

In the second advertising strategy, vendors specializing in printed goods pointedly sold maps next to picture prints. As early as 1721, American shopkeepers, like William Price in Boston, placed ads selling maps along with prints as the same line of products, either by simply listing "Pictures and Maps" (1722) or by using more descriptive terms: "a great Variety of all Sorts and Sizes of the newest Maps and Prints by the best Masters, in Frames and Glass or without" (1733).[15] Ads like these imitated the classification of maps as picture prints practiced by British overseas wholesalers. Sales catalogs produced by the most prominent eighteenth-century print sellers—ranging from the Bowles dynasty to start-up entrepreneurs like Robert Sayer and John Bennett—headlined "prints" and "maps" as commercially and conceptually com-

can map production was very low until the 1790s. See Bosse, "Maps in the Marketplace," *Cartographica*, XLII (2007), 1–9.

14. *PG*, Feb. 20, 1750, Apr. 25, 1754; Bosse, "Maps in the Marketplace," *Cartographica*, XLII (2007), 10.

15. *Boston Gazette*, May 28, 1722, Jan. 8, 1733. Price continued ads in this vein until 1750; see Timothy Clayton, *The English Print, 1688–1802* (New Haven, Conn., 1997), 12. Historians frequently mention the affinities that link the production of picture prints and maps. See ibid., 105, 150, 220; Antony Griffiths, *Prints and Printmaking: An Introduction to the History and Techniques* (Berkeley, Calif., 1996), 144; Richard L. Hills, *Papermaking in Britain, 1488–1988: A Short History* (London, 1988), 48, 79; E. McSherry Fowble, *Two Centuries of Prints in America, 1680–1880: A Selective Catalogue of the Winterthur Museum Collection* (Charlottesville, Va., 1987), 276–283.

patible goods. Trade cards by Fenwick Bull (1753) or frontispieces, such as the one introducing John Bowles's *Catalogue of Maps* (Figure 2), went one step further. Using the shorthand effect of the *trompe l'oeil,* the card not only explicitly classified maps along with pictures but also with the pictorial contents of print genres deemed morally edifying or tasteful entertainment. Included next to images of figural drawing books, picturesque landscapes, and seascapes, maps were identified as printed products originating from the very image-making industry that served a new audience invested in the visual arts. During the early eighteenth century, prints became separated from the traditional classification of pictures. While paintings were unaffordable and unavailable to most people, printed images became an inexpensive alternative that was at once widely available and generated new demand. The commercial packaging of maps with picture prints reflected more than the paradigmatic separation between prints and pictures. It was a sign that, with the spread of printmaking, sellers and buyers categorized maps wholesale as one distinct genre among many printed pictures.[16]

The third sales strategy for maps hinged on the material finish and packaging of maps. By midcentury, American shops sold not only hefty folio imports containing large folded maps, such as Thomas Jefferys's *American Atlas* (1775), but offered a variety of less weighty paper genres bearing map imprints, such as pamphlets, magazines, and almanacs. Having already stressed the similarity between pictures and maps, map sellers advertised unbound maps not in the terms of books, bindings, or stationery goods. Rather, when sold in loose sheets, map advertisements used the language reserved for the sale of pictures and their material hardware. Consider the following examples:

> Large and handsome sconce and pier Looking-Glasses, small Glasses by the Dozen, suitable for Traders, Maps of the Four Quarters of the World, ditto of the four Provinces of Massachusetts, New Hampshire, Rhode Island, and Connecticut. A Variety of large and small Metzotinto Prints,

16. John Bowles, *A Catalogue of Maps, Prints, Copy-Books, etc. from Off Copper-Plates* (London, 1731); *Robert Sayer's New and Enlarged Catalogue for the Year MDCCLXVI of New, Useful, and Correct Maps* . . . (London, 1766); Sayer and John Bennett, *Sayer and Bennett's Enlarged Catalogue of New and Valuable Prints, in Sets, or Single; Also Useful and Correct Maps and Charts* . . . (London, 1775). For other examples using map images as visual backdrops, see the frontispieces introducing Bowles, *A Catalogue of Maps* (1731) or the trade card of Peter Griffin (1747), stating: "All sorts of Maps both Foreign and English,—Fine French, Italian, Dutch, and English Prints." Reproduced in Clayton, *The English Print,* 105, 110. On the generic split between prints and pictures, see ibid., 25–35.

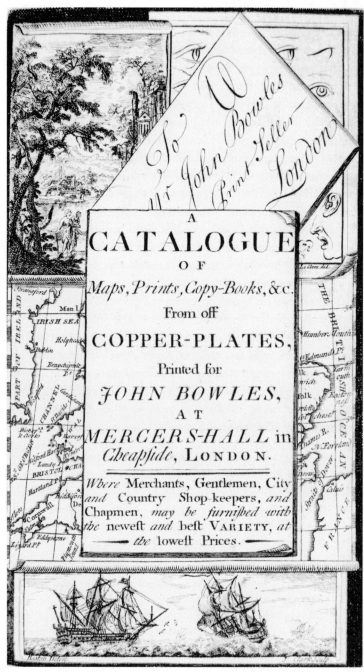

FIGURE 2. John Bowles, frontispiece to *A Catalogue of Maps, Prints, Copy-Books* ... (London, 1753). Image courtesy of Special Collections, University of Delaware Library, Newark, Del.

plain and coloured, among which are the King and Queen, the late Lord Mayor Beckford, the Rev'd George Whitefield, the newest Impression, and others of Note, suitable for painting on Glass, with the best London Crown Glass for that use. [1771]

The World . . . in two large Hemispheres. . . . This Map is decorated all round with 20 small Maps . . . Printed on 28 Sheets of Royal Paper, and measures 9 Feet in Width, 6 Feet 4 Inches in Depth, and is very useful and entertaining, for large Rooms and for Screens. Price 15s. in Sheets, uncoloured; on Canvas, with Rollers, and coloured, £1 15s. [1775][17]

A few material additions—involving cloth, wood, glass, or paints—resulted in a categorical slippage that allowed maps to jump consumer scales. In the case of large multisheet maps, cartographic "pictures" turned into oversized wall furniture. Measuring anywhere from fourteen (Henry map) to fifty-four square feet (the map of *The World*), these maps were mounted on cloth and attached to hanging rollers, and thus resembled material formats that were usually associated with rich tapestries, curtains, and other textile wall hangings. A similar material redefinition took place for two- or single-sheet maps. These maps were sold on "super-fine writing paper," "glazed," "framed," or "varnished." Such material additions transformed the sales strategy of maps. Whether the map was supersized or regular-sized, or whether it was sold at "the picture shop" or at the general retail store, by selling maps along with prints and picture frames advertisers steered audiences rather bluntly toward a decorative turn in map consumption.[18]

17. Christopher M. Klein, *Maps in Eighteenth-Century British Magazines: A Checklist* (Chicago, 1989); David C. Jolly, *Maps of America in Periodicals before 1800* (Brookline, Mass., 1989). Small single-sheet maps were regularly tipped into bound volumes such as geographies, histories, and travel narratives; see Jim Walsh, *Maps Contained in the Publications of the American Bibliography, 1639–1819: An Index and Checklist* (Metuchen, N.J., 1988). For the examples, see *Boston News-Letter,* May 16, 1771; Sayer and Bennett, *Sayer and Bennett's Enlarged Catalogue,* 25. Maps were catalogued by size: "Large Maps" like the world map were followed by "Maps on Four Sheets," such as *A New and Accurate Map of North America, Describing and Distinguishing the British, Spanish, and French Dominions . . . according to the . . . Treaty . . . 1763 . . .* by Emmanuel Bowen and John Gibson, Geographers, "Price 5 s. On Canvas, with Rollers, 9s" (34), and "One Sheet Maps," like Lewis Evans's *General Map of the Middle British Colonies . . . Corrected by Thomas Jefferys* (57), sold for 1s. 6d.

18. These material additions to maps are specified in *PG* ads from Nov. 27, 1755, July 16, 1767, or July 13, 1774. Between 1730 and 1800, advertisements in *PG* consistently list entries for "maps" next to "pictures," "prints," or "cuts." During the eighteenth century, quality maps were printed on soft-sized laid paper so that maps would be "absor-

Even before material finishes were used to recommodify maps into orna-
ments, sales catalogs reveal that the very commodity status of maps involved
an economic model linking them to decorative prints. Throughout the eigh-
teenth century, map producers and consumers treated maps as commodities
in the conventional materialist sense of the term, that is, as things produced
for sale with specific monetary value. Published map prices, combined with
prices printed in shop ads and inventories, indicate that map buyers pur-
chased maps according to a finely tuned scale matching a map's commercial
price and ornamental value. A 1766 broadside advertising a map sale held
by Philip Freeman in Boston shows that map prices were arranged by size
("4 Sheets"), by content ("Europe"), and by material add-ons, such as canvas,
rollers, or bookbinding.[19]

The broadside's language and price structure is representative of map cata-

bent without being too soft or spongy; was smooth in texture, of regular thickness, and
free from roughness, lumpiness, and specks of foreign matter; and was of a suppleness
that resisted crumpling." See Anthony Dyson, *Pictures to Print: The Nineteenth-Century
Engraving Trade* (London, 1984), 165; and Mary Sponberg Pedley, *The Commerce of Car-
tography: Making and Marketing Maps in Eighteenth-Century France and England* (Chi-
cago, 2005), 66. On paper in colonial America, see John Bidwell, "Part Two: Printers'
Supplies and Capitalization," in Hugh Amory and David D. Hall, eds., *The Colonial
Book in the Atlantic World*, vol. I of *A History of the Book in America* (Cambridge, 2000),
163–183; and Dard Hunter, *Papermaking: The History and Technique of an Ancient Craft*
(New York, 1967), esp. 136–137. See also Hills, *Papermaking in Britain*.

19. Philip Freeman, *Boston, September 30, 1766; on Monday, the 13th of October Next,
Will Be Offered to Sale at a Store in Union-Street, Opposite to the Corn-Field, a Valuable Col-
lection of Books, a Variety of Maps and Prints . . .* (Boston, 1766). The commodification
of maps begins long before the eighteenth century. For the sixteenth and seventeenth
centuries, see David Woodward, ed., *Cartography in the European Renaissance, Part 2*,
vol. III of *The History of Cartography* (Chicago, 2007); L. Bagrow, "A Page from the His-
tory of the Distribution of Maps," *Imago Mundi*, V (1948), 53–62; Chandra Mukerji,
From the Graven Images: Patterns of Modern Materialism (New York, 1983), 79–130. For
the eighteenth century, see J. B. Harley, "The Bankruptcy of Thomas Jefferys: An Epi-
sode in the Economic History of Eighteenth Century Map-Making," *Imago Mundi*, XX
(1966), 27–48; David Bosse, "The Boston Map Trade of the Eighteenth Century," in
Alex Krieger, David Cobb, and Amy Turner, eds., *Mapping Boston* (Cambridge, Mass.,
1999), 36–55; and Pedley, *Commerce of Cartography*. On the conceptual repositioning
of maps as commodities in map criticism, see Catherine Delano-Smith, "The Map as
Commodity," in David Woodward, Delano-Smith, and Cordell D. K. Yee, eds., *Plante-
jaments i objectius d'una història universal de la cartografia / Approaches and Challenges in a
Worldwide History of Cartography* (Barcelona, 2001), 91–109; and Barbara Bartz Petche-
nik, "Maps, Markets, and Money: A Look at the Economic Underpinnings of Cartog-
raphy," *Cartographica*, XXII, no. 3 (Autumn 1985), 7–19.

Map of the Globe, 4 Sheets, —— ——	£0	7	6
—— Europe, Do. —— ——	0	7	6
—— Asia, Do. —— ——	0	3	8
—— Africa, Do. —— ——	0	3	8
—— North-America, Do. —— ——	0	5	0
—— Globe and Quarters, 2 Sheets,	0	6	8
Ditto, a better Edition, North and South America separate,	0	13	4
—— Globe, 4 Sheets, on Cloth and Rollers, —— ——	0	13	0
—— Europe, 4 Sheets, on Cloth and Rollers, —— ——	0	13	0
—— Asia, Do. Do.	0	10	4
—— Africa, Do. Do.	0	10	4
—— No. America, Do. Do.	0	10	4
—— West-Indies, —— ——	0	2	5
—— Mediterranean, —— ——	0	6	0
—— Coast of New-England, —— ——	0	2	2
—— Antigallican North-America, with Forts, —— ——	0	2	6
—— Land of Canaan, Cloth and Rollers, 13 Sheets, ——	1	7	8
Senex's Atlas, 34 Maps, bound together,	3	6	8
Plan of London, —— ——	0	0	8
Ditto by Gibson, —— ——	0	1	4
Prints of the Landing at Quebec,	0	1	4

logs circulating between 1750 and 1800. During this period, catalogs maintained a fairly predictable classification scheme. A survey reveals that physical size and detail rather than content or message dictated a map's monetary value (see Appendix 1). Extra-large multisheet maps, involving twenty or more sheets, were sold for anywhere between 10.5s. and £3. The more conventional four-sheet maps, measuring around five by four feet, were offered between 2s. and 10s.[20] Two-sheet maps went from anywhere between a mere 6d. and 6s. 8d. One-sheet maps, printed on paper ranging from imperial- to

20. *Sayer and Bennett's Enlarged Catalogue*, 34. The Bowen-Gibson map is listed as a two-sheet map but was sold in four sheets when refitted for Thomas Jefferys's *American Atlas* (1771).

demi-size, were sold from 6d. to 3s. For all maps, markups occurred when maps were to show more information and thus involved more detailed work by engravers, such as the maps of Europe or America.

Within the nexus of maps, prints, and decorative arts, the upshot of these price patterns is twofold. First (and this is one possible answer to the question: What are ornamental maps?), prices indicate that sellers treated maps at once as diversified and price-flexible display objects. The capacity for material adaptation (backings, rollers, paint) made maps readily available to consumers of vastly differing tastes, interests, and, above all, purse strings. Few map buyers would have belonged to the wealthy cohort of Virginia plantation owners who could (or would), like George Washington, pony up the hefty sum of £1 10s. for the Henry map. But many more could have afforded sizable two-sheet or one-sheet maps selling for one shilling or a mere sixpence (and at much less expense than lending and late fees charged by American library companies in Philadelphia, Redwood, R.I., Burlington, N.J., or Hatborough, Pa.).[21]

Second, by the same token that sellers listed maps in catalogs along with decorative prints, price lists further reified the pictorial connotation by categorizing maps along with engraved prints according to sheet size and *not* according to content.[22] Indeed, in contrast to our modern penchant for reading maps as either scientific or ideological representations, price lists rarely used content as a classification scheme. With the exception of Thomas Jefferys's 1763 catalog *Maps, Charts, Plans,* in which he timed the sale of maps showing North America to coincide with the end of Anglo-French hostilities, price lists showed neither a geotopical preference nor a particular focus on

21. Whereas George Washington paid £1 10s. for the Henry map, Thomas Jefferson, one of the early subscribers, paid this sum in two installments at 15s. each. See Bosse "Maps in the Marketplace," *Cartographica,* XLII (2007), 17. Lending or late fees for nonmembers of circulating libraries were between 5s. and 8d. for folio editions, including atlases such as Emanuel Bowen's *New Complete Atlas; or, Distinct View of the Known World* (London, 1752) or "A Collection of Maps, to Explain G. Anson's Voyage." See *The Charter, Laws, and Catalogue of Books of the Library Company of Philadelphia . . .* (Philadelphia, 1757), 25; *The Charter, Laws, and Catalogue of Books, of the Library Company of Burlington* (Philadelphia, 1758), 5; *Laws of the Redwood-Library Company* (Newport, R.I., 1764); John Mein, *A Catalogue of Mein's Circulating Library . . .* (Boston, 1765); and *The Charter, Laws, and Catalogue of Books of the Union Library Company of Hatborough . . .* (Philadelphia, 1788).

22. In 1753, Bowles's *Catalogue of Maps* sold two-sheet picture prints for 1s. plain to 2s. 6d. colored, and thus in the same price range as two-sheet maps (24); ditto in 1786, when *Sayer's Catalogue* offered two-sheet prints from 1s. plain to 5s. colored (85–88).

the maps' date of production. Freeman's 1766 broadside classifies maps according to continents and regions ("Europe," "Coast of New-England"), with the occasional propaganda map ("Antigallican North America") and thematic map ("Land of Canaan") thrown into the mix. The logic of organization vacillates between map size and geography textbooks, which arranged knowledge, chapters, and maps either along cardinal points from north to south or along the lines of European imperial ideologies, listing Europe first and America last (until Jedidiah Morse switches the latter sequence). Similarly, publication dates were by and large inconsequential to the sale of maps. Although specific maps like the Henry map were advertised directly by the author as related to historic events, map catalogs tracked map titles without assigning a proper publication date. Indeed, selling loose maps of indeterminate date was common in eighteenth-century America. Consisting of recycled book maps, reengraved maps showing updates, or pirated maps disguised by new titles and names of authorship, eighteenth-century maps not only had surprisingly long lives in the marketplace of prints but also undercut our modern expectation that map sellers eagerly offered (and that map buyers eagerly demanded) useful rather than ornamental maps and our assumption that the former were more up-to-date and therefore more accurate and better maps.[23]

The sale of outdated or refurbished maps was concomitant to the maps' categorical association with the decorative arts and the maps' ornamental valuation.[24] By the same token that the similarity in price and size classified maps along with picture prints, the relentless repetition of this classification by advertisings—like the ones published in the *Virginia Gazette* or the *Pennsylvania Gazette* (and countless ads in newspapers) between 1750 and 1800—redefined maps less in terms of conventional cartographic use value than, following Walter Benjamin's interpretation of art in the age of mechanical reproduction, as

23. Brückner, *Geographic Revolution*, 164; Bosse, "Maps in the Marketplace," *Cartographica*, XLII (2007), 8. On the longevity of maps, see, for example, the print histories of maps by Lewis Evans and John Mitchell delineated in Pritchard and Taliaferro, *Degrees of Latitude*, 168–175.

24. I would not go as far as Tony Campbell's suggestion that map sellers purposely "fobbed-off" audiences with out-of-date land and sea maps. See his "Cutting Costs," in Peter Barber and Christopher Board, eds., *Tales from the Map Room: Fact and Fiction about Maps and Their Makers* (London, 1993), 35. Bosse attributes the consistent sale of old maps to the economics of mapmaking (sale of overstock) and a flourishing secondhand map business. But I depart from his interpretation that old maps "would presumably have appealed more to a collector than to a consumer needing maps for some utilitarian purpose" ("Maps in the Marketplace," *Cartographica*, XLII [2007], 8); old maps would have served a utilitarian purpose by becoming a decorative object.

objects imbued with surplus value extending beyond the commodity price index. The catalogs and ads make evident that a map's surplus value revolved not exclusively around its accuracy, newness, or, for that matter, its actual capacity to help us with navigating the physical world. Instead, a map's surplus value appeared to hinge on its functional adaptability. As consumer goods, decorative maps embodied the important semantic slippage inherent to the word "commodity," not only as "a thing produced for use or sale" but also an experiential concept ("the quality of being commodious"). Applied to maps, their surplus value depended on their "commodiousness," that is, on their capacity to accommodate multiple perceptions and ideas about representations of spatial relationships in a burgeoning marketplace of picture prints.[25]

PUBLIC GIANTS

Spectacular examples illustrating the "commodious" understanding of maps occurred in public institutions at the intersection of strategic map purchase and interior architecture. Perhaps the most prominent example involved a map order by Benjamin Franklin and the decoration of the Old State House, today's Independence Hall, in Philadelphia. In 1747, Benjamin Franklin, acting as the secretary of the Pennsylvania Assembly, enthusiastically placed a repeat order for Henry Popple's *Map of the British Empire in America* (1733; Figure 3). He writes:

> I must desire you to send per first Opportunity the Maps [I] formerly wrote for, viz. Popple's large One of North America pasted on Rollers; Ditto bound in a Book: and 8 or 10 other Maps of equal Size if to be had; they are for the long Gallery and the Assembly Room in the Statehouse. If none so large are to be got, let Prospects of Cities, Buildings, etc. be pasted round them, to make them as large.[26]

Similar to the case of the Henry map with which the essay began, by the time Franklin ordered the Popple map he selected a cartographic work that had already been widely criticized as a faulty product. A generation behind in its display of North American geography, this map had been repudiated by

25. Walter Benjamin, "The Work of Art in the Age of Mechanical Reproduction," in Benjamin, *Illuminations,* ed. Hannah Arendt, trans. Harry Zohn (New York, 1968), 217–252; Delano-Smith, "The Map as a Commodity," in Woodward, Delano-Smith, and Yee, eds., in *Plantejaments i objectius d'una història universal de la cartografia,* 93.

26. Franklin ordered the Popple map for the second time on November 28, 1747; his first order is recorded on May 22, 1746. See Leonard W. Labaree et al., eds., *The Papers of Benjamin Franklin* (New Haven, Conn., 1959–2008), III, 77, 321. Franklin ordered the Popple map at least once more on June 20, 1752 (IV, 323).

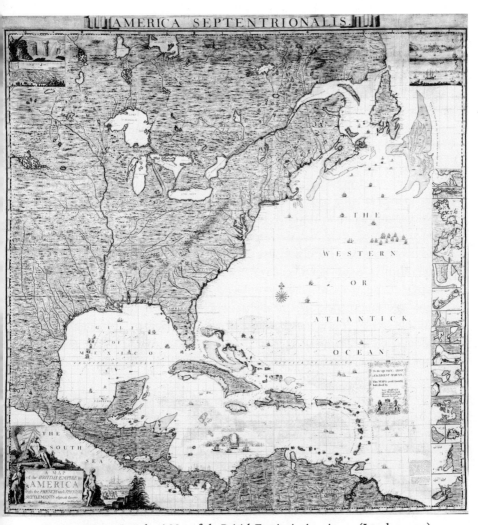

FIGURE 3. Henry Popple, *A Map of the British Empire in America* . . . (London, 1733). Permission, The Colonial Williamsburg Foundation

its initial sponsor, the Board of Trade, for misrepresenting British territorial claims. But, as the map order reveals, the Assembly's motivations had more to do with cartographic pictures than with accurate geographic knowledge. The Assembly had ordered the single largest map printed in England during the eighteenth century. Consisting of twenty sheets, the Popple map measured roughly one hundred by one hundred inches when fully assembled. Or, as John Adams wrote to his wife, Abigail, on August 13, 1776: "It is the largest I ever saw, and the most distinct Not very accurate. It is Eight foot square." By

making the Popple map the material standard for customizing an additional "8 or 10 other Maps of equal Size," Franklin's insistence on enlarging smaller maps with "Prospects of Cities, Buildings, etc." indicates that the Assembly was less concerned with map content and more with acquiring supersized map pictures to cover empty wall space in the rooms of the State House.[27]

The Pennsylvania Assembly's desire for large display maps recalls the material tradition of early modern "map galleries" that had been maintained for public and semipublic functions since the sixteenth century, first by European courts and later by institutions such as observatories and civic governments. In that tradition, special rooms contained multiple forms of map giants, ranging from murals and wall paintings (the Vatican in Rome or Schloss Bürresheim in Mayen, Germany), to large canvas-mounted wall maps and atlases measuring "neere 4 yards large" (Whitehall in London), to marble and tile floor maps (the observatory in Paris and the "Burger Zaal" in Amsterdam's former "Stadt Huys," today's Paleis op de Dam).[28] Extra-large printed maps were relative latecomers to public displays, as were prints showing city views and landscapes. Specifically designed as wall decorations, involving multiple sheets, continuous border patterns, spectacular cartouche designs, and hanging mechanisms, such maps superseded not only murals and floor maps but large paintings of Dutch and Spanish make in which maps and map-

27. On the Board of Trade's repudiation of the Popple map, see Mark Babinski, *Henry Popple's 1733 Map of the British Empire in America* (Garwood, N.J., 1998). The same commissioners then "agreed to allow the expence of one of Mr. Henry Popple's maps for each Government in America, to be charged in the incidents of this office" (cited in William P. Cumming and Helen Wallis's introduction to Henry Popple, *A Map of the British Empire in America* . . . [1733] [Lympne Castle, Kent, 1972]). For John Adams to Abigail Adams, Aug. 13, 1776, see L. H. Butterfield, Wendell D. Garrett, and Marjorie E. Sprague, eds., *Adams Family Correspondence*, II (Cambridge, Mass., 1963), 92. The Assembly also seemed unconcerned about the costs. Given that the Popple map's price was "in Sheets 1£:11s:6d / Bound 1£:16s:6d / On Rollers and Colour'd 2£:12s:6d," ordering a dozen map giants would have been an expensive decoration to be paid for by Pennsylvania taxpayers. Popple published the price list in the lower left corner of his map.

28. On the early history of map galleries, see Juergen Schulz, "Maps as Metaphors: Mural Map Cycles of the Italian Renaissance," in David Woodward, ed., *Art and Cartography* (Chicago, 1987), 97–122; Barber, "Maps and Monarchs," in Oresko, Gibbs, and Scott, eds., *Royal and Republican Sovereignty*, esp. 110–116; and Peter Barber, ed., *The Map Book* (New York, 2005), 164. On floor maps in Paris, see Jacob, *The Sovereign Map*, trans. Conley, ed. Dahl, 94; for Amsterdam's "Burger Zaal," see http://www.paleisamsterdam .nl/ and the prints in Jacob van Campen, *Afbeelding van't Stadt Huys van Amsterdam, in dartigh Coopere Plaaten* (Amsterdam, [1661]).

ping images were frequently featured for the dual purposes of authenticating territorial possessions and the work of the artists.[29]

The public use of map galleries had fallen from favor by the early eighteenth century. But, as Franklin's map order suggests, its concept had migrated to America where it continued to appeal to audiences in modified formats. A rare object in North America, the fully assembled Popple map still managed to reach large and socially diverse audiences when put on display in the strategic setting of the Philadelphia State House. Only one other official display is on record today. The Popple map was "fram[ed] and hanging on Trucks" in the Boston State House in 1751.[30] Much more common during the period between 1750 and 1800 were public displays of comparatively smaller wall maps, such as John Mitchell's *Map of the British and French Dominions* (1755; Figure 4). Consisting of eight sheets and measuring fifty-three by seventy-six inches, this map hung framed in the Boston State House's "Council Chamber" in 1760, where it might have been on display along with several other large wall maps. Further to the south, the Mitchell map was owned by the Pennsylvania Assembly where, if we follow Edward Savage's portrayal of *The Congress Voting Independence* (1788–1795; Figure 5), it hung above the Assembly's side entrance (on the left) and probably faced the Popple map as the Assembly's second cartographic picture (and where it would stay at least until the Peace of 1783).[31] Large-map displays—showing the continents, political

29. The iconography of maps has been the topic of fascination in a range of studies: Svetlana Alpers, *The Art of Describing: Dutch Art in the Seventeenth Century* (Chicago, 1983), 119–168; Richard Helgerson, "The Land Speaks: Cartography, Chorography, and Subversion in Renaissance England," *Representations,* no. 16 (Autumn 1986), 51–85; Edward S. Casey, *Representing Place: Landscape Painting and Maps* (Minneapolis, Minn., 2002). On the material designs of the "wall map," see Wallis and Robinson, *Cartographical Innovations,* 77–80.

30. I would like to thank Robert L. Giannini for showing me Independence Hall and for sharing his unpublished report, "Furnishing Review: Second Floor, Independence Hall," Cultural Resource Management Division, National Park Service, Independence National Historical Park (Philadelphia, 1995). On the Popple map at the Boston State House, see Harold F. Nutzhorn, *The Old State House in Boston, Mass.* (Boston, 1938), 1751, n. 360. Under "Furnishings in the town house, 1748–1776" is the entry for a 1751 invoice: "to framing and hanging on Trucks Popple's map of America 20 sheets £ 3-5-4." I would like to thank Holly Smith, librarian at the Bostonian Society, for this record.

31. Nutzhorn, *Old State House in Boston,* 1760, n. 455 ("to framing one of Mitchel's Mapps for the Council Chamber to Stephen Whitney £ 1/10/- "). According to the *Journals of the House of Representatives of Massachusetts, 1756,* XXXII, part 2 (Meriden, Conn., 1958), 342 (Feb. 18, 1756), legislators ordered seven maps, which, judging by

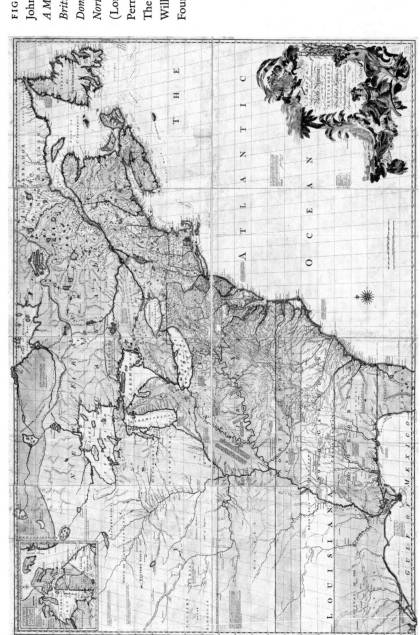

FIGURE 4.
John Mitchell,
*A Map of the
British and French
Dominions in
North America . . .*
(London, 1755).
Permission,
The Colonial
Williamsburg
Foundation

FIGURE 5. Edward Savage, after Robert Edge Pine, *Congress Voting Independence.*
1788–1795. The Historical Society of Pennsylvania (HSP), Transparency Collection.
Note the Mitchell map's placement above the left door on the Assembly's eastern
wall

their titles, included the Mitchell map, Lewis Evans's *Map of the Middle British Colonies*
(1755), John Green and Thomas Jefferys's *Map of the Most Inhabited Part of New England*
(1755), and Thomas Jefferys's *North America from the French of Mr. D'Anville . . .* (1755).
See Matthew H. Edney, "John Mitchell's Map of North America (1755): A Study of the
Use and Publication of Official Maps in Eighteenth-Century Britain," *Imago Mundi*, LX
(2008), 81 n. 23.

A map of proportions similar to the Mitchell map is outlined above the left door
frame of the Pennsylvania State House, which has gone virtually unnoticed in critical
discussions of the painting. Savage's painting is said to be based on a sketch by Robert
Edge Pine. On painters and dates, see Martin P. Snyder, *City of Independence: Views of
Philadelphia before 1800* (New York, 1975), 164. Of course, the iconographic use of the
map is not a concrete proof of its presence. As Ron Hoffman has pointed out to me,
the painting is a composition resorting to artistic license; it includes characters that
were absent at the vote *(WMQ*-EMSI Workshop: "Grounded Histories: Land, Land-
scape, and Environment in Early North America"). On the historical significance of
the Mitchell map, see Edney, "John Mitchell's Map," *Imago Mundi*, LX (2008), 70; Sey-
mour I. Schwartz and Ralph E. Ehrenberg, *The Mapping of America* (New York, 1980),

regions, or specific local places—can be traced to several formal spaces of public relevance, including library companies and civic spaces such as magistrates' office rooms. But the majority of such displays happened in informal public spaces. Inventories indicate that maps frequently hung on the walls of taverns, coffeehouses, and clubs, not to mention counting rooms, print shops, and general stores. Patrons of shops, taverns, and coffeehouses would have most likely seen only one map on display; but in some places they could experience a room filled with maps, when, for example, a dozen maps were hanging on the walls of a York County tavern in Virginia.[32]

Once maps were hung on the walls of assembly rooms and office spaces they entered into a new landscape, the material world of wall hangings, architectural designs, and their attending rules of decoration. Handbooks by Isaac Ware, Abraham Swan, or Thomas Chippendale were quite clear about decorative Dos and Don'ts. Beginning with the semantic coding of a complete building as a "fabrick," all visual features of the building, whether they are structural or ornamental, had to obey the logic of "Decorum." According to Richard Neve's *City and Country Purchaser's and Builder's Dictionary* (1736), "decorum" meant for building plans "the keeping of a due Respect between the Inhabitant and Habitation." "Decorations," however, signified simultaneously the notion of "due Respect" and "those Things in Architecture that inrich [sic] or adorn a Building." Samuel Johnson's *Dictionary of the English Language* (1755) turns the architectural definitions into something slightly different. "Decorum" means "Decency; behaviours contrary to licentiousness, contrary to levity; seemliness," whereas "Decoration" means simply "Ornament; embellishment; added beauty." These definitions suggest that architectural spaces on the whole had to perform a tricky balancing act involving, on the one hand, designs intent on harmonizing the relationship between in-

159–160; Cumming, *The Southeast*, 25–26, 274–275; and Lawrence Martin and Walter Ristow, "John Mitchell's Map of the British and French Dominions in North America," and Richard W. Stephenson, "Table for Identifying Variant Editions and Impressions of John Mitchell's Map of the British and French Dominions in North America," in Ristow, ed., *A La Carte: Selected Papers on Maps and Atlases* (Washington, D.C., 1972), 102–113.

32. The Mitchell map is recorded as early as 1757 in *The Charter, Laws, and Catalogue of Books, of the Library Company of Philadelphia* (Philadelphia, 1757), 22. For records documenting the presence of maps in colonial public spaces, see Margaret Beck Pritchard, "Maps as Objects of Material Culture," *Magazine Antiques* (January 2001), 212–220; Pritchard and Taliaferro, *Degrees of Latitude*, 43–56; Kym S. Rice, *Early American Taverns: For the Entertainment of Friends and Strangers* (Chicago, 1983), 24 and appendices; Bosse, "Maps in the Marketplace," *Cartographica*, XLII (2007), 20.

habitants and habitation, and, on the other hand, the reconciling of these designs with those behavioral codes that commanded respect or inspired emotions of gravity rather than levity. In this context, maps emerged as the ideal decoration because they were not easily mistaken for pictures offering light or licentious entertainment. As suggested by the catalogs discussed above, maps were categorized separately, located between serious books and allegorical prints. Even maps famous for their decorative cartouches containing nude bodies were earmarked as "safe" pictures, the perfect aesthetic source for performing the decorative work of balancing people in relation to their spaces while also upholding moral codes of conduct.[33]

The placement of the large Popple and Mitchell wall maps in the Assembly Room of Philadelphia's State House created a sense of spatial balance and an atmosphere of respect. Both maps would have immediately attracted the visitors' eyes because they were the only wall hangings in a space that was reportedly rather plain in contrast to its architectural neighbor, the "Supreme Court," which was "ornamented with a breast-work and a cornish supported by fluted pilasters of the Doric order." Until 1776, the Popple map hung beside the main entrance to the Assembly Room (facing west); shortly after, as the Savage painting shows, the new Congress saw the Mitchell map hanging above the left side entrance (facing east). The Popple map was thus placed on the wall opposite the Assembly speaker's seat and thus in balance to the room's central locus of authority. The presiding officer would always have the map in view, while the seated members of the Assembly had their backs to it. The Assemblymen were seated facing east, that is, toward the speaker's seat, the Mitchell map, and, by extension, England. Inside the visual field of the Assembly Room the maps would have hardly served the utilitarian purpose of geographical reference. If we pieced together the vectors of the Assembly's sight lines, both maps would have eluded close inspection (especially the Mitchell map, above the door frame). Instead, given their anamorphic placement on the margins of the assemblymen's field of vision, the maps' spatial work was purely symbolic.[34]

33. See "Decorum" and "Decorations" in Richard Neve, *The City and Country Purchaser's and Builder's Dictionary* . . . (London, 1736), and in Samuel Johnson, *A Dictionary of the English Language* . . . , I, II (London, 1755). The terms of decorum resonate with Bernard Herman's discussion of "comportment," or "the ways in which people stand in relationship to one another and the worlds they inhabit; it is an evocation of the etiquette of everyday life." See Bernard L. Herman, *Town House: Architecture and Material Life in the Early American City, 1780–1830* (Chapel Hill, N.C., 2005), 5.

34. Compare the description of the "Supreme Court" to, "The Assembly room is finished in a neat but not an elegant manner," in John W. Jordan, "A Description of

Both wall maps operated as strategic props for the public staging of state power. They responded to a symbolically choreographed "politics of size" in which the maps' material size visually illustrated not only particular geopolitical demands but also asserted authority over the territories shown on the maps. In their capacity as giant wall hangings they provided a sense of empirical reality and evidentiary gravitas during debates and declarations. Conversely, as theatrical props both maps provided a dramatic background for impressing local politicians and foreign diplomats. By title and design, both maps projected sheer political power; their material status as large decorative pictures turned even a skeptical gaze, like the one of John Adams, into one that was respectful and admiring.[35]

Modern map studies have identified respect, admiration, and the implicit submission to maps as agents of political domination as the intended modalities shaping the early modern viewer's response to cartographic representation.[36] Following the critical chorus of the 1980s and 1990s, both the Popple and the Mitchell maps would have wooed audiences by turning the overt celebration of British imperialism and later American nationalism into spectacles of silence. Variously called a schema, a matrix, or an analog, maps invoked the rhetorical conceit of being silent signifiers: from the linguists' perspective, maps were ultimately ideographic signs and thus unpronounceable (there are no sounds or utterances that can imitate or express cartographic symbols). Applying this rationale to the Popple and the Mitchell maps, the act of looking at the maps closely would resemble the solitary, silent, and, above all, passive posture of the map gazer (Figure 6), a figure frequently occupying satirical prints and tableaux made by eighteenth-century engravers.[37]

the State-House, Philadelphia, in 1774," *Pennsylvania Magazine of History and Biography,* XXIII (1899), 418. Jordan cites the manuscript school gazette, called the *Universal Magazine and Literary Museum,* edited in 1774 by Samuel L. Wharton. According to Charles Dorman, there were flags hanging in the Assembly Room. Although there is certain evidence for the presence of flags captured during the Canada campaigns, it is not clear if national colors were on display. See Dorman's unpublished "Furnishing Plan of the Assembly Room, Independence Hall," Independence National Historical Park, Philadelphia, 1970.

35. Louis Marin, *On Representation,* trans. Catherine Porter (Stanford, Calif., 2001), 247. I borrow the phrase "politics of size" from Rosemarie Zagarri, *The Politics of Size: Representation in the United States, 1776–1850* (Ithaca, N.Y., 1987).

36. On power and map reception, see Harley, *New Nature of Maps,* ed. Laxton, 51–81. On the association of sight, cartography, and domination, see Denis Cosgrove, *Geography and Vision: Seeing, Imagining, and Representing the World* (London, 2008), 4–8.

37. Karl Popper, *Unended Quest: An Intellectual Autobiography* (La Salle, Ill., 1976),

FIGURE 6. Detail of *Corps de Garde van Hollandsche Officers; Corps de garde des officiers Hollandois*. Engraving, 1859. George Arents Collection, The New York Public Library, Astor, Lenox and Tilden Foundations

American consumers were familiar with picture prints that turned the delineation of reverie into one of reverence and submission. For literate audiences, there was Bernard Roman's tableau-like frontispiece for his *Concise Natural History of East and West Florida* (1775), in which a native American figure kneels in silence before the figure of Britannia, who, seated in a neoclassical architectural setting, receives the map instead of weapons at her feet. An equally quiet transfer of power was enacted in 1760, when, in the wake of the British victory over the French, a public "Illumination" presented to the literate and illiterate a silent spectacle of "the following Designs . . . Britannia, a Female Figure, representing France, prostrate, her Sword broken, and subjecting a Map of Canada at the Feet of Britannia." In both of these tableaux, maps were theatrical props, material links between the staged actors and visual links connecting audiences to the dramatic action. Above all, they were the source of moral messages; offered up in silence, they were spectacles designed to edify and improve the viewer's mind. If applied to the spatial arrangement of the Philadelphia Assembly Room, the Popple and the Mitchell map could be viewed as participating in similar acts of silent symbolic submission. But, instead of placing America at the feet of either the British or American state authority, the maps' abstract representation of British America was held up for all to see.[38]

Yet, in the context of large decorative wall maps, the response was different; if maps were intended to foster political harmony through dramatic acts of reverence, their material size and location invited acts of irreverence. All we have to remember is that the Popple and Mitchell maps were hung in a room that was as theatrically overdetermined as it was constantly open to public inspection. The Assembly Room provided the formal setting for civic affairs, including parliamentary-style meetings and courtroom dramas. One floor above, the Long Gallery was a space in which local officials and patrons of the arts enacted communal rites of sociability: it witnessed refined gather-

77; E. H. Gombrich, *Art and Illusion: A Study in the Psychology of Pictorial Representation* (New York, 1960), 90; Nelson Goodman, *Languages of Art: An Approach to a Theory of Symbols* (Indianapolis, Ind., 1976); and J. B. Harley, "Silences and Secrecy: The Hidden Agenda of Cartography in Early Modern Europe," in Harley, *New Nature of Maps*, ed. Laxton, 83–107. The figure of the map spectator shows up in William Hogarth's series *A Rake's Progress: The Tavern Scene* and the *Mad House* (1732). It is a staple in cartoons published during the conflict between England and the colonies; see *The Horrors of War a Vision or Scene in the Tragedy of K:Rich:3*, Library of Congress, Prints and Photographs Online Catalog (PPOC), http://hdl.loc.gov/loc.pnp/ppmsca.13640.

38. Brückner, *Geographic Revolution*, 71–73; Pedley, *Commerce of Cartography*, 63; *PG*, Oct. 9, 1760.

ings in the European tradition as well as more rustic native American meetings; it was the stage for lectures on the arts and sciences, musical and theatrical performances, and, last but not least, formal and informal banquets. Considering these settings, the supersized maps sponsored by Franklin were not only intended for public display but also invariably became devices similar to early modern movable stage scenery, a theatrical backdrop against which to project public debate. Franklin's initial map order was paid for by the taxpaying public; the subsequent map displays would have attracted citizens who were eager to inspect the community's cartographic investment in a theatrical setting notorious for choreographed spectacles and noise rather than stale imagery and silence.[39]

Satirical prints riffed on the theatrical nature of large ornamental maps and their failure to uphold "decorous" behavior. In the crudely drawn political cartoon, *An Extraordinary Gazette; or, The Disappointed Politicians* (1778; Figure 7), a giant wall map on the left entitled *A Map of America Belonging to the English in 1762* provides the background for a group of English men caught in the act of debating current affairs in the Atlantic provinces following the latest news of a dispatch from General Henry Clinton, possibly even referring to his evacuation of Philadelphia in June 1778. The visible map is intentionally staged to complement the missing map at the center of the debate, shown only by its title *A Map of America Belonging to the English in 1778* (a swirl of snakes surrounding the title cartouche could be viewed as a much reduced version of both map lines and territorial possession). With present and absent maps providing the tableau's meta-setting, two handbills—announcing a play called *All in the Wrong* and the capture of a French general (possibly Lafayette)—further underscored the performative discourse surrounding public or quasi-public map displays (the punch bowl on the table implies settings ranging from tavern to club). By comparison, the professionally drawn print *The Council of the Rulers, and the Elders against the Tribe of ye Americanites* (1775; Figure 8) invokes a wall map hanging on rollers as the cause for vociferous mayhem. Showing a large map entitled *North America*

39. On the theatrical nature of maps in eighteenth-century America, see Martin Brückner, "Addressing Maps in British America: Print, Performance, and the Cartographic Reformation," in Sandra M. Gustafson and Caroline Sloat, eds., *Cultural Narratives: Textuality and Performance in American Culture before 1900* (Notre Dame, Ind., 2010), 62–67. On the State House as a stage for cultural events, see Giannini, "Furnishing Review"; Harold Donaldson Eberlein and Cortlandt Van Dyke Hubbard, *Diary of Independence Hall* (Philadelphia, 1948); and Frank M. Etting, *An Historical Account of the Old State House of Pennsylvania Now Known as the Hall of Independence*, 2d ed. (Philadelphia, 1891).

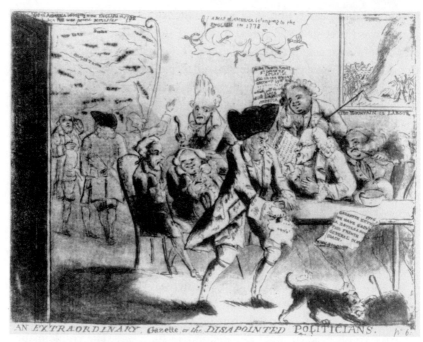

FIGURE 7. *An Extraordinary Gazette; or, The Disappointed Politicians* (1778). Library of Congress Prints and Photographs Division, Washington, D.C. (LC-USZ62-1516)

exploding into flames, this political print signals more than impending geo-political hostilities; rather, prominently displayed inside the distinctly archi-tectural setting of a council chamber the ornamental map presides over a cast of map viewers who are in the process of losing their studied polite behavior. As far as theories of decoration went, public map displays certainly would not have lent themselves to creating settings promising social harmony. On the contrary. If it had been the intent that spectacular maps were to awe audi-ences into silent consent, the very maps that were put on display in public spaces like taverns and coffeehouses would have turned this silence into noisy face-to-face debates, if not collective expostulations of political dissent.

PRIVATE SPECTACLES

The story of colonial map displays changes significantly when we look at pri-vate consumer habits and the decoration of domestic spaces. At the same time that rarified map giants were entering into the decor of public spaces, a multi-tude of wall maps had begun to appear in American homes. Historically, the domestic display of wall maps reached back to the fifteenth century, when Europe's nobility used maps as wall hangings in ancestral halls and studies.

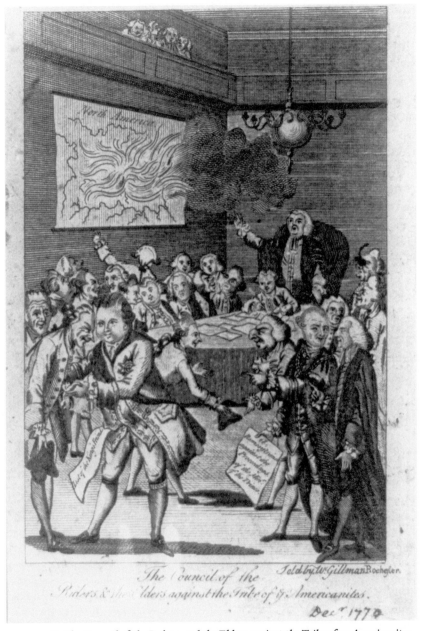

FIGURE 8. *The Council of the Rulers, and the Elders against the Tribe of ye Americanites* (1775). Library of Congress Prints and Photographs Division, Washington, D.C. (LC-USZ61-79)

During the seventeenth century, the display of wall maps became more common, moving from palaces of the political elite into the homes of the Italian, Dutch, and English nouveau riches as well as the emergent middling sort. Paintings, such as Jan Vermeer's *Officer and Laughing Girl* (1658) and *The Art of Painting* (1666), illustrate in great detail how oversized wall maps were integrated into the material decor of merchant homes. Shown next to tapestries, mirrors, and framed paintings, canvas-backed maps suspended on rollers were the only large printed goods to join decorative objects specifically intended for the vertical display afforded by architectural interiors.[40]

Beginning in the mid-eighteenth century, British Americans who were not governors or owners of vast landed estates had also discovered the pleasure and efficacy of wall map displays. The *Virginia Gazette* captured the domestic appeal of wall maps in ads like this: "A very large Map (being Five Feet long, and Four Feet broad, on Two Sheets of Elephant Paper) it's not only Useful, but Ornamental, for Gentlemens Halls, Parlours, or Stair-cases." Wills and inventories of the affluent indicate that wall maps rarely hung in isolation.[41] In 1743, the house of the Salem merchant Samuel Browne displayed twenty-nine

40. Mukerji, *From Graven Images*, 129–130; Alpers, *The Art of Describing*, 119–168; David Woodward, *Maps as Prints in the Italian Renaissance: Makers, Distributors, and Consumers* (London, 1996), 79–87.

41. *Virginia Gazette*, Sept. 9–16, 1737. The following interpretation is based on probate data gleaned from a range of sources that include: [Office of the Register of Wills], *Wills, County of Philadelphia, Pennsylvania, 1682–1875* (Philadelphia, 1970), microfilm, 1750–1800 (hereafter cited as *Philadelphia Wills*); Jane Baldwin Cotton, ed., *The Maryland Calendar of Wills*, IX–XIII (Westminster, Md., 1988–1994); wills and estate inventories in the Downs Collection of Manuscripts, Winterthur Museum and Library, Winterthur, Del.; furnishings and floor plans, such as George B. Tatum, *Philadelphia Georgian: The City House of Samuel Powel and Some of Its Eighteenth-Century Neighbors* (Middletown, Conn., 1976), and Doris Devine Fanelli, *Furnishings Plan for Graff House, Philadelphia, PA* (Philadelphia, 1988); and the ground-breaking survey of map sales and ownership offered in Bosse's "Maps in the Marketplace," *Cartographica*, XLII (2007), 1–51, and Pritchard's "Maps as Objects," *Magazine Antiques* (January 2001), 212–220. Maps have cropped up regularly but without further development in descriptions of early American interiors. See Richard L. Bushman, *The Refinement of America: Persons, Houses, Cities* (New York, 1992); Elisabeth Donaghy Garrett, *At Home: The American Family, 1750–1870* (New York, 1990); Edgar de N. Mayhew and Minor Myers, Jr., *A Documentary History of American Interiors: From the Colonial Era to 1915* (New York, 1980); Abbott Lowell Cummings, "Inside the Massachusetts House," in Dell Upton and John Michael Vlach, eds., *Common Places: Readings in American Vernacular Architecture* (Athens, Ga., 1986), 219–239; and Jane C. Nylander, *Our Own Snug Fireside: Images of the New England Home, 1760–1860* (New York, 1993).

maps in the "lower room entry" and another sixteen in the "Chamber entry." Lord Botetourt, the patron of the Henry map, had at least thirteen large maps on display throughout his mansion, including three in the parlor, five in the "Little middle Room," and three in the pantry. Households owning a dozen large wall maps were exceptional. Much more common was the display of map ownership as documented by the Philadelphia register of wills. For example, "John Fox's Will . . . Carpenter," recorded November 20, 1749, lists "5 Mapps." The "Inventory of the Moneys Goods and Chattels Late the Estate of Richard Brockdeu" (July 21, 1756) is more specific: *In Back Parlor:* Looking Glass 3-15-0 / Ten Glas'd Pictures 3-0-0 / Two Maps Fram'd 0-15-0." And so is the "Inventory of the Goods and Chattels of Charles Jenkins" (March 22, 1768), where in the *"Middle Chamber"* were found "1 Looking Glass, 3 Maps, 2 Glazed Pictures, and Window Curtains 1-2-6"; ditto the "Inventory of . . . the Estate of Samuel Bryan" (1775), which lists on the "First Story, Back Parlour . . . 3 Maps 1-1-0." That the maps listed in these wills were wall maps can be assumed because they were listed immediately next to wall hangings, such as mirrors and pictures, or next to andirons and other fireplace equipment, suggesting their placement as overmantel decorations.[42]

Although we expect to find wall maps in affluent households eagerly pressing the advantage of their owner's educational capital, the wills of much less affluent households listing maps are surprising. Wall maps appear as frequently in the estates of the middling sort when map ownership is adjusted in proportion to the assessed household value. Estates assessed at high value tended to count more than one wall map. By comparison, estates assessed at low value, which in theory should have been unlikely candidates for wall displays of any kind, were more likely to display a single wall map than a single picture print. The distribution of wall maps as decorative objects thus appears to cut across class boundaries, including not only gentleman farmers occupying mansions on the Schuylkill or wealthy merchants living in Georgian townhouses but also carpenters living above their shops or widows renting rooms.

42. On Samuel Browne, see Bosse, "Maps in the Marketplace," *Cartographica*, XLII (2007), 20. According to the inventory of Lord Botetourt's estate, maps were on display in the governor's mansion in the parlor ("Fry Jefferson's Map of Virga / Bowen's and Mitchell's Map of N. America"); in the dining room ("Henry's Map of Virga"); in the little middle room ("5 Maps"); in the pantry ("2 Maps"—next to "14 prints"—and a "Map of New England"); in the library (a "Map of N. & S. America" next to "20 prints"). See Graham Hood, *The Governor's Palace in Williamsburg: A Cultural Study* (Williamsburg, Va., 1991), Appendix 1, 287–295. See also John Fox, *Philadelphia Wills,* 1749/W 123, Richard Brockdeu, 1756/W 268, Charles Jenkins, 1768/W 161, Samuel Bryan, 1775/W 163.

A synthesis of wills like the ones from the greater Philadelphia region reveals three distinct patterns of map consumption between 1750 and 1800.

First, the record shows a surprising lack of qualitative preference when it comes to map content. Establishing the identity of specific maps owned by Pennsylvanians is made difficult because the vast majority of inventories list wall maps only by count: "4 Maps" (1730), "Four old Char[t]s," "4 old Maps" (1768), "Three maps" (1779), and so forth.[43] Inventories further fail to indicate if the map was a wall map by design, such as the Henry map, or a map that was cut from an atlas or geography book before it was transformed into a wall hanging. The few records that do list maps by content reveal that map owners were interested in a wide variety of topical maps. Consider the following entries gleaned from Philadelphia wills: "1 Large Map of England/4 Maps, Asia, Africa, Europe and America" (1750); "One Large Mapp of Egypt" (1750); "The map of the first Christian people" (1760); "1 Map of the River St Lawrence" (1765); "1 Map of England" (1765); "two Chinese Maps" (1770); "Two Maps Asia and Africa" (1770); "1 Map of Philadelphia" (1775); "A Map of Pennsylvania" (1775); "A Map of America" (1780); "*Maps:* North America . . . Connecticut . . . England and Wales . . . Vermont . . . Newjersey . . . Globe" (1796).[44]

These map descriptions suggest that map displays were mostly informed by the owner's personal passions, ranging from piety and Anglophilia to local pride and geographic curiosity. What the topical entries do not suggest is a widespread movement toward any particular map content. Only a few topical maps owned by Philadelphia's decedents reflect historical events—such as the Peace of 1760, the Peace of 1783, or the subsequent onset of nation building— all of which caused a massive redrawing of political boundaries on maps and

43. "Inventory of the Goods and Chatels of Austin Paris," *Philadelphia Wills*, 1730/W 146, "Inventory of Sundry House Hold Goods . . . Peter Wagoner," 1750/W 85, "An Inventory of the Real and Personal Estate of William Davis . . . House Carpenter," 1768/W 177; "Inventory of the Goods . . . of John Paschall . . . Darby, County of Chester [1779]," Downs Collection, 61, Box 25/PH 553, Winterthur Museum and Library.

44. "Inventory of the . . . Effects of Thomas Burgess . . . May 26, 1750," *Philadelphia Wills*, 1750/W 166, "Inventory . . . James Morris . . . Dec 7, 1750 . . . in Back Room (1st floor)," 1750/W 225, "An Inventory of . . . Henry Funck," 1760/W 274, "Inventory of the Goods and Chattels . . . of Ferdinand Bowd," 1765/W 130, "Inventory of All and Simpler the Goods and Chattels . . . of William McCalla," 1765/W 156, "Inventory of . . . Henry Steel," 1770/W 363, "Inventory of . . . Estate of Henry Robinson," 1775/W 113, "Inventory . . . of Christian Lehman," 1775/W 168; Anonymous will [1770], Downs Collection, 61, Box 10/55.526, Winterthur Museum and Library, "Inventory of . . . Thomas Wilcox . . . Concord, County of Chester [1780]," Box 25/PH 554, "A True and Perfect Inventory . . . of Nathan Webb . . . Apothecary [1796]," Box 2/54.37.86.

all of which triggered well-documented increases in map production. This assessment changes, however, when we concentrate on inventories of private libraries. Topical maps showing aspects of North America were staple objects in the libraries of American notables, such as Benjamin Franklin and James Logan in the 1740s or Lord Botetourt and Thomas Jefferson between 1770 and 1800. The same America-centric preference can be found in inventories itemizing private libraries of lesser known Americans, like Thomas Whiting (1768), Isaac Chapman (1770), Peter Olive (1777), Thomas Wilcox (1780), or Nathan Webb (1796). If we apply etiological models of explanation—for example, that lower classes mimicked consumer behaviors of their more affluent peers, or that estate assessors often lumped maps together with books because they counted as printed objects—it is highly probable that many of the untitled maps listed by inventories were maps showing parts or all of America. If this was the case, the cartographic picture of America was most likely one of the more popular images displayed in private settings.[45]

Second, quantitatively speaking—and after making allowances for the numerical uncertainties that haunt the analysis of probate records of any sort—wall maps were a fairly widespread possession in British American households. Maps were not owned as frequently as a "looking glass" or "pictures" (that is, prints). But, in contrast to Carole Shammas's findings, according to which during the 1770s only 10 percent of the wealthiest population owned "fine wood pieces, upholstered leather chairs, window curtains, and even floor coverings," the distribution of maps in relatively less affluent homes undercuts the verdict that "the vast majority of owners of rural English and American houses . . . just did not decorate rooms." Looking at the quantitative distribution of "map" entries in Philadelphia wills (atlases and geography books were listed separately), and these are wills that include mostly household inventories of the "relative affluent" (as opposed to the wealthiest 10 percent), maps are listed at annual ratios that range between one listing per one hundred wills in some years to a ratio of one map listing per fifteen wills in years such as 1750, 1765, 1768, or 1775 (these ratios discount multiple map entries per estate). Without adjusting these numbers to reflect, say, that this was an urban population, that there was a high influx of immigrants, or that the num-

45. "Inventory of Sundry Goods . . . Estate of Thomas Whiting . . . Merchant (Oct 10, 1768)," *Philadelphia Wills*, 1768/W 221, "Inventory of . . . Isaac Chapman," 1770/W 4; "Inventory of . . . Estate of Peter Oliver, Esq . . . Middleborough [1777]," Downs Collection 61, Box 24/PH 437, Winterthur Museum and Library, "Inventory of . . . Thomas Wilcox . . . Concord, County of Chester [1780]," Box 25/PH 554, "A True and Perfect Inventory . . . of Nathan Webb . . . Apothecary . . . June 15, 1796," Box 2/54.37.86.

ber of inventoried estates was probably less than the number of uninventoried estates, they suggest that cartographic wall displays were a common decorative object shared by American households of different cultural and economic backgrounds.[46]

Third, whereas portraits, wallpaper, or window treatments were displayed in the socially most important spaces of the first-floor front rooms, wall maps occupied American homes in a more indiscriminate fashion. The majority of map displays were concentrated in those spaces of the home that were considered the most public. They were thus listed in entrance halls, passage- and hallways, or the front parlor—social spaces accessible to members of the family, servants, and any visitor who entered the house on formal business or as an informal guest. But they were listed with equal frequency in back parlors, dining rooms, or studies ("libraries"), thus in semipublic spaces reserved for rituals of sociability that included the family meal, the mixed-gender visit, or gender-segregated acts of reading and polite conversation. Finally, wall maps even ended up hanging in the home's back rooms, in upstairs bedrooms, and in garrets (servant quarters)—in spaces considered private, feminine, and generally off-limits to the visiting public.[47]

Placed inside American homes wall maps generated a spectacle that dif-

46. On the problem of statistical biases embedded in probate records, such as gender or professional occupation, see Gloria L. Main, "Probate Records as a Source for Early American History," *William and Mary Quarterly*, 3d Ser., XXXII (1975), 89–99; and the essays collected in Peter Benes, ed., *Early American Probate Inventories* (Boston, 1989), esp. Benes, "Editor's Introduction: Unlocking the Semantic and Quantitative Doors," 5–16. To this I add that, because maps were valuable commodities, they were possibly sold during the owner's lifetime and thus would frequently fail to register at the time of inventory. See also Carole Shammas, *The Pre-industrial Consumer in England and America* (New York, 1990), 172. Her findings inform studies of early American interior decoration, in this case John E. Crowley, *The Invention of Comfort: Sensibility and Design in Early Modern Britain and Early America* (Baltimore, 2001), 102.

47. The 1754 inventory of Sarah Logan's estate (widow of James Logan)—the Stenton House in Germantown, Pa.—lists a total of ten maps on display on the second floor of her private lodgings: "3 maps, 0.7.6" in the Blue Chamber; "an old chest of drawers, a Rush bottom chair, 3 maps and a dressing glass for 0.17.6" in the Green Chamber; and "a servants feather bed and bedstead and 4 Latin maps, 2.10.0" in the south back garret (*Philadelphia Wills*, 1754/W 121; thanks go to Laura Keim, curator at Stenton Park, for providing this information). Because a woman's bedroom was never totally private, maps on display in bedrooms would have been seen by select visitors and, of course, servants or slaves. See Jessica Kross, "Mansions, Men, Women, and the Creation of Multiple Publics in Eighteenth-Century British North America," *Journal of Social History*, XXXIII (1999), 399–400.

fered from public displays in both decorative theory and practice. Following architectural design books, such as Isaac Ware's magisterial volume *A Complete Body of Architecture* (1756) — and books like his were eagerly bought by affluent Americans as well as borrowed from circulating libraries by the less affluent — wall maps were an implied option for "the decoration of the inside of rooms," in particular for the adornment of "sides" and "chimneys." In British interior spaces, in which, according to Ware, "paper has, in great measure, taken the place of sculpture," designers had the choice of three kinds of decoration: "First, those in which the wall itself is properly finished for elegance . . . ; secondly, where the walls are covered with wainscot; and thirdly, where they are hung; this last article comprehending paper, silk, tapestry and every other decoration of this kind." That maps, like picture prints and paintings, fell into the third category of "other decoration" intended for covering empty walls we already have seen above in newspaper advertisements and print catalogs. What architectural designers like Ware clarify is not only the placement of large wall hangings but also their subsequent reception.[48]

In order to become a decorative wall object, maps demanded a place of high visibility and physical proximity to the map-viewing audience. The floor plan illustrating Ware's chapter "Of Inside Decorations" reveals ample space for hanging large wall objects (Figure 9). Whether framed or on rollers, wall maps would have hung suspended on exposed cords running from nails close to the ceiling. Thus suspended they would have most likely hung on walls opposite windows and fireplaces for better light and views. As suggested earlier, they were also found hanging above the fireplace as a form of overmantel decoration.[49] But, in order to understand the visual work of ornamental maps, note that rooms appointed in the Queen Anne, Chippendale, or the

48. Isaac Ware, *A Complete Body of Architecture: Adorned with Plans and Elevations, from Original Designs* (London, 1756), 468–469.

49. Floor plans that show space for wall hangings implicitly and explicitly can also be found in Abraham Swan, *The British Architect; or, The Builder's Treasury of Stair-Cases . . .*, 2d ed. (London, 1750); and Swan, *The British Architect; or, The Builder's Treasury of Stair-Cases . . .* (Philadelphia, 1775); Thomas Sheraton, *The Cabinet-Maker and Upholsterer's Drawing Book . . .* (London, 1793); and [George] Hepplewhite, *The Cabinet-Maker and Upholsterer's Guide . . .* (London, 1794). Many estate inventories list maps in the same entry with fireplace equipment; see, for example, "Three Maps, Andiron fire Shovel and Tongs 7/5/0" in the "Inventory of the Goods . . . of John Paschall . . . Darby, County of Chester . . . [1779]," Downs Collection, 61, Box 25/PH 553, Winterthur Museum and Library. For overmantel displays, see Anna O'Day Marley, "Rooms with a View: Landscape Representation in the Early National and Late Colonial Domestic Interior" (Ph.D. diss., University of Delaware, 2009).

FIGURE 9. Isaac Ware, *A Complete Body of Architecture: Adorned with Plans and Elevations, from Original Designs* (London, 1756), plate 68. Courtesy, The Library Company of Philadelphia

Federalist styles would have had maps hanging fairly high in relation to viewers standing up or sitting down. In rooms with high ceilings, maps would have been displayed significantly above chair rails, at or above shoulder height, and thus at a substantial remove from the map viewer. In rooms with low ceilings, wall maps would have also been hanging at elevated levels but, given the spatial constriction, closer to the viewer, at eye level in parlors, and at shoulder height in more cramped traffic areas such as hallways and staircases.[50]

Yet, visibility was not enough for wall maps to be taken seriously as decorative objects. On the contrary, depending on their size and number, map displays potentially usurped decorative concepts such as *"Eurythmia . . .* [the] agreeable Harmony between the Breadth, Length, and Heighth of all the Rooms of the Fabrick [that is, building], which from a secret Power in Proportion is very pleasing to all Beholders." It also would have disrupted *"Symmetry . . .* a due Proportion of each Part in respect of the whole; whereby a great Fabrick should have great Apartments or Rooms, great Lights or Windows, great Entrances or Doors." Some critics always would construe maps and their asymmetrical content as too unwieldy or unsightly. Yet encyclopedic handbooks such as Richard Neve's *City and Country Purchaser's and Builder's Dictionary* made provisions for decorative choices that distorted or disrupted the golden rule of proportion and symmetry. By the same token that *"Decorations"* are supposed to maintain "a due Respect between the Inhabitant and Habitation," disproportionate decorations, such as oversized wall maps hanging above the inhabitants' heads, were excusable offences because classical designers, "for Instance, *Palladio[,]* concluded, That the principal Entrance was not to be regulated by any certain Dimensions, but by the Dignity of the Master." Similar to a disproportionate doorway or a grotesque window treatment, a giant map put on display—for example, in the dining rooms of the Virginia governor, Lord Botetourt, or the Philadelphia citizen, John Peters—would have disrupted the symmetry of architectural lines in the eyes of the aesthete (Figure 10). But it would have been precisely the oversized map's malapportioned display that would have turned it into the kind of visual decor representing the owner's "Dignity" and his social, economic, or educational status.

50. Mayhew and Myers, *Documentary History of American Interiors,* 88, 132. Ceiling height is conspicuously absent in many interpretations but can be deduced from Shammas, *Pre-industrial Consumer,* 157–169; from floor plans and house profiles shown in Herman, *Town House;* and from Dell Upton "Another City: The Urban Cultural Landscape in the Early Republic," and Damie Stillman, "City Living, Federal Style," 137–174, in Catherine E. Hutchins, ed., *Everyday Life in the Early Republic* (Winterthur, Del., 1994), 137–174.

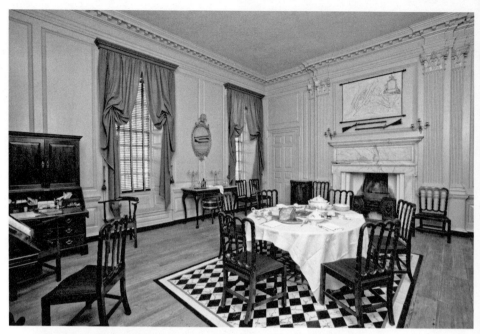

FIGURE 10. Dining Room, Governor's Palace, Williamsburg, Virginia.
Permission, The Colonial Williamsburg Foundation

After all, to quote a double-entendre by Thomas Sheraton, author of several architectural handbooks, "Such prints as are hung in the walls ought to be memorials of learning, and portraits of men of science and erudition."[51]

Although the elevated placement of the wall map as visual centerpiece is similar to its placement in public structures, the visual effect as a spectacle in private spaces is rather dissimilar. The unique context of domestic decorations transposed the look of maps into a decorative field driven by visual quotation. Maps published between 1750 and 1800 trace a genealogy of design patterns borrowed from wood- and metalworks. In particular, map cartouches and the graphic designs framing the map on the margins served as a visual bridge linking the maps' cartographically inscribed interiors to the material designs surrounding maps in domestic spaces. Cartouche designs, for

51. Neve, *City and Country Purchaser's and Builder's Dictionary*, s.v. "Buildings"; Hood, *Governor's Palace in Williamsburg*, Appendix 1, 287; "Inventory of . . . John Peters . . . ," *Philadelphia Wills*, 1770/W 414; Thomas Sheraton, *Thomas Sheridan's Cabinet Dictionary* (1803), intro. Wilford P. Cole and Charles F. Montgomery, 2 vols. (New York, 1970), II, 216.

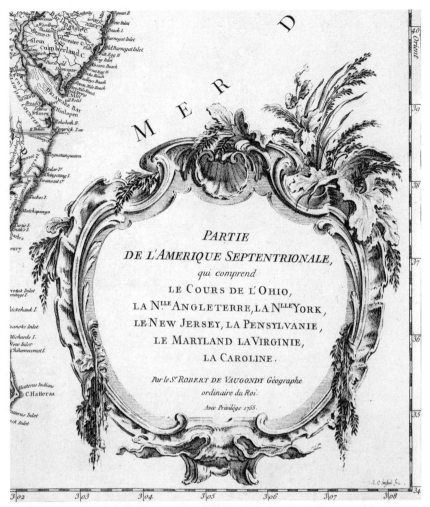

FIGURE 11. Cartouche in Robert de Vaugondy, *Partie de l'Amérique septentrionale ...* (1755). Courtesy, The Library Company of Philadelphia

example, imitated patterns used in materials framing pictures and mirrors. Map engravers borrowed liberally from the same scrolled and lapping-leaf design patterns: compare the cartouche of Robert de Vaugondy's map *Partie de l'Amérique septentrionale* (1755; Figure 11) to the frame designs published in Thomas Chippendale's *Gentleman and Cabinet-Maker's Director* (1754; Figure 12). Over the decades, the formal parallels between frames surrounding mirrors, pictures, frontispieces, and map titles adjusted to changing tastes—map cartouches shifted from the baroque auricular frame, with its paired volutes,

Pier Glass frames.

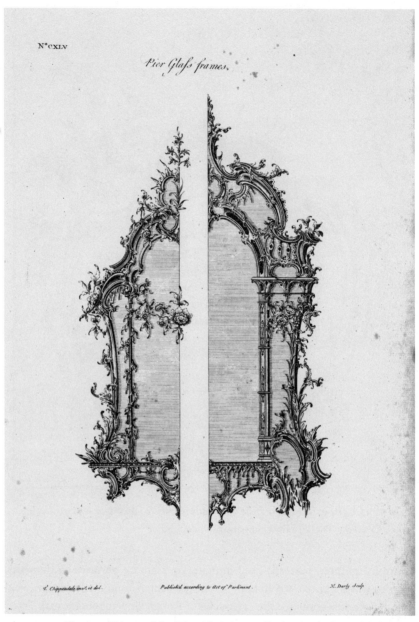

FIGURE 12. Thomas Chippendale, "Pier Glass Frames," *The Gentleman and Cabinet-Maker's Director . . .* (London, 1755), plate CXLV. Courtesy, The Library Company of Philadelphia

scrolls, foliage, and floral buds, to the more neoclassical designs emphasizing geometric lines and architectural structures.[52]

The use of mirrors further calibrated the overlap between ornamental maps and domestic material culture as visual spectacle. Beginning with baroque interiors, as John Crowley has shown, design patterns "concentrated on the arrangement of windows, mirrors, and fireplaces" as access to light became increasingly a function of interior design and style. By the mid-eighteenth century, mirrors were rapidly becoming a common household good in America even without the influence of architectural manuals and were present in more than 75 percent of rural and urban homes. If we consider that "the ideal location for a looking glasses was in axial orientation to a fireplace," mirrors added more than light and luster to interior decorations; they doubled the visibility of chimney maps. In households that could not afford large mirrors in cramped spaces, savvy print sellers (such as John Bowles) offered smaller mirrors for the visual amplification of map displays, in particular the "*Diagonal Mirrour*, in which method of looking at them, they appear with surprising beauty, and in size but little inferior to the real places."[53]

The interplay between map and mirror went beyond the quotation of formal design elements. Even if optical gadgets like the zograscope were not used for map displays proper—they were intended for magnifying perspective views—we get a keen sense of the visual experience of maps as a product of visual triangulation. As if caught in a mirrored cabinet consisting of surfaces that included glazed maps, looking glasses, and window panes, the map viewer experienced the map's image as a product of multiple reflections.

52. The same scrolled and lapping-leaf design patterns can be found in Thomas Johnson's *One Hundred and Fifty New Designs* (London, 1758). On baroque picture frames, see Jacob Simon, *The Art of the Picture Frame: Artists, Patrons, and the Framing of Portraits in Britain* (London, 1996), 51–54; and Paul Mitchell and Lynn Roberts, *A History of European Picture Frames* (London, 1996).

53. Crowley, *The Invention of Comfort*, 124, 129. For a microanalysis of mirrors in mid- to late-eighteenth-century households, see Kevin M. Sweeney, "Furniture and the Domestic Environment in Wethersfield, Connecticut, 1639–1800," in Robert Blair St. George, ed., *Material Life in America, 1600–1860* (Boston, 1988), 286–288. On mirrors and prints, see John Bowles, *A Catalogue of Maps, Prints, Copy-Books* . . . (London, 1753), 39; also in *Robert Sayer's Catalogue of New and Interesting Prints* . . . (London, 1786), Sayer advertises "DIAGONAL MIRRORS for shewing these views, neatly fitted up in Mahogony, with Looking glass, etc. One Guinea each" (49). Based on its description, this mirror seems to suggest the zograscope, a magnifying glass placed before images to create the stereographic effect of depth when viewing architectural or landscape prints, also called by catalogs "perspective views."

This experience would have included not just reflection but also refraction. Because the map would have been placed on walls along with a mirror and a window, the viewer's experience would have been informed by a) catching his or her own face in the looking glass, b) the mirrored reflection of map images, and c) the view of real places from windows overlooking the grounds of a country seat or the gardens and streets next to town houses.

With the refraction of map objects into multiple facets, the visual experience of domestic map displays hinged on multiple acts of seeing. As suggested by the images of the solitary map reader and the satirical cartoons discussed above, maps were viewed intensively. As long as map content was the focus of attention, it invited the fixed gaze as map viewers inspected and read maps when looking for specific places, roads, and contested boundaries. Conversely, maps that were placed in the position reserved for decorative wall ornaments (such as those hanging high up above fireplaces or above door frames) would have attracted a more passing glance rather than a concentrated stare. This more cursory viewing would certainly be true for maps hanging in high traffic areas such as hallways and staircases; walking up and down dim-lit stairs, viewers would have seen maps anamorphically, through sidelong glances that distorted the perception of images and things. We do not need to marshal literary theories of reading or empirical studies of visual cognition to realize that decorative maps were thus subject to a double vision consisting of intensive gazes and extensive glances. Because viewers had the stereoscopic experience of simultaneously espying cartographic particulars close-up while also seeing nonlinear and rhizomatic map shapes from afar, the impact of ornamental maps on visual experience was as pervasive as it was radical: in the domestic sphere, wall maps encouraged the cartographic enclosure of the viewers' field of vision.[54]

MATERIAL IMPLICATIONS

The interplay of map images and decorative objects complicated the carto-coding of visual experience and, for that matter, the visual field in both public

54. The literature on the map gaze is rich, especially in relation to interpretations of imperial power. For a survey of studies, see Cosgrove, *Geography and Vision* and his *Apollo's Eye: A Cartographic Genealogy of the Earth in the Western Imagination* (Baltimore, 2001); also see Jacob, *The Sovereign Map*, trans. Conley, ed. Dahl, esp. 66, 77, 114. On the glance, see Edward S. Casey, *The World at a Glance* (Bloomington, Ind., 2007); Lyle Massey, *Picturing Space, Displacing Bodies: Anamorphosis in Early Modern Theories of Perspective* (University Park, Pa., 2007); Jen E. Boyle, "The Anamorphic Imagination: Embodying Perspective in Seventeenth- and Eighteenth-Century Literature and Science" (Ph.D. diss., University of California, Irvine, 2003).

and private spaces during the second half of the eighteenth century. Beginning with domestic walls, maps had to compete early on with the ultimate big print medium, the "hanging" or wallpaper. But, as suggested by a 1787 fictional sketch called "Frettana," maps handily controlled this latest newcomer to domestic print furniture: writing about her bookish husband, the female narrator complains that "the pretty flower'd paper in the hall is all cover'd over with nothing but maps, and drafts, and carts [sic]." If paper maps were not decorative enough, textile maps printed on cotton or silk, such as Lewis Evans's *General Map of the Middle British Colonies in America* (1755) or James Smithers and John Reed's *Map of the City and Liberties of Philadelphia* (1774), provided a more textured cartographic wall cover. Leaving the walls behind, but still put on vertical display, giant maps were set up along walls and windows in the form of a "most curious SCREEN, adorned with a Map of the Globe, Orbs, the Countries of Europe, etc.," or close to fireplaces in the form of "firescreens with maps on both sides."[55]

Moving from the gigantic to the miniature, from vertical placements on walls to the horizontal distribution of furniture, the spectacle of maps included luxury goods and everyday consumer objects, or "cartifacts," whose visual appearance had been enhanced by the transfer of map images.[56] On the one hand, hefty folio atlases, such as Thomas Jefferys's *American Atlas* (1775) required ample table space for the viewing of large fold-outs, such as the Fry-Jefferson map or the Bowen-Gibson maps. On the other hand, since the late 1750s male and female occupants of both the public and the private spheres carried assorted map handkerchiefs showing military campaigns; these were made for pockets or as neckties, including, for example, *A Map of the Present Seat of War in North America* (1776; Figure 13). For women, "map fans useful and entertaining" showed campaign maps as well as maps of Germany, the English and French coasts, and the French encroachments in America. For

55. Catherine Lynn, *Wallpaper in America: From the Seventeenth Century to World War I* (New York, 1980), 17–30, 156–158. On "Frettana," see *Columbian Magazine*, I (August 1787), 594 (also cited in Pritchard, "Maps as Objects," *Magazine Antiques* [January 2001], 217). A copy of the Evans map on silk is shown in Schwartz and Ehrenberg, *Mapping of America*, 165. A copy on cotton of the Smithers-Reed map is at the Winterthur Museum. On giant maps as screens, see *PG*, Jan. 28, 1768. On maps as fire screens, see Botetourt Papers, cited in Hood, *Governor's Palace in Williamsburg*, 324 n. 59.

56. A "cartifact" is defined as "an object that uses a cartographic motif primarily as a design rather than to convey information. An ashtray with a map of the London Underground would be an example: you might use it to get around, but the purpose of the object is to take ash." See http://www.allwords.com/word-cartifact.html (accessed February 2009). To date, the *Oxford English Dictionary* does not recognize the term.

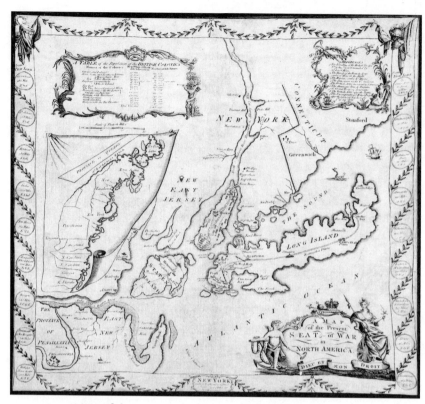

FIGURE 13. *A Map of the Present Seat of War in North America.* 1776.
Courtesy, Winterthur Museum

the cartophile man of the house, special "watch papers" to be inserted into
pocket watches showed map images rather than royal or family portraits.[57] At

57. See the ad "map and field work purple and white superfine linen handkerchief,"
in *PG,* Apr. 14, 1773. On the phenomenon of map handkerchiefs in general, see Mary
Schoeser, *Printed Handkerchiefs* (London, 1988). Map handkerchiefs were apparently
worn for show, as suggested by an ad published in *PG,* June 9, 1773: "SIX DOLLARS Re-
ward. RUN away from the subscriber, . . . an English servant man, named JOHN CLARK,
about 5 feet 4 inches high, of a pale complexion, sandy hair, lisps when he talks, is lame
of his left foot, which is crooked and turns out, . . . had on and took with him, . . . three
handkerchiefs, one black silk, one red and white map, and the other check, white
thread and stockings, and good shoes." On map fans, see Clayton, *The English Print,* 150.
He cites ads such as the *Public Advertiser* (London), Aug. 16, 1759. For later examples
that include map gloves, see Diane Dillon, "Consuming Maps," in James R. Akerman
and Robert W. Karrow, Jr., eds., *Maps: Finding Our Place in the World* (Chicago, 2007),
289–343. *Robert Sayer's New and Enlarged Catalogue for the year MDCCLXXIV: New,*

tables, visitors to American taverns and homes would have discovered "geo-graphical" playing cards for the entertainment of adults; for children, geo-graphic study cards, board games, and map puzzles.[58] School-age children put on display in parlors and academies creatively embellished map draw-ings as well as map needlework samplers. And then there were map vignettes, which were transfer-printed on curtains, bed hangings, and seat covers. Even cupboards and sideboards were not immune to map displays; enterprising English printers transferred map cartouches to jugs and plates, selling them to American citizens beginning in the 1790s. The only object missing in the American records of cartifactual goods is the British-made porcelain figurine called the "Map Seller" (produced circa 1745–1769).[59]

Of course, American households would have rarely displayed the whole gamut of map things all at once. With actual maps circulating in American public and private spaces, the material presence of maplike objects further refracted and modified the visual experience of maps. In addition to the re-fined gaze or cursory glance, the material diversity of map displays extended the sensory experience to combine sight, touch, smell, and perhaps even taste. Once removed from elevated wall placements, maps made of paper, cotton,

Scarce, and Valuable Prints in Sets and Single, Books of Architecture, Drawing and Copy-books . . . (London, 1774) offered "Designs in Miniature for watch cases" that included a map. See also map "roundels," in Geoffrey L. King, *Miniature Antique Maps* (Tring, Hertfordshire, 1996), 152.

58. *PG*, Nov. 17, 1773. On maps and card games, see Edward T. Joy, *Gaming* (London, 1982); in particular, the 1768 publication of a deck of cards in which "each of the four suits dealt with a continent and the court cards bore portraits of contemporary rulers. The Joker was a cannibal set against the background of the West Indies, described as Cannibal Islands; the suit of America was clubs, the king being John IV of Portu-gal with a description of Brazil on his card" (12). Also, see Robert Tilley, *Playing Cards* (New York, 1967). On study cards and board games, see Brückner, *Geographic Revolu-tion*, 181–183. On puzzles, see Anne D. Williams, *The Jig Saw Puzzle: Piecing Together a History* (New York, 2004); and Linda Hannas, *The English Jigsaw Puzzle, 1760–1890: With a Descriptive Check-List of Puzzles in the Museums of Great Britain and the Author's Collection* (London, 1972).

59. Brückner, *Geographic Revolution*, 135–139; Mary Kelley, *Learning to Stand and Speak: Women, Education, and Public Life in America's Republic* (Chapel Hill, N.C., 2006), 66–111; Florence M. Montgomery, *Textiles in America, 1650–1870: A Dictionary Based on Original Documents, Prints and Paintings, Commerical Records, American Mer-chants' Papers, Shopkeepers' Advertisements, and Pattern Books with Original Swatches of Cloth* (New York, 2007); Patricia Halfpenny, *Success to America: Creamware for the American Market* (New York, 2010). We know that Americans were buying Meissen figures, but I have yet to trace the "Map Seller" in North America.

silk, ceramics, or cardboard would be subject not only to eyes but also to fingers tracing topographic lines, roads, and borders. Seeing maps was no longer exclusively predicated on the map's being a picture; rather, the tactile interaction with the map's materiality would have complemented the visual experience and invariably would have incorporated the map's material staging grounds, that is, the map-bearing furniture such as tabletops, bookshelves, and sartorial accessories. Varnished maps exhaling fumes of turpentine and maps exuding musty odors of bleached paper attached smell to the sensory experience of maps. As to tasting maps, the historical archives show no evidence of edible maps. But, when George Washington returned from a ball on February 15, 1760, he commented in his diary on the use of pocket handkerchiefs as a substitute for "Table Cloths and Napkins." Chances were good that, given the aftermath of the 1758 siege of Louisbourg, one of the ballgoers would have wiped his mouth and chin with a map handkerchief bearing the cartographic imprint of the fortress (an image published widely in almanacs at the time).[60]

Put on display in American spaces of high and low significance, decorative maps now must be considered as sensory agents that actively structured not only spatial cognition but conduct. Over the last two decades, a generation of scholars has closely examined the relationship between maps and conduct, emphasizing the link between mapping practices and the politics of conquest, colonization, and nation building (see the Introduction to this volume). As long as we consider the widely approved scientific "useful" maps — from the Mitchell map to the first generation of maps showing the united American nation-state by Amos Doolittle, Abel Buel, or William McMurray — in relation to their strategic display in locations such as the State House in Philadelphia or the schoolrooms of Susanna Rowson's female academy, the argument that cartographic visuality affected territorial behaviors and questions of geopolitical identity stands firm. But, in dealing with the question of the maps' ornamental function, this assessment begins to appear as "too

60. "Friday Feby. 15th [1760] . . . Went to a Ball at Alexandria—where Musick and Dancing was the chief Entertainment. However in a convenient Room detachd for the purpose abounded great plenty of Bread and Butter, some Biscuets with Tea, and Coffee which the Drinkers of coud not Distinguish from Hot water sweetned. Be it remembered that pocket handkerchiefs servd the purposes of Table Cloths and Napkins and that no Apologies were made for either. I shall therefore distinguish this Ball by the Stile & title of the Bread and Butter Ball." See Donald Jackson and Dorothy Twohig, eds., *The Diaries of George Washington*, I, *1748–65* (Charlottesville, Va., 1976), 238. Thanks to Matthew Keagle, fellow in the Winterthur Program in American Material Culture, for this reference.

static, mediated, distanced and restricted to have much bearing on every-day embodied activity"—in short, as too detached from the cultural perfor-mance surrounding the spectacle of maps. Just as personal and social identity are now regarded as "constructed and labile, made and altered in the perfor-mance of everyday life," so, too, did personal and theatrical interactions with ornamental maps mobilize and redefine the static image of political maps. As the demands of material culture turned national maps into the equivalent of commercial billboards and doilies, the ornamental function of maps supplied new meaning to sensory perceptions and personal identity that fed on self-interest rather national interest, personal habits rather than economic invest-ment, commercial fads rather than rules of refinement.[61]

Inside American interiors, then, the decorative wall map becomes the "transposed map," shifting its visual function from being a picture containing symbolic signs or narratives to a decorative object that actively carto-coded modes of self-representation.[62] Eighteenth-century American painters, simi-lar to Dutch and Spanish painters from a century before, explored the re-lationship of map images and map viewing habits in portraits that showed sit-ters in public and domestic settings. Subjects painted by Ralph Earl, Edward Savage, and Samuel F. B. Morse frequently hold or point to maps in surround-ings that consist of the very decorative objects (curtains, carpets) against which wall maps were competing inside domestic settings (Figure 14). Show-ing some sitters seated next to windows overlooking specific geographic places, such as the family estate or local landscape, portraits that contain map images specify not only the geographic location of the sitter but also his or her sense of place outside the home.

In this configuration, the paintings call attention to competing modes of spatial representation. The portraits offer two choices to picture the sit-ters' identities in situ: the painter's graphic conventions that situate subjects through the imitation of natural space using linear perspective, colors, and the realistic portrayal of objects, or the mapmaker's cartographic conventions used for plotting objects inside a uniform, abstract, and geometric space. Al-though the portraits privilege the former mode of representation, by showing the principal sitters touching maps rather than paintings or books the por-traits enmesh the sitters in a sensory world in which the ornamental picture

61. Here I apply the terms of Cosgrove's critique of the primacy of the visual in geo-graphic analyses. See Cosgrove, *Geography and Vision*, 5.

62. I borrow the term from Victor I. Stoichita, *The Self-Aware Image: An Insight into Early Modern Meta-Painting*, trans. Anne-Marie Glasheen (Cambridge, 1997), 173–174. Stoichita examines a visual field consisting of painting, map, and mirror.

FIGURE 14. Ralph Earl, *Thomas Earle.* 1800, oil on canvas. Andrew W. Mellon Collection, Image courtesy National Gallery of Art, Washington, D.C.

of the planar map operates as both the visual and tactile link connecting not only the various sitters' interior settings but also their very sense of interiority to an external, cartographically defined environment in which the sense of self is grounded at once in the mapping of real estate and cartographic competence, territorial identity, and self-worth.[63]

63. Here I depart from Margaretta Lovell's observation that "Americans preferred the image of an independent unitary household vaguely located in an unancestral, unspecific space." See Lovell, *Art in a Season of Revolution: Painters, Artisans, and Patrons in Early America* (Philadelphia, 2005), 147.

In the end, the spectacle of maps presents a response to the academic understanding of maps and cartographic representation. Unlike conventionally used maps, the ornamental use of maps emerged from the performative field of social rituals in which personal and communal relations were balancing aesthetic theory and convivial play, critical interrogation and theatrical performance. By inhabiting these various discourses, ornamental maps not only carto-coded a people's spatial consciousness but also their sense of lifeworld. On the macro level, they offered a scenic alternative to conventional natural landscapes; on the micro level, they provided a reference point for bodily everyday activities. On the whole, the decorative map's multiform material presence served to reconcile personal and communal expectations about nature and country, home and state. Just as architects imagined their spatial designs to establish "a due Respect between the Inhabitant and Habitation," ornamental maps offered a spectacular way for the self to become at home with the American space.[64]

64. Neve, *City and Country Purchaser's and Builder's Dictionary*, s.v. "Decorum."

Year of sale	Title/ material add-ons	No. of sheets	Price (£/s./d.)
1733	Popple, *Map of the British Empire*/ colored, rollers	20	1/11/6 2/12/6
1753	Moll, *The British Dominions*	1	0/5/0
	Moll, *The British Dominions*	2	0/1/6
	America . . . from the Observations of the Royal Academy of Sciences	4	0/2/6
1755	Evans, *Middle British Colonies*/ colored	—	0/1/0 0/2/0
1766	Freeman, *Maps and Prints*	2	0/6/4 to 0/2/6
	North America	4	0/5/0
	"better edition, *North America*"/ cloth, rollers	4	0/7/8
	No. America/ cloth, rollers	4	0/10/4
1768	Henry, *Map of Virginia*/ colored, rollers	4	0/15/0 1/10/0
1775	Evans, *Middle British Colonies* (rpt.)	1	0/1/6
	Bowen and Gibson, *A New and Accurate Map of North America*/	4	0/5/0
	colored, rollers		0/9/0
	The World/	28	0/10/6 to 0/15/0
	colored, rollers		1/15/0 to 3/3/0
1777	*A New Map of the State of Connecticut*/ colored, rollers	4	0/8/0 0/18/0
1783	McMurray, *Map of the United States*	2	[$3.33]
1785	*Map of the Four New-England States*	4+	0/14/0
1786	"Common Two Sheet Maps and Prints for Country Dealer . . . on Elephant Paper, 3 by 2 feet" (in *Sayer's Catalogue of New and Interesting Prints*)/	2	0/0/6 (whole-sale only)
	colored		0/1/6

Year of sale	Title/ material add-ons	No. of sheets	Price (£/s./d.)
1795	Carey, *Catalogue of Books*	1	[$0.37]
	Lewis, *Map of the United States* (in Matthew Carey Accounts, LCP)	2	0/15/0
1796	Bradley, *Map of the United States/* colored, rollers	4	[$3.50] [$5.00]

Sources: Prices reflect source materials, listed here in chronological order, that reference maps advertised in commercial venues but not in personal or institutional inventories: John Bowles, *A Catalogue of Maps, Prints, Copy-Books* . . . (London, 1753); William and Cluer Dicey, *A Catalogue of Maps, Prints, Copy-Books, Drawing-Books* . . . (London, 1754); Lewis Evans's prices, *Pennsylvania Gazette* (Philadelphia), Nov. 2, 1755; *Maps, Charts, and Plans, Published for, and Sold by Thomas Jefferys* (London, 1763); Philip Freeman, *Boston, September 30, 1766; on Monday, the 13th of October Next, Will Be Offered to Sale at a Store in Union-Street, Opposite to the Corn-Field, a Valuable Collection of Books, a Variety of Maps and Prints* . . . (Boston, 1766); *Robert Sayer's New and Enlarged Catalogue for the Year MDCCLXVI of New, Useful, and Correct Maps* (London, 1766); Robert Bell, *A Catalogue of New and Old Books* . . . (Boston, 1770); Garrat Noel and [Ebenezar] Hazard, *Catalogue of Books* . . . (New York, 1771); William Faden and Thomas Jefferys, *A Catalogue of Modern and Correct Maps, Plans, and Charts* (London, 1774); Robert Sayer and John Bennett, *Sayer and Bennett's Enlarged Catalogue of New and Valuable Prints, in Sets, or Single; Also Useful and Correct Maps and Charts* . . . (London, 1775); Robert Bell, *A Catalogue of a Large Collection of New and Old Books* . . . (Philadelphia, 1783); William McMurray's *Map of the United-States,* advertised in *Pennsylvania Packet; or, The General Advertiser* (Philadelphia), Aug. 14, 1783; *Robert Sayer's Catalogue of New and Interesting Prints* . . . (London, 1786); Mathew Carey, *Catalogue of Books, Pamphlets, Maps, and Prints* (Philadelphia, 1795); Matthew Carey Accounts, nos. 2176, 2340, 2396, 2817, microfilm, roll 1, Library Company of Philadelphia. For individual maps, see the records reproduced by J. B. Harley, "The Bankruptcy of Thomas Jefferys: An Episode in the Economic History of Eighteenth Century Map-Making," *Imago Mundi,* XX (1966), 35; David Bosse, "The Boston Map Trade of the Eighteenth Century," in Alex Krieger, David Cobb, and Amy Turner, eds., *Mapping Boston,* 38–39; Bosse, "Maps in the Marketplace: Cartographic Vendors and Their Customers in Eighteenth-Century America," *Cartographica,* XLII (2007), 9–16; and Mary Sponberg Pedley, *The Commerce of Cartography: Making and Marketing Maps in Eighteenth-Century France and England* (Chicago, 2005), Appendix 5.

HURRICANES AND
REVOLUTIONS

Michael J. Drexler

I begin with a coincidence. If one were to correlate areas under the threat of slave resistance with those subject to periodic and often devastating hurricanes, one map would suffice to capture an image of this doubly dangerous zone. The resulting map would correspond, perhaps unsurprisingly, to what Immanuel Wallerstein has defined as the extended Caribbean. Peter Hulme has offered one explanation of this region's extranational features: ecological integrity, its association in the European imagination with cannibalism, and its susceptibility to hurricanes (Figure 1).[1]

Hulme's study of the extended Caribbean closes at the end of the eighteenth century. For him, it "is essentially an historical entity, one that came into being in the sixteenth century and that has slowly disappeared," presumably replaced by the nationalized spaces that follow the U.S. War of Inde-

The author wishes to acknowledge Dan Heuer and the Bucknell University Library staff for their help with the illustrations. He is also grateful to Ed White for reading early drafts of the essay.

1. Peter Hulme, *Colonial Encounters: Europe and the Native Caribbean, 1492–1797* (New York, 1986), 3–4. Similar claims about the extranational, regional integrity of the Caribbean can be found in Caribbean historiography and cultural studies. See, for example, Franklin W. Knight, *The Caribbean, the Genesis of a Fragmented Nationalism* (New York, 1978); and Michaelle Ascencio, *Lecturas Antillanas* (Caracas, 1990). Although Hulme's map of the extended Caribbean reaches northward to Jamestown, Virginia, Caribbeanists typically imagine the material geography of the region encompassing only the southern tip of Florida. In contrast, Silvio Torres-Saillant argues that any holistic account of the Caribbean must consider its insular, continental, and diasporic reach, three cultural spaces that extend the Caribbean to Latin America, the United States, and the immigrant communities in major European cities. See Torres-Saillant, *An Intellectual History of the Caribbean* (New York, 2006), 21. Sites of slave insurrection included Cuba, Guadeloupe, Guyana, Florida, Louisiana, New York, South Carolina, several of the Virgin Islands, Virginia, and, of course, Saint Domingue.

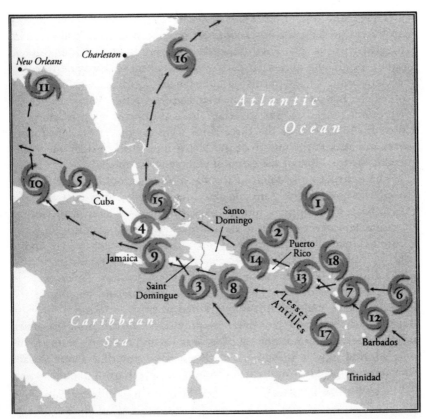

FIGURE 1. Verifiable Hurricane Strikes and Trajectories, June–November 1772. Drawn by Rebecca L. Wrenn

pendence, the Haitian Revolution, and the later independence movements throughout the Antilles, the West Indies, and Latin America. Although Hulme does concede that the "transnational legacy" of the extended Caribbean is "still palpable," a more robust account of the material and cultural salience of the extended Caribbean in the era of struggles for colonial independence and national autonomy seems warranted. A fluid geopolitics periodically restructured the political orientation of Caribbean spaces throughout the latter eighteenth and then the nineteenth century, but patterns of economic activity, human migration (forced and voluntary), and the nonanthropocentric sharing of flora, fauna, and weather continued to denote regional integrity.[2]

Indeed, recent scholarly work has argued persuasively for privileging transnational determinants of political, economic, and cultural development.

2. Hulme, *Colonial Encounters,* 5.

Central to these studies have been the human responses to the long historical experience of periodic natural disaster in the region, namely, hurricanes. Stunningly, a simple transposition of terms drives a similar set of human responses to slave resistance. Scholars of slaveholding societies and resistance to them have explored not only the repressive and reactionary activities of the master class but also the circuits of communication among disparate Afro-Caribbean populations that leveraged an activist and productive notion of an extended or pan-Caribbean identity to transform history from below.[3]

What follows, then, is a stereographic analysis of semiotic continuities. Given these two bodies of scholarship that both work against the grain of nationalist historiography, what deeper connection might exist between their subject matter? Did cultural responses to either slave resistance or environmental catastrophe inform one another, and, if so, how? When period writers and respondents recognized the coincidence of slave revolts and hurricanes was the social, literary, or scientific imagination stifled or was critical reflection on the continuing interconnections across national boundaries empowering? What is happening culturally and ideologically when slave resistance takes on the figurative language of hurricanes? And, vice versa, what is going on when hurricanes are imbued with or deprived of instrumentality or agency—whether from a deity or because they are anthropomorphically yoked to human will? What does the specific, seemingly redundant, and only speciously subtle deployment of a literary trope tell us about material and social being or the struggle to represent it? We will approach these questions with four brief case studies ordered strategically, not chronologically: Herman

3. Some examples of relevant environmental historiography include Sherry Johnson, *The Social Transformation of Eighteenth-Century Cuba* (Gainesville, Fla., 2001); Matthew Mulcahy, *Hurricanes and Society in the British Greater Caribbean, 1624–1783* (Baltimore, 2006); and Louis A. Pérez, Jr., *Winds of Change: Hurricanes and the Transformation of Nineteenth-Century Cuba* (Chapel Hill, N.C., 2001). For scholarship on slave resistance, of which I can only provide a sampling, see Herbert Aptheker, *American Negro Slave Revolts* (New York, 1983); W. Jeffrey Bolster, *Black Jacks: African American Seamen in the Age of Sail* (Cambridge, Mass., 1998); Laurent Dubois, *Avengers of the New World: The Story of the Haitian Revolution* (Cambridge, Mass., 2004); Eugene D. Genovese, *From Rebellion to Revolution: Afro-American Slave Revolts in the Making of the Modern World* (Baton Rouge, La., 1979); Genovese, *Roll, Jordan, Roll: The World the Slaves Made* (New York, 1974); Julius Sherrad Scott III, "The Common Wind: Currents of Afro-American Communication in the Era of the Haitian Revolution" (Ph.D. diss., Duke University, 1986); John K. Thornton, "African Soldiers in the Haitian Revolution," *Journal of Caribbean History*, XXV, nos. 1, 2 (1991), 58–80; and Thornton, *Africa and Africans in the Making of the Atlantic World, 1400–1680* (New York, 1992).

Melville's 1856 novella *Benito Cereno,* Philip Freneau's 1785 poem "The Hurricane," Benjamin Franklin's map of the Gulf Stream (1769), and a brief glimpse at Frederick Douglass's only work of fiction, *The Heroic Slave* (1853).

MELVILLE'S CAPE

Herman Melville sets *Benito Cereno* off the coast of southern Chile. The year is 1799, and the foundering ship *San Dominick* has entered the harbor of an isolated island and approaches another ship at anchor, the *Bachelor's Delight,* captained by Amasa Delano of Duxbury, Massachusetts. Captain Delano, who is a "person of a singularly undistrustful good nature" (681), fails to draw a connection between the foreboding natural environment and the *San Dominick,* which upon closer view is revealed to be a slave ship. Partially obscured by the fog, the *San Dominick* looms closer, a light from the cabin window streaming forth "much like the sun ... which ... showed not unlike a Lima intriguante's one sinister eye" (682). Among the first instances of irony, the comparison of ship to sinister woman is narratologically thick, initiating a series of geographical, ethnocultural, and categorical displacements.[4]

The *San Dominick*—a clear reference to the Haitian Revolution unfolding on the French colony of Saint Domingue at the time of the novella's setting—has been positioned, not in the Caribbean, but off the southern coast of Chile. The lawless sea is then compared to a plaza in Lima, seat of the Viceroyalty of Peru. The *San Dominick* reminds Delano of a monastery in the Pyrenees and then of untenanted balconies above the Venetian Grand Canal. This series of displacements leads ultimately to the most important one for our purposes: the *San Dominick* rests off the coast of Chile, not—as the concocted cover story crafted by the slave rebel Babo tells it—because of an environmental condition (a heavy gale followed by two months of windless seas and accompanied by an epidemic of scurvy aboard), but because of a slave mutiny.

Worth underscoring here is that Melville's narrative strategy for intertwining hurricanes (or gales) and black violence is one of displacement, not of relation. As we will see below, accounts of hurricanes and other oceanographic phenomena often manifest an excess, or supplemental, quality that *relates* them to the vocabulary of slave resistance. In Melville's story, this interpretive expectation is precisely reversed. The *San Dominick* is *either* where it is because of the storm *or* because of a revolt, the former designed to hide the latter. In a sense, Delano will reach any conclusion but one of relation, cate-

4. Herman Melville, *Benito Cereno,* in *Moby-Dick, Billy Budd, and Other Writings* (New York, 2000), 681–763 (page numbers for quotations are indicated in parentheses in the text).

gorically refusing the semiotic excess that reference to storms might otherwise generate. Moments of relation are fleeting and phantasmatic, the "apprehensive twitch in the calves of his legs" (695) Delano tries to suppress "by ignoring the symptoms, to get rid of the malady" (716).

In a brief commentary on *Benito Cereno,* Guyanese novelist Wilson Harris insightfully mapped the operation of Melville's strategy of displacements. Unwilling or unable to see the materiality of the situation before him—a ship in conflict—Melville's Delano transfers the ghostly emptiness of his first impressions onto a plane where he is secure in his superiority over what lies before him. Delano's train of associations are, according to Harris, not merely comic indicators of naïveté (the black slaves appear, at a distance, like monks wearing cowls). Rather, the semiotic substitutions reveal how Delano intuitively copes with uncertainty. "[I]ntuition," writes Harris,

> is not a turning away from concrete situations. It is, in fact, a revelation of other capacities at the heart of a concentration within and upon given situations. A revelation and concentration that exact a formidable price upon sensibilities which may recoil from what is "seen" or "learnt": recoil as before a mirage or as before issues by which they are non-plussed: issues that lack an immediate philosophical anchorage and conventional explanation.

Although Delano sees the "true character" of the *San Dominick*—"a Spanish merchantman of the first class; carrying negro slaves, amongst other valuable freight"—he ranges to explain its disarray and disrepair—what is "seen" or "learnt" (683). Following Harris, we can describe how Delano finds his answer. Rather than acknowledge the contemporary referents of the name *San Dominick*, the Yankee Delano opts for those more remote. Surveying the rotting hull and the "slovenly neglect pervading her" (683), Delano arrives at a sense of national superiority. His benevolent and tidy Yankee Protestantism supersedes the claustrophobic communal values of monastic Catholicism and imperial Spain; the robust cleanliness of mercantile trade overcomes the "warlike and Froissart pattern" (683) of inquisition and conquest, the corruption for which Venice was infamous. This exercise extends to Delano's assessment of the *San Dominick*'s captain, Cereno, who cannot be Delano's equal whether by rank or skill, but rather assumes the form of a "hypochondriac abbot" (687), wasting away the hours in all-consuming, but fruitless, preoccupation.[5]

As the novella continues, Delano vacillates between suspicion, benevolent

5. A. J. M. Bundy, ed., *Selected Essays of Wilson Harris: The Unfinished Genesis of the Imagination* (London, 1999), 124.

paternalism, and pity for Cereno. Matters come to a head in one of Melville's most accomplished vignettes, the dramatic shaving scene in the captain's quarters. In this episode, Babo, the mastermind of the slave revolt, draws "first blood" (727) from Captain Cereno's neck as Cereno and Delano discuss the implausible narrative of the *San Dominick*'s journey around Cape Horn. Told that the *San Dominick* was beset by a gale off the Cape and then foundered for two months before arriving at Saint Maria on the southern coast of Chile, Delano is incredulous, having himself navigated those seas in a matter of days. When Cereno strategically *forgets* having mentioned traversing Cape Horn, Babo guides him to the cuddy for his daily shave and, when Cereno again falters in his description of the gales off the Cape, Babo cuts him to prevent him from alerting Delano to the ship's original itinerary, a northerly journey from the Port of Valparaiso, Chile, to the Port of Callao (Lima) in Peru. This original itinerary would not have taken the *San Dominick* around Cape Horn. The Cape Horn story is a necessary fiction to explain why the *San Dominick* lies off the southern coast of Chile—south of her point of departure for Lima. And, in reality, crossing the Cape would be in the vessel's future plans should Delano release it to continue its journey to repatriate the rebel slaves in Africa. After commandeering the ship, Babo has rerouted it on a southerly course to be followed by a northeasterly heading to Senegal (Figure 2).

Cape Horn is quite literally the point on which Melville's novella pivots. It is the polar counterbalance to the imperial ports of Valparaiso and Buenos Aires, a point relatively equidistant from either seat of imperial power. It also marks the divide between the Pacific and the Atlantic Oceans, the former aligned with trade (Delano's ship, the *Bachelor's Delight,* is returning via the Pacific from China) and the latter with rebellion (Haiti and the Senegal plot). And, as the southern point on an imaginary, but significantly hemispheric, compass, it is the polar opposite to the absent northern referent, at once, or, rather, as a spinning turnstile, now Haiti and now the northeastern United States. Fundamentally, the Cape is the point of contention between Babo and Cereno. As we learn toward the novella's end, little has been resolved on the *San Dominick* at the moment Amasa Delano boards her, despite the slave revolt that has toppled the hierarchy of master and slave. True, the slaves' owner, Alexandro Aranda, has been killed, and Cereno has lost control of his ship; nevertheless, matters aboard have reached a tense stalemate. Having recklessly killed the ship's navigator, the blacks must rely on Cereno to transport them to Senegal.

Only during the deposition of Cereno—in the last third of the novella—do readers learn the true state of affairs on board. Earlier on, readers must choose between the narrator's or Delano's point of view. A third possibility—that

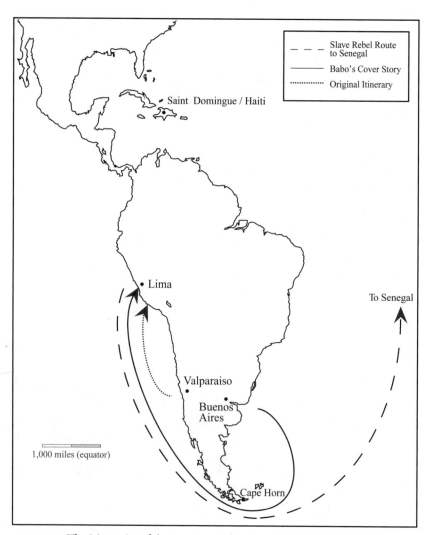

FIGURE 2. The Itineraries of the *San Dominick* in Herman Melville's *Benito Cereno* (1856). Drawn by Michael Drexler

the ship remains divided, in the midst of conflict—is strategically occluded. Let us return to the beginning of the novella, where readers witness the first sighting of the *San Dominick* by sailors aboard the *Bachelor's Delight*. By revisiting Melville's opening scene, we will be able to see the false choices Melville devises to tempt his readers into errors of interpretation. Once again, we note that Melville's Delano fails to perceive the connection between the natural environment and the mysterious human drama playing out before him. The narrator provides the first sleight of hand, placing the *San Dominick*

in a natural setting that has already been invested with semiotic richness. The seemingly neutral grayness of the scene is quickly imbued with sinister overtones: the "troubled gray fowl" and the "troubled gray vapors," the "shadows present, foreshadowing deeper shadows to come" (681). Within this loaded setting, the narrator suggests that the *San Dominick* itself is a malign agent. Here, the personification of the ship misleads by insinuating that the vessel has the integrity of a human subject. Delano, too, mistakes the *San Dominick* for a subject; however, his view differs significantly while falling for the same categorical fallacy. Like the narrator, Delano also feminizes the *San Dominick*, applying the conventional, if figurative, language of the sea to *her:* "The ship, in navigating into the harbor, was drawing too near the land, for her own safety's sake, owing to a sunken reef making out off her bow" (682). Unlike the narrator, however, Delano does not view the ship and the setting as of a piece; rather, he sees the two at odds.

For Delano, the *San Dominick* is subject to the hazards of nature. If, as the narrator suggests, the *San Dominick* is driven by ill intent, then Delano is the dupe of his own "singularly undistrustful good nature." Delano, however, is convinced that he has nothing to fear because the actions of the *San Dominick* mark her as an incompetent subject. Here we enter the discourse of the feminine invalid, the damsel in distress, and the broader terminology of domesticity. Delano, the patriarch or knight errant, positions himself to husband the distressed ship. In Delano's eyes, the *San Dominick* is an incapacitated agent; incompetent in her surroundings and unable to cope with duress, she is reduced to the status of an object. With regard to the forces of nature in which she is positioned, she has no power to realize her will. Though the inkling of subterfuge flickers continuously on the periphery, Delano suppresses his concerns by recourse to his own unflappable egotism. Unlike the *San Dominick* and its hypochondriac captain, Delano imagines himself as a fully realized, competent subject: a master of wind and sea.

Melville's circuit of displacements brings us back, then, into the time present of the novella, yoking Delano's theoretical, nationalist chauvinism to his applied maritime skills. This synthesis, not unimportantly, also allows the absent United States to supersede absent Haiti as Delano's northerly point of reference. Thus, the geographically mapped plot (zones of confusion to those of clarity) connects Cape Horn to the diminished seat of Spanish power in Lima and then to the United States, now figured as the rightful successor. This series obscures another that would add Haiti to the mix, thereby radically transforming its narrative. In place of a diachronic story of imperial succession, this latter, occluded narrative would draw synchronic ties between north and south, highlighting points of complicity with and resistance to

the slave trade. The first might be represented by a series, whereas the latter would look like a cycle.

Narrative I	Cape Horn	Lima		United States
Series	?	—		+
	Confusion	Mismanagement		Resolution

Narrative II	Cape Horn	Lima	Haiti	United States
Cycle	X	Y	X	Y^1
	Revolt	Stasis	Revolt	Stasis

Because Delano sees only Narrative I, the material referents of the *San Dominick*, the "negro slaves, amongst other valuable freight" (683), recede from view. For the plot, they are negligible: objects, not agents. With blind confidence in his own maritime skills, Delano is able to discount Cereno, the *San Dominick*'s now, but nominal, steward, the effeminate, bad captain— incompetent, ill prepared, and perhaps batty to boot. And, when the black characters / cargo come under his appraisal, Delano's behavior mirrors the same self-satisfied posture. Like the winds and sea, natural phenomena pacified under the exercise of human agency and skill, the blacks appear naturalized in Delano's view, thus subservient to his authority. To him, they are like Newfoundland dogs, or, as a black woman is described, "like a doe in the shade of a woodland rock" (712). Despite hailing from the slave-free state of Massachusetts, Delano even offers to buy Babo from Cereno for fifty doubloons.

What Melville has done here in *Benito Cereno*, bringing together Massachusetts and Saint Domingue in the tranquilizing waters of the Pacific Ocean round Cape Horn off the coast of Chile, is remarkable. Transposed from the Caribbean Sea, the slave revolt on the *San Dominick* is at first unrecognizable and then wholly containable. Even though Delano gets it all wrong until the moment when, like a flash of lightning or a slumbering volcano at once awoken, he captures the real state of affairs before him, he nevertheless maintains control. The mask torn away, the revolt revealed, does not incapacitate him; it spurs him into efficient action. He hails his crew, has the guns run out, and leads the assault that brings the revolt to an end. This ending, which may seem at odds with the history of the slave revolt on Saint Domingue, is sustainable because of the deterritorialization of the slave rebellion. Much as Delano euphemistically refers to the slave ship as a "negro transportation-ship" (684), taking the slave revolt out of the Caribbean plays on readers' gullibility. It may also signal Melville's broader pessimism about the outcomes of Haiti's inde-

pendence. By the middle of the nineteenth century, the stormy revolutionary energy of the rebellion had drifted, wracked by internal division, unstable and draconian leadership, internecine violence, and corruption.[6]

If geographic deterritorialization enables Melville to sustain the believ-ability of Delano's mastery of both nature and man, how do literary represen-tations actually located in the Caribbean region function? If mastery of the sea is a trope for managing or stabilizing the relationship between master and slave, what happens to this literary figuration when wind and sea are out of control?

FRENEAU'S ABYSS

We can explore these questions by jumping back to 1785 and Philip Freneau's thirty-six-line poem "The Hurricane." Freneau spent many years working and sailing in the Caribbean and the Atlantic. He worked on a Danish West Indies plantation in the 1770s, managed the transport of goods between New York and the Azores in the eighties, and was operating his own brig in the Carib-bean Sea in 1785 when "The Hurricane" was written:

Happy the man who, safe on shore,
 Now trims, at home, his evening fire;
Unmov'd, he hears the tempests roar,
 That on the tufted groves expire:
Alas! on us they doubly fall,
Our feeble barque must bear them all.

Now to their haunts the birds retreat,
 The squirrel seeks his hollow tree,
Wolves in their shaded caverns meet,
 All, all are blest but wretched we —
Foredoomed a stranger to repose,
No rest the unsettled ocean knows.

While o'er the dark abyss we roam,
 Perhaps, with last departing gleam,
We saw the sun descend in gloom,
 No more to see his morning beam;
But buried low, by far too deep,
On coral beds, unpitied, sleep!

6. Jean-Pierre Boyer abdicated his presidency in 1836, initiating a long period of instability that eventually led to President Faustin Soulouque's declaring himself em-peror in 1849.

But what a strange, uncoasted strand
 Is that, where fate permits no day—
No charts have we to mark that land,
 No compass to direct that way—
What Pilot shall explore that realm,
What new Columbus take the helm!

While death and darkness both surround,
 And tempests rage with lawless power,
Of friendship's voice I hear no sound,
 No comfort in this dreadful hour—
What friendship can in tempests be,
What comfort on this raging sea?

The barque, accustomed to obey,
 No more the trembling pilots guide:
Alone she gropes her trackless way,
 While mountains burst on either side—
Thus, skill and science both must fall;
And ruin is the lot of all.

Freneau's apocalyptic poem begins by distinguishing the man at home from the sailors on a ship at sea. Within the domestic space, the man ashore is doubly "unmoved," the winds neither control his bodily fate nor his emotions; he hears the howling gales but remains in repose, not fearing for his own safety. For the shipmates on the barque caught in the middle of the storm, however, all is in a state of flux; they are doubly *moved*. On shore, the man and the animals of the natural world are connected. Each finds within nature a place of comfort, but the sailor in the storm is wretched, while all others seem blessed. He is a stranger to repose, subject to the movement of the natural world—apart from it, its object, its target.[7]

A transition occurs in the next couple of stanzas. Whereas the beginning of the poem separates domestic tranquillity from seafaring dangers, stanzas 3 and 4 attempt to draw connections by transferring the figure of the storm from the materiality of the ocean tempest to the metaphysics of death. The sun descends into the abyss, sinking for these gazers for the last time, and the unknown realm of the afterlife is considered. Where the figuration of home and natural repose dominated in the first two stanzas, now the figuration of the sea directs the new topic. Death is that "uncoasted strand" for which all

7. Philip Freneau, "The Hurricane," in Fred Lewis Pattee, ed., *The Poems of Philip Freneau: Poet of the American Revolution*, II (Princeton, N.J., 1903), 250–251.

humans are equally unprepared. Each lacks the tools to navigate it or a leader to follow, here denominated by an absent Columbus. The end of the poem returns us to the ship, *imaginable* as a tool subservient to the will of the sailors or a trusted pilot, but, here, as with the metaphorical ship-as-soul in the afterlife, wholly at the mercy of its environs. The "lawless" power of the storm baffles the sailors' ability to maintain control of the ship. Neither science nor skill works any longer. "Ruin is the lot of all." For Freneau, then, the hurricane is associated with a loss of agency that is the polar opposite of the master's repose gained within a secure domestic space. In this way, both Freneau and Melville are thinking through a similar problem. Each tries to imagine how to link the experience of the sea and wind to life on shore, and for each the Caribbean Sea, with its unpredictable and "lawless" winds, proves to be the limit case.[8]

The link between the uncontrollable storms of the Caribbean and colonial management goes back to the beginnings of English colonization of the West Indies. In 1638, John Taylor published a pamphlet in London entitled *Newes and Strange Newes from St Christophers of a Tempestuous Spirit, Which Is Called by the Indians a Hurry-Cano or Whirlewind*. In his pamphlet, Taylor yokes the hurricane to the unruliness of the native inhabitants of the Caribbean islands. Slavery and bondage, Taylor writes, have the advantage not only to extract labor value from Caribbean bodies but also to discipline the soul: "Through slavery and bondage many people and Nations that were Heathens, and barbarous, have been happily brought to Civility and Christian Liberty." "Yet in the latest Daies of the World," Taylor continues, "all are not civliz'd; there are yet many Heathens, *Indians,* and barbarous Nations unconverted: as for knowne Examples in *America,* and in divers Islands adjacent, where this *Hurri Cano* is frequent." Here Taylor perhaps initiates the trope where the cartography of danger that maps the area where "lawless" hurricanes are frequent is also the same zone wherein the disciplinary regime of slavery is least effective or is frequently resisted.[9]

Taylor places the storm in a grand, providential narrative, where the storm lies beyond or outside the dominion of the true religion. The source of the

8. In a complementary move, Sean X. Goudie argues that "lawless power" may also refer to "British tyranny over U.S. commerce in the Caribbean." Thus, if the domestic scene demonstrates mastery (the successful prosecution of the American Revolution and the establishment of independent law), the sea is that place where U.S. merchants remained vulnerable to British assault, to seizure warranted by the disadvantageous terms of the Treaty of Versailles. See Goudie, *Creole America: The West Indies and the Formation of Literature and Culture in the New Republic* (Philadelphia, 2006), 132.

9. John Taylor, *Newes and Strange Newes from St Christophers of a Tempestuous Spirit, Which Is Called by the Indians a Hurry-Cano or Whirlewind* ... (London, 1638), 2, 3–4. Taylor's pamphlet is discussed in Hulme, *Colonial Encounters,* 97–101.

hurricane is located in a region associated with barbarism and theologically by extension with the agency of Satan. Similar notations exist in North American Puritan texts, which figured the colonial frontier as a howling wilderness. In 1639, John Winthrop described a tempest that, while damaging some property, allowed the Massachusetts Bay Puritans to marvel at how "the Lord miraculously preserved old, weak cottages" and also to see divine justice in the death of five Indians "pawwawing in this tempest" and thus subject to the devil's machinations. Throughout the seventeenth century, New England Puritans refined the interpretive schema of reading the signs of the natural world and of its un-Christianized inhabitants. We can recognize here the familiar Puritan sermon tradition in which the Indians or natural phenomena were not signs of Satan's power but rather instruments of divine agency empowered to test or correct the behavior of the orthodox, if wayward, saints. Thus did Increase Mather and later Jonathan Edwards find comfort in thunderstorms and lightning strikes, both confirmation of the deity's engagement in the affairs of believers and apostates.[10]

If there is a connection between this seventeenth-century theological view of hurricanes and the more secular attitudes of the eighteenth century, we might locate it in the manner in which those beings that lay outside the traditional protections of a providential narrative are treated: in these earlier accounts of devastating storms, native Americans, and in later accounts, African slaves. A number of accounts of hurricanes from the eighteenth and early nineteenth century focus on property losses, and almost always in these accounts one finds an accounting of lost slave laborers amid the list of wreckage. This treatment of slave lives as a class of property among the buildings and crops also destroyed is consistent with the earlier depiction of a storm's devastating effect on pagan Indians. It is also consistent with the development of Anglo-Caribbean slave codes, which were different from Spanish counterparts; for the British islands, the slave was not a lesser human being but was reduced completely to a special class of property. True, the seventeenth-century believer wants dead Indians, or at least finds theological confirmation in their demise, while the slave master wants to avoid dead property. Nevertheless, in both cases, the tallying of losses confirms the special status of the survivor. In either case, a sense of control in the aftermath of the devastating experience of natural catastrophe is reestablished by keeping tabs of objectified losses, a ledger in which bodies are so many broken things.[11]

10. Richard S. Dunn, James Savage, and Laetitia Yeandle, eds., *The Journal of John Winthrop, 1630–1649* (Cambridge, Mass., 1996), 286.

11. For example, here is how Aaron Burr described the aftermath of a storm he ex-

Among the slaveholding regions of the extended Caribbean was a counter-vailing anxiety in the aftermath of devastating natural disaster—that slaves would take advantage of the resultant chaos to revolt. Despite the absence of any major slave-revolt activity following on the heels of any particular storm, British West Indian authorities sated their fears with coordinated plans to thwart rebellion by making visible the already extensive policing regime, which included town watches, militia units, and regular troops. Moments of crisis thus tested the limits of slaveholding societies' self-assessment of their own vulnerability. In response to storms and the resultant feelings of existential insecurity, they ran out all manifestations of control to contain anxiety about the loss of sociocommunal agency.[12]

The supplemental or excessive display of already extensive policing regimes begs the question whether other mechanisms for rationalizing and thus gaining some control over the dehumanized forces of nature also illustrate a complementary excess. The most obvious challenge to the providential analysis of the source of hurricanes was scientific rationalism, whose practitioners took increasing interest in meteorological observation and analysis throughout the eighteenth century. Scientific theories of wind patterns and storm trajectories attempt to ameliorate the sense of disempowered human agency even if the knowledge alone could not prevent future catastrophes. The science of oceanography and wind analysis did, however, offer some predictive instruments that in turn diminished, if not supplanted, theological explanations of natural disasters. What is interesting about these early attempts to grapple scientifically with the phenomena of weather is how these forays into empirical analysis elevated regional, transnational networks over the artifice of political boundaries. This is one of the supplemental effects of Benjamin Franklin's determination that weather patterns in Boston and Philadelphia were linked to winds in the Caribbean basin.[13]

perienced while visiting a plantation in Georgia in September 1804: "Major Butler has lost nineteen negroes (drowned), and I fear his whole crop of rice, being about two hundred and sixty acres. Mr. Brailsford, of Charleston, who cultivates in rice an island at the mouth of the Alatamaha, has lost, reports say, seventy-four blacks. The banks and the buildings on the low lands are greatly injured." See Aaron Burr and Matthew L. Davis, *Memoirs of Aaron Burr with Miscellaneous Selections from His Correspondence*, 2 vols. (New York, 1836–1837), II, 340. See also Elsa V. Goveia, *Slave Society in the British Leeward Islands at the End of the Eighteenth Century* (New Haven, Conn., 1965); and Goveia, *A Study on the Historiography of the British West Indies to the End of the Nineteenth Century* (Washington, D.C., 1980).

12. Mulcahy, *Hurricanes*, 100.

13. See Benjamin Franklin to Jared Eliot, Feb. 13, 1749–50, in Franklin, *Writings,*

As early as 1749, Benjamin Franklin was already collecting observations that would lead to his plotting of the Gulf Stream, published first in 1768 and recirculated widely in 1785 (see Figure 3, below). In a letter to Jared Eliot, Franklin answered a query concerning why coastal northeastern storms begin to "leeward," rather than coming into the coast from the east, and are thus experienced at North Carolina, Virginia, and Pennsylvania before in Boston. In his response, Franklin proposed a meteorological circuit of winds linking the Gulfs of Florida and Mexico to the Northeast:

> Suppose a great Tract of Country, Land and Sea, to wit Florida and the Bay of Mexico, to have clear Weather for several Days, and to be heated by the Sun and its Air thereby exceedingly rarified; Suppose the Country North Eastward, as Pensilvania, New England, Nova Scotia, Newfoundland, etc. to be at the same time cover'd with Clouds, and its Air chill'd and condens'd. The rarified Air being lighter must rise, and the Dense Air next to it will press into its Place; that will be follow'd by the next denser Air, that by the next, and so on. Thus when I have a Fire in my Chimney, there is a Current of Air constantly flowing from the Door to the Chimney; but the beginning of the Motion was at the Chimney, where the Air being rarified by the Fire, rising, its Place was supply'd by the cooler Air that was next to it, and the Place of that by the next, and so on to the Door. So the Water in a long Sluice or Mill Race, being stop'd by a Gate, is at Rest like the Air in a Calm; but as soon as you open the Gate at one End to let it out, the Water next the Gate begins first to move, that which is next to it follows; and so tho' the Water proceeds forward to the Gate, the Motion which began there runs backwards, if one may so speak, to the upper End of the Race, where the Water is last in Motion.[14]

Notwithstanding the accuracy of Franklin's observation, our interest must not stop here. Note Franklin's reliance on analogy to make his scientific description clear: cool air rushing toward the "rarified air" instigated by fire, water rushing toward a previously stopped gate, air in a state of calm. By extension, the hot, southerly climate of the Caribbean instigates a similar rushing motion, literally sucking the northern air downward and triggering, in

ed. J. A. Leo Lemay (New York, 1987), 440–442. See also C. F. Volney and C[harles] B[rockden] Brown, *A View of the Soil and Climate of the United States of America; with Supplementary Remarks upon Florida; on the French Colonies on the Mississippi and Ohio, and in Canada; and on the Aboriginal Tribes of America* (Philadelphia, 1804), 159–160.

14. Franklin to Eliot, in Franklin, *Writings*, ed. Lemay, 440, 441.

Franklin's words, "violent" storms inland once the gates between north and south are opened. Here, the Caribbean is a weight that draws northern points down and exposes them to violence. It does not take a great leap of imagination to visualize how a system so described might animate a Puritan gloss on the slippery slope of sin. Thus, a rationalist approach to weather phenomena is pliable and, by metaphoric association, it can become an exemplum of what it putatively was designed to contest. Note that Franklin's initial interest in this particular weather pattern was owing to the frustration its effect caused him. Unable to view a lunar eclipse because it was shrouded from view by storm clouds at Philadelphia, Franklin is astonished that friends in Boston reported seeing it clearly an hour before the same storm arrived there. Prevented from witnessing a natural marvel and one often associated with omens and portents, Franklin ranges for an enlightened, rational explanation to supplant his previously blocked curiosity. Having assumed the storm would have originated off the Northeast coast, Franklin now has proof of an inland genesis. Insight into the cause of the storm assuages blindness brought about by its effect, an episodic event now mastered.

We might trace a political analogy as well. Produced during the period of Franklin's career that has been described as one of "paracolonial ambivalence," might Franklin's explanation productively illustrate the dangers of too close a connection between mainland commercial networks and the slaveholding colonial economies to the south, the hot economy of the southern plantation system eventuating stormy troubles in the Northeast? The metaphoric associations Franklin used to explain his empirical insights, it seems, warrant a more basic observation. Empirical science would appear to be at odds with another imaginary discourse so much at the center of eighteenth-century colonial culture: the political borders that, however tenuously secured, momentarily defined and parceled the region. To put it succinctly: into the 1790s and beyond northerners aimed rhetorically to distinguish their own economies from the slaveholding regimes of the mainland South and the Caribbean region. Nevertheless, weather patterns and the trade routes that they enabled continued to tell a different story of mutual dependence and even moral complicity.[15]

Part of the work of the environmental historians discussed above has been to underscore how the especially tumultuous hurricane seasons during the later years of the eighteenth century reoriented trade alliances among British, French, Spanish, and colonial American mercantile entrepôts. They have

15. See Goudie, *Creole America*, on "paracolonial ambivalence," 111–152 (quotation on 111). Goudie helpfully surveys Franklin's writing on the Caribbean (36–54).

helped us understand that responses to hurricanes provide important and determinative insights into the scale, longevity, or failure of revolutionary movements. Human agency is now, it has been argued, contingent on antihuman forces of the natural world. The devastating late-century Caribbean storms led to intercolonial, but intrahemispheric, alliances as local officials turned to imperial rivals in neighboring colonies for assistance when support from the home country was delayed or denied. Colonial antagonists formed regional networks, even against official sanction, in response to catastrophic damage from storms. Anecdotal support for this mode of intercolonial cooperation can be found in Franklin's writings.

Consider the following from "Narrative of the Late Massacres," a text written to condemn the barbarism of the Paxton Boys, who murdered a community of Conestoga Indians in an act of collective punishment. In sympathy for the Indians and in outrage against the "CHRISTIAN WHITE SAVAGES," Franklin praises the rival Spaniards, alongside the "ancient *Heathens*," "*cruel Turks*," and even the "*Negroes* of *Africa*," among whose company the Indians would have been safer:

> Justice to that Nation, though lately our Enemies, and hardly yet our cordial Friends, obliges me, on this Occasion, not to omit mentioning an Instance of *Spanish* Honour, which cannot but be still fresh in the Memory of many yet living. In 1746, when we were in hot War with *Spain*, the *Elizabeth*, of *London*, Captain *William Edwards*, coming through the Gulph from *Jamaica*, richly laden, met with a most violent Storm, in which the Ship sprung a Leak, that obliged them, for the Saving of their Lives, to run her into the *Havannah*. The Captain went on Shore, directly waited on the Governor, told the Occasion of his putting in, and that he surrendered his Ship as a Prize, and himself and his Men as Prisoners of War, only requesting good Quarter. *No, Sir*, replied the *Spanish* Governor, *If we had taken you in fair War at Sea, or approaching our Coast with hostile Intentions, your Ship would then have been a Prize, and your People Prisoners. But when distressed by a Tempest, you come into our Ports for the Safety of your Lives, we, though Enemies, being Men, are bound as such, by the Laws of Humanity, to afford Relief to distressed Men, who ask it of us.*[16]

These ad-hoc colonial responses to storms point to analogous plans to prevent or quell slave resistance. Intercolonial and regional integration appears

16. Benjamin Franklin, "A Narrative of the Late Massacres, in Lancaster County, of a Number of Indians, Friends of This Province, by Persons Unknown, with Some Observations on the Same," in Franklin, *Writings*, ed. Lemay, 551, 555, 556.

to mitigate fear of slave insurrection in a way similar to how these transpolitical ties proved compensatory in the aftermath of natural disasters. Supranational civility here diminished the need to understand slave conspiracy, resistance, and revolution as the outcome of rational, coordinated, and strategic human responses to oppression. In other words, reducing slave resistance to a type of natural phenomenon on the order of scientifically explainable if not preventable natural catastrophes was a mechanism for suppressing a broader acknowledgement of what slave resistance was really about. Transferred then to the figural register, appeals to intercolonial comity provided an alternative explanation to the highly practical and rationalistic legal codes that explicitly acknowledged the likelihood of slave conspiracy and rebellion. It should be noted that these, too, were widely circulated. For example, one can trace the migration of provisions against slave insurrection in the Barbados slave code of 1661 as these were serially adopted throughout the Caribbean.[17]

Franklin's empirical study of the Gulf Stream, a band of water originating in the Caribbean and extending as a swift-flowing current hugging the eastern seaboard and then projecting eastward into the Atlantic, eerily illustrates a similar dynamic (Figure 3). Uncannily resonant of Amasa Delano's nautical chauvinism, Franklin had his map printed to instruct British packet ship captains how to speed their journey from London to the Northeast coast. Just as these captains had proven "too wise to be counseled by simple American fishermen" in the past, Franklin, too, found his own advice "slighted."[18]

It is instructive to view the larger map from which Franklin's chart was extracted for wider publication (Figure 4). Note that the darkened swath representing the Gulf Stream remains the map's most distinctive feature despite the grander scope of the complete Folger engraving. Excerpted, the Gulf

17. One should not overplay interimperial cooperation. It was also common for imperial rivals to take satisfaction in the other's struggles against both storm and rebellion. Another reason for differences between metropolitan policy and practical implementation was frequently shifting allegiances on the ground or at sea. Loyalty to king and country could be fickle among sailors who could be impressed into naval service multiple times on many sides of a given conflict. Merchants, for their part, desired the continuation of trade no matter what governing authority sanctioned it.

18. Benjamin Franklin, "A Letter from Dr. Benjamin Franklin, to Mr. Alphonsus Le Roy, Member of Several Academies, at Paris; Containing Sundry Maritime Observations," American Philosophical Society, *Transactions*, II (1786), 315. Ellen R. Cohn dates the original map, produced for Franklin with the assistance of his cousin, Thomas Folger, sometime in February 1769. See Cohn, "Benjamin Franklin, Georges-Louis Le Rouge and the Franklin / Folger Chart of the Gulf Stream," *Imago Mundi*, LII (2000), 132.

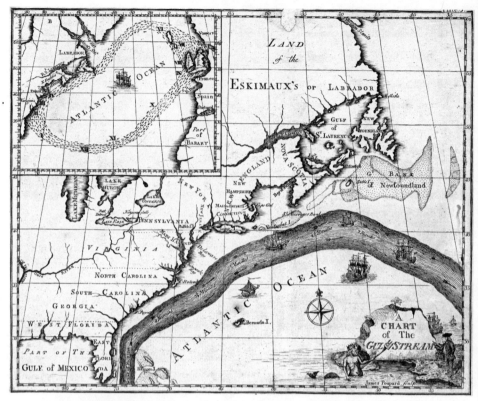

FIGURE 3. Benjamin Franklin, *A Chart of the Gulph Stream.* From *Remarks upon the Navigation from Newfoundland to New-York in Order to Avoid the Gulph Stream on One Hand, and on the Other, the Shoals That Lie Ten Leagues Due South of Nantucket, and Southwest of the Shoalest Ground on St. George's Banks, Twenty-Eight Leagues* (Boston, 1790). Courtesy, Geography and Map Division, Library of Congress

Stream chart negates the Caribbean, though the current itself indeed originates south and west of the Florida peninsula.

On one level, the Gulf Stream map, embedded in Franklin's own narrative of disrespected Yankee ingenuity, once again illustrates the power of Enlightenment science to tame natural forces. Whereas the British literally sail against the current, the rival North Americans have harnessed nature and have begun to reroute the conventional mercantilist hierarchy. The Gulf Stream carries the commercial fecundity of the New World to the Old. Nevertheless, his public-spirited intent notwithstanding, Franklin's chart reveals much more than a natural phenomenon and how commercial interests ought to profit from it. There is something excessive about the darkened channel, its origins truncated, sweeping along the contrastingly blank American coast.

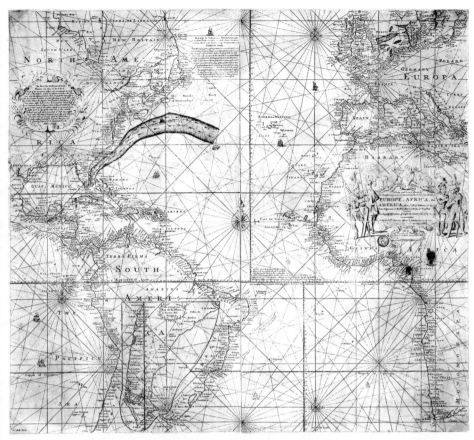

FIGURE 4. Benjamin Franklin, Franklin-Folger Chart of the Gulf Stream (London, [circa 1768]). Courtesy, Geography and Map Division, Library of Congress

Though he joined the ranks of the abolition movement later in life, writing satiric attacks on slavery and developing paternalistic schemes to manage the gradual emancipation of Philadelphia's slave population, Franklin's earlier writings attack slavery through a white supremacist fantasy to purge North America of the "Sons of *Africa*." In "Observations concerning the Increase of Mankind" (1751), Franklin writes that "the Number of purely white People in the World is proportionally very small."

While we are, as I may call it, *Scouring* our Planet, by clearing *America* of Woods, and so making this Side of our Globe reflect a brighter Light to the Eyes of Inhabitants in *Mars* or *Venus,* why should we in the Sight of Superior Beings, darken its People? why increase the Sons of *Africa* by Plant-

ing them in *America,* where we have so fair an Opportunity, by excluding all Blacks and Tawneys, of increasing the lovely White and Red?

Might Franklin's black swath contain an anamorphic solution to the conundrum of racial mixing? Might the Gulf Stream offer a solution sanctified by nature to contain the force of black slave labor, harness it, convert it for profit, and safely keep it at a distance from the North American mainland? Or, perhaps, is it a natural conduit for purging the hemispheric economy of its black slaves, sweeping them speedily back to Africa?[19]

Franklin's chart might remind us of Peter Stallybrass and Allon White's discussion of urban sewer systems in *The Politics and Poetics of Transgression,* where the relationship between the visible street level and the filthy conduits below constitutes a symbolic system. The sewer contains, renders invisible, and sweeps away evidence of the material and social formations that sustain the sanitized domain of the rising bourgeoisie. Stallybrass and White describe this system as "one of the dominant tropes of western metaphysics: truth lies hidden behind a veil." Look again at Figure 4, above, where well-masted and well-laden ships navigate the surface of the black channel below, carrying eastward the fruits of slave labor that has been disciplined under the repressive apparatus of the plantation system. Only the black swath indicates the residue of the slave economy, black bodies—both their labor power and their potential for revolt—veiled from view. The illustration appears to have anatomical correlates as well. As with the sewer, associated in Stallybrass and White via Victor Hugo and Sigmund Freud with excrement, the Gulf Stream resembles a cloaca or rectal canal.[20]

The dehumanizing reduction of slave labor to an anamorphic black swath on Franklin's chart of the Gulf Stream is especially pronounced when placed next to Winslow Homer's *Gulf Stream* (Figure 5). Produced in a different context at the end of the nineteenth century, Homer's painting embraces human agency by featuring a black man as its focal point.

19. Benjamin Franklin, "Observations concerning the Increase of Mankind, Peopling of Countries, etc," in Franklin, *Writings,* ed. Lemay, 374. See "An Address to the Public from the Pennsylvania Society for Promoting the Abolition of Slavery, and the Relief of Free Negroes Unlawfully Held in Bondage," "Plan for Improving the Condition of the Free Blacks," and "Sidi Mehemet Ibrahim on the Slave Trade," all ibid., 1154–1160.

20. Peter Stallybrass and Allon White, *The Politics and Poetics of Transgression* (Ithaca, N.Y., 1986), 140. Franklin's efforts to cleanse the streets of Philadelphia are famously recounted in Part 3 of *The Autobiography;* see Leonard W. Labaree, ed., *The Autobiography of Benjamin Franklin* (New Haven, Conn., 1964).

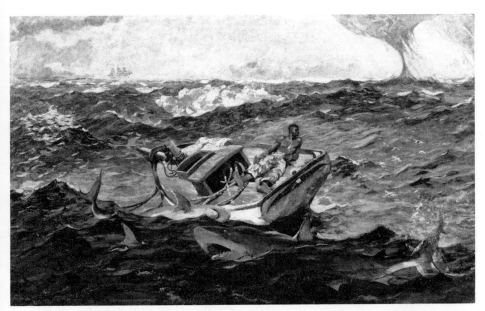

FIGURE 5. Winslow Homer, *The Gulf Stream*. 1899. Oil on canvas, 28 ⅛ × 49 ⅛ in. The Metropolitan Museum of Art, Catharine Lorillard Wolfe Collection, Wolfe Fund, 1906 (06.1234). Image © The Metropolitan Museum of Art

Homer produced this striking image in 1899 after visiting the South, where he witnessed the collapse of Reconstruction and the increasingly hostile environment faced by the region's black citizens, newly subject to nationally sanctioned segregation laws and de facto policing by lynch mobs. Here we see a heroic and muscular black man, perhaps dressed in military fatigues, charting a course between voracious sharks and an oncoming squall. The ship apparently has been dismasted during an earlier storm, but the human figure nevertheless appears to be at rest, seemingly unconcerned with the dangers that surround him. Though the black man's presence and posture caused confusion among Homer's patrons and reviewers, some even suggesting that the figure is irrelevant to the broader symbolism of the work, his realistic and detailed treatment undeniably draws the eye. In contrast to the repressed black presence in Franklin's chart, Homer represents a fully humanized subject that, as one recent critic notes, "marked a new direction in the graphic interpretation of African-American character and identity." Compelling is Peter H. Wood's fascinating and elegant interpretation, which employs the black figure and other objects associated with him to explore how Homer's work "deals in subtle and extended ways with slavery, U.S. imperialism in the Caribbean, southern race wars, and Jim Crow segregation." And yet, despite

the prominent placement of the black man, he is still represented as a victim of his circumstances. Homer does not indicate whether the Gulf Stream is a temporary respite from the hurricane of white racism on the horizon and the ravenous sharks below. In addition to the damaged state of the sloop, which diminishes the black man's agency, Homer also depicts the man bound to the boat by the sugarcane spilling from the hull that may represent chains.[21]

DOUGLASS'S BILLOWS

Homer was one of the earliest white American artists to place black people at the center of the frame. Among his earliest works in this vein was a sketch of Frederick Douglass addressing an abolitionist convention in Boston for *Harpers Weekly* in 1860. It is fitting, then, to conclude with Douglass's own contribution to the use of wind and sea in his antislavery writings. In Douglass we can witness how African American writers worked to reappropriate the figurative energy of the hurricane into the middle of the nineteenth century. Following the passage of the fugitive slave law in 1850, Douglass's attitude toward violent resistance to slavery changed. Having broken with William Lloyd Garrison over whether the U.S. Constitution was a pro-slavery document, Douglass began to vigorously tie resistance to slavery to the revolutionary discourses of American independence. In 1853, he wrote his only work of fiction, a novella entitled *The Heroic Slave*, which celebrated the successful slave mutiny led by Madison Washington in 1841. At the end of the novella, Madison wins over the respect even of his former captors, despite having violently commandeered the slave ship. The mutiny coincided with an oncoming squall, and the tempest strikes the ship right after its conclusion. Tom Grant, the mate formerly in control of the vessel, describes his estimation of Madison:

> During all the storm, Madison stood firmly at the helm,—his keen eye fixed upon the binnacle. He was not indifferent to the dreadful hurricane;

21. An extensive reading of Homer's *Gulf Stream* can be found in Albert Boime, *The Art of Exclusion: Representing Blacks in the Nineteenth Century* (Washington, D.C., 1990), 36–46. See also Henry B. Wonham, *Playing the Races: Ethnic Caricature and American Literary Realism* (New York, 2004), 3; Peter H. Wood, *Weathering the Storm: Inside Winslow Homer's "Gulf Stream"* (Athens, Ga., 2004), 91. Wood suggests that the waterspout may indicate the storm over Cuba in 1898 (43–47). African American troops were deployed to Cuba, sparking controversy among both whites and blacks. Even if, as Wood writes, Homer's "juxtaposition of a strong black man with a spiraling storm over Cuba should not be surprising," it remains unclear whether the storm is a source of the black man's strength or evidence of racial strife in the United States linked to events in Cuba.

yet he met it with the equanimity of an old sailor. He was silent but not agitated. The first words he uttered after the storm had slightly subsided, were characteristic of the man. "Mr. mate, you cannot write the bloody laws of slavery on those restless billows. The ocean, if not the land, is free."

"I confess, gentlemen," Grant continues, "I felt myself in the presence of a superior man; one who, had he been a white man, I would have followed willingly and gladly in any enterprise." Like Amasa Delano, then, Madison Washington solves the dilemma of slave resistance by guiding the ship safely into port. But unlike in "Benito Cereno" where in Lima the slaves are brought to justice—the slave rebel Babo's head impaled on a stake—here, to the horror of Grant, "a company of *black* soldiers came on board, for the purpose . . . of protecting the property," but they refuse to recognize the former slaves under that category. When told that, "by the laws of Virginia and the laws of the United States, the slaves on board were as much property as the barrels of flour in the hold," the black soldiers "rolled up their white eyes in horror, as if the idea of putting men on a footing with merchandise were revolting to their humanity." And, as a consequence, the slaves' freedom is acknowledged, and they leave the ship never to be property again. Douglass thus reanimates the forces of nature, restoring to the desacralized winds a purposive and progressive trajectory.[22]

The contrast between Madison Washington's mastery of the wind and sea and that of Amasa Delano could not be starker. Faced with the incomprehensible, Delano objectifies his surroundings. As agent, Delano pacifies an unruly world and reduces it to an order that corresponds unproblematically with his intuition: blacks are cargo, the Spanish have let *things* get out of hand, order must be restored. One can only imagine how Madison Washington's slave rebels and the Bahamian soldiers might respond to Delano's sunny disposition at the conclusion of the novella, where he is caught off guard by Cereno's continuing gloom. Melville leaves speculation on this account to our imaginations.

Interestingly, Madison Washington and Amasa Delano share the view that the *meaning* of sea and sky cannot be fixed. But Madison Washington's "restless billows" (162) that resist any attempt to engrave upon them the laws of slavery are not Amasa Delano's clear blue sea and sky that, having "turned over new leaves," bear no traces of historical memory. This Don Benito Cereno understands: to Delano's "astonished and pained" question, ". . . you are saved;

22. Frederick Douglass, *The Heroic Slave* (1853), in William L. Andrews, ed., *The Oxford Frederick Douglass Reader* (New York, 1996), all quotations on 162–163.

what has cast such a shadow upon you?" Cereno replies, "The negro" (762). The ensuing silence envelops Cereno's cryptic answer, drawing a lasting equivalence between him and Babo, who after his capture resolved to utter no sound whether by volition or force. Their silence, however, is the silence of human agency and memory, not the forgetfulness of Delano's anthropomorphic nature.

The language of storms provided a rich vocabulary, a discursive reservoir, for representing phenomena that denoted broad and deep social, commercial, and natural connections that belie the significance of arbitrary national and political borders. Nevertheless, even as this vocabulary pointed to the centrality of the Caribbean, or the circumatlantic more broadly, it was neither precise nor efficient enough to be exhausted by any particular signification. In a sense, the geographic, meteorological, and oceanographic representations of regional commonality worked against those that might have leveraged more human-constructed trans-Caribbean connections; thus, rather than together adding to the evidence of foundational regional solidarity, these representations effectively cancelled out one another. That is not to suggest a hermeneutic dead-end. There is much to learn about how various appeals to the lived experience of regional integrity intersected with the projects of nationalism, anticolonial struggle, and race consciousness in the Americas.

Martin Brückner is associate professor in English and Material Culture Studies at the University of Delaware. He is the author of *The Geographic Revolution in Early America: Maps, Literacy, and National Identity* (Chapel Hill, N.C., 2006) and, with Hsuan L. Hsu, co-editor of *American Literary Geographies: Spatial Practice and Cultural Production, 1500–1900* (Newark, Del., 2007).

Michael J. Drexler is an associate professor of English at Bucknell University. He is the co-editor of *Beyond Douglass: New Perspectives on Early African-American Literature* (Lewisburg, Pa., 2008) and is the editor of Leonora Sansay, *Secret History; or, The Horrors of St. Domingo; and, Laura* (Orchard Park, N.Y., 2007). His current project, a monograph coauthored with Ed White, is titled, "The Traumatic Colonel; or, The Burr of American Literature."

Matthew H. Edney is Osher Professor in the History of Cartography, University of Southern Maine, Portland, and director of the History of Cartography Project at the University of Wisconsin-Madison. He is the author of *Mapping an Empire: The Geographical Construction of British India, 1765–1843* (Chicago, 1997).

Jess Edwards is principal lecturer in English at Manchester Metropolitan University. He is the author of *Writing, Geometry, and Space in Seventeenth-Century England and America: Circles in the Sand* (New York, 2005) and is currently researching and writing on Daniel Defoe's contribution to eighteenth-century geographic culture.

Júnia Ferreira Furtado is titular professor of Modern History at the Universidade Federal de Minas Gerais, Brazil. She is the author of *Chica da Silva e o contratador dos diamantes: o outro lado do mito [Chica da Silva and the Diamond Dealer: The Other Side of the Myth]* (São Paulo, 2003), which was translated as *Chica da Silva: A Brazilian Slave of the Eighteenth Century* (Cambridge, 2009), and of *Homens de Negócio: a interioriazção da metrópole e do comércio nas Minas setecentistas [Men of Commerce: The Penetration of the Metropolis and of Commerce in Minas Gerais Captaincy in the Eighteenth Century]* (São Paulo, 1999). She is also a co-author of *Cartografia da conquista das minas [Cartography of the Mining Discoveries]* (Lisboa, 2004).

William Gustav Gartner is academic staff and a lecturer in the Department of Geography at the University of Wisconsin-Madison. He is the author of numerous articles and essays, including "Mapmaking in the Central Andes," in David Woodward and G. Malcolm Lewis, eds., *Cartography in the Traditional African, American, Arctic, Australian, and Pacific Societies*, vol. II, book 3 of *The History of Cartography* (Chicago, 1998), 257–300.

467

Gavin Hollis is an assistant professor in the Department of English at Hunter College of the City University of New York. He is the author of "'Give Me the Map There': *King Lear* and Cartographic Literacy in Early Modern England," *Portolan*, LXVIII (2007), 8–25, which won the 2006 Ristow Prize for academic achievement in the history of cartography. He is currently working on a book-length project about representations of the Americas in sixteenth- and seventeenth-century drama.

Scott Lehman received a master of arts in English Literature from San Francisco State University. He lives with his wife in Ventura, Calif., where he works as a carpenter.

Ken MacMillan is associate professor of history at the University of Calgary. He is the author of *Sovereignty and Possession in the English New World: The Legal Foundations of Empire, 1576–1640* (Cambridge, 2006) and co-editor of *John Dee: The Limits of the British Empire* (Westport, Conn., 2004).

Barbara E. Mundy is an associate professor in the Department of Art History and Music at Fordham University. She is the author of *The Mapping of New Spain: Indigenous Cartography and the Maps of the Relaciones Geográficas* (Chicago, 1996) and winner of the 1996 Nebenzahl Prize in the History of Cartography. She has published widely on indigenous maps and manuscripts. Most recently, she is co-author (with Dana Leibsohn) of *Vistas: Visual Culture in Spanish America/Cultura Visual de Hispanoamérica, 1520–1820*, an innovative bilingual DVD (Austin, Tex., 2010).

Andrew Newman teaches English at Stony Brook University. His recent articles include "The *Walam Olum:* An Indigenous Apocrypha and Its Readers," *American Literary History*, XXII (2010), 26–56, and "'Light Might Possibly be Requisite,' *Edgar Huntly*, Regional History, and Historicist Criticism," *Early American Studies*, VIII (2010), 322–357. His book, *On Records: Delaware Indians, Colonists, and the Media of History and Memory*, is forthcoming from the University of Nebraska Press.

Ricardo Padrón is associate professor in the Department of Spanish, Italian, and Portuguese at the University of Virginia. He is the author of *The Spacious Word: Cartography, Literature, and Empire in Early Modern Spain* (Chicago, 2004), and, as a specialist in the literature and culture of the early modern Hispanic world, he has also published numerous articles on lyric and epic poetry, historiography, and cartography.

Judith Ridner is associate professor of history at Mississippi State University. She is the author of *A Town In-Between: Carlisle, Pennsylvania, and the Early Mid-Atlantic Interior* (Philadelphia, 2010).

INDEX

Page numbers in italics refer to illustrations.

Account of the Eastern and Western Oceans (Dong xi yang kao), 255, 272

Account of the History, Manners, and Customs of the Indian Nations (Heckewelder), 249–250

Adams, Abigail, 407

Adams, John, 407, 414

Aeneid (Virgil), 249, 265–266, 268, 270–271

Aesthetic movement, 346

Agassiz, Louis, 9

Alarçon, Hernando de, 165

Albemarle, earl of, 354, 355, 358

Algonquian, 166–167, 248

Al Jazeera Television Network, 339–340

Allegorical maps: *Aspecto symbólico del mundo Hispánico* (Memije), 35, *36*, 38, 40; four parts of the world, 45, *46*; *Carta Chorographica del Archipielago de las Islas Philippinas* (Díaz Romero and Ghandia), *51*, 52–55; *Carta hydrographica y chorographica de las Yslas Filipinas* (Murillo Velarde), *56–57*; of Brazil, 117, 119–121, 125

Amadas, Philip, 78

America: the idea of, 1; first map showing name of, 12; invention of, 28, 64

America (Ogilby), 95, 102, 103, 105, 156

America (Tanner), 1, *3*, 4

Americae Pars, Nunc Virginia Dicta, Primum ab Anglis Inventa (de Bry), 73, *74*

Americae Sive Novi Orbis, Nova Descriptio (Ortelius), 1, *2*

American Atlas (Jefferys), 399, 433

Anderson, Benedict, 10, 365

Andrade, Gomes Freire de, 123

Andrews, Kenneth, 68, 91

Anglo-Caribbean slave codes, 454

Anglo-French conflict in North America, 292, 294–295, 300–303

Arbousset, Thomas, 272

Architecture: giant wall maps and, 412–413; and Skidi Pawnee, 216, 218–219; *A Complete Body of Architecture* (Ware), 425, *426*

Aristotle, 35

Armitage, David, 91, 99, 107

Armstrong, John, 310

Arneil, Barbara, 109

"Arrival of the Whites, The," 248–250

Arthur, Gabriel, 154

Art of Painting, The (Vermeer), 420

Ashley, Anthony Ashley Cooper, Baron, 97–100, 105, 109–114, 154, 156

Aspecto geográfico del mundo Hispánico (Memije), 35, *36*, 38, 60–62

Aspecto symbólico del mundo Hispánico (Memije), 35, *37*, 38, 40, 49, 59–61

Astrobiology, 200–201

Atlas, Laureano, 38

Atlases, Mexico, 363–364, 367, *368*, 369

Atlas geográfico, estadístico é histórico de la República Mexicana (García Cubas), 30, 363–364

Atlas pintoresco e histórico de los Estados Unidos Mexcanos (García Cubas), 366–367, *368*

Auditory geography, 162–163

Audubon, John James, 9

Azevedo Fortes, Manoel de, 125, 135

Aztec people, 363, 370, 373, 376–377

Bacon, Francis, 81

Bad Heart Bull, Amos, 238

Bagrow, Leo, 395
Baranda, Joaquín, 369
Barbacena, Visconde de, 131, 133
Barbados slave code, 459
Barbeau, Charles Marius, 257
Barbosa Lage, Domingos Vidal de, 131
Barlowe, Arthur, 78
Barros, João de, 265
Batts, Thomas, 154
Belyea, Barbara, 151, 153
Benito Cereno (Melville), 445–451, *448*,
 459, 465
Benjamin, Walter, 405
Bennett, John, 398
Berkeley, William, 104, 153, 158, 167
Beverley, Robert, 285
Big Black Meteoric Star Bundle, 190, 193,
 194, 197, 213–216
Blaeu, Willem, 87, *118*
Blathwayt, William, 87–89
Blathwayt Atlas, 87–89
Blunston, Samuel, 315
Bodener, Gabriel, 350
Bolla, Peter de, 346
Border illustrations, 138
Bosse, David, 398
Botetourt, Lord, 392, 421, 423, 427
Bowles, John, 399, 431
Brasilia (Blaeu), *118*
Brayne, Henry, 100–101
Brazil: Portuguese encroachment on, 48;
 and boundary disputes, 64; rivers as
 dividing lines of, 119
Brazil, maps of: and myth and power, 117,
 119–121, 125; Jesuit creation of, 123; and
 revolution, 129, 133–141. *See also* Minas
 Gerais
*Briefe and True Report of the New Found
 Land of Virginia* (Hariot), 73
Briggs, Henry, 80
Brito, Felipe de, 261
Brito Malheiro, Basílio de, 133
Browne, Samuel, 420–421
Brückner, Martin, 161
Brunswick, 279

Brunswick Proprietors. *See* Kennebec
 River land grant dispute
Bucius, Johannes, 38, *39*
Buckstaff, Ralph N., 208
Buel, Abel, 436
Bull, Stephen, 102
Bullock's hide story, 248–251
Bundle ceremonies, 197

Cabeza de Vaca, Alvar Nuñez, 377
Calvert, Cecilius, 154
Câmara, José Mariano de, 131
Cambodia, 251
Camden, William, 80, 94
Camões, Luis de, 265
Cantino, Alberto, 12
Capassi, Domingos, 123
Captain Jim, 193
Captain Pipe, 257
Caribbean, extended, 442, *443*
Carlisle: Hamilton on, 306–307; com-
 mercial value of, 306–307, 312–313,
 338; strategic value of, 308; patron-
 age connections and, 310; site selec-
 tion for, 317–320; and grid survey
 model, 321–322, *323*, 324, 329–330,
 333–335; central square of, *331, 336*;
 naming patterns in, 332–333; growth
 of, 336–337; the prison and churches
 of, 337–338; and settler's indepen-
 dence, 338
Carlos III, 61
Carolina, 95, 99, 106–107, 109–114
Carolina, mapping of: *Lords Proprietors'
 Maps*, 96, 103–104, 106, 108; Locke
 and, 99–106, 108–110, 114–115; and pro-
 motional geography, 99–106, 110; ver-
 bal geography of, 109; and surveyors'
 responsibilities, 113; and patriarchal
 geometry of proportion, 114
*Carta Chorographica del Archipielago de
 las Islas Philippinas* (Díaz Romero and
 Ghandia), 49, 50, *51*, 52–54
*Carta de los ferrocarilles de los Estados
 Unidos Mexicanos*, 375

Cartagena, 347, 349

Carta General de la República Mexicana (Cuba), 13, *381*

Carta hydrographica y chorographica de las Yslas Filipinas (Murillo Velarde), 49–50, 53–54, *56–57*

Cartas chilenas (Gonzaga), 132

Cartier, Jacques, 165–166

Cartographic canon: changes in the, 15–18, 38, 40

Cartographic culture, early American, 3–4, 13, 17

Cartographic descriptions archive, 164–168

Cartographic studies, 15–18, 25

Cartography: changes in form and function of, 1, 4; and adoption of neologism, 5–6; and nontextual modes of analysis, 17–18; training in, 125

Cartography, early American: development of, 1, 3; quality and content of, 4–5; Eurocentric conception of, 4–6, 11; historiographies of, 7–12; ideology and, 12–14; textual approaches to, 15–17; critical approaches to, 15–18, 25–27; pluralism in, 19–21, 24–25. *See also* Maps, colonial

Cartouche design, 428–429, *429*, 431

Catalogue of Maps (Bowles), 399

Catholic Church, 35, 62

Cave, Edward, 341, 344. See also *Gentleman's Magazine*

Cecil, Thomas, 73, 81

Center-periphery relationships, Anglo-colonial: theory of, 67–70; depiction of, on maps, 69–70; and symbols of imperial hegemony, 70, 71, 81–89; and transition from *T-O mappa mundi* to Mercator projection, 70–71, 73; and zone of marginality, 77; and zone of mastery, 77; and zone of exchange, 77–78; and *ecumene*, frontier, and transfrontier, 77–81, 86, 88; and Committee for Trade and Plantations, 87, 89; and semiotic and rhetorical de-

vices, 88–89; challenges to, 89–90, 92; as created by artists, 90; reasons supporting the positive nature of, 90–92; as established by imperial surveyors, 121; *Inconfidência Mineira* and, 127–133, 141; transposition of, 139. *See also* Imperialism

Certeau, Michel de, 10, 367, 385

Chamberlain, Von Del, 186, 191, 193, 194, 201, 203, 204

Champlain, Samuel de, 167

Chaplin, Joyce, 106

Chapman, Isaac, 423

Charles II, 68, 87, 94

Charles V, 377, 379

Chavero, Alfredo, 373

Chesapeake, Va., 147

Chimney maps, 421, 425, 431

Chippendale, Thomas, 412, 429, *430*

Christianity, 386

City and Country Purchaser's and Builder's Dictionary (Neve), 412, 427

Clark, William, 19–20, 22

Clarke, G. N. G., 395

"Classic" maps, 16

Cline, Howard, 382–384

Clinton, Henry, 417

Clothing: maps on, 433

Colleton, John, 99

Colleton, Peter, 101, 106, 110

Colonization: and political philosophy, 109; and Dido legend, 249, 254–256, 260–264, 265–271; of Ireland, 327, 333; forms of, 333

Colorado River, 165

Columbus, Christopher, 64, 369–370

Columbus centennial of 1892 (Madrid exhibition), 30, 369–370, 373–374, 376

Commerce and trade: maritime, 58; influence of cartography on, 58, 61–62; in furs, 306–307, 311–314, 319–321; native American, 311–314; effect of hurricanes on, 456–457

Community space: and central square

model, 330, *331*, 335; and boundary walking, 387

Complete Body of Architecture, A (Ware), 425, 426

Concise Natural History of East and West Florida (Roman), 416

Conestoga, 457

Congress Voting Independence, The (Savage), 409, *411*

Control Room, 339

Cookson, Thomas, 317–320, 335

Cooper, James Fenimore, 9

Cooper, William, 334

Corn Planting Ceremony, 199

Coronelli, Vincenzo, 239

Cortés, Hernán, 265, 377, 379–380, 383

Cosgrove, Denis, 10

Cosmopolitan maps, 29–30

Council of the Rulers, and the Elders against the Tribe of ye Americanites, The, 417, *419*

Council of Trade and Foreign Plantations, 98, 99

Creek, 259

Crowley, John, 350, 352, 358, 431

Cruz Cano y Olmedilla, Juan de la, 64, 65, 66

Cumming, William, 96, 103, 108, 156

Dean, Nora Thompson, 258

De Bry, Theodore, 73, *74*, 75, 78, 79, 81–83

Decorative maps. *See* Ornamental maps

Delaware (people), 248–251, 257, 259, 263–264, 275, 316

Delgado, Juan, 50

Demarcation cartography, 45, 47–49, 59, 62–63

De nieuwe en onbekende Weereld (Montanus), 95

Descrição geográfica, topográfica, histórica, e política da Capitania de Minas Gerais (Rocha), 126, 133

Descripçam do Continente da America Meridional, 123

Descripción de las Indias Ocidentalis (Herrera), 40, 41, *42*, 45, 47

Descripción de las Indias Poniente (Herrera), 40, 41, *43*

Description of New England, A (Smith), 73

Díaz Romero, Francisco, 49, 50, *51*, 52–55, 61, 64

Dictionary of the English Language (Johnson), 412

"Dido Cutting the Ox-Hide" (Stimmer), 267

Dido legend: and colonization, 29, 255–256, 265–271, 273–275; and Algonquian tradition, 248–251, 254–256; validity of, 260; dissemination of, 260–264; in Europe, 265–271, 267, 268, 269

"Dido's Problem," 274

"Dido Story in Asia, The" (Laufer), 261

Discourses on Livy (Machiavelli), 265

Discoveries of John Lederer, The (Lederer), 153–161

Dishes: maps on, 435

Divine right, 97

Doolittle, Amos, 436

Dorsey, George A., 190, 193, 194, 200

Douglass, Frederick, 464–466

Douglass, William, 299

Draper, William, 64

Drayton, Michael, 80

Dutch (people), 53, 54, 77

Dutch cartography, 70–71, 87, 117, 119

Dutch colonists: and Dido story, 255–256, 260–262, 264, 267, 269–275

Dutch East India Company (VOC), 262, 269–271, 273

Earl, Ralph, 437

East Indies, 44

Echo-Hawk, Roger, 216

Ecumene, frontier, transfrontier, 77–81, 86, 88

Edney, Matthew, 145

Edward III, 82

Edwards, Jonathan, 454

Egypt, 119
Ehrenberg, Ralph E., 12
Eliot, Jared, 456
Elizabeth I, 68
Empty spaces, cartographic, 94
Enlightenment, Age of, 139; maps of, *39*,
　135–137
Entertainment: maps for, 435
Ephemeral maps, 19–20, 150, 159, 163
Ethnocartography, 145–147, 149–153,
　164
Euro–native American cartographic col-
　laboration, 145–153, *148*
Euro–native American cartographic en-
　counters, 153, 157, 159, 162–168
Europa Regina (Bucius), 38, *39*
Evans, Lewis, 433
*Extraordinary Gazette; or, The Disap-
　pointed Politicians, An*, 417, *418*

Faith (personified), 52
Fallam, Robert, 154
Fans: maps on, 433
Farrer, John, 73, 82, 87
Fels, John, 178
Feminine space, 348, 352
Fermor, Juliana, 332
Ferro's Meridian, 138, 141
Filmer, Robert, 97
First Lords Proprietors' Map (Ogilby-
　Moxon), 28, *96*, 103–104, 106, 108, 110,
　154
Florentine Codex, 377
Folk cartography, 250–251, *252–253*, 385
Fort Amsterdam, 274
Fort Saint Frédéric, 300, 302, 303
Foster, George, 347
Four parts of the world, 45, *46*, 60
Four Pole Ceremony, *198*, 198–200, 216,
　227
France: and Paris meridian, 138; and Ken-
　nebec River maps, 291–292, 294–295,
　300–303; and alliance with Spain, 349
Franck, Harry A., 264

Franklin, Benjamin, 17, 406, 408, 409,
　423, 455–464, *460*, *461*
Frazer, James, 260
Fredericksz, Cryn, 274
Freedom of the Seas, The (Mare Liberum)
　(Grotius), 269, 270
Freeman, Philip, 402, 405
Freneau, Philip, 451–455
Freud, Sigmund, 462
Frontier, *ecumene*, and transfrontier,
　77–81, 86, 88
Fry, Joshua, 389
Fugitive slave law, 464
*Fundamental Constitutions of Carolina,
　The* (Ashley), 99, 106–107, 109, 111–113
Furniture: maps on, 435, 436
Fur trade, 311–314, 319–321

García Cubas, Antonio, 13, 30, 363, 366–
　367, 369, 373, 376, 380
Garrison, William Lloyd, 464
Gartner, William Gustav, *173*
Gascoyne, Joel, 106, *107*, 108, 156
*Generall Historie of Virginia, New-
　England, and the Summer Isles* (Smith),
　79–80, 84, *85*, 167
*General Map of the Middle British Colonies
　in America* (Evans), 433
Gentleman and Cabinet-Maker's Director
　(Chippendale), 429, *430*
Gentleman's Magazine, 300, 341–342
Gentleman's Magazine, maps in: as illus-
　tration of the news, 341–343; as a
　source of news, 344, 346; and public
　opinion, *345*, 346–348; of Havana in-
　vasion, *345*, 347–350, *351*, 352–353, *356*,
　357–358; of West Indies, 348
*Geografía histórica da Capitania de Minas
　Gerais* (Rocha), 126, 135
*Geografía y descripción universal de las
　Indias* (López de Velasco), 40, 43
Geographical education, 125, 135
Geographic alterity, 138
Geographic literacy, 343

Geographic maps: characteristics of, 367, 382

Geography: as promotion, 99–106, 108, 321–322; and language of negotiation and accommodation, 115; of slave resistance, 442, *443*, 455

Ghandia, Antonio de, 49, 50, *51*, 52–55, *56*–57, 61, 64

Giant maps. *See* Wall maps

Giddens, Anthony, 10

Gilbert, Humphrey, 78

Glen, James, 145, 147, 161, 163

Glimpses of Japan and Formosa (Franck), 264

Gonzaga, Tomás Antonio, 131, 132

González de Barcia, Andrés, 40

Goode, John Paul, 190

Good Eagle, 193

Gosnold, Bartholomew, 78, 167

Gottfried, Johann Ludwig, 266, *268*

Great Britain: early mapping culture of, 13–14; Philippine Islands and, 64; and Kennebec River maps, 291–292, 294–295, 300–303; and public's interest in North America, 299, 301; and Irish colonization, 327, 333; and colonization and town planning, 337; geographic literacy in, 343; journalistic cartography in, 343–344, *345*; and maps of Havana invasion, *345*, 347–350, *351*, 352–355, *356*, 357–358; and maritime rule, 349–350, 354. *See also* Center-periphery relationships, Anglo-colonial

Great Cleansing Ceremony, 213

"Great" maps, 16

Great Treaty, 259

Great Washing Ceremony, 173, 229–231, 238

Green, John, 295, *296*, 297–299, 300, 302–304

Greene, Jack P., 67, 69, 89

Greenwich meridian, 138

Grenville, Richard, 78

Greville, Fulke, 13

Grotius, Hugo, 269–270, 273

Ground Breaking Ceremony, 215, 227, 233

Gulf Stream, The (Homer), *463*

Gulf Stream map (Franklin), 456–464, *460*, *461*

Gusmao, Alexandre de, 123

Guthrie, William, 393

Hakluyt, Richard, 71, 165–166

Hakluytus Posthumus (Purchas), 80

Hako ritual, 204–205, 207, 233

Halchidhoma, 165

Hall, David, 277

Hall, Ralph, 73, 81

Hamilton, Andrew, 334

Hamilton, James, 306–307, 312, 330, 334

Handkerchiefs: maps on, 433, 436

Hariot, Thomas, 73

Harley, J. B., 15, 69, 93–95, 108, 134, 145–147, 151–152

Harris, William, 159–160, 163

Harris, Wilson, 446

Harrison, John, 100

Harvey, David, 10

Havana, maps of, in *Gentleman's Magazine: Plan of the City of Havanah*, *345*; and public opinion, *345*, 347–348; and support for invasion, 347–349; and depiction of a quasi-feminine space, 348, 352; and accompanying narrative, 348, 355, 357–358; and visual messages encouraging invasion, 350, *351*, 352–353; and penetrative orientation, 352–353; and lack of written text, 353; post-invasion, 354–355, *356*, 357–358

Heath, Joseph, 302

Hébert, John, 147

Heckewelder, John, 248–250, 254, 260

Helgerson, Richard, 69, 94–95, 108

Henry, John, 389, *390*, 391–393, 397, 404, 405

Herman, Augustine, 147

Heroic Slave, The (Douglass), 464–466

Herrera y Tordesillas, Antonio de, 40, *42, 43, 45, 46,* 47, 59, 61

Hidatsa, 19

Hide story of deceptive land purchase ("hide trick"). *See* Dido legend; Land acquisition, deceptive practices of

Hildebrandt, Stefan, 274–275

Hilton, William, 105

Hispanic World, 49

Historia de la Provincia de Philipinas de la Compañía de Jesús (Murillo Vellarde), 50

Historia general de los hechos de los Castellanos en las Islas i Tierra Firme del Mar Océano (Herrera), 40

Historia general sacro-profana política y natural de las Islas de Poniente llamadas Filipinas (Delgado), 50

Historische chronica (Gottfried), 266, 268

History of Carolina (Lawson), 156

History of Rome (Livy), 266

Holder, Preston, 197

Hollis, Gavin, 104

Holme, Thomas, 324, 327

Homann, Johann, 156

Homer, Winslow, *463*

Horcasitas, Fernando, 384

Hottentots, 272

Hudson, Henry, 249, 254

Hugo, Victor, 462

Hulme, Peter, 442–443

Humboldt, Alexander von, 17

"Hurricane, The" (Freneau), 451–455

Hurricanes: and geography of slave resistance, 442, *443,* 455; map of, *443;* theological view of, 454, 455; disempowered human agency with, 454–455; scientific theories of, 455; trade and, 456–457; and intercolonial and regional responses, 457–458. *See also* Slave resistance and hurricanes

Huske, John, 299–300

Hutchinson, Edward, 280

Iberian Union, 119

Imaginative maps, *39*

Imperial cartography. *See specific countries*

Imperialism: maps in the deployment of, 13–14, 21, *23–24,* 69–70, 78–81, 121, 294–295, 377, 379; and semiotic and rhetorical devices, 81–86; and Kennebec River maps, 291–292, 300–303. *See also* Center-periphery relationships, Anglo-colonial

Imperial sovereignty principle, 109

Inconfidência Mineira, 127–135, 141

Independence Hall, 406

"Indias Occidentales," 44

Indies, the, 40, 44–45, 47, 49, 64

Indies of the West, 44, 47

Indigenous maps: ephemerality of, 19–20, 150, 159, 163; explorers' use of, 19–20, 158, 376–377, 379; European cartography and, 145–153, *148,* 377, *378,* 379; validity of, 151–152, 159–160, 163; translation of, 153, 159, 162–166; and itinerary form, 161, 363; auditory geography in, 162–163; and descriptions archive, 164–168; in a national cartography, 363–364, 367, *368,* 369; symbolic weight of, 377, 379; history recorded on, *380,* 382–388; and creation of space, 381–382; and the *titulos primordiales* tradition, 384; and the time-space relationship, 384, 386–388; and the organization of space through hierarchies of places, 385. *See also* Native Americans; Skidi Star Chart

Individual dominion theory, 97

Insignia: and imperial power, 139

Inter Catera, 71, 79

Invention, cartographic, 28, 64

Iraq: war in, 339–340

Ireland, 326–327, *328, 333,* 337

Iroquois, 165–166, 286, 314, 316

Irving, Washington, 254–255, 274

Iser, Wolfgang, 353

Islands, 80–81
Islands of the West, 44, 47
Isle of Pines, The (Neville), 81
Itinerary form, 161, 363

Jacob, Christian, 396
James (duke of York), 97
Jansson, Johannes, 87
Jefferson, Peter, 389
Jefferson, Thomas, 64, 423
Jefferys, Thomas, 354, 399, 404, 433
Jennings, Francis, 313
Joao V, 125
Johnson, Samuel, 393, 412
Johnston, Thomas: and the Kennebec
 River maps, 281, *283, 286, 287, 288–
 289, 290–292, 293, 294–295, 297–298,
 300, 302–303, 304
Journalistic cartography: as illustra-
 tion of the news, 341–343; as a source
 of news, 344, 346; and public opin-
 ion, *345,* 346–348; and creation of the
 news, 346
Judith (of the Old Testament), 35, 62

Kennebec River land grant dispute: con-
 testants of, 278; broadside 1753 Bos-
 ton map in the, 278–281, *283, 284–287,
 286,* 304; beginnings of, 279; archival
 and legal discourse of, 280–281, *282,
 284;* and legal recourse, 290–291
Kennebec River maps: mystery of, 276–
 277, 287; and competition for empire,
 277, 291–292, 294–295, 300–303; pub-
 licity and public discourse of, 277–278,
 280–281, 284–287, 291, 294–295, 301–
 305; broadside 1753 Boston map, 278–
 281, *283, 284–287, 286,* 304; and North
 survey, 279; large 1755 Boston map,
 287, *288–289, 290–292, 293, 294–295,
 304;* small 1755 London map, 295, *296,
 297–304*
Keppel, George (earl of Albemarle), 354,
 355, 358
Khader, Samir, 339

Kitchin, Thomas, 296, 297, 299
Knickerbocker's History of New York
 (Irving), 254–255
Kottenkamp, Franz, 263–264
Kraft, Herbert, 258
Kulikoff, Allan, 114

Labor theory of value, 93, 97–98, 114
Lachine Rapids, 165
Lake Miccosukee, 156
Lake Ushery, 156, 158, 166
Lakota maps, 238
Lamhatty, 149
Land acquisition, deceptive practices
 of: and ox-hide measure, 29, 248–251,
 252–253, 255, 257–264, 271, 275; in fic-
 tion, 254–255; Dutch colonization and,
 255–256, 260–262, 269–275. *See also*
 Dido legend
Lane, Ralph, 78
Language of maps: quantitative, 45,
 47–49, 59, 62–64; uniformity in, 125,
 135, 138; indigenous, 153, 159, 162–165;
 and auditory geography, 162; and em-
 pire, 300–303
Laslett, Peter, 100
Latour, Bruno, 10, 116, 139
Laufer, Berthold, 261, 262, 272
La Vega, Garcilaso de, 266
Law of Prize and Booty, The (De Jure
 Praedae) (Grotius), 269
Lawson, John, 149, 156
Lederer, John, 104–105, 109–110, 153–163,
 166–167
Leerstelle concept (empty placeholder),
 353
Lefebvre, Henri, 10
Lemire, Charles, 248–251
Lenape, 257, 259
LeTort, James, 314, 318
Lewis, G. Malcolm, 150, 157, 161, 165–166
Lewis, Meriwether, 19
Lewis, Samuel, 22
Lewis and Clark expedition, 19–21
Ley Lerdo, 366

Leyte Island, 54, 55

Lienzo de Petlacala, 384

Lienzo de San Pedro Ixcatlan, 380–388, *380*

Lines of demarcation, 45, 47–49, 59, 62–63

Linton, Ralph, 185, 190

Lisbon meridian, 138

L'Isle, Guillaume de, 156

"Little" maps, 16

Livy, 249, 266

Lobo da Silva, Luís Diogo, 125

Local maps, 19–20, 24, 28–30, 69

Locke, John: labor theory of value of, 93, 97–98, 114; theory of property of, 93, 111; and mapping Carolina, 95, 99–106, 108–110, 114–115; and *The Fundamental Constitutions*, 111–113; political writing of, 269

"Locke 1671," 104

Logan, James, 313, 423

London Magazine, 300, 342

Longitude, 44, 63, 138, 141

López de Legazpi, Miguel, 273

López de Velasco, Juan, 40, 44–45, 61

Lords Proprietors of Carolina, 98–99, 101, 103, 105–113, 154

McConville, Brendan, 92

Machiavelli, Niccolò, 265

Maciel, José Alvares, 131

Mackellar, Patrick, 355, 358

McLeod, Bruce, 93

McMurray, William, 436

Madrid exhibition (Columbus centennial of 1892), 30, 369–370, 373–374, 376

Magazines: British, 343–344, *345*, 346; critiques of maps in, 391–393. See also *Gentleman's Magazine*; Journalistic cartography

Maie e Barbalho, José Joaquim da, 131

Maize ceremonials, 226–229

Mandan, 19

Mapa da capitania de Minas Geraes com a devisa de suas comarcas (Rocha), 135–137, *136*, 141

Mapa das Cortes, 123, *124*

Mapa de Sigüenza, 363

Mapa geográfico de América Meridional (Cruz Cano), 64, *65*

Map catalogs, 402–404

Map galleries, 408–409

Mapmaker: label of, 6

Mapmaking vs. mapping, 170–172

Map-moments, 152–153, 161

Map of Lewis and Clark's Track, across the Western Portion of North America, A (Clark), 20–21, 22

Map of the British and French Dominions (Mitchell), 16, 409, 413, 414, 416

Map of the British Empire in America (Popple), 406–408, *407*, 413, 414, 416

Map of the City and Liberties of Philadelphia (Smithers and Reed), 433

Map of the Most Inhabited Part of Virginia (Fry and Jefferson), 389

Map of the Present Seat of War in North America, A, 433, 434

Map of the United States (Melish), 13, 21, 23

Map of the Whole Territory Traversed, A (Lederer), 154, *155*

Map of Virginia, A (Smith), 73, 147, 149, 167

Mappa da Comarca do Sabara (Rocha), 138–139, *140*

Mapping industry: professionalization of, 5–6

Mapping vs. mapmaking, 170–172

Mapp of the Sommer Ilands Once Called the Bermudas (Norwod), 79, 84

Maps: standardization of, 5; definition of, 6, 8, 24–25, 134, 146, 391, 393–394, 412; as geometrically configured, 10–11, 14; extracartographic applications of, 17; and manipulation of scale, 348; evaluation of, 391–394; as objects, 396; as luxury items, 398; surplus value of, 406; as silent signifiers, 414; conduct and, 416, 436. See also Language of maps

Maps, Charts, Plans (Jefferys), 404

Maps, colonial: as agents of domination, 11; nation building and, 12–14, 19–21; individual colonies as focus of, 73–77, *74, 76; ecumene,* frontier, transfrontier depicted on, 77–81, 86, 88; and perspective, 80–81; national symbols on, 82; and toponyms, 83–84, 89; ornamental value of, 393–397; commodification of, 402–403, 406, 440–441; and class and consumption patterns, 421–424, 427–428; cartouche design of, 428–429, *429,* 431; in fiction, 433; diverse uses for, 433–435; visual experiences of, 435–438, *438. See also* Cartography, early American; Ornamental maps; Wall maps

"Map Seller," 435

Map trade, 397–399, *400*

Maria I, 128, 130

Maritime commerce, 58

Marlowe, Christopher, 266

Martyr, Peter, 377

Maryland, 311, 315–317

Mason, John, 73, *77,* 78, 81, 82

Massachusetts, 167

Mather, Increase, 454

Mathews, Maurice, 108, 113

Mayhew, Robert, 94

Melish, John, 13, 21, *23,* 24, 26

Melville, Herman, 445–451, *448,* 459, 465

Memije, Vicente de, 35, *36, 37,* 38, 48–49, 58–64

Memória histórica da Capitania de Minas Gerais (Rocha), 126, 132

Memoria para servir a la carta general del imperio Mexicano (García Cubas), 367

Meneses, Luís da Cunha, 126, 132–133

Meneses, Rodrigo José de, 126

Mental maps, 123

Mercator, Gerard, 71

Mercator projection, 1, 70–71, 73, 87

Merian, Matthäus, the Elder, 266, *268*

Mexico, early indigenous maps of: in national atlases, 363–364, 367, *368,*
369; celebratory exhibition of, 369–370, *372,* 373–374; as spatial narratives, 380–388, *381*

Mexico, early maps of: in atlases, 363–364, 366–367, *368,* 369, 372–373; imagining dominion of, 365; and mathematical modeling of space, 365; and Madrid exhibition, 369–370, 373–374, 376; and railroads, 374, *375,* 376

Mexico, nineteenth century: social and ethnic divisions of, 365–366; and Ley Lerdo reforms, 366; indigenous space in, 366, 367, *368*

México a través de los siglos (Mexico through the Centuries), 372

Miami, 312

"Middling" maps, 16

Military siege maps, 341–343, 346–349. See also *Gentleman's Magazine*

Millar, Andrew, 298–302

Miller, Samuel, 248

Minas Gerais: Rocha's maps of, 116, 121, 133–141; Portugal's claim to, 117; El Dorado in, 120; captaincy of, 121–123, 125; secrecy surrounding maps of, 122; Jesuit mapping of, 123; *Inconfidência Mineira* and, 127–135, 141

Mindanao island, 53–55

Ming Annals, 261, 272

Ming shi, 272

Mirrors, 431–432

Misquihuala map, 371, *372*

Mitchell, John, 16, 299, 409, 413, 414, 416, 436

Mitchell, W. J. T., 396

Mixed-media maps, 341

Montanus, Arnoldus, 95

Monthly Intelligencer. See Gentleman's Magazine

Morga, Antonio de, 272–273

Morgan, Frank, 275

Morning Star Sacrifice, 205–208

Morse, Jedidiah, 405

Morse, Samuel F. B., 437

Moteuczoma, 377, 379

Moulton, Forest Ray, 188, 193, 198–202

Moxon, James, 103, 108

Munsee Delaware, 167, 257

Murie, James: and the Skidi Pawnee, 177, 182, 187, 188, 193, 194, 197, 203–205, 207, 214–216, 220–221, 229, 232, 235, 239

Murillo Velarde, Pedro, 49–50, 53–54, 56–57, 58–59, 64

Muscogee (Creek), 259

Myth of continents, 45, 119

Narrative: with maps, 348, 355, 357–358; lack of, with maps, 353; of spatial control, 380–388, *381*; within cartographic space, 385

"Narrative of the Late Massacres" (Franklin), 457

National identity, 363–370, *368*, 372–373, 376

Nation building: and America, 12–14, 19–21; meridians and, 138; and Mexico, 364–365, 380

Native Americans: and thinking in cartographic terms, 19; and empire and dominion, 106, 108–111; portrayal of, on maps, 108, 110, *140*, 285–286, *286*; fair dealings with, in Carolina, 109–110, 114; European cartographic encounters with, 153, 157, 159, 162–168; as guides, 157–158, 377; trade with, 311–314; massacre of, condemned, 457. *See also* Indigenous maps

Native place-names: eradication of, 83–84, 89, 108, 110–111

Nebuchadnezzar, 62

Nechecole, 19–20, 24

Needham, James, 154

Neve, Richard, 412, 427

Neville, Henry, 81

New Amsterdam, 248

New and Accurate Map of Virginia, A (Henry), 389, *390*, 391–393, 397, 404, 405

New Atlantis (Bacon), 81

New Discription of Carolina, A (Ogilby), *96*

New England (Smith), 73, 75, *76*, 79, 81–83

Newes and Strange Newes from St Christophers of a Tempestuous Spirit (Taylor), 453

Newfoundland (Mason), 73–74, 77, 81, 82, 84

New Map of America from the Latest Observations, A (Senex), 156, 157

New Map of the Country of Carolina, A (Gascoyne), *107*

Nez-Pierce, 19

Noël, Jacques, 166

North, John, 279, 302

Norwood, Richard, 79, 84

Oettinger, Marion, 384

Officer and Laughing Girl (Vermeer), 420

"Of Property" (Locke), 93

Ogilby, John: *First Lords Proprietors' Map*, 28, 96, 103–106, 108, 110, 154; Charles II's coronation and, 94; *America*, 95, 103, 105, 156; *New Discription of Carolina, A*, 96; Locke and, 101, 113–115

O'Gorman, Edmundo, 12

Old State House, 406

Olive, Peter, 423

Oriental India, 47

"Origin of the Basket Dice Game" (Dorsey), 200

Ornamental maps: useful vs., 393, 394; sales strategies for, 398–399, 400; redefinition of, as picture prints, 398–399, 400, 401–402, 404–406; price patterns of, 402–405, 440–441; sale of outdated and refurbished, 405; giant wall maps used as, 406–407, 407, 409, 410, 411, 415, 416–418; public display of, 406–412; wall maps used as, 420, 425, 427, 431–432; overmantle, 421, 425, 431; domestic display of, 425, 427; as firescreens, 433; diversity in, 433,

434, 435; as sensory agents, 436–438, *438*. *See also* Wall maps

Ortelius, Abraham, 1, 2, 4, *46*, 71

Otherness, 138

Packe, Christopher, 394

Paintings: maps in, 437–438, *438*

Palacio, Vicente Riva, 373

Paris meridian, 138

Parkman, Francis, 9

Parsimonious Universe, The (Hildebrandt and Tromba), 274–275

Partie de l'Amérique septentrionale (Vaugondy), 429

Paso y Troncoso, Francisco, 370, 376

Patriarcha (Filmer), 97

Patriarchal stewardship doctrine, 109–111, 114

Pawnee Nation, 169, *173*. *See also* Skidi Pawnee

Pawtuckets, 167

Pejepscot Company. *See* Kennebec River land grant dispute

Penn, Thomas (proprietor of Pennsylvania): towns founded by, 306–307, 317; vision of, 307–308; and political challenges and patronage politics, 309–310, 317; and urban development, 310–314; and settlement of Indian lands, 315; settlers sought by, 315–316; and land acquisition, 316–317; goals of, 329. *See also* Carlisle; Urban planning

Penn, William, 259, 308, 311, 313, 324, 327

Pennsylvania: demographics of, 308–309; political climate of, 309–310; competition and commerce in, 311; and border disputes, 311, 315–317; Indian trade in, 311–314; planned towns of, 321–322, *323*, *325*, 326–327, *328*, 329, 333–335

Pennsylvania Assembly, 406–409, *411*

Pennsylvania Gazette, 405

Perecute, 154

Performative cartography: in understanding maps, 17–18; oral rituals and, 19; newsroom as, 339–340; and boundary walking, 387; wall maps as, 416–418, *418*, *419*. *See also* Skidi performance cartography

Perry, William, 393

Personification: and Spanish cartography, 35, *37*, 38, 49, 59–61; and the four parts of the world, 45, *46*, 60

Peru, 64

Peters, John, 427

Peters, Richard, 307, 312, 318

Philadelphia, *323*, 324, 327, 333–334

Philippine Islands: cartographic representations of, 35, *37*, 49–55, *51*, *56–57*, *58–59*; colonial America and the, 40; control of, 48–50, 61–62, 64

Pictures: redefining maps as, 398–399, *400*, 401–402, 404–406

Places: renaming of, 83–84, 89, 110–111

Plan of the British Dominions of New England (Douglass), 299

Plan of the City and Harbour of Havana, *351*

Plan of the Siege of the Havana, A, *356*

Playing cards: maps on, 435

Pluralism: cartographic, 17–21, 24–25

Plymouth Company. *See* Kennebec River land grant dispute

Pocock, George, 354, 355, 358

Political Magazine, 342

Poma de Ayala, Felipe Guamán, 40

Pombal, Marquês de, 130

Pomponius Secundus, 273

Popple, Henry, 406–408, *407*, 413, 414, 416

Population maps, 134

Porfirio Díaz, José de la Cruz, 369–370, 372

Porto Bello, 344, 349

Portugal: and colonization of Brazil, 48, 117, 119–122, 125; Philippine Islands and, 48–50; and conflicts with Spain, 53, 64, 117, 119–121; Mercator projection and, 71; geographical training in,

125; and meridian of Lisbon, 138; and
Dido legend, 260–262, 265, 271. *See
also* Minas Gerais
Powhatan, 167
Price, William, 398
Primer nueva corónica y buen govierno
(Poma de Ayala), 40
Principal Navigations (Hakluyt), 71, 72,
165–166
Promotional geographies, 99–106, 108
Propaganda: maps as, 339–340, *345*, 347–
350, *351*, 359
Property: private, 106, 120, 454, 465. *See
also* Kennebec River maps
Property rights: Lockean theory of, 28,
93, 97–98, 108, 111–112
Ptolemy, 119
Public discourse: Kennebec River maps,
277–278, 280–281, 284–287, 291, 294–
295, 301–305
Publicity: Kennebec River maps, 277–
278, 280–281, 284–287, 291, 294–295,
301–305
Pufendorf, Samuel, 269
Pulteney, William, 347
Purchas, Samuel, 80
P'u Sung-ling, 262

Quirino, Carlos, 38, 50

Railroad maps, 374, *375*, 376
Rajamora, 273
Ralegh, Walter, *77*
Ratterman, H. A., 156
Rebellious maps, 129, 133–141
Reconstruction era, 463
Reed, John, 433
Reid, Anthony, 260–261
Relaciones geográficas de Indias, 40
Relación geográfica, 370–371, *372*
*Relation of a Discovery Lately Made on the
Coast of Florida, A* (Hilton), 105
Religious liberty, 109
Rembrandt, 269–270

Rementer, Jim, 258
Renaissance geographical thought, 45
Restoration period, 94–95, 99
Revolution: maps of, 129, 133–141
Ribeiro, José Pereira, 131
Rio de Janeiro meridian, 138
Ritual: maps and, 19–20; architecture of,
216–219, *217*, 222–224, *223*. *See also* Per-
formative cartography
Rizal, José, 61
Roaming Scout, 193, 194, 199, 203, 214,
215, 232
Robinson, Arthur, 394
Rocha, José Joaquim da: Minas Gerais
maps by, 116, 121; as military cartogra-
pher, 125–127; *Inconfidência Mineira*,
127–135, 141; as rebellious mapmaker,
133–141, *136, 140*
Rodaway, Paul, 162
Roman, Bernard, 416
Romane Historie (Livy), 249
Roselli, Francesco, 178
Rowson, Susanna, 436
Royal coat of arms, 71, 81–83, 88–89, 111

Sagadahoc River, 279
Saint Lawrence River, 165–166
San Pedro Ixcatlan, 380–388, *381*
Sarr, Johann Jacob, 262
Savage, Edward, 409, *411*, 437
Saxton, Christopher, 69, 80–81, 84, 90
Sayer, Robert, 398
Schoolcraft, Henry, 259
Schwartz, Seymour, 12
Scot's Magazine, 342
Second Lords Proprietors' Map (Gas-
coyne), 108, 156
Second Treatise of Government (Locke),
93, 98, 107
Seed, Patricia, 254
Seeing Eagle, 193
Seller, John, 87
Senebier, Jean de, *39*
Senex, John, 156

Sensory experiences of maps: auditory, 162–163; visual, 350, *351*, 352–353, 414, *415*, 431–432, 435–438, *438*

Servius Grammaticus, 274

Seven Years' War, 64, 343, 349

Shakespeare, William, 267

Shammas, Carole, 423

Shawnee, 314, 316

Shelling the Sacred Ear of Corn Ceremony, 173, 226–227, 238

Sheraton, Thomas, 428

Sheridan, Thomas, 393

Shils, Edward, 67

Shippen, Edward, 320

Shirley, William, 291, 294, 300

Short, John Rennie, 12

Shoshone, 19

Silva Xavier, Joaquim José da ("Tiradentes"), 129, 130, 133–135

Skidi Pawnee: summer hunting camps of, 183, *184*; and symbolic importance of cervid skin, 185; Big Black Meteoric Star Bundle of, 190, 193, 194, 197, 213–216, 225; world creation story of, 194–197, 199–200, 237; and basket dice game, 200; architecture of, 216, 218–219; and bundle rotation scheme, 229; oral traditions of, 240–247

Skidi Pawnee heartland, *173*

Skidi performance cartography: and Thunder Ceremony, 173, 187, 193, 198, 213, 216, 218–226, *223*, 233, 235, 238; and Shelling the Sacred Ear of Corn Ceremony, 173, 226–227, 238; and Great Washing Ceremony, 173, 229–231, 238; and bundle ceremonies, 197; and Four Pole Ceremony, *198*, 198–200, 216, 227; and Corn Planting Ceremony, 199; and Hako ritual, 204–205, 207, 233; and Morning Star Sacrifice, 205–208; and Great Cleansing Ceremony, 213; and Big Black Meteoric Star Bundle, 214–216; and Ground Breaking Ceremony, 215, 227, 233; earth lodge as ritual stage for, 216–219, *217*,

222–224, *223*; and maize ceremonials, 226–229; and Young Corn Plant Ceremony, 229; integration of map form, content, and context in, 231–235, *234*; in understanding content and context of Skidi Star Chart, 236–237

Skidi Star Chart: scholarly interpretations of, 172–175; traditional uses of, 173; photograph of, *174*; and map form analysis, 178–179; cartographic signs and symbols of, 179, *180*, *181*; and spatial syntax, 182–183, 210–211; canvas of, 183, 185–186; pigments used on, 186–187; application techniques of, 187–188; age of, 188, 190–192; and map content analysis, 192–193; identification of celestial objects on, 193–194; world creation and, 194–197, *196*; as conceptual portrait of the heavens, 197–198; and the Seven Stars, 198–202; referents for celestial objects on, 198–202, 237–238, 240–247; and color and directional symbolism, 202, 204–205; and World Quarter Stars, 202–205; cross size on, 208–209; and map context analysis, 211–214; cover for, 215; Thunder Ceremony and, 224–226; viewer orientation of, 232–236, *234*, 238; understanding of, 236–238; purpose of, 236–239; ritual and tradition depicted on, 237; graphic narratives embodied in, 238; time and space depicted on, 238

Slave resistance and hurricanes: geography of, 442, *443*, 455; in *Benito Cereno* (Melville), 445–451, *448*, 459, 465; and "The Hurricane" (Freneau), 451–455; and Gulf Stream map (Franklin), 456–464, *460*, *461*; and *The Heroic Slave* (Douglass), 464–466

Slavery, 110, 454, 461–462, 464

Smith, John: *A Description of New England*, 73; *New England*, 73, 75, 76, 79, 81–83; *Virginia*, 73, 75, 77, 79, 81–83, 147, *148*, 166; *A Map of Virginia*, 73, 147,

149, 167; *Generall Historie of Virginia, New-England, and the Summer Isles,* 79–80, 84, *85,* 167; Algonquian maps for, 166–167

Smithers, James, 433

Snake, Bessie, 257

Soares, Diogo, 123

Social topography, 390–391

Soja, Edward, 10

"Soneto a Boscán desde la Goleta" (La Vega), 266

Space: cartographic configuration of, 10–11; empty, 94; ordering of, by mapping, 330, *331,* 332–333, 337; and community, 330, *331,* 335, 387; quasi-feminine, 348, 352; mathematical modeling of, 365; physical representations of cartographic, 373–374, 381–382, 385–386; organization of, through hierarchy of place, 385. *See also* Performative cartography

Space-time relationship: and maps, 238, 384, 386–388

Spain: and Dido legend, 29, 261, 266, 271–273; cartographic images of, 38; official maps of, 41, *42, 43;* Philippine Islands and, 48, *51,* 52–55, *56–57,* 58–59, 64; conflicts of, with Portugal, 53, 64, 117, 119–121; and Iberian Union period, 119; indigenous peoples configured by, 366; and Madrid exhibition, 370

Spanish cartography: personification in, 35, *37,* 38, *39,* 49, 59–61; line of demarcation in, 40, 41, 44–45, 47–49, 59; discrepancies in, 44–45; and Hispanic World defined, 49; Catholicity emphasized in, 60; ideological claims of, 61; and a metageography of sovereign aspirations, 63–64; Mercator projection and, 71

Spanish conquistadores: and use of indigenous maps, 376–377, 379

Spate, Oskar, 38

Speed, John, 81, 90, 154

Stallybrass, Peter, 462

State of the British and French Colonies (Green), 301–302

Stimmer, Tobias, 266, *267*

Strachey, William, 268

Sucesos de las Islas Filipinas (Morga), 272–273

Sullivan, Florence, 102

Susquehanna Valley, 313–314, 316

Susquehannock, 313, 314

Swan, Abraham, 412

Swanton, John R., 257–258

Symbolic weight of maps, 377, 379

Symbols, cartographic: of authority, 14, 69, 70, 81–83, 88–89; on Skidi Star Chart, 179, *180, 181*

Talbot, William, 104, 109, 154, 156, 159–160, 167

Tanner, Henry S., 1, *3,* 4

Taxation, 131, 132, 134

Taylor, John, 453

Tempest, The (Shakespeare), 267

Tenochtitlan, 377, *378,* 379

Textuality of maps, 15–17

Theatre of the Empire of Great Britaine, The (Speed), 90, 154

Theatrical dimension of maps, 17–18, 19. *See also* Performative cartography; Skidi performance cartography

Theatrum Orbis Terrarrum (Ortelius), 1, *46*

Thematic maps, 17

Theses mathemáticas (Memije), 48–49, 59, 61–64

Thornton, John, 87, 88

Thunder Ceremony, 173, 238; offering sticks in, 187, 229; participants in, 193; and role of Big Black Meteoric Star Bundle, 213; and earth lodge topology, 216, 218, 223; overview of, 219–226; viewer orientation of, 233, 235

Tillyard, E. M. W., 9

Time-space relationship: and maps, 238, 384, 386–388

Tocqueville, Alexis de, 9
T-O mappa mundi, 70–71
Toponyms, 83–84, 89, 110–111
Trade. *See* Commerce and trade
Tragedie of Dido Queene of Carthage (Marlowe), 266
Transcendental maps, 236
Transfrontier, *ecumene*, and frontier, 77–81, 86, 88
Treaty of Aix-la-Chapelle, 349
Treaty of El Pardo, 48–49, 64
Treaty of Lancaster, 312
Treaty of Madrid, 27, 48, 49, 59, 123, 125
Treaty of San Ildefonso, 48, 49
Treaty of Tordesillas, 40, 71, 79, 117, 119, 122
Tromba, Anthony, 274–275
True Reportory of the Wrack (Strachey), 268
Two Treatises of Government (Locke), 97, 98, 108, 111–112

Universalis Cosmographia (Waldsee-müller), 12
Universal Magazine, 342
Urban planning: competition and commerce in, 306–307, 312–314, 319–321; Penn's vision of, 307–308; and site selection, 313, 317–320; and incentives for settlers, 321–322; objectives in, 321–322; and grid survey model, 321–322, *323*, 324, *325*, 326–327, *328*, 329, 333–335; and ordering people and spaces, 330, *331*, 332–333, 337, 385; and central square model, 330, *331*, 335; and naming patterns, 332–333; and symbols of authority, 337
Utopia (Moore), 81
Utopian literature, 81

Valcojo, Luis, 383
Vasconcelos, Diogo de, 131
Vassall, Florentius, 290–291, 295, 297–298, 302
Vaughn, William, 73

Vaugondy, Robert de, 429
Verelst, John, 286
Verhoef, Willem Pieterzoon, 271
Verhulst, Willem, 273
Vermeer, Jan, 420
Vernon, Edward, 344, 349
Virgil, 249, 265–266, 268, 270–271
Virginia (Smith), 73, *75*, 77, 79, 81–83, 147, *148*, 166
Virginia Gazette, 391–393, 405, 420
Virgin Mary, 35
Visscher, Nicolas, 87
Visual experience: maps and, 350, *351*, 352–353, 414, *415*, 431–432, 435–438, *438*
Vorsey, Louis de, 161

Wagner, Charles, 347
Wahunsunacawh, 167
Waldseemüller, Martin, 12
Walking Purchase, 250, 259
Wallerstein, Immanuel, 10, 442
Wall maps: as decorative objects, 413, 425, 427, 431–432; visual experience of, 414, *415*, 431–432; in domestic settings, 418, 420–425, 427–429, *428*, 431–432, 437; ornamental value of, 420; in portrait paintings, 437–438, *438*. *See also* Maps, colonial; Ornamental maps
Wall maps, giant: decorative value of, 406–407, *407*, 409, *410*, *411*, 413, *415*, 416–418; public display of, 406–407, 408–409, *410*, *411*, 412–414, 416–418; architecture and, 412–413; and performative discourse, 414, 416–418, *418*; satirical commentary on, 417, *418*; as room screens, 433
Ware, Isaac, 412, 425, *426*
Warhus, Mark, 150
War of Jenkins's Ear, 343, 344, 346, 347, 349, 350
War of the Emboabas, 127
Waselkov, Gregory, 147, 149, 150, 161
Washington, George, 404, 436
Watch paper: maps on, 434

Weason, Jack, 154
Webb, Nathan, 423
Weltfish, Gene, 177, 201–203, 205, 220, 227, 229
West India Company, 273–274
Weymouth, George, 78
Wheatley, Paul, 200
Whig party, 95, 97, 111–112
White, Allon, 462
White, John, 78
Whiting, Thomas, 423
Wilcox, Thomas, 423
Williams, Raymond, 145
Wilson, Samuel, 106, 108, 110
Winthrop, John, 454
Wood, Abraham, 154

Wood, Denis, 178
Wood, Peter H., 463
Wood, Stephanie, 384
Wood, Thomas, 154
Woodward, David, 69, 134, 177–178, 235, 395
World creation story, 194–197, 199–200, 237
Wright, Edward, 71, 72, 87
Wroth, Lawrence C., 287, 290, 291
Wyandot, 259

Yuchi, 259

Zhang Xie, 255, 272
Zograscope, 431